ABSTRACT EXPRESSIONISM AND THE MODERN EXPERIENCE

Abstract Expressionism and the Modern Experience

STEPHEN POLCARI

CAMBRIDGE
UNIVERSITY PRESS

Published by the Press Syndicate of the University of Cambridge
The Pitt Building, Trumpington Street, Cambridge CB2 1RP
40 West 20th Street, New York, NY 10011-4211, USA
10 Stamford Road, Oakleigh, Victoria 3166, Australia

First published 1991
First paperback edition 1993

Printed in the United States of America

Library of Congress Cataloging-in-Publication Data

Polcari, Stephen.
Abstract Expressionism and the modern experience / Stephen Polcari.
p. cm.
Includes bibliographical references (p. 397) and index.
ISBN 0-521-40453-3
1. Abstract expressionism – United States. 2. Arts, Modern – 20th
century – United States. I. Title.
NX504.P65 1991
700'.973'0904–dc20 90-49472

A catalog record for this book is available from the British Library.

ISBN 0-521-40453-3 hardback
ISBN 0-521-44826-3 paperback

TO P. AND W.,
MY PARENTS,
AND TO BETH

CONTENTS

Contents

Part Three Transformations

ILLUSTRATIONS

Illustrations

Illustrations

ACKNOWLEDGMENTS

Adolph Gottlieb and Barnett Newman stimulated my inchoate interest in Abstract Expressionism as a young graduate student and critic years ago. This book is a product of their generosity, but even more of their example as human beings. Their grappling with the fate of their generation, even if one does not concur with their resolutions, made one realize that art can be serious business—although today it seems to be just business.

During the years of this study, I benefited from the generous support of many others. One never writes a book without a personal and professional support system too numerous to acknowledge. I would however like to thank the University of Illinois Research Board for summer, travel, and fellowship support. I would also like to thank Irving Lavin and the Institute for Advanced Study for a Visiting Member Fellowship, and the National Endowment for the Humanities for an Independent Fellowship, both for 1982–83. I am indebted to Debbie Edelstein and Mona Hadler for reading a draft and compelling significant selections, and to Beatrice Rehl, Russell Hahn, and Richard Hollick of Cambridge University Press.

Esther Gottlieb, Ethel Baziotes, Elaine De Kooning, Kate Rothko Prizel, Lee Krasner, and others graciously spent time sharing their experiences with me. The scholarship of Abstract Expressionism is greatly indebted to Sanford Hirsch of the Adolph and Esther Gottlieb Foundation and to Bonnie Clearwater of the recently disbanded Mark Rothko Foundation. Adding a new dimension to the study of their artists, they were invaluable to me, as they have been to other scholars.

This book could not have been written without the independent perspective, wisdom, and patience of Beth Alberty.

I want to say that those I have mentioned, important as they were for developing and challenging my thinking, are in no way responsible for my final manuscript. Art history is an endless debate, now more than ever, and this book can only be fuel for its fires.

The author and publisher wish to thank the museums, galleries, and private collectors who gave permission to reproduce and supplied photographs of works

Acknowledgments

in their collections. Photographs (listed by number) from other sources—individual photographers—are gratefully acknowledged below. All works are oil on canvas unless otherwise described; height precedes width.

David Allison: 163; Noel Allum: 132; Allan Baillie: 109; E. Irving Blomstrann, New Britain, CT: 233; Rudolph Burckhardt: 206; Eduardo Calderon: 33; Paul Cacapia, Seattle: 221; Geoffrey Clements, New York: 117, 207, 285, pl. 12; Eeva-Inkeri: 177; Carmelo Guadagno, New York: 61, 129; P. Halsman: 24; David Heald, New York: 181; Hickey and Robertson, Houston: 83, 178; Peter A. Juley and Son: 249, 253; Paulus Leeser: 141; Rod Hook: 184; Robert E. Mates: 81, 99, 111, 166, 204, 267; Peter Muscato: 94, Hans Namuth, New York: 228; Otto E. Nelson: 85, 86, 87, 89, 90, 91, 92, 93, 106, 114, 119, 120, 165; Eric Pollitzer: 122, 145, 146; Quesada/Burke: 55, 56, 71, 74, 75, 77, 82, pls. 4, 7; Earl Ripling: 150; Jon Reiss: 156; Kevin Ryan, New York: 265, 266; Steven Sloman, New York: 255; Julia V. Smith: 41; Jerry L. Thompson: 151; Malcolm Varon, New York: 142.

INTRODUCTION

The emergence of Abstract Expressionism and the New York School in the post–World War II period, and the subsequent recognition of American art and culture, constituted a decisive rite of passage for American art. As the first American style of international renown, Abstract Expressionism was instrumental to generating an entire modern American art establishment. There were few American artists, critics, or even modern art historians of the 1950s and early 1960s who did not cut their teeth on it.

From its very beginning, Abstract Expressionism has been interpreted in the light of the cultural and intellectual ethos of whatever generation of critics was examining it. The generation of the 1950s understood Abstract Expressionism as Harold Rosenberg's Action Painting, according to which the artists theatrically expressed their personal anguish on a blank canvas, with little attention to form, style, or subject matter. For Rosenberg, painting was an autobiographical act of self-creation in the everyday world, and the expression of individual personality. The concept of Action Painting recapitulates the modernist romance of artists as rebels against society struggling to assert and maintain their integrity, and of Americans as anti-intellectual, naive, emotionally tortured, but honest noble savages. Although Rosenberg's criticism became more sophisticated later, Action Painting dressed Abstract Expressionism in the vogue of French existentialism during the late 1940s and early 1950s.

The concept of Action Painting was supplanted in the late 1950s and early 1960s (although such elements of it as personal anxiety remained in most subsequent interpretations) by the New Criticism and formalism of Clement Greenberg and his supporters. Their interpretation dismissed Rosenberg's subjectivist melodrama and substituted the advancement of certain principles of a virtual international modernist art as the Abstract Expressionists' primary intention and achievement. Giving the art the best pedigree—by linking it with Impressionism, Cubism, and Surrealism—this formalist approach focused on the Abstract Expressionists' stylistic evolution while proposing for them an exclusive concern with formal questions: purifying the medium, squeezing out illusionism, and remaking space as optical rather than tactile. It limited the artists' subjects to personal expression, everyday experience, and a few generalizations about nature or the human condition.

Since the 1970s, a different line of thought has matured and come to dominate the critical debate—although the interpretations of Greenberg and Rosenberg continue to determine the understanding and reception of Abstract Expressionism among most "lay" people and several post-modernists. Beginning in the 1940s, but diffused among different authors and artists, critical attention has been addressed to the subjects and meaning as well as the forms of Abstract Expressionism. Evident at first in the often anonymous reviews and later in articles by the artists' friends, this tendency blossomed in the work of Dore Ashton and Irving Sandler, among others, and in that of a number of recent scholars. Abstract Expressionism was reborn as an art with serious subject matter, as the artists had long claimed it was. This revisionist criticism used traditional iconographic methodologies to examine the intellectual and cultural context of Abstract Expressionism and to arrive at an understanding of the work itself. The Abstract Expressionism that emerges from this scrutiny has transformed previous interpretations, as new information has revamped understanding of the artists' basic interests and thematic concerns and how these are embodied in the forms.

The fundamental change in all of this is the significance attached to the artists' early work in the 1940s. Dismissed by critics and played down by the artists themselves, the initial work of the Abstract Expressionists has previously been considered to be merely derivative of European modernism, especially Surrealism. New scholarship has examined the work in much greater depth. Still acknowledging Surrealism as a primary artistic influence, it now appreciates that the early work is as rich in thematic and stylistic innovation as the later, more abstract work.

The new perspective of the early work as significant not only adds to our understanding, however, but also completely transforms our perspective on Abstract Expressionism. Because of the formal originality of the abstract work of 1947 and later, Abstract Expressionism has been defined by critics from the beginning in terms of the late work. As a result, it has been seen to be a style with postwar themes such as existentialism, alienation, individuality, freedom, and universality. The Big Bang theory of Abstract Expressionism, as Robert Rosenblum has wittily called it, argued that this abstract work erupted suddenly, fullgrown from virtually nowhere. The early work was primarily examined only to demonstrate how it supposedly prefigured the forms and content of these themes, for example, in its use of automatism, in its probing of the unconsciousness, and in its absorption of the modern artistic tradition.

In the view of this observer, however, this traditional perspective has distorted and miscast the nature of Abstract Expressionism. Rather than thoroughly breaking with their early work, Abstract Expressionist artists pruned, synthesized, and concentrated their themes, added to them, and then recast their formal expression of them. They replaced cultural and symbolic forms with new pictorial metaphors. As Lee Krasner noted about the work of her husband, Jackson Pollock, Abstract Expressionism was formed in the late 1930s and early 1940s and was consistent throughout. Rather than looking backward from the 1950s and applying the artistic, political, and critical issues of that decade to the early work, we will simply begin at the beginning and move forward. It will become evident that there are no absolute breaks or total transformations in the art and thought of the mature artists. Rather, the themes and subjects of the early work provide a set of references for judiciously considering the more difficult abstract forms as well. There is continuity as well as change.

The Abstract Expressionism that emerges will be seen as a product of a complex of ideas present in the culture of the interwar and war years. Scholars

now realize that intellectual and literary figures such as Frazer, Joyce, Jung, and Eliot influenced Abstract Expressionist subjects and formed a wellspring of ideas from which arise both the early and late images and forms. They have redrawn the portraits of the artists, replacing the image of emotionally tortured, inarticulate figures with that of literate, informed artists who came of age in a fertile moment in American and Western cultural history and who consciously represented new ideas in their art.

This new image of the Abstract Expressionist artists in turn undermines the entrenched critical notion that their work is solely the product of spontaneous generation. Whether dressed up as Action Painting or as Surrealist automatism, Abstract Expressionist painting has usually been seen as the product of a direct, virtually seismic, tapping of the unconscious, as painting without preconceptions. While they painted without a model, and hence in one sense their work can be considered spontaneous, the artists' commitment to serious matter circumscribes the traditional interpretation of the *tabula rasa*. However they began, however different each resulting canvas, they had certain themes that they wanted to express and directed their energies to them accordingly.

Despite these changes, however, certain problems persist in contemporary scholarship. The continued emphasis on the individual artist and his or her achievement, paralleled by the production of monographic essays, Balkanizes Abstract Expressionism. Many scholarly works focus on single figures or on a single idea or element and thus minimize and ignore those elements that lie outside their range. Owing to this focus on individual style and iconography— and to the sheer difficulty of discussing more than one figure in depth—the artists have become enveloped in a mythology of individual concerns that cloaks their communality and their truly greater distinctness. Only through a close examination of each artist within the context of the whole group and the history and culture of its time can the Abstract Expressionists' accomplishments be appreciated.

Indeed, it quickly becomes evident that despite the claims to the contrary of friends, family, critics, and the artists themselves, the artists had a great deal in common and form a loose culture. Future generations of critics will undoubtedly see an underlying unity to the period despite the simultaneous appearance— and reality—of complete individuality and heterogeneity. While hardly intended as a complete review of the intellectual history of the period, this study investigates and attempts to sketch broadly the large features of the cultural climate out of which Abstract Expressionism arose; such material forms a semiindependent cultural history exploring the field of ideas of the Abstract Expressionist period in America. Individually and collectively, the Abstract Expressionists are seen as one voice among the many and analyzed and discussed as such. Indeed, this period—the late 1930s to the early 1950s—forms a distinctive cultural episode that has been largely unrecognized by historians. Its culture is that of the Second World War. After 1947 a postwar culture began to transform America and disguised the uniqueness of the war years and those that immediately preceded them. Much of the cultural material is presented in the chapter on intellectual roots. It is among the first attempts to look at Abstract Expressionist ideas as an integrated whole and constitutes the beginning of a "theory" of them.

It is rare to assert that there is such a thing as Abstract Expressionist culture. What I mean by this—and "culture" or complex is merely a shorthand reference to this meaning—is the matrix of preoccupations and thought, supported by the ideas and writings of many in diverse fields of cultural endeavor, from which each artist drew in his or her own individual way. This matrix can best be reconstructed by studying the interplay among the subjects, forms, titles, and

statements of the artists; and by comparing the artists' preoccupations, ideas, and themes to those of contemporary figures with which they were familiar. These ideas formed a group of crisscrossing explorations, points of contact, and analogies that, when taken separately, may be considered unique, but when examined together, constitute a circle of principles and beliefs. Considered as a group, the artists and writers provide an elaborate frame of reference or field of imaginative association, that is, a combination and overlapping of core themes along a shifting stream, that no single work of art or artist alone could communicate. The artists' works form a coherent spectrum in which the several parts illuminate the larger structure while casting light upon one another.

The importance of titles, among other data, has been a primary focal point for questions about the nature of Abstract Expressionist ideology. The artists seldom worked with programmatic intent, that is, they never planned their paintings as doctrinal or merely intellectual theses. Titles were most often added after the paintings were finished—sometimes several months after in titling sessions with friends—which has led to their dismissal as irrelevant to interpreting the artists' meanings.

The argument that titles are irrelevant is convincing if one concentrates only on the surface differences of the ideas implicit in the titles: they can be from Greek myth, Native American ritual, or nature, and so they cannot be related or share meanings. If one probes beyond the surface to the underlying, overlapping themes, however, the titles fall into place as different points along the thematic stream. They make perfect sense in regard to the mainstream of the artists' work and thinking. The classic case is Pollock's *Pasiphaë* of 1943, which was originally entitled *Moby Dick*. It was retitled after the suggestion of a critic and friend, James Johnson Sweeney. Moby Dick was a symbol of the struggle with the dark animal nature of human beings in the period. The story of Pasiphaë restates the struggle with the physical union of a Cretan Queen and a powerful bull that leads to the issue of the Minotaur, half human, half animal. While not identical, the two titles address the same idea from different angles. Such is the nature of Abstract Expressionist titles as a whole. They often can be interchanged from painting to painting, for example, Lee Krasner's *Gaea* and *Combat* of the mid-1960s with their dramatic, swirling, mythic, biomorphic forms, or Adolph Gottlieb's *Voyager's Return* with its sailing ship imagery and *Untitled—Heavy White Lines* with its ship-rowing forms, both of the mid-1940s—as long as the intended underlying associations are recognized. Such associations originate from the artists' and the culture's themes. That a critic suggested Pasiphaë as a title to Pollock also indicates how widespread were particular themes and associations in the period. As Lee Krasner once said of Pollock's titles, Abstract Expressionist titles ultimately had to agree with the artists' "thinking." Disinterring and integrating their "thinking" is the subject of this book.

The larger group that makes up the Abstract Expressionist context includes some widely divergent types—Friedrich Nietzsche, Joseph Campbell, Carl Jung, Ruth Benedict, Margaret Mead, Martha Graham, Herbert Read, T. S. Eliot, James Joyce, Thomas Mann, Winston Churchill, Hollywood film makers, and the World War II footsoldier and homefront volunteer. They disagreed on many issues, both among themselves and with the Abstract Expressionists. Yet, in reading their work and statements—from the most elaborate formulations to the diaries and memoirs of the war—it is hard not to be struck by congruences in their concerns, in their assumptions about what were the urgent issues and the possibilities for addressing them, in their conceptions of the past and of the status of nature, spirit, and human resources, past and present. These congruences build a picture of a historical and cultural moment specific to the West in the

1940s. This is not, of course, the whole culture, nor even the whole of intellectual culture, of the 1940s. The picture of it that I give is reconstructed from the evidence of the artists' own interests, in which were found thematic relations around very broad ideas. The ideas were widely, although not necessarily universally, shared beyond the Abstract Expressionist group. It has been my purpose to identify, describe, and explicate the ideas of the Abstract Expressionists, since their work was for many years discussed without searching reference to the concepts they claimed. It has been beyond my scope to criticize those ideas, particularly according to ideas of artistic probity current today.

The absence of a general account of the culture of the 1940s out of which Abstract Expressionism arose has been one of the unfortunate weaknesses of individual studies. Under the limitations of such investigations, scholars have had to rely on the "smoking gun" theory of evidence, which requires that a corroboration of direct knowledge be offered before the influence of a given figure or idea on an artist can be accepted. In the world of the specialized monograph, it can be difficult to offer anything else. But not all such influences can be definitively proved, and not all influences are so direct. It is the assertion of this study that a loose ensemble of ideas informed the cultural matrix of Abstract Expressionism in the 1940s and that the art and thought arose from it whether we can prove direct "influence" or not. I have written an argument by inference and analogy as well as direct evidence.

Abstract Expressionism consists of individual statements of historically and culturally bound and formed metaphors or symbolic generalizations that constitute an open network of interlocking ideas, influences, and events. The generalizations fall into suggestive and illuminating micro- and macro-patterns. It goes without saying that the artists are not academic intellectuals; rather, they express their context in the latent and manifest content of their shared and personal idioms. So much is shared and believed that open allusion is scarce. The repetition of sources, forms, and subjects (themes, topics, and ideas) not only in their paintings but in their verbal statements bears subtle witness to the prevailing culture. As De Kooning said, "You didn't talk about your painting directly. You talked in aphorisms because you could see each other's values."[1] Gottlieb concurred: "We had common assumptions, talked together, hung around and respected each other's works despite differences."[2]

This book reformulates an Abstract Expressionist culture and resets its individual voices. It posits a unique Anglo-American view of world culture beginning in the late 1930s and 1940s out of which Abstract Expressionism arose. It is an interaction of a multitude of forces—the work of Joyce and Eliot (the "Anglo"), Jung and the Bollingen program, surrealism, anthropological concepts of world culture, American art and culture of the 1930s, intellectual critics such as Lewis Mumford, and World War II. In England some of it lay behind what is called the neo-Romantic art of the 1940s. It forms an identifiable unit that can be understood as such fifty years later, when a perspective on it can be established.

The greatest influence on the artists' art and thought was the crisis in the West brought about by the perceived collapse of much of the political, social, and economic order during and after World War I, and intensified by the coming of World War II. Leftist scholars and critics have attempted to associate the production and reception of Abstract Expressionism with the Cold War. While the Cold War is related to some elements of the critical miscasting and sponsorship of American art and culture in the 1950s, the argument is incomplete and ultimately unconvincing.

Although more recent scholarship has mentioned the war as an influence, it has not fully assessed its impact. Through an examination of the crisis and the

war and the resulting expression of public and private needs, it will be seen that Abstract Expressionism is a historical and public art that consciously addressed socio-psychological concerns and historical experience. Abstract Expressionism begins with and codifies American and Western society's responses to the crisis and World War II as the eternal and timeless. It is, in a sense, an art of crisis and war. Yet it was not political in that it had direct ideological involvement in a nexus of governmental policies. The history it relates is a diffuse field of imagination, associations, and emotion, of people, both celebrated and unknown, of its period as recorded in memoirs, diaries, and histories of participants (not necessarily only combatants, and from all classes, genders, and nations) in the crisis and war and its aftermath, elevated in intellectual and artistic verse. The artists were not interested in ideological politics. Rather, the themes and culture of Abstract Expressionism drew from the psychological experience of their time, that is, from the sense of ordeal, terror, and hope of the general population as found in its specific individual and collective expressions and modes of perception and behavior, and recast it in sophisticated culture and form. In a sense, this study proposes some elements of an iconology of the experience and understanding of modern war. In so doing, it indicates that the methods of Erwin Panofsky are sufficiently rich and flexible to advance an interdisciplinary social and historical understanding of modern abstract as of traditional art.

This reappraisal of Abstract Expressionism thus challenges another fundamental premise of the critical appraisals. Abstract Expressionism has primarily been treated as an individualistic art that is telling of the personal lives and concerns of the artists themselves. Even in more recent studies, the artists' work is considered self-expressive and privately philosophic musing. While every artist's expression is personal and subjective, my contention is that the Abstract Expressionist artists consciously engaged historical, cultural, and social questions in their work. Abstract Expressionism emerges as an unrecognized public art attempting to ascertain, define, and represent historical crisis and its resolution. It has continuities with and is in some ways analogous to American art of the 1930s, which also addressed what was seen at the time as the collapse of the West, albeit through different forms and themes.

In structuring my material I had two choices. Since my interest has been in the ideas permeating Abstract Expressionism and their historical resonances, I could have chosen to make each chapter a discussion of a significant theme and within that to show how the idea appeared and what role it had in various artists' works. Instead, I have chosen to concentrate on the ideas in one long chapter and to do monographic essays on the artists. This method allowed for the continuity and variety of the complete work of the artists and their interaction with the intellectual life and history of the period, as well as with each other. It has allowed the inclusion of many more and different ideas than would have been possible with the thematic approach and has permitted the individual artist to remain in charge rather than appear to be subordinate to outside forces alone, so as to make apparent that each artist was engaging in a very personal dialectic interaction with history and culture.

The argument is carried forth through contextual theme and variation, iteration, illustration, analogy, and cross-reference. Within art and culture, it builds a web of idea, imagery, and metaphor in short and long-range connections, parallels, and contrasts. This cumulative approach allows for some repetition as the artists and culture reiterate, vary, and embellish a set of ideas over and over again. It also allows for an enriched complex flow of art, thought, and history gradually moving forward in each artist's work (from early to late) and the era

as a whole from the 1930s to the war period and its aftermath, and to the new generations of the 1950s and 1960s.

Variance with previous formalist historiography of Abstract Expressionism also lies behind the book's method. I often mention an artist's concept or theme, then elucidate and follow it and its ramifications among colleagues or in the cultural climate. For example, some of the ideas, such as the so-called primitive, have been noted before in the literature but have seldom been adequately explained. That is, a work or form may be labeled or sketched as deriving from primitive art, but discussion has traditionally, stopped there. In contrast, I try to find the sources and more fulsome meanings of the ideas. In regard to the "primitive," I examine what forms the artists were interested in, the rituals and myths associated with them, the sources of this knowledge and its authors' places in the evolution of their fields (anthropology, art history, art criticism, philosophy), and the reconciliation of the idea with other interests such as nature, psychology, and world culture.

Sometimes I discuss the idea *per se* and not just the artists. This is intentional, for I am writing a history of Abstract Expressionism as a direct part of an unrecognized and only partially interrelated and understood cultural episode. We can understand the art better if we compare and contrast the similarities and differences of key ideas of authors and artists alike.

The depth of discussion is also intended to refute the view that the artists are anti-intellectual and anti-content, while advancing them to a level that makes them literate but not literary. When I refer to an idea or to several figures besides the artist under discussion, it is not to indicate that the artist was so educated as actually to hold variants of an idea from different sources in his mind (which would make them scholastic or academic artists), but rather something simpler—that the ideas were so widespread that they were common dialect in the period. Thus, I gather as many different artistic, intellectual, and historical sources as possible. It is the frequency and broad familiarity of the general ideas that I emphasize. The general spirit, meanings, and pattern of the context—that with which the artist is interacting—must be ever present in the book. To put this material in the footnotes would be to minimize it in the text, producing yet another sketchy, thin view of the themes and artists.

My study is, then, an examination of the interaction of art, culture, and history, in New York at the most threatening moment in modern Western history. One result was Abstract Expressionism, an art of historical and mytho-religious character addressing the spiritual life of the West. The artists included in this study are those who, I believe, came to terms with the historical moment and its core themes in the most original way. They include Clyfford Still, Mark Rothko, Adolph Gottlieb, William Baziotes, Jackson Pollock, Willem De Kooning, Robert Motherwell, Bradley Walker Tomlin, Lee Krasner, Hans Hoffman, Richard Pousette-Dart, and Ad Reinhardt. The Abstract Expressionist sculptors, such as Seymour Lipton, David Smith, Isamu Noguchi, Theodore Roszak, Herbert Ferber, David Hare, and Ibram Lassaw are included but not discussed biographically. Arshile Gorky, because of his intermediate and transitional position, I do not discuss.

THE PSYCHOLOGY OF CRISIS
The Historical Roots of Abstract Expressionism

the shrine lies open to the sky,
the rain falls, here, there
sand drifts; eternity endures:

ruin everywhere, yet . . .
the fallen roof
leaves the sealed room
open to the air.

Hilda Doolittle, *The Walls Do Not Fall*

Abstract Expressionism is a mode of art responding to the gravity of historical events in the first half of the twentieth century. It documents, analyzes, and seeks to transfigure what it considers collective human experience resulting from the collapse of the West in a depression and a modern Thirty Years War. In its attempt both to explicate and to redeem the experiences of its generation, Abstract Expressionism sought to affirm and at times regenerate Western life.

"Overcoming nihilism," to use Nietzsche's phrase, was the task the Abstract Expressionists generally set for themselves. They attempted to recreate a purpose and pattern to human life when, in the darkest days of Western civilization, there seemed no end to the human capacity for evil, that medieval concept rediscovered in a modern world of machines, technology, and science. By attaching the idea of human endeavor to the pattern of dynamic historic continuums, to the processes and cycles of nature, to the heritage and hope of psychological life, to heroic mythic pattern and ancient ritual as they understood them in their own time, the artists sought, again in Nietzsche's words, to "reevaluate all values" in order to master and overcome present realities and begin a more realistic pattern and process of human affairs. Abstract

Expressionism both diagnosed the inner crisis of its world and proposed to heal its manifestations in the mind, spirit, and behavior.

Abstract Expressionist art grew out of the great tragic period of modern Western history, the first half of the twentieth century. The men and women who became known as the Abstract Expressionists became artists between the world wars. By the time their mature styles emerged in the 1940s, they were mostly between thirty and forty years of age and had known little history other than economic crisis, conflict, and war.

The decline and seeming collapse of the West began in 1914 and, despite moments of stability, continued through the late 1940s. For many people in the 1920s, the West's power and vitality were at an end. André Malraux compared the continent to a vast cemetery—lifeless, melancholy, and haunted by the ghosts of dead conquerors. The mood was nihilistic, destructive, and profoundly negative.[1]

Oswald Spengler's pessimistic forecast, *The Decline of the West,* articulates this feeling. Published in 1919 and popular in Europe and America through the 1950s,[2] Spengler's book proposed that all cultures pass through an inevitable course of birth, growth, maturity, and death. Organizing Western history by means of biological cycles, a symbolic order that he termed *morphological* and that prefigured Abstract Expressionism's symbolic codes, Spengler seemed to capture and explain the inexorable decline of Europe and the West. He argued that the future of the West was equally grim. It would be characterized, like the last days of the Roman Empire, by perpetual warfare led by new Caesars. The best any individual could do was to face and perhaps modify in a limited way the few possibilities open to him. *The Decline of the West*

3

was a symptom, a diagnosis, and a prophecy of a culture anticipating its own end.

The crises of the early twentieth century brought about an intensive examination and repudiation of many traditional assumptions and values in the West. Contempt for prevailing political systems, for parliamentary democracy, and for bourgeois values was strong. From communism to Nazism to socialism, schemes for total societal transformation dominated the period. In the 1930s the calamity of worldwide economic collapse again underscored the problem. It became increasingly clear that there was a desperate need to reverse the decline and to revitalize the West.

AMERICAN ART OF THE 1930s AND THE IDEA OF CULTURAL REGENERATION

While America did not suffer as greatly as Europe from the effects of World War I, it retreated inward in the 1920s. When the Depression struck at the end of the decade, the reassessment of Western society began in earnest in America, leading to an analysis of, and in many cases a disillusionment with, the American system. Some Americans sought radical changes through reform and revolutionary movements, while other Americans turned to the seemingly more tranquil and successful past. American art of the 1930s shared this reassessment.

American artists, whether in their independent easel painting or in murals done as part of the government art projects, rejected the modernist, School-of-Paris art of, as many saw it, mere introspection and subjectivity. They preferred an art seemingly more public in subject matter—concerning itself with the life and development of the American people—and more traditional in technique—reviving three-dimensional space, representational drawing, and narrative, Renaissance modes of expression. Because of this revival of "outmoded" art and the later complete triumph of modernist tendencies in American art of the 1940s, American art of the 1930s has been most frequently characterized in the postwar period as reactionary and nationalistic, as almost populist academicism, and Abstract Expressionism is usually seen as a repudiation of both its subject matter and its stylistic modes.

On both counts this traditional evaluation is being questioned. While it does not fit comfortably into the juggernaut of the "advancement of modern art," American art of the 1930s was innovative in both subject matter and style. The best of it presented a new twentieth-century conceptual, at times allegorical, cultural realism in which a seemingly illusionistic style embodied fundamental and eternal principles of human experience in folk epics. Fur-

thermore, while Abstract Expressionism obviously rejected most of thirties art's revivals of academic forms and its sociopolitical representational and nationalist subjects, the underlying questions of thirties art determined significant directions for the very different Abstract Expressionism. Let us look briefly at the ideas and approaches that the Abstract Expressionists, almost unconsciously, retained and turned to new account in the 1940s.

American art of the 1930s offered one of the first modern totalizing views of American and Western society. It presented a society ordered by the idea of culture, pattern, and subordination of the individual. It also proposed the representation of an American and Western psyche and psychological pattern. With its holistic pattern of human history and psychological fulfillment, it imaged a social order of technological and scientific advance and of individual and social beneficence.

American artists analyzed the distinctive components and activities and the very definition of culture in general and American mythic or symbolic culture specifically.[3] The idea of culture as a means of organizing social institutions and purposes was itself new in the first half of the twentieth century. Previously, culture had been considered simply the enlightenment and refinement offered by a nation's arts and literature. The idea of the culture of a nation as separate from its history or religion was unprecedented. The new definition, which was first and best stated in anthropology, an emerging discipline in the first half of the twentieth century, dominated the study of culture, and American artists relied on the anthropological definition as filtered through history, sociology, and psychology, as well as anthropology itself.

The new definition of culture was first set forth in the late nineteenth century by Sir Edward Tylor. Culture was "that complex whole which includes knowledge, belief, art, morals, law, customs, and any other capabilities and habits acquired by man as a member of society."[4] Tylor's definition emphasized that culture was learned, not inherent. Culture, not race, united a people. At that time, as Margaret Mead has noted, the "idea that our every thought and movement was a product not of race, not of instinct, but derived from the society within which an individual was reared, was new and unfamiliar."[5] This idea was the cornerstone of anthropology, for culture as a whole explained behavior and became the determinant of "human nature."

The components of a culture were not random, however. Anthropologists saw traits organized into a pattern, configuration, or style. The concept of patterning, especially historical patterning, was a major proposition of American cultural theory in the 1920s and 1930s.[6] Very important in its formation were the works of Ruth Benedict, whose *Patterns of Culture* of 1934 was the most

popular American anthropology book ever written, and those of Margaret Mead. Benedict and Mead argued that culture is an articulated whole with institutionalized motifs, emotions, and values. Benedict defined culture as being like an individual: that is, "a more or less consistent pattern of thought and action," with manners and morals that "are moulded to one well-defined pattern."[7] Furthermore, its elements are considered to be historical, having shaped the culture in the past as well as in the present, but not fixed, for they are part of a continually changing process. The concept of process accorded with general American social science, which emphasized becoming, achievement, and change rather than essence or being, as in concepts of instinct or race.[8]

Benedict had another important concept: that the pattern or configuration is psychological. Each culture has an ethos, an organizing and synthesizing spirit, a characteristic psychology that denotes the culture as a whole. For example, she characterized the cultures of three Native American groups: one, the Pueblos of the Southwest, she saw as Apollonian—calm, orderly, measured, cooperative; the second, the Plains Indians, were Dionysian—egotistical, irrational, combative; the third, the Kwakiutl of the Northwest Coast, were paranoic—conflictive, tense, and dangerous.[9]

Furthermore, as Benedict wrote, since anthropology is the study of human beings as creatures of society, it is interested in human behavior as shaped by tradition.[10] For Benedict, culture shapes and fosters the individual and the individual's personality:

The life history of the individual is first and foremost an accommodation to the patterns and standards traditionally handed down in his community. From the moment of his birth the customs into which he is born shape his experience and behavior. By the time he can talk, he is the little creature of his culture, and by the time he is grown and able to take part in its activities, its habits are his habits, its beliefs his beliefs, its impossibilities his impossibilities.[11]

Heterogeneous human experience and personality are integrated and patterned in every society by the society's psychological pattern. Though conceding some independence to the individual, for the most part Benedict, Mead, and anthropology in general in the 1930s offered what amounted to cultural determinism of customs and tradition. For both Benedict and Mead, cultures were integrated wholes, personalities "writ large." In other words, a people's culture was constructed and represented by its psychic traits. Cultures had psyches and varied psychological configurations dominated different cultures. These ideas, which were not limited to anthropology, were essential to American thought in the 1930s.

The need to examine the constituents, psychology, and

behaviors of American culture led to a general examination of the purposes of art. In two associations formed by artists, the Artists' Union and the Artists' Congress, discussion tended to be about content and the appropriateness of a certain style to a certain content.[12] Artists also questioned the role of art and artists in society, an issue of most profound philosophic, political, and artistic speculations. Artists made an attempt to define the scope of, and the relationship between, their social and artistic actions.

Such an attitude was in fact necessary for federally funded art projects such as the Works Progress Administration, because large-scale support for the artists required them to attempt to communicate with a wide public. Administrators such as Holger Cahill, director of the WPA art project, expected that government support would aid artists in establishing an active relationship between society and its culture, which would lead to the progress and renewal of both. The art projects were therefore devoted to communication with all the people, not just the elite or Eastern city dwellers, and artistic expression was to be broadened by mass participation as well as appreciation.

To bridge the gap between art and life, Cahill emphasized the ideas of John Dewey, as expressed in *Art as Experience*, published in 1934 just as the projects were beginning. Through Cahill, Dewey's ideas became a large part of the rationale for the WPA:

John Dewey and his pupils and followers have been of the greatest importance in developing American resources in the arts. . . . Among these is the WPA/FAP [Works Project Administration/Federal Arts Project]. . . . [T]he Project has held to the [Deweyian] idea of the unity of art with the common experience, the continuity between "the refined and intensified forms of experience that are works of art and the everyday events, doings, sufferings, that are universally recognized to constitute experience." . . . [T]he Project has encouraged the closest possible collaboration between the artist and the public for which he works.[13]

In the project he directed, Cahill tried to translate Dewey's philosophical idea of art as a "mode of interaction between man and his environment" into a specific program. He took as his model the relationship between art, culture, and ceremony in primitive societies:

Very few nations of our industrial world have achieved much in the way of community participation in the arts. For contemporary examples of community sharing in the art experience we must turn to societies such as those of the Pueblo Indians of our Southwest. In these coherent societies, art tradition is rooted firmly in community experience, and is kept alive through participation by the whole people. Here official art and folk art are united. If anyone wishes to see what art expression at the level of a whole community can be, let him visit one of the dance ceremonials at Santa Domingo, or Zia, or Cochiti in New Mexico. Here the entire resources of a community, resources of

design and song and chant, have been poured into a ceremony in which everyone participates. Here is undoubtedly the most moving and impressive example of community expression and community sharing in the arts which our contemporary world affords.[14]

The project activity that attracted the most attention and seemed to exemplify many of Cahill's attitudes as well as the central ideals of the 1930s in America was mural painting. Mural projects were devoted to communicating directly with the public, to relating the common culture of the country, to finding Cahill's "usable past,"[15] and to recapturing the present in terms of the past. Mural paintings, in Mitchell Siporin's words, were intended to be

an epic art of our time and place. We have discovered for ourselves a richer feeling in the fabric of the history of our place. There is the "big parade" for us now of the past melting into the present, a parade in which each event begs the artistic transformation into a moving sociocultural critique, and the spirit of each historical personality begs of us nothing less than epic portrayal.[16]

Cahill believed that the quest of the American artist in the 1930s was to seek out the American "native epic" or "myth,"[17] which was to be expressed in "qualitative unities which make the pattern of American culture."[18] Mural painting would recreate, as one muralist wrote, "the sense of significance of a generalized event. . . . Mural painting . . . is . . . by nature not intimate, but general or universal in thought and appeal. Through its monumental approach it goes beyond the recording of outward appearances to include also the inner significance of the society and time in which it is painted."[19] The sociocultural values of America were to be generalized in universal pattern and myth of history.

In rural areas, such as western New York state, these "American Scene" murals illustrated the activities and history of the particular locale. In cosmopolitan New York City, especially in school buildings, where they were seen as educational, murals were more nearly universal.[20] In them, artists examined the development not only of

Figure 1. James M. Newell, *The Evolution of Western Civilization* [detail], ca. 1935–38. Fresco. Bronx, New York, Evander Childs High School Library.

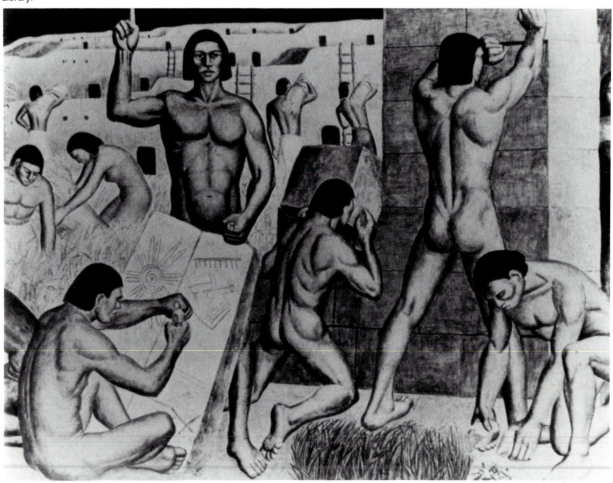

American civilization but of the world. These pictures were epic in intent, establishing a historic continuum. They include *The Evolution of Western Civilization* by James M. Newell for Evander Childs High School (fig. 1), *The History of the World (Hall of History)* by Alfred Floegel and Fosdem Ranson for De Witt Clinton High School, *Cultural Development of Art and Civilization* by Geoffrey Norman for Charles Evans Hughes High School, and *History of Mankind in Terms of Mental and Physical Labor* by Maxwell Stair for Brooklyn Technical High School. Sculpture too became a medium for representing epic development, as in William Bahnmuller's relief, *The Cultural Development of the United States* for Richmond Hill High School.

Whether international or American, individual subjects were investigated in a progressive evolutionary or developmental manner from the past to the future. For instance, music is the subject of Lucienne Block's *The Evolution of Music* at George Washington High School and of Seymour Fogel's *Primitive Music* and *Religious and Modern Music* for Abraham Lincoln High School; law is the subject in Attilio Pusterla's *Law through the Ages* for the New York County Court House, and clothing in Mons Breidvik's *Evolution of Costumes through the Ages* for Charles Evans Hughes High School. Even Arshile Gorky approached subjects in terms of evolution, as in his *Aviation: Evolution of Forms under Aerodynamic Limitations* for the Newark Airport.

The development of medicine was a subject favored for murals in hospitals. Walter Quirt's murals, *Growth of Medicine from Primitive Times,* in Bellevue Psychiatric Hospital, contrasted the earlier primitive methods of treatment (described in Sir James Frazer's *The Golden Bough*)[21] with modern, scientific methods that would benefit future generations. In most of these murals, development was seen as both inevitable and beneficent. By showing the application of reason, technology, and science, the mural painters symbolized the creative striving for an enlarging, progressive future. Science led to material progress and a technological Eden.

Figure 2. John Steuart Curry, *The Tragic Prelude [John Brown]*, 1937–42. Oil on tempera on canvas. North wall of the East Corridor, Kansas State Capitol, Topeka. Photo: Courtesy of Kennedy Galleries.

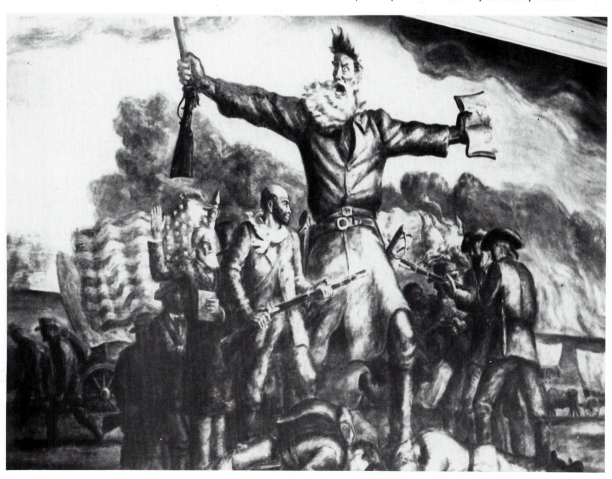

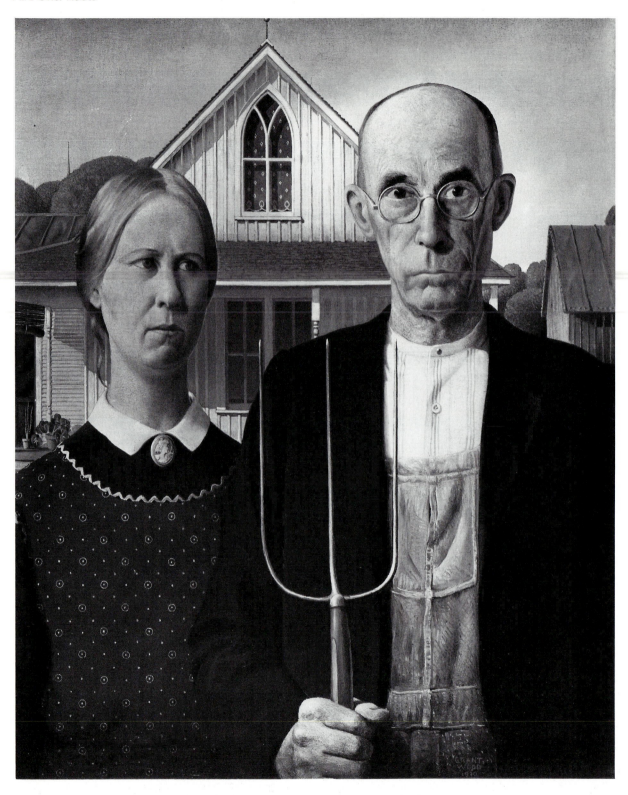

Figure 3. Grant Wood, *American Gothic*, 1930. Oil on beaver board.
$29\frac{7}{8} \times 27\frac{7}{8}$ inches. Friends of American Art Collection, 1930.934. ©
1989 The Art Institute of Chicago. All Rights Reserved.

In representing a continuity of development, mural paintings illustrated one of the prevailing ideas, the historical continuum. The idea of the interconnected, ever-advancing nature of human experience was pervasive in the 1930s. The concepts of "Evolution, Tradition, Progress," as Sheldon Cheney referred to them in his *Expressionism in Art* of 1934, were fundamental to the art of America at this time, whether American Scene or modern. They represented the theme of continuity with change and progress. Using organic metaphors, Cheney wrote:

Life is change, growth; institutions are passing means towards change; art and the spiritual life of which it is a part—expression and experience—are never more than an accompaniment of a stage attained by man along the way, geared to his comprehension, which is ever enlarging.[22]

Several mural artists portrayed a continuous dialectical pattern of development much like John Steuart Curry's Topeka murals. In episodic epics consisting of multiple panels narrating a continuous sequence of popular archetypal events, interlocking emotions, and circumstances, Curry tells a tale of pioneer beginnings (*Coronado and Plainsman*), conflict and struggle (*The Tragic Prelude* [*John Brown*]) (fig. 2), and eventual "renewed strength and vitality" in the achievement of pacific plenitude, familial harmony, and economic development (*Kansas Pastoral*). In many murals, the continuity, survival, and triumph of Americans, of the family, and of the community become almost a mythic, symbolic, utopian dream. The American past of many small towns pointed the way to the American future.[23]

Additionally, in these pictures, people and their activities are described as sociocultural and economic entities. They are pictured as workers, farmers, yeomen, and mothers. People were defined by impersonal character, socialized personality, and custom, marching in conformity with and contributing to the pattern of development. Paintings such as Grant Wood's *American Gothic* of 1930 (fig. 3) portrayed individual personality as historic-cultural personality, continuous with the past and the future. Custom, folklore, religious ceremony, and ritual dominated the mythic patterns of life and the organism of society, as in Curry's *Baptism in Kansas* of 1928 (fig. 4) and *Return of Private Davis*. For individual as well as cultural life, the murals suggested a wholly enveloping continuum of an emblematic process of historical growth and development, or an emotional, mythic, folk epic of origins, crisis, and recovery and renewal.

The artist whose work best exemplifies a coherent statement of many of these ideas is Thomas Hart Benton. In his rejection of much modern art, in his popularization of the mural, in his construction of a historical, mythic, cultural, and psychological pattern of American culture,

Benton undoubtedly suggested innumerable possibilities for American artists in this period. He was among the most articulate—and controversial—artists of the 1920s and 1930s, if not of American art as a whole.

Benton wrote two books and many essays about his work that reveal artistic and intellectual influences. One paragraph from his autobiography, *An American in Art*, is particularly telling:

The concept of our society as an evolution from primitivism to technology through a succession of peoples' frontiers which sparked my first attempts at painting American history pre-dated my knowledge of [Frederick Jackson] Turner. At least I think it did. My original purpose was to present a peoples' history in contrast to the conventional histories which generally spotlighted great men, political and military events, and succession of ideas. I wanted to show that the peoples' behaviors, their *action* on the opening land, was the primary reality of American life. Of course this was a form of Turnerism, but it was first suggested to me by Marxist-Socialist theory which ... was very much in my mind when I turned from a French-inspired studio art to one of the American environment. This socialist theory treated "operations" and "processes" as more fundamental than "ideas." It also maintained the theoretical supremacy of the "people." I had in mind, following this theory, to show that America had been made by the "operations of people" who as civilization and technology advanced became increasingly separated from the benefits thereof.[24]

Benton here provides a clue to the influence of Marxism on the art of the 1930s, beyond its obvious, presumed reflection in the social-realist concern with the workers and the plight of the poor evidenced in the subject matter of William Gropper. That influence takes the form of the dynamic continuum of human effort. Benton admits that Marxism, along with Turner, reinforced his interest in illustrating the lives of the "people." But he also states that it helped him understand American development in terms of "processes" and "operations" of the people. Marxism provided support for his idea of the "culture" and history as a developmental "continuum"[25] and a dynamic process synthesizing a new whole.

To the concept of the process continuum, Benton and others added Turner's theme of continual frontier renewal. Turner's essay "The Significance of the Frontier in American History," though written in 1890, had a major impact on American thought in the first third of the twentieth century.[26] Freely admitting his interest in Turner, Benton declared that he had even attended history symposia on Turner, and that "frontierisms" were behind his mural of Missouri. "The pattern of frontier behaviors and the folk images growing therefrom ... I pictured as the fundamental realities of Missouri."[27]

Turner's thesis was that the "existence of an area of free land, its continuous recession, and the advance of American settlement westward, explain American devel-

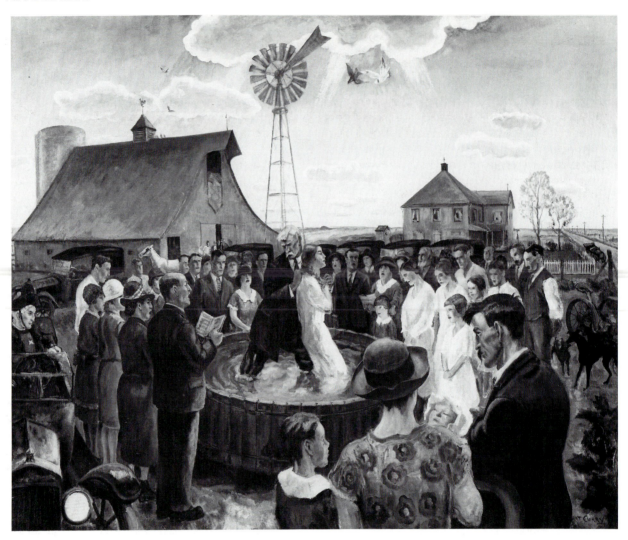

Figure 4. John Steuart Curry, *Baptism in Kansas*, 1928. 40 × 50 inches. Collection of the Whitney Museum of American Art, 31.159.

opment."[28] In repeated moves west, a pattern was developed that Turner argued was peculiarly American. Civilization was continually begun and begun again. There was a "perennial rebirth," a fluidity to American life, and a continual development from the simple primitive frontier society and culture to a more complex and civilized one. Turner conceived this continuous process and development as American social evolution, involving the continuing creation of new institutions, beliefs, values, and cultural traits. The process remade America at every new geographical boundary, and it remade and recreated an American character. The history of America is not one of static institutions or constitutional forms or only custom and "inherited ways of doing things." It is a history of "vital forces" that call these into life and shape them to meet new and changing conditions. The peculiarity of American institutions is their continual adaptation to and transfor-

mation by new environments and new conditions. American history is yet another continuum of cultural beginnings, maturation, and renewal.

The frontier also reinforced the concept of a common national personality and psyche and helped create an American mind with particular characteristics:

That coarseness and strength combined with acuteness and inquisitiveness; that practical, inventive turn of mind, quick to find expedients; that masterful grasp of material things, lacking in the artistic but powerful to effect great ends; that restless, nervous energy; that dominant individualism, working for good and for evil, and withal that buoyancy and exuberance which comes with freedom.

For Benton as for many in the 1930s, that culturally predetermined mind expressed its formative patterns and experiences in its art. Benton was influenced by the nineteenth-century French art critic Hippolyte Taine, whose

Philosophie de l'Art he read in Paris around 1910.[29] Taine's most famous idea is that art is a product of the forces of race, milieu, and moment expressed in a national mind.[30] Art is a product of national character, of custom and habits and institutions, and of a particular time and point of development. These produce a historical and contemporary national character and spirit that the artist captures in representational art. Every country and age has a spirit that determines its art. When a nation loses its energies, its art degenerates. Art reveals a nation's mind, its mentality. The history of art is the history of one mentality or mode of thought replacing another. For Taine, what one perceived through a work of art was the state of mind that produced it.

Benton and other artists of the 1930s shared a conception that was widespread—and modern: Art is the product of a national psychoculture. Like Maillol and his *Mediterranean* of the early 1900s or the German expressionists with their evocation of German Gothic, he saw art as indices of national personality and psyche.

What Benton and others proposed is, on one level, a cultural and environmental, an almost psychologically behavioristic theory of art.[31] A society generates states of mind, attitudes, values, beliefs, aspirations, and needs which are dynamic, constantly "changing, affecting and being affected by the play of instrumental and environmental factors."[32] As Benton put it, a collective American social psyche would generate new artistic form:

If subject matter determined *form* and the subject matter was distinctively American, then we believed an American form . . . would eventually ensue. . . . Let your American environment . . . be your source of inspiration, American public meaning your purpose, and an art will come which will represent America.[33]

As a result of this conditioning, the artist's subject matter reveals the national mind—the "scenes, behaviors, and mythologies"[34] or "psychologies" and "cultures" of American life that are organized in a pattern.[35] Culture is defined as a "living thing,"[36] a sum of behavior patterns and the attached complexes of a living and going society.[37] "A civilization . . . is a thought and behavior complex."[38] Human behavior is not singular but part of interrelated patterns: "patterns of American life"; "cultural patterns"; and "thought patterns."[39]

Painting, for Benton, is an expression of American patterns of the past and present. His famous rhythmic sequences—from foreground to background, uniting and including all objects and forms—express the continuous energy, activity, and movement of American life, history, and experience. Original, too, is a correlation of forms. Each object seems to echo, parallel, and counter another. In fact, Benton's figures, apparently based on El Greco and sixteenth-century Italian artists such as Cambiaso, are symbolic.[40] Their exaggerated attenuation and rhythmic curving reveal an idea of anatomy as cultural expression, as cultural entity, as a statement of the spirit and restless energy of America.

In his 1930s murals, Benton united analogous episodes, events, activities, behaviors, figures, and natural forces in the same panel.[41] His murals for the state capitol of Missouri, *A Social History of the State of Missouri* (fig. 5), contain varied yet interrelated groups of rhythmic images and scenes both within one panel and among several panels around a room. Benton represented Missouri's social life, activities, history, and life in a sociocultural continuum or "epical progression."[42] In two and three dimensions, in linear forms and proportions, in subject

Figure 5. Thomas Hart Benton, *Politics, Farming and Law in Missouri [A Social History of the State of Missouri]*, 1936. Oil and egg tempera on linen mounted on panel. 14 × 23 feet. Missouri State Capitol, Jefferson City.

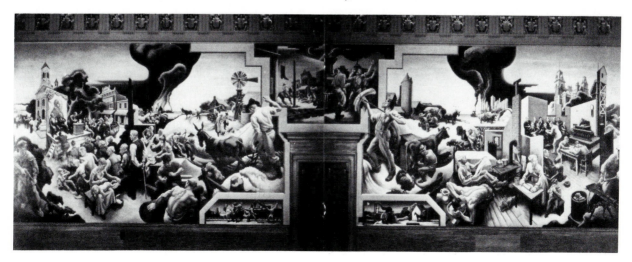

sequences, Benton correlated longitudinal and panoramic patterns of development in original form. He saw American history and experience as a series of collective human activities and ritual behaviors such as farming, cooking, hunting, raising children, or changing diapers, and his pictures portrayed the significant and trivial, serious and crude behavior patterns of the people of the state in flowing sequences, analogies, and unities over space and time.[43]

Benton wrote that the prime objective of his Harry Truman murals was to create "a 'flow' from one area of the mural to another so that the 'unity of the whole' is *emphatically* apprehended."[44] His "correlating process" had no pretensions to absolute truth, but was frankly emotional: he wanted to create emotional sequences, human action balanced with meaning, artistic logic with experience. He wrote:

Successful work is a measure of both [form and subject]. The various logical devices of painting—the division of things into planes, the counterpoint of line and plane, the playing of color against color, light against dark, projection against recession, et cetera—are instrumental factors set to the service of unifying experienced things.[45]

Benton's style consists of an episodic unity that seems to reflect his early interest in cubism as well as Renaissance and Mexican mural painting. Specifically, images and episodes, space and surface, flow into one another yet remain separable, as a simultaneous, "imagist" Analytic Cubist construction. Benton creates a complex, integrated unity consisting of ritual behaviors and traditions. This type of structuring is especially distinctive in his murals for the New School for Social Research, collectively called *America Today*. For instance, his *City Activities* panel (fig. 6) contains individual scenes of boxers, prayer meetings, subways, park-bench lovers, and burlesque, which spill over into one another at a portion of their boundaries, creating an all-over unity somewhat like that of Analytic Cubist *passage*. Each individual scene, framed on three sides as an Analytic Cubist shape is outlined, flows into the neighboring space. One cannot focus on one scene for too long without being led into the next. The space moves from surface to depth and back again. Figures and forms

Figure 6. Thomas Hart Benton, *City Activities with Dance Hall [America Today]*, 1930. Distemper and egg tempera on gessoed linen with oil glaze. 92 × 134½ inches. Courtesy of the Equitable Life Assurance Society of the United States.

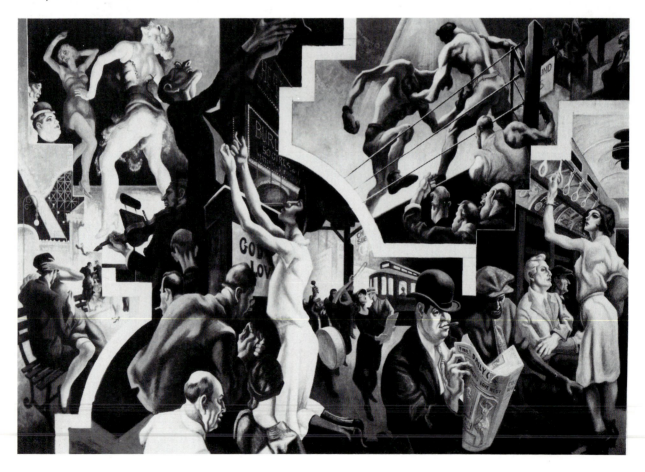

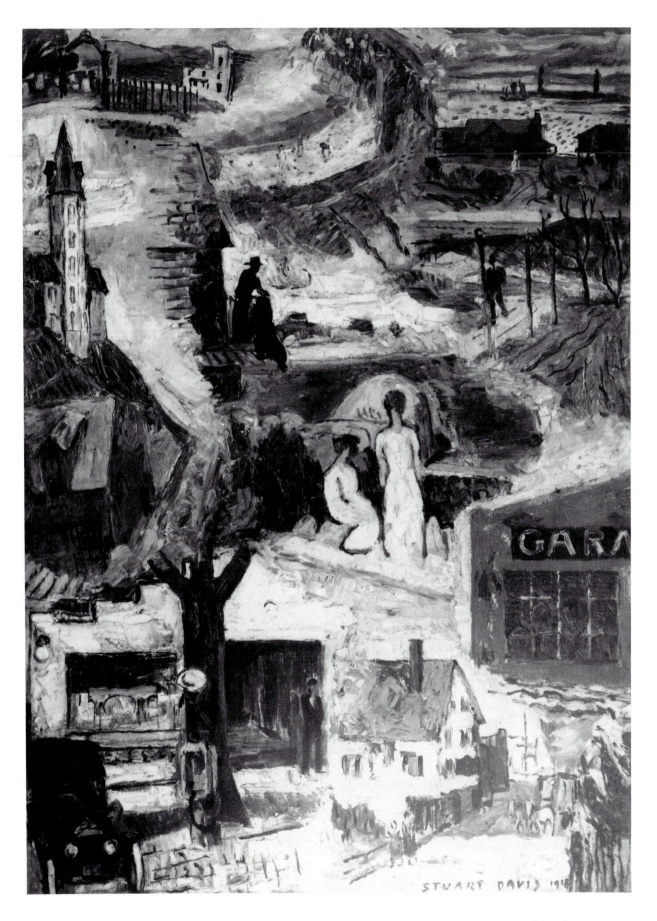

Figure 7. Stuart Davis, *Multiple Views*, 1918. 47¼ × 35¼ inches. Collection Mrs. Stuart Davis.

of high value contrast sharply with darker ones or blend into even lighter shapes, resulting in an all-over flashing of lights and darks. The figures reinforce this changing rhythmic pattern, as the eye is led from scene to scene and point to point by their exaggerated shapes, poses, and movements. Their curving and straight contours reinforce or contrast with similar lines formed by internal frames of Art Deco design.

Benton was not alone in using these cubist, integrated schemes to create a holistic design of multiple incidents. Stuart Davis also used them. His interest in cubist construction is more obvious, of course, but he too created pattern sequences uniting experiences and image, past and present, reflecting the contemporary American, that is, "the mental as well as the ordinary material environment."[46] In an early work, *Multiple Views* of 1918 (fig. 7), there are no cubist sequences but there is a clear concern with visual and temporal simultaneity. In *Multiple Views* he created a "montage of vignettes" in different perspectives that infuses the picture with a dimension of time, memory,

and experience.[47] Davis sought to reduce the various aspects of visual nature to a logical system in which what is observed sequentially is presented simultaneously. This system, he wrote, "brings into one focus and one plane, the past, present, and future events involved in the act of observation of any given subject."[48] *Sunrise* of 1933 (fig. 8) successfully accomplishes this. *Sunrise* is divided into two major areas. The left consists of a variety of views of the Cape Ann landscape, including rocky, tree-covered hills, a gothic revival house in a field, and one wagon. On the right side, Davis combines a variety of waterfront scenes. "Notions of changing history, season, hour, and location co-exist on a single, formally integrated pictorial surface."[49] Although Davis does not emphasize epic historical and social progression as did his thirties colleagues such as Benton, the fluctuant views of cubism have been expanded into the landscape and temporal anecdotes and are subtly integrated. Other muralists of the 1930s also integrate different scenes of American or world experience both within one and among several panels as did

Figure 8. Stuart Davis, *Sunrise*, 1933. 10 × 14 inches. Private Collection.

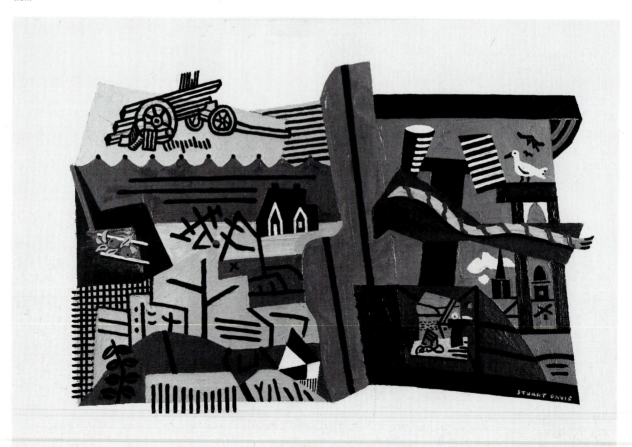

Curry in his Topeka murals. Artists with a cubist training, however, carried the unification further, creating a rhythmic unity of style and subject that suggests an emotional and symbolic sense of movement and process.

One last development in art of the 1930s that bears comment is the revival of allegorical history painting. The rebirth and modernization of allegory, the extended representation of abstract concepts or process, is one of the fundamental achievements of interwar art. From the works of Mexican artists such as Diego Rivera in his *Creation* of 1922–23, *History of Mexico: From the Conquest to the Future* of 1929–30, and *Allegory of California* of 1931, and José Clemente Orozco in *Prometheus* of 1930 and *Allegory of Mexico* of 1940, to Curry's *Parade to War: Allegory* of 1939 and James Brooks' *Flight* of the early 1940s, artists sought to revive the use of symbolic gods, folk legends, classical mythology, and Christian and biblical rituals to parallel, condense, and highlight historical process. Such a mode was traditional in the art of the Old Masters. It was extended in the modern Romantic era in work such as Jacques-Louis David's *Death of Marat* of 1793 (fig. 9) and Baron Antoine-Jean Gros's *Napolean in the Pesthouse at Jaffa* of 1804, where modern political heroes are likened to Christ and elevated by the use of Christian symbolism.

In the same way, history in the 1930s was often conceived of as myth, legend, ritual figures, archetypal behaviors, and heroes. WPA guidebooks, for example, related a local history consisting of part fact and part folk legend and hero. In perhaps one of the best known and most successful examples of such thirties allegorical history, Orozco painted a series of murals at Dartmouth College in New Hampshire (fig. 10) that represent a typical epic evolution of the civilizations and cultures of North and South America. He organizes the paintings around the theme of the appearance, disappearance, and return of

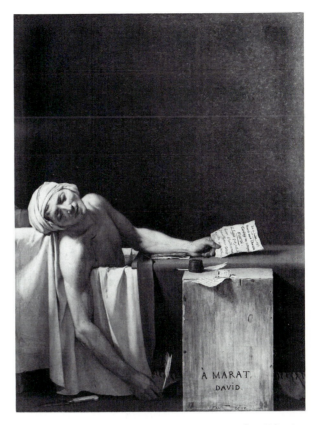

Figure 9. Jacques-Louis David, *Death of Marat*, 1793. 63¾ × 50⅝ inches. Royal Museum of Fine Arts of Belgium.

Figure 10. José Clemente Orozco, *The Coming of Quetzalcoatl*, from *The Epic of American Civilization*, 1932–34. Fresco. Courtesy of the Trustees of Dartmouth College, Hanover, New Hampshire.

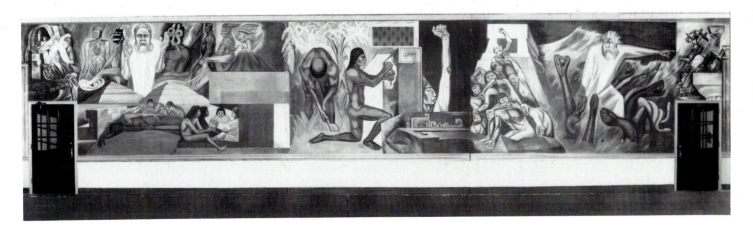

the pre-Columbian cultural hero and god Quetzalcoatl, while taking the history of the Americas through a sequence of historical and cultural episodes including ancient rites, a golden age of Aztec culture, the age of the gods of the ancient world, the coming of Quetzalcoatl, his dramatic departure and damning prophecy, its fulfillment in the coming of Cortez and the creative and destructive forces of Western civilization, and Quetzalcoatl's rebirth as Christ, the Creator and Destroyer in a journey or modern migration of the human spirit. As was typical for allegorical painting of the period, Orozco explains and symbolizes complex historical dynamics through personifications of historical and religious or ritual figures. Through this renewal of symbol and myth, he and other artists revived the Renaissance tradition of symbolic narrative and recast it as an allegorical epic that describes the pattern of the historical forces at work in modern life.

Art of the 1930s was original in its detached, epic perspective on the heritage and evolution of culture and civilization, its anthropological, sociocultural subjects, and its realist and allegoric, dynamic style. It portrayed, as Margaret Mead declared in another context, the process of cultural continuity and change: a culture creating "the social fabric in which the human spirit can wrap itself safely and intelligibly, sorting, reweaving, and discarding threads in the historical tradition."[50] American art of the 1930s thus sought to play the role described by Benton: "Art is not only art but a regenerative force and because of that, permanently valuable to men."[51]

VEILS OF ILLUSION

By the late 1930s, however, these beliefs had lost much of their force. As Benton wrote, international problems seemed to deny and belittle the renewal of American art and culture:

By the late autumn of 1941 my mind was so much on the international situation that I found it difficult to concentrate on painting. The American scene which had furnished the content and motivations of my work for some twenty years was outweighed by the world one. As I had no pictorial ideas applicable to this new scene, I was almost completely frustrated.[52]

The scale of the difficulties was now worldwide and epic. With the outbreak of the Spanish Civil War and the inexorable slide toward a new war, fear and unrest gripped the Western world. George Orwell noted: "by 1937 the whole of the intelligentsia was mentally at war."[53] After the Anschluss of 1938, "the veil of illusion" which makes life bearable was violently torn. There developed a collective anxiety, panic, fear, unrest, hysteria, and "will to die," and after Munich many people died psychically, "a

great many faiths died."[54] With the bombing of Pearl Harbor, one woman recalled, "people were panicking, my mother was crying that the end of the world was coming."[55] Another man recognized that "this was a turning point, that our lives would never be the same again."[56] Telford Taylor, the chief prosecutor at Nuremberg, noted that "for most people my age, the war and its aftermath were the most intense experiences of our lives. So many crises that overtook me were directly due to the war."[57] A businessman stated, "In a short period of time, I had the most tremendous experiences of all of life: of fear, jubilance, of misery, of hope, of comradeship, and of the endless excitement, the theatrics of it."[58]

Civilization embarked on its second self-destructive course in twenty years. For many, it seemed that there had only been a pause in the "long week-end" between the First and Second World Wars. Winston Churchill and the Nazi Alfred Rosenberg "both found it easy to conceive of the events running from 1914 to 1945 as another Thirty Years' War."[59]

For the second time in two decades, personal lives were dominated by public life. Since the Civil War, the Depression and World War II were the most traumatic epochs in American history. Both changed the psyche as well as the face of the United States and its relationship to the world. Although the war generation forgot or suppressed their experiences, and the generations afterward neglected the war or confronted it as merely a series of Hollywood romantic adventure stories and romantic encounters, World War II left an indelible mark on people of the Abstract Expressionist generation. It permanently altered their patterns of thought and life.

The change in thought in America from the thirties to the war period is sharply delineated by comparing Thornton Wilder's famous plays, *Our Town* of 1938 and *The Skin of Our Teeth* of 1942. A classic of thirties culture, *Our Town* celebrates the continuity of life and custom in Smalltown U.S.A., where generations of American families, representing Everyman, follow the same routines, work, and social customs. Wilder presents this life cycle as an endless simple rhythm of countless lives reenacting allegorical rituals of birth, initiation, courtship, marriage, and death. Typically, the local is universalized and mythologized in an epic of the cosmic rhythms and everlastingness of life. The only disruption is the preacher's occasional overindulgence in drink.

Life is very different four years later. The protagonists of *The Skin of Our Teeth* are once again members of an American family, but now the family represents the twenty-thousand-year-old human race, as the play takes place simultaneously in layers of primordial and modern, geological and biblical time. The father, Antrobus, is the archetypal father of humanity (Adam), the discoverer of the

wheel and an inventor of the alphabet. He lives in New Jersey with his wife (Eve). Cataclysmic events take place. Mammoths and dinosaurs, a biblical flood, the Ice Age, and war approach. Man struggles with nature and with himself. The human family has to fight to survive, and it has to decide along the way whether to save the civilization represented by such ancient, symbolic figures as Homer, the Three Muses, and Moses. When the war is over, the family emerges from its symbolic subterranean location, where the conflict actually took place, to pick up the pieces and bring forth the "new world" one character predicts is coming. Man survives these cosmic disasters, and civilization is saved, but the evil within is now apparent. Antrobus's son, symbolically representing Cain, has proved to be an uncontrollable killer, evil incarnate. The play ends with expressions of hope embedded in references to the stars as philosophers, with their ancient and eternal wisdom and inheritances for mankind. Seeds of a new yet similar cycle, however, are present. The references to archetypal and biblical figures and situations; to the beginning and continuity of history; to the conflicted Family of Man; to the polarity of the sexes; to cosmic, timeless events and figures; to ancient wisdom; to conflict, catastrophe, and struggle; to death and destruction as natural forces; to human treachery yet hope and endurance; and to the perpetual need to rebuild after destruction as the perpetual life cycle—all foretell Abstract Expressionist themes as they document and elaborate on contemporary events.

Wilder was of course responding to World War II and America's entrance into the titanic conflict. Struggle, evil, cataclysm, and the need to rebuild were not fictions but realities of life in the early 1940s. The war brought an end to the uneasy alliance of art and politics that had existed in the thirties. Political solutions were discredited as politics itself was dwarfed, absorbed and transformed by the new business at hand. To be sure, revitalization and regeneration were sought, but now increasingly through individual as well as cultural transformation. With the outbreak of the Second World War, the intellectual pessimism of earlier decades seemed to be confirmed—the destruction of civilization was at hand. But, in contrast to the often nihilistic response to the First World War, the Second World War galvanized in many a new and even more intense determination to reshape life and society. The war gave politics a moral dimension that led many European and American intellectuals—among them, Sartre, Camus, Boll, Pavese, and Silone—to act and write in defense of human dignity and in hope of truly meaningful change after the war.[60]

The catastrophe that would engulf the West for six years brought out this need for new affirmation. "Spiritual Revolution" was a common theme in the West, especially in the European Resistance and its press. The words "renewal," "reconstruction," "regeneration," and "revolution" appeared frequently. The aim was to promote a new spiritual fulfillment rather than just a new socioeconomic order, as had been the case in the 1930s. In Europe, a humanism that was still leftist, as in the prewar period, was combined with a new value—the individual's dignity and worth—a value that had been ignored in the free-for-all competition of leftist and rightist collectivist utopias of the 1920s and 1930s.

For the nation, homefront mobilization changed the behavior of ordinary people, as community spirit took over. One of the Andrews Sisters said, "It was like everybody in the United States held on to each other's hands."[61] The armed services proved to be a great leveler of class difference. The soldier became Everyman. National camaraderie and sacrifice were great: "It was the notion that we were all bound together to save and conserve in order to help our fighting men."[62] Despite the fact that most of the war was overseas and America remained the most untouched nation, crisis behavior and a sense of responsibility dominated everything: "The war pervaded every aspect of our lives. Even the Christmas parade. The tanks would go down Pine Avenue, great hulking machines, then Santa Claus would come. And we cheered for the tanks as much as we cheered for Santa Claus."[63] Many Americans were afraid of air raids and submarine bombardments, and the media brought the war home: "*Life* came every week to deliver the war to our doorstep and replenish our fear."[64] As the Abstract Expressionist sculptor Seymour Lipton recalled, "The war was all around you. You couldn't get away from it."[65]

Ironically, the war brought about the social revolution that was often discussed in the 1930s. It was a revolution independent of theory and almost improvised. "Total war is the most catastrophic instigator of social change the world has ever seen, with the possible exception of a violent revolution."[66] New patterns of lives were established and new opportunities. With factories transformed for war production, with farm products in great demand, the American population found itself with money in its pocket for the first time in a decade or more. Even black Americans could say "Go west. . . . Everything is great in California, all doors are open, no prejudice, good jobs, plenty of money."[67] Women went to work and, although they lost their jobs after the war, the experience showed them another way of life. One noted, "The war produced some good things, and self-reliance was one of them for me."[68] Both men and women learned new skills in the war industries that carried over into peacetime.

Commitment to the war effort was no less the case for artists than for the general public. As an editorial by Forbes Watson in the January 1942 *Magazine of Art* emphasized,

Part One: Roots

the mood was "What Can I Do?"[69] The problem was how to respond as individuals and artists. For the average artist:

It was felt that the very magnitude of the Second World War ... intensified the need for American artists to use whatever powers they had ... to help clarify the issues in order to marshall both the spiritual and material resources of the country in a struggle between the forces of progress and darkness. ... Artists were advised to play the role of commentator, penetrating deeper and more cogently than maps, charts, and news reports by combining accuracy with emotion and spirit.[70]

Many artists made art for the war effort, for posters, victory-parade floats, battle-scene illustration, camouflage, propaganda, and so on. Other artists contributed prints illustrating political programs, as in a print competition of 1943, "America in the War." Most of these were WPA-like images of material production and work, images adjusted to represent the war effort. Others illustrated the opposing camps. The Axis powers were demonized to represent cruelty, bestiality, and perfidy as in Benton Spruance's *Souvenir of Lidice* with its allegorical reference to Calvary (fig. 11), while the Allies were portrayed as either innocent or millitant and heroic (fig. 12). Most

significantly, Christian iconography was again adapted to new historical needs.

Interestingly, of the Abstract Expressionists only Ad Reinhardt and James Brooks went into military service. The others were either too old or, like Rothko, Pollock and Gottlieb, were turned down. Determined to contribute, however, some joined the homefront mobilization. Gottlieb bought tools to pass himself as a welder so that he could work in the Brooklyn Navy Yard.[71] Still worked at a shipyard on the West Coast. Gorky studied camouflage, and Krasner and Pollock did propaganda designs for the new war-related government window displays.

The Metropolitan Museum of Art and the Museum of Modern Art held exhibitions of war-related art such as *Britain at War*. These exhibitions indicate the art world's involvement and moral commitment to the war effort, as well as the war's obvious impingement and pressure on the nation's psyche. But it was not the special exhibitions, nor even war art, that revealed the art world's growing deeper responses.

Artists were called upon to identify with the "hearts of men in these soultrying times" in the modest words of an

Figure 11. Benton Murdock Spruance, *Souvenir of Lidice*, 1943. 31 × 46.4 cm. Lithograph. Print Collection, Prints and Photographs Division, Library of Congress.

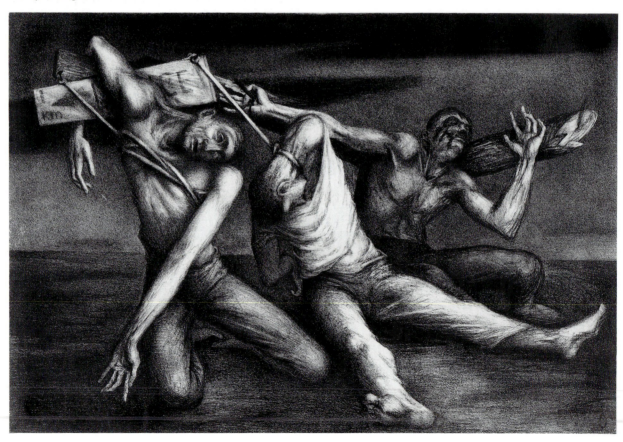

18

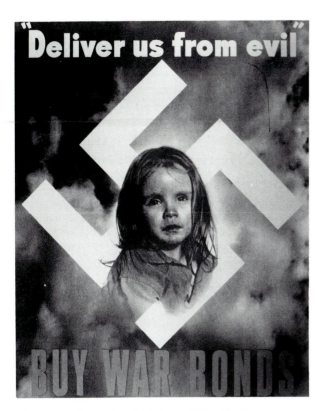

Figure 12. *"Deliver Us From Evil."* Poster. National Archives.

editorial in *Art News* in 1940, but it was not easy to do this and make an original artistic contribution.[72] War art such as the "Artists for Victory" exhibition of 1943 was criticized for lacking profundity and emotional power, for not rising above the level of propaganda.[73] Under the onslaught of news of battles and military technology, it was difficult for artists to generate coherence as well as penetrate beyond the surface. Lillian Hellman said that in 1944 she kept copious notes for her writing. But looking at them later, she realized that they did not include "what had been most important to me, or what the passing years have made important."[74] An RAF airman in the war found:

From all the quite detailed evidence of these diary entries I can't add up a very coherent picture of how it really was to be on a bomber squadron in those days. There's nothing you could really get hold of if you were trying to write a proper historical account of it all. No wonder the stuff slips away mercury-wise from proper historians. . . . No wonder it is those artists who re-create life rather than try to recapture it who, in one way, prove the good historians in the end.[75]

In the late 1930s and early 1940s—the very gestation period of Abstract Expressionism—the interest in fictional history, or rather its disguise, symbolical and metaphoric art, was renewed among artists. The catalogue for the

exhibition *Britain at War* of 1941 at the Museum of Modern Art exemplifies the subtle and far-reaching change taking place. Prewar art and thought were being recontextualized as war art. In other words, the war established a new intellectual framework through which art and culture would become historically meaningful.

Britain at War was intended to show the life of the common Britain at war and at home through photographs, paintings, posters, cartoons, and poetry. With a poem by T. S. Eliot, texts by curator Monroe Wheeler, and an essay by Herbert Read, however, the catalogue also reveals how the intellectual and cultural worlds shifted and readjusted their usual intellectual concerns to focus on contemporary history. Wheeler writes:

With admirable wisdom, in this war as in the last, the British Government has recognized the usefulness of art to enliven the idealism with which its people are united in self-defense, to ennoble the scene of their common suffering and to provide visual imagery of their great cause and their peril. This book and the exhibition which is its subject matter offer a necessarily limited survey of what the artist can do in time of war.[76]

To the need to represent idealism, to ennoble common suffering, and to provide imagery of Britain's peril, Eliot dedicated a poem, "Defense of the Islands," which compares Britain's contemporary warriors to their ancestors. Both contributed "their share to the ages' pavement of British bone on the sea floor" in the fight with "the power of darkness in air and fire." Herbert Read notes that some artists dutifully report the reality of the war while others achieve "a new order of reality or vision." Figures are no longer individuals but representative "types" visualized from the immense epic of the war. The portrait of *Group Captain Sweeney* transcends mere reality to become a symbol of "visionary enterprise." Ultimately the exhibition records, in the words of E. J. Carter, the Librarian of the Royal Institute of British Architects, not only war, not only "destruction," but "re-creation," for "civilized man cannot live among destruction without a desire to create."

Other exhibitions articulated further changes in thinking. Less obvious than specific war exhibits, but more important, was a new concern with how nonmilitary, nonpolitical art reflected the state of the modern soul in this time of crisis. For example, in the catalogue for Salvador Dali's show at the Museum of Modern Art in 1941, Monroe Wheeler described his art as among the best arising from a troubled epoch because it "neither reports nor comments upon the trouble, but is in itself a significant happening in history; a sudden and perhaps unconscious revelation of the spirit of the day and age."[77] Wheeler claimed that Dali had been prescient about the calamities of the time, and he compared Dali's subject matter and temper to an earlier time—the era between Bosch and Callot. In

that era Rome had been sacked, Vienna was beseiged by Turks, Jews herded from country to country, and the Netherlands savaged by the Spanish. (The comparison of the war era to earlier precedents and the emulation of earlier artists of disaster such as Callot, Goya, and others is typical of wartime art.)[78] In the same catalogue, James Thrall Soby wrote that Dali painted his birthright—high-pitched Spanish emotion and an "Inquisitional heritage of cruelty and pain, the Catalan love of fantasy, and sanctification of instinct." Dali was taken to give the ultimate representation of the psychology, immense neuroticism, and hidden psychosis of his era, an era in which, he lamented, no "spiritual regeneration" had yet succeeded. Dali's images of disturbed mental life were thus taken to exemplify contemporary history. Indeed, common descriptions of the war were in terms of psychological upheaval and disorder.

In like fashion, James Johnson Sweeney, an important art world figure, argued in his catalogue for the influential Miró show in 1941 at the Museum of Modern Art that Miró belonged to and could show the way to the future, to the new era that was replacing the old, decadent world which had brought about the war:

In Miró's researches, we have the reflection of a[n] ... age. But his work is not a scoffing ... or defeatist expression of this period-character. It is the record of a persistent constructive effort to achieve a sound balance of the spiritual with the material in painting, an esthetic paradigm of a fuller, richer life in other fields. Disillusion and reflections on decadence have no place in it. Miró's work belongs to the youth of a period that is opening, rather than old age of a closing one. ... Miró's vitality ... [and] native lyricism, and love of life are today, auguries of the new painting in the new period which is to come.[79]

Miró's painting was seen as representing the undercurrent hopes of the war, for, after all of these sacrifices, "There was a feeling of optimism. It will be a better world."[80]

Other art critics engaged the crisis in a way that proved equally prophetic for Abstract Expressionism. Herbert Read, the principal contemporary English-language critic read by almost all Abstract Expressionists at this time, squarely addressed some of the darkest moments in human history in his *Politics of the Unpolitical* of 1943. He argued that artists have the talent of prescience that would aid in the work of "reconstruction": "let us ... declare, that throughout all the chances of history, in the face of defeat and despair, in spite of long epochs of darkness and retrogression, man has established facilities which enable him to distinguish ... absolute values."[81] Humanity has established a moral sense to guide itself: the aesthetic sense which in the end is vital for knowing its needs and for seeking essential values. With so much destruction, the need for the reestablishment of secure verities asserted itself.

The Abstract Expressionists engaged the metaphysical and emotional needs evident in the early days of the 1940s. Like Eliot, Read, and Wheeler, they did not simply illustrate the era's crisis and respond with banal realism and WPA production images but rather sought ways to address the needs of humanity through the vehicle of modern art and thought. *Abstract Expressionism arose largely through the application of modern artistic and intellectual modes to historical, social, and cultural crises of the times.*

It was through the new canons such as myth, psychology, and natural history that Abstract Expressionists were able to make sense of events that otherwise would have seemed merely accidental and calamitous.[82] For them as for many, "the war was the beginning of ... seeing things. You just can't stay uninvolved and not knowing when such a momentous thing is happening. ... You put one piece with another. Suddenly, a puzzle begins to take shape."[83] Modern subjects became the framework for historical explorations. In discussing primitive art, as Gottlieb and Rothko explained it in a radio interview in 1943:

All primitive expression reveals the constant awareness of powerful forces, the immediate presence of terror and fear, a recognition and acceptance of the brutality of the natural world as well as the eternal insecurity of life.

That these feelings are being experienced by many people throughout the world today is an unfortunate fact, and to us an art that glosses over or evades these feelings, is superficial or meaningless.[84]

The Abstract Expressionist sculptor Theodore Roszak summed up the change in American art from the 1930s to the 1940s in the catalogue for the Museum of Modern Art show in 1946, in which he exhibited constructivist geometric work indicative of the social idealism of thirties art in America, writing "At the same time that these 'constructive' ... intentions exist, the world is fundamentally and seriously disquieted and it is difficult to remain unmoved and complacent in its midst."[85] World War II had destroyed his belief in the illusion of the utopia of material technology; soon afterward, he too changed to an Abstract Expressionist aesthetic, that is, to mythological, ritualistic, naturalistic, and psychological primitivism and archaism as part of the search for new beginnings and spiritual regeneration that ultimately underlies much Abstract Expressionist art and thought. At this point there arrived in New York Picasso's *Guernica*, a modern history painting of mythic figures and cubist form, and European Surrealist artists became important. It is the Surrealists' interest in humanity's inner life, elemental instincts, formative and destructive forces, and the concept of change through internal transformation that made them seem newly relevant to Americans' needs.

SURREALISM, MODERNISM AND ABSTRACT EXPRESSIONISM

A mood of profound introspection followed the coming of the war, and the Abstract Expressionists, like many Americans, turned toward an art and thought that presented history not as a progression toward a technological ideal but as a more complex drama of human achievements and failures. This art was modernist and especially surrealist. So widespread was the search for internal explanations of events that Benton, the Regionalist par excellence of the 1930s, momentarily ended his frustrated search for "applicable pictorial ideas" by turning to the work of the surrealist Salvador Dali,[86] which he, like the Abstract Expressionists, combined with Christian ritual.

Benton's *Year of Peril* series reflects his interest in a more emotional, fantastic, and ultimately mythic work characteristic of the 1940s (fig. 13).

Surrealism was most appropriate, for it was an art that grappled with the primary and elementary qualities of human nature, life process, instinct, and change. Surrealism attempted to reveal the fundamental sources and substances of the universe. It represented in original form violence and strife (particularly in the work of Masson, Dali, Ernst, and Miró). It understood life as streaming through space and time (particularly in the work of Dali, Masson, and Tanguy). It proposed that human life had a dialectical nature (particularly in the work of Masson and Ernst). With its explication of the profundities of human nature, it depicted the built-in limits of human existence in

Figure 13. Thomas Hart Benton, *Again [from Year of Peril]*, 1941. Egg tempera and oil on canvas mounted on panel. The State Historical Society of Missouri, Columbia.

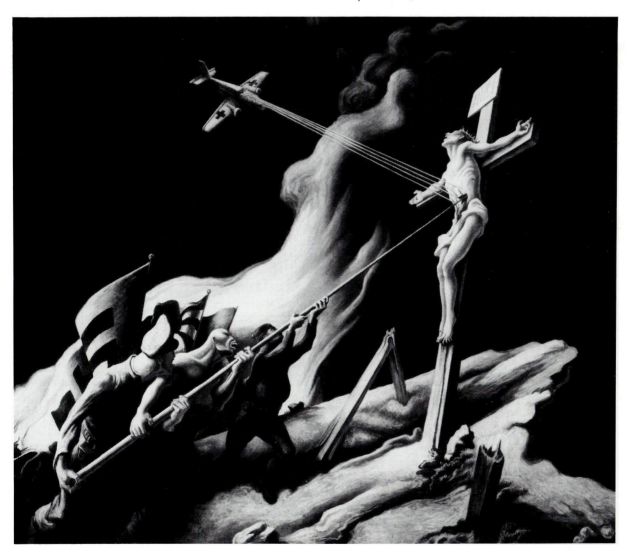

a time of war, fascism, and totalitarianism, locating sources for human behavior in the elemental unconscious. When the surrealists fled the Nazis in 1940 and came to New York, they brought with them an artistic precedent for comprehending the psychology of the crisis at hand.

Critics have long attributed the genesis of Abstract Expressionism to the appearance of the surrealists in America, but closer examination makes clear that the catalyst was not so much the arrival of the artists as a new interest in their ideas. Surrealist art had been known and exhibited in America since the early 1930s. New York galleries such as Julien Levy and Pierry Matisse showed their art, and Gorky and others saw it there. Hartford's Wadsworth Atheneum exhibited surrealist art in 1931, and in 1936–37 the Museum of Modern Art held a very comprehensive exhibition of surrealist art, *Dada, Surrealism, and Fantastic Art*. There were also known American surrealist artists in the 1930s, such as Walter Quirt, Kay Sage, and Bruno Margo, though they emphasized the Daliesque branch of surrealism—three-dimensional space and form—rather than the abstract Miróesque and automatist branch that arrived in the 1940s. By the 1930s, John Graham, a Russian émigré and sophisticated avant-garde artist from Europe, had introduced Pollock, Gottlieb, David Smith, and Gorky to surrealism and Picasso as well as to the value of primitive art. Thus the Abstract Expressionists were already familiar with many principles of modernism and surrealism prior to the surrealists' arrival and, indeed, some had already embarked on their modernist development. Gorky was well along. Pollock already knew of automatism and the importance of primitivism and biomorphic forms and was drawing from Picasso. Still had already studied American Indian art and ceremony as well as cubism. Both Gottlieb and Rothko did Dali-like and De Chirico-like paintings respectively before 1940, and Baziotes had studied Picasso.

When the surrealists arrived, they mostly kept to themselves. André Breton, titular czar of surrealism, never learned English. André Masson and Yves Tanguy settled in Connecticut. Only the Chilean Matta Echaurren and Wolfgang Paalen befriended and worked with Abstract Expressionists such as Baziotes, Motherwell, Gorky, Pollock, and others. The surrealists' arrival did however lead to more frequent exhibitions of their work and to increased information about their artistic principles. Gordon Onslow-Ford's lectures, for example, were attended by many Abstract Expressionists. However, other avant-garde artists also emigrated, including Mondrian, Chagall, and Leger, and they too held more exhibits than usual in New York. The artists who truly interested the Abstract Expressionists, Picasso and Miró, as Pollock noted, never actually came. The growth of interest in surrealism and modernism thus resulted partly from the intellectual migration and Europeanization that transformed American thought and life in innumerable spheres besides art at this time.

Despite the seemingly firm rejection of modern art by American artists in the thirties, that decade did see the gradual growth of a commitment to modern art. Major collections such as the Gallatin Collection of Living Art at New York University were formed. Major institutions such as the Museum of Modern Art and the Museum of Non-objective Art were established in 1929 and 1937 respectively. New galleries appeared. There was more modern art visible in New York by the end of the thirties than ever before. Consequently, the Abstract Expressionists became very knowledgeable and, as Matta noted, less partisan about modern painting than many of their European counterparts.[87] By the early 1940s, the process of modernist acculturation begun by Alfred Stieglitz in 1908 with his gallery 291 and the Armory Show in 1913 was brought to its first fruition.

The Abstract Expressionists were particularly interested in cubism, the major formal innovation of the twentieth century, and its opposition, surrealism. But, while indebted to cubism's composition and pictorial autonomy, they, along with the surrealists and other artists of the interwar period such as Arp, Klee, and Mondrian, rejected its limited subject matter—a close, rational analysis of familiar environments and studio subjects—for more irrational and "hidden" subjects. Surrealism itself was partially a product of the First World War and its aftermath. It organized Dadaist irrational and antibourgeois outbursts in a theory of inner transformation that sought to create a new society partially through new psychic life.

Many surrealists had originally sought liberation and revolution through traditional European left-wing causes. They were antinationalist, anticleric, antireligious, anticolonial, anticonventional, and supported sexual liberation, esotericism, and occultism. In the 1920s they aligned themselves with the Communist Party and were pro–Soviet Russia; but by 1929, after many bitter internecine feuds, Breton declared that surrealism would henceforth be independent of the Communist Party although the surrealists would continue to share its ultimate goal—the overthrow of a bourgeois, capitalist society. The surrealist "revolution" was to be more than a new political order, however. Surrealism addressed itself to what Max Ernst called a "crisis of conscience and of awareness."[88] Western bourgeois culture was to be changed by changing its values and "realities." The surrealists sought to bring about such a revolution by creating a new mode of thought and shock. The liberation of thought and mind would liberate the individual, and man could then make himself anew, could transform himself and then the future of mankind. Surrealism attacked the restrictions and limitations of bourgeois, logical, and rational reality and tried to present

a view of alternate inner lives with irrational and fantastic images. Through the exploration and discovery of the inner world, partially conceived as Freudian-inspired dreamlife and the unconscious, the surrealists intended to develop a world for which there was no previous outer model. An inner revolution would thus effect an outward transformation of bourgeois society.

The surrealist influence on Abstract Expressionism is significant but would require almost a study in itself. It has never been discussed in detail and is indeed very difficult to describe. Some influences are obvious—the idea of the unconscious as the source of art; the surrealist form-language of biomorphism, and the pictorial and intellectual method of tapping the unconscious—automatism. Just as obvious are ideas that had little or no influence—the occultation of the object, the revival of Old Master illusionism, the subversion of everyday "reality," sexual games, the invention of techniques of chance. In other matters— the emphasis on change and transformation, on the rehabilitation of subject matter, on the transcendence of the merely subjective—surrealism and Abstract Expressionism are deeply intertwined and it is difficult to separate the threads. Nevertheless, a brief attempt should be made if we are to come to a fuller understanding of their individual natures. Although no hard and fast lines can be drawn between the two, it is evident that there are significant correspondences as well as differences, and even if we get a little ahead of our study of meanings in Abstract Expressionism, a comparison between the two—

in no way complete or thorough—will be illuminating.

To liberate man from everyday bourgeois reality, Breton, in the First Surrealist Manifesto in 1924, adopted some of the premises of Freudian psychology, with which he had become acquainted as a medical orderly during the First World War:

SURREALISM, N. Pure psychic automatism by whose means it is intended to express, verbally, or in writing, or in any other manner, the actual functioning of thought. Dictation of thought, in the absence of all control by reason and outside of all aesthetic or moral preoccupations.

ENCYCLOPEDIA. *Philosophy.* Surrealism is based on the belief in the superior reality of certain forms of associations hitherto neglected, in the omnipotence of dreams, in the disinterested play of thought. It tends to ruin, once and for all, all other psychic mechanisms and to replace them in solving the main problems of life.[89]

Of importance for Abstract Expressionism was the surrealist technique of automatism.[90] As a visual parallel to Freud's psychoanalytic mode of free association, Surrealist automatism was a method of initiating exploration of the unconscious. Emptying his mind of any preconceived ideas, knowledge, or rational control, the artist, almost but not quite a mere medium, would put himself in a passive, receptive state. With the mind free from control, its vitality would be captured in a series of random marks, lines or doodlings. In the second state of the process the artist would deliberately transform these random visual clues

Figure 14. André Masson, *Battle of Fishes,* 1926. Sand, gesso, oil, pencil and charcoal on canvas, 14¼ × 28¾ inches. Collection, The Museum of Modern Art, New York. Purchase.

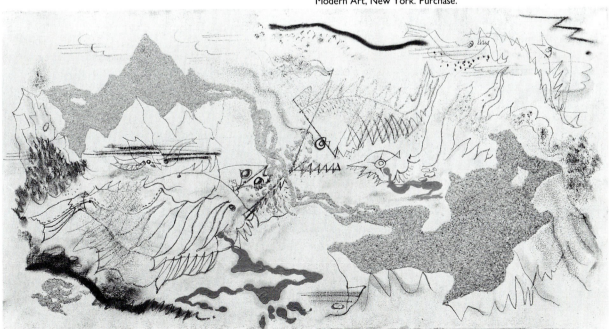

into subjects and forms. Victor Brauner described the process: "I start out from a pencil line without knowing where I'm going. I follow my hand. I understand gradually what I want to do and from a certain moment onward the drawing itself commands my intention."[91]

Surrealist automatist methodology, whether the more abstract variety called automatist writing or the more imagistic, such as frottage, collage, and grattage, allowed for the emergence of instinctual feelings and of hidden "desires" in images of irrational combinations such as Ernst collages of the late 1920s. It valued chance and revelation. Automatism aimed, however, at more than an uncontrolled beginning for artistic images. With the creation of these images, the surrealists sought to subvert bourgeois rational reality and its attendant mode of living and thinking. Old, spent "realities" would thus be destroyed, and with the new beginnings, a new "marvelous" reality would be created. The marvelous liberated the mind and the individual.

It is important to remember that automatism required only the initial suspension of the conscious mind. As noted, automatism was a mode of beginning, but once the picture was begun the artist understood what he wanted to do in both form and content. Robert Motherwell described this second stage: "Once the labyrinth of 'doodling' is made, one suppresses what one doesn't want, adds and interprets as one likes, and 'finishes' the picture according to one's esthetic and ethic."[92] What emerged and the artist brought to finished form were the subjects he ultimately intended. In other words, automatism was a means of initiating the conscious subjects and themes of the artist and not an end in itself. The artist channeled unconscious vitality recorded by the hand into his predisposed themes. Chance merged with and became directed by intention. Masson's automatist markings were elaborated into representing the struggle for survival among fish in his *Battle of Fishes* of 1926 (fig. 14), which was a common subject for him, repeated in his less automatist series, Combats and Massacres. Miró's automatism was directed toward his interest in genesis. In the *Birth of the World* of 1925, he dripped, spilled, and wiped paint across the surface of a canvas and then drew elementary forms out of the resulting shapes, thereby suggesting the emergence of life forms from the primordial void. In his automatist drawings, Jean Arp, the inventor of automatism, suggested the intertwining and unity of floral and human forms, again his usual subject. Automatism was thus a mode of suggesting the artist's general subjects but avoiding any preconceived literal presentation.

Automatism's importance for the Abstract Expressionists lay in the following: (1) it was an intuitive mode of beginning that emphasized the unconscious as a source of creation; (2) it was a means of expression which assumed

not just the initiation, not just the style, but part of the meaning of the work itself; (3) it was the primary creative principle to which Abstract Expressionist subjects were added, and which subsumed them; and (4) it tapped and stood for inner life as a whole. It recorded the idea of endless creative energy, innumerable new beginnings, and perpetual inner life. Most Abstract Expressionists, in an American definition, used automatism for the "summing-up and reinterpretation of [the] personal and cultural past, as well as a charging of the past, the known, with new life through ... metamorphoses."[93] In their use, that meant conveying in its "vibrations and fusions of meaning ... the boundless reaches of presentiment and memory ... of man" and "the physical universe."[94]

Ultimately the Abstract Expressionist use of automatism differed from the central surrealist use because rather than free associating a flow of images and subverting banal reality and logic with them, Abstract Expressionists used automatism as a key to creativity and creative life. Their use was more in keeping with a thematic subbranch of surrealism, Masson's idea of creative forces. Mainstream surrealist automatism transformed life through questioning the real; the Americans, like Masson, transformed life by symbolizing and representing creative and destructive change.

Figure 15. Max Ernst, *Napolean in the Wilderness*, 1941. 18¼ × 15 inches. Collection, The Museum of Modern Art, New York. Purchase and exchange.

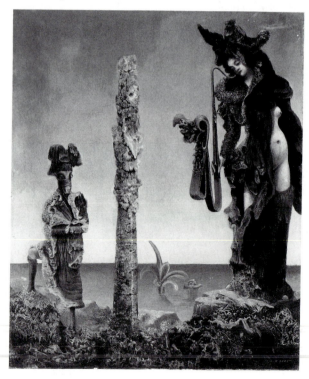

To further symbolize constituents of dynamic change, surrealist and Abstract Expressionist artists employed another conception, metamorphosis. Automatist flux created a sense of the continual change of one thing into another, as in Ernst's *Napolean in the Wilderness* of 1941 (fig. 15):

Plants turn into living animals, architectural shapes turn into statues which are at once plant, human shape and *tropaion*. The metamorphosis takes place so smoothly that it is impossible to make out whether a living substance has been petrified or an inanimate one brought to life, whether these are plants revealing human forms or humans revealing plant forms.[95]

Metamorphosis is fundamental to the surrealist creative enterprise. It enlarged reality with the formation of, in Breton's words, "new beings" or hybrids.[96] Inner flux represented the unconscious inner world and thus man's inner nature. Like automatism, metamorphosis became more than a technique; it became a theme. It came to represent capacity for continuous inner development. For example, in *Growth* (fig. 16), Arp's meandering curvilinear forms suggest elemental shapes and their process of creation and change. Arp's metamorphosis seems to cap-

Figure 16. Jean Arp, *Growth*, 1938. Bronze. Philadelphia Museum of Art: Curt Valentin.

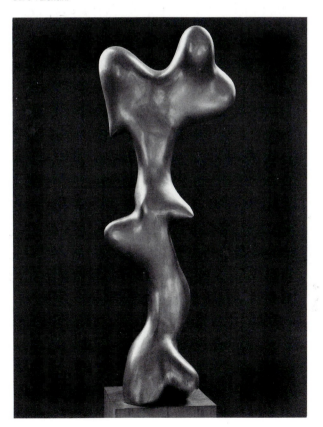

ture elemental processes as well as the striving, even transitory, nature of existence. For Arp, metamorphosis represented an inner spirit: "Art should lead to spirituality, to a mystical reality."[97]

Quite different is Masson's conception and use of metamorphosis. As Carolyn Lanchner describes it:

Masson's apprehension of man's condition rests supremely on the concept of metamorphosis, the Heraclitean recognition that there is no reality except the reality of change, that permanence is an illusion of the senses; nothing is but is in a state of becoming. All things carry with them their opposites; death is inherent in life and life potential in death. . . . In 1921, on the threshold of his career, his credo was "To paint forces: the open road."[98]

Automatic drawing turned into a metamorphic struggle of generation, dissolution, and renewal among life forms, as in Masson's *Meditation on an Oak Leaf* (fig. 17). Metamorphosis represented the life process, an unending cosmic, natural, and inner transmutation.

The Abstract Expressionists drew greatly on this conception of eternally changing and transforming forces of inner and outer life. The idea of creative and destructive forces was a foundation of their themes and styles. Many, however, after their formative surrealist-influenced work, attained an abstract portrayal of the eternally renewing forces of life, a plastic fluidity and vitality that the surrealists never realized. Their metamorphosis became the history of the spirit and endeavor of mankind over space and time.

Metamorphosis broke down the barriers between different things, different states of being, and different processes. It also brought to the forefront of art the elimination of man's dominant role in nature. A leitmotif of surrealism is the fusion of man and nature, of plant, animal, and even cosmological forms in a form-language called biomorphism. Biomorphism replaced and countered cubism's rectilinear forms with generally curvilinear shapes. It constituted a form-language that was used by many different mid-twentieth century artists, not just the surrealists.[99] For the surrealists and the Abstract Expressionists, biomorphism came to represent the integration of the forces of man and nature, of the inner and outer worlds, of human and universal experience.

Each Surrealist employed it in a way consistent with his themes or aesthetic. Arp described one of his first sculptures, *Human Concretion* of 1932, as representing a biomorphic growth process:

Concretion is the result of a process of crystallization: the earth and the stars, the matter of the stone, the plant, the animal, man, all exemplify such a process. Concretion is something that has grown.[100]

Miró used biomorphism to create hybrids of animal-human-stone elements. In *The Family* of 1924 he created

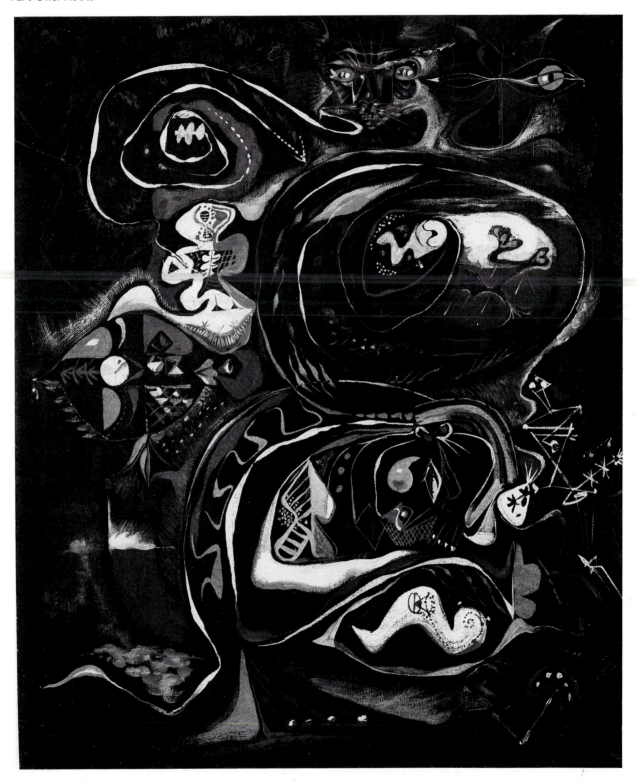

Figure 17. André Masson, *Meditation on an Oak Leaf*, 1942. Tempera, pastel and sand on canvas, 40 × 33 inches. Collection, The Museum of Modern Art. Given anonymously.

a biomorphic personage with an exaggerated sex to suggest procreation. The personage is made up of stone and bonelike forms that recall ancient representations of prehistoric animal and human life. Similarly, Masson turns a horse, a fish, and female anatomies into cosmic constellations.[101] In *Battle of the Fish*, one of his greatest automatist works, he symbolizes human struggle and strife by analogy with their equivalents in the animal world. And in *Napolean in the Wilderness*, Ernst unites the varieties of life in a totemic image.

The more artistically conservative "dreamscape" branch of surrealism represented by Dali, Tanguy, and Magritte used similar images of a unitary physical and inner reality in their "mindscapes" (fig. 18). Tanguy represents the timeless and profound depths of the mind with an image of a deep submarine expanse. The space is sparsely populated with biomorphic forms suggesting humans, animals, and even prehistoric stone constructions native to his birthplace in Brittany. It is a mental rather than just a physical landscape.

Surrealist biomorphism restored man to his "place in nature" and is the source of Pollock's famous statement "I am nature." Surrealism also saw art as a natural form and product. Breton declared that the mission of art is not to copy nature but to express it.[102] For the surrealists and ultimately for the Abstract Expressionists, art is "a fruit that grows in man, like a fruit on a plant, or a child in its mother's womb."[103] Artistic creation formed an analogy to natural process and product.

In the search for alternative modes of thought, the surrealists drew upon widespread anthropological conceptions of primitive thinking, especially Sir James Frazer's *The Golden Bough* and the works of Lucien Levy-Bruhl,[104] a prominent anthropologist in the 1920s and 1930s. Levy-Bruhl's book, *How Natives Think (Les Fonctions mentales dans les sociétés inférieures)*, postulates an alternative to Western thought—the elemental thinking of non-Western people whose mode of thought Levy-Bruhl described as "pre-logical"; that is, a mode that does not differentiate between animate and inanimate and does not subject nature to what are seen as scientific laws. Though surrealism is only partly a primitive style—except for such later surrealists as Wilfredo Lam and Wolfgang Paalen, only Miró and to a degree Ernst can be called artists of the primitive—it combined an investigation and emulation of primitive thought and art with an investigation of the workings of the mind and especially of the unconscious. This linkage is crucial for Abstract Expressionism, which developed surrealism's interest in primitive thinking, primitive religion, and magic.

The surrealists used a mode of transformation aimed at a nonlinear, evocative, indirect, unforeseen and multiple associational image. In other words, they used metaphor,

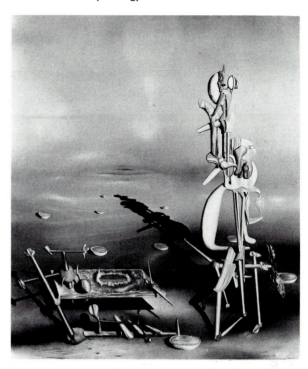

Figure 18. Yves Tanguy, *Divisibilité Indefinie [Infinite Divisibility]*, 1942. 40 × 35 inches. Albright-Knox Art Gallery, Buffalo, New York. Room of Contemporary Art Fund, 1945.

simile, and analogy to undermine reason and logic. For example, in Ernst's *Oedipus Rex* and *The Couple*, both of 1924, and his *collage-romans*, figures and objects are exaggerated in size, fragmented, and combined with other objects so that relations between physical things and ultimately between the viewer and habitual expectations are recreated in a new way. The Abstract Expressionists also made use of these poetic principles, as in their references to nature as "human" as well as mere physical nature. They too rejected any merely analytical or illustrative views of life or contemporary events or needs. They too avoided any literal or circumstantial portrayals of the human situation. But they were less interested in subverting reality than in universalizing their themes through poetic allusions to similar examples.

Ultimately, Abstract Expressionism is greatly indebted to surrealism not just in these general areas but also for more specific subjects and themes. The duality and unity of opposites, of consciousness and unconsciousness; the Heraclitean flux; the cycles of birth, death, and renewal; the symbolic uses of the sea, the night, and the eye; and the emphasis on origins and evolution, are all partially derived from surrealism.

Yet Abstract Expressionism is not surrealism but something different along a shifting spectrum. Events, culture, and individual interests intervened and produced a related

but new style. Abstract Expressionism is a pared down, simpler, less urbane and inventive, less technically experimental style. It is a more "earnest" version, partially derived from American art of the 1930s, from the emphasis on historical patterns of change and transformation. When Wheeler said of Dali that his conduct may have been "undignified," but the "greater part of his art is a matter of dead earnest, for us no less than for him," he was characterizing the entire surrealist enterprise in a way that would differentiate the Americans from the more playful surrealists.[105]

Although the artists readily admitted their debt, in the early 1940s they saw their orientation as different from that of the surrealists and they criticized them for a number of reasons. In 1942 Motherwell and Baziotes tried to enlist Matta in an exhibition at Peggy Guggenheim's gallery that would discredit the surrealists as dogmatic painters no longer attuned to the contemporary world because they had betrayed their own principles of psychic automatism and exploration.[106] Greenberg criticized surrealism for reviving Old Master techniques and literary themes.[107] Newman criticized them for creating not new art and life but simply a "phantasmagoria."[108] He could not believe they did not change their style in response to the war and its horrors.[109] In 1940 he wrote, "Some of us woke up to find ourselves without hope," for "painting was dead." Seemingly, he would start from scratch, to paint as if painting had never existed before, to paint a new "world."[110] Gottlieb concurred when he declared that he and Pollock at that time had a feeling of absolute desperation, that it was necessary for one to dig into oneself and create one's own values.[111]

A fresh start was thus needed culturally and artistically. Surrealism, indeed all European style, had to be transcended. Surrealism was considered a spent force intellectually and artistically, unable to respond to the new needs of the day. Even though some surrealists painted responses to the political and historical events of the period—for example, Ernst's *The Angel of Hearth and Home* of 1937, *The Nymph Echo,* and *Barbarians Marching to the West;* Miró's *Aidez l'Espagna;* and Masson's series *Contemplation of the Abyss;* and in a sense their work had always been such a response—their style seemed relatively unchanged. Picasso's *Guernica* (fig. 19) more successfully captured the Americans' imagination as a direct response to disaster and savagery, but only Matta eventually responded in a way that was prophetic for Abstract Expressionism:

I had some kind of trauma when I realized what the war was, and the concentration camps, and I went one step further in my understanding. I tried to use, not my personal psychic morphology, but a social morphology. Using the totemic images involved in a situation which was more historical: the torture chambers. . . . I tried to pass from the intimate imagery, forms of vertebrae, and unknown animals . . . to cultural expressions, totemic things, civilizations. . . . I was still being under the laws of morphology, but this time not so much of the forming . . . of an organism which was symbolic of myself, this time it was the formation of cultures confronting each other. Battlegrounds of feelings, and ideas, fighting to see if something would come out of these clashes. . . . I thought at one point that the introspection transformed itself into world introspection . . . [a] vision [of] . . . this world of which I was a part. And not only what the world was doing to me. . . . This imminence of tragedy and war, etc. These things were like rain catching up with a man who is running.[112]

Figure 19. Pablo Picasso, *Guernica,* 1937. 11 feet 5½ inches × 25 feet 5¾ inches. Prado Museum. © ARS, New York.

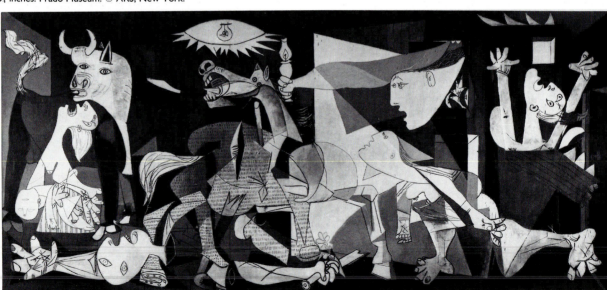

Matta's remarks trace the fundamental change from surrealism to Abstract Expressionism. Much Abstract Expressionism presents a view of the psyche as historical and cultural and not only as a modernist mode of the subjective or personal. The Americans emphasized the psyche, inner life, the unconscious, and nature—surrealist-derived themes—through a vantage point of humanity as a universal historical and mythic entity, not simply a bourgeois object of left-wing scorn. The Abstract Expressionists understood and undertook the investigation of humanity's inner life as a universal, epic, historical and cultural search. They adapted the idea of the creative unconscious and creative inner life and focused on its development through time and space. They historicized the unconscious, going back to its origins in the prehistoric, the primitive, and the ancestral, and recapitulated these first human experiences as permanent truths, not just as alternative modes of "reality." The unconscious past is for them the contemporary present and the future. Many surrealists criticized contemporary Western bourgeois culture; Abstract Expressionism recapitulated the history of man's inner life and his search for meaning, purpose, change, and transformation. Surrealists sought the expression of the universal in the particular; the Abstract Expressionists found the personal in the universal. Some surrealists emphasized an individual, rationally unaccountable, self-generated change. Many Abstract Expressionists emphasized the historic forces of change, metamorphosis, and evolution. They were indifferent to the merely rationally unaccountable, taking it for granted. Abstract Expressionism emphasized change as a result of a mythic and historical cycle of constructive and destructive forces.

It is this concentration on the creative will and its rendering through a more abstract pictorial means rather than a semireal, semisymbolic complex language that marks Abstract Expressionism. It fused surrealist metamorphosis, vitalist biomorphism, and psychological change with American historical evolutionism. In other words, the Americans wedded selections of surrealist ideas with simpler, more direct, and more powerful plastic form. In a more monumental art, the Abstract Expressionist rendered the history of inner life over space and time.

The constituent elements of the surrealist program thus proved to be fertile soil for the Abstract Expressionists. Surrealism's opposition to "art for art's sake," its emphasis on subject matter, its attempt to change Western culture, its formal language, its notion of ideal transformation through the expansion of consciousness, and its emphasis on alternatives to a rational and logical reality were ideas that the Abstract Expressionists absorbed and shared. The surrealists had also, in Robert Goldwater's words, reintroduced "ambiguous and 'literary' meanings" into modern art. Like the folk allegories of American art of the 1930s, they contradicted the self-sufficient plastic compositions of cubism and reinstated the "traditional alloys—narrative, sentiment, emotion and myth—whose use (or at least whose abuse) the general trend of painting and sculpture in our century had earlier renounced."[113] Unlike surrealists (for example Breton, who called painting a "lamentable" expedient), Abstract Expressionism wanted to develop a new pictorial vocabulary, but it also inherited surrealism's interest in many of the thinkers most important to modern times. Heraclitus, Freud, Nietzsche, Worringer, Levy-Bruhl, Frazer, the German Romantics, the French Symbolists—all of these were central for both Surrealism and Abstract Expressionism. They replaced the systems, values, and beliefs of the influential figures of American art of the thirties—Frederick Jackson Turner, Charles Beard, Marx, Craven, and Ruth Benedict—just as World War II replaced utopian strivings and "the evolution of world civilization."

But it was not just aspects of American thirties and surrealist art that lay behind Abstract Expressionism. It was the whole of modern culture in its contemporary form in the late 1930s and early 1940s. To describe the indescribable, the Abstract Expressionist had to pass beyond surrealism in both art and thought. The Americans drew on what was lacking for those in the First War, a sophisticated culture of waste, horror, fear, and anger. The earlier generation of English writers and soldiers had relied on *The Pilgrim's Progress* to explain their experience of war. The Americans (and the new generation of British artists called the Neo-Romantics) had the surrealists, Sir James Frazer, the newly popular myth of the Grail and *Moby Dick*, Joyce, *The Waste Land*, and much more. These figures and subjects provided much of the intellectual language, methods, and imagery for bringing their experience and emotions to consciousness.

The Abstract Expressionists invented and absorbed, adapted and expanded the idioms and subjects of a broad modern culture for their ends. It is through a study of themes and subjects originating in important twentieth-century thought, and their reflection and development in a largely historically and culturally induced style that Abstract Expressionism's symbolic and abstract painting can be best understood. Through these sources and precedents, the artists assimilated the unknown; "unprecedented meaning thus had to find precedent motifs and images."[114]

PROPAEDEUTICS

The Intellectual Roots of Abstract Expressionism

There comes a time when force attempts to subdue the mind.... It is then that the true humanist recognizes his role. Refusing to give in, he opposes brute strength with another, invincible power: that of the spirit.
<div align="right">Andre Gide, 1937</div>

Now that the flood waters of propaganda have subsided . . . we have come to the conclusion that many people in this country desire analysis and orientation. And so we have taken up the task.
<div align="right">Eugene Kogan (German), 1946</div>

In the late 1930s and early 1940s, the artists later to be known as the Abstract Expressionists consciously and unconsciously took up a search for the causes of contemporary chaos. They came to ask serious questions about the fundamental character of life in their world, the origins of its catastrophe, the elements of humankind that could bring the cataclysm about, the basic character of human beings and their future. The answers constitute Abstract Expressionism.

Under the pressure of the "collapse" of the West, interwar history, and the advent of two apocalyptic world wars in a generation, Abstract Expressionism investigated human mental, emotional, and spiritual history and life from the psychological, cultural, and historical vantage point of an interwar and then war culture. It sought a moral and spiritual truth and theory of existence. Most of the artists were thus not interested in the sociopolitical explanations of the Marxist/Communist ideologues of the 1930s, and like most Americans, including Marxists, they viewed the war as more than the usual sociopolitical arena of conflict. The war absorbed most social causes and dwarfed and made marginal virtually all prewar revolutionary agendas. With the advent of total world war that involved all classes and political-economic systems, the class victim became the anonymous, universal human victim.

The political beliefs of Abstract Expressionists were ill-defined, or rather the artists tended to hold that combination of anarchist-bohemian-conservatism typical of many modern artists. Indeed, most American artists of the 1930s, despite the easy talk in artists' unions of political revolution were, as we have seen in mural painting, more interested in representing evolution, continuity, and change than violent revolution.

Most Abstract Expressionists were members of the artists' unions, but despite attempts to associate them with the truly political extremists of the unions, most had joined only for social and professional, not political reasons. A brief examination of Abstract Expressionist artists and politics in the 1930s and 1940s makes their apolitical nature abundantly clear. In the 1930s, Clyfford Still painted Regionalist pictures and held a thunderous Nietzschean contempt for socialism and any "collectivism" of the time. He condemned the Bauhaus for such reasons and later compared it to Buchenwald. In the 1930s Rothko was an anarchist painting nudes, still lives, and subway riders. In 1959 he recalled that "Sometime in the Twenties, I guess, I lost all faith in the idea of progress and reform. So did all my friends because everything seemed so frozen and hopeless during the Coolidge and Hoover era. But I am still an anarchist. What else?" In the mid-1930s, like his colleagues, Baziotes participated in WPA demonstrations for personal reasons (wanting its continuing support) not for political reasons. To a friend of this time he criticized wasteful "social consciousness" talk and the political nature

of Diego Rivera's art. In his essay of 1949 "The Artist and His Mirror," written after the war, he repeated his dismissal of political art: "And when the demagogues of art call on you to make the social art, the intelligible art, the good art, spit down on them and go back to your dreams, the world, and your own mirror."

Newman was an anarchist who had nothing but contempt for Marxism/communism in the 1930s. He ran for mayor of New York in 1933, and A. J. Liebling, the journalist, published an article about his program in which he reported that Newman detested Marx and considered it a tragedy that some of the leaders of the day were "sullen materialists." A vote for the communists would help saddle New York with a "regime incompatible with art." Running as an intellectual on a platform of cultural reform, Newman called for a municipal opera house and orchestra, and a civic art gallery and street cafés, and he envisioned a city where even the "maniacs of dogma," the Socialist and Communist parties, could enjoy themselves. Newman considered Marxism one of the great tragedies of modern times, a belief he maintained throughout his life. In 1962, he restated his anarchist beliefs, declaring that if his entire work could be read properly, it "would mean the end of all state capitalism and totalitarism," that is, Soviet Marxism. Newman also wrote an introduction to Peter Kropotkin's *Memoirs of a Revolutionist* in 1968 in which he criticized the New Left of the 1960s for what he considered their new variant of the old dogmatism.

The question of Pollock's politics has been confused and contradictory. Pollock attended what may have been communist meetings when he was a teenager in high school in the 1920s, but for most of the 1930s, he practiced a Regionalist art under the influence of Benton, who in the 1930s stood for the right side of the political spectrum and whose art was exaggeratedly likened to fascism by H. W. Janson in 1946. Late in the 1930s he was influenced by Orozco who, unlike his colleagues Diego Rivera and David Alfaro Siqueiros, had nothing but contempt for a relationship between art and politics. Orozco was criticized in Mexico as a "bourgeois skeptic." He once said that those artists who painted politics were not artists. Pollock did participate in a Siqueiros workshop in 1936–37 for two months, but seemingly less for Siqueiros's politics than for the opportunity to learn the use of Duco in mural painting, the medium would shortly exploit in his poured paintings. His relationship with Siqueiros terminated in a fistfight. Pollock followed these artistic influences with four years of psychotherapy at a time when, in contrast to today's linkage of Marxism and Freud, Marxists denigrated it as merely another indication of bourgeois alienation. At the same time, he began his painting in obvious emulation of modern styles that also, in terms of art and politics in the 1930s, were unacceptable. Pollock

may have been a leftist in 1942 according to Motherwell, but, as Motherwell said also, politics had little to do with his art. There is no evidence he painted any pictures of communist leaders or obviously political work. (There is none by the other Abstract Expressionists either.)

Gottlieb further described the situation in the 1930s:

I think that Marxist ideas were very strong in this country for a while, and they were prevalent in the art world in the 1930s and '40s, but I don't think they had any effect on the art. If they had any effect, the effect was harmful. ... [T]he Soviet Union ... want[s] to control the ideological content of painting. They have specific people who are delegated to supervise that. This existed here in the 1930s, for instance, in the American Artists Congress, an organization that existed for exhibition purposes. Because of this problem, I and some other artists finally resigned and the Congress was exposed and broken up in 1939.

Elsewhere he concluded:

The Communist party had a strong hold on what was happening in art, and they were encouraging the idea of social realism. I thought it was ridiculous, because if you want to influence people, you can't influence people through painting. Television, radio, and movies are much better; they have much more force. ... We're not in the period of Daumier. ... So I thought it was ridiculous and it eventually proved to be so, because even though they still have this line in the Soviet Union, ... I question very much how much influence it's ever had. I think they just do it out of a kind of stupidity about art.

In the 1960s Motherwell reinforced Gottlieb and the others in an answer to a question of the art critic Max Kozloff about the reconciliation of radical politics and the esthetic values of French painting, when he said they were not "reconciled": "One of the things that characterizes people who came to be the best-known Abstract Expressionists was a deep reaction against anything that had any political content whatever."

In contrast to their colleagues, however, to a certain degree Motherwell (a banker's son who in the 1940s would dress down for his colleagues by wearing clothing with holes in it so that he could appear to be a Marxist-bohemian), Ad Reinhardt (who came from a left-wing family), and especially David Smith were more politically radical in the 1930s and for the first half of the 1940s. Smith in particular took the extremist view that the Second World War was mostly a capitalist war, and he criticized it in his famous Medals of Dishonor and in sculptures until 1945 such as *Race for Survival (Spectre of Profit)*. After the war and its revelations, their leftism evaporated or disappeared to microscopic traces as with their colleagues.

There is no hard evidence that most Abstract Expressionists were committed communists in the 1930s, the only time Marxism had any support in America, although they may have shared in some of its goals in the brief days

of the Popular Front (whose popularity was largely due to its anti-Fascism and not necessarily to its revolutionary agenda). When Stalin's purges of 1936 wiped out thousands, Stalin betrayed the cause of anti-Fascism with the Nazi-Soviet nonaggression pact, the Depression ended, the artists' unions disbanded, World War II began, the Fascists were beaten, and prosperity followed the war, the direct inspiration for the Marxists' brief moment on the American stage was dissolved. Gorky summed up the Abstract Expressionists' general attitude toward Social Realism and its call for the subordination of art to politics in his famous witticism, "poor painting for poor people."[1]

Rather than politically oriented, the Abstract Expressionists viewed history historico-culturally. Their art comprised subjects from anthropology, religion, psychology, metaphysics, the history of consciousness, biology, evolution, and history itself. Abstract Expressionism sought a universal, ancient, and historical pattern to Everyman's existence as conceived in the early war years, and to human emotional life and behavior under historical impress.

Abstract Expressionism represents the American turn to modernism as presenting the best answers to the questions of the artists' historical circumstances. It is an art of the modern imagination, having little to do with types of modern art that deal with personal memory or visual perception and analysis. Abstract Expressionism partook of the particular culture of its time. It drew on an understanding of mythic and religious symbols and metaphors of the primitive and prehistoric origins of mankind, of man's instinctual and animal nature, of the history of human and inner conflict, of the struggle of man's desires and his spiritual life, of the eternal need for continuity with others and for repeated new beginnings. It is a secularly spiritual art that gathered the most serious conceptions of human life it could find to explain, translate, and ultimately transform humankind's current situation.

The intellectual heroes of Abstract Expressionism include Freud and Jung, Jessie Weston and Sir James Frazer, Nietzsche and Lucien Levy-Bruhl, Joseph Campbell and Herbert Read, T. S. Eliot and James Joyce among many others. Their writings, which make up veritable classics of the thought of the first half of the twentieth century, examine the origins of individual behavior and of Western society and culture as a whole. These figures adopted a broad historical perspective in their analyses of culture and consciousness; many rejected technological growth or utopias as the pinnacle or goal of Western civilization. Their general assessment that modern Western civilization was in a state of profound crisis became the lens through which the Abstract Expressionists and many others approached their times. For most, modern culture could be understood and transformed only through the recognition

of the individual's psychology and the transformation of inner being. Only the early writing of Read in the 1930s saw any value in external reformatory schemes such as Marxism or Roosevelt's New Deal.

This chapter will examine the cultural complex, the sources and ideas of the themes, subjects, and metaphors of Abstract Expressionism, and the way in which they helped the Abstract Expressionists form their world view. There is a limited, circumscribed set of ideas and metaphors that constitute the Abstract Expressionist ethos or ideology and most of their art can be best understood when we examine how these basic elements are employed by the artists in their art. We seek the origins and conceptual metamorphosis of their art.

THEMES OF ABSTRACT EXPRESSIONISM

In her notebooks, the great choreographer and guide to themes of Abstract Expressionist thought, Martha Graham wrote for her dance drama of 1946, *The Dark Meadow of the Soul:*

> The eternal woman caught up into
> circumstances—
> The resolving of the difficulties
> The return to the original state
> (A Season in Hell) re-born[2]

To be caught in a web of difficulties and to seek to overcome them through an inward transformation and rebirth: these are the themes of Abstract Expressionism, however variedly the artists articulated them. Abstract Expressionism ultimately suggests a process of tragedy and triumph induced by historical events.

The Return to Origins

In accord with Western epistemological approaches, Abstract Expressionism sought to determine the fundamental nature of humanity by explaining its origins. It was a search for the elemental forces, the original forms and times, the primal emotions, the embryonic yet eternal sources and pattern of human life, history, and behavior. This parallels a similar retrospective and historical tendency in American art of the 1930s with its search for the American Genesis. The Abstract Expressionists sought the spiritual or inner, however, and not the outer or social, genesis of humanity.

The Human Continuum

All Abstract Expressionist art consists of some form of dynamic, energetic, pulsating flux or dynamic organic and

painterly continuity. The images of dynamic motion are metaphoric and analogous images of the continuous strivings, impulses, and emotions of humanity throughout all space and time. The human continuum includes simultaneous occurrences of similar events or transcends the particulars of time, place, culture, or history by means of a paradigmatic image of man's universal, eternal inner life. Abstract Expressionist art represents an order of process and perpetual struggle, human effort without ultimate utopian climax. The Abstract Expressionists converted the 1930s ideals and images of a dialectic process into those of eternally inward spiritual struggle. Pollock indicated his visual realization of this idea when he agreed that his work seemed to have no beginning nor end;[3] Gottlieb confirmed the idea when he said he saw all-over composition, the basic structural mode of Abstract Expressionism, as a continuum;[4] and Lee Krasner literally depicted it in her painting *Continuum* of 1949 (fig. 20).

Conflict and the Dualistic Pattern of Human Life

Central to Abstract Expressionist art and thought is the representation of the fundamentals of human life, which the artists conceived of as filled with disorder, suffering, conflict, and terror, as well as sublime joy and hope. They portrayed human emotional history as a pattern of universal and endless struggle and conflict, which began in the ancient/primitive/prehistoric past. Abstract Expressionist art reveals a quest for security, continuity, and harmony in a world of inexorable and unavoidable chaos and tragedy. Although all the artists said it in their own way, Martha Graham verbalized it best in her notes. For instance in *Center of the Hurricane:*

the artist reaches harmony & unity by way of strife & inward discord.[5]

New Beginnings, Creativity, Potency, Change, and Transformation

The last major theme of much Abstract Expressionism is its defiant life-affirming optimism. The return to origins, the universal striving or inner continuum of all life, and the pattern of human conflict and struggle all point to a climax in a desired new beginning.

The theme is frequently recorded in this period, from Gottlieb's *Persephone* of 1942, and Paalen's and Newman's paintings, *Beginnings* and *The Beginning* (Plate 1) of 1945 and 1946 respectively, to the lines from Delmore Schwarz's poem "In the Naked Bed in Plato's Cave." of 1947—"The mystery of beginning/Again and again, while History is unforgiven"—to Martha Graham's quotation of T. S. Eliot's words from *Four Quartets*, "In

Figure 20. Lee Krasner, *Continuum*, 1947–9. Oil and enamel on canvas. 54½ × 43⅞ inches. Robert Miller Gallery, New York.

my end is my beginning/In my beginning is my end."[6]

In individual Abstract Expressionist subjects, there were always new possibilities. Nature, with its vitalism, perpetual metamorphoses, and evolutionary struggle suggesting creative process, transformation of the species, and flowering in growth and change, continually brings about the new. Psychology, especially Jungian psychology, proposed a new world and individual harmony by means of the semidivine forces of the unconscious. Ancient, primitive, and Christian ceremonies, magic, and initiation rituals create new beings with enhanced powers and an altered identity. Nietzsche's Dionysian forces and creative struggle result in procreation and growth. For Joseph Campbell, the mythological hero is the "champion not of things become, but of things becoming," who continually shatters "crystallizations of the moment."[7] Creative acts lead to rebirth and represent "the singleness of the human spirit in its aspirations, powers, vicissitudes and wisdom."[8]

Most Abstract Expressionist art aims at an eternally creative consciousness and ceaseless new growth. In the 1940s this seemed to be the historically and culturally necessary ideal of man. Belief in the possibility of recovery, of new life with new understanding, was part of the

endeavor to prevent repetition of the mistakes that had led to the catastrophes of modern life. The thirties belief in a new economic and social utopia seemed naive to a generation needing more profound solace in Western civilization's darkest moment. The artists felt only a search for the fundamental character of life in their world and the history of human origins, motivations, and legacy as recorded in psychology, ritual, and myth could offer a new understanding that might aid their world.

If Abstract Expressionism is an optimistic art, however, it is optimism given with trepidation. More likely, it suggests tempered hope, chastened desire, and a new maturity. Perhaps Martha Graham was closest to the true Abstract Expressionist spirit:

> How does it all begin?
> I suppose it never begins, it just continues—
> Life—
> generations[9]

THE PRIMAL HERITAGE

The Abstract Expressionists searched for explanations of contemporary history in much the same way as their predecessors, the American artists of the 1930s. For both, a return to the past enabled one to pare away extraneous elaborations and phenomena and reach for essences. These are to be found in the origins of civilization and humanity. The past for the Abstract Expressionists consisted of tradition, frequently the Western tradition; prehistory, the non-Western and so-called primitive; the relationship of these cultures through time and space; and a community of continuum and change.

Tradition

The great architectural historian and advocate of modern architecture, Sigfried Giedion, wrote that his classic book *Space, Time, and Architecture: The Growth of a New Tradition* of 1941 was intended "for those who were alarmed by the state of culture and anxious to find a way out of the chaos of its contradictory tendencies." He added

Today we consciously examine the past from the point of view of the present to place the present in a wider dimension of time, so that it can be enriched by those aspects of the past that are still vital. This is a matter concerning continuity but not imitation.[10]

This attitude lies behind American art of the 1930s and 1940s. To establish a continuity with people of other times and places became an epistemological mode of analyzing and putting into perspective one's own predicament and culture. The art critic Al Frankfurter further underlined

this approach in an editorial in 1940, where he wrote that the period allowed artists to become, as their ancestors once were, "part of the stream of life at their time," and their art "forms . . . give a people its place in the history of civilization."[11]

The most popular definition of the need for continuity and tradition was provided by T. S. Eliot. In the interwar period, many Americans "grew up with Eliot and Joyce as sacred texts."[12] For example, Gottlieb and Rothko discussed Eliot in the 1930s with Milton Avery.[13] Motherwell knew and loved Eliot's work; Bradley Walker Tomlin gave him a book of Eliot criticism, and in 1983, Motherwell painted *The Hollow Men*, the title of which comes from Eliot's poem of 1925.[14]

Eliot's work in general reflects many issues with which American art of the 1930s and 1940s was grappling. In his essay in "Tradition and the Individual Talent" of 1922, he articulated basic interwar concepts of tradition, arguing that it is not merely the new but part of something larger than the individual, artist, or culture. Tradition consists of

the historical sense . . . [which] involves a perception, not only of the pastness of the past, but of its presence; the historical sense compels a man to write not merely with his own generation in his bones, but with a feeling that the whole of the literature of Europe from Homer . . . has a simultaneous existence and composes a simultaneous order. This historical sense, which is a sense of the timeless as well of the temporal and of the timeless and temporal together, is what makes a writer traditional. And it is at the same time what makes a writer most acutely conscious of his place in time, of his contemporaneity.[15]

To engage tradition is to engage history. History, then, is more than the compilation of dead facts; it is "an insight into a moving process of life."[16] Tradition makes necessary a wide survey of the whole domain of human activity, not so much to imitate bygone periods, but to conduct our lives against a wider historical background.

For Giedion and the Abstract Expressionists, present history or "destructive confusion of events in the world at large today" necessitates a move toward universality.[17] Giedion writes:

To plan we must know what has gone on in the past and feel what is coming in the future. This is not an invitation to prophecy but a demand for a universal outlook upon the world. . . . Today the urge toward . . . universality is deeply felt by everyone. It is the reaction against a whole century spent in living from day to day. What we see around us is the reckoning that this shortsightedness has piled up. . . . [I]t is neither natural nor human. . . . The demand for a closer contact with history is the natural outcome of this condition . . . in other words, to carry on our lives in a wider time-dimension. Present-day happenings are simply the most conspicuous sections of a continuum.[18]

Like Benton, and like American art of the 1930s, Giedion fuses tradition, history, and universality in a continuum of

space and time. "History is however not static but dynamic," a pattern of living and changing that is "part of our own natures."[19] Giedion further declares that it is the general line of this evolution or "approach to life" through different periods, social orders, and races that is most interesting. Formal and stylistic variations that mark the separate stages are of little importance, as the task of contemporary architecture is "the interpretation of a way of life valid" for the period. The choice, as he sees it, is not that between "Death or Metamorphosis" but that of "evolving a new tradition."[20]

To render history as dynamic and continuous, many Abstract Expressionists conceived of their work as unfinished objects representing moments of a continuity or, in other words, a stream of consciousness. For example, in 1950 at the Abstract Expressionists' meeting place, The Club, the sculptor Herbert Ferber noted: "I would say that I don't think any piece of sculpture I make is really 'finished.' . . . There is a stream of consciousness out of which these things pop like waves, and fall back." The sculptor Richard Lippold added: "There are those here who feel that the things which they make are simply moments of a continuity and therefore, in themselves, are not objects for their own sakes. . . . Is there an irreconcilability in making an object in itself which, at the same time, reflects continuity."[21]

To render a stream of consciousness, many artists drew on the master of the literary continuum of space and time, James Joyce.[22] Abstract Expressionists and members of the New York School who admired him include Pollock, Gottlieb, Rothko, Newman, Motherwell, Reinhardt, Brooks, Tomlin, and Tony and David Smith. Joyce's influence was perhaps best stated by James Brooks and Ibram Lassaw who said, when discussing Bradley Walker Tomlin's work and readings, that they, Tomlin, and others in the late 1940s were strongly affected by Joyce's "non-narrative," or "overall" expansive style that was a continuum without focal points.[23] David Smith also summarized Joyce's stature when he said he did not need to reach French literature or draw on Breton partially because "I've read James Joyce."[24]

Joyce's stream-of-consciousness technique in *Ulysses* and then *Finnegan's Wake* provided a dynamic mode of linkage of history, myth, culture, and interior and exterior life. Its compressions of dense, interwoven symbolism and interlocking themes moving in a holistic, cyclic unity offered a completeness and continuity that the Americans sought. *Ulysses* suggests a mode of recasting ancient traditions and mythic patterns in modern life, while in *Finnegan's Wake*, Joyce, following Vico, divides history into a four-part cycle that becomes the stages of the book's continuous journey. Each phase of history is characterized by particular forms of government and culture (not unlike mural cycles of the

1930s). A prehistoric theocratic period is governed by mythic gods, giants, and heroes. It is followed by an aristocratic and then democratic phase, and after chaos, a return to the original phase of the cycle. Joyce set forth a sophisticated holistic continuum as well as innumerable themes—split personalities, dualities, cyclicality, fertility symbols, rebirths—that underlie Abstract Expressionism.

For Joyce, American muralists of the 1930s, Spengler, and many Abstract Expressionists, the historical continuum was divided into stages or periods. These stages represented the cycles or "periodicity" of time, nature, and experience. In the words of the contemporary poet and close friend of Rothko, Stanley Kunitz:

"periodicity." This is what we learn from our immersion in the natural world: its cyclical pattern. The day itself is periodic, from morning through noon to night; so too the stars in their passage, the tides, the seasons, the beat of the heart, women in their courses. This awareness of periodicity is what gives us the sense of a universal pulse. And any art that does not convey that sense is a lesser art. In poetry . . . it leads us toward an organic principle.[25]

For these figures and for the introspective Abstract Expressionists of the early 1940s, to step back to the past is to step forward into the future; the present is merely a link in a chain. For example, the title *Finnegan's Wake* summarizes the theme of the cycle of death and rebirth. "Fin" is French for end; "egan's" is again; "wake" is to awake or be reborn. The characteristic Abstract Expressionist sense of history produces not a "tradition of the new," in the words of Harold Rosenberg, but its very opposite— the new of tradition. As Seymour Lipton notes:

a sense of history, of retaining worthwhile values of the past, enters lovingly into the assimilated experience of image-making. Yet, paradoxically, new and contrary interpretations of these old values are remade, transvalued in terms of today. Conservation and rebellion occur together. The past and the future make the present. Love of art forms and meanings of the past are molded in terms of aspirations for the future.[26]

Primitive and Archaic Heritage

In their search for origins and continuity, the Abstract Expressionists turned toward anthropology, the study of humanity and its cultures. Anthropology as an intellectual discipline had developed in the last half of the nineteenth and the beginning of the twentieth centuries. By the 1920s and 1930s, it had reached widespread popularity in intellectual circles. In New York, American anthropology came of age under the direction of Franz Boas at Columbia University. Boas and his students, Ruth Benedict, Margaret Mead, Alfred Kroeber, and many others, dominated American anthropology in the first half of the twentieth century.

Different schools of anthropology offered different theories about the origins, development, structure, and nature of society and culture, both Western and non-Western. They discussed the geographical and temporal diffusion of culture; the relationship of institutions to human behavior; the relationship of culture to individual mental processes; the rationality of human behavior and culture in general; the consistency, integration, or randomness of culture; the individual personality's independence from or dependence upon culture; the effects of environment and technology on the evolution of culture; and the utility and purpose of institutions. In short, anthropology offered a world view of man, culture, and personality based on analyses of primitive cultures that provided information about alternatives to the dominant social, psychological, and cultural arrangements in the West. And it tried to answer the question "What is human nature?" by studying traditional behaviors in other cultures. (It is to be understood, of course, that the term "primitive" in this study is being used in its historical sense. The societies it alludes to are in many ways the equal of and superior to Western societies.)

Most Abstract Expressionists were interested in the primitive in general, and in the Native American in particular. Consequently, they schooled themselves in the newly available writings of many anthropologists. The American Indian was the special field of study of Boas and his followers. Newman had read Boas's *Primitive Art* and Benedict's *Patterns of Culture*.[27] Gorky read Boas as well as Geza Roheim, a psychoanalyst who applied Freudian concepts to primitive cultures.[28] Kunitz stated that Margaret Mead and Benedict were familiar names to him in the 1930s and 1940s and that Malinowski was read (though by whom is not clear).[29] He considered *Patterns of Culture* "seminal." *Patterns of Culture* was in Pollock's library when he died. Herbert Ferber read Mead's *Coming of Age in Samoa* and knew of Boas but did not read him. In the period, he had "talked about" Malinowski.[30] Seymour Lipton read *Primitive Art* as well as Robert Goldwater's *Primitivism in Modern Art* of 1938.[31]

It was not only through the primary writings of the anthropologists that the Abstract Expressionists developed ideas about the primitive and culture, but also through other sources such as the works of Read, Freud, Jung, Eliot, Pound, and Joyce, which incorporated the current ideas of anthropology on primitive and classical cultures. Through these writers, the Abstract Expressionists developed a less culturally determined concept of personality. They saw the primitive or archaic as representing the fundamental, elemental, and ancestral nature of humanity, its very origins and beginnings, as well as its heritage and legacy. It is with the primitive and archaic that the "old and familiar rhythm" (Yeats) of human tradition

and pattern began. In other words, for many Abstract Expressionists, the concept of the primitive was broadened to include world traditions of many cultures.

Abstract Expressionist primitivism additionally differs from, although it is related to, Robert Goldwater's conception of the romantic, emotional, and intellectual primitivism of late nineteenth- and early twentieth-century art. Under the influence of the interwar and war experience, American artists' primitivism was *historical*, that is, it was retrospective. According to Sir James Frazer and psychologists, rituals, beliefs, and modes of thought were interpreted in the contemporary world either as survivals or as the

Figure 21. Clyfford Still, *1936–7–#2*. 64 × 33⅛ inches. San Francisco Museum of Modern Art. Gift of the artist.

unconscious layer of the mind. For several Abstract Expressionists, contemporary humanity was the heir to the original and unalterable human that originated with the first human and the beginnings of the world. From Newman's discussions of the "First Man" and Still's totemism (fig. 21) to Rothko's "survivals" and "memories," the Abstract Expressionists were interested in the very origins of human life and the beginnings of human nature, the ancestral, ancient, and common heritage of mankind that forms a tradition and continuity extending to the present as a collective "living tradition" to be succored. As Eleanor Roosevelt noted in the introduction to the major exhibition of Native American art at the Museum of Modern Art in 1941—an exhibition reflecting the intention of the New Deal and its Indian Arts and Craft Board of undoing the oppressive effects of previous policies of "civilizing" Native American culture:

In appraising the Indian's past and present achievements, we realize not only that his heritage constitutes part of the artistic and spiritual wealth of this country, but also that the Indian people of today have a contribution to make toward the America of the future.[32]

Topics of Abstract Expressionist primitivism and archaism include: the religious, spiritual, and temporal quest for regeneration expressed in the ritual of primitive/prehistoric, ancient, medieval, and modern societies; totemism—the primitive's participation in and interchangeability with nature and natural life and their spiritual forces; psychic primitivism—the primitive's consciousness and primitive thinking as part of the psychic history and present workings of the human mind; the world tradition or the holistic unity of Western and non-Western cultures; ancient wisdom and behavior or world consciousness; and physical anthropology and natural history.

Sir James Frazer's *The Golden Bough* was a key study for Abstract Expressionist thought. Evidence for the acquaintance of individual artists with *The Golden Bough* is convincing. Both Motherwell and Betty Parsons have stated that all Abstract Expressionists were familiar with it.[33] Clay Spohn, who taught with Still and Rothko at the California School of Fine Arts, has stated that Still knew the book.[34] Rothko indicated his knowledge of one of its famous legends, the killing of kings, in a recorded conversation.[35] Newman and Pollock owned the book.[36] Stamos said it was an important book for him in the 1940s.[37] And Gorky and the sculptor David Hare also read it.[38] That the Abstract Expressionists should avail themselves of *The Golden Bough* is no surprise. It is the classic study of early humanity and the human cultural odyssey and was read by most educated figures from Eliot to Joyce to the surrealists. It unquestionably is one of the influential books of the first half of the twentieth century.

The Golden Bough is ostensibly concerned with an ancient Mediterranean legend about political succession. The priest of Nemi, responsible for the continued success of his people, was periodically removed and replaced by a new priest who, to continue that success, plucked a golden bough from the sacred wood. In reality, *The Golden Bough* is a history of early man and his development through the early phases to the modern Western adult. Its main thesis is the evolution of human thought and culture from "savagery" to civilization. *The Golden Bough* is also a history of religion and custom, as Frazer examines and compares similar institutions and legends, and compiles and synthesizes a monumental number of legends, myths, rites, customs, and institutions from classical to modern, from Greco-Roman through non-Western cultures. In its time, *The Golden Bough* was considered almost an encyclopedia of the ancient and primitive life from which modern "civilized" man developed. It provided a continuous history of mankind and illustrated the sources and the continuity the Abstract Expressionists sought. For the Abstract Expressionists it was an anthropological history of the human struggle.

In *The Golden Bough* (under the influence of Sir Edward Tylor's evolutionism), Frazer proposes a hypothetical scale of human progress, an evolutionary ladder, which began with simple primitive societies (societies limited in number, territory, technology, and division of labor) and peaked with complex nineteenth-century European society. Frazer divides history into three stages. The first was an age of magic. To Tylor's idea of animism as the governing law of primitive life, Frazer adds the universal practice of magic, which provides the means to control the spirits. This age was then replaced by those of religion and science. Frazer constructs a picture of how man thinks and acts and how the primitive mentality persists in modern man. Although many of Frazer's points have been rejected by later anthropologists and many of his sources have been found to be unreliable, *The Golden Bough* remains a classic exposition of an early modern attitude toward understanding the origins and development of human thought and custom.[39]

Primitive Religion

It was not only its breadth and depth that ultimately made *The Golden Bough* a renowned classic, but also its pioneering study of magic and religion. One of Frazer's innovations was to examine the religion historically as a phenomenon of consciousness and not of truth or dogma. He saw magic, religion, and science as stages in the evolution of human consciousness.

Frazer's book reflects the direction of the Abstract Expressionists' primitivism. American artists of the 1930s

were interested in Native American art as an agent of social coherence. With the Abstract Expressionists, the religious conception was equally important. In other words, a keystone for the 1940s was the interaction suggested between mankind and the supernatural. The Abstract Expressionists' interest in *The Golden Bough* reflects the particular nature of Abstract Expressionism, its *religiosity* defined as the relation of man to sacred forces larger than himself that control his fate. A concern with man's relation to the *numena* is typical of Native American and Abstract Expressionist art. Both Frazer and Abstract Expressionism explored the primitive belief in forces, influences, and actions imperceptible but nonetheless real, and their engagement in cosmic, natural, and terrestrial processes. They saw primitive religion—magic, myth, ceremony, ritual, and spirits—as a symbolic means to mediate between and curry favor with those mental, cultural, and spiritual forces of creation and destruction loosed upon the world.

Primitive man, as Frazer and many other writers noted, made no distinction between the natural and supernatural. All natural process was a reflection of supernatural powers—day to night, season to season, moon to moon, growth to death. Primitive religion highlighted the primitive's perpetual struggle for existence, survival, continuity, and growth. Natural fertility and good fortune, individual, communal, and universal life history were linked. Magical dramas and ceremonies were attempts to better man's fate and alter his destiny.

That which manages and dominates the world of the primitive is thus not merely natural but the original sacred—the primitive mythic-religious. The world is worked by supernatural agents—mythic spirits—that direct its powers. For the Abstract Expressionists, the supernatural agents were often totemic, that is, ancestral, figures. Frazer describes many, including tree gods, Diana, Christian figures, the elements of Water and Fire, and the Spirits of Vegetation among others. They are humanity's ancestors and their lives make up the cognitive and narrative behaviors of all life. They are the metaphors for human hopes, dreams, desires, and fate. Wolfgang Paalen wrote of the totemism of the Northwest Coast Indian in 1944 in *Dyn*'s special issue on the American Indian. I quote from Martha Graham's citation of Paalen's article for her dance of 1946, *The Dark Meadow of the Soul:*

On the northwest coast of the American continent between a tempestuous sea & a virgin forest, there arose an art with the profile of a bird of prey; masks, heraldic columns, torch light dances, myths of the killer-whale & the thunderbird tell us of a great savage life in which man & the elements, man and his dream and beast and man mingled in wars & loves without quarter.[40]

Relations between man and nature, the mythical-supernatural man and animals, the infrahuman and suprahuman are reciprocal in the primitive world. Everything is linked and fused in a great chain of being and action. The human and natural share the same qualities—instinct, culture, consciousness, and savagery. In Abstract Expressionist primitivism, man, the natural, and the supernatural are virtually interchangeable.

The primitive's world is one of spirit powers or forces whose cooperation humans seek to secure through ritual, magic, and shamanism, as with the Kwakiutl Indians of the Northwest Coast:

it is impossible to understand Kwakiutl ritual behaviors without first realizing that the prime agency of causality is not human action but spirit-power action, and that humans control the action only temporarily, and then only if they observe . . . ritual.[41]

The basic relation of the human to the spirit-power is subordination; even seers, sorcerers, and shamans are mere receptacles of the power through which the spirits control human destinies. For the primitive and for the Abstract Expressionist, as in the myths of Adonis, Osiris, Attis, and other vegetation deities in *The Golden Bough*, ritual was used to attain continuity, orderly succession, and security.

Psychic Primitivism

Lucien Levy-Bruhl, a follower of Emile Durkheim, was another influential figure in European thought at this time. Aspects of his work appear in the writing of Jung, Read, and Ernst Cassirer. Busa, Ferber, and Kunitz have all stated that Levy-Bruhl was a familiar name to them.[42] Most Abstract Expressionists would have been familiar with Levy-Bruhl through Jung and Read, if not through the surrealists in general and Joan Miró and his friends George Bataille and the ethnologist Michael Leiris in particular.[43]

Levy-Bruhl postulated that primitive thinking was different from modern thinking, characterizing it as "mystic"—implying a belief in impersonal forces, influences, and actions imperceptible to modern man. To the primitive, no object or event is seen as merely physical; all things and events have mystic, that is, spiritual and emotional, forces. Unlike modern man, primitive man does not *differentiate* in his thinking and perception between two objects, between object and subject, or between an object and its spiritual force:

That which to us is perception is to him mainly the communication with spirits, souls, invisible and intangible mysterious powers encompassing him on all sides, upon which his fate depends and which loom larger in his consciousness than the fixed and tangible and visible elements of his representations.[44]

The connections perceived between these mystic suprasensible forces Levy-Bruhl called "pre-logical." By pre-

logical he did not mean antilogical or alogical. He simply means a different kind of logic, a system logical in the context of its own assumptions. Western man's thinking and logic is characterized by differentiation into classes, numbers, and so on. Primitive man's is not. He "sees" forces with which all things are imbued and of which he is a part. He, his body, his things, and his actions participate in this tribal envelope of forces. His thinking is thus governed by the idea or law, as Levy-Bruhl called it, of participation. The primitive individual fuses his identity with the collective need, emotions, legends, and myths of the group. In his thinking, he does not differentiate himself from the forces or things of the group, and consequently his sense of self, governed by the law of participation, is much enlarged in comparison to that of the typical Western man. The primitive mentality thus imagines a continuum of mystic forces in which the individual participates.

Levy-Bruhl portrayed the irrational, unscientific, and supernatural as a non-Western mode of thinking. The Abstract Expressionists were interested in primitive man's psychology as well as his religion and ritual. The primitive's thought reflected a particular view of the world. Frazer and Levy-Bruhl presented a picture of a world quite different from the late eighteenth-century Rousseauean concept of the noble savage at peace in an idyllic world. For Frazer, the surrealists, and the Abstract Expressionists, primitives such as the Kwakiutl lived in a world of terror, fear of the unknown, and ignorance. It was a world of totemic animal—human ancestral—savagery. Animals, their actions, and their behavior, were seen as symbols, and models for human behavior. They represented the forces and characteristics that constitute the cosmos. For the primitive there was no difference between primitive self and world, between the human behavior and animal behavior. And for many Abstract Expressionists and major parts of Western culture in the first half of the twentieth century, there was a direct relationship between elementary consciousness, whether ancient or primitive, and that of Western humanity.

Many Abstract Expressionists returned to origins as a step in the direction of the self-analysis, conservation and change of civilization. In rejecting the cult of modernity and the machine of the previous decades, in returning to a different conception of the past from America of the 1930s, the artists sought to describe their notion of the true origins of their predicament but also to retrieve the cultural insights, moral wisdom, and psychic, spiritual, and social cohesion that seemed fatally lacking in their time. To recollect and recover past understandings of human reality was a necessity in their conception of the preservation and renewal of human dignity and life.

Myth and the Grail

The Abstract Expressionists returned to the past to gain perspective and provide parallels for their interwar situation of civilizationwide human struggle. Such an approach supports E. D. Hirsch's theory of how new meanings get proposed:

No one would ever invent or understand a new type of meaning unless he were capable of perceiving analogies and making novel subsumptions under previously known types. . . . By an imaginative leap the unknown is assimilated to the known, and something genuinely new is realized.[45]

To explain the human journey, the pattern and tradition of human struggle and strife, the Abstract Expressionists absorbed, adapted and revivified a new cultural tradition that had developed in the West during and after the First World War—the modern tradition of ancient myth, ritual, and romance.

Following in the wake of the American thirties' own search for a myth that expressed the "unity" of the American pattern, as well as Joyce, surrealism and others, many Abstract Expressionists searched for a holistic view of the human historical continuum. This perhaps inevitably led to ancient myth and ritual. Myth is considered by many to be the earliest and most original source of man's thoughts about his relationship to the universe. Myth, indeed, formed early civilization's outlook and philosophy of life. The Abstract Expressionists almost certainly drew much of their understanding and knowledge of myth from *The Golden Bough* as well as from Eliot's and Joyce's use of it. Both Freud and Jung employed myth to support their theories and thereby gave mythology a contemporary psychological importance. Robert Graves's *The White Goddess*, with its message of rebirth, was a popular book, and in 1940 Edith Hamilton's *Mythology* was published. And while there is no evidence that any American artists except Reinhardt read him, the great philosopher Ernst Cassirer gave further importance to myth in his *A Study of Man* and his multivolume *Philosophy of Symbolic Forms*.[46]

The Abstract Expressionists drew largely on ritual and myth, not for its own sake—for its anecdotes, secrets, metamorphoses, heroes, and fictions, which would seem charmingly escapist and unrelated—but in order to form into a dramatic whole archetypal human experiences reflective of concrete historical circumstance. Such a use of myth and ritual during the Second World War follows a precedent that had arisen during the First World War.

Among literate British soldiers in World War I, there was a popular literary, paradigmatic precedent for their experience: John Bunyan's *The Pilgrim's Progress*.[47] *The*

Pilgrim's Progress presents an allegorical journey of spiritual trial and tribulation in which an archetypal hero, Christian, after innumerable hazards and ordeals, through "Valleys of the Shadows of Death," achieves spiritual redemption at the Celestial City. Soldiers of the First World War frequently came to grips with their experience through allusions to Bunyan's classic. For example, an artillery soldier, appropriately named Christian Crewell Carver, in his imagination reenacts *The Pilgrim's Progress* while on a night patrol on the Somme:

To our right and below us is the river stretching across a vista of broken stumps, running water and shell pools, to the skeleton gleaming white of another village on the far bank. If only an artist could paint the grim scene now while the hand of war and death is still hovering over it. In our steel helmets and chain visors we somehow recall *Pilgrim's Progress,* armored figures passing through the valley of the shadow. On—for Apollyon's [the demon of despair] talons are ever near.[48]

To present the trials and struggles of their times in terms of mythic journey and passage, many Abstract Expressionists, consciously and unconsciously, absorbed and adapted one of the central allegories of the interwar period, the quest for the Holy Grail. Along with the vegetation rituals of *The Golden Bough,* Eliot's kingfisher and "freeing of the waters" in *The Waste Land,* Carl Gustave Jung's semireligious psychology, and Joseph Campbell's hero journey and universal search for redemption, many artists and writers drew from Jessie Weston's *From Ritual to Romance* of 1920.[49] *From Ritual to Romance* narrated a psychomythic and historiocultural quest that several Abstract Expressionists employed to come to terms with, structure, and point a way out of the crises that dominated their time. In other words, many Abstract Expressionists partially imposed a mythic structure of ancient rite and medieval romance on their vision and form for historical struggle and affirmation. In their own way, like many during the First World War, they ritualized history.[50]

In *From Ritual to Romance* Weston argues that the quest for the Holy Grail consists of prehistoric and ancient ritual, pagan and Christian gods and ceremonies, and medieval and modern romance as part of the fundamental, anthropological history of humanity that still underlies and survives in secular beliefs. In other words, the quest is a fundamental theme of religion and culture that lies below the surface of human society. It reappears throughout history as a myth of renewal:

The Grail story is not *du fond en comble* the product of imagination, literary or popular. At its root lies the record, more or less distorted, of an ancient Ritual, having for its ultimate object the initiation into the secret sources of Life, physical and spiritual. This ritual, in its lower, exoteric, form, as affecting the processes of Nature, and physical life, survives to-day . . . all over the world, in Folk ceremonies. . . . In its esoteric "Mystery" form it was freely utilized for the imparting of high spiritual teaching concerning the relation of Man to the Divine Source of his being, and the possibility of a sensible union between Man, and God. The recognition of the cosmic activities of the Logos appears to have been a characteristic feature of this teaching, and when Christianity came upon the scene it did not hesitate to utilize the already existing medium of instruction, but boldly identified the Deity of Vegetation, regarded as Life Principle, with the God of the Christian Faith.[51]

The various parts of the ritual, called the Nature Ritual or Drama—the illness or "waste" of land ruled by the Fisher King, the hero's task of restoring its health through ritual battles that "Free the Waters" of fertility; the continuity among ancient, medieval, pagan, and Christian cultures of these nature or vegetation rites of rebirth; the symbols of the resurrection, the Medicine Man, the mysteries and the secret knowledges—become basic subjects of Abstract Expressionism. In other words, the crisis in the Western

Figure 22. Clyfford Still, *1945–H (The Grail?)*. $90\frac{3}{8} \times 68\frac{3}{4}$ inches. San Francisco Museum of Modern Art. Gift of the artist.

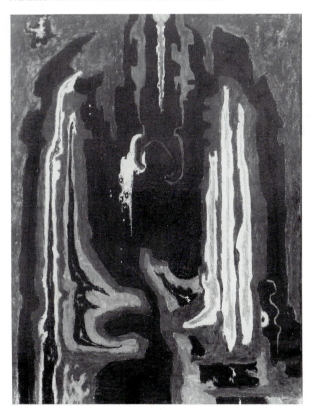

land, the recalling of some historically and anthropologically ascertained rites of understanding and reformulation, the pattern and process of struggle and strife, and the ritualistic, spiritual healing of the king and his land in imagery of new fecundity are clothed in what Weston describes as the Grail quest.

Most Abstract Expressionists employ myth, ritual and ceremony in their work, from Rothko's and Pollock's *Ritual*s of 1944 and 1953 to Gottlieb's *Quest* of 1948 to Lipton's *The Grail* of 1965. (Still's *1945–H* [fig. 22] was entitled *The Grail* and dated 1947 when reproduced in the Abstract Expressionist magazine, *The Tiger's Eye,* but he denied the title was his.)[52] Ritual regeneration forms a central thesis in *Dark Meadow of the Soul* of 1946 as well as other works by Martha Graham.[53] And it lies behind, in

Newman's words, society's "quest for Salvation."[54] In the late 1940s and 1950s, for two of his sculpture series, Lipton defined the Quest in perhaps the most characteristic Abstract Expressionist allegorical terms—first as a rite of passage followed by a new flowering, as in *Pavilion* of 1948 (fig. 23): "Here is the home and church of man amid the rites of passage through stages of life to a final flowering";[55] then as a mythic hero of the past who passes through the cyclic pattern of strife, and with nature ritual symbolism, brings about regeneration. Lipton's mythic hero, *Hero* of 1957, had beginnings in the remote past, but was still alive today. Abstract Expressionists first personified and then represented abstractly this cycle of waste and renewal to physically and spiritually heal their land in its time of illness and waste.

Figure 23. Seymour Lipton, *Pavilion,* 1948. Wood, copper, and lead. 24 × 14 × 25 inches deep. Courtesy Michael Lipton.

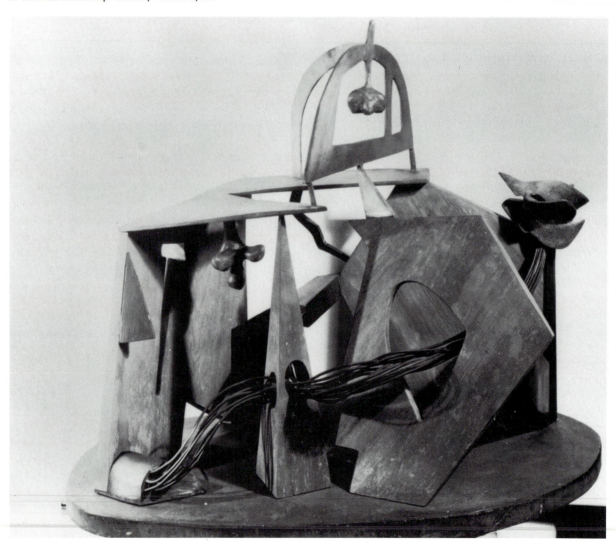

Jung and the Psychomythic Quest

In the film *The Mortal Storm* of 1940, the narrator at the beginning ascribes the recurrence of world war in the twentieth century to internal elements within humanity itself and not external elements such as political systems. In other words, a popular Hollywood film explained the war in terms of the psychological nature of human beings. Most Abstract Expressionists shared this assumption.

To enhance their understanding of human behavior, many Abstract Expressionists turned to depth psychology. Like Weston's cultural anthropology and other Abstract Expressionist interests, Jung's psychology is both a product of its culture and a contributor to it. Jung's psychology (called Analytic Psychology to differentiate it from Freud's psychoanalysis) reflects in its issues and popularity the continued interest in anthropology, ancient lore, folktales, myth, and ritual that began in America in the 1930s under different circumstances. Like the Grail quest, it integrated them in a thesis of healing. In a sense, Jung added a psychological justification and explication of ritual and the Grail quest, which his psychological theory internalized. The patient descends beyond consciousness into himself; he makes the past come alive again; he confronts the trouble-causing traumas and battles the hidden demons which are uncovered; and he emerges from his ordeal with the death of the old and the birth of a new self. Through undergoing analysis, the patient confronts his unconscious monsters and ghosts to find psychic health: psychic redemption and "freeing of the waters" follow this modern ritual trial of social science.

Depth psychology, like anthropology, was one of the new so-called sciences that altered Western thinking. Modern psychology offered apparent insight into the nature of human beings and the causes of their illnesses and those of society. As anthropology had replaced the traditional concept and determinants of "human nature" with that of culture, depth psychology replaced it with "psyche."

Pollock's acquaintance with Jungian psychology is well known. Pollock (not the only Abstract Expressionist to undergo analysis) underwent Jungian psychotherapy during 1939–42. In the 1950s he stated: "We're all of us influenced by Freud, I guess. I've been a Jungian for a long time."[56] Gottlieb said: "Oh, we were all interested. First we discovered Freud, and then Jung."[57] Newman, Still, Lipton, Parsons, Krasner, Rothko, and John Graham were also familiar with Jung, and he was of fundamental importance to Martha Graham who was the only other major artistic figure of this era besides Pollock actually to undergo Jungian analysis.[58] In 1943 the art critic Herbert Read became director of the publication of Jung's collected work. Read's criticism exemplified and even influenced the development of the interwar tradition in many ways.

From an early belief in the utopian power of machine technology to alter society, Read moved to advocacy of Marx, then of Freud, Nietzsche, Frazer, and Levy-Bruhl in the late 1930s, and finally to Bergson and Jung, a journey along a path similar to that taken by many Western, especially Anglo-Saxon, intellectuals in the period.

Most of Jung's major writings had been translated and published and there were practicing Jungian analysts in America by the late 1930s. In 1936 a psychology club (later the Jung Foundation) dedicated to the dissemination of information on Jung's psychology was established in New York. In 1937 Jung himself was invited to lecture at Yale during one of his frequent trips to America, an event signaling his increasing importance. It was the particular nature of Jung's thought, however, rather than any increase in the mere number of practitioners, that was responsible for his importance to the world of art and intellectual life in the late 1930s and 1940s.

In general, Jung proposed to study the problems of modern humanity by reaching an understanding of the historical layers of the unconscious and by examining the dynamics of what he considered to be the spiritual nature of man. As with Frazer's, Weston's, and the artists' conception of past, the distinguishing quality of the Jungian unconscious is that it is historical and cross-cultural, that is, it represents the ancient psychic and behavioral heritage of mankind that cuts across time and space.

This premise was largely responsible for the best known, most controversial, and most fruitful Jungian concept, the theory of archetypes, in which forces and images from past cultures arise from the unconscious layers of the historical psyche to alter and heal the modern individual's—and culture's—wounded life. In the historical archetype, Jung believed he had found the source of unconscious images in dreams and visions, as well as spiritual motifs of different religions, mythologies, and art. Archetypes constitute fundamental historical patterns of symbol formation which occur in all cultures throughout time and are, therefore, ancient and primordial. The images that represent archetypes and archetypal patterns are both universal and adapted to individual cultures, however, and although individuals ultimately create archetypal symbols, the symbols express more than particular personal needs. They express the common needs and potentials of the group as well. Indeed, archetypes contain images and symbols found in myths, rituals, and religions that the individual could not have invented. The Collective Unconscious refers to and reveals psychic contents deeper than, prior to, and more fundamental than mere individual personality. Jung's psyche expresses the communal inner life of man with which the individual must recreate himself. In this way, Jung's concept of the Collective Unconscious or psychic heritage of humanity drew upon but ultimately

altered the idea of social collectivity of the 1930s. Psychic collectivity and pattern were added to or replaced the collectivity of custom and habit.

Since universal images or archetypes have primordial sources, ancient, primitive, or "archaic" man, as Jung called him, had already developed and revealed the common psychological feelings and images. Archaic man, his rites, myths, and symbols, play an important part in Jung's psychology as opposed to Freud's. Archaic man represented to Jung the state of almost totally unconscious behavior. To describe his unconscious primordial behavior (and revealing once again the crisscrossing of idea and source in the cultures of this time), Jung drew on Frazer, but especially on Levy-Bruhl's "participation mystique," and gave it a specific psychological dimension and role: "In the primitive world everything has psychic qualities. Everything is endowed with the elements of man's psyche—or let us say, the human psyche, of the collective unconscious, for there is as yet no individual psychic life."[59] For Jung, and for the Abstract Expressionists, primitive man is submerged in unconscious psychic forces. Primitive man is unconscious man—as is modern man at the deeper levels of his psyche. Jung's psychology integrates primitive and ancient life, religion, myth, and ritual into cultural and individual subconscious, psychic process, and development.

In a critique that resembles that of the Abstract Expressionists and others of the 1940s, Jung says that humanity is troubled because of the overemphasis in modern times on consciousness, reason, and science and the corresponding underemphasis on the unconscious with its intuitions, archetypal behaviors, and myths. Modern society's overvaluing of rationalism has brought terrible results, the worst of which are world war and totalitarian states.[60] Furthermore, since the individual personality represents major elements of his culture as a whole, and especially the unique qualities and problems of its particular historical phase,[61] reason and consciousness have been overvalued by the individual. The result has been an imbalance in the psyche, and neurosis. As Wheeler's discussion of Dali also indicates, modern warfare is a manifestation of the breakdown of the modern psyche.[62]

To correct this psychological imbalance, like the narrator of Hollywood's *The Mortal Storm*, Jung proposed a spiritual solution, a religious or numinostic experience, but not a creed, which, for Jung, is merely a codified and dogmatized form of a once original religious experience.[63] Religion, as the Latin word denotes, is a careful and scrupulous observation of the *numinosum*, that is, a dynamic existence or effect, not caused by an arbitrary act of will. On the contrary, religion seizes and controls the human subject, which is always rather its victim than its creator.[64] The numinosum causes an alteration of consciousness.

Modern man's search, as with the Grail and primitive ceremonies in general, is for such divine effects. For Jung, they will arise spontaneously from the unconscious in the form of archetypal archaic images from which new gods will be formed. Modern man searches for such symbols and images, which can only arise from the historical depths of his soul. The history of man's inner life and its manifestations in art, myth, religion, prehistory, and so on, reveal both his past and his future.

In general, Jung wrote little about art [by which he specifically meant literature; however, his ideas are applicable to the visual arts also]. When he did write about art he argued that art could play a role in the transformation of society. Jung divided art into two types, the psychological and the visionary, of which the latter is of prime importance to the Abstract Expressionists, for it reveals the artist as seer or shaman. The first mode, the psychological, is what is typically known as the subjective in modern art. The psychological mode derives from consciousness and includes known commonplace psychological experiences. The visionary mode derives from the historical unconscious, and points to things unknown, hidden, and secretive. It represents a primordial experience, communal in intent, and by no means merely personal. It is a true symbolic expression, as Jung defined the symbolic.[65] The visionary artist portrays a strong collective, rather than personal, psychic life. "Art is a kind of innate drive that seizes him and makes him its instrument, and the visionary artist is 'collective man'—one who carries and shapes the unconscious, psychic life of mankind."[66] He or she is an artistic shaman or seer, a god-artist, whose work comes from the unconscious, historical depths, from the realm of the *mithos*. To understand visionary art, the viewer must see that the artist has "penetrated to that matrix of life in which all men are embedded, which imparts a common rhythm to all human existence, and allows the individual to communicate his feeling and his striving to mankind as a whole." For Jung, "The secret of artistic creation and of the effectiveness of art is to be found in a return to the state of *participation mystique*— to that level of experience at which it is man who lives, and not the individual, and at which the weal or woe of the simple human being does not count, but only human existence.[67] This concept is close to the Abstract Expressionists' concept of art.

Jung's psychology, as well as Freud's, is best understood as a contemporary theory of human relations, and it is in this way that its relationship to Abstract Expressionism should be examined. Depth psychology presented a fresh new approach to age-old questions of human nature,

behavior, and possibility. These psychologies were philosophies of human behavior and experience and expressed not just the individual's unique point of view but the individual's understanding of the world and how it worked. The artists' use of their psychology is at least as much a *social and public act* as a primarily private and personal one. In other words, the quest for the representation of inner life was not merely, if at all, a quest to represent the artists' own unique psyches and lives, their autobiographies, as 1950s interpretations of Abstract Expressionism would have it. Rather their quest was to represent the *collective inner life and needs of modern humanity and the body politic.* As Gide wrote in 1937, one fought brute force with an ineffable "spirit" from within.[68]

As Benedict and others in the 1930s had given a cultural profile to psychology, Jung and Freud gave a psychological identity to culture. In other words, what Jung and Freud conceived as characteristic of the individual mind and its hierarchy of layers from conscious reason and conscience to unconscious savage drive and non-Western spirit was an internalization of the divisions and relations of Western and non-Western cultures as seen in the first half of the twentieth century. For Jung, Freud and the Abstract Expressionists, psyche was psychocultures and civilizations writ large.

Much Abstract Expressionist art reflects a synthesis of Freud and Jung. Aside from such concepts as the existence of the unconscious, of a hidden inner life, and of a structure to the mind, Freud's most influential idea—transported independently and through surrealism—was the origins of man's behavior in his animal inner nature. Most Abstract Expressionists absorbed Freud's pessimistic view that man is partly biological and that the biological drives in the psyche, in primitive man, and in the contemporary neurotic resulted in a life of perpetual conflict. For Freud, man's inner nature reflects the physical causation of instinctual drives which can never be conquered, for they are "cruel and inexorable." The principal task of civilization is to defend itself from humanity's biological being.

These themes form part of Abstract Expressionist subject matter, but many of the artists, like Jung, saw a way to transcend these instincts through a view of the unconscious as a creative, vitalist, divine force. Jung and Abstract Expressionists partially conceived of the unconscious as a source of impelling positive forces, as something that energizes. The artists adopted Jung's idea that there is an informing spiritual principle behind the historical psyche and its varied cultural manifestations. For Freud, the primitive and his mind, the unconscious, the religious, the artistic are infantile mental products. The transformation of mankind, if at all possible—and Freud was most skeptical—can only come through the application of those things

that Jung and the Abstract Expressionists criticized as overemphasized in their time—reason, science, morality, modern culture. For Jung and the artists, inner conflict was not between instinct and civilization, between the pleasure principle and the reality principle but between inner spirit and modern culture. In a sense, the Freudian solution was that of America of the 1930s—reason and science. The Abstract Expressionists sought a spiritual solution in a Grail quest routed through the depths of the psyche.

Freud and Jung redirected many of the themes of the era into the psyche. The comparison, reweaving, and reintegration of cultural and behavioral patterns of the 1930s became patterns and processes of the psyche; the rejection of science and reason became a rejection of consciousness; the return to the past to find the behavioral origins, heritage, and continuity of humanity throughout space and time became a journey back into the sources and memories of the psyche; the human struggle became the conflict of the component layers of the psyche; and the advent of new psychic health became the search for the spiritual transformation of the individual/world. As in the 1930s, the problems and solutions were partially understood as historically psychocultural.

Jung himself recognized individual psychic life as a metonymy of historical events, struggles, and fears. With him, as with the Abstract Expressionists, human warfare became psychic warfare. In 1926, Jung had a dream in which he was "driving back from the front line with a little man, a peasant, in his horse-drawn wagon. All around us shells were exploding, and I knew that we had to push on as quickly as possible." He added:

> The shells falling from the sky were, interpreted psychologically, missiles coming from the "other side." They were, therefore, effects emanating from the unconscious, from the shadow side of the mind. . . . The happenings in the dream suggested that the war, which in the outer world had taken place some years before, was not yet over, but was continuing to be fought within the psyche.[69]

The Diffusion of the Jungian Program: Mary Mellon and the Bollingen Foundation

Jung's approach was accepted into American cultural life in the single generation of the late 1930s to the 1950s. Interest in Jungian psychology was spurred not only by the predisposition of American and English culture (such as Eliot, Joyce, and Read) to many of its themes and sources, the rise of a general interest in myth and depth psychology, and the psychocultural needs of a crisis-ridden civilization, but also by the efforts of the philanthropists Mary and Paul Mellon, founders of the National Gallery of Art. Mary Mellon became interested in Jungian thought in the

late 1930s after she attended some lectures at the Psychology Club in New York. As the European conflict grew into a universal conflict, she decided to set up a foundation to disseminate Jung's point of view. The Bollingen Foundation was established in 1943 with the expressed purpose of bringing Jungian thought to America.[70] (This is also the year, of course, that Herbert Read became the editor of Jung's collected works.) Her layperson's response to Jungian thought is crucial to the understanding of its importance to the intellectual life and the avant-garde in America in the early 1940s. Although most of the artists were already familiar with Jung, the publications of the Bollingen Foundation helped to define and elaborate what proved to be the central stream of Abstract Expressionist subject matter and meanings.

As the war brought into question the nature of man, the Mellons looked for a means of understanding that would light the way out of the crisis. In 1942 Mary Mellon wrote and explained her plans to Jung:

The world is in such a mess that it becomes all the more important to me to do what I can to keep alive and make available such works as yours, and those of others who can contribute real, scholarly and imaginative books about Man and the history of his soul.[71]

In general, Mary Mellon concurred with what Jung and others had argued earlier: that the upheaval of the world and an upheaval in consciousness were one and the same. Her program for the Bollingen Foundation is of particular importance, for it illuminates the thought behind the appearance of a body of writers to whom the Abstract Expressionists partially turned:

[The foundation] will of necessity embrace all fields, since Man has approached the problem of his own consciousness from every direction. This problem is under very little consideration at this moment in history. While man is busy killing himself he has no time for why he is doing it—who he is, or who he may become for so doing. But for this very reason ... the few who are concerned with consciousness are forced to make even more manifest their belief in the part of Man which is his ever nourishing and renewing force; and without which he cannot live.

During the struggle for survival in which we are now engaged there are men in Europe, Asia, and this country who are writing & there are documents already written, neglected or perhaps not translated into English, which are concerned with the evolution of human consciousness. As the documents which have been left to us from ages past or which are being written in the present are of paramount importance at this moment, we must have a point of reference in each stage of Man's eternal struggle for consciousness if we are not to lose all we have inherited. We must also attempt to understand the new statements that are being formed—the new efforts to set forth who we are and why.

It is a mistaken concept that Philosophy and Religion are the two main channels for this inquiry. Consciousness is the endeavor

... to bring together within us those several parts which are at odds with one another. If not correlated one part or another becomes overemphasized—thus producing an exaggerated leaning in Man toward one phase of himself or another. Man can only be explained in all his parts, and can only become conscious by admitting all sides of himself and giving them their due—in order that they may fall into place & work in harmony together. Anger and hatred, for example—if realized in their proper place—can obviate war.

Therefore Philosophy & Religion are but two important facets of this question. Art in all its forms, the myth, the new science of psychology, archaeology, anthropology, ethnology, & the history of the word itself are equally important. For they show Man's depth and breadth—his various expressions of himself, the variety of his experience within and without.

The [Bollingen] Series then ... is interested in making known to the English-speaking public those books of both past & present which will help it understand that the human soul or consciousness is not circumscribed; that it may be found in many unexpected places—and that through admitting the manifold aspects the One may be found which lies in Man himself.[72]

Mary Mellon saw Jung and his circle of interests as giving an understanding of the contemporary experience and an insight into the universal pattern of human purpose and growth. New knowledge, gleaned from the eternal history of man, would lead to new forms of culture and aid in keeping alive the creative force. For the Mellons, for the Abstract Expressionists, and even for FDR, the universal pattern of life pointed the way to the future. (In a speech entitled "A New Order of the Ages," given on an Armistice day at the Tomb of the Unknown Soldier during the war, FDR declared that he recognized that one must look beyond the present and salute the "eternal verities" that lay within and that made up the future of mankind.)[73]

The Foundation's authors were drawn from all disciplines and make up a pantheon of refugee and contemporary intellectuals at midcentury: James Johnson Sweeny, St.-John Perse, Paul Valéry, Paul Radin, Jean Seznec, Gershom Scholem, Max Raphael, Joseph Campbell, Heinrich Zimmer, Edgar Wind, and many others. Its Andrew Mellon Lectures in the Fine Arts speakers included Read, Giedion, Kenneth Clark, Andre Grabar, and Jacques Maritain.[74] These figures were obviously not all Jungians, but they worked in areas within Jung's and the Bollingen Foundation's range: myth, religion, psychology, art, prehistory, occult symbolism, anthropology, alchemy, and the perennial wisdom. At the same time, Mary Mellon integrated her early interest in art (she worked in New York art galleries and was friends with the Abstract Expressionist sculptor Isamu Noguchi, Ferdinand Leger, and Marian Willard, among others) with her new concern with the expansion and "evolution of human consciousness."[75] While Paul continued his support for the National Gallery, Mary, for a time, was interested in creating a museum of the

American Southwest, which would focus on Native Americans, especially the Navajo. The first commissioned Bollingen author, Maud Oakes, had studied Navaho sand painting under Bollingen auspices and had exhibited her watercolors of sand paintings at the National Gallery in 1943. (A party for the exhibition was held at the Bollingen offices and the art critics Edward Alden Jewell and Monroe Wheeler were present, indicating Mary Mellon's continued personal, as well as intellectual, linkage to the contemporary art world.) Mary also established an archive of images of ancient symbols and hired art historians to work on it; it is still in operation today at the Jung Foundation in New York. Pollock's analysts, Violet de Laszlo and Joseph Henderson, contributed to the Foundation.

The program of the Bollingen Foundation reflected the cultural themes prominent after the war: the revival of religion, the Europeanization of the educated in America, and the recognition of the significance of art. The program sought, like other Jungian institutions such as Eranos in Switzerland, to integrate in one perspective a comprehensive understanding of man's universal thought and life or "Quest . . . the Way of the Soul."[76] It sought to collect and renew the past for new forms of culture, and even if many of the Bollingen authors were not full-fledged Jungians, its publications "resembled nothing more than the gathering, ordering and observing of amplifactory data in a Jungian analysis."[77] The works were attacks on rationalism and attempted to indicate moral values and find solutions to the intellectual and spiritual dilemmas of the 1940s and modern life. Jungian psychology and the Bollingen amplification of it were part of the organic growth of modern intellectual and cultural life. "For 2 decades its concerns were at the center of Western life"[78] (except for the French, who in contrast to the Anglo-Saxons, were not very responsive to Jungian ideas; although there were a few Jungians in France before the war, much of Jung's work was not translated into French until 1957.)[79] Kenneth Rexroth, the poet, summarized the importance of the Bollingen Foundation:

It is obvious that the Bollingen Series constitutes an important pivot in the swing of Western culture to a new taste . . . contrary to the one dominant between the wars . . . whether . . . Eliade, Zimmer, Campbell, or Blake or Coleridge. . . . What is the program? A steady drive toward reclaiming interiority, reinstating values that cannot be reduced to quantities; an advance for significance, a quest for meaning, . . . a part of the struggle for revaluation and refounding of a collapsed Western civilization.[80]

Joseph Campbell and the Monomyth Process

In the 1946 issue of *Chimera,* one that Gottlieb owned, a search for a single, unified myth was noted:

We have today reached the point at which we are interested not so much in the substance of particular myths as in the essential pattern or structure of myth in general. . . . Perhaps there is, after all, only one myth—the Myth. And in that case, the effort of the intellect can only be to determine more clearly its outline . . . its order . . . its process.[81]

Joseph Campbell, a Bollingen writer and coauthor of the *Skeleton Key to Finnegan's Wake* of 1944, which Pollock owned, published what was described by *The Tiger's Eye* as his "long-awaited" *The Hero with a Thousand Faces*[82] in 1949 and answered that search. He was quickly invited to speak at the Abstract Expressionists' meeting place, The Club, in that year when most of the artists' work had already become abstract. De Kooning heard him and drew from him; Pollock owned *The Hero;* David Smith and Lipton read the book and produced, in the 1950s, a series of sculptures directly inspired by it; and Campbell was a major influence in Martha Graham's turning toward myth in the mid-1940s. Yet the Abstract Expressionists' interest in Campbell's book reflects not only its direct influence but also its continuity and expansion even in 1949 of their ensemble of interests, authors, and subjects of psychic, ancient, and primitive mythoreligious culture.

From the very first pages, Campbell ties together the Abstract Expressionists' orbit of interests into phases of the common story known as a new *pattern*—of the mythological hero—that was the climax of American cultures search from the 1930s onward. He draws from and unifies Jung, Frazer, Boas, Freud, Roheim, Nietzsche, Joyce, and countless others as he acknowledges their interpretations of myth as reflective of the many sides of mythology:

Mythology has been interpreted by the modern intellect as a primitive, fumbling effort to explain the world of nature [Frazer]; . . . as a group of dreams, symptomatic of archetypal urges within the depths of the human psyche [Jung]; as the traditional vehicle of man's profoundest metaphysical insights [the Bollingen's Ananda Coomaraswamy]; and as God's Revelation to his Children [Christian ritual]. (323)

Campbell understood that modern thought granted psychological significance to mythological symbolizations. In particular, he felt that psychologists, whatever their differences, agreed on a body of common principles—that the patterns and logic of myths and folktales correspond to man's universal inner life, so much so that the "long discredited chimeras of archaic man have returned dramatically to . . . modern consciousness" and could be appreciated as symbols of modern man's inner life (221).

Unfortunately, Campbell complains, the realization that myths reveal inner desires and the unconscious led to the modern belief that the tales of legendary heroes, the powers of the divinities of nature, the spirits of the dead,

and totem ancestors could be read, or more accurately, misread as *only* biography and mere "foreground" everyday psychology in Jungian terms. Mythology should be read as primal, not merely personal psychology, that is, as evidence of the "deep forces that have shaped man's destiny and . . . continue to determine both our private and our public lives" (222). Myths reflect and communicate in pictorial patterns the traditional wisdom of whole societies. For Campbell, mythological metaphors have been examined and discussed for centuries, since they were continually used by societies for the instruction and initiation of the young. Myths bring into play the energies of the psyche of every culture. Myths are the profoundest means of moral and metaphysical instruction, and thus they are not just symptoms of the unconscious, but reasoned statements that have remained constant throughout the course of human history.

Briefly, mythology for Campbell teaches that all things of the world are the effects of the one power out of which they arise, which makes them manifest and then ultimately dissolves all. For Campbell, this power to science is called energy, to the American Indians it is *wakonda,* to Christians the power of God, and to the psychologists libido. Furthermore, its manifestation in the cosmos is the structure and flux of the universe itself. Myths, gods, and rituals make this power visible by analogy. Mythological and unconscious symbols are "telling metaphors of the destiny of man, man's hope, man's faith, and man's dark mystery" (225). For Campbell, and for the Abstract Expressionists, the mythological is linked to the unconscious and to the metaphysical. The key to one is an important key to all of them. Mythic symbols of whatever sort are symbols of continuous creation. They reveal "the mystery of the maintenance of the world through the continuous miracle of vivification which dwells within all things." Myth's function, according to Campbell, is to serve as a powerful "picture" language for the communication of traditional wisdom. The myth is brought into being through the psyche of an individual. But, in his most Jungian argument—and Campbell is far more Jungian than Freudian—Campbell contrasts Freud and Jung (and by implication, surrealism and Abstract Expressionism):

Dream is the personalized myth, myth the depersonalized dream; both myth and dream are symbolic in the same general way of the dynamic of the psyche. But in the dream the forces are quirked by the peculiar troubles of the dreamer, whereas in myth the problems and solutions shown are directly valid for all mankind. (24)

Myth is best represented by a universal pattern, the advent of the hero. The hero is for Campbell a figure who symbolizes the group's problems, struggles, and triumphs in his own actions. The hero has a journey that should be familiar to us by now: he ventures forth from the everyday into a region of supernatural wonder and conflict; he wins the conflict, gains new power, and bestows it on his fellow man. Rites of passage (separation, initiation, return) symbolize the pattern of what Campbell called the *monomyth* (31). The monomyth structure, pattern, and process underlie all mythic utterances and are behind totemism, primitive religions, Christianity, cosmogonic cycles, and psychotherapy. As with Weston and Jung, a mythic quest or "hero-quest" consists of a penetration to the source to do battle with the dark, mysterious powers, that, after they are vanquished, are brought back to the "kingdom of humanity" where they will renew the community, the nation, and the individual.

Campbell, like Jung and Rothko and his band of mythmakers, argued for the modern need for a new myth. The triumph of the secular state, the decline in world religions, the stultification of the social order, and the war's "titanic battlefields" and "terrible clashes" revealed the need for a new psychic mythological symbol (329). For Campbell, it has always been the prime function of mythology and rite to supply the symbols that carry forward the human spirit. The heroic mythmakers are truly creative figures. Artists have such power. The work of the mythmakers reflects the dying of the old and the creation of the new human spirit in its aspirations, powers, vicissitudes, and wisdom. Despite the fact that modern individuals have discredited gods and devils, their myths and legends may still delineate our still human course.

All of Campbell's statements of 1949 intersect with the Abstract Expressionists' interests. As with the artists and Martha Graham, he synthesizes ideas of religion, myth, the primal unconscious, initiation rites, and their fulfillment of eternal needs into another version of a pattern of struggle and change. But like many figures in the matrix we are describing, he is as much its product as a contributor. We need only conclude with another statement from *The Hero* that could have been made by any of several Abstract Expressionists, for it describes myth as "timeless," universal, and surviving today.

What is the secret of the timeless vision? From what profundity of the mind does it derive? Why is mythology everywhere the same, beneath its varieties of costumes? And what does it teach? . . . Freud, Jung, and their followers have demonstrated irrefutably that the logic, the heroes, and the deeds of myth survive into modern times. (13)

Compare those words with the following statement that Rothko made in the radio broadcast with Gottlieb on WNYC in New York in 1943:

If our titles recall the known myths of antiquity, we have used them again because they are the eternal symbols upon which we must fall back to express basic psychological ideas. They are the

symbols of man's primitive fears and motivations, no matter in which land or what time, changing only in detail, but never in substance, be they Greek, Aztec, Icelandic or Egyptian. And modern psychology finds them persisting still in our dreams, our vernacular, and our art, for all the changes in the outward conditions of life.[83]

Martha Graham, Abstract Expressionist of the Dance

The Bollingen interests were similar to those of many of the Abstract Expressionists and of a branch of the avant-garde in America during the late 1930s and 1950s. The search for the human soul was carried on elsewhere, too, in particular in the dance dramas of Martha Graham.

Graham, along with Isadora Duncan, Diaghilev, and Balanchine, changed the face of dance in the twentieth century. Her dance dramas, especially her Greco-mythic period beginning in the 1940s, paralleled Abstract Expressionist subjects and sources as they, too, sought to lay bare the "primaries of experience."[84] Like the artists, she illuminated the eternally inward by means of expressive, symbolic art. According to James Johnson Sweeney, she is dance's equivalent to the modern primitivizing artist who seeks to strip aesthetic experience to its fundamentals.[85]

Graham's dancing involved treating the body as a dynamic force of energy in close relationship to the natural ground, unlike traditional dance. She stripped the dancers of tutus and developed the leotard to streamline and naturalize the movement of the body. Her body movements emphasized periodic expansion and contractions, as though the body were breathing. Beginning with symbolist topics, then moving to the Americanist *Frontiers* and *Appalachian Spring*, before arriving at world archaic subjects, her dances took place in stark, increasingly biomorphic and primitivist settings that suggest eternal time. The settings were created by the Abstract Expressionist sculptor and Bollingen fellowship recipient Isamu Noguchi, who was her set designer from 1935 to 1966 (fig. 24).

Graham said she intended to "make visible the interior landscape," and she described her work in contemporary terms of the "journeying" into herself. Indeed, she revealed her commitment to the whole panoply of John Graham, Abstract Expressionist, and Bollingen interests as early as 1937, when she wrote that a dance of hers moves into "depths of man's inner nature, the unconscious, where memory dwells."[86]

Paul Valéry once wrote in an essay on Leonardo Da Vinci that few artists ever had the courage to reveal how they produced their works. Fortunately, Martha Graham is not one of those. In 1973 she published *The Notebooks of Martha Graham*, her record of her accumulated thoughts, studies, and reading for her dances. They are notebooks of many of the themes, subjects, and sources of the

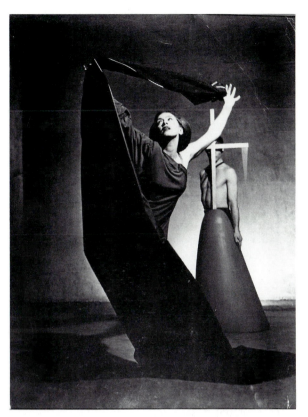

Figure 24. Isamu Noguchi, set for Martha Graham, *Dark Meadow of the Soul*, 1946. Photo: P. Halsman.

mythic, psychic, religious culture out of which Abstract Expressionism arose. No study of Abstract Expressionism is complete without the insight revealed on those pages. In one place, Martha Graham has provided a general summary in citations and notes of major threads of 1940s culture and ideology—primal ritual in combination with anthropology, myth, and depth psychology.

Graham was also a Jungian who saw the era as a search for Woman's eternal soul. Her notebooks are filled with thoughts from many of the sources discussed on these pages, including Jung, Weston, Frazer, Zimmer, Campbell, Joyce, Eliot, and Graves, many of whom were published by the Bollingen Foundation. (She was a particular friend of Campbell, with whom she taught at Sarah Lawrence College in the 1930s.) A brief examination of a sample page reveals familiar Abstract Expressionist subjects and sources: *The Golden Bough*, the underworld, war, discord, Prometheus, Lucifer, prophetic figures, Earth Mothers, fire, mythology, the "sublimation of fire into light," Wolfgang Paalen's article on totemic art of the Northwest Coast, the mingling of man and beast, and Paalen's statement about the natural evolution of consciousness.[87] Graham's notes, thoughts, and dances reveal the complex sources and culture behind her famous mythic, Jungian,

and Greek dramas such as the *Dark Meadow of a Soul, Night Journal, Clytemnestra,* and *Law of the Heart.*

Although a typically personal and individual interpretation of the material, Graham's work unifies the mythic-ritual, psychological, archaic, and primitive interests of the period under a theme of the ancient wisdom and the eternal nature of mankind. Greco-Roman myth and literature, the recreation of the past, totemic and psychic primitivism, and the continuum of humanity's soul constitute the concept and subject of humanity's perennial inner life. Her concepts underscore the general Abstract Expressionist conception of the eternal and archetypical of humankind. Since her notebooks are so invaluable to understanding the culture of Abstract Expressionism, for this study she will play the role of Virgil in Dante's *Inferno,* guiding the reader through their ideas and forms.

Many Abstract Expressionist subjects and themes are familiar elements in twentieth-century art. Much modern art has searched for elementary primitivism and many artists have looked for the occult religiosity that many of the writers just discussed border on or represent. Earlier influential occult conceptions, such as that of theosophists and of the Rosicrucians, are well known. The concern with man's inner life was not new. Neither was the idea of spiritual change and regeneration. One need only think of Kandinsky. But what *is* new is the combination of these elements, the new elements such as the unconscious to justify them, the particular historical events that fused and ignited their unique shape of the material, and their recurrence among the Americans. The themes of Abstract Expressionism and their sources and reflections in Frazer, Jung, Levy-Bruhl, Campbell and others are both old and new in the context of modernism. These writers and their ideas must be considered in one sense as the contempo-

Figure 25. Seymour Lipton, *Earth Loom,* 1959. Bronze on Monel metal. 32 × 38 inches. Founders Society Purchase, Friends of Modern Art Fund. © Detroit Institute of Arts.

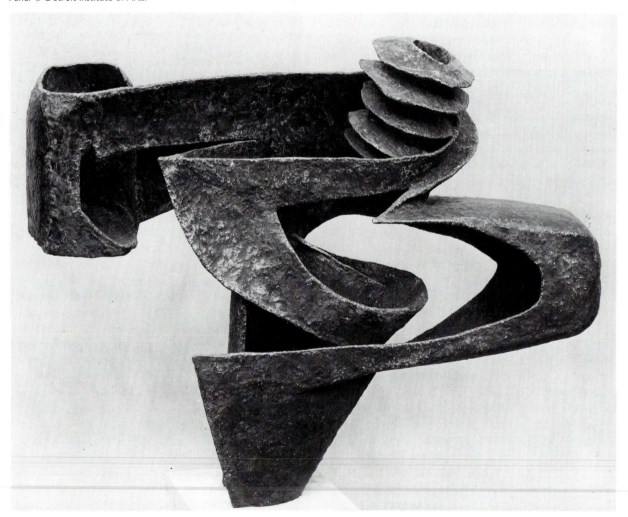

rary variants and dress of traditional modernist interests while at the same time they were absorbed, adapted, and reinvigorated to meet the profound needs of American life and culture in the 1940s.

NATURE

Fundamental to Abstract Expressionism and its sources in surrealism, primitivism, mythology, anthropology, and psychology is a concept of nature. Nature is an exclusive concept for the Abstract Expressionists, although the artists were never interested in simply, prosaically, like latter-day impressionists, analyzing nature's appearance for its own sake. Instead, they understood it as extension of and equal participant in their thematic concerns. Two statements by Seymour Lipton about his "nature" sculptures make this clear. In 1949 he wrote:

The drive was toward finding sculptural structures that stemmed from the deep animal makeup of man's being, and that when finished had their own reason for being. The ferocity in all these works relates to the biological reality of man; they are all horrendous but not in any final negative sense, rather they are tragic statements on the condition of man, thereby ironically implying a courage needed to encompass evil, indifference, and dissonance in the world of man.[88]

And later, he summed up his central perspective:

Basically "man" concerns me in all the various things I make. I find "inner spaces" of man in things outside himself; in the sea, under the earth, in animals, machines, etc. ... When I made *Sanctuary*, for example ... the work as a whole suggests a flower. Yet botanical nature was a secondary concern. Man was primary. This is true for me in such an apparently remote thing from man as *Earth Loom* [fig. 25]. For me this work involves the forces of energy, of potential, of the subconscious, operating and weaving patterns of experience that may later become overt and conscious. This is true throughout nature, but most directly I feel its application to man even though the work suggests a botanical machine form. Whether or not I use the gesture of man, or forms other than man, all the works in a fundamental way concern human life—are an expression of what I feel about myself and others. This can happen because of the interrelatedness of all biological nature and broad laws applicable to all life.[89]

For the Abstract Expressionists, nature is in many ways humanity, a metaphoric alter ego. *Nature is human nature.* Those elements that characterize nature—its origins, forces, primitiveness, traits, instincts, predatoriness, germination, metamorphosizing—constitute metaphors of human source, tradition, process, and possibility as conceived by many in this era.

Abstract Expressionism naturalism, then, is *natural primitivism,* a nature comprised of primitivistic traits and processes. It can also be characterized as *psychic and spiritual*

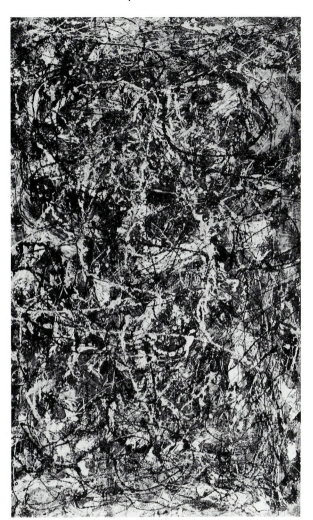

Figure 26. Jackson Pollock, *Full Fathom Five,* 1947. Oil on canvas, with nails, tacks, buttons, key, coins, cigarettes, and matches. $50\frac{7}{8} \times 30\frac{1}{8}$ inches. Collection, The Museum of Modern Art, New York. Gift of Peggy Guggenheim.

naturalism, for the functioning, forms, and forces of the psyche and inner life originated with and allied themselves with nature. Like the surrealists, the Abstract Expressionists naturalized consciousness. Nature's potential is ancestral, cultural, psychic, and collective. It is no wonder several Abstract Expressionists, including Baziotes, Lipton, Pollock, and Gottlieb, visited the American Museum of Natural History in New York, where on display together were the primitive and natural ancestry of humanity.

Evolution and Natural History

The Abstract Expressionists expressed their idea of the origins and continuity of human life as natural evolution— the struggle for survival and growth and the transmutation

of form to higher levels. Through analogies to nature, the Abstract Expressionists sought to symbolize the primordial, essential, universal space-time process of life, for example, the ceaseless flux of the sea, the cosmos, and the human spirit.

Subjects of eternal change predominate. Some refer to geological time: Rothko's *Geological Reverie* of about 1946, Newman's *Tundra* of 1950, and Lipton's *Earth Loom*. Some refer to biological, botanic, or oceanic process: Rothko's *Birth of Cephalopods*, Gottlieb's *Persephone* of 1942 and *Sea and Tide* of 1951, and Pollock's *Full Fathom Five* of 1947 (fig. 26). Some refer to cosmic source: Pollock's and Newman's *Galaxys* of 1947 and 1949 respectively, Pollock's *Comet* and *Shooting Star* of 1947.

All suggest new growth and endless change over time, a continuity of action, and the transmuting power of nature. They allude to an on-goingness from the primeval through the present and to the future. The surrealist metamorphosis of plant forms (Arp) or space-time cycles (Masson) was absorbed as natural history. To many Abstract Expressionists, life was a continuity of self-sustaining action, an eternal mutability, forever operating on the same principles and forces. It was continual generation, a constant energy, a change in time. Man and all forms of life from cephalopods to stars were part of an evolving, dynamic life-web. The notion that life is a natural continuum of instability, rising, falling, evolving, and struggling constituted a challenge to the American artists of the 1930s, who saw life not as evolution but as progress, an ever-unfolding scientific, technological, and rationalistic developmentalism, an attainable utopia. For the Abstract Expressionist generation, life was a process of origins, conflict and only temporary triumph. The natural struggle for existence was permanent and unrelenting.

The Supernaturalism of Vitalism

Although they used naturalistic analogies, many Abstract Expressionists believed that man seeks to transcend his powerful animal nature through the development of consciousness and spiritual life. To a degree, they adopted the Freudian solution, the regulation and sublimation of instinctual drives by means of creative reason and culture, but they searched for a more inward, a more spiritual transformation of life than control by simple reason. Their evolutionism became a theory of spiritual struggle and transformation over space and time in all cultures. It is symbolized by a dynamic, naturalistic principle widely influential because it represented a central tendency in twentieth-century art and thought—*vitalism*.

Vitalism argues that life, although it has a naturalistic basis, is not just chemically or biologically animated. Vitalism represents the principle of a dynamic, physical, and metaphysical or spiritual force to life. In the words of Jack Burnham, whose *Beyond Modern Sculpture* includes the best study of vitalism in sculpture, "Vitalism, based as it is on non-physical substances and states of life, is a metaphysical doctrine concerned with irreducible effects and manifestations of living things. It was the great discovery of twentieth-century sculpture that these did not have to be appreciated through strict representationalism."[90]

Vitalism attempted to join idealism with a new understanding of biological capability and life, and it has traditionally been allied to a concern for religion, metaphysics, and art against the corrosive effects of mechanistic naturalism, industrialism, and science. It represents nature through metaphor, not mimesis, and generates an intuition that in the art object, its materials, and the process of its making, life is not literally, but plastically present.

Artist manifestations of this metaphysical naturalism include surrealist biomorphism and metamorphoses. Another is the likening of the artist and his creative processes to nature and natural forces. As Burnham notes:

Slightly tinged with romantic loneliness, the vitalist sculptor, according to the image nurtured for the last forty years, works in single-minded harmony with the forces and shapes of nature, somehow quelling on a macrocosmic level the eroding torrents of science.[91]

The artist gives spiritual as well as physical life to artistic material, for art represents some inner force. The organic sculptor Barbara Hepworth has made the connection quite explicitly:

The idea—the imaginative concept—actually *is* the giving of life and vitality to material. ... When we say that a great sculpture has vision, power, vitality, scale, ... we are not speaking of physical attributes. Vitality is not a physical, organic attribute of sculpture—it is a spiritual inner life. Power is not manpower or physical capacity—it is inner force and energy.[92]

Modern artists have also frequently referred to nature and its forces as their own. Rodin, for example, declared in an almost primitive "pre-logical view":

The artist, full of feeling, can imagine nothing that is not endowed like himself. He suspects in Nature a great consciousness like his own. There is not a living organism ... which does not hold for him the secret of the great power hidden in all things.[93]

Henry Moore, with his figurative sculptures of fused bone shapes, stone abrasions, and geological formations, wrote that he found his "principles of form and rhythm" by studying natural objects, "rocks, bones, trees, plants ... [which] show Nature's way of working. ... [F]or me a work must have a vitality of its own ... a pent-up en-

ergy."[94] The Abstract Expressionists concurred. In 1950 Pollock said, "The modern artist ... is working and expressing an inner world—expressing the energy, the motion, and other inner forces,"[95] and De Kooning referred to his women, as in *Woman I,* as representative of "the forces of Nature." Martha Graham's dancers, too, represented "a vitality, a life-force, an energy, a quickening that is translated through you into action,"[96] and Lipton, as quoted earlier, described his work as a balance of organic forces.

Artistic vitalism representing naturalistic and spiritual vitality is fundamental to Abstract Expressionism. Burnham saw Henri Bergson's philosophy of intuitive evolution and vitalist process as the literary and philosophic conception for the artists in the first half of the twentieth century. Bergson was a particular influence on the surrealists and thus on the Abstract Expressionists,[97] but there are many more conceptions to which vitalism was parallel and ultimately conjoined. For the Abstract Expressionists, Campbell's concept of the underlying vitality of animate and inanimate things, known in different cultures by names such as God, *wakonda,* or energy, is one. Psychic energies and forces, that is, Freud's and Jung's conceptions of the libido are another.

For Freud and Jung the term unconscious itself meant the large, amorphous creative area within the psyche, understood in its German philosophic sense—dynamic, demiurgic life forces. In depth psychology, Freud conceived of the psyche as motored by active biological drive or libido, in other words, unconscious natural forces. Jung, too, conceived of the psyche as dynamic, but it was animated not by nature, but by a spirit or godlike force, although he frequently described the movement of energies constituting psychic processes in symbolically physical terms, as though there were actual physical structures and processes. His descriptions were simply metaphors, derived from the physical sciences, and were not intended to imply the structures' real existence. The libido moves up or down, backward and forward through the psyche. He wrote that if he were to personify the unconscious, he would include a living sense of the rhythm of organic growth, flowering, and decay of an unceasing stream,[98] the aim of which is to bring about within every individual a state of fluidity, change, and growth in which there is no longer anything externally fixed and hopelessly petrified.[99] The formation of archetypes and their myths and symbols was engendered by the creative and transformative energies of the ongoing process.

For the Abstract Expressionists, automatism, the space-time continuum, and mythic deities became the means to represent vitalism. To the artists, nature meant evolution, change, transmutation, animated and spiritual vitality. Na-

ture, like their notions of heritage primitivism and internal psychic life, symbolized the conflicts and continuity of life.

Elementaries, Dualities, and Multiplicities

From Breton's and surrealism's theory of the resolution of opposites into a new synthesis, represented by Lautremont's often-quoted remark, "Beautiful as the chance encounter on a dissecting table, of a sewing machine and an umbrella," the Abstract Expressionists adopted the principle of the duality and synthesis of opposites and the perpetual metamorphosis of life in cycles. In this they were also following popular conceptions of change as a search for unity amid opposites or as Mary Mellon phrased it, the finding of the "One" which underlies the "Manifold."

In an attempt to control the disintegrating forces that are at work in our society, we must resume the search for unity; and to this end, we must explore the historic nature of the modern personality and the community, in all their richness, variety, complication, and depth. . . . As the processes of unity take form in the mind, we may expect to see a similar integration take place in institutions.[100]

Motherwell, for example, presented as a principle of his work in the late 1940s a synthesis of psychic and pictorial dualities:

The Spanish Prison, like all my works, consists of a dialectic between the conscious (straight lines, designed shapes, weighed color, abstract language) and the unconscious (soft lines, obscured shapes, *automatism*) resolved into a synthesis which differs as a whole from either.[101]

Gottlieb's late works, the Bursts, with their "polarities," are another example. Lipton made perhaps the most articulate Abstract Expressionist statement of the dialectic multiplicity of human nature and life when he said:

On a biological level we find that life in general is an aggregate of tensions. It is generally true that in any drive, one side engenders attention to its polar opposite. There are all kinds of such polar limits in the life of man—strife and peace, good and evil—as well as such esthetic limits as form and content, romanticism and classicism. . . . The drive I have felt these past few years is toward an organization of such polar opposites. I have looked for an interplay of tensions: of lines, planes, forms, spaces, and suggested meanings to develop energy, and to evoke the mystery of reality.[102]

The Abstract Expressionists' notion of the multisided nature of man and life aimed at the typical, one may say archetypal. Rothko spoke of his work as representing the cyclic opposites "tragedy, ectasy, doom." Martha Graham described the feelings she tried to communicate using figures symbolizing archetypical concepts: Fate, Wisdom,

Timelessness, Prophecy.[103] She also considered her subjects, in *I Salute My Love,* to be "Love, Death, Life, Battle, Divination, Birth-growth,"[104] in other words, a continuum punctuated by periodic transformation into opposites.

The Abstract Expressionists' spiritual vitalism and dynamism represented eternal changeability and dialectic variety, the perpetual metamorphosis of being. Campbell described the principle in relevant, mythic terms:

Yet from the standpoint of the cosmogenic cycle, a regular alteration of fair and foul is characteristic of the spectacle of time. Just as in the history of the universe, so also in that of nations: emanation leads to dissolution, youth to age, birth to death, from creative vitality to the dead weight of inertia. Life surges, precipitating forms, and then ebbs, leaving jetsam behind. The golden age, the reign of the world emperor, alternates in the pulse of every moment of life, with the wasteland, the reign of the tyrant. The god who is the creator becomes the destroyer in the end.[105]

Dialectic struggle and movement between opposites and their ceaseless metamorphosis into something new is part of the fundamentalism of twentieth-century art as a whole. Such a process wrestles with the modern problem defined by Yeats in his famous words "the center does not hold." For the Abstract Expressionists, the idea of the perfectibility of humankind had to be replaced by a more complex conception that took in the alternate pulses of life and nations, of "fair and foul," that is, the new experiences, but allowed a new totality. Their paintings, in Lipton's words, celebrate the interplay of dichotomies yet continuities of life: "its irony, absurdity, and tragedy . . . the excitement of man . . . a celebration of what is possible within the span of life."[106]

ART AS DIONYSIAN VITALISM AND UNFOLDING CONSCIOUSNESS

Most Abstract Expressionists considered art to be a representation of, if not participant in, the historical process. Perhaps Read's Bergsonian formulation best sums up the idea: the work of art is not just an analogy for but a participant in the essential act of consciousness.[107] It does not merely represent the pattern of mental evolution but is the apex of the vital process itself.

The writings of Nietzsche fostered the notion of art's central role in the furthering of a new understanding. Nietzsche was an important philosopher on both sides of the Atlantic in this period. Many Abstract Expressionists read his first book, *The Birth of Tragedy Out of the Spirit of Music (Die Geburt der Tragödie aus dem Geiste der Musik),* originally published in 1872, which seemed to address many of their interests: the cultural weakness of the West; the superiority of the natural and the primitive;

the importance of myth; the overemphasis on reason, science, and consciousness; the need for reliance on intuition and unconscious impulse; the duality of human possibility; the terror and suffering and tragic quality of existence; and the redeeming relationship of art to life. His other writing proposed nothing less than the reevaluation of Western culture.

The Birth of Tragedy was one of Rothko's favorite books in his youth.[108] Nietzsche was crucial to Still, who defended the philosopher against the "oppression" of interpreters much as he consistently defended his own work.[109] His colleague, Clay Spohn, and student and friend, Ernest Briggs, said that Still considered Nietzsche to be a poet.[110] According to Annalee Newman, Newman liked *The Birth of Tragedy* but disliked Nietzsche's other writing.[111] Ferber and Lipton read Nietzsche,[112] and Dore Ashton has written that, in the 1930s, others such as John Graham, Stuart Davis, Gorky, and Gottlieb were well acquainted with his thought.[113] The importance of *The Birth of Tragedy* was further attested to in an issue of the Abstract Expressionist magazine *The Tiger's Eye.* The book is quoted, together with a poem whose author is "Dionysus," and an essay by Nicolas Calas on tragedy.[114] In the early 1940s, when the surrealist Gordon Onslow-Ford lectured in New York about the creative principles of the Apollonian and Dionysian, Rothko and other Abstract Expressionists were in the audience.

Nietzsche addresses the traditional problems of Western philosophy: morality, values and ethics, forms of consciousness, art, rationality and thought, God, reality and appearance, determinism and free will. His philosophy provided a vision of change for modern culture. From his nineteenth-century perspective, Nietzsche felt that the scientific "Death of God" had led to a crisis in Western culture. The elimination of Christian hierarchy, the afterlife, and its justification of this life, created a void he feared would lead to pessimism and nihilism. With the fall of Christianity, he felt all values of truth, knowledge, and human worth might be destroyed. To counter the effects of nihilism he proposed new values that would transform life and affirm it.

Nietzsche proposed a new human identity that was more primitive and naturalistic, that is, he wanted to rid humanity of the ascetic, self-denying man that Christianity had defined. Nietzsche posited a person of a "higher type," who in his highest and noblest capacities is "wholly nature and embodies its . . . dual character."[115] He felt that humanity should be "de-deified" and reintegrated into nature.[116] He denied that a transcendent, supernatural substance—a soul—constitutes a person, and for him spiritual life was to be instinctive life, morality an instinctive form of natural expression. Nietzsche, however, did not mean to reduce humanity to the merely animal level. To

be the higher type, humanity has to transcend its origins; it cannot return to a natural state. Once humanity recognizes its naturalness, it has to separate itself from it by its actions. Nietzsche's goal is cultural development and enhancement, not biological expression. Discipline and reason are needed. However humanity naturalizes spirit and human relations and society, it transcends nature to make a primitive, severe but noble anti-Christian human nature.

When Nietzsche discusses the world, he discusses process—the life processes and their profusions. The life process is not just mechanical. It is a developmental process, a struggle for growth. Life is activity, need, doings, becomings, spirit. Nietzsche sees human capacities in terms of health and growth: one who has superior will wants to grow, expand, and gain ascendancy. He writes: "The great and small struggle always revolves around superiority, around growth and expansion, around power—in accordance with the will to power which is the will to life."[117] Will, the dynamic principle, is the decisive sign of sovereignty and strength, the instinct for life.

Nevertheless, Nietzsche's concept is not optimistic, for the will to power is a sign of an endless strife and struggle in which only temporary success is possible. Whatever is created is eventually destroyed, only to recur once more. The desire for and endurance of what Nietzsche called the Eternal Recurrence is a decisive test: if one can live with that conception, one affirms life. Life is the dualistic, cyclic process of creation and destruction, and there is no transcendent, eternal realm of security and safety.

There is one person throughout Nietzsche's writing who has the courage to affirm what is "questionable and terrible in existence." That is the tragic artist, a Dionysian figure. As one would imagine, Nietzsche had no use for art for art's sake, which he felt was purposeless, aimless, "the virtuoso croaking of shivering frogs, despairing in their swamp."[118] Instead, he saw art as the means transforming consciousness and redeeming life. Nietzsche conceived the Dionysian artist as the higher type and art-making as his means. The Dionysian artist is one of the few to have "courage and freedom" before powerful enemies, before sublime calamities, before dreadful problems, to choose, nevertheless, to celebrate humanity and to affirm life. Art is the great stimulation of life, an intoxication and its own will to life.

The pre-Socratic Greeks realized this, especially the playwright Aeschylus, according to Nietzsche, and his first famous work, *The Birth of Tragedy,* analyzed their art in a way that transformed notions of artistic purpose and form. In *The Birth of Tragedy,* Nietzsche offers a new conception of Greek civilization and art which sees them rooted in a pre-Socratic tradition of tragedy ruled by two gods, Dionysius and Apollo. He contrasted Greek culture before and after Socrates, that is, before and after the

advent of Socratic rational knowledge and "wisdom," to the detriment of the latter. Contemporary life is the continuance of Socratic rationalism.

Nietzsche asserts that the development of art—and more generally civilization (he applied this analysis more to culture as a whole than to art alone in his later writings)—was bound up with the Apollonian and Dionysian impulses. The Apollonian and Dionysian first existed as natural impulses without the mediation of the artist, in dreams and Bacchic dances and festivals. The Dionysian musical and tragic impulse was behind ancient festivals, out of which Greek drama arose. Dionysian music reflects primitive instincts and passions in its primal and universal melody. Its emotional power and dynamics create a sense of awe and primordial terror. For Nietzsche, the Dionysian represents the fundamental, indestructible flow of life, a primordial vitalism.

The Apollonian constitutes the visual and the dream in drama and classic Greek temples and sculpture. It harnesses Dionysian energies and stands for the genius of restraint, measure (delimiting boundaries), and harmony. The Apollonian represents freedom from wild Dionysian emotion, illusion, and the principle of individuality. The apex of Apollonian individuation is the particular thing created by *measure,* that is, creation by delimiting form out of the Dionysian flux of infinity.

In *The Birth of Tragedy,* Nietzsche argues that the combination of the Apollonian and Dionysian created tragic myth and drama, which, as all art should, dramatized the terror and struggles but goodness of existence. This to Nietzsche is the Greek and the ideal way of overcoming brute life and affirming its beauty. Art "justifies" existence, in Nietzsche's famous phrase.

Nietzsche thought that Socrates and Euripides, with their optimism, reasonableness, and belief in knowledge and understanding, had undermined tragic drama and myth. He saw in the nineteenth century the possible return of the Dionysian wisdom of tragic life-affirmation. His vision was realized in the twentieth century, when the Abstract Expressionists drew on it for the real tragedy of their time. To a large extent, Nietzsche's Dionysianism both shaped and re-presented Abstract Expressionist culture. With its own return to origins, pattern and continuity of strife and struggle, and concluding affirmation and transformation, it, like most of the cultural history we have explored, asserts a paradigmatic life-historical process.

CONCLUSION

In any national disaster, public and private leaders must identify with national grief. They must begin the public mourning and heal the hurt, but also confine and direct it

lest it evolve into a sense of defeat and despair. They have a responsibility to share emotion but also to channel and shape it and ultimately transform it into a positive force. After an economic disaster, an assassination, an attack and plunge into war, an exploded spacecraft, leaders must not only document, analyze, and come to terms with the causes and place of events, but also reestablish purpose, confidence, and a sense of destiny for the society as a whole. The long view—the ups and downs of the human journey—must be put forth so that sense can be made of events that would otherwise seem gratuitous. The public spirit must be deliberately engaged. Heroes, martyrs, enemies must be celebrated or denounced. Elegy, solemnity, spirit, and bravery, a call for renewed determination and courage—these are the things that leadership necessarily addresses.[119]

Virtually any reference to the crash and war recalls this fundamental scenario. Whether popular or learned, military or civilian, personal or public, studies and memoirs of this period recall human gallantry, sacrifice, suffering, loss, memory, and the nobility of human beings in those intense and overwhelming years. For example, in discussing the battle of the Atlantic, Winston Churchill alludes to this experiential pattern:

The Battle of the Atlantic was the dominating factor all through the war. Never for one moment could we forget that everything happening elsewhere, on land, at sea, or in the air, depended ultimately on its outcome, and amid all other cares we viewed its changing fortunes day by day with hope or apprehension. The tale of hard and unremitting toil ... in the presence of unseen danger, is lighted by incident and drama. ... Vigilance could never be relaxed. Dire crisis might at any moment flash upon the scene with brilliant fortune or glare with mortal tragedy. Many gallant actions and incredible feats of endurance are recorded, but the deeds of those who perished will never be known. Our merchant seamen displayed their highest qualities.[120]

It is out of this psychological and historical situation that most Abstract Expressionism arose.

In their art, the Abstract Expressionists sought to put the modern Thirty Years War and crisis in the perspective of history. They proposed to look at human development for an explanation, conceiving a pattern of human struggle over space and time beginning with human origin. And they designated a way to transcend the present, if only in a wary and limited fashion, with a new level and stage of the continuum, an alteration of consciousness, a new knowledge about human strengths and limitations, a change in the psychocultural balance of Western civilization, and a spiritual transformation. The Abstract Expressionists created an art that was largely public and as socially spirited as American art of the thirties, but filtered through modernism and individual expression.

Paul Ricoeur defined the hermeneutic enterprise as twofold—the reduction of illusions and the restoration of the fullness of meaning by shifting its immediate reflection in consciousness to a more compelling level he calls the sacred.[121] The Abstract Expressionist paradigm of sacred emotion, nature, experience, psychology, and history, was succinctly and summarily expressed by Seymour Lipton, who synthesized the sacred themes in terms of a cycle of negation and affirmation, of the triumph of life over death:

The dark inside, the evil of things, the hidden areas of struggle became for me a part of the cyclic story of living things. The inside and outside became one in the struggle for growth, death, and rebirth in the cyclic renewal process. I sought to make sculpture as an evolving entity: to make a thing suggest a process.[122]

Wilder's Mr. Antrobus was a bit more straightforward:

Oh, I've never forgotten for long at a time that living is struggle. I know that every good and excellent thing in the world stands moment by moment on the razor-edge of danger and must be fought for. ... All I ask is the chance to build new worlds.[123]

Abstract Expressionism is the most original artistic resistance to arise in the West in the 1940s, taking its place among other intellectual resistances in Europe and American. It was an art of the quest for affirmation in a time of trial.

The first artist we will examine is Clyfford Still, who confronts the crisis in the West by seeking to transform his personality and his culture. For Still, to recast himself is to recast his world.

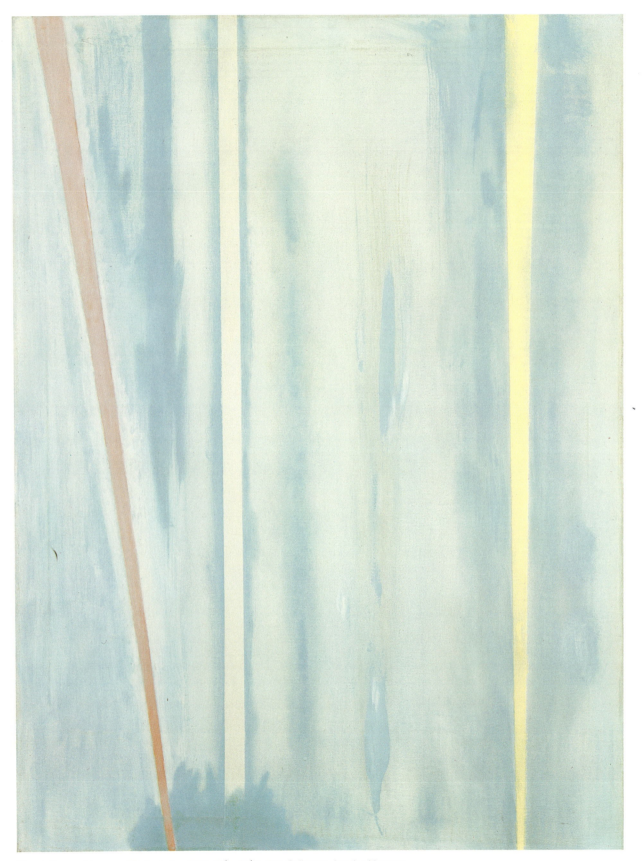

Plate I. Barnett Newman, *The Beginning*, 1946. 40⅛ x 30⅛ inches. Collection Annalee Newman.

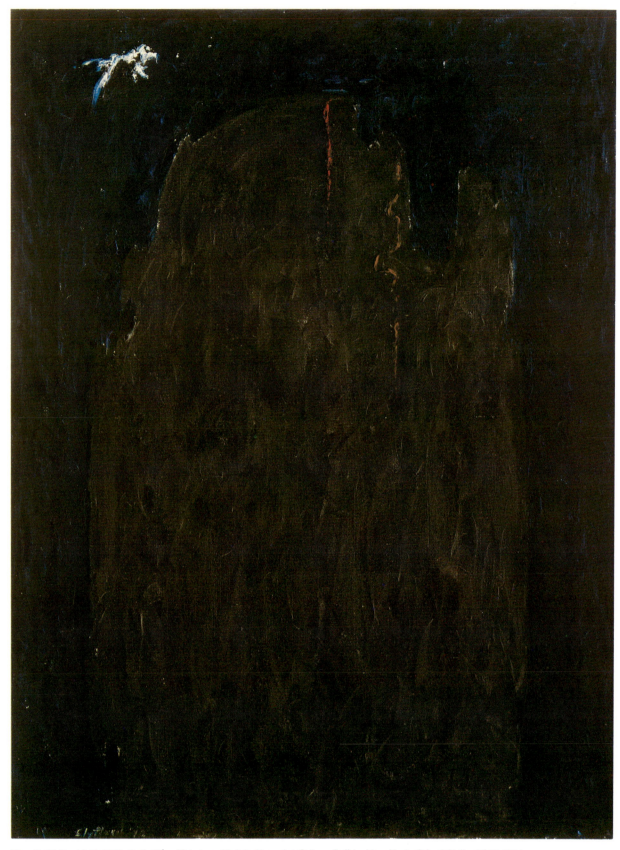

Plate 2. Clyfford Still, *1941–2–C.* 42½ x 32 inches. Albright-Knox Art Gallery, Buffalo, New York. Gift of Clyfford Still, 1964.

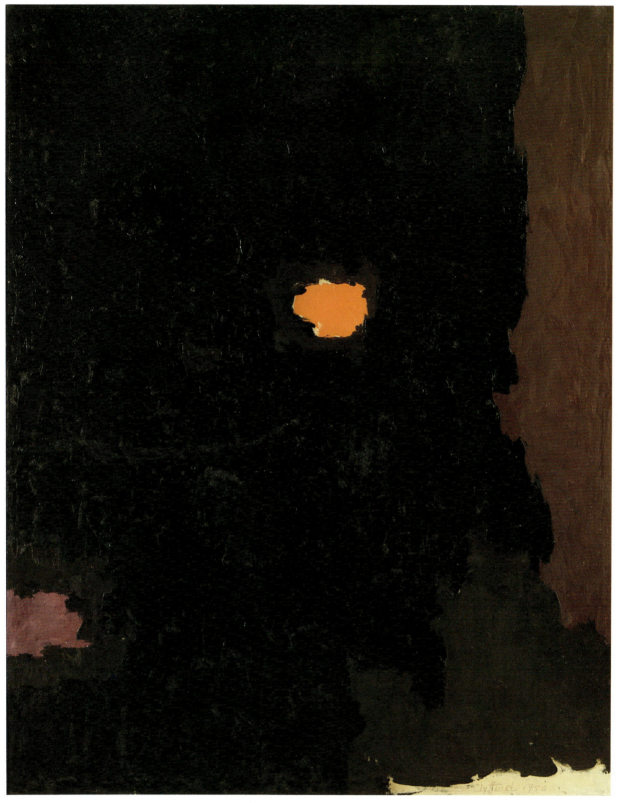

Plate 3. Clyfford Still, *1950–B.* 84 x 67 inches. The Phillips Collection, Washington, D.C.

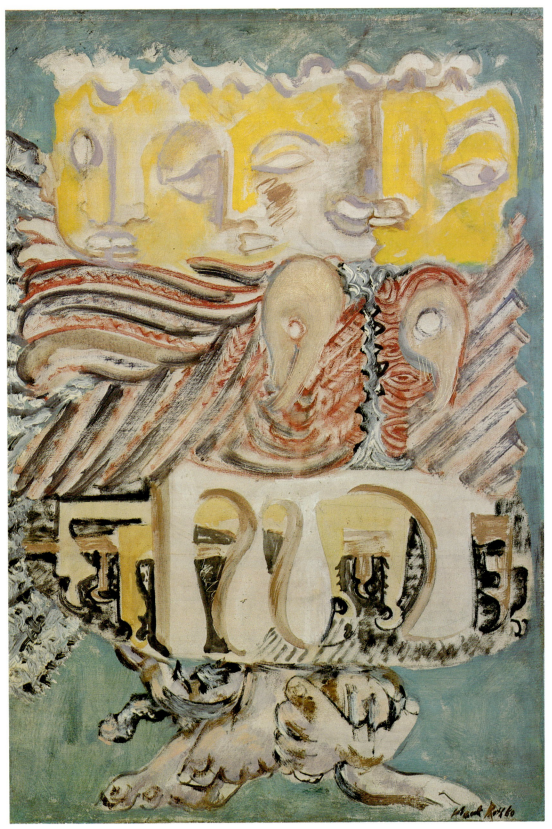

Plate 4. Mark Rothko, *The Omen of the Eagle*, 1942. 25¾ x 17¾ inches. Oil and graphite on canvas. National Gallery of Art, Washington, D.C. Gift of the Mark Rothko Foundation. (1986.43.107)

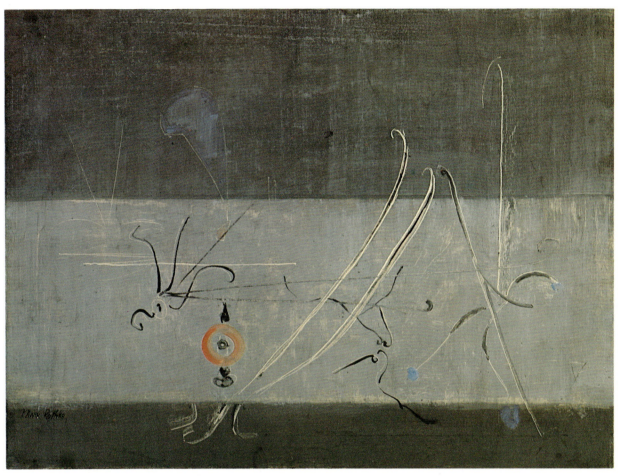

Plate 5. Mark Rothko, *Untitled,* 1945. 22 x 30 inches. Copyright 1989 Kate Rothko Prizel and Christopher Rothko/ARS N.Y. Photograph courtesy of The Pace Gallery, New York.

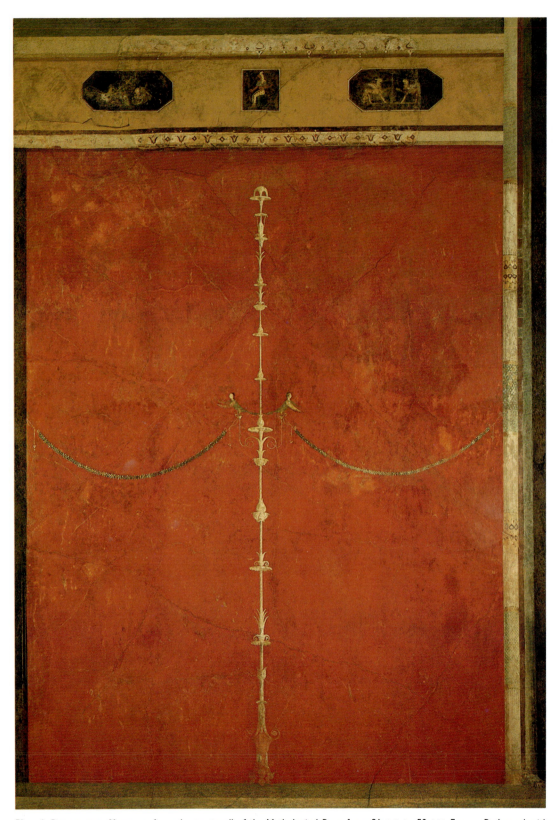

Plate 6. Boscotrecase [fragment from the west wall of the Mythological Room], ca. 31 B.C. to 50 A.D. Fresco. Red panel with candelabrium and yellow frieze. The Metropolitan Museum of Art, Rogers Fund, 1920. (20.192.13)

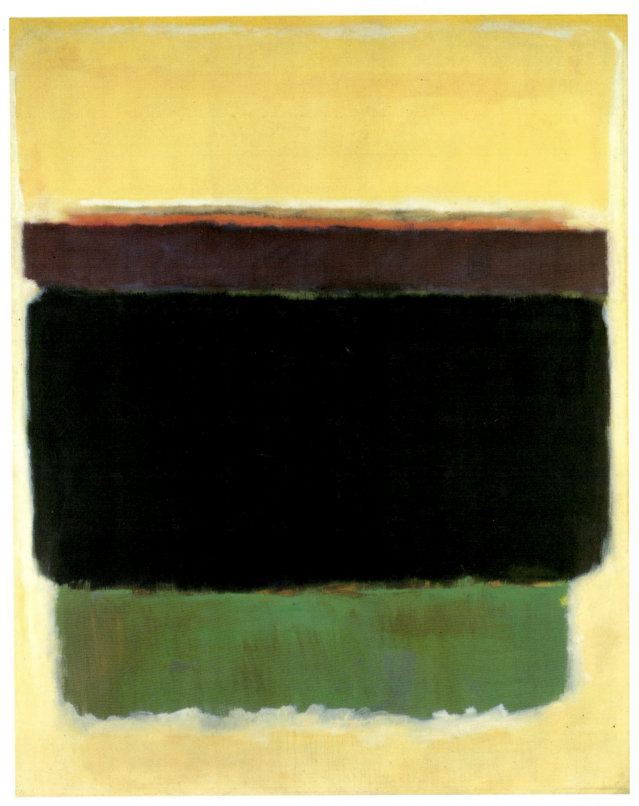

Plate 7. Mark Rothko, *Untitled,* 1949. 81⅝ x 66⅛ inches. National Gallery of Art, Washington, D.C. Gift of the Mark Rothko Foundation. (1986.43.138)

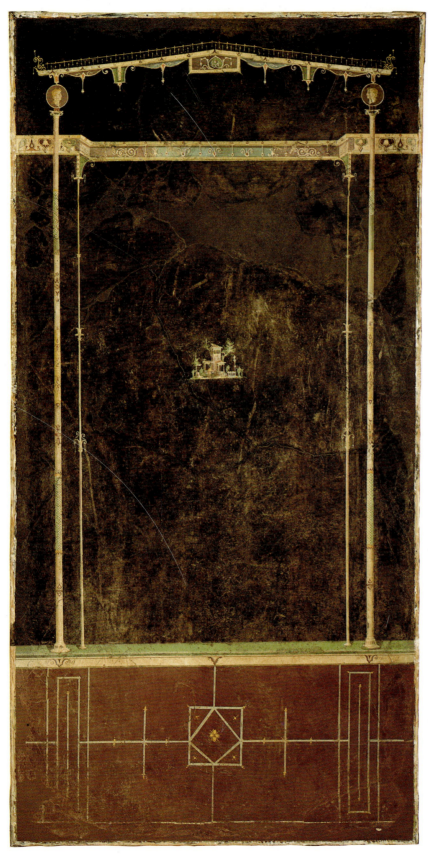

Plate 8. Boscotrecase [fragment from Black Room, north wall], ca. 31 B.C. to 50 A.D. Fresco. 95 x 48 inches. Central pavillion with landscape vignette. The Metropolitan Museum of Art, Rogers Fund, 1920. (20.192.1)

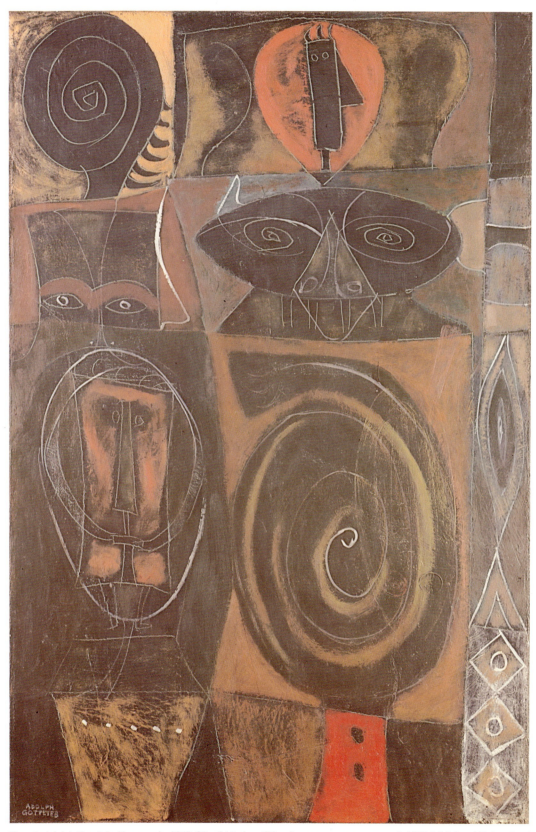

Plate 9. Adolph Gottlieb, *Masquerade*, 1945. 36 x 24 inches. Oil and egg tempera on canvas. © 1979 Adolph and Esther Gottlieb Foundation, New York.

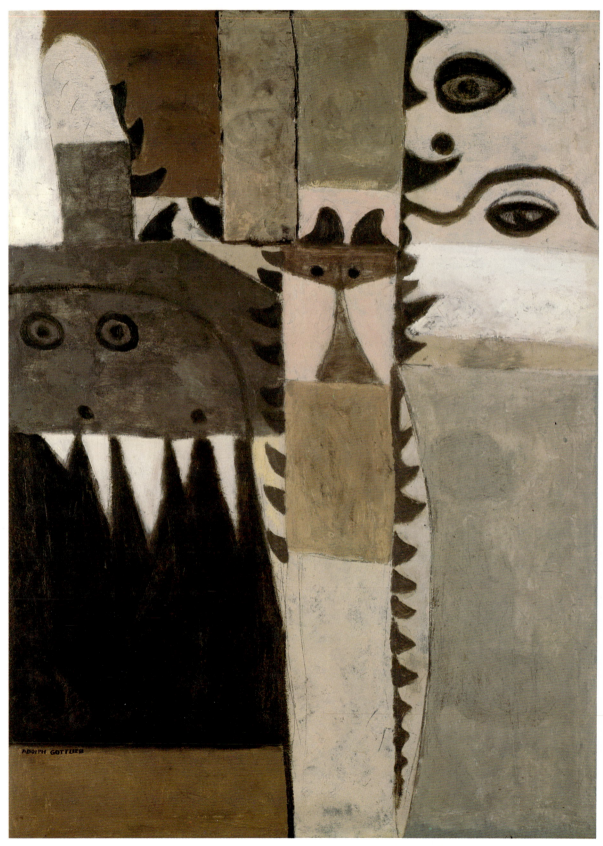

Plate 10. Adolph Gottlieb, *Pictograph—Symbol*, 1942. 54 x 40 inches. © 1979 Adolph and Esther Gottlieb Foundation, New York.

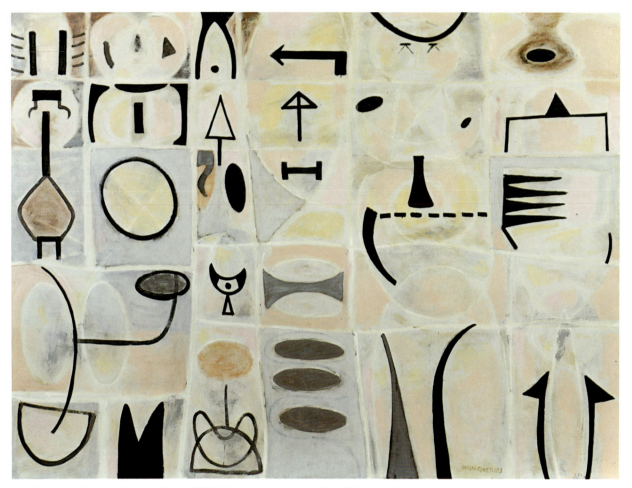

Plate 11. Adolph Gottlieb, *Omens of Spring,* 1950. Mixed media on canvas. 68 x 92½ inches. Private collection.

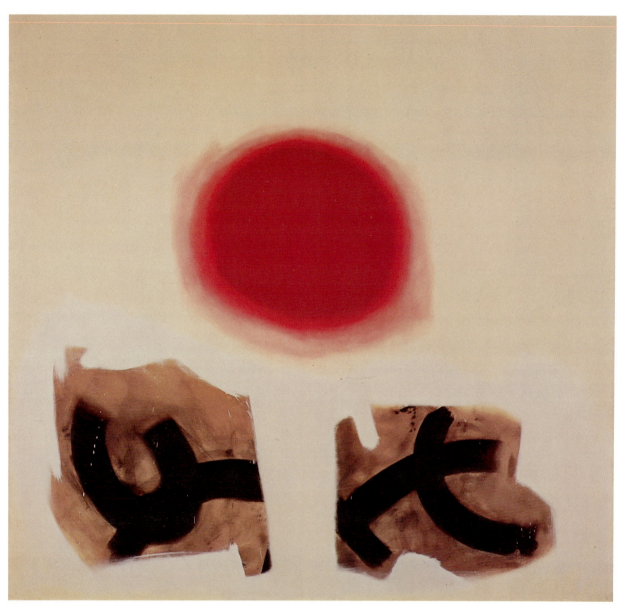

Plate 12. Adolph Gottlieb, *Excalibur*, 1963. 84 x 90 inches. Collection of the Whitney Museum of American Art. Purchase, with funds from the Friends of the Whitney Museum of American Art. (64.5) Photo: Geoffrey Clements.

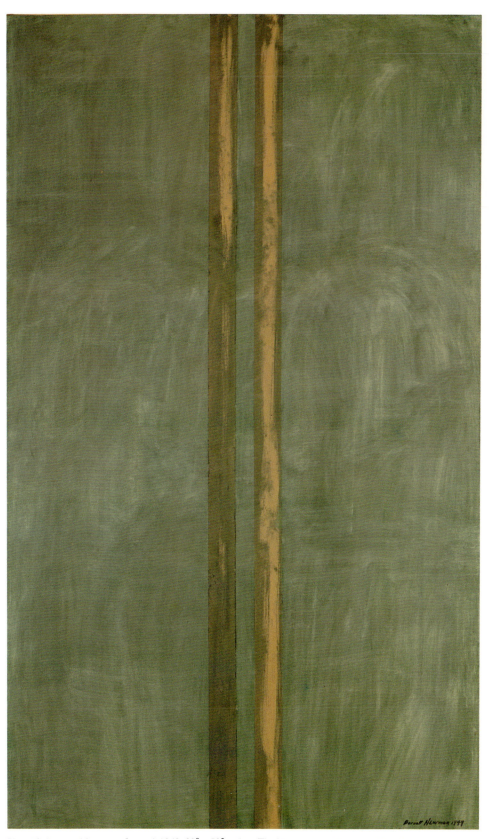

Plate 13. Barnett Newman, *Concord,* 1949. 89¾ x 53⅝ inches. The Metropolitan Museum of Art. Purchase. George A. Hearn Fund, 1968. (68.178)

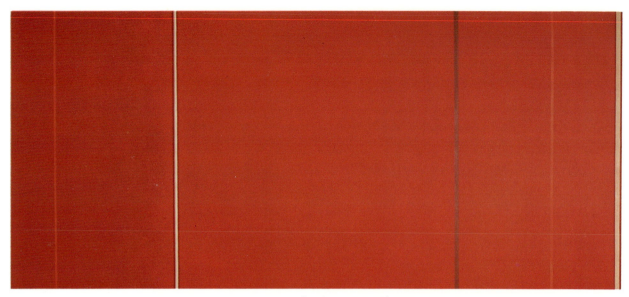

Plate 14. Barnett Newman, *Vir Heroicus Sublimis,* 1950–51. 7 feet 11⅜ inches x 17 feet 9¼ inches. Collection, The Museum of Modern Art, New York. Gift of Mr. and Mrs. Ben Heller.

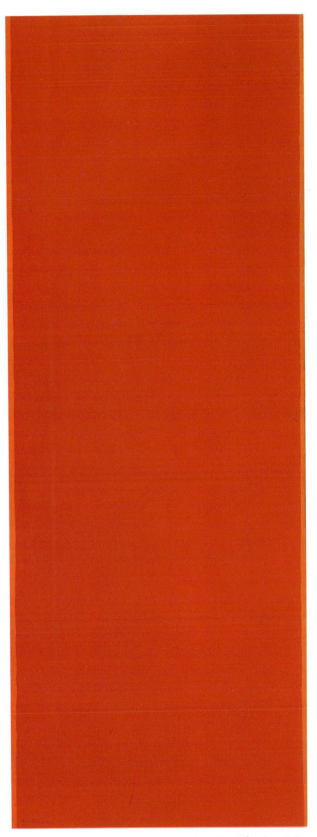

Plate 15. Barnett Newman, *Day One*, 1951–52. 132 x 50¼ inches. Collection of Whitney Museum of American Art, New York. Purchase, with funds from Friends of the Whitney Museum of American Art. (67.18)

Plate 16. Barnett Newman, *Be II*, 1961–64. Oil and acrylic on canvas. 80 x 72 inches. National Gallery of Art, Washington, D.C. Robert and Jane Meyerhoff Collection. (1986.65.15)

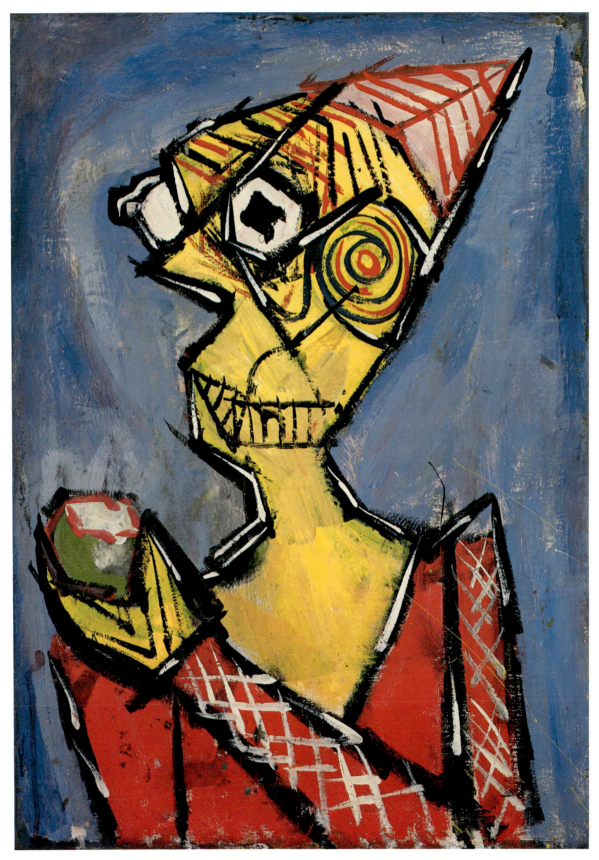

Plate 17. William Baziotes, *Untitled (Clown with Apple)*, 1939–40. 28 x 20 inches. Estate of William Baziotes. Photo: Courtesy BlumHelman Gallery, New York.

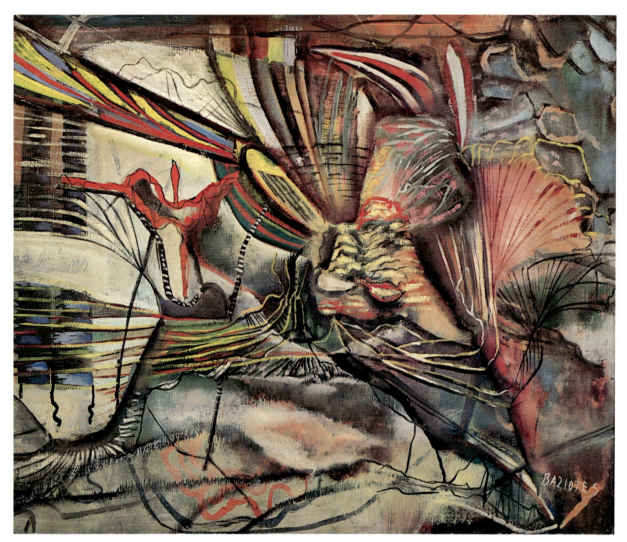

Plate 18. William Baziotes, *The Butterflies of Leonardo da Vinci*, 1942. Duco enamel on canvas. 19 x 23 inches. Estate of William Baziotes. Photo: Courtesy BlumHelman Gallery, New York.

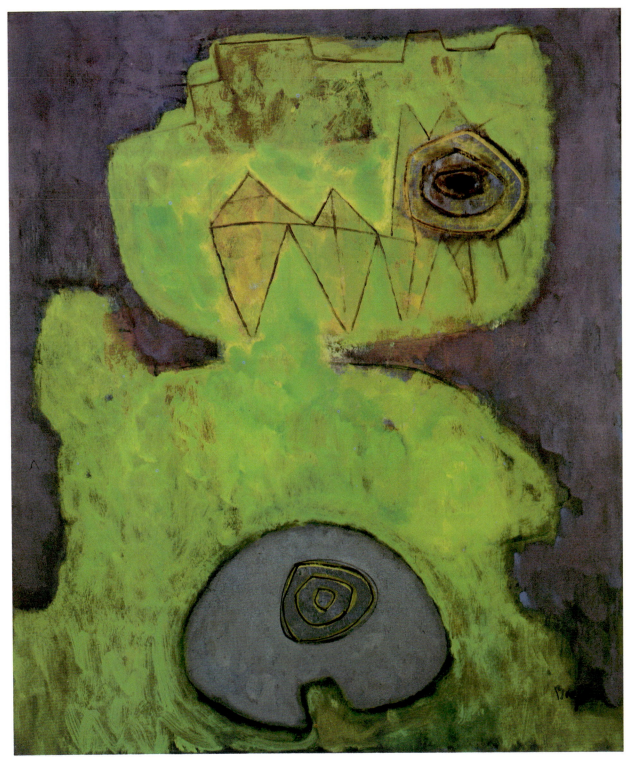

Plate 19. William Baziotes, *Dwarf*, 1947. 42 x 36⅛ inches. Collection, The Museum of Modern Art, New York. A. Conger Goodyear Fund.

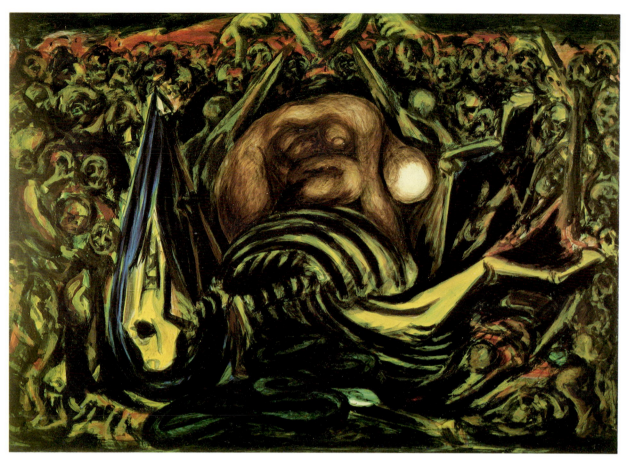

Plate 20. Jackson Pollock, *[Bald Woman with Skeleton],* ca. 1938–41. Oil on masonite. 20 x 24 inches. Gerald Peters Gallery, Sante Fe, New Mexico.

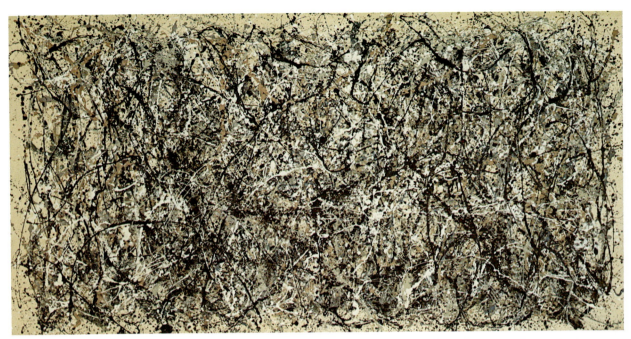

Plate 21. Jackson Pollock, *One [Number 31, 1950]*. Oil and enamel on canvas. 8 feet 10 inches x 17 feet 5⅝ inches. Collection, The Museum of Modern Art, New York. Sidney and Harriet Janis Collection Fund (by exchange).

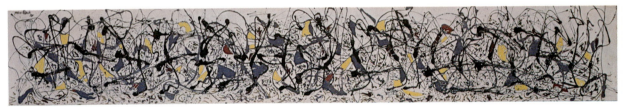

Plate 22. Jackson Pollock, *Summertime: Number 9A, 1948*. Oil and enamel on canvas. 33¼ inches x 18 feet 2 inches. The Tate Gallery, London.

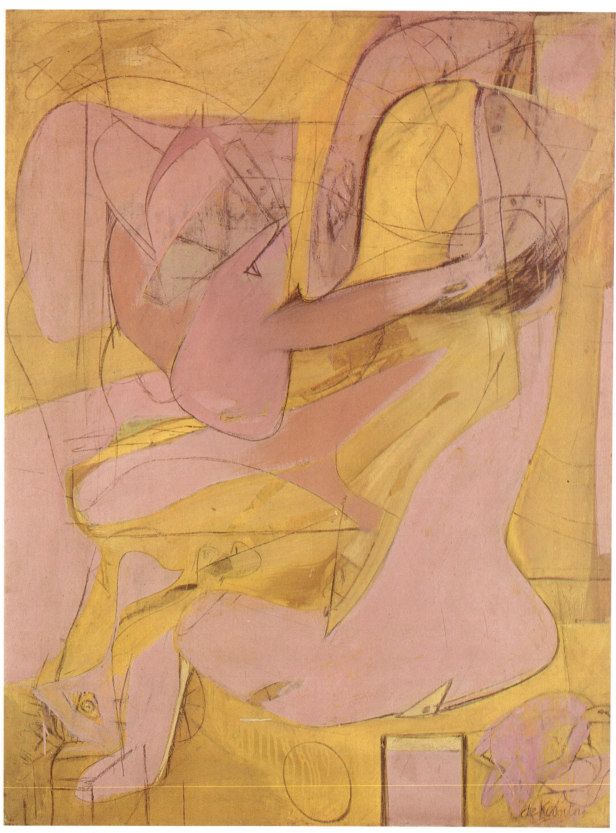

Plate 23. Willem de Kooning, *Pink Angels*, ca. 1945. Oil and charcoal on canvas. 52 x 40 inches. Frederich Weismann Art Foundation.

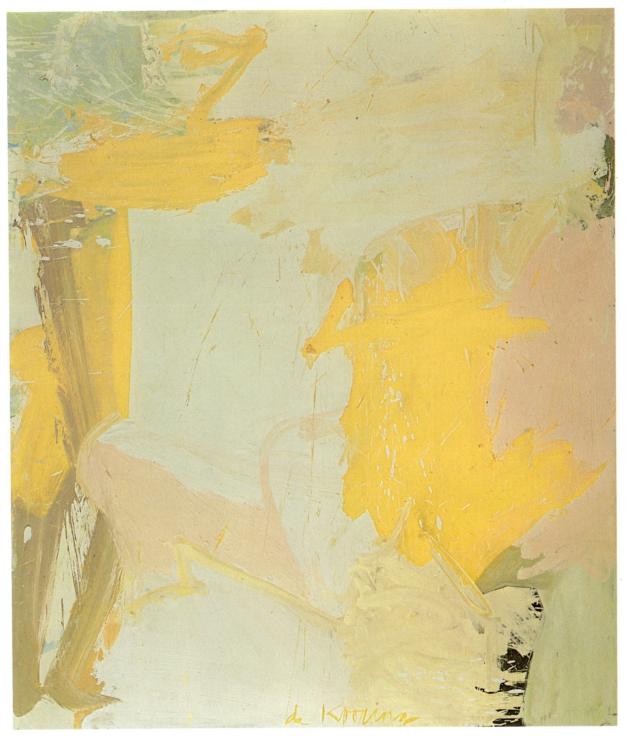

Plate 24. Willem de Kooning, *Rosy-Fingered Dawn at Louse Point*, 1963. 80⅛ x 70⅞ inches. Collection Stedelijk Museum, Amsterdam.

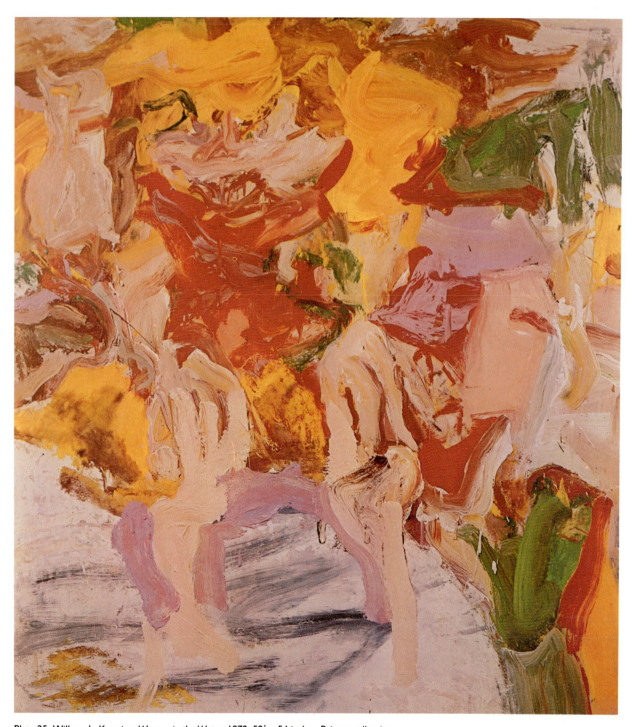

Plate 25. Willem de Kooning, *Woman in the Water*, 1972. 59½ x 54 inches. Private collection.

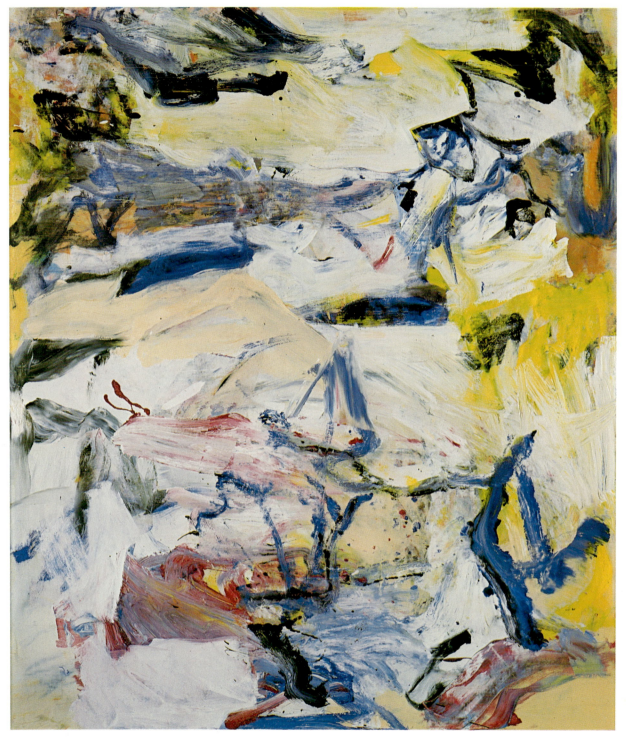

Plate 26. Willem de Kooning, *North Atlantic Light,* formerly *Untitled XVIII,* 1977. 80 x 70 inches. Collection Stedelijk Museum, Amsterdam.

Plate 27. Robert Motherwell, *Summer Open with Mediterranean Blue,* 1974. Acrylic on canvas. 48 x 108 inches. Courtesy Robert Motherwell.

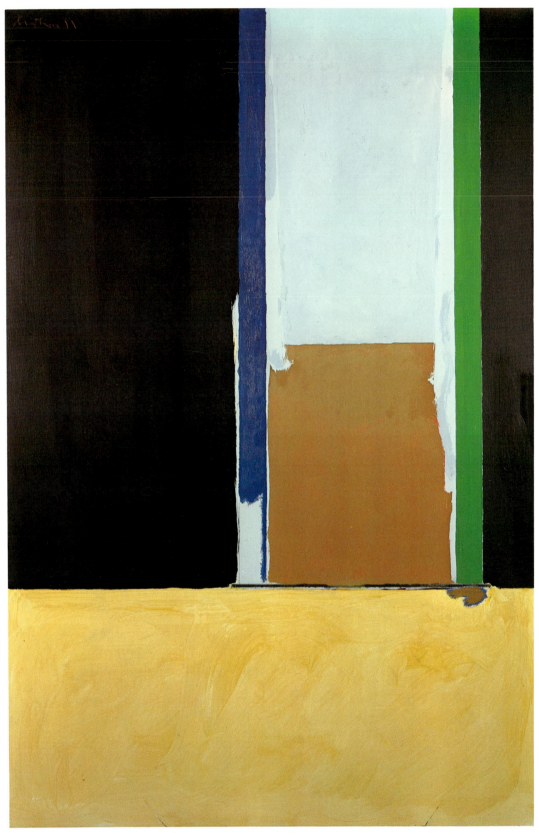

Plate 28. Robert Motherwell, *The Garden Window,* formerly *Open #110,* 1969. Acrylic on canvas. 61 x 41 inches. Courtesy Robert Motherwell.

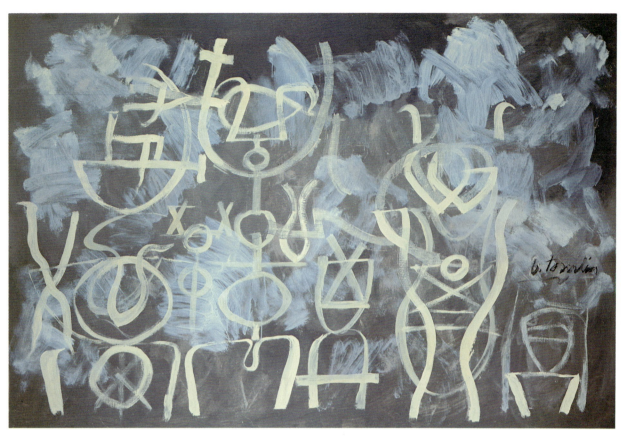

Plate 29. Bradley Walker Tomlin, *All Souls Night,* 1947. 42½ x 64 inches. Courtesy Vivian Horan Fine Art, New York.

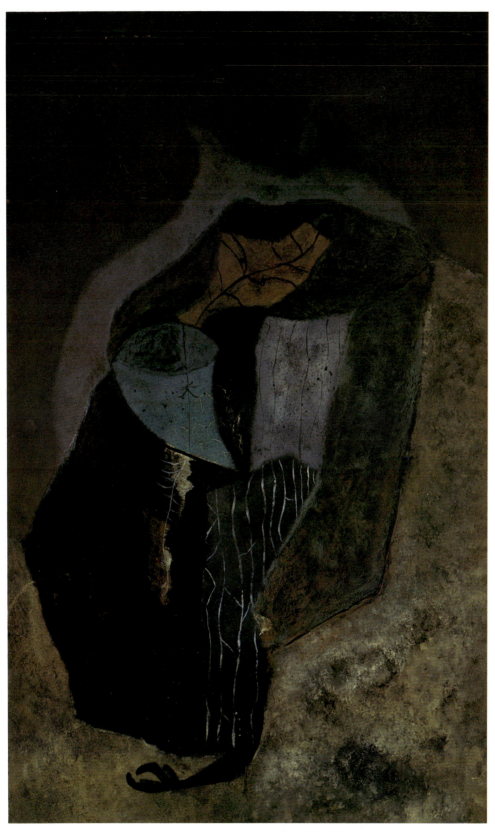

Plate 30. Theodore Stamos, *Shofar in the Stone*, 1946. Oil on masonite. $39\frac{3}{4}$ x $24\frac{1}{2}$ inches. Collection Savas Family.

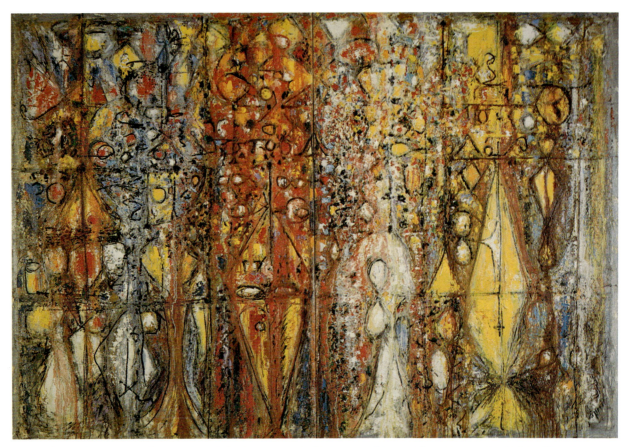

Plate 31. Richard Pousette-Dart, *Blood Wedding,* 1958. Oil on linen. 72 x 112 inches. Collection of Dr. and Mrs. Arthur E. Kahn. Photo: Courtesy of the artist.

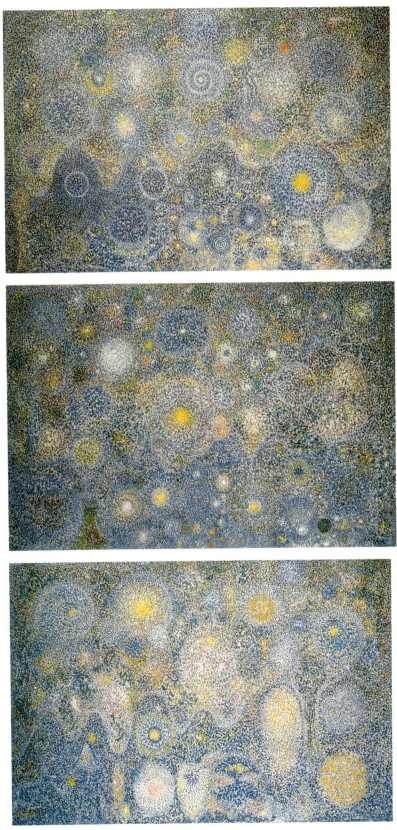

Plate 32. Richard Pousette-Dart, *Radiance*, 1973–74. Acrylic on linen. Three panels, each 72 x 108 inches. Collection of the artist.

PART 2

THE ARTISTS

CHAPTER 3

CLYFFORD STILL
Of Plenitude and Power

By remaining in his place, like the Polar Star, [he] draws all the constellations around him.

Holgar Cahill, *Looking South to the Polar Star*

Clyfford Still painted rugged and potent images. With their crude palette-knifed and troweled surfaces, their immense space, their strong color, their relentless vertical and horizontal expansiveness, Still's abstract works project a forcefulness perhaps unequaled in Abstract Expressionist painting. "Still makes the rest of us look academic," Pollock remarked in 1955.[1] Of all the Abstract Expressionists, he seems to be the least influenced by cubism and surrealism. He originated the color-field style with its large color shapes and sections as the major pictorial element, and colleagues Newman and Rothko, and second-generation color-field painters Sam Francis, Kenneth Noland, and Morris Louis, among others, share a debt to him. Yet Still has remained relatively undervalued.

Though often tagged as evocative of the Far West and of the Romantic sublime, his art includes much more. It reflects what he saw to be the decadence and doom of Western culture, and it forms an image of his own liberation. Still's subject matter and its symbolism are his own growth and struggle. His personal drama becomes a search for change and salvation in the historical situation intended as an exemplar for Western culture at large.

Still was born in 1904 in North Dakota to a family of farmers. He spent his childhood in Alberta, Canada, and Spokane, Washington, in lands of bare desert and high mountains, lonely prairies and ageless mesas. In 1925 he traveled to New York to study art, but he dropped out of the Art Students League moments after he enrolled,

feeling that it had nothing to teach him. Back in the West, he graduated from Spokane University in 1933.

Little of Still's early work is known, in part because he kept it to himself.[2] In the early works, an American Regionalist and raw figurative style is apparent. The heretofore unknown figure 27 represents the building of the Grand Coulee Dam. An unpublished letter of September 17, 1934 tells of Still's commitment to Regionalism. Visiting the Regionalist art critic and Benton supporter Thomas Craven, he noted that "we found our viewpoints almost too coincident."[3] In *PH–323* of 1934 (fig. 28) a naked and extremely elongated bone figure forcefully strides across a dramatic landscape. The figure, which dominates the dark, earth-colored landscape, is seen in profile and has a simplified eye and mouth (rendered by palette-knife strokes) and shovellike hands. Its striding movement announces the dynamism characteristic of much art and thought of the era, from the aggressive forward thrust of streamlined trains and planes to Lipton's sculptures such as *Herald* of 1959.

In 1934 and 1935 Still spent time at Yaddo in Saratoga Springs, New York, where his work underwent a major change and became, in his own characterization, "tragic."[4] A photograph of additional unknown works of the 1930s shows the transition from Regionalist subjects to the more primitive bone figures of around 1937 (fig. 29–29a–h). Farmers predominate in the earlier works, then disappear. In the most representational of the works (fig. 29a), Still himself or his father appears in a three-quarter portrait. But in this work as in others (fig. 29b), new and significant developments occur. The frontal figure oddly places his fist perpendicular to the picture plane. Other farmers are thin and emaciated (figs. 29c–e) yet are grouped with a

Figure 27. Clyfford Still, *Grand Coulee Dam*, 1930s. Private collection.

pregnant woman. In figure 29f, there is a strange and awkward Pietà or Lamentation scene with a dying ribbed figure, in a classical Patroclus and Meleager pose, about to be suckled by a large-breasted woman. In other works (figs. 29g and 29h), Still experiments with cubist interlocking and, significantly, Native American forms.[5] The narrow, seemingly negative form in figure 34h is that of the thunderbird spirit as recorded in the pictographic notations of nineteenth-century shamans (fig. 30 second line, third from left). Its shoulder is a high-rising white bone, below which flow the striated lines of magic power, according to Native American ceremony and ritual (fig. 30, third line, last form).

All of these works were done between 1934 and 1937 and they reflect Still's transformation from a representational artist to a modern and primitivist one. Certain features that will define his art and thought emerge: the use of bone images to suggest ancient sources; fists and vertically rising forms to suggest Still's power and force; bony thinness contrasted with pregnancy, and death contrasted with nurturing breasts to symbolize the cycle of death and rebirth; crude and deliberately ugly forms to suggest a primitive and American lack of sophistication; and allusions to Native American symbols and rituals of magic power. Although these themes and forms are used here in conjunction with Regionalist farmers to suggest the possible renewal of American rural life in the 1930s, they will also characterize Still's more abstract, totemic work.

Another mid-1930s work, *Brown Study* of 1935 (fig. 31), further illustrates his developing idea. *Brown Study* consists of a figure whose massive, tall, stonelike head, articulated only by deep eye sockets, stretches above a more loosely defined torso. To the left and providing a vertical parallel to the head, is an outsized hand, dropped

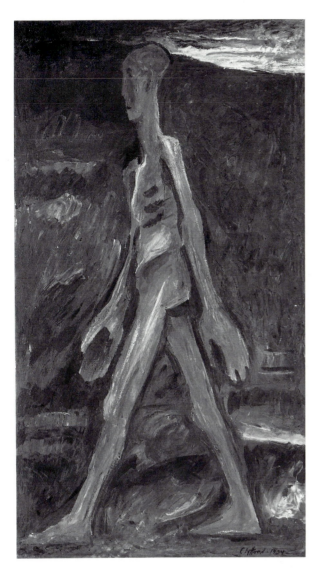

Figure 28. Clyfford Still, *Untitled (PH–323)*, 1934. 57⅝ × 31⅝ inches. San Francisco Museum of Modern Art. Gift of the artist.

from a bent wrist. The image partially reflects Still's admiration for Cezanne. Still had written a Master's thesis on Cezanne in which he saw him as a provincial "primitive" who made the best of his limited gifts. Still praised Cezanne for rejecting the facile techniques of the Old Masters and decadent modernism in favor of a more honest and ultimately more original plastic "means to power."

Cezanne commenced his work with a given unit of form or color.... [He] manifests ... his ability for rhythmically synchronizing rugged volumes. ... The particular or superficial became subordinated to the whole. ... Cezanne ... in the process pushed form [forward] ... to ... the structural coordination and realization of form as color.[6]

Brown Study incorporates stylistic features from two different periods of Cezanne's work. The loose, rambling

right shoulder, arm, and hand are drawn from his early, violent, painterly style of the 1860s before his absorption of impressionism; the small diagonal strokes throughout and the continuous flow of planes from the head to the lower central area reflect Cezanne's post-impressionist *passage*. Still fuses all of these forms with a single brown color and extends figure, plane, and form to the very edges of the canvas. Here form is extended color and vice versa, much as it is in his late style.

PSYCHIC RECAPITULATION

Two statements from 1966 provide the key to Still's artistic development. The first comes from Still himself: "I had not overlooked the organic lesson; ontogeny suggested that the way through the maze of sterility required recapitulation of my phylogenic inheritance."[7] Here Still declares his attempt to return to the past and recreate its pattern of human development: he will follow the biological model. "Ontogeny recapitulates phylogeny" was one of the fundamental theories of nineteenth-century biology.[8] While primarily a biological conception defined by German Romantic biologists, the *Naturphilosophen*, and thinkers such as Schelling, recapitulation was also a cultural idea. It proposed a corresponding development in consciousness and spirit between humanity and its cultures: the Western child's maturation recapitulates the historical development of culture and consciousness from the lower species and non-Western races to its apotheosis in the Western adult. (The theory obviously reflects nineteenth-century racial attitudes.) The modern individual is a microcosm that recreates the macrocosm—its organic history, human and cultural development, even psychic history.

The influence of recapitulation theory was widespread in the nineteenth and early twentieth centuries. Freud, Jung, and Herbert Read, for example, believed that the mentality of the young child or the contents of the unconscious reflected the earlier (that is, primitive) levels of thought and culture. In popular parlance, recapitulation was mistakenly understood to suggest that one could recreate the stages of consciousness through which the culture had passed. The search for the primitive and childlike in modern art reflects this idea.

Still seems to declare an intention to return to the "original" culture and consciousness. It is in the primitive past that humanity's physical existence, its understanding of the world, its consciousness and art, and its social expressions began. Like other Abstract Expressionists, Still is interested in the antecedent forms of life, but unlike them, he does not return to the past to engage the collective tradition of civilization or the historical contin-

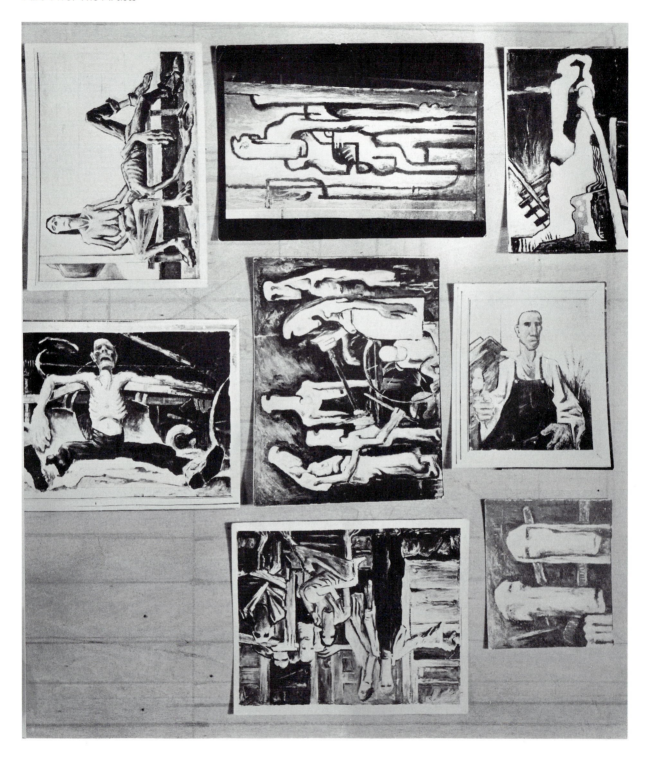

Figure 29. Photographs of eight early Still paintings. Whereabouts unknown.

Figure 29a-h. Diagram of photo of early Still paintings.

whom he taught at the California School of Fine Arts from 1946 to 1950. Spohn wrote, "After seeing many of Clyfford Still's work I have come to the conclusion that he is a sorcerer with powerful magic. . . . Nay! An Earth Shaker." Still told Spohn at the time that he was the only one who understood his work.[9]

Spohn's statement was not simply poetic excess but an allusion to one of the most powerful figures in Native American societies—"Earth Shaker" is one name for a shaman. The name comes from a particular ceremony: to summon spirits to answer questions about the future, a Native American shaman encloses himself in a tent and begins incantations:

Soon the lodge trembles, the strong poles shake and bend as with the united strength of a dozen men, and strange, unearthly sounds, now far aloft in the air, now deep in the ground, . . . approaching near and nearer, reach the ears of the spectators.[10]

When the spirits arrive, they shake the tent and speak in animal voices (fig. 32).[11] From the tent, the shaman could then make magic flights.

The word *shaman* comes from Siberia. The shaman is a diviner, prophet, and miracle-worker. "The shaman is the great specialist in the human soul"; writes Mircea

uum but to reassert human origins in order to make a new beginning for himself—and for modern culture.

The second statement published in 1966 illuminates Still's primitivist persona. The epigraph to the 1966 Albright-Knox catalogue is part of a statement written in 1947 by Still's friend and fellow teacher, Clay Spohn, with

Figure 30. Capt. S. Eastman, Shaman Mnemonic System of the Grand Medicine Society, in Henry R. Schoolcraft, *Information Respecting the History, Condition, and Prospects of the Indian Tribes of the United States*, Bureau of Indian Affairs (Philadelphia: Lippincott, Grambo, 1853) volume I, part I, opposite p. 373.

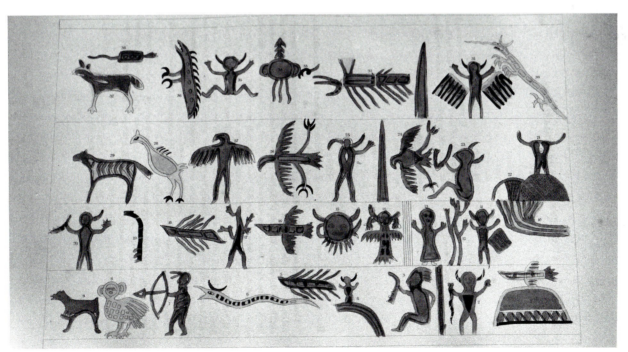

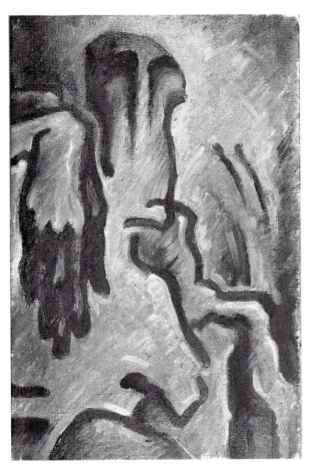

Figure 31. Clyfford Still, *Brown Study*, 1935. 29$\frac{15}{16}$ x 20$\frac{1}{4}$ inches. Munson–Williams–Proctor Institute Museum of Art, Utica, New York. Purchase.

Eliade, "he alone 'sees' it, for he knows its 'form' and its destiny."[12] In all societies with shaman figures, he is recognized as a supernatural being who gets his powers in visions, dreams, and trances directly from gods and spirits. In general, a person becomes a shaman after being struck by a mysterious illness (often provoked by ancestral spirits) in which he imagines that he has died and been reborn (initiatory death and resurrection); the only cure is to take up shamanism. When the shaman is in a trance, a supernatural being enters his body and speaks through his mouth. The shaman's soul goes on long journeys to the sky or the underworld. In several societies, he is also a medicine man, and his greatest responsibility is curing the sick. With his intimate relationship to the spirit world and its powers, the shaman may use his gift for self-glorification and greater power within the society.[13] Ultimately, he has a direct relationship with the sacred and manipulates its manifestations.

Most of the writers familiar to the Abstract Expressionists valued the magician/shaman as the most important primitive personage. (Not all tribal members seeking magicoreligious powers are shamans, however.) For Frazer, the sorcerer-magician-artist-king ruled primitive society and tried through magic rites and customs to control and bend forces of nature for the betterment and renewal of the group, totem, or clan. Positive magic was used to make rain fall, the sun rise, or the wind blow. Negative magic created taboos that prevented things from happening. According to Frazer, the magician-sorcerer's "whole being, body and soul, is so delicately attuned to the harmony of the world that a touch of his hand or a turn of his head may send a thrill vibrating through the universal framework of things."[14] For Levy-Bruhl, the sorcerer was the figure most attuned to the enveloping continuum of suprasensible forces. In the Grail vegetation ritual dramas, the healer of the ill king and land is part priest and part medicine man. For Nietzsche, the artist was a saving sorcerer, an expert healer, who redeemed man by means of the sublime. For Read, the magician, as the supreme figure in primitive societies, was engaged in a dialogue on a subconscious level between individual and group consciousness. He was the ideal social leader, who led by expressing, not impressing, the group. As "the maker of magic, the voice of the spirits, the inspired oracle, the intermediary through whom the tribe secured fertility for the crops or success for their hunters . . . [his] hand was veritably the hand of God."[15] Breton and some surrealists also conceived of the artist's role as that of a seer, though more in a Rimbaudlike sense than in the sense of a primitive magician. Ernst, however, actually thought of himself as a primitive shaman.[16]

We have already seen aspects of shaman power in Still's work—the bird, bone, and skeleton figures. The bird figure may indicate shamanic costume, which often takes the form of ornithological symbolism. While bones, ancestral morphologies, primordial landscapes, elementary organic forms, and internal body or skeletonal structures constitute common images and themes in interwar art, including that of Picasso, Tanguy, O'Keefe, Moore, Giacometti, and Lipton, Still's boned figures have a specific reference. They echo Native American ancestral bones used to reconstruct lost worlds and make the dead come to life. They symbolize the mythoritualistic process of the refleshing of the bones of ancient tribal figures, in other words, the tribe's death and resurrection. The ribbed figures reflect the shaman's power to strip away the outer self and reveal the spirit forces within and are indebted to the x-ray style of Native American carvings like those of the Columbia River tribes near Pullman and Spokane, Washington (fig. 33).

Both the x-ray images and the rising of old bones refer to the shamanistic ceremony of transformation or rebirth from bones. In native American myth, bones contain the

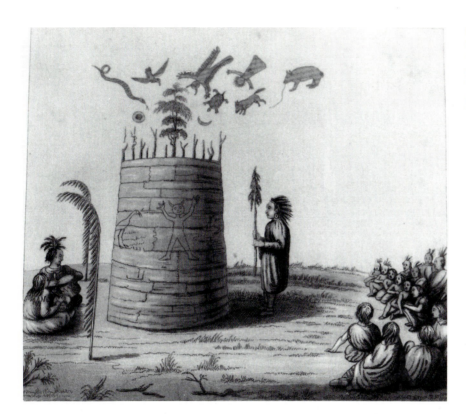

Figure 32. J. C. Tidall, Ojibwa Lodge, in Henry R. Schoolcraft, *Information Respecting the History, Condition, and Prospects of the Indian Tribes of the United States*, Bureau of Indian Affairs, (Philadelphia: Lippincott, Grambo, 1853), volume 5, part 1, p. 428.

spirits of slain animals. When they rise from the earth, as in figure 29h, they will eventually reclothe themselves with flesh.[17] Lipton was on a similar track when he wrote in 1947:

I have been finding the paleozoic in man. The dinosaur and its bones have come alive to me. The bud, the core, the spring, the darkness of the earth, the deep animal fountainhead of man's forces are what interest me most, as the main genesis of artistic substance. The old bones are moving again in a new body, a new organism.[18]

Martha Graham expressed the idea in her use of Noguchi bone sets and in her writing: "I hear them as they grow, bones of a new age on earth."[19] Like his generation, Still explored *interior* sources for human roots and through them attempted to give birth to ancient powers as part of the ritual life-and-death cycle of the shaman, the leader of his tribe.

Still often used references to shamanistic ceremonies and song as fundamental signs, as in *1943–J* (fig. 34). Here the use of a feathered staff signifies the presence of bird spirits and the shaman's ability to communicate with the spirit world. Such a staff is standing outside the tent that is shaking in figure 32. The figure also has multiple eyes, a common symbol of the great power of deities, as evidenced in this Alaskan shaman song:

My whole body is covered with eyes:
Behold it! be without fear!
I see all around.[20]

In *1945–K* (fig. 35), the trunklike figure with the branch or magic line at the left stands near a long clublike form with several teeth. This object resembles sacred drumsticks such as those recorded in the mnemonic script of shaman ceremony (fig. 30 third line, first and second forms). (The name "shaman" itself is a variant of the Eskimo word for drummer and drums are fundamental instruments of magic by virtue of which the shaman is able to communicate with and animate the spirits.)[21] The teeth and the notched forms many have been used to perform spirit flight. Asian shamans often went to the sky, an action symbolized by climbing a ladder or notched poles. Still often used the notched forms as the basis of his formal structures. They became for him as well steps to the gaining of greater spirit power.

Additional themes from Native American culture lie behind Still's attempt to recapture the primitive past. They form the basis of his pre-1947 figurative imagery. To create primitive man's consciousness of his relation to the world, Still used his concepts of life, his symbolic knowledge of the world—myth and ceremony—in a number of early paintings. Myth in general explains cosmography, the

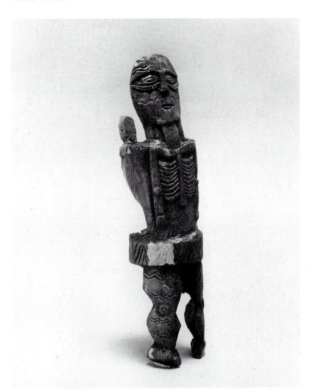

Figure 33. Female figure with child. Carved antler, Columbia River, Chinook, Sauvies Island. 18 x 5 inches. Courtesy of the Thomas Burke Memorial Washington State Museum, catalog number 2–3844. Photo: Eduardo Calderon.

relationship between man and universe, between man and nature. It explains history, society, the origin of custom, community life, and morality. It also explains the various experiences of psychic life. Myths are devices for simplifying nature, culture, and the psyche and pulling them into a comprehensible whole. For the primitive man, they are compact substitutes for a scientific theory of the cosmic and natural order of the world.

Many of Still's early works may have had mythic titles, though by the late 1940s he had removed them and they are lost to us today. The presence of mythic personages, ceremonies and subjects seems undeniable, however.[22] For instance, in *1936–7–#2* an animistic spirit appears to be merged with the trunk of a tree behind which a column of white light rises to or plunges down from the top of the picture. The spirit has large feet that seem to echo similar blunt forms found frequently in Native American art of the Great Plateau. To the right a white hand grasps a cut limb.

This painting in general represents some version of the Tree of Life myth. While tree myths are common among Native Americans in the northern and western states as representations of the shaman's ascent to the sky, Still's version can perhaps be best explained by one of the many discussed by Frazer. According to *The Golden Bough*, the

tree spirit was usually considered a god of vegetation and fertility. The spirit of the oak tree controlled thunder and lightning, and lightning was seen as the very incarnation of the divine as it cut across the heavens. By imitating or controlling the oak-tree spirit in magic rites, primitive man could control the gods, the heavens, and thus the success of his crops and his tribe.[23] Though one cannot identify the tree as an oak in Still's painting, the animistic spirit, the blackened tree, and the thrust of white light seem to fit this myth as recorded by Frazer.

Figure 34. Clyfford Still, *1943–J (PH–198)*. 69⅛ x 32¾ inches. San Francisco Museum of Modern Art. Gift of the artist.

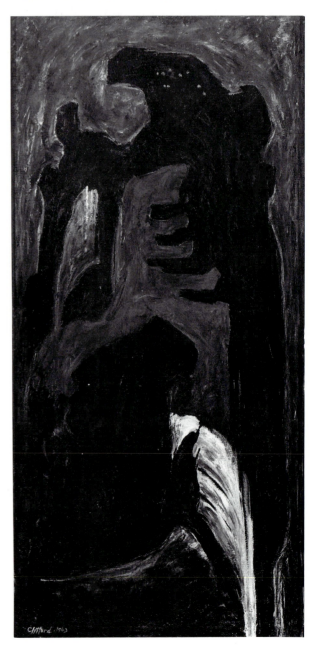

Subjects of natural and human generation are frequent in primitive and ancient myths (including that of the Grail), and symbols standing for human, animal and vegetal fertility recur in primitive art works—all those "idols," in De Kooning's famous words. In *1936–7–#2,* Still emphasizes the idea of fertility and procreation with a white (magical) hand—its exaggerated size and shape reflects many Native American representations of hands—grasping a phallus-limb on the right.

The ideas of fertility, creation, and renewal are also evident in *Untitled (PH–436)* of 1936 (fig. 36). A truncated figure (an enlargment of the bone heads of figure 29b), perhaps a phallic shape itself, grasps a disproportionately large phallic head with an equally exaggerated hand. At the right, the figure is penetrated by a white phallic shape, which is actually a continuation of the surrounding sky. (The phallic shape may be drawn from Cezanne's *The Black Clock* of 1870.) What should be a traditional background, then, is not neutral but an active fertile force. The picture represents the attempt of the primitivized figure to control primordial fertile forces, those forces responsible for all organic and human existence and growth. The image presented here is the literal grasping of the generative force.

In his use of a phallus as a symbol in *PH–436,* Still not only parallels similar images in primitive art, but also invokes the psychological idea of the phallus as a symbol of the libido and the numinous creative forces of the unconscious. Jung, fusing myth and psychology, wrote that the libido can be a generative force:

Here the libido appears very properly as an impulse of procreation, and almost in the form of an undifferentiated sexual primal libido, as energy of growth, which clearly forces the individual towards division, budding, etc.[24]

The phallus, furthermore, can represent general psychic and creative strength incarnate in humanity. For instance, Jung related the phallus to creativity and to the mythological seer or artist in particular:

The phallus is the being … which sees without eyes, which knows the future; and as symbolic representative of the universal creative power existent everywhere immortality is vindicated in it. It is always thought of as entirely independent, an idea current not only in antiquity, but also apparent in the … drawings of our children and our artists. It is a seer, an artist and a worker of wonders; therefore it should not surprise us when certain phallic characteristics are found again in the mythological seer, artist, and sorcerer.[25]

The figure in Native American and non-Western societies who most often has the role of controlling and manipulating "the universal creative power" is, of course, the shaman.

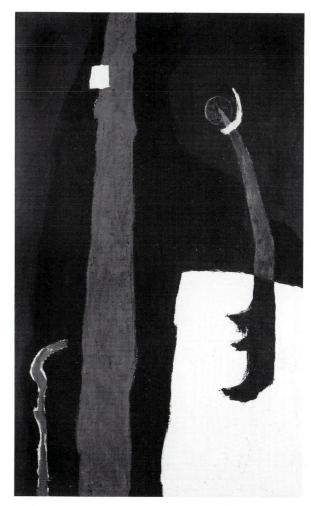

Figure 35. Clyfford Still, *1945–K.* 50 x 31 inches. Albright-Knox Art Gallery, Buffalo, New York. Gift of Clyfford Still, 1964.

Still presents another image of creative strength among Native Americans of his region in *PH–298* of 1942 (fig. 37). The work consists of a bull head and a skeletal snakelike line coursing downward and through the mouth of a mask form with a quill headband that has been shaken empty of feathers during a ceremony. The line then becomes the skeleton of the mask spirit. The buffalo bull is among the most powerful of animal spirits, and Joseph Campbell recognized the importance of the bull image in primitive cultures when, in a discussion of an image that strongly resembles Still's *PH–298,* he wrote that an earlier culture hero with a snake body and bull head carried within him from birth the spontaneous creative power of the natural world.[26]

Shamanistic and primitivistic images representing power, strength, and growth, in other words, *generating form and force,* characterize Still's early semi-figurative and later

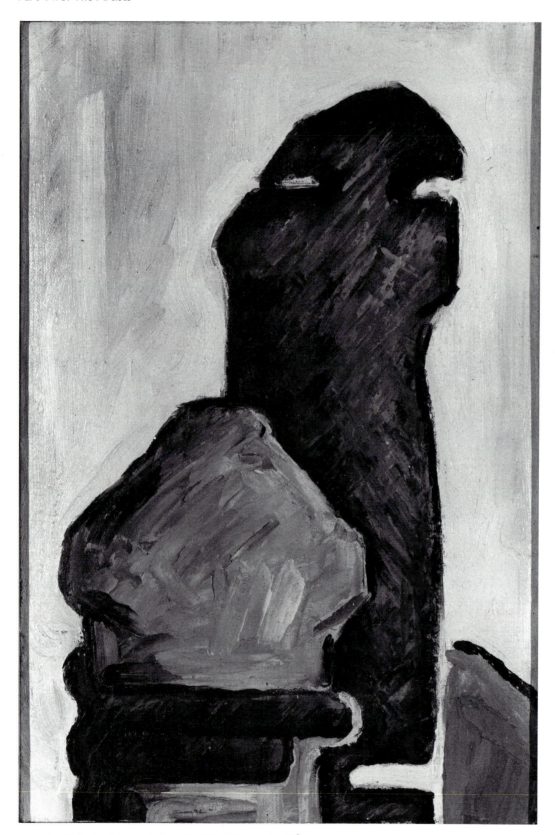

Figure 36. Clyfford Still, *Untitled (PH–436)*, 1936. Oil on burlap. 24⅞ x 16⅞ inches. San Francisco Museum of Modern Art. Gift of the artist.

abstract work. Their literal expansion can be seen in two final images. In *1938–N–#1* (*Totemic Fantasy*) (fig. 38), there is a figure with a wedge-shaped head; large, powerful, apparently dismembered hands; the ancient rebirth bone for its right shoulder; and a dramatic light and dark background. The figure appears to be a representation of the mythic Earth Mother or Father. In form the figure also resembles Mirós of the 1930s, which is not surprising since the Earth Mother was a subject of early surrealist painting, as in Andre Masson's *Woman* of 1925. It was also a frequent subject of the Abstract Expressionists and their milieu, as in the mythic egg of Newman's *Gea* of 1944, De Kooning's innumerable *Women,* and Joyce's characters, Molly Bloom and Anna Livia Plurabelle, for example. Still's image is in dark earth colors and seems to be like both stone and bone.

The Earth Mother is a primitive and mythic archetype that personifies the female principle and symbolizes the source of all life and the earth to which it returns in death. Its fundamental attributes are the capacity to give birth, nourish, and devour. Its equivalent, the masculine creative deity, is a derivation "analytically and historically psychologic, of the 'Father-Imago,'" that is, the human and divine father.[27] As female or male, the figure totemically personifies creative, healing, and destructive forces which, once placed in the theory of depth psychology, become the powers of the libido.[28]

Interestingly, a significant part of the generative principle in Still's images is the emphasis on the hands. As Jung wrote of the hand that appeared as part of an Aztec image in the dream of one of his patients: "Especial interest attaches to the hand, which is described as 'open,' and the fingers, which are described as 'large.' . . . We have seen . . . that the hand has actually a phallic, generative meaning."[29] In Still's earthy image, the hand of this figure seems to have borne immediate fruit. From its sides, brown lines grow. They seem to be primitive planting sticks or rising branches. The form creates life.

A similar figure appears in an untitled drawing of the 1940s (fig. 39). Here the planes have generally been eliminated except for a yellow "face" plane with two red dot eyes, part of a body, and a flamelike shape at the left. The figure and ground seem to be nothing but rising lines or tendrils. The hands are lines or tendrils also. The figure thus seems to be enveloped in growing branches. The image is one of almost total generation. The flamelike form of the tendrils may also symbolize generation. *The Golden Bough* contains numerous legends and tales of primitive fire festivals in which fire promotes the growth of the crops and the welfare of man and beast.[30] In other words, fire is used by primitive man as a magical rebirth rite to stimulate the growth and renewal of vegetation and to benefit man. Fire ritual is also part of the great

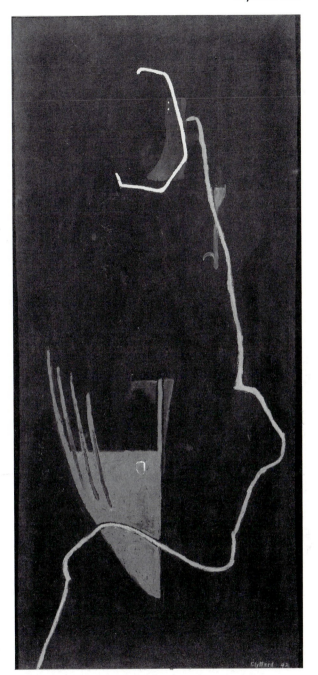

Figure 37. Clyfford Still, *Untitled (PH–298),* 1942. Oil on blue denim. $57\frac{1}{2} \times 26\frac{1}{2}$ inches. San Francisco Museum of Modern Art. Gift of the artist.

vegetation ritual, discussed by Weston and others in Still's era.

In his introduction to Still's exhibition at Peggy Guggenheim's Art of This Century gallery in 1946, Mark Rothko gives us another clue to the meaning of Still's work. Rothko quotes Still as saying that these paintings of the 1930s and 1940s are of "the Earth, the Damned, and the Recreated."

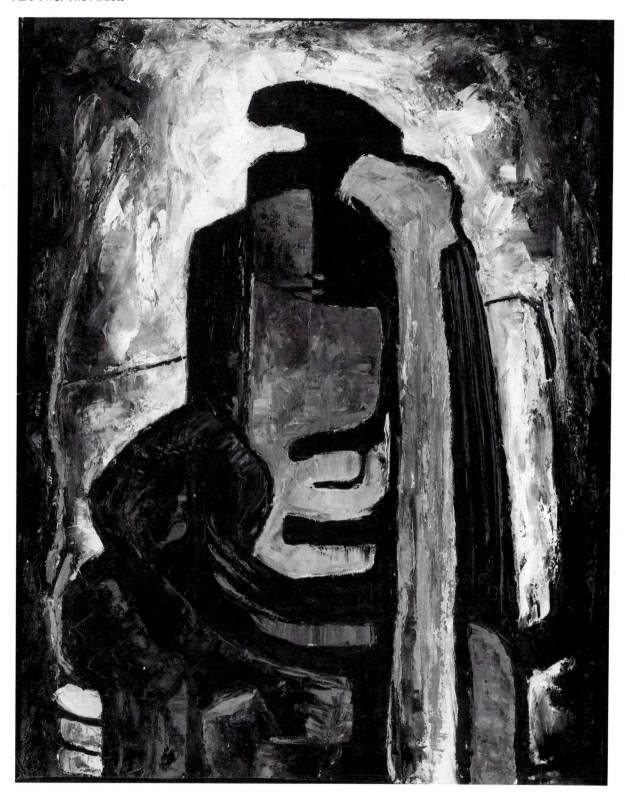

Figure **38**. Clyfford Still, *1938–N–#1 (Totemic Fantasy) (PH–206)*. 31
x 25 inches. San Francisco Museum of Modern Art. Gift of the artist.

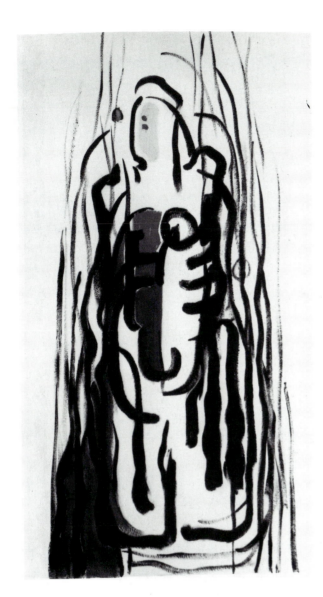

Figure 39. Clyfford Still, *Untitled*, mid-1940s. Collection of Senator Frank R. Lautenberg.

For Rothko they are an "extension" of the familiar Persephone myth, symbolizing a cyclic process of transformation—death and rebirth. This process is fundamental to Native American ceremony, shaman ritual (rebirth from bones), Jungian psychology (the spiritual transformation of the individual through a process of psychic death and rebirth), and the works of Campbell, Martha Graham, Joyce, and many others. Still has returned to the primitive and primordial past to effect that transformation in his images of magical processes, myths, ritual, archetypal figures, and generative forms.

The struggle for generation and renewal in Still's paintings forms a symbolic analogy to the struggle for inner renewal and change of cultural consciousness widespread in the 1930s. In addition to their consciousness-altering irrational imagery, many surrealists, including Arp and Miró, used organic life to symbolize human growth and change. Still's imagery and themes are firmly embedded in his own era, yet his conception is different and more American. His idea of transformation is *cultural change and renewal*. Still intends to renew himself, and thus modern culture, through his spiritual transformation effected by the rebirth of an ancient, phylogenetic culture.

The theme of spiritual transformation through cultural renewal and vice versa is shared by several Abstract Expressionists. Still's rendering of it in dark, glowering figures and crude, primitivistic landscapes is perhaps the most powerful, yet he has a unique interpretation of the idea. He has said that throughout his work, "he the artist is the image and sole source of imagery."[31] Still projected himself as the primal force and *dramatis personae* of his painting. In these early works the ideas are realized through both figurative images and formal effects. In his mature work, Still largely disposes of the more obvious figurative containers of these ideas. He realizes them in the formal construction of an emblematic or ideographic color field.

GENERATING FIGURE, GENERATING FIELD

Still's ideas reflect the broad vitalist trends of his period as a whole. The relationship of spiritual events and natural activities appeared as a theme in the work of several of the authors with whom the Abstract Expressionists were generally familiar. Still, however, had a specific concept of the integration of the human, the organic, and the natural: the *participation mystique* of primitive man's mode of thinking. (I am not arguing here that Still adopted Levy-Bruhl but that the participation mystique exemplifies a conception of a non-Western cognitive mode that was recognized and emulated by many in the period.[32] Still's knowledge of the mystique was not necessarily literary and conceptual but experiential—on the Native American reservations.) In the primitive's way of thinking, all phenomena are the result of "pre-connected" spirit-power action; the primitive individual is one force in a surrounding envelope of mystical, suprasensible forces. The primitive mentality imagines a continuum, "an unstable ensemble of mystic actions and reactions, of which persons, things, phenomena, are but the vehicles and manifestations."[33]

The development of Still's abstract art seems to represent these concepts of primitive man's view of the world. Still's abstract art originates in the idea of the relationship of the primitive individual to his internal and external physical and psychic world and reveals the absorption or participation of the individual in the ground, in spirit-nature. Nature's growth and individual growth become one and the same.

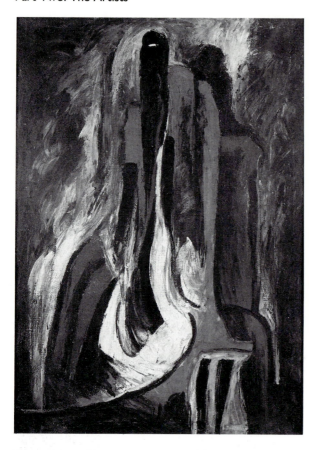

Figure 40. Clyfford Still, *1937–8–A*. 47 x 33½ inches. Albright-Knox Art Gallery, Buffalo, New York. Gift of Clyfford Still, 1964.

An anonymous review of Still's show at the Betty Parsons Gallery in 1947 noted that Still said he was "preoccupied with the theme of the figure in the landscape, with overtones of man's struggle against and fusing with nature."[34] Still himself has written, though the date he gives is premature:

By 1941, space and the figure in my canvases had been resolved into a total psychic entity, freeing me from the limitations of each, yet fusing into an instrument bounded only by the limits of my energy and intuition. My feeling of freedom was now absolute and infinitely exhilarating.[35]

In discussing formal elements, he proposed a similar idea:

I never wanted color to be color. I never wanted texture to be texture, or images to become shapes. I wanted them all to fuse into a living spirit.[36]

In Still's mature paintings, the idea of fusion or participation of the individual in nature and its larger spiritual forces is reflected in the relationship of figure to ground. The formal elements portray the emblematic struggle of man, mind, nature, and spirit power. Deities and totems of powerful growth are represented abstractly.

Still's abstract art developed through three different approaches we will examine: the multiplication of human, organic, and earth forms and totems; the expansion of the figure to the point where it constitutes the entire image; and the reduction of the figure, first to a schematic skeletal form and dot eye and then to its dispersal in a field of naturalistic forms and forces.

The first approach, the multiplication of figurative and organic forms and planes can be seen in *1936–7–#2* and in *1937–8–A* (fig. 40), where totemic shapes are differentiated by hue as well as contour. Light planes are interspersed with dark ones as they take on a strong vertical orientation. At the top of the central vertical is a barlike stroke denoting an eye, while at the bottom right is a stonelike hand. The figure and its spreading planes and forms present a dramatic, ominous appearance. The result of this expansion, multiplication, and interspersal is that figure and ground, bone and sinew, human and landscape, and natural and spirit force merge.

In *1945–H* (*The Grail* [?]), Still has given the forms and planes the same rough edge and value. He eliminates shading and extends the forms to the edge of the picture, so that organic shape and background landscape space alternate laterally across a more unified surface. The figure-on-ground arrangement of earlier works is no longer present. At the same time, the fingered hand becomes a claw and the familiar figures, narrow at the top (echoing Native American drumsticks) and broad below, are turned in profile. The totemic figure at the left seems to consist only of a long body, an eye, and a claw seemingly drawn from Tlingit ceremonial clubs (fig. 41). At the right, several brown and white vertical force lines emerge from the notched figure shape. A more rectangular, notched claw form is at the top center, and yellow and red dot eyes scatter at its left on what seems to be mere background.

In *1946–L* (fig. 42), the dispersal of human shape, natural form, and spirit force is even greater. The painting consists of thickly painted, rough-edged shapes mixed with one another across the surface. The claw shape in black (reminiscent of the earlier sacred drumsticks) and a white, seemingly bearded, moon crescent head with two red eyes seem to be just simple shapes among many others in a sky and landscape painting. In *1949–M* (fig. 43) differences are defined by hues and texture among the planes and space. This is a mature abstract color-field painting of crude graphic power.

Still's abstract work consists of almost nothing but large color shapes and areas of thick paint laid down with trowels and palette knives as well as brushes. Figure and ground totems have become roughly handled matter that manifests a dark, glowering power. The pictures are, in one sense, metaphoric visualizations of primitive man's world of terrifying nature and its deities, of the all-

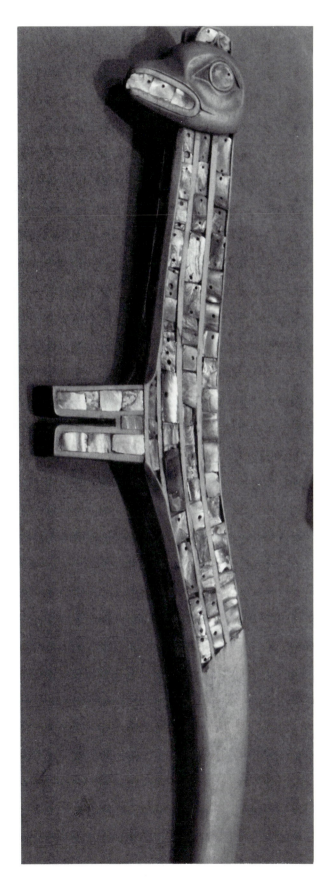

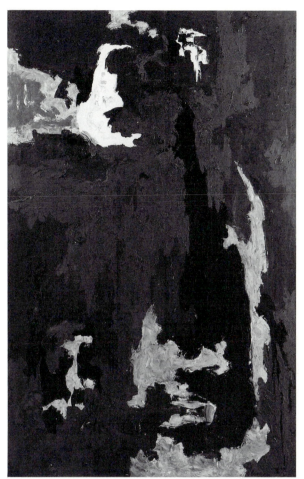

Figure 42. Clyfford Still, *1946–L.* 71 x 45½ inches. Albright-Knox Art Gallery, Buffalo, New York. Gift of Clyfford Still, 1964.

encompassing dangers and forces of the primordial world. Still's original color-field style is characterized by the fusion and expansion of human and natural spirit powers.

In the second approach, the expanded figure shape is identified with and transformed into an entire field. The figure *becomes* the field, and the field inherits the psychic and creative force of the figure. *1938–N–#1* (*Totemic Fantasy*) and *1943–J* both contain dark figures against lighter grounds. In *1943–J*, however, the wedge-headed figure is more vertical and extends almost to the four edges of the canvas. The surrounding white space that appeared in *1938–N–#1* is eliminated and the background is closer in value and color (dark green) to the brown and black figure. Differences between figure and natural ground are thus reduced. The figure itself is simpler and contains fewer elements than *1938–N–#1*.

Figure 41. Tlingit Ceremonial Club. Courtesy Heye Foundation, Museum of the American Indian. Photo: Julia V. Smith.

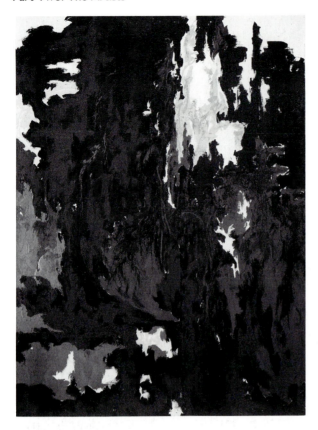

Figure 43. Clyfford Still, *1949–M*. 93 x 69½ inches. Albright-Knox Art Gallery, Buffalo, New York. Gift of Clyfford Still, 1964.

While chronologically more advanced, *1943–J* is stylistic regressive for its year, a confusion resulting from the painting's given date (or perhaps, a nonlinear evolution of Still's work). A more advanced picture in this approach is *1941–2–C* (Plate 2). Here the figure, again almost expanded to the canvas edges, is totally flattened, and independent body members are eliminated. Only two red lines, descending from the top of the figure, disrupt the flat surface. Value differences dividing the figure from the ground are minimal. At the same time, the figure grows increasingly powerful in appearance.

In *1947–8–W–#2* (fig. 44), the figure seems to disappear totally, replaced by a black field that expands almost completely to the four edges. Again red lines descend from the top. *1947–8–W–#2* is a mature color-field painting whose roots lie in Still's expanding nature figure.

A final example of this approach is *Untitled* (PH–58) of 1951 (fig. 45). The painting consists of only a black field expanded up to and, by implication, beyond the edge. Again a red line, barely perceptible in reproduction, descends from the top; a tiny red shape cuts in from the left at the bottom. The image is again totally abstract and powerful. It should be known that Still thought of the color black as "warm—and generative."[37]

The third approach to abstraction—the reduction of the figure to a schema and its dispersal in a color field—begins with works like *Untitled* (PH–298). As we saw, a single line functions simultaneously as the body of the bull buffalo with two yellow dot eyes (again barely visible in reproduction) and the skeleton of a masked creature. This figural schema will allow great expansion of the ground.

Still made important strides in this approach in 1944. In *1944–G* (fig. 46), a white line crosses from top to bottom. The red dot eye next to it at the top signifies that the line is figural; or it is perhaps a lightning streak as figure. Lightning is a symbol of fertility among many Southwest Native Americans, as it suggests rain and thus generation and fruitfulness, while for other Native Americans, it can designate a shaman's celestial origins.[38]

In a 1944 oil on paper, the vertical-line figure and dot eyes are repeated, this time with what appear to be infrahuman forms, lung shapes, and a Native American claw hand. The white area around the figure defines, negatively, Still's typical figure shape. (Like his early skeletal rib forms, in shaman myth, the revelation of interior form means the shedding of the exterior material world and the emergence of a purely spirit being. Campbell remarked that in typical adventures of the mythic hero, a connection is reestablished with the infrahuman.)[39] The background, which was a dark tone in *1944–G*, is now a bright brown-orange and of increasing importance, indicated by texture as well as color.

In the last approach, the line figure is combined with or dispersed among multiple planes, as in *January 1947* and *January 1948* (fig. 47). This results in the break-up of the schema as the dot eyes and line figures are scattered among the large and small color planes of a mature color field painting. In Still's later paintings, for example *1955–D* or *Untitled* (PH–968) (fig. 48), the figurative elements function as painterly marks, dots, lines, or shapes. They may appear to be abstract elements, simply part of the total configuration of Still's fields of large powerful shapes, but they carry a vestigial figural connotation.

Still's intention to create an image of "psychic unity" and "living spirit," of the struggle against and fusion with nature is fulfilled, as figure and ground, figure and space, matter and spirits, internal and external forces, become one and the same. Still's fields of continually flowing powerful totemic shapes can be considered spirit-power figures from primitive man's psychic-naturalistic world. They represent the forces Still is creating and against which he is struggling. The generating figure of his early work has been transformed into a vertically and laterally expanding force in a field or into the field itself, which abstractly realizes totemic growth, spirit, and power.

Formally, Still's mature work reflects his earlier interpretation of Cezanne. The qualities he attributed to Cezanne,

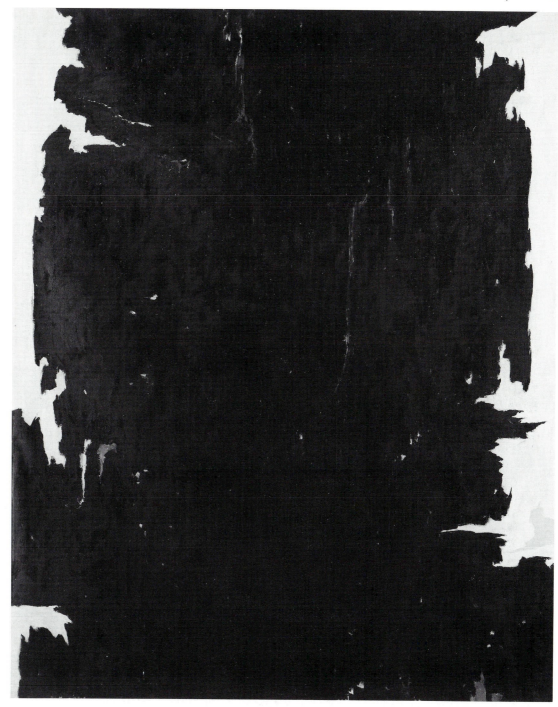

Figure 44. Clyfford Still, *1947–8–W–#2*. 108½ x 88 inches. Albright-Knox Art Gallery, Buffalo, New York. Gift of Clyfford Still, 1964.

including massively rugged and rhythmically synchronized color planes, the elimination of independent contour, the integration of form and color, the structural use of color, and the emphasis on surface unity, constitute qualities of his own work as well. Still's notched field shapes enlarge the expansiveness of Cezannean *passage*.

Still's abstract work pares down yet expands his earlier form and its powers. The color field originated in his attempt to express more fully his themes of shamanistic power and the process of spiritualization. The powerful nature shapes typical of his abstract art are the live spirit powers of his new world, and of himself. The vertical,

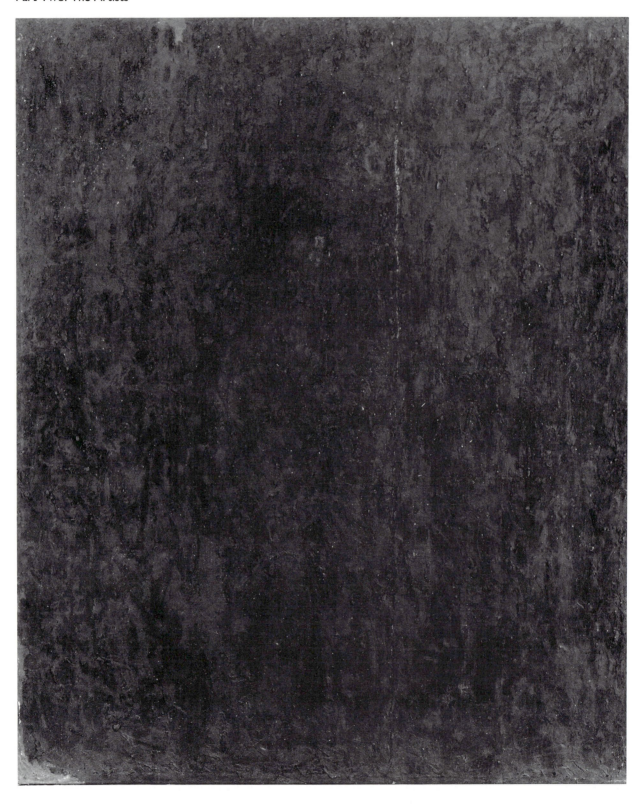

Figure 45. Clyfford Still, *Untitled (PH–58)*, 1951. 82 x 68¾ inches. San
Francisco Museum of Modern Art. Gift of the artist.

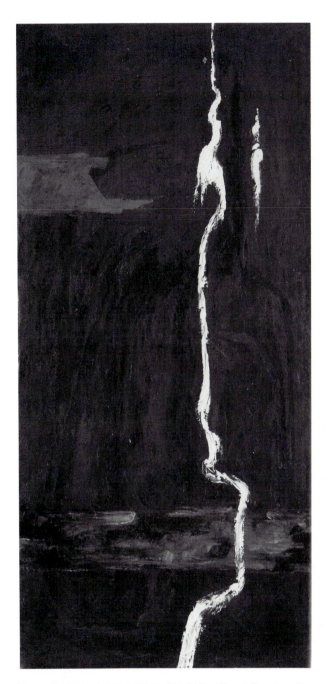

Figure 46. Clyfford Still, *1944–G (PH–204)*. 68¼ x 31⅝ inches. San Francisco Museum of Modern Art. Gift of the artist.

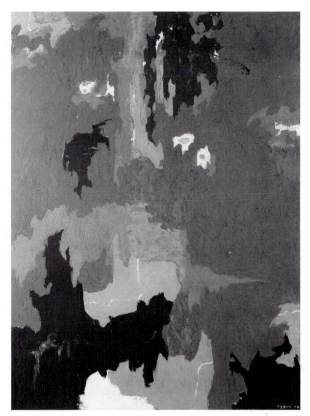

Figure 47. Clyfford Still, *January 1948*. 79 x 60 inches. Albright-Knox Art Gallery, Buffalo, New York. Gift of Clyfford Still, 1964.

elongated forms with thin, bearded heads are expansive self-portraits of the artist as an ever-growing, ever-renewing spirit power. An almost literal representation of a man's head in profile with an orange, cosmic dot eye is evident in *1950–B* (Plate 3), which Still himself described as his "head" picture.[40] Other works consist of Still as a linear, lightning force. For example, *1955–D* has an elongated totemic shape in the center and a thin line, which Still

described as the "skeletal line" to which he reduced the figure, snaking from top to bottom.[41] (Skeletal forms are part of the death and resurrection ritual of the refleshing of bones.)[42] He also called such lines "life lines," a Native American term for the life force.

Many of Still's works suggest sky and mesa-like forms. These probably represent his spirit power engaged in shamanistic magic flight in the sky. The life-line figure at the right with a snaking line and wings at the left in *Untitled (PH–282)* (fig. 49) of 1943 seems to represent one such flight. The craggy, black and white forms with the snaking line and eaglelike notched head at the top of one of his expanding totemic forms, *PH-128* of 1948 (fig. 50), represents another. The wavering line in both works echoes carvings of undulating spirits that accompany a shaman in his or her magic journey (fig. 51). Still's crusty surfaces, often in earth tones, are the materialization of nature and the aura of its forms and forces. (Still's admiration for Lucretius's *De Nature Re,* in which the world is described as a living human being, reinforced his totemism.)[43]

Partially, Still's purpose was to renew communion with the earth and sky, and their spirits, in forms symbolic of the beings and powers of nature. His paintings present a

109

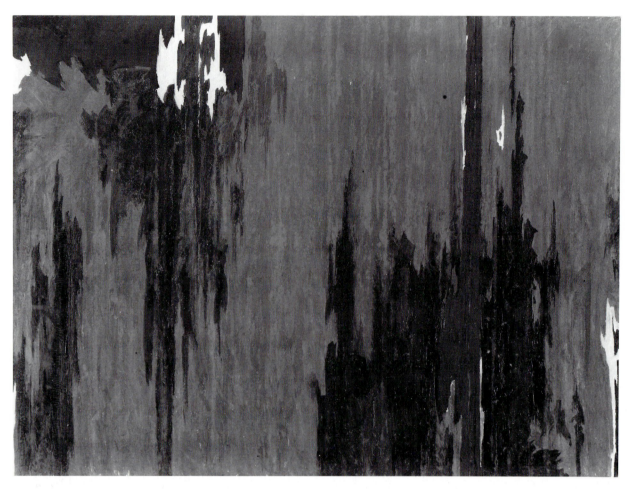

Figure 48. Clyfford Still, *Untitled (PH–968)*, 1951–52. 113⅜ x 156 inches. San Francisco Museum of Modern Art. Gift of the artist.

continuum of intensely emotional and dramatic spirit and visionary forces, images representing his struggle of becoming, the forming and reforming, the creating and recreating of what is, in the end, invisible—a new cultural entity and its powers.

Still's color fields of spirits and powers are also a metaphoric representation of his own unfettered creativity, a kind of abstract self-portrait of his creative spirit power and strength. When one critic asked him "what his main thrust had been, he answered 'self-discovery,' but he made clear that for him self-discovery was less concerned with finding out about himself than with creating himself."[44] His subject in part has been himself as self-creating asethetic subject. Still attained what he considered to be a goal of Coleridge, "the subjection of matter to spirit so as to be transformed into a symbol, in and through which the spirit reveals itself."[45] Matter was mythicized nature, which, he also wrote, became reflected, humanized, and sentient in himself.

THE TRANSFORMATIVE POWERS OF ART

In creating himself by returning to the primitive psychic past, by forming a world of spirit powers and struggle, by inventing an art of pictorial and thematic power that looks into the depths of time and culture, Still intersects with a variety of cultural themes of his era.

For example, in his effort to renew himself by returning to the psychocultural past, Still accords with a major theme in Jungian psychology as well as interwar culture. (Here as elsewhere it is not so much a question of Jung's direct influence on Still's thought, although there is evidence for that, but rather, of the intersection of Still with Jungian psychology and its interest in mythology and the primitive mind.) The key process of Jungian psychology, individuation, involves the creation of a new self—a spiritual rebirth—by integrating unconscious elements with consciousness. With such an integration, the personality is enlarged and transformed. The use of mythic archetypes,

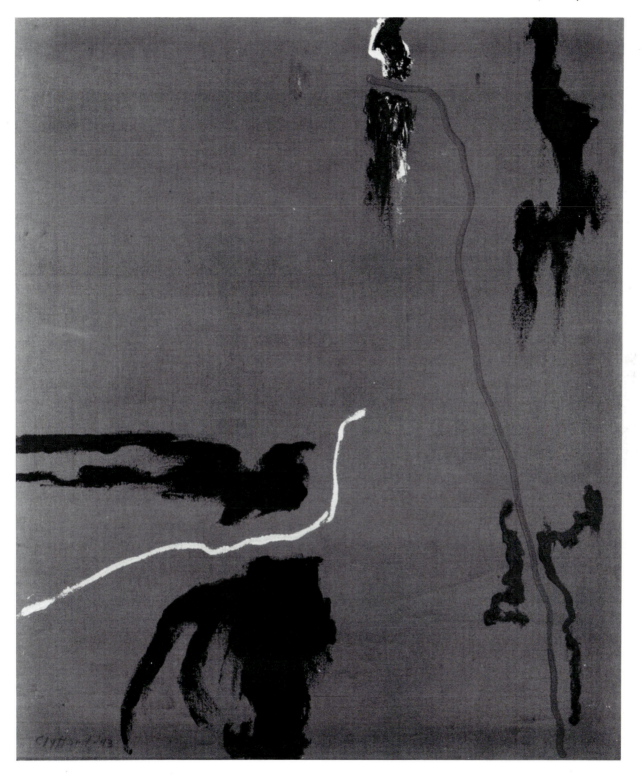

Figure 49. Clyfford Still, *Untitled (PH–282)*, 1943. Oil on cloth. $35\frac{1}{2}$ x $30\frac{1}{2}$ inches. The Metropolitan Museum of Art. Gift of Mrs. Clyfford Still, 1986. (1986.441.1)

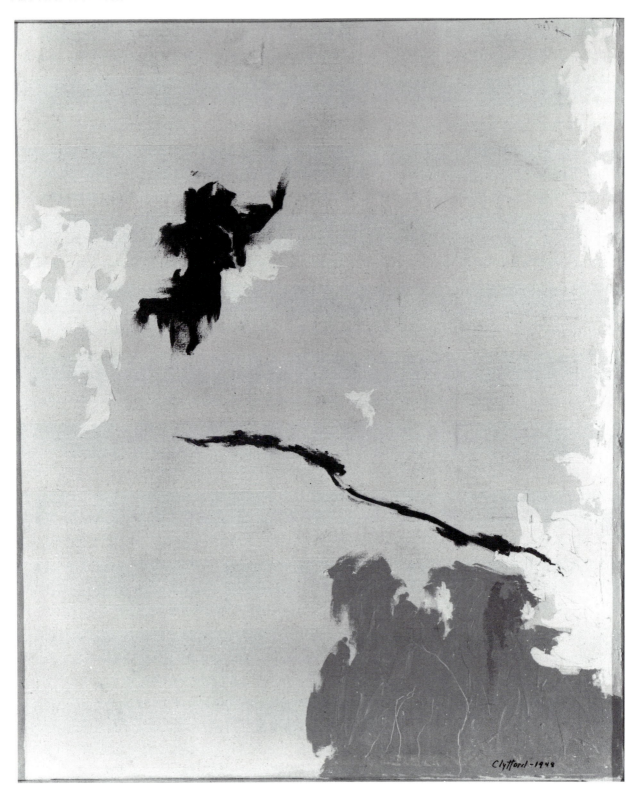

Figure 50. Clyfford Still, *Untitled (PH–128)*, 1948. 52 x 43¼ inches. San Francisco Museum of Modern Art. Gift of the artist.

Figure 51. Ivory carvings. Dorset culture, from Mansel Island, Northwest Territories, Canada. National Museums of Canada.

the desire to recapitulate the primordial past, and the emulation of primitive man's mode of thinking are parts of this process.

Still's forces are seemingly magical, both creative and destructive of conscious, rational life. Jung conceived of unconscious forces similarly:

[Man's reason] has done violence to natural forces which seek their revenge and only await the moment when the partition falls to overwhelm the conscious life with destruction. Man has been aware of this danger since the earliest times, even in the most primitive stages of culture. It was to arm himself against this threat and to heal the damage done that he developed religious and magical practices. This is why the medicine-man is also the priest; he is the saviour of the body as well as of the soul, and religions are systems of healing for psychic illness. ... Man is never helped in his suffering by what he thinks for himself, but only by revelations of a wisdom greater than his own [that is, from the ancient past of the Unconscious]. It is this which lifts him out of his distress. ... [F]rom the psychic depths which cast up the powers of destruction the rescuing forces will come also.[46]

For Jung, the figure best suited to releasing these new transforming psychic forces is the visionary artist, whose images, Jung wrote, represent:

a strange something that derives its existence from the hinterland of man's mind—that suggests the abyss of time separating us from pre-human ages, or evokes a super-human world of contrasting light and darkness. It is a primordial experience which surpasses man's understanding, and to which he is therefore in danger of succumbing. The value and the force of the experience are given by its enormity. It arises from timeless depths; it is foreign and ... many-sided, demonic and grotesque. ... [I]t bursts asunder our human standards of value and of aesthetic form. ... [T]he primordial experiences ... allow a glimpse into the unfathomed abyss of what has not yet become. Is it a vision of other worlds, or ... of the unborn generations of the future? We cannot say that it is any or none of these.

Shaping—re-shaping—
The eternal spirit's eternal pastime.[47]

Still has repeatedly asserted that he is the sole subject of his work. He has even stated that "all of his work was one subject."[48] It can thus be assumed that Still's total oeuvre, including his abstractions with vestigial figurative elements, are representations of the role Still has conceived for himself. He, a visionary artist, creates images of these new, primordial psycho-cultural forces that will liberate man.

For Still, the viewer, in order to grasp the meaning of the work, must allow himself to be shaped as the artist was shaped, by these emerging healing and transforming forces. The viewer of Still's art must see that the artist has, as Jung wrote, "penetrated to that matrix of life in which all men are embedded, which imparts a common rhythm to all human existence, and allows the individual to communicate his feeling and his striving to mankind as a whole."[49] For Jung, and for Still, the "secret of artistic creation and of the effectiveness of art is to be found in a return to the state of *participation mystique*."[50] In other words, the viewer must at least sympathize with, and ideally be affected and perhaps transformed by, the images of struggle and renewal.

To evoke this response, Still drew on the theory of the sublime that he knew from his youth. Most of those qualities of the sublime in nature that Edmund Burke said created the psychological and emotional reactions of terror and astonishment are those of Still's art—obscurity; darkness; power; scale; illusions of infinity, successiveness, and uniformity of parts; strong, abrupt light; intense earth colors; and holistic unity. Still, then, joins an eighteenth- and nineteenth-century aesthetic doctrine with twentieth-century ideas of the primitive to create a field of powerful and transforming psychic forces.

The visionary concept of the role and power of the first artist, the sorcerer, lies at the root of Still's oracular statements on art. It informs his conception of his role as a leader of change—artistic, psychic, intellectual, and social. Still's ultimate concern was with the very *nature* and *values* of art, with the place of art in history, society, culture, and consciousness. Still's art is a symbolic incarnation of a new consciousness, new because it is so old as to be forgotten under the weight of reason, science, mechanics, and control in the modern age. Through his own experience and by creating, deliberately or not, visual parallels to current anthropological, psychological, and philosophical theories of society, Still sought to bridge the gap between artist and society, between art and life itself. Still's art, symbolizing the struggle to create a new identity, sought to establish an organic relationship between man and nature, between individual and society, and between art and consciousness. For him, as Jung said, the "upheaval of our world and the upheaval in consciousness is one and the same."[51]

More than an autobiographical statement, Still's self-creation is a "life statement."[52] Still seeks to recast his psychocultural personality. As we have seen, the identification, analysis, and possible remaking of Western cultural personality was a fundamental theme of the 1930s from Benton to Mead and Benedict. American culture as a whole sought to reweave a new blend of being from elements of the past (the "usable past"), folk behaviors, modern culture, and perhaps from other non-Western cultures. Individuals constitute those living patterns of culture, behavior, and personality, and to change the way one lived, thought, and acted was to change the larger whole. As Lewis Mumford suggests, the creation and selection of new potentialities from "inside and outside the human personality" anticipates and points toward the future.[53]

Still wrote in his thesis in 1935, art is a "will" and "means" to power. These key words further illuminate his avenue of change. It is in Nietzschean thought that art is conceived as a will to power of the self-created individual. Still's art, thought, and behavior at lest from his years at Yaddo reflect his internalization of Nietzschean themes and his adaptation of them to the need for the transformation of personality. Still addresses the crisis in the West as a question of culture and personality choices.

Still adapted Nietzsche's basic conceptions to the primitivizing of his Abstract Expressionist milieu. The powerful imagery, what has been called Still's megalomania, and his mountain-top crankiness result from Still's commitment to Nietzsche's ultimate goals—the creation of a new human being who would reevaluate all values, repudiate the decadence of contemporary Western culture, life and art, and create a new future.[54]

Still's totemic expanding figures represent his conception of the Nietzschean self-generating, self-mastering, and independent natural individual. The figure is a dynamic force unto itself, perpetually becoming. It seeks to enlarge and control its interactions with others, to dominate with its own natural, not socially granted, power. This figure, with its will to power, was to lead the creative, cultural alteration of his world.

As the West moved through the catastrophes Nietzsche "anticipated,"[55] as Christianity rendered Western humanity "weak," Still, in his own words, rejected its "crypto-Christian" culture and sought to go back to the origins of the West in the primordial past.[56] Nietzsche, too, advised such a recapitulatory return: "Countless things that humanity acquired in earlier stages, but so feebly and embryonically that nobody could perceive this acquisition, suddenly emerge into the light much later—perhaps after centuries; meanwhile they have become strong and ripe."[57] Like Still, Nietzsche preferred the inheritances of our ancestors: "rare human beings of an age . . . suddenly emerging late

ghosts of past cultures and their powers . . . atavisms of a people and its *mores*."[58]

The Nietzschean enterprise is thus the Still enterprise. Both wanted a "noble" primitive type, "strong, creative men, able to take the hardships of life in their stride,"[59] whose objective measure of value was solely the quantum of enhanced and organized power and naturalistic force, who represented a superiority of an "excess of strength."[60] This individual would affirm the world with its possibilities of change. Life is defined as activity, need, doing. Human nature is willing, striving, growing, and expanding. The new morality and value will be the capacity to create, and not an adherence to prescribed mores and careerist rules. It is through competition, struggle, conflict, through the deliberate creation of enemies, that one's nature is formed or transformed. Natural instinct is sublimated into creative pursuits.

For Still, as for Nietzsche, "The essential thing remains the facility of . . . metamorphosis . . . [of] continually transforming [one]self."[61] Unlike modern culture, which both men saw as blandly stultifying life, the creative Dionysian figure affirms the good of this world, transfigures himself, and through himself, the world. Art is a means. Artists need:

intoxification . . . a feeling of plenitude and increased energy. . . . In this condition one enriches everything, out of one's own abundance: what one sees, what one desires, one sees swollen, pressing, strong, overladen with energy. The man in this condition transforms things until they mirror his power—until they are reflections of his perfection. This *compulsion* to transform into the perfect is—art.[62]

The artist is the Dionysian force of continual creation. Through creating and mastering himself, he creates the paradigm of life—a superior will, expanding, ascending not only out of immodesty but out of life as the will to power.[63]

These Nietzschean concepts lie at the base of Still's entire art and thought: his search for the ancient power of the shaman and his capacity for self-enhancement and transformation, the dramatization of his persona, and the behavioral confrontation and critique of modernity and the West. His desire for the rights and power of the individual will, for the wonder and infinity of creation, for the liberation and emancipation of the spirit were part of his attempt to build his own soul. His spirit, "thus *emancipated* . . . in the midst of the universe," in Nietzsche's words, is Dionysian.[64] In the words of a student and colleague, Still seeks to "control his own environment . . . and create his personal order."[65]

Still presented himself as the embodiment of archaic creativity. Much like Ezra Pound, he sought to become an ancient living being in the midst of the twentieth century.

Like Martha Graham, he defined the artist as a vehicle of rebirth.[66] But more than the other Abstract Expressionists, he emphasized individual creativity and not the collective creative tradition of mankind. Indeed, it may not even be a question of becoming an individual but of men simply living a new way. Only a few emancipated people could do that. But like the others, Still saw himself and his art, his ethics and aesthetics, as the conscience of humanity. That he adopted a role of singularity from the 1930s onward was extraordinary in its anticipation of the existential quest for self-responsibility and personal growth that emerged in the 1950s as the creative response to the collective murder of World War II and the Stalinist state. Still already saw growth and the enhancement of human life as possible without the "correct" political solution, before the struggle among these solutions on the battlefield of World War II.

Still would like to be understood as an ancient nature spirit of power, plenitude, and fullness, staring down at the spectator from the heights. Through the historical crisis and the needs of the day, Still believed he represented what Nietzsche calls:

the higher man, the higher soul, the higher duty, the higher responsibility, creative fullness of power and master—today being noble, wanting to be by oneself, the ability to be different, independence and the need for self-responsibility [which] pertains to the concept "greatness"; . . . the philosopher will betray something of his idea when he asserts: "He shall be the greatest who can be most solitary, the most concealed, the most divergent, the man beyond good and evil, the master of his virtues, the superabundant of will; this shall be called greatness: the ability to be as manifold as whole, as vast as full."[67]

Still appears as part of a character in the novel *The Polar Star* by his friend Holger Cahill that tells the story of a wartime return to the ancestral cultures of China. Still is the one "who sways others by turning his face to the south in the way of the Great Shun, who simply by remaining in his place, like the Polar Star, draws all the constellations around him."[68]

THE CULTURAL MOLOCH

It is now possible to understand Still's overbaked rejections of modern art and the culture that produced it in his monotonous repudiations of what he called the Cultural Moloch.[69] With both his behavior and his principles, he confronted the powers of his time with his Superman personality.

Still claimed he repudiated "taste-makers," whether artistic, political, architectural or critical, and their power and dogma: "I hold that unless a man's art gives him the strength to deny the value of social power for the real

security of his inner comprehension he is on a devil's path to frustration."[70] He repudiated European thought from Hegel and Kierkegaard to Croce and now Cezanne.[71] The claims of science and his own time, he stated, had no hold on him: "I'm not interested in illustrating my time. A man's 'time' limits him, it does not *truly* liberate him. Our age—it is of science—of mechanism—of power and death. I see no point in adding to its mammoth arrogance the compliment of graphic homage."[72] Still also believed he rejected European art and art history from antiquity to cubism and surrealism, which he felt had "failed to emancipate":[73] "I felt it necessary to evolve entirely new concepts (of form and space and painting) and postulate them in an instrument that could continue to shake itself free from dialectical perversions. The dominant ones, cubism and expressionism, only reflected the attitudes of power or spiritual debasement of the individual."[74] Still felt that the history of art forced the artist into an accepted and controlled evolutionary path; his true freedom was thus taken away.

Still saw the Cultural Moloch as an authoritarian entity that subjugated the artist and his work to its commercial, capitalist, commodity-based uses and values.[75] This was the motivation behind Still's refusal, for the most part, to sell or exhibit except on his own terms. He even threw collectors out of his house. In this view, Still agreed with Herbert Read's still Marxist characterization of culture as a rarefied, expensive object for the adornment of the homes of the rich. For Read and Still, the best art was socially formative and prophetic and not a pleasant, prestigious object for trade.

Still sought to identify himself and freedom with his paintings: "painting must be an extension of the man, of his blood, a confrontation with himself. Only thus can a valid instrument of individual freedom be created."[76] As an instrument of freedom, Still's paintings had to repudiate modern European styles of art—Fauvist color and touch, cubist small balanced relationships, "Bauhaus stability," and control within the edge.[77] Still apparently saw these styles and stylistic elements as rife with social implications—passivity, pleasantness, control, and orderliness—that he had to reject.

If Still was to create forces of transformation and renewal for himself, for art, and for society, his paintings had to renew the spirit by, in Still's words, "liberating" it: "elements of my paintings, ineluctably co-ordinated, confirmed for me the liberation of the spirit."[78] The series of irregular, immensely powerful shapes extending across every picture were thus conceived as forces of liberation, of revelation conjured up by the artist in the struggle for life. Still claimed his paintings were metaphysical gestures; that they were, as he described them, an "Act, intrinsic and absolute,"[79] with power to shape existence and con-

sciousness, power even for "life and death."[80] His art was an instrument for cutting through cultural opiates.[81]

Nietzsche, anticipating today's emphases on linguistic structures, considered language an expression of valuations, of particular interpretations of the world which he rejected. Language fixes conventional thought, popular ideas, and common psychology. It ignores individual differences. Truth becomes fixed: "a uniformly valid and binding designation of things is invented" and the governance of language gives the laws of truth.[82] Language then falsely classifies and evaluates.

Still adopted Nietzsche's suspicion of language and used it to explain his contempt for most verbal discourse and art criticism. He, of course, refused to use titles and to appear in group shows or even to be part of the "myth" of art history because individuality disappeared in general preconceptions. He had a Nietzschean abhorrence of interpretation that buttressed the bohemian contempt of artists of critics. Nietzsche wrote, for example, that the French Revolution had been so "interpreted" that the text disappeared beneath the interpretation.[83] Similarly, Still defended Nietzsche against interpretation when a new book appeared: "So the scholar makes his contribution to the mass of murderous knowledge and the creator is supplanted by the pedant and all his work negated or hidden from those who might have some desire to experience it."[84] By the very force of his paintings, Still wanted the viewer similarly to confront his own being, consciousness, and culture, and rethink their implications.

By recapitulating what were thought to be man's origins, Still, like all Absract Expressionists, sought to enhance mankind's future. While no doubt personal in conception, Still's is a *mythic transformative* art, attempting to engage the social and psychic problems of the era through images and themes of ancient individual development. What is personal for Still is a paradigm for society at large: the individual must undergo a psychocultural transformation. His art, again in accord with Read, Jung, and many of his era, related individual consciousness to group consciousness through the means of mutual regeneration.

Although he believed that he was a total original behol-

den to no one, Still, of course, was firmly rooted in his time for both his general principles and for many of the specifics. He rejected modernity and the technological utopias of the 1930s, and drew upon well-known anti-modern conceptions from primitivism to Nietzsche. His art and thought were the products of an individual personality concerned with power and authority as well as the new, and he sought out those aspects of his era that most strongly emphasized them.

Yet however circumscribed, his art and particular conceptual variants are original in form and in the fervent use of Native American ritual. Like thirties American art with its search for "usable past," Still stepped back into the origins of culture to begin anew. If it was not really possible to become an ancient figure in a modern society, Still's art and thought nevertheless participated in the attempt to revivify modern life by broadening it to include a newly found and appreciated past. And through his very incarnation of contention, struggle, and the increase of a man's power and restoration of his force, Still sought to expand the present choices of cultural being and personality. The goal of life is not the accumulation of knowledge but the creation of new moral values, not "truth" but something else: growth, power, and life. Though unrealistic and, in the wrong hands, dangerous, Still's program was optimistic. His art was the first with the Abstract Expressionist theme of the psychic alteration of modern culture through the presentation of the personality of the "other." With his own image and behavior as the human symbol, Still presented his cultural alternative, his enhancing new "personality writ large."

In contrast to Still, the following four artists do not confront the crisis in the West by confronting themselves but by engaging the power and effects of the Second World War. Navigating through their era, Rothko, Gottlieb, Newman, and Baziotes develop an allegorical and epic art of primal strife, struggle, and triumph that forms perhaps the central stream of Abstract Expressionism.

MARK ROTHKO

"In My Beginning Is My End"

We are the skilled, the masterful, we the great fulfillers, memories of grief, we awesome spirits stern, unappeasable to men, disgraced, degraded . . . banished far from god to sunless, torchlit dusk, we drive men through their rugged passage, blinded dead and those who see by day. And so it holds, our ancient power still holds. . . .

Aeschylus, *The Eumenides*

Mark Rothko's abstract art, consisting of a few softly modulated rectangles of color seeming to float above one another on a colored ground, has proved baffling to observers. The absence of any recognizable figures, the pictures' silence (a favorite word for describing Rothko), and Rothko's own reticence have made his art difficult to interpret. But Rothko's art is anything but silent, for it bears witness to the history that many of his generation considered to be eternal fate. His art represents a modern pessimistic view of that fate.

Rothko understood his artistic enterprise as a philosophic one. He declared that painting is a "means of philosophic thought" and more than mere visual reactions or sensations.[1] He differentiated his art from mainstream School of Paris art, especially that of Picasso, for this reason. He criticized Picasso's work for not expressing "any very deep or esoteric philosophy," for being purely physical, concerning itself with mostly sensuous color, form, and design, which it did not transcend. In contrast, he once advised young artists that, while it was important to master the skills of painting, it was equally if not more important to formulate a personal philosophy of painting by getting some "general understanding of psychology, philosophy, physics, literature, the other arts, and the writings of mystics." Though in his treatment of Picasso he oversimplified, Rothko nonetheless made it clear that his

own art was one of ideas and not merely of sensuous form and color. In this, he is typical of the Abstract Expressionists, and, indeed, of many artists and critics of his era from Read, who called his criticism philosophic, to Newman and Imbram Lassaw, who publically called their painting and sculpture the same.

HERITAGE

Mark Rothko was a mostly self-taught artist. Although he studied with Max Weber, the early American modernist, at the Art Students League in 1925 and remained a member of the League until 1929, he seems not to have undergone a vigorous artistic training. He learned on his own through friends, especially Milton Avery, whom he and Gottlieb came to know in the late 1920s. In this period he painted large, generous Picassoid nudes and bathers in a watercolor style derived from Avery, who was to remain an influence and friend for the rest of his life. Similarly, he absorbed John Marin's style of framed, painterly watercolors. Rothko thus began his career indebted to several of the first generation of American modernist artists who have never gotten their due as teachers of modern precepts to the Abstract Expressionists.

Rothko's art from the very first posits a view that the individual is a product of his or her mental environment and heritage. Widespread in American art and thought of the 1930s, this belief could be found in artists such as Thomas Hart Benton and Grant Wood, whose ideas and forms deliberately tried to reflect American habits, customs, and traditions. It even appeared in artists like Stuart

Davis, quoted in chapter 1, to whom modern art reflected the American "mental as well as the ordinary material environment."

Rothko combined this environmental determinism with a search for primitive or, better yet, archaic roots and patterns. He was thus in accord with contemporary descriptions of modernism that emphasized its traditional sources. As Sheldon Cheney wrote: "The Moderns, indeed, go to man's past reverently. They recognize the life of the ages as soil from which contemporary art takes nourishment."[2] For Cheney, the moderns had to step back into the past in order to go forward. In a similar vein, James Johnson Sweeney wrote, in *Plastic Redirections in 20th Century Painting*, "It was realized that a new epoch could grow only out of a new archaism. The surface soil had become exhausted. It had to be turned deeply and completely to produce anything young in vigor or sap."[3] Like these writers and artists, Rothko recognized that an individual's or a society's formative environment was that of the mental and cultural past. Unlike the majority of the thirties artists, however, Rothko saw the mental and cultural past and its heir, modern life, as deriving not only from an American version of a universal Renaissance tradition, but from the ancient, particularly Greco-Roman, heritage of the West.

The coming of World War II had led to a new level of introspection among American artists, just as the Depression had led to the cultural introspection of the 1930s. The Abstract Expressionists, of course, participated in this cultural examination. The investigation of human life and habit—tradition—of American art of the 1930s became for them in the 1940s an investigation of eternal human inner history. Psychology, particularly Freudian and Jungian psychology, mythology, and surrealism became three of the tools for examining the origins of human behavior.

Rothko expressed his concurrence with the growing popularity of the notion of a collective psychology or rather, of a series of constants of human behavior, during a joint radio broadcast with Gottlieb in 1943. He declared that such a common psychology constitutes a tradition that began in antiquity and was rendered by myths. These myths and their underlying concepts expressed the primaries of human experience whatever the outward and topical differences in culture.

If our titles recall the known myths of antiquity, we have used them again because they are the eternal symbols upon which we must fall back to express basic psychological ideas. They are the symbols of man's primitive fears and motivations, no matter in which land or what time, changing only in detail but never in substance, be they Greek, Aztec, Icelandic, or Egyptian. And modern psychology finds them persisting still in our dreams, our vernacular, and our art, for all the changes in the outward conditions of life.[4]

The nature of Rothko's approach to the past, the archaic, and the antique was further clarified in 1943 in his first draft of the famous letter to *The New York Times* before it was altered by Barnett Newman and Adolph Gottlieb:

Any one familiar with the evolution of modern art knows what potent catalyzers Negro sculpture and the art of the Aegean were at its inception. Ever since this inception the most gifted men of our time, whether they seated their models in their studios, or found within themselves the models for their art, have distorted these models until they awoke the traces of their archaic prototype and it is their distortion which symbolizes the spiritual force of our time.

To say that the modern artist has been fascinated primarily by the formal relationship aspects of archaic art is, at best, a partial and misleading explanation. For any serious artist or thinker will know that a form is significant only insofar as it expresses the inherent idea. The truth is therefore that the modern artist has a spiritual kinship with the emotions which these archaic forms imprison and the myths which they represent. The public therefore which reacted so violently to the primitive brutality of this art, reacted more truly than the critic who spoke about forms and techniques. That the public resented this spiritual mirroring of itself is not difficult to understand.[5]

In this passage, Rothko stated many of his lifelong interests and commitments, including the idea of archaic art as a prototype and of modern art as archaic *trace;* the belief in form as idea and in art as a spiritual mirroring; and his sense of a spiritual and emotional kinship with earlier art and myth.[6] Rothko examined human life through the concepts of the *inwardly* archaic and traditional. As a central element of his art, Rothko painted the collective inner history of Western life. This concept indicates one of the original aspects of Abstract Expressionist art, its retrospective and traditionalist quality. In the preamble to the constitution of the Federation of Modern Painters and Sculptors, written in 1940, Rothko and another artist, probably Gottlieb, indicated their retrospective attitude by condemning art which negated the world traditions on which they felt modern art was supposed to be founded.

Rothko himself was a serious student of ancient culture. He was drawn to ancient art, particularly Greek painting and architecture, partially because of his interest in Greek religious and mythological scenes, especially of the underworld. He often visited the Near Eastern and Greco-Roman rooms of the Metropolitan Museum.[7] He drew classical architectural motifs from buildings in New York (and perhaps from the garden at the Brooklyn Museum),[8] and he copied books on ancient art and architecture in the 1920s, in order to illustrate a bible.[9] The results of those studies are perceptible in his art. The general composition of some of his important formative work from about 1938 to 1946 consists of horizontally segmented frieze bands inspired by ancient art and by Greek

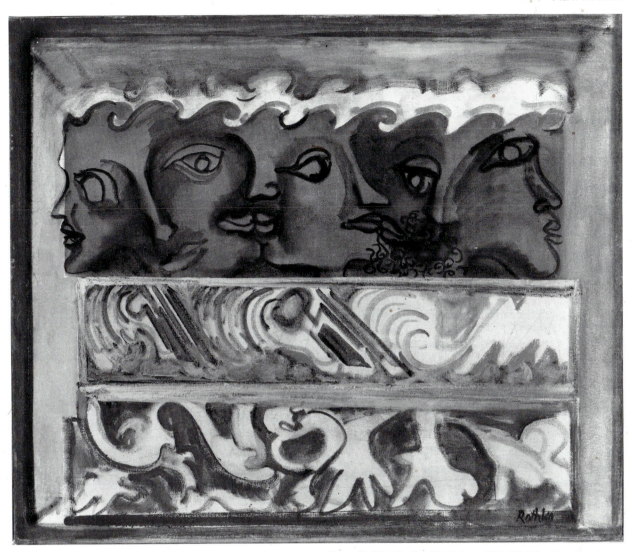

Figure 52. Mark Rothko, *Untitled*, ca. 1939–40. 29¾ x 36 inches. Courtesy of Richard E. and Jane M. Lang Collection, Medina, Washington.

vase painting, architecture, and architectural sculpture. Many works incorporate fragments, quotations, traces and ghosts of barely perceptible and recognizable ancient art, which function as evocations and signs of the past.[10] Rothko uses his ancient fragments to join the past to the present as part of a new creation and "spiritual mirror" of contemporary life.

In an early painting, *Untitled* of 1939–40 (fig. 52), Rothko portrayed as ancient heritage the unity and continuity of humanity and the roots of civilization. The painting consists of three rows of forms. The top band contains heads representative of various ancient civilizations. To the extreme right is the head of the Egyptian pharaoh Akhenaten, recognizable because of its curving chin (cf. fig. 53). The head flows left into a double Greek and Assyrian profile head with a curly beard, then into what is perhaps an Oriental head with swelling cheeks in profile, which

shares a nose with the head and elongated lips of a face with an Archaic Kouros-like smile. The profile of a warriorlike head in Corinthian helmet completes the frieze. The heads are joined by a scalloped, wavy line of hair similar to Greek decorative bands called "running dogs," many examples of which could be found in vases at the Metropolitan Museum (cf. fig. 54).

The center tier consists of fragments of classic Greek architectural decoration. In the bottom register, forms resembling ancient architectural ornaments, including acanthus leaves, signify humanity's dual roots in nature as well as Greek civilization, because they also suggest claws, tentacles, and bones. These forms thus function as signs of our past, both ancient and biological. (Similar ancient claw bones make up the roots of the figures in Rothko's later *Slow Swirl by the Edge of the Sea*.)

Rothko's *Untitled* of 1939–40 suggests a combination

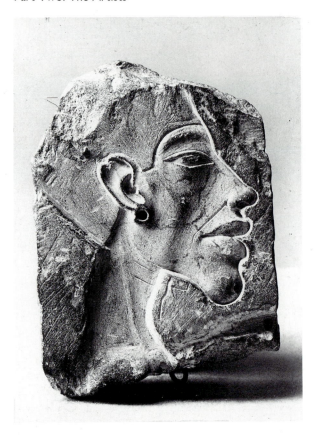

Figure 53. *Akhenaten [Amenhope IV]*, ca. 1365 B.C. Height 44 inches. State Museum, Berlin.

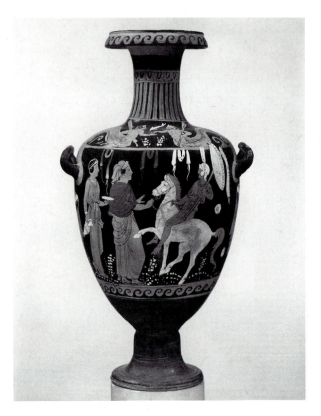

Figure 54. *Arrival of a Warrior*, fourth century B.C. Red-figured hydria, terracotta. 23½ inches. The Metropolitan Museum of Art, 1901 (01.8.12). Purchase.

of figural and architectural compositions typical of much classical and traditional art. This combination had appeared in Rothko's work in the 1930s in works such as *Untitled—Nude* of 1936–38 (fig. 55) in which a nude woman walks toward the corner of two walls and looks back over her shoulder. The walls seem to place the figure in an environment that encloses her. In the 1940s, that embracing environment of figure and architecture has become ancient and mythic, an idea that Rothko begins to symbolize by inserting ancient architectural fragments in the figural frame in *Untitled*. Rothko's paintings now symbolize the internalization of tradition.

The use of a fused figure in this and other works reflects Rothko's decision, made jointly with Gottlieb in the early 1940s, to make the human figure the centerpiece of his art. Both artists remarked that they wanted to portray the human figure but not mutilate it, an important issue given their epoch. Gottlieb and Rothko felt compelled, however, to create representations of the human figure that would address complex ideas of the fate and forces at work on humanity. Their work would have to

be both figurative and conceptual. For this, the conventional whole human shape was simply inadequate. What was needed was a composite form. Gottlieb decided on the partially Renaissance-inspired pictograph structure in which in a series of compartments he placed parts of human forms, objects, and shapes and signs evocative of primitive and ancient forms among others. Rothko experimented in at least one painting with a similar compositional scheme in which compartments are filled by Crucifixion fragments with Greek/Christ heads (fig. 56) but his primary solution was the architectonic frieze figure form we have just seen. Such a totemic composition allowed him to suggest the human frame—head on top, feet below—but to integrate and layer his concepts of the roots and sources of its human nature.

Rothko's figures, then, are not really figures in any conventional sense. They are not single beings but complexes: varied, dynamic forms and shapes, ancient traces and fragments, conceptual signs, and philosophical or cultural symbols. Figural appearance or form does not matter except as some function of attribute or sign. Rothko's

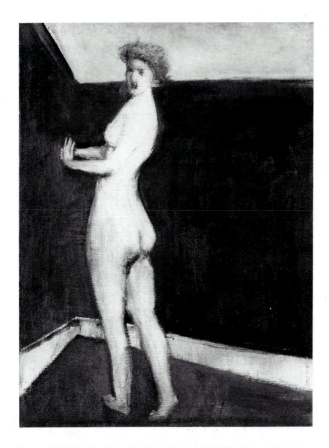

Figure 55. Mark Rothko, *Untitled–Nude*, 1936–38. 24 x 18 inches. National Gallery of Art, Washington, D.C. Gift of the Mark Rothko Foundation. (1986.43.115) Photo: Quesada/Burke.

work, like most Abstract Expressionist art even at this stage, consists of personifications of concepts and not forms drawn from everyday life or objects.

TRAGIC MYTH

Greek literature was a natural source for Rothko. His early art includes signs and symbols of scenes and characters taken from ancient dramas, especially the plays of Aeschylus, the first tragic poet of the West. Rothko drew on Greek literature to expand and develop his notion of environment to include a heritage and tradition of disaster. A particular source was Aeschylus's trilogy the *Orestia,* which portrays the history of the ancient Greek world as a sequence of intergenerational murders, insensate discord, perennial menace, and political, religious, and familial disaster. It depicts the conflicts and legacy of the "world war" of the Greek world, the Trojan war, and it forms a drama of extreme emotions and violent situatioins, of life and death, and of inward conflict and obligation. That

Rothko chose these themes and this source reinforces the point that Rothko's art was indeed partially rooted in the reaction to World War II and the uncertainty about humankind that prevailed among American artists of the time. Cassandra's description of the House of Atreus in *Agamemnon* could have been a description of his world: "The house that hates god, an echoing womb of guilt, kinsmen torturing kinsmen, severed heads, slaughterhouse of heroes, soil streaming blood." For Aeschylus and for many in the 1940s, "the storms of ruin live."

Rothko's interest in Aeschylus and ancient tragic drama derived, in part, from a great influence on his youthful thought, Nietzsche's *The Birth of Tragedy Out of the Spirit of Music.* Nietzsche's description of an art of tragic myth, Dionysian energies, and severe joy resulted from his valuation of Aeschylean drama. Nietzsche's assertions that art should dramatize the terror and struggles of existence must have seemed to Rothko an intellectual ratification of the terror of contemporary history. Nietzsche's own primitivization of the root cultures, history, and art of the West through his new emphasis on preclassical and pre-Socratic Aeschylean drama and his advocacy of a visionary art provided the link between the primitive and the classical that lies at the base of Rothko's art. Rothko's classicism is a Nietzschean Dionysian archaism new to twentieth-century art and thought. It reflects the modern vision of the classical world that replaced for many Wincklemann's "a calm simplicity, a noble grandeur." By archaicizing it, Rothko, through Nietzsche, modernized classicism to conform to his world.[11]

Nietzsche argued that Aeschylean tragedy and tragic myth represent universal truths that are infinite and eternal. For Nietzsche and Rothko, myth condenses and concentrates the tragic Dionysian nature of life in symbolic form. Nietzsche wrote:

Dionysian truth takes over the entire domain of myth as the symbolism of *its* knowledge which it makes known partly in the public cult of tragedy and partly in the secret celebrations of dramatic mysteries, but always in the old mythical garb. ... Through tragedy the myth attains its most profound content, its most expressive form.

Originally a god of fertility, Dionysius became a symbol of tragic suffering. In early rites, he symbolized suffering, dismemberment, and restoration. Nietzsche pictured the Dionysian force as a kind of god and savior who could lead mankind by means of art to the redemption of suffering. In Nietzschean tragic drama and myth, Dionysius fused the individual with a larger set of values and a higher form of life than the merely individualistic. The Dionysian force, through its forms, the tragic myth and music, advanced culture and awareness.

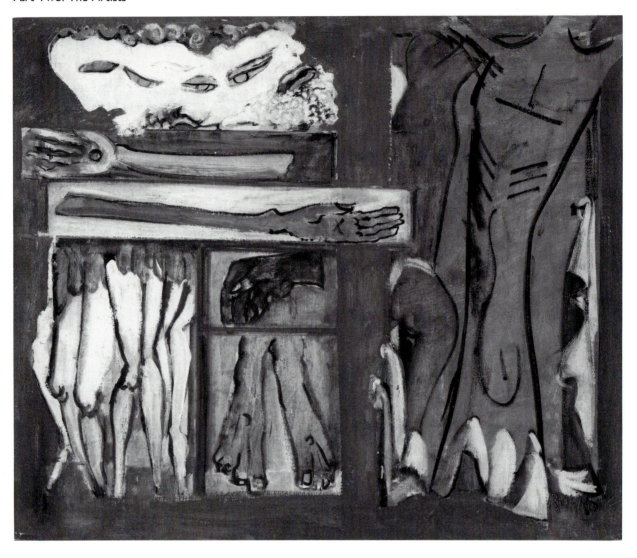

Figure 56. Mark Rothko, *Untitled*, 1941–42. 30 x 36 inches. National Gallery of Art, Washington, D.C. Gift of the Mark Rothko Foundation. (1986.43.34) Photo: Quesada/Burke.

A belief in the necessity of myth, especially the supra-personal or communal myth, underlies Rothko's art. In 1945, for example, Rothko indicated his belief that a "Myth-Making" movement had begun during the war and that Clyfford Still was part of it (although Still later chastized Rothko for including him).[12] In the catalogue to Still's 1945 exhibition at Peggy Guggenheim's Art of This Century Gallery, Rothko wrote:

Bypassing the current preoccupation with genre and the nuances of formal arrangements, Still expresses the tragic-religious drama which is generic to all Myths at all times, no matter where they occur. He is creating counterparts to replace the old mythological hybrids who have lost their pertinence in the intervening centuries.

Here Rothko states his desire to get at the central theme of all myths—much like Campbell, who, in his *The Hero with a Thousand Faces* sought the "monomyth." Campbell saw the modern mythmaker as the truly creative power whose myths reflect the course of the human spirit in all its aspirations, vicissitudes, powers, and wisdom. Rothko, seeking the pattern of human life in modern times, probably saw himself in this role.

The Omen of the Eagle of 1942 (pl. 4) is a key example of the complex of ideas with which Rothko was engaged in the early 1940s, presenting his concerns with all-encompassing myth and origins. It combines in hybrid images the past and present, the totemic primitive and the classical (the totem being a major borrowing of Rothko from both

primitive and classical sources), the artistically modern and ancient, and the mythic and tragic. Like several other Rothko works of this time, such as *The Omen* and *The Sacrifice of Iphigenia*, the subject of *The Omen of the Eagle* is taken from Greek literature. Here the source is the first play of the *Orestia, Agamemnon,* in which two eagles sweep down on a pregnant hare and devour its unborn young. This is an omen of the coming war with Troy and of the coming sacrifice of the innocent Iphigenia.

The imagery of *The Omen of the Eagle* evokes both the classical and the mythological. At the top is a series of Hellenic heads and at the bottom a corresponding set of human feet. The image of feet below a horizontal line derives from chiton-clad figures in Greek vase painting. Between the heads and feet are somewhat abstract eagle heads and (possibly Assyrian) wings, surmounting an architectural arcade echoing classical forms and receding into background space. Again a symbolic architectural environment has been internalized. Two of the arcade's columns are rounded and pendulous, suggesting nurturing breasts, while other columns end in hooks suggesting talons or tentacles.

The arcade also suggests ח or *chai,* the Hebrew sign for life. In the American surrealist magazine *VVV* (fig. 57) illustrating an article by Andre Breton, Max Ernst had dotted a nude female figure superimposed on the letter *J* with Hebrew words.[13] Although the word or sign for "life" was not among them, Rothko seems to have adopted the idea (as well as the curve of the figure and Ernst-like late-1920s forms for legs) for his painting and thus created a dualistic, dialectic symbol of both life and death—the affirmative and the negative—within the human figure.

The composite human-bird-architectural figure that comprises *The Omen of the Eagle* also represents, according to Rothko, a totemic mythic creature. In describing the work, Rothko indicated his intention to make of his figures something primitive and religious. He also declared, however, that he was *not* interested in illustrating stories but only in evoking their general spirit, meaning, and pattern:

The theme here is derived from the Agamemnon Trilogy of Aeschylus. The picture deals not with the particular anecdote, but rather with the Spirit of Myth, which is generic to all myths at all times. It involves a pantheism in which man, bird, beast and tree, the Known as well as the Knowable—merge into a single tragic idea.[14]

The figure is therefore the point of reference in this work, as in most of Rothko's work, and it is made to embody and express the complex nature of the human being. *The Omen of the Eagle* is a single-figure totem intended to represent Rothko's ideas about the phylogeny of culture and consciousness. It resembles surrealist hybrids, espe-

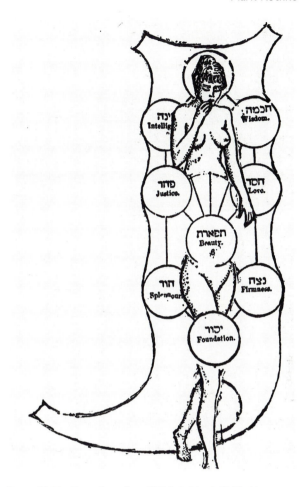

Figure 57. Max Ernst, figure from *VVV,* 2–3 (March 1943): 44.

cially those of Ernst and Miró, in its composition of dissimilar and variegated parts and spatial dimensions. However, it is distinguished from them by its allusions to the past and to mythic pattern. In some ways, Rothko's figural structure, with its simultaneity and interrelated by disjointed parts, is equivalent to T. S. Eliot's and Joyce's stream of consciousness.

STRATA OF SPACE, TIME, AND CONSCIOUSNESS

At the center of *The Omen of the Eagle* and of Rothko's art in general is the parallel between his time and the ancient world. What Dore Ashton wrote of the Abstract Expressionists seems especially pertinent to Rothko:

To commune with the great and tragic past, with the immemorial human drama, with matter and time personified, seemed to many in those early years of the war, the only respectable function of the poet and of the painter.[15]

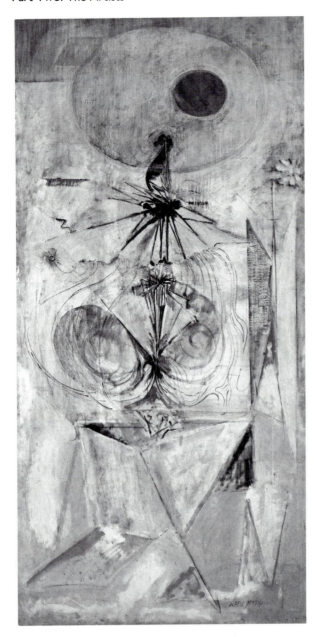

Figure 58. Mark Rothko, *Tiresias*, 1944. 79¾ x 40 inches. Estate of Mary Alice Rothko.

The fusion and continuity of the past and present was a fundamental theme of Rothko's era, in Joyce's and Eliot's writings, De Chirico's perspectives, Picasso's Neo-Classic women, Dali's *The Persistence of Memory*, and Tanguy's *The Furniture of Time*. Rothko's archaism engages the present and the future through imagery of the past. In the layering and overlapping of forms, fragments, and figures from cultural, geological, and psychological strata suggesting different times and places or spaces, through friezes of the primordial and contemporary, the human and organic,

the conscious and the unconscious, and through the creation of a transparent tracery effect suggesting ghostlike forms remembered in a dream, he suggests the common roots from which contemporary life emerged and continues to evolve. In Rothko's early work, the past is not only environment but legacy and prophecy.

Time is subject, image, and structure. For example, Rothko suggests time through the theme of divination. By referring to omens in *The Omen of the Eagle*, Rothko invokes the ancient religious practice of predicting the future course of events. In 1944, he painted *Tiresias*, the seer of Sophocles's Oedipus trilogy (fig. 58). The blind but all-seeing Tiresias is the figure who understands the story of Oedipus and Clytemnestra and, as Campbell phrases it, "he saw in his own interior darkness the destiny of Oedipus."[16] As prophet and diviner of signs, Rothko's *Tiresias* personifies the projection of space and time, memory and forecast, suggesting the simultaneous, collective nature of time. As he observed in 1949 to his friend Douglas MacAgy, "an atavistic memory, a prophetic dream, may exist side by side with the casual event of today."[17]

Rothko also evokes time as memory and survival. According to an article in the surrealist magazine *View* in 1946, modern artists were seeking the "irrational fields of the subconscious" where lay the "pre-natal memory, the survival of ancestral customs and the automatic and instinctive activity of the spirit."[18] The survival of customs and rites was a theme common to Frazer, Jung, Weston, Joyce, and Eliot, and it also informs such antimodernist works of the 1930s as Grant Wood's ancestral portrait *American Gothic* and his *Victorian Survival* (fig. 59). In his own deliberately archaic style, Wood personified American traditions, much as Rothko created totems of Western heritage.

Several works by Rothko, including *Ancestral Imprint, Dream Memory, Prehistoric Memory, Tentacles of Memory*, and *Untitled* of around 1945 (pl. 5), refer specifically to ancient memories and to the subconscious within which the memories are buried. (Rothko is thus in accord with Bergson's and Jung's definitions of the unconscious as a treasure house of memories.) In the last work, the dark bands and the image of attenuated filaments are drawn from the bands and incised lines of Greek vase paintings (fig. 60). Memory is history to Rothko—the shared experiences that bring human beings together across time and space. As Mumford suggested in 1944, the human "soul" or psyche consists of the memories that "join the past and the present . . . to retain . . . things heard long ago."[19]

Rothko repeatedly refers to the modern as a version of the past by combining surrealist with Greco-Roman imagery that becomes increasingly more abstract in sign and form in the years 1942 to 1946. He develops more

Figure 59. Grant Wood, *Victorian Survival*, 1931. 32¼ × 26½ inches. Private collection.

Figure 60. Attributed to Sophilos, *Confrontation of Two Boars*. Black-figured krater, sixth century B.C., terracotta. 19⅜ × 21⅞ inches. The Metropolitan Museum, Mr. and Mrs. Martin Fried Gift, 1977. (1977.11.2)

fugitive and abbreviated allusions to ancient art and architecture, such as slight suggestions or traces of toga folds and fluted columns, in conjunction with limited automatist experiments and surrealist biomorphism. (Despite traditional conceptions, as indicated in chapter 1, Rothko, like several of his colleagues, had limited uses for automatism.[20] If he used it at all, he seems to accord with Edward Renouf's American definition of automatism described in chapter 1 as a means of "memory and presentiment.") In *Sacrifice* of 1943 (Fig. 61), for example, he combined a Miró-like figure with the end of a fluted column and the scroll of an Ionic column turned on its side. (The Metropolitan Museum of Art has a particularly outstanding example of an Ionic column from Artemis at Sardis [fourth century B.C.] in its ancient sculpture galleries [fig. 62]; the capital and shadowed fluting may have been one source of this image.) Forms in other works (e.g. fig. 63) suggest a fantastic figure consisting of vertically stacked planes and fluted shafts—roughly derived from the same Ionic column—and volutes that evoke both architectural and human curves. In other works, tonalities allude to ancient life by echoing the ochres of Greek vases or the Aegean blues frequently associated with the sea around Greece.[21]

The faintness of Rothko's forms also suggest the past. In many of Rothko's mid-1940s works human shapes barely materialize. Forms seem to have only begun to emerge from their ground, their contours not yet fully developed or clearly defined. Formed by thin washes and watercolor, they often suggest the appearance and disappearance of a remote shape—a ghost from the past. Others of the period had similar ideas. Martha Graham wrote: "twilight—ghost/memory of past acts/memory of past experiences,"[22] and Eliot recalled in *Four Quartets*, "Time before and time after in a dim light: neither daylight ... nor darkness." Time, then, appears as a shade or even *daimon* of the past in Rothko's work.

With these parallels to ancient Greek experience, tragedy, and myth brought forth as encompassing fragments of modern being, Rothko re-presented his understanding of the nature of contemporary civilization in the 1940s. For Rothko, humanity was governed from the depths of its soul by traditions and myth. At the heart of contemporary being partially lay ancient life and identity.

Rothko's paintings thus reveal a further development of Rothko's theme of the absorption of the figure by the environment. Such an absorption suggests the continuity and fatal embrace of the past. In 1948, an anonymous critic succinctly presented Rothko's conception: "the thing he is trying to say I'm told is that forms and space are one,

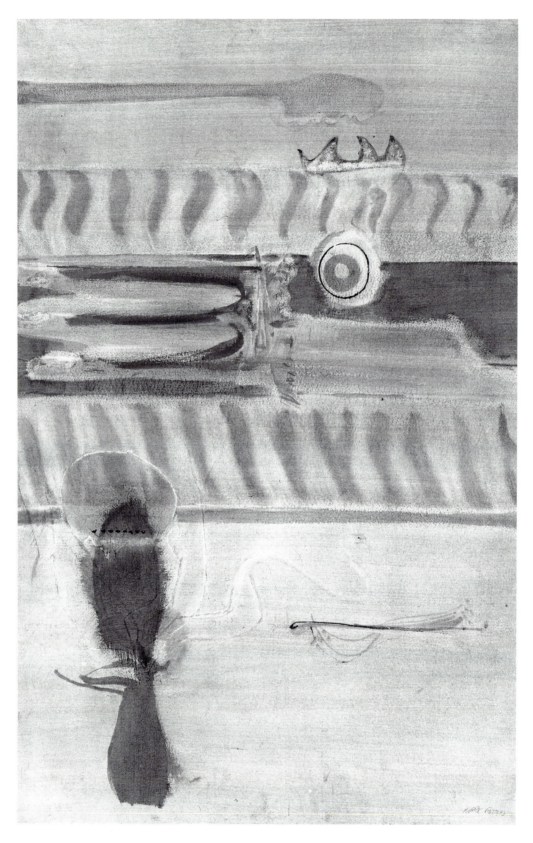

Figure 61. Mark Rothko, *Sacrifice*, 1943. Gouache on paper. 39¾ × 26 inches. The Peggy Guggenheim Collection, Venice. The Solomon R. Guggenheim Foundation. Photo: Carmelo Guadagno.

Figure 62. *Ionic Capital* from the Temple of Artemis at Sardis, fourth century B.C. Marble. The Metropolitan Museum of Art, Gift of the American Society for the Exploration of Sardis, 1926.

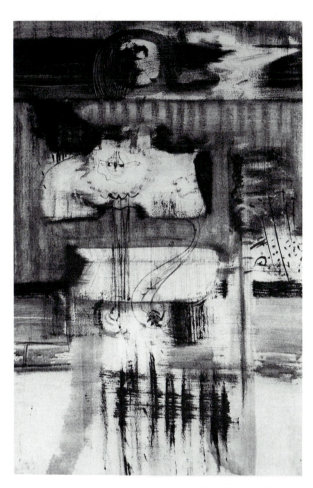

Figure 63. Mark Rothko, *Untitled*, 1945–46. 40½ x 27 inches. Watercolor on paper. © 1989 Kate Rothko Prizel and Christopher Rothko/ARS N.Y.

that there is no beginning or end of anything, that *we all are part of our environment* [my italics]."[23]

In 1944–46 Rothko began to symbolize the legacy of early civilization and human life in a new way, with a set of signs based on evolutionary biology and geological time.[24] Like many of his generation, Rothko was interested in the idea of the parallel origins of organic life and consciousness, and he developed images in which biological roots fuse with cultural and psychic roots. In *Geological Reverie* of around 1946 (fig. 64), for instance, he divided the canvas into horizontal strata differentiated by tone or color like bands of Greek vase painting. These variously colored strata are also typical of paleontological diagrams (fig. 65), another major influence on Rothko's work. Within and cutting through the strata are biomorphic shapes—birds, fish, and other elemental biological (and mythic) forms. Through the conflation of diagram and vase bands, Rothko associated primal civilization with primal earth—and with death, for in *Geological Reverie*, the bands are chalky, evoking the texture of Greek funeral vases, the *lekythos*, that were most often placed with the dead. Other works such as *Birth of Cephalopods* and *Primeval*

Landscape of 1945, evoke similar themes, although only the latter painting emphasizes stratigraphic divisions.

Rothko symbolized the depth of time with these evolutionary structures. A geological time scale invokes the forces that shaped the planet and its inhabitants throughout time and thus implies the continuation of vast epochs into the present. In this, Rothko echoes James Hutton, considered by many the father of geology, who observed in 1780 that, peering into the geologic records of the past, he could see "no vestige of a beginning, no prospects of an end." Fossils and earth strata are nature's hieroglyphs or "unconscious," giving signs of humanity's past but also making prophecies for its future. Rothko's paleontological and evolutionary pictures suggest a return to the past to find the fundamentals that underlie and foretell the present and the future. They also evoke the constant change and transmutation of all species. The drama of evolution represents human roots and civilization's eternal continuity. Rothko thus sees human life grow and perish and ebb and flow against a continuum of nature.

127

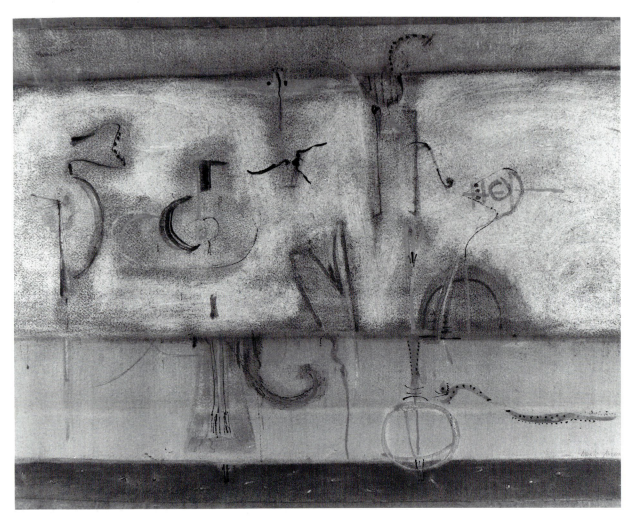

Figure 64. Mark Rothko, *Geological Reverie*, 1946. Watercolor and gouache. 21¾ x 29¾ inches. Los Angeles County Museum of Art, Gift of Mrs. Marion H. Pike.

Ancient identity is to be found within the evolution of the human mind. The origins and genesis of consciousness formed a major theme of Abstract Expressionism, and it was Rothko who issued its strongest statement. In repeated discussions in 1945 he contrasted the development of his art with previous modern art: "If previous abstractions paralleled the scientific and objective preoccupations of our times, ours are finding a pictorial equivalent for man's new knowledge and consciousness of his more complex inner self."[25] Rothko criticized cubist artists like Picasso and Leger for making the human figure mechanical, and he announced that he would "sooner confer anthropomorphic attributes upon a stone than dehumanize the slightest possibility of consciousness."[26]

Rothko's early pictures reflect his desire to seek the psychic origins of human experience—consciousness—in its ancestral and natural sources. In the letter to the *New York Times* in 1945 quoted earlier, where he discussed a relationship between his art and archaic art, he observed that "we are concerned with similar states of consciousness and relationship to the world. With such an objective we must have inevitably hit upon a parallel condition for conceiving and creating our forms." Around this time Rothko painted a work, *Conscious Genesis*, about which little is known, but whose title confirms his preoccupation with this idea.

Rothko's pictures of the ancient and primordial roots of humanity recapitulate the emergence of a primal consciousness in modern man. This recapitulatory concept was prevalent in Rothko's intellectual milieu in 1944 and was summarized by Wolfgang Paalen in *Dyn*, another contemporary surrealist magazine with which Rothko was probably familiar. Paalen wrote, "In order to pass from emotion to abstraction, man is obliged, in the maturation

Interrelationships of the different groups of fish

Millions of years ago

Eras	Periods		
CENOZOIC	Quaternary	Recent	
		Pleistocene	
	Tertiary	Pliocene	
		Miocene	
		Oligocene	
		Eocene	
		Paleocene	65
	Cretaceous		135
MESOZOIC	Jurassic		190
	Triassic		225
	Permian		280
PALEOZOIC	Pennsylvanian		300
	Mississippian		345
	Devonian		395
	Silurian		440
	Ordovician		500
	Cambrian		

Cartilaginous Fish Ray Finned Fish Lobe Finned Fish

To Land Vertebrates

Jawless Fish Placoderms BonyFish

Figure 65. Paleontological time scale: evolution of sea life. Diagram reprinted by permission of Grosset & Dunlap, Inc., from *Prehistoric Animals* by Barry Cox, © 1969 The Hamlyn Publishing Group Ltd., © 1970 by Grosset & Dunlap, Inc.

of each individual, to pass through the ancestral stratifications of thought, analogously to the evolutionary stages of the species that must be traversed in the maternal womb."[27] Significantly, Martha Graham quoted this passage in her notes for *The Dark Meadow of the Soul* of 1946, and in her notebooks she underscored the fundamental unity between humanity and natural consciousness: "This state of being one with the world is the reflection, in consciousness, of the condition of that unconscious 'Vegetative Soul' in us which is the foundation of our conscious life."[28] The subconscious also reveals the primordial mind. Jung wrote, prophetically in view of Rothko's work, "Through buried strata of the individual soul we come indirectly into possession of the living mind of the ancient culture."[29] Jung also phrased the idea in recapitulatory terms:

We spoke of the ontogenetic re-echo of the phylogenetic psychology among children, we saw that phantastic [unconscious] thinking is a characteristic of antiquity, of the child, and of the lower races; but now we know also that our modern and adult man is given over in large part to this same phantastic thinking, which enters as soon as the directed [conscious] thinking ceases.[30]

Perhaps Rothko's colleague, the sculptor David Hare, offered the best summation of the themes of myth and time common to Rothko and Abstract Expressionism. Appropriately enough, of a Greek myth he later painted, Hare said:

I use myth as a symbol, as a jumping off place. *Cronus* was part man, part earth, part time. I use him as a symbol of growth through time. Primordial mind growing into life, growing into man but always remembering its beginnings ... *Cronus*, half-man, half-time, a link between the in and the outside. Always about to venture out, always about to return. ... Making the rational appear fantastic and fantasy appear rational.[31]

CEREMONY AND RITUAL

Rothko's early work was intended to evoke the original human mind, soul, and spirit. Ancient, preclassic, or primitive mythology represents in general the cosmological and spiritual order of the world. Rothko's early art includes several references to universal anthropological rites, of which he often spoke,[32] such as sacrifice (*The Sacrifice of Iphigenia*), lamentation (*The Entombment*) (fig. 66), ceremony (*Ceremonial*), ritual (*Ritual*), trial (*Gethsemane*) (fig. 67), magic (*Vessels of Magic, Implements of Magic*), initiation (*Baptismal Scene*) (fig. 68), and totemism (*Totem Sign*). In these works Rothko expresses his kinship with the past and with man's ritual attempts to govern life and the journey of the spirit. In the 1940s, mytho-ritual is one, if not the most important, subject and theme of Abstract Expressionism. It distinguished Abstract Expressionism from surrealism and most other art of the period.

Anthropologists call religious practices "ritual." Like mythology, rituals celebrate or commemorate intangible transhuman powers which are considered the fundamental causes of natural and cultural phenomena.[33] Weston and Frazer, of course, described such ceremonies in great detail. For Frazer, many of these ceremonies represent an exchange of life and souls between a man and his totem and ceremonial deaths and rebirths to guarantee the reproductive energies and renewal of the tribe. Rituals and ceremonies often include rites of passage and enact the law of perpetual regeneration. Primitive ceremonies could be cyclic, accompanying and assuring the changes of the year, season, or months, and would thus define stages in a perpetual transition "with rhythmic periods of quiescence and heightened activity.[34] While generally represented by nature symbols, ritual regeneration expressed more than mere natural or physical regeneration; it ex-

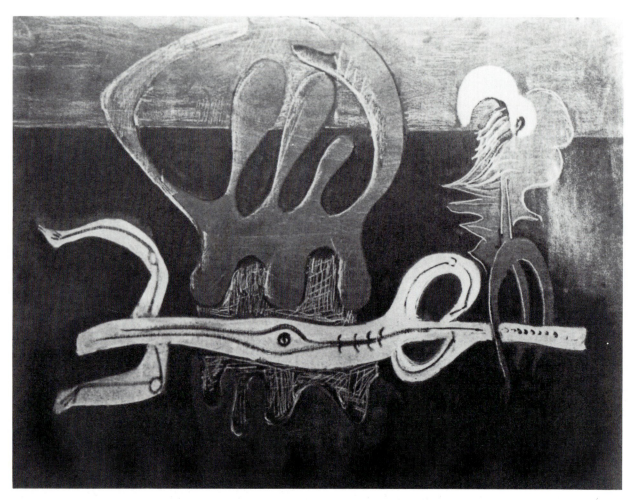

Figure 66. Mark Rothko, *The Entombment*, ca. 1946. 23 x 40 inches. Collection Herbert Ferber.

pressed a spiritual/religious one as well. As Weston wrote, the Grail story, for example, fuses nature ritual with spiritual quest, pagan deities of vegetation with Christ.

Ritual could also represent a mytho-psychic change. Pagan rites set the pattern of psychic growth in premodern times. Independently or as rites of passage, they were the original means of growth and development. Ritual was often a means of demonstrating one's newly acquired powers, say as a warrior, or advancing to the next stage of life, as in puberty ceremonies.

Rothko's era psychologized ritual. Campbell, for example, noted that primitive rites "conduct people across those difficult thresholds of transformation that demand a change in the patterns not only of conscious but also of unconscious life."[35] For Jung, experiences created by rituals emphasize the continuity of life. "The initiate," Jung declared, "... takes part in a sacred rite which reveals to him the perpetual continuation of life through transformation and renewal. In these mystery-dramas the transcendance

of life as distinct from its momentary concrete manifestations, is usually presented by the fateful transformations—death and rebirth—of a god or a godlike hero."[36] Rothko's work employs these primitive and pagan, Christian and modern sacred ceremonies, with their subterranean and natural deities, to evoke the transitional process and cyclic journey of the spirit from initiation to death and entombment. (In the first half of the twentieth century, perhaps beginning with Frazer, most significantly, Christian, classical, and primitive ritual were considered related and almost interchangeable in substance. This expansion of ritual is fundamental to Rothko and most Abstract Expressionists for their ritualization of history.)

Ritual initiation and new life is evident in Rothko's Christian *Baptismal Scene*. Baptism is a Christian rebirth ceremony. The ritual water is the vehicle for regeneration of the child. As Campbell writes, baptism is the Christian counterpart of the use of transformative waters known to all systems of mythological imagery. This rite generates and

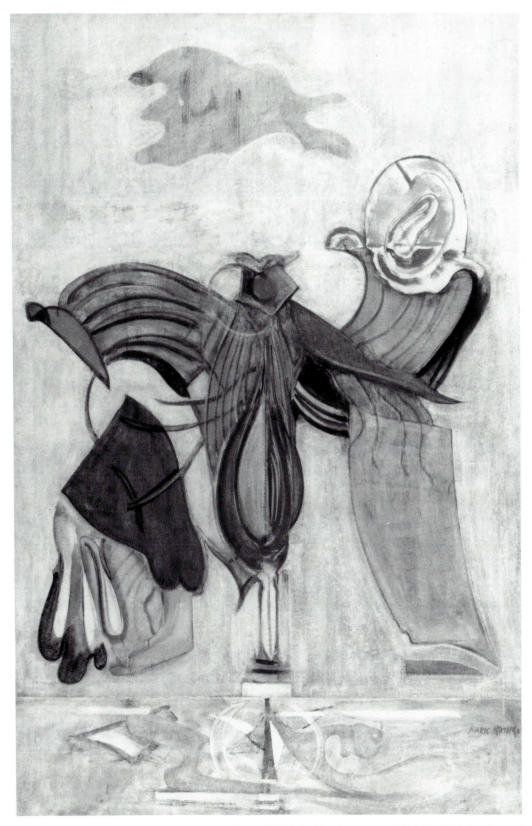

Figure 67. Mark Rothko, *Gethsemane*, 1945. 54¾ x 35⅞ inches. Estate of Mark Rothko.

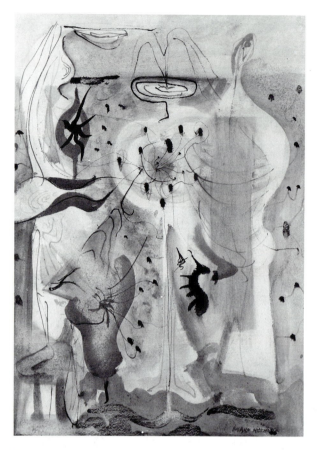

Figure 68. Mark Rothko, *Baptismal Scene*, 1945. Watercolor on paper, 19⅞ x 14 inches. Collection of Whitney Museum of American Art. Purchase. (46.12)

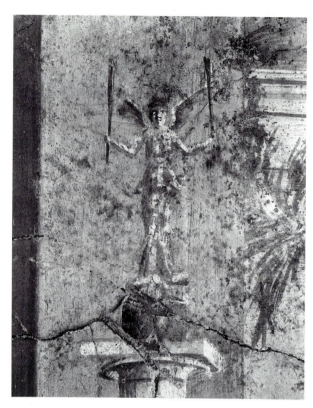

Figure 69. Boscoreale cubiculum (detail: Hekate), first century B.C. Fresco. Metropolitan Museum of Art. Rogers Fund, 1903. (03.14.13)

regenerates the world and man: "To enter into this font is to plunge into the mythological realm ... to cross the threshold into the night-sea. Symbolically, the infant makes the journey when the water is poured on its head. ... Its goal is a visit with the parents of its Eternal Self, the Spirit of God and the Womb of Grace. Then it is returned to the parents of the physical body."[37] In the painting, bodies of three calligraphic figures engaged in the ceremony and a caterpillarlike shape lie below the horizon line of this subterrannean world (although there is some slight tonal texturing on top similar to the zones below) while the heads of two of the figures rise above it. The two large figures seem to be pouring water on a central, smaller form. This configuration reflects traditional Renaissance compositions such as the Presentation of the Virgin, with its two figures standing next to a small child, as well the Roman relief sculpture of *Demeter, Triptolemos, and Persephone* in the Metropolitan Museum of Art. Rothko has modernized this ritual form with biomorphic and linear, perhaps automatist, shapes.

In image, tradition, and theme, Rothko's *Baptism Scene*

marks a positive, initiatory point in a Christian cycle. His *Gethsemane* and *Entombment* of around 1946 accent other stages of the suffering, death, and rebirth cycle of the Christian hero and through him all humanity. In *Gethsemane,* an Ernst-derived totemic creature rests on a classic column. This grouping is an allusion to similar winged gods on columns in the Boscoreale frescoes at the Metropolitan Museum that, together with the Boscotrecase frescoes, Rothko, De Kooning, Baziotes and others Rothko loved. In the Boscoreale cubiculum, gods on columns signify the presence of a sacred landscape and garden and are thus appropriate for an image of Gethsemane (fig. 69). By this allusion, Rothko maintains the reference to earlier roots and traditions but combines it with his new interest in surrealist forms. He thus modernizes an ancient and traditonal subject. While echoing Boscotrecase forms, biomorphic tentacles descending from the columnar totem in *Gethsemane* suggest that the form/experience is rooted in primary layers. Martha Graham wrote of Gethsemane in a way that illuminates its meaning for Rothko too: "garden in the desert—an oasis of hope—faith/symbol of re-birth—continuity of life."[38]

Another way of symbolizing the continuity of the past that Rothko developed around 1946 is exemplified in a

series of paintings each entitled *Entombment.* These paintings constitute a dialectic symbol of this same cycle of spiritual journey from death to rebirth. The Entombments take their basic compositions from Renaissance Lamentations or Pietàs.[39] One *Entombment,* for example, consists of a biomorphic figure that suggests another multibreasted figure in Rothko's oeuvre as well as the one in *The Omen of the Eagle:* a Virgin Mary with raised arms above and an Ernst-derived scissorslike biomorph below lying across her lap. The apparent wailing pose of the upright figure and the prominent display of the prone body also seem related to Greek *protheses* or public displays of the dead which could be seen in vases at the Metropolitan Museum (fig. 70). Here Rothko presents in one figure a dualistic, symbolic summary of the entire life journey: death and the milk of nurturing breasts as life. (The configuration also recalls Still's similar, although more vernacular, Pietà scene in figure 29.)

By using a surrealist biomorphic form for the body, a claw for an arm, and a shell-like shape for the figure's lower body, and by placing most of the figure underground as if it were part of a paleontological diagram, Rothko combined the legacy of Entombments with the legacy of nature. In other words, he suggests that such death scenes are part of natural life, that death is part of a natural cycle. Other Entombments repeat the basic structure of horizontal and vertical crossings but contain no allusion to human forms, although Rothko naturalizes the forms and cycle of Pietàs/*protheses* by making them appear organic. The compositional structure becomes a sign of man's mortal fate, an index of the eternal fate of all things—the cycle of life and death, death and resurrection—and it finds a permanent place in Rothko's work, including both the semiabstract art with its burgeoning, spreading forms above the horizontal line (fig. 71), and the fully abstract work.

Figure 70. Attic Geometric Diplon decorated with funeral scenes showing mourners, chariots and warriors (detail: prothesis), eighth century B.C. The Metropolitan Museum of Art, Rogers Fund, 1914. (14.130.15)

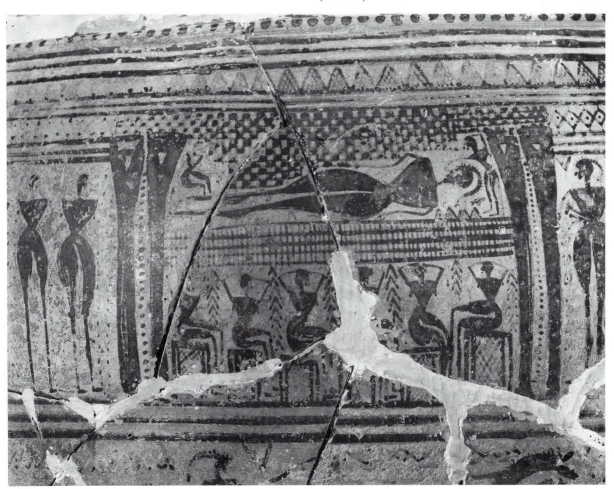

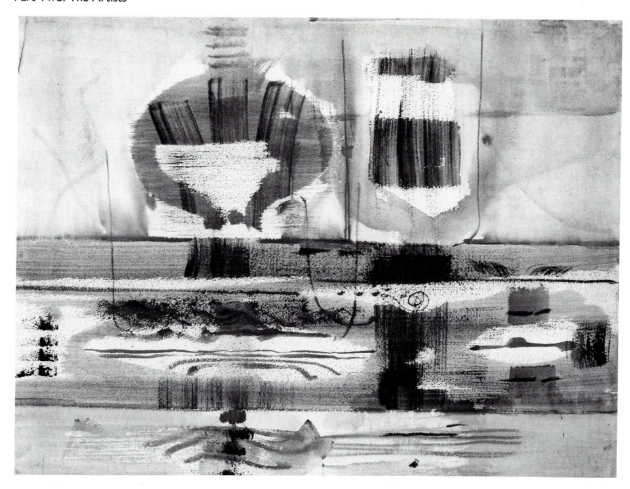

Figure 71. Mark Rothko, *Untitled*, ca. 1945–46. Watercolor and ink on paper. 22⅛ x 30¹³⁄₁₆ inches (image). National Gallery of Art, Washington, D.C. Gift of the Mark Rothko Foundation. (1986.43.226) Photo: Quesada/Burke.

SANCTIFICATION

Rothko's sanctification of death was part of a generation's concern with the institutionalization of mass death, a World War I concern revived by the Spanish Civil War and World War II. The Second World War brought, as war often does, a deliberate and heartfelt ritualization of life. This was true even in 1942, when the full horror of the concentration camps was still unknown. To save, savor, and sanctify human life and to make death universally significant was to resist the war's terrible waste. As after World War I, the increased need for myth, ritual, and sanctification in the 1940s reflected a need to honor life. America experienced a religious revival in the postwar period, and death was given significance by prayer and ceremony in various forms of art and popular expression.

In Rothko's era, the cultivation of sacred and tradition-laden symbols and ceremonies of death was to be found not only in Rothko's work and that of his colleagues, for example, Lipton's *Pietà* of 1946 (fig. 72), but also in poster prints, such as Prentiss Taylor's *Uprooted Stalk* (fig. 73), which with its nature soldier and rifle parallels the death and rebirth imagery of *Entombment*, and films dealing with the war. Like Rothko's work, these popular media drew on Renaissance iconography to mythologize contemporary history. Films frequently sanctified death by highlighting prayer and the burial of soldiers and the innocent. In one of the first films depicting Americans in combat, *Wake Island* of 1942, for example, following a very self-conscious prayer typical of Hollywood wartime death scenes, an American airman killed in a Japanese attack is laid to rest in a panoramic image that clearly refers to the Deposition or Entombment.[40]

The theme of man's vulnerability and mortality is ultimately reinforced by the formal construction of Rothko's early work. Besides the presentation of figures as ghosts

and shades, some forms—the top and bottom ones in *Gethsemane*—seem to have been imprinted rather than drawn on the ground. In works like *Baptismal Scene,* the ground actually shapes the figure, which is unpainted negative space—somewhat like the negative representations of ancient seals. Other shapes are more fully formed and defined, for example, those of *Entombment.* As in the forms of a *lekythos,* Rothko sometimes makes the details of shape stronger than the entire figure itself, which fades out, or he "embodies" the figure with one or two brushstrokes. Differences in hue between strata can be very slight and then very sharp. These formal characteristics occur frequently in Greek painting and in the variety of forms and modes of representations of surrealists like Ernst and Miró.

In Rothko's works, space oscillates between surface and depth. Although the 1943 letter to *The New York Times* states, "We are for the large shape because it has the impact of the unequivocal. We wish to reassert the picture plane," Rothko's work actually contains numerous small shapes and figures that suggest a complex layering of space equal to the intricacies of the forms. The theme of the continual journey and struggle of life is reinforced formally in the continual dialectic emergence, definition, and dissolution of form. This process creates a sense of movement from vestiges of the past to a gestating future. Through symbol, structure, and form, Rothko's early work evokes what he and others consider the eternal spiritual journey and fate of matter and spirit, emotions and consciousness in space and time.

Archaic Phantasy of 1945 (fig. 74) sums up Rothko's early work: his layering of associations, symbols, and signs

Figure 72. Seymour Lipton, *Pieta,* 1946. Bronze. 20 inches high. Courtesy Michael Lipton.

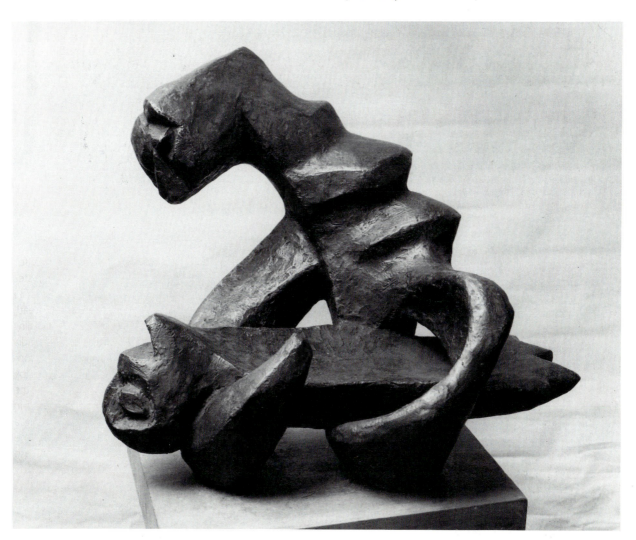

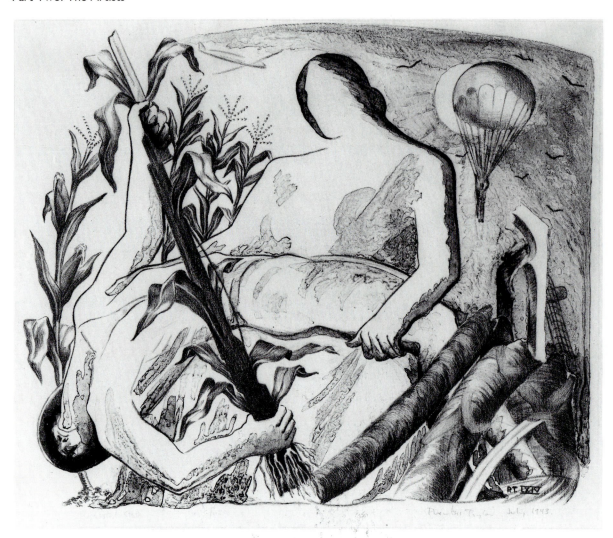

Figure 73. Prentiss Hottel Taylor, *Uprooted Stalk*, 1943. 26.2 x 31.6 cm. Litho-tint. Library of Congress.

within combined figural and architectural organisms suggestive of the internal and external human environment and its fateful cycle. While such an organism or figure may seem at first glance to be a variant of a surrealist form created by automatist meanderings, it is in reality a deliberate, layered complex, a "compound ghost" to use Eliot's phrase from *Four Quartets*, made up mostly of signs, traces, and memories that define human fate as Rothko conceived it. *Archaic Phantasy* combines a triangular figure-form similar to that in Ernst's *The Couple* of 1924 with other forms that suggest the spidery arms of an insect, feathers and scales (from the top of the Artemis column), the curvilinear folds of a toga, and a crown or capital. The whole figural complex is placed below an earth stratum of fluted striations and the center of what looks like an Ionic scroll, and activated by swirling incised lines suggesting movement. *Archaic Phantasy* is a totem of

humanity's past, a conflation of Rothko's concepts of external/internal beginnings and ends, and a reflection of the idea that human beings are to be explained by original rather than by final causes.

In *Archaic Phantasy* as in most of his early work of the 1940s, Rothko presents his theme of art as a specter or hazy dream image formed from shades of the past made into modern form and expression. Rothko's modernist art reflects a self-conscious examination of a civilization of which the contemporary is merely a momentary fragment.

The character of this early work is clearly stated in an anonymous introduction, which Rothko must have approved, to the catalogue of his exhibition at the Art of This Century gallery in 1945:

Rothko's painting is not easily classified. It occupies a middle ground between abstraction and surrealism. In these paintings the abstract idea is incarnated in the image. Rothko's style has a

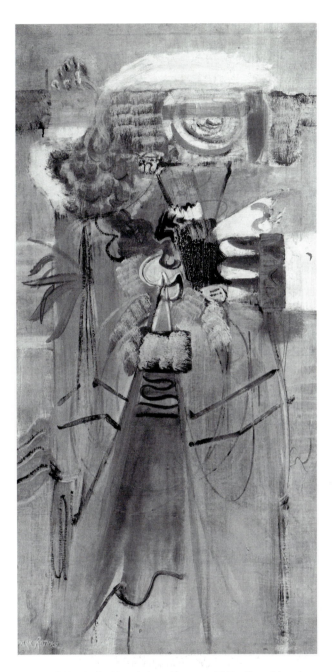

Figure 74. Mark Rothko, *Archaic Phantasy*, 1945. 48 x 24 inches. National Gallery of Art, Washington, D.C. Gift of the Mark Rothko Foundation. (1986.43.1) Photo: Quesada/Burke.

latent archaic quality which the pale and uninsistent colours enforce. This particular *archaization, the reverse of the primitive, suggests the long savouring of human and traditional experience as incorporated into myth*. Rothko's symbols, fragments of myth, are held together by a free, almost automatic calligraphy that gives a peculiar unity to his paintings—a unity in which the individual symbol acquires its meaning, not in isolation, but rather in its melodic adjustment to the other elements in the picture. It

is this feeling of internal fusion, of the historical conscious and subconscious capable of expanding far beyond the limits of the picture space that gives Rothko's work its force and essential character [italics added].

His work is not primitivism per se—a search for the elemental—but a combination of archaism and its apparent opposite, tradition. His emphasis on roots is not a repudiation of civilization, as Gauguin's primitivism was, but part of an argument for archaicism as civilization. In his myth-making he intends to begin a new and modern version of humanity's uninterrupted chain of existences; like Joyce, he offers a *reincarnation* of tradition in the new forms of the present.

Rothko painted the sweep of human origin and fate as a modern spiritual drama. As many of his generation sought to do, he made aspects of the human heritage come alive as a living tradition. "The poet," as Eliot proclaimed in "Tradition and Individual Talent," "...is not likely to know what is to be done unless he lives in what is not merely the present, but the present moment of the past, unless he is conscious, not of what is dead, but what is already living." This idea permeates the history of the period, from biographies in the 1930s, which demonstrated "that the past is a living past of the present," to Albert Gallatin's Gallery of Living Art, to the "living story" of the war in Europe reported over the radio.[41]

The bitter irony for Rothko and his generation was that the living tradition was one of tragedy, death, and periodic entombment. Rothko's early choice of the *Orestia* was auspicious for him, for as an archaic tale of suffering and strife, it asked why and to what end human beings suffer, a most relevant question in the 1940s. The answer in the *Orestia* is "suffering until truth," suffering for regeneration, suffering for a new order, for a new harmony that comes in the last play of the trilogy, *The Eumenides*. The Furies, dark forces of vengeance, are transformed through law into forces of civilization and justice. The *Orestia* ends optimistically.

Rothko's art is not so affirmative. While his work engages the theme of origins and spiritual journey, as a whole he emphasizes the downward side. His work has a sense of eternal Greek and modern Spenglerian tragic fate. All life emerges to die. His early work contains more funereal signs and associative images of mortality than that of any other Abstract Expressionist. And Rothko repeatedly stated this as his intention. In 1958 he said that his art reflects "A clear preoccupation with death," and added that "all art deals with intimations of mortality."[42] Rothko's living tradition constituted some of the most original tragic art in American and modern art history.

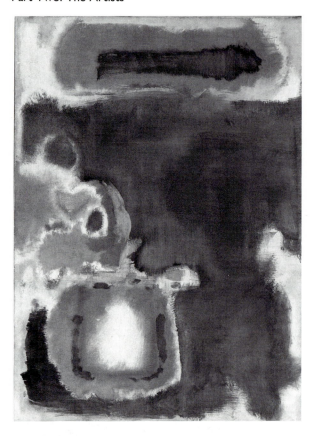

Figure 75. Mark Rothko, *Number 17, 1947*. 48 x 35⅞ inches. The Solomon R. Guggenheim Museum. Gift of the Mark Rothko Foundation. Photo: Quesada/Burke.

WALLS OF COLOR

In 1946, partially under the influence of Clyfford Still, Rothko's work became increasingly abstract and his forms became rougher and more painterly in edge and shape.[43] They resemble landscapelike forms or surfaces more closely than ever before. During the same time, Still made his dramatic totemic images less representational, providing Rothko with examples of several things: the elimination of details, the blurring of outlines, and the stronger use of vertical shapes. Still also showed Rothko how to equalize light and dark values in an all-over composition and how to further incorporate naturelike surfaces into the figure. Rothko, however, translated Still's example into his own language—the classicizing figure/landscape and, eventually, colored light. *Number 17, 1947* (fig. 75), for example, suggests figures painted in large, rough shapes reminiscent of Still's works such as *1945–H (The Grail [?])*, yet the image also resembles a figure with a vase or harp shape, a combination typical of Greek vases.

Rothko was profoundly taken by Still's antagonism toward the art world and remained so the rest of his life. He adopted many of Still's attitudes, which extended his own standard bohemian, anarchist, anti-art world feelings. Rothko's new reluctance to exhibit in group shows, his decision no longer to title his work, and his refusal to write about or explicate it reflect Still's stance. In the early 1950s he and Still refused to participate in a European exhibition. The reasons that he gave to Katherine Kuh in 1954 in response to a request for a statement about his work clearly reflect Still's Nietzschean position, though without Still's thunderous tone of contempt.

Forgive me if I continue with my misgivings, but I feel that it is important to state them. There is danger that in the course of this correspondence an instrument will be created which will tell the public how the pictures should be looked at and what to look for. While on the surface this may seem an obliging and helpful thing to do, the real result is paralysis of the mind and imagination (and for the artist a premature entombment). Hence my abhorrence of forewords and explanatory data.[44]

To balance the more abstract and naturalistic imagery of his work in the late 1940s, Rothko drew on a planar colorist who constructed more architectonic settings than Still—Matisse. Specifically, Rothko studied Matisse's *The Red Studio* (fig. 76), which was put on display at the Museum of Modern Art in the late 1940s.[45] *The Red Studio* provided what Still's color figures did not: a rethinking and transformation of an architectonic environment from architectural forms to color walls.

In the Matisse, a single color environment spreads and envelops both an architectonic setting and the specific objects within it. Paintings, furniture, and other objects are silhouetted as mostly color shapes and independent scenes within a unified expanse of color. The combination of a color field of architectonic shapes, Still's color figures, and his own idea of the enclosure by ancient architecture paved the way for Rothko's mature art. The influence of Matisse's colors, such as the red of the *The Red Studio*, appears in many of Rothko's works in the late 1940s and early 1950s, and was reinforced by the vibrant painthandling of Rothko's friend Milton Avery.

In the transitional works, Rothko transformed his earlier figures and compositions into abstract shapes. He unified figure and strata, figure and environment, figure and its inheritances more than before. The entire field of the canvas is alive with floating, softly edged, two-dimensional, painterly shapes, although the subjects are obscured. *Number 11, 1949* (fig. 77), for example, recalls his classical figures, like that of *Tiresias, Untitled* (fig. 63), and his columnar fluting.

In "The Romantics Were Prompted," Rothko explained why he felt it necessary to give up his totemic hybrids (in words parallel to Still's Nietzschean-inspired reluctance for identifying sources):

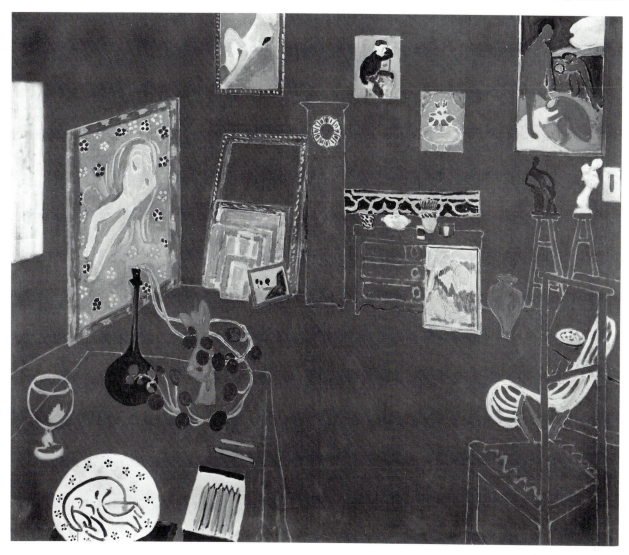

Figure 76. Henri Matisse, *The Red Studio*, 1911. $71\frac{1}{4}$ x $86\frac{1}{4}$ inches. Collection, The Museum of Modern Art, New York. Mrs. Simon Guggenheim Fund.

Even the archaic artist, who had an uncanny virtuosity found it necessary to create a group of intermediaries, monsters, hybrids, gods and demi-gods. The difference is that, since the archaic artist was living in a more practical society than ours, the urgency for transcendent experience was understood, and given an official status. As a consequence, the human figure and other elements from the familiar world could be combined with, or participate as a whole in the enactment of the excesses which characterize this improbable hierarchy. With us the disguise must be complete. The familiar identity of things has to be pulverized in order to destroy the finite associations with which our society increasingly enshrouds every aspect of our environment.[46]

Rothko turned to abstraction partially because even his hybrids were too limiting and specific in the end. He gave up titling for the same reason. Abstract shapes provided a more direct, immediate, open, yet deliberately—in the modern tradition since symbolism—inscrutable image for his themes. Yet Rothko continued to insist that his shapes were "organisms" in a "drama":

They are unique elements in a unique situation. They are organisms with volition and a passion for self-assertion. They move with internal freedom, and without need to conform with or violate what is probable in the familiar world. They have no direct association with any particular visible experience, but in them one recognizes the principle and passion of organisms.

Rothko shaped new forms that continued the previous principles and passions of his earlier shapes, their inexora-

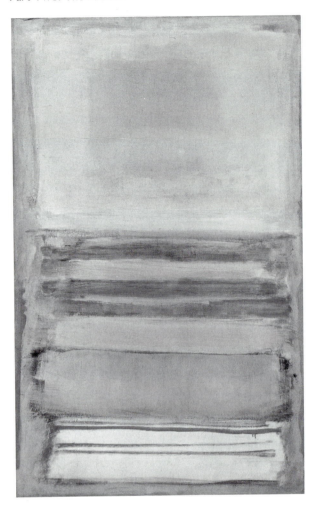

Figure 77. Mark Rothko, *Number 11, 1949*. 68⅛ x 43⁵⁄₁₆ inches. National Gallery of Art, Washington, D.C. Gift of the Mark Rothko Foundation. (1986.43.144) Photo: Quesada/Burke.

ble journey and entombment. Gradually he turned his irregular, painterly shapes into color rectangles of varying size, until they were few in number. By the end of the 1940s, Rothko's work was poised for a new flowering of his original figural complexes.

THE ENVIRONMENT WITHIN

Rothko's mature paintings consist of several parallel rectangles, often similar in value but different in hue and width, extended to the edges of the canvas. The shapes lack distinctive textural effect, seeming to be veils of thin color applied with sponges, rags, and cloths as well as brushes. Line has been eliminated altogether. Like Abstract Expressionist works in general, Rothko's work achieved great simplicity and unity of design, integration of elements, and sameness and repetition of shape, value,

color, edge, and paint handling. Yet this greater simplicity and unity allowed for wide variation in detail.

In his painting of 1950 onward, Rothko translated and transformed his earlier tiered-figure pattern into abstract pictorial form. In other words, Rothko completed the elimination of specific symbolic forms and arrived at a mode of more general allusions, signs, and evocations. The development of his work seems to follow what he wrote in his notes in the 1930s about children's art, that it is possible continually to simplify form as children simplify a round shape to a mere circle.[47] He developed this idea in his early works through fragmentary forms, traces, and memories. Now he used abstract form that makes it nearly impossible to follow the traces and signs. Instead, the new work depends on abstract leitmotifs, general compositions, new metaphors, and emotional effect.

Like other mature Abstract Expressionist painting, Rothko's mature art can be considered emblematic or ideographic. In the 1948 exhibition "The Ideographic Picture," arranged by his friend Newman at Betty Parson's gallery, Rothko's *Tiresias* and *Vernal Memory* appeared along with the mythic work of other Abstract Expressionists such as Stamos and Still. Newman, writing in the catalogue, characterized the artists' work as "ideographic" and defined it as follows:

Ideograph—A character, symbol of a figure which suggests the idea of an object without expressing its name. Ideographic—Representing ideas directly . . . applied specifically to that mode of writing which by means of symbols, figures or hieroglyphs suggests the idea of an object without expressing its name. *The Century Dictionary*. Ideograph—A symbol or character painted, written or inscribed, representing ideas. *The Encyclopedia Britannica*.

Newman argued in the catalogue that Kwakiutl art is ideographic because it uses abstract shapes as a plastic language directed by "ritualistic will towards metaphysical understanding." Shapes were a living "vehicle for an abstract thought-complex, a carrier of . . . awesome feeling." Rothko's mature art, even more than Newman's, can be characterized this way. It consists of an ideographic form—part figure, part architecture, part nature, part past, part present, part future, part entombment, part subconscious, and part emotion. His paintings are ideographic signifiers or totems of the eternal inner tradition and not "abstract" paintings, that is, mere abstractions of natural forms and phenomena for their own sake. The totemic shape or abstract thought-complex ultimately alludes to the more specific early forms—the rectilinear architectural fragments, the Greek column figures, the stratigraphic zones, the tiered figures, the entombment composition—his totems of the roots and traditions, the materialist and spiritual events and forces of life. Rothko could render

pictorially his earlier personifications of fate, of the flux of life, not just through vestigial, half-figure, half-form signifiers and disguised substitutions, but within and through formal features and activity. His mature works perfectly fit Martha Graham's definition of form: "What is Form? Form is the Memory of Spiritual Content."[48]

Memories of Rothko's earlier themes and their complex associations can be seen first of all in the vertical tiered arrangement, the shapes of which Rothko himself described as a "figure": "It was not that the figure had been *removed*, not that the figures had been swept away, but the [ritual] symbols for the figures, and in turn the shapes in the later canvases were new *substitutes* for the figures."[49] They recall the segmented nature of the human body and of his earlier figures. Paintings such as *Number 11* of 1949 resemble the earlier column figures with their segmentations and bands, and can be considered intermediate between them and the mature figure. *Untitled* of 1949 (fig. 78) suggests a column-figure with a middle section of dentils. *Number 22*, also of 1949 (fig. 79), has a middle zone of striated lines that recalls the classical fluting Rothko used earlier and also the simplified reclining figure of the Pietà or *prothesis* watercolor (fig. 71). Rothko, however, soon gave up even these remote allusions for an architectonic layout.

Rothko's abstractions, edged with thin bars, consist of stacked rectilinear color panels recalling the architectural ensembles and figures fundamental to his work from the 1930s onward. This relationship is enhanced by the resemblance of his abstract work to the painted walls of Roman murals, not only the Boscoreale frescoes (fig. 80) but also those of the Boscotrecase (pl. 6).[50] Rothko seems to have turned the panels on their sides for his horizontal works or combined the vertical and horizontal panels together in other works. Many of the Roman Third Style works consist only of rectilinear panels of opaque color, framed by illusionistic columns. Others depict architectural facades devoid of figures.

Rothko called his mature paintings "facades,"[51] although it was only in the late 1950s that he said he recognized that he had been painting "Greek temples" all his life. During his second trip to Europe, Rothko saw both the subconscious and habitual architectonic structure of his work and its relationship to sacred myth and drama,[52] while standing in front of the vermilion walls of Pompeii's Villa of Mysteries that depict the sacred mystery plays and initiation rituals of Dionysus.

The Boscotrecase fresco indicates how Rothko made the connection between his earlier architectural figures and his new color walls. The Boscotrecase wall of color contains several small compartments of Egyptian ritual scenes. It is, in other words, an ancient precedent for Matisse's *The Red Studio*, a modern painting of walls of

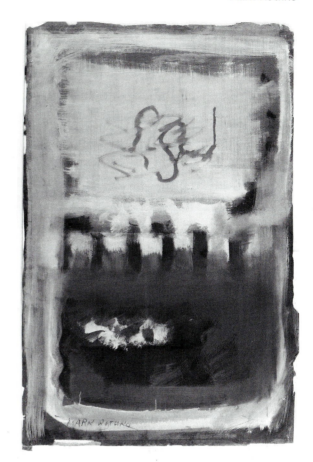

Figure 78. Mark Rothko, *Untitled*, 1949. Watercolor, tempera on paper. $39\frac{3}{4}$ x $26\frac{5}{16}$ inches (image). Copyright 1989. Kate Rothko Prizel and Christopher Rothko/ARS, New York.

color containing paintings as scenes within it. Rothko's interest in walls of color in *The Red Studio* found a parallel in those of Boscotrecase and he combined them to found his mature style on analogies between the friezes of the ancient and modern worlds.

Rothko also retained signs of his earlier entombments in his mature work. The thin horizontal plane often placed between two larger planes echoes the general configuration of his earlier *protheses* scenes and Renaissance entombments.[53] *Violet, Black, Orange, Yellow on White and Red* of 1949 (fig. 81) is a good example. A symbolic black line with the thinnest trace of a black "head" at the left resides between a vertical color figure with two upraised red "arms," as in a combination of the Virgin Mary with Christ on her lap and a Greek wailing figure. (The slim "arms" also resemble the stalk columns at the edge of several Boscotrecase frescoes.) By eliding classical structures under and through the suggestions of nature, Rothko retains in his abstract shapes the complex significations of his earlier figures.

Orange, Gold and Black may be either another en-

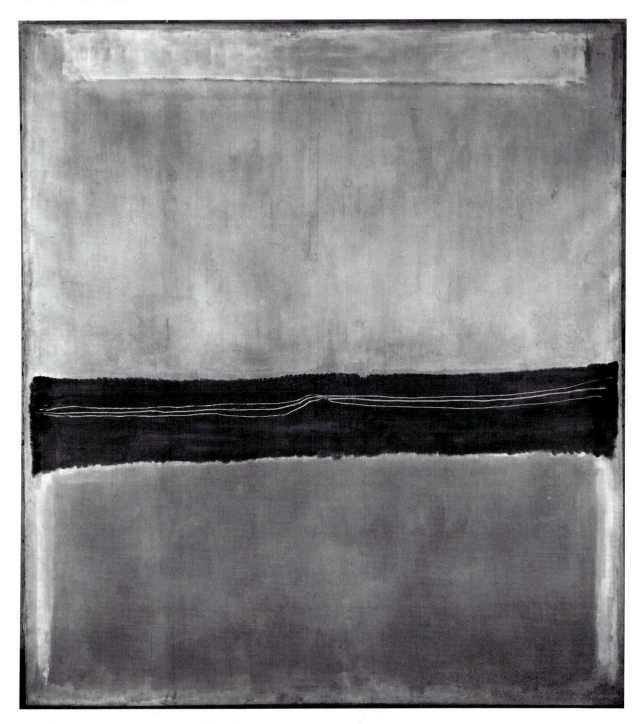

Figure 79. Mark Rothko, *Number 22, 1949*. 117 x 107⅛ inches. Collection, The Museum of Modern Art, New York. Gift of the artist.

tombment composition with a slash of black across its middle for Christ or, more simply, a column figure with abacus. Whichever it is, it presents Rothko's themes in more abstract and pictorial terms. *Orange, Gold and Black* consists of a red square on top, a black rectangular corpse or abacus, and a mottled white ("gold") square with flecks of yellow on a red-orange ground. The red square seems to emerge from or melt into its ground. The black contrasts sharply with the red and with the ground. The gold occupies an intermediate place in these contrasts.

Figure 80. Boscoreale fragment, first century B.C. Fresco. The Metropolitan Museum of Art, Rogers Fund, 1903. (03.14.11)

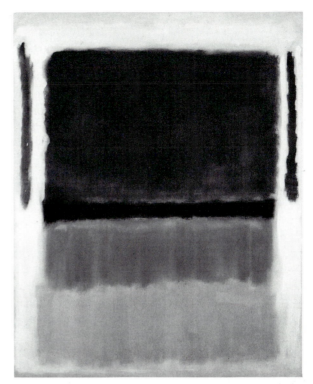

Figure 81. Mark Rothko, *Violet, Black, Orange, Yellow on White and Red*, 1949. 81½ × 66 inches. The Solomon R. Guggenheim Museum, Gift, Elaine and Werner Dannheisser and the Dannheisser Foundation, 1978. Photo: Robert E. Mates.

The gold is the most fluid and turbulent, the red less so, and the black is the smoothest. The red and gold have equally amorphous edges, but the red, because it blends with the ground, is more indistinct, more formless, than the gold or black. The gold shape is the most translucent, the top red the most expansive (perhaps to show the expansive spreading of the wailing "arms" by means of color?), and the black (cadaver) the most defined, opaque, contained, and static. The red and black colors are clearer than the gold in hue, but the black, because it contrasts with the ground and the indistinct red shape, is the more striking and defined. In fact, the black is actually a clear,

formed shape while the others seem more like shaped spatial activity. The painting thus contains a variety of movements and significative effects within its emblematic structure.

Rothko created an abstract rendering of his theme of the eternal journey, ritual cycle or, as he said, "oval" of shapes, the inward tradition of humanity through time and space.[54] The theme is now embodied in the overall form, structure, and movement of his mature paintings, as in *Untitled* of 1949 (pl. 7). Each picture is constructed through a series of choices between opaque or translucent surfaces, straight or irregular edges, agitated or smooth brushwork, the blending or contrasting of the color rectangles with the ground, substantiality or insubstantiality of color, expansion or contraction of color, intense or pale hues, and spatial advancement or recession. While there are compositional similarities between the "figural" and abstract paintings, the colored shapes are less fixed in the latter: they seem to be continually emerging, forming, receding, and dissolving to different degrees. This imagery of fluid transitions—of slow expansion, agitation, contraction, and quiescence in paint and color—is a metaphor of distilled organic, mythic, and human process. Rothko identified this process: he often talked of "birth, dissolution and death."[55]

This historical, ritual, and mythic paradigm as the rhythm of his work suggests the fulfillment of part of the statement in the catalogue of his exhibition of 1945 cited earlier. The anonymous author wrote that Rothko's work consisted of mythic fragments in a "peculiar unity" of melodic adjustment to one another. Meaning was obtained not through individual units in isolation but collectively. In his mature work, Rothko's shapes move in contrapuntal rhythm and attain full power through their context. In other words, Rothko's abstractions depend on the accumulation, the piling up of his carefully gauged color and brushwork sonorities in dialectic consonance or dissonance. No shape functions alone, but each is part of a complex interaction of beginnings, maturations, and dissolutions, ebbings or flowings, or risings and fallings in different stages and sequences. Rothko himself declared to William Seitz in 1952 that he often held his shapes in Nietzschean antitheses or confronted unity in momentary stasis.[56] While abstract, then, the works reenact, as he also said, a contrapuntal or dialectic "mythic action" as the parable of his time.[57]

To the new abstract form of ritual passage and process in his mature work, Rothko added references to organic life and nature. If there has been a consistent general interpretation of Rothko's mature work, it has been in terms of nature—of landscape forms in the horizontal shapes, of natural lighting in the evocative color, and of natural movement in the swelling and receding of his forms. Such perceptions reflect Rothko's continuing symbolic use of nature as an aspect of human roots, identity, and fate. His abstract forms suggest natural process in a pictorial rhythm of expansion and contraction. In these paintings, as it has been said of Martha Graham's dances—with their body movements of expansion and contraction and rising and falling—"one has inescapably the sense of observing *natural* events, courses of action that are a part of and are taking place directly within a natural order."[58] For Rothko and Graham, their compositions indicate natural action and human drama as simply natural truth. Both tried to formalize natural impulses and myth in order to abstract human feeling and experience over space and time into a set, expressive language. Rothko made his art an organism of expression.[59]

Rothko's ideographic emblems of flow represent in abstract terms his concept of organic change over time. He condensed the past and the present in the tremulous throb of color and gave "material existence to many unseen worlds and tempi."[60] The emblematic treatment is immeasurably enhanced by the nuances and muted transitions of the brushwork, created by disguising and blending individual brushstrokes. These nuances create sensations of *immanence*, of indwelling vitalist emotion and radiant spirit more sensed than perceived. The rich, lumi-nous color directly renders a sensuous and sensual feeling, Rothko's painterly substitution for his earlier organic forms. He once said that sensuality was his "basis for being concrete about the world,"[61] and he often insisted that his work was not mystical but materialistic. Rothko was able to transform physical matter or nature—the pigment and vehicle of paint—and the concreteness of sensations directly into emotional and spiritual effect without the intermediaries of recognizable outer forms and symbols. The emblematic totemic shapes behave as any organism would—breathing, expanding, and striving. The forms generate vague suggestions of new metamorphic life within a structure of utmost simplicity.

CYCLES OF EMOTION: "TRAGEDY, ECSTASY, DOOM"

The challenge facing Rothko in the 1950s was to transform his ideas into new pictorial form and into immediate emotional experience. In 1949 Rothko prophetically wrote that his purpose was to move toward "clarity: toward the elimination of all obstacles between painter and idea, and between the idea and the observer."[62]

The viewer is engulfed by a mature Rothko painting, as Rothko's earlier figures were engulfed by their environments. It has often been noted that Rothko's shapes move toward the viewer and draw him or her into the work. Like his earlier surrounded nude, like *The Omen of the Eagle*, the figure of the mature work and of the viewer in front of it are now equally enveloped in suprapersonal effects and forces. This search for environmental effect lies behind Rothko's insistence on subdued lighting in exhibitions of his work. By creating something like a sacred grotto or chapel, Rothko can extend the light of the *sacra* into the viewer's space and envelop him or her. As he said of his work, in a symposium on combining architecture and painting, "you are in it. It isn't something you command."[63] By image, pictorial structure, and active effect, the individual viewer is *concretely* engulfed and shaped by Rothko's idea of the forces of destiny and fate beyond his or her own personal powers. As he said:

I'm *not* an abstractionist. . . . I'm not interested in relationships of color or forms or anything else. . . . I'm interested only in expressing basic human emotions—tragedy, ecstasy, doom, and so on—and the fact that lots of people break down and cry when confronted with my pictures shows I *communicate* those basic human emotions. . . . The people who weep before my pictures are having the same religious experiences I had when I painted them. And if you . . . are moved only by their color relationships, then you miss the point![64]

He also said in 1951 that the reason he painted was precisely because he wanted to be very "intimate and

human."[65] In the 1950s his lifelong interest in the human drama was rendered with more direct power. He had rid himself of previous "conventions," "memories," and "ghosts," as he said, so that he could have a direct "transaction" with the viewer's need and spirit.[66] His means was abstract painting's capacity to form signifying analogies and metaphors with simple pictorial elements.

Rothko's lifelong love of music partially lay behind his conception of his work as directly emotional and dramatic. He often played music in his studio, particularly Mozart, whom he regarded as a great tragic artist.[67] He once said, "I became a painter because I wanted to raise painting to the level of poignancy of music and poetry."[68]

In this paralleling of art with music, Rothko again drew from Nietzsche's *The Birth of Tragedy from the Spirit of Music,* which offered an emotional conception of music. For Nietzsche, music is a Dionysian, tragic art, its melody primal and universal, a vehicle for the rendering of elemental passion, primal images, and primordial unity among man, nature, and the universe. Music is antiparticular and antiphenomenal, in other words, like Rothko's work, abstract, direct, and concrete:

music makes every painting, and indeed every scene of real life and of the world, at once appear with higher significance . . . in proportion as its melody is analogous to the inner spirit of the given phenomena. . . . [M]usic . . . gives the innermost kernel which precedes all forms, or the heart of things.[69]

To Nietzsche music, like geometry, is also universal in its expressiveness, capable of conveying elemental passions more powerfully than phenomenological art:

All possible efforts and excitements, and manifestations of will, all that goes on in the heart of man and that reason includes in the wide, negative concept of feeling, may be expressed by the infinite number of possible melodies, but always in the universal, in the mere form, without the material, always according to the thing-in-itself, not the phenomenon, the inmost soul, as it were, of the phenomenon without the body.[70]

Similarly, Rothko seeks to render elemental passions in simple images which pare away those things that are perceptible, to get at the "heart of things"—the inner spirit and inmost soul of his journeying, striving forms. In his early work, such as *Tiresias, Slow Swirl by the Edge of the Sea,* and *Ritual,* he had symbolized tragic music by using fragments of musical instruments and notation such as clefs and bridges as part of his figures or as the figure itself.[71] In his mature art, he intensified the analogy by suggesting emotional life more directly with the expressiveness of his color and the a priori universality of his geometric shapes.

The existentialism and emotionalism in cultural circles of the late 1940s and early 1950s undoubtedly also played a role in Rothko's new directness of expression. Existentialism was more than a fascination with Sartrean fluency,

openness, and directness. It was part of a major shift toward involvement in the individual life as opposed to the deep concern with cultures and civilizations that had characterized intellectual life in the 1930s and 1940s. In the 1950s American culture turned from an emphasis on grand historical questions to a more Kierkegaardian concern with the individual's own struggles for life and preservation of integrity. Kierkegaard's writing, with its emphasis on personal feeling and mood, on individual anguish and pain, and its repetition of words like "fear" and "trembling," "sickness" and "death," parallels Rothko's new sense of intense and specific emotionality. His segmented figures seem to stand for various contrasting states of emotion as well as ritual stages of history and civilizations.

Art criticism in the early 1950s reinforced this emphasis on emotionality.[72] So did the popularity of Suzanne Langer's *Philosophy in a New Key* which, although published in 1942, sold thousands at this time. Langer's idea that the artist portrays feeling that transcends mere personal experience is representative of Rothko's work and American art at this time. It should be understood, however, that many of the artists, and Rothko in particular, were seeking to portray objective, universal, and not merely subjective, autobiographical emotion. Their art remains as testament to a generation that cultivated and condensed concepts of human history and fate to concepts of impersonal, universal, anonymous human feelings such as the cycle of "tragedy, ecstasy, and doom." Previously, their art—much like American art of the 1930s or the work of a Ruth Benedict or a Thomas Mann—had represented civilizations by psychological principles. It is as though the artist could give a concrete shape to feeling in the same way that his generation had discovered there was a concrete shape or pattern of psychic principles and behaviors to history. Rothko managed to intensify and make immediate a representation of the emotional embrace of human origins and fate. To a large degree, like his colleagues, he transfigured forms and emotions of tragedy into those of melodrama, as he surrounded the viewer with a pictorial environment, form and theater of emotion and history.

HIEROPHANY

In the late 1950s Rothko developed new means to represent his theme of the ritual drama of humankind. Throughout his work, he manifested the sacred from primitive to modern in terms of space, time, nature, the cosmos, and life itself. In his mythoritualistic abstract art, he came closer than perhaps any other modern artist to rendering a disguised or "ironic," in his words, religious view of the world. Rothko's art is one long hierophany, or manifestation of the sacred.

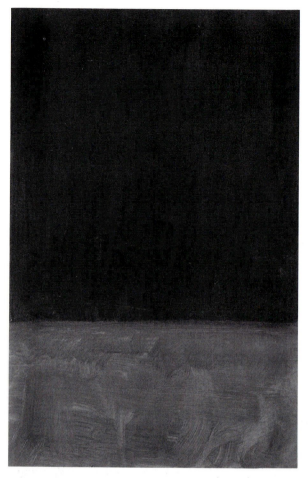

Figure 82. Mark Rothko, *Untitled*, 1969. Acrylic on paper. National Gallery of Art, Washington, D.C. Gift of the Mark Rothko Foundation. (1986.43.283) Photo: Quesada/Burke.

In his late work, Rothko further modernized traditional metaphors to express ritual experience. For example, he increasingly employed the traditional metaphor of light or illumination as an indication of the divine. Rothko's paintings became increasingly darker in the late 1950s and 1960s, as in *Untitled* of 1969 (fig. 82). Contrasts formerly made between bright hues are now made between subdued, light and dark blues, blacks, browns, and grays. Darkness and radiance become intangible indications of sacred life, like the light of consecrated places such as Gothic cathedrals. Indeed, he considered as one of the best essays on his work an article comparing it to the light of cathedrals.[73] In his late work, Rothko expresses a more powerful solemnity and gravity than ever before. It is no wonder that he admired Fra Angelico and felt that he came "straight out of Rembrandt." Like Rothko, both artists are masters of understated human action and inner illumination.

As noted, Rothko visited Europe in 1959, and the paintings of ebony landscapes in Pompeii may have reinvigorated for him the practice of evoking experience through dark light. The colors of some of his late works may well have been inspired by earlier sources such as black-figured vase paintings or the maroon and black Boscotrecase frescoes (pl. 8) with their immeasurable depths and floating darknesses.

Descriptions of the Boscotrecase frescoes seem to fit Rothko's mature painting as well. In both wall scenes, "simple settings [are] ambivalent, actual distances indeterminable."[74] Landscapes seem suspended in mid-air and the wall suggests active sky and water. The primary artistic innovation of the Boscotrecase frescoes is that the wall is made to suggest undefined air and depth. In other words, the two-dimensional surface alone produces the illusion of three dimensions. "Representation becomes suggestion, reality a vision, and a picture a mirage" world in which "Gods and legends become fairy tales." In both, incoherent perspective and color create their own magic and mythic world.

In his late work, the emblematic cycle of interior and exterior is sounded in a more sonorous and resonant key. The alternating zones of light and dark suggest the depth and action of his sacred drama. The writer Novalis, popular among the surrealists, wrote of light in a way that also clarifies Rothko's idea: Light was "the breath of life itself, simultaneously decaying and being formed anew... an action of the universe... a divining agent."[75]

In Rothko's development of a greater physical realization of his themes, it was perhaps inevitable that a more concrete mode of cyclicality, that is, serial mural painting, would arise. In the late 1950s, opportunities arose for a series of architectonic presentations of groups of his work. At the Duncan Philips Collection in Washington, several of his paintings were hung together. The effect was to give a sense of dramatic, contrasting interaction between works and parts of works, as though they were a linked series; in other words, these interwoven paintings reconstituted ancient and modern 1930s fresco cycles in new terms. Rothko was also commissioned to do several paintings for the Four Seasons restaurant in New York. These works were eventually given to the Tate Gallery in London with the condition that they were be kept together to form an environment. He also did rooms for Harvard University in 1962 and Houston's Ecumenical Chapel for Human Development in 1965–66 (fig. 83).[76] These series can be considered as a climax to his oeuvre.

In Europe, Rothko visited Florence and was impressed by the blank, interior classicizing walls of Michelangelo's Laurentian library. When he returned home, he seemed to find a new symbol for the rites of passage: the portal or sacred door. In the vertical rectilinear forms of the Harvard murals Rothko stressed the notion of portals as

well as architectonic enclosure. The paintings combine references to Michelangelo's rectilinear doorways with those of the Boscoreale and Boscotrecase panels, with their small, decorative rectangles on top and illusionistic architecture.

Rothko spoke of his work as a doorway and often stressed that it represented the transcendental. Such themes are part of the symbolization of the ritual passage to sacred places. Fundamental to all religious and mythic conceptions is the founding of a sacred space. To enter it one must pass through a threshold, which is often symbolized by a door, and in so doing, one transcends the profane world. As Mircea Eliade, the renowned Bollingen scholar of religious practices, writes:

On the most archaic levels of culture . . . possibility of transcendence is expressed by various images *of an opening;* here, in the sacred enclosure, communication with the gods is made possible; hence there must be a door to the world above, by which the gods can descend to earth and man can symbolically ascend to heaven.[77]

In ritual, mankind opens a pathway to the transcendent world. Rothko's Harvard murals represent the sacred site of passage and once again form modern versions of traditional images: the Boscotrecase frescoes contain allusion to such a sacred gateway in their dark, shimmering surfaces (fig. 84).[78] Such passages symbolize the process of death and rebirth. Rothko himself suggested "that the dark mood of the monumental triptych was meant to convey Christ's suffering on Good Friday; and the brighter hues of the last mural, Easter and the Resurrection."[79] But again, while the gateway suggests a glimpse to the transcendental, Rothko concludes pessimistically, following Michelangelo's blank portals, that there is no real escape.[80] All exits are blocked.

Figure 83. Mark Rothko, north, northeast, and east wall paintings in the Rothko Chapel, 1965–66. Photo: Hickey and Robertson.

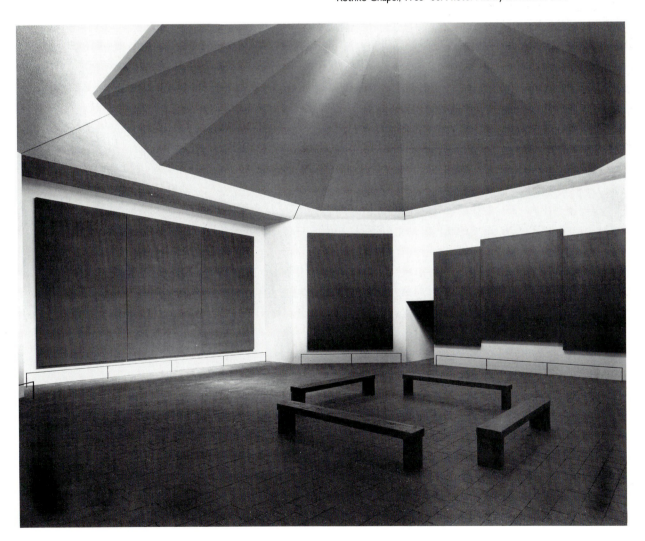

Figure 84. Boscotrecase fragment, detail of Sacred Gate, ca. 31 B.C. to 50 A.D. Fresco. The Metropolitan Museum of Art, Rogers Fund, 1920. (20.192.10)

Rothko appropriately concluded his re-creation of sacred space in the Ecumenical chapel in Houston. Here he founds a holy ground, a space nearest God and the gods, in one of their representations on earth, the temple or church. In religious belief, such a site forms an *imago mundi,* a consecration of the cosmos, a physical and earthly re-creation of the divine and transcendent world of the gods.

The Ecumenical Chapel in Houston renews Rothko's lifelong goal of establishing a modern version of religious tradition in architecture and painting. Although he struggled with Philip Johnson over the design and lighting of the chapel, its octagonal shape successfully echoes one of Rothko's favorite buildings, the Torcello baptistry and church in Venice. The paintings, too, evoke the sacred past. They are done in solemn and grave blacks and

maroons. Some of the panels are arranged in triptychs and some have raised central panels that allude in particular to Renaissance Crucifixion and Deposition scenes.[81] Rothko may also have considered the paintings as a Stations of the Cross series, in other words, yet another sacred Christian ritual of death and rebirth. Again, hue, format, and tradition, as well as form, underscore his theme.

The chapel paintings climax Rothko's lifelong subject: the absorption of the individual by his spiritual environment. The paintings and chapel together, the within and without, fulfill his theme of the enclosing, embracing world of humanity's inner tradition and inherited fate. At Houston, more than ever before, Rothko's work moves out into the room and envelops the viewer within his own cultural and emotional past. Adopting the role formerly played by figures of sectarian religious creeds, like Christian and ancient patriarchs he admired, Rothko sought to engage the history of human spirit and foretell the embrace of the fate of his tribe through a ceremonial art of his own time.

CONCLUSION

Rothko's art is a modern version of the Greek idea of tragedy. Seeing humanity at the mercy of the gods, the Greeks wrote tragedy. Rothko reinvented the Greek tradition in modern pictorial form, attempting to infuse in the viewer an understanding of the modern gods that shape his destiny—psyche, environment, heritage, and tradition.[82] Yet his intentions were not simply to portray bleak fate. Rothko offered images of the enduring history, continuity, and sacredness of human life. He exhibited boldness and imagination in attempting to cope with extraordinary historical events by seeking their sources, by seeming to argue that disaster was not new to the West but familiar and even a tradition. Like many of his generation, he did not accept the Second World War as an exceptional single event signifying the decline of the West, as was commonly thought after the first "Great" War. Instead, by making war seem to be part of recurrent human experience, indeed, merely a new incarnation of human disaster, Rothko offered a reassuring, if wrenching way to cope. Although his work uses the past to rationalize and ennoble the foolishness and waste of the present, like that of many of his colleagues it gauges the changes forever wrought in the American and Western imagination by history and posits a foreboding continuity between ancient and modern times. Eliot's widely influential formulation of one of the most fundamental conceptions of his generation expresses Rothko's sense of things: "In my beginning is my end."

ADOLPH GOTTLIEB

The Allegorical Epic

Graspings: wholes and not wholes, convergent, divergent, consonant, dissonant, from all things one and from one thing all.

Heraclitus 124

The counter-thrust brings together, and from tones at variance comes perfect attunement, and all things come to pass through conflict.

Heraclitus 75

The sun is new every day.

Heraclitus 48A

Adolph Gottlieb was perhaps the most professional and self-aware of the Abstract Expressionists. In the early 1940s, he achieved a fertile style, the Pictographs, that served him for more than a decade and made major contributions to the development of Abstract Expressionism. In the Burst series of 1957 onward, he followed with an abstract art of monumental cosmic and psychic melodrama that is among the most sophisticated achievements of postwar art. The Pictographs and Bursts embody a balancing act, an attempt to think through and mediate the multiplicities of art, style, and human possibilities as a whole. With Gottlieb, duality or the "versus" habit within the stream of human endeavor reaches its apogee—as philosophic maxim, style construct, and allegorical process of history.

Adolph Gottlieb was born in New York on March 14, 1903. He decided to be an artist when he was quite young. By the early 1920s he was taking art classes at Parsons, the Art Students' League, and The Cooper Union in New York.[1] He studied Hamilton Easter Field's *The Technique of Oil Painting and Other Essays* of 1913, which gave him the basics of oil painting and a palette of earth colors that he associated with the Old Masters;[2] indeed, in the 1940s, earth colors would become a major thematic importance in his art. He also studied Max Dorner's book on paint materials and techniques and referred to it throughout his life.[3] At the Art Students League he heard lectures by the Ash Can painter Robert Henri, who advised painting on canvas without preliminary sketches. Gottlieb followed this advice and later coupled it with the concept of automatism. In 1920–21 he studied with another Ash Can artist, John Sloan, who influenced Gottlieb's interest in modernism. The following year he traveled to Europe, which was unusual for an American-born Abstract Expressionist, studying at the Grande Chaumière school in Paris and visiting Berlin and Munich.

Throughout the 1920s and most of the 1930s Gottlieb painted traditional still lifes, nudes, and portraits, some of which he exhibited in his first show at the Dudensing Gallery in 1930. These works indicate that he was at first unaware of or uninterested in recent developments in modern art and its subject matter (surrealism). His style is painterly and tonal, with loosely defined shapes reflecting a myriad of influences from Picasso to Walter Kuhn to his friend, Milton Avery. In the early years of his career, he developed as a student of first-generation traditional modernism.

Perhaps the most interesting early painting is *The Wasteland* of 1930 (fig. 85). It is significant not for its style—it is a rather bland figure composition of brown color patches resembling the work of Jules Pascin, who exhibited at the Weyhe gallery—but for the way Gottlieb presented the great issue of the day, the Depression, using ideas and images from Eliot's poem *The Waste Land*, which he had just read and with which he was "fascinated."[4]

Figure 85. Adolph Gottlieb, *The Wasteland,* 1930. 22 x 34 inches. ©
1979 Adolph and Esther Gottlieb Foundation, New York. Photo: Otto
E. Nelson.

Eliot's poem has nothing to do with the Depression, of
course, but Gottlieb drew what he described as a parallel,
using specific images from it: the dry, infertile, "brown"
land; the trees with "roots that clutch"; the mood of
empty, dull inaction; and the "loitering" despair of unem-
ployed men waiting for hope and rebirth, who are brushed
as "The wind Crosses the brown land, unheard." While
the subject is unusual for Gottlieb at this time, it foreshad-
ows his later approach: addressing historical issues by
adapting literary or philosophical ideas. In this unusual
painting, Gottlieb comes to terms with history not through
political imagery but by means of modernist thought and
"symbolic figuration."[5]

In 1937, Gottlieb moved to Arizona for his wife Esther's
health, and his work changed significantly. While it is
arguable that the desert sky and space had much to do
with the changes, the mix of American styles that had
dominated his early 1930s work had begun to break
down and Gottlieb looked elsewhere for inspiration. In
1936 the Museum of Modern Art had held a major
surrealist show, and Gottlieb's art newly reflected the

impact of illusionistic surrealism, the first wave of surrealist
influence in America. Gottlieb had also become ac-
quainted with the work of the Mexican artist Rufino
Tamayo who, after first exhibiting in New York in 1926
at the Weyhe Gallery, settled in New York in 1936 as a
Mexican delegate to the American Artists' Congress. He
remained for twenty years, teaching at the Dalton School
and exhibiting regularly. Tamayo exhibited an unknown
gouache still life in the first Art Congress show in 1936–
37 in which Gottlieb himself exhibited a landscape.

These new influences can be seen in Gottlieb's still-life
painting from the Southwest. Paintings such as *Untitled
[Still Life—Landscape in Window]* of 1938 (fig.86) recall
Tamayo's *Still Life with Hand* of 1928 and perhaps also
paintings by Gottlieb's friend Avery. Tamayo and Gottlieb
set objects on a high-rising corner of a table placed before
a divided back plane of a window edge and landscape
view. Both artists emphasize the contrast of shapes and
have a soft handling of paint. In *Untitled (Pink Still Life—
Curtain and Gourds)* of 1938 (fig. 87) Gottlieb even more
sharply develops Tamayo's high-angled vantage point and

dispersal of objects. The hole of the angular gourd echoes that of the candlestick (?) in the Tamayo. Significantly, the painting contains a checkerboard of light and dark squares which foretells Gottlieb's lifelong mode of composition: the checkerboard dispersal of objects over a flat surface.

In several of his still lifes of the late 1930s, time seems to be a growing theme. The catalyst may have been Tamayo's emphasis on heritage in works such as *The Alarm Clock* (fig. 88), combined with the Southwest desert of the geological past, and Gottlieb's own continued absorption of Eliot, or the emergence of time and space as a theme among the future Abstract Expressionists, including not only Gottlieb's friend Rothko but Baziotes, whose *Clown and Clock* of 1944 contains a faceless clock representing a Baudelairean suspension of time, in other words, eternity.[6]

On a Braque-like tilted table in *Still Life—Alarm Clock* (fig. 89) Gottlieb set a clock with the numbers awry and not in proper order, thereby denying the idea of the progression of time in a measurable mechanical sequence. A strong angular shadow here as in other works suggests Gottlieb's familiarity with one of Rothko's sources, de Chirico, master of the representation of magical mysteries and irrational time. (Dali's *The Persistence of Memory*, with its watch and near and distant spaces suggesting the processes of time, may also have been a source.)

As he introduced a contrast between contemporary and eternal time, Gottlieb also set up a dialogue between flatness and depth, between the near and far, between juxtaposition and contrast, that would characterize his work for the remainder of his career. In *Untitled [Still Life—Landscape in Window]*, for example, he sets bones, petrified wood, and cacti on a table next to a window with a view of a distant mountain range. A journey in time is suggested by the near and remote aspects of time and space. Ancient objects are physically close to the picture

Figure 86. Adolph Gottlieb, *Untitled (Still Life—Landscape in Window)*, 1938. 29⅞ x 39⅞ inches. © 1979 Adolph and Esther Gottlieb Foundation, New York. Photo: Otto E. Nelson.

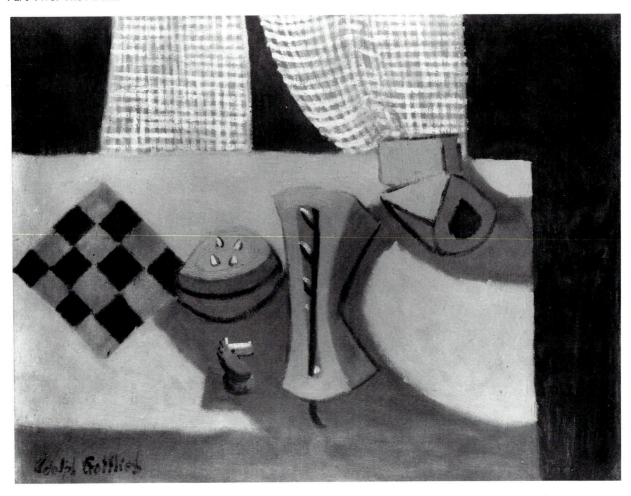

Figure 87. Adolph Gottlieb, *Untitled (Pink Still Life—Curtain and Gourds)*, 1938. 30 x 39¾ inches. © 1979 Adolph and Esther Gottlieb Foundation, New York. Photo: Otto E. Nelson.

plane and viewer, while the contemporary landscape is physically remote. Fragmentary shapes sharply contrast with one another, yet everything is held together by a brown tone. The great impact of Eliot and interwar concerns with time present and time past is evident in the more inventive form of these works which prefigure his mature art.

In 1939 Gottlieb returned to New York and painted a handful of Daliesque box pictures which are often considered of crucial importance to his work (fig. 90). These paintings contain objects Gottlieb had collected and placed in single compartments.[7] However, the box paintings are exceptional, there being no more than five or six of them. More significant as the resolution of his late 1930s checkerboard still lifes is the two-dimensional tablet form, for example, *Pictograph—Tablet Form* of 1941 (fig. 91) in which the table plane is now vertical and objects have become abstract and symbolic shapes. The claw form and

the compositional concept of pictograph mark the emergence of his renowned paintings of the 1940s.

UNITY IN COLLECTIVITY: THE PICTOGRAPHS

In 1939–41 Gottlieb, like Benton and many of his colleagues, felt a crisis on several levels. The end of the Artists' Congress put the finishing touches on the 1930s as an art historical entity in America, yet the arrival of the abstract surrealists only intensified the problem of how and what to paint. The end of the thirties meant an end to Gottlieb's still-life painting. He, like the other Americans, wanted an art of his own. His solution was to wed abstraction to a world tradition and surrealism, producing the original ideographic abstraction of Abstract Expressionism, that is, a style with the look of near abstraction

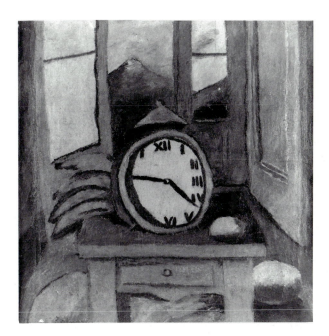

Figure 88. Rufino Tamayo, *The Alarm Clock*, 1928. Courtesy Mary-Anne Fine Art, New York.

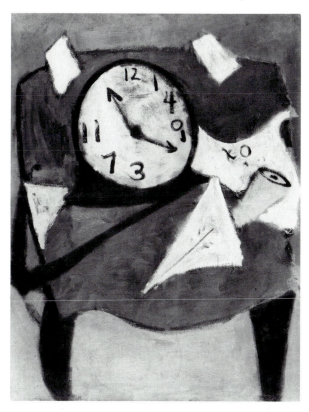

Figure 89. Adolph Gottlieb, *Still Life—Alarm Clock*, 1938. $33\frac{7}{8} \times 25\frac{11}{16}$ inches. © 1979 Adolph and Esther Gottlieb Foundation, New York. Photo: Otto E. Nelson.

but imbued with and structured upon interwar themes.

But the issues were more serious than style: subject matter was just as problematic. When he joined Newman and Rothko in proclaiming in the letter to *The New York Times* of 1943 that there "is no such thing as good painting about nothing," Gottlieb indicated that the choice of subject and not style was most important to him. That letter to *The New York Times* is one of the classic statements about the content of Abstract Expressionism. In response to Edward Alden Jewell's befuddlement over Gottlieb's *The Rape of Persephone* and Rothko's *The Syrian Bull*, shown in a Federation exhibition, Gottlieb and Rothko declared:

We consider them [the paintings] clear statements. . . .

It is an easy matter to explain to the befuddled that "The Rape of Persephone" is a poetic expression of the essence of the myth; the presentation of the concept of seed and its earth with all its brutal implications; the impact of elemental truth. Would you have us present this abstract concept with all its complicated feelings by means of a boy and girl lightly tripping?

It is just as easy to explain "The Syrian Bull", as a new interpretation of an archaic image. . . . Since art is timeless, the significant rendition of a symbol, no matter how archaic, has as full validity today as the archaic symbol had then. Or is the one 3000 years old truer? . . .

The point at issue . . . is not an "explanation" of the paintings but whether the intrinsic ideas carried within the frames of these pictures have significance. . . .

It is a widely accepted notion among painters that it does not matter what one paints as long as it is well painted. This is the

essence of academicism. There is no such thing as good painting about nothing. We assert that the subject is crucial and only that subject matter is *valid which is tragic and timeless*. This is why we profess spiritual kinship with primitive and archaic art.[8]

Through these words, Gottlieb, with Rothko and Newman, defined the subjects that underlie his Pictographs: the holistic unity of the multiple cultures and civilizations, histories, religions, myths, and artistic languages of humankind.

In the early 1940s Gottlieb, with Rothko, decided his subject matter should be classical myth:

If we were to do something which could develop in some direction other than the accepted directions of that time, it would be necessary to use different subjects to begin with and, around 1942, we embarked on a series of paintings that attempted to use mythological subject matter, preferably from Greek mythology. I did a series of paintings on the theme of Oedipus and Rothko did a series of paintings on other Greek themes. Now this is not to say that we were absorbed in the mythological, although at that time a great many writers, more than painters, were absorbed in the idea of myth in relation to art. However, it seemed that if one wanted to get away from such things as the American scene and social realism and perhaps

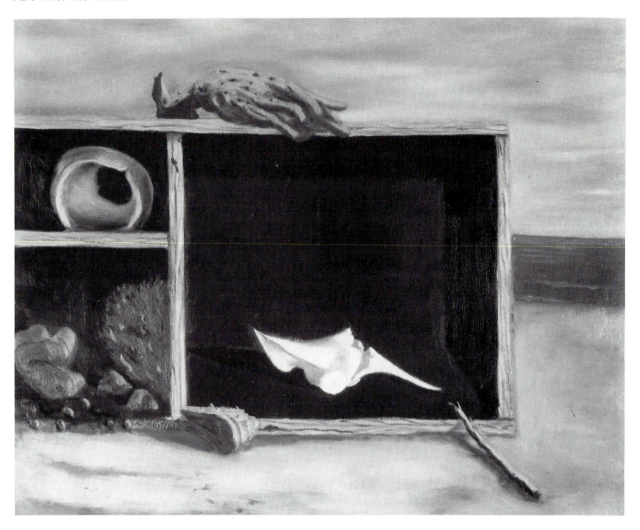

Figure 90. Adolph Gottlieb, *Untitled (Box and Sea Objects)*, 1940. Oil on linen. 25 x 31⅞ inches. © 1979 Adolph and Esther Gottlieb Foundation, New York. Photo: Otto E. Nelson.

cubism, this offered a possibility of a way out, the hope was that given a subject matter that was different, perhaps some new approach to painting, a technical approach might also develop; such a new approach did develop.[9]

The Oedipus myth was the classic tale of misadventure and tragedy. In Freud's interpretation it is of course representative of sexual drive, instinct, and taboo, and thus is mostly a personal, sexual and autobiographic myth and experience. Gottlieb ignores such an interpretation. His view is that Oedipus is a general tale of universal, suprapersonal significance, that is, of the collective or public experience of humankind. Gottlieb also read Jung at the time and recognized him as the one "who came up with the idea of the collective unconscious."[10] He attributed the general freedom and variety of his paintings more to Jung than Freud.[11] Gottlieb's turn toward myth

has overtones of a turn to universal inwardness, which has roots as well in the search for heritage in the interwar period as a whole. Jung made the connection between the modern era and the collective inner past, common in his era, in a discussion of Oedipus:

We realize with astonishment that Oedipus is still alive for us. The importance of this realization should not be underestimated, for it teaches us that there is an identity of fundamental human conflicts which is independent of time and place. What aroused a feeling of horror in the ancient Greeks still remains true, but it is true for us only if we give up the vain illusion that we are *different*, i.e., morally better than the ancients. We have merely succeeded in forgetting that an indissoluble link binds us to the men of antiquity.[12]

Gottlieb in general accords with several of his era's concepts of representing antiquity and myth as modern sub-

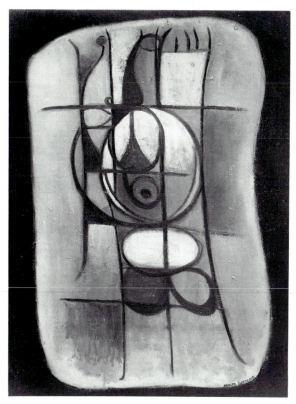

Figure 91. Adolph Gottlieb, *Pictograph—Tablet Form,* 1941. 48 × 36 inches. © 1979 Adolph and Esther Gottlieb Foundation, New York. Photo: Otto E. Nelson.

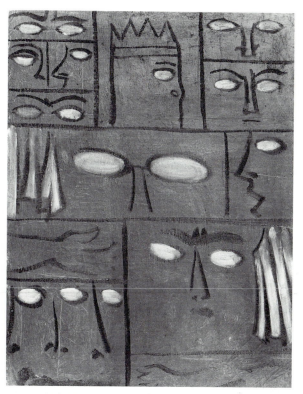

Figure 92. Adolph Gottlieb, *Eyes of Oedipus,* 1941. 32¼ × 25 inches. © 1979 Adolph and Esther Gottlieb Foundation, New York. Photo: Otto E. Nelson.

conscious reality rather than as mere stories. Myth also offered a conceptual approach to style in which new subjects engendered new forms, and not vice versa. In this, Gottlieb was echoing, as noted by Benton, the American approach to art in the 1930s, where choice of subject preceded and shaped choice of style.

WORLD TRADITION

Pictographs reflect their partial origins in archaic, traditional, and primitive signs or petroglyphs. A pictograph is defined in the dictionary as an ancient or prehistoric drawing or painting on a rock wall and as one of the symbols belonging to a pictorial graphic system. To Gottlieb it was a new tool for investigating the "near and far" of inner history and life. In one of the first exhibitions of Gottlieb's Pictographs, at the Wakefield Gallery in 1943, the Pictographs were listed in groups entitled "Relics," "Fragments," "Symbols," "Archaic Themes," and "Ancient Motifs." Much like Rothko, Gottlieb sought what was thought to be humanity's common past, but while Rothko focused on the Greco-Roman tradition, Gottlieb more fully incorporated primitive and world heritages.

Let us first examine the structure of the Pictographs. In the first series, the *Oedipus* group from 1941 to 1945, Gottlieb divides the canvas into multiple compartments. In one of the earliest examples, *Eyes of Oedipus* of 1941 (fig. 92), the compartments are roughly drawn, half empty or filled with frontal or profiled eyes and faces with uninflected expressions.[13] Gottlieb draws more than paints here, and he plays with the ideas of drawing as painting, of line versus plane, and of grid versus zigzag lines. This picture resembles Rothko's early work, with its segments of anatomies, especially in the joined frontal and profile heads in the lower left compartment. More effective are *Hands of Oedipus* and *Pictograph #4* (fig. 93), both of 1943, which have more developed compartments and images. The former is more linear, the latter more planar in the forms of the shapes.

There were several sources for the Pictographs. The primary one is the early Western tradition—the early Renaissance predella with multiple narrative scenes. Gottlieb indicated that these were the primary reference, but he also distinguished his work from them by denying the presence of their logical sequence and temporal narrative in his own work:

First I'd put down the grid of lines. The grid was an anti-formal device, an arbitrary structuring. What I had in mind were 14th

century predellas which were pictures with a series of boxes each containing an event in the life of Christ. My pictographs were similar but different. They were divided by lines but the images were to be seen simultaneously and instanteously. There were different focus points and many different times while the predellas were chronological and had a line of focus.[14]

In many Renaissance predellas, the life of Christ followed a sequence from his birth to the Resurrection. The Pictographs have a different sense of layered space: "In other words, you could begin at any point and look in any direction and keep going back and forth and every which way."[15]

Primitive art was another source for the Pictographs. Gottlieb was familiar with primitive art from at least 1935, when he began collecting African art on a trip to Paris.[16] His interest in the primitive was partially the result of a friendship with John Graham, who collected primitive art and wrote about its relationship to the unconscious. Graham was for Gottlieb, as he was for Gorky, De Kooning, Pollock, and David Smith (whom Gottlieb knew well in Brooklyn in the late 1930s), among the first direct links to the new modern subject matter—the primitive and the unconscious.[17]

Gottlieb also frequented the Brooklyn Museum collection of primitive art and, when living in the the Southwest, he visited the Arizona State Museum in Tucson, where he saw several pots in its "marvellous collection of Indian things."[18] And he undoubtedly saw the 1937 exhibition *Prehistoric Rock Pictures in Europe and Africa* and the 1941 show on *Indian Art of the United States,* both at the Museum of Modern Art.

Most critics, limiting discussion of Abstract Expressionism to modernist ideologies of primitivism, have emphasized only the primitive sources for the Pictographs, often the Chilkat blankets of the Northwest Coast. This emphasis misses the point. As Gottlieb noted of his Pictographs, "I was interested in reading Jung at the time and the idea [of the collective unconscious] interested me.... [I]t just corroborated my idea that I wasn't really interested in primitive art."[19] While the primitive is a source, the Pictographic structure and use of imagery from traditional as well as primitive societies declare that the Pictographs represent an archetypal form, one found in wall murals of innumerable cultures from the Assyrian to the Egyptian to Native American and Oceanic. Gottlieb's Pictographs parallel Rothko's compositional registers drawn from ancient friezes and further indicate that Abstract Expressionism's concept of originality involved a connection with the past rather than modernity for its own sake.[20] In this, Abstract Expressionism harmonizes with American art of the 1930s, and with the thought of contemporaries such as Jung, Joyce, Pound, and Eliot.

Gottlieb appropriated several aspects of these cultural scripts. The tablet form used in such works as *Pictograph—Tablet Form* and *Persephone* of 1942 (fig. 94) recalls archaic writing tablets such as cuneiform tablets. The form itself suggests a simple humanoid totemic shape and has only implicit references. In *Persephone* Gottlieb also alludes to Native American masks by placing, in the bottom center, a form with a wedge-shaped mouth derived from similar grimacing mouths he had seen in the 1941 exhibition and, probably, in the American Museum of Natural History (e.g. fig. 95). Gottlieb adds an African profile at the right, which is partially taken from the profile of an African carving he owned (fig. 96—the figure on the left). Leaf-eye forms finish the composition, which is painted in earth tones.

The Pictograph structure also addressed itself to modern painting, specifically the rectilinear compositions of Mondrian, whom Gottlieb admired, and perhaps, the Latin American artist Joaquin Torres-Garcia whose work Gottlieb had seen in the Gallatin collection of the Living Gallery. Torres-Garcia's work consists of flat compartments of signs and symbols from modern and Pre-Columbian culture. Gottlieb acknowledged that his Pictograph grid may have been influenced by Torres-Garcia's cubist grids, though he felt the two had very different ends.[21] Whatever the relationship, Gottlieb's work is richer, less linear, and more varied in allusion than that of Torres-Garcia. Gottlieb's structure also roughly approximates synthetic cubist compositions such as Picasso's *The Studio,* although Gottlieb felt cubism to be a trap, both historically and intellectually.

Thus, the Pictographic structure situated itself in several cultures and evoked memories across time and civilizations.[22] Regardless of the images within the compartments, the Pictographic structure itself formed an elemental, primitive, Renaissance, and modern world tradition. Gottlieb's concept of originality is the gathering in a new way of older forms that reflect age-old human needs and cultures rather than the creation of new forms alone.[23]

Octavio Paz, in defining the position of Tamayo in modern Mexican painting, also illuminates the universal goals of Gottlieb, Torres-Garcia, and others of the inter-war and war periods:

The Revolution is a return to origins as well as a search for a universal tradition.... The Revolution is, on the one hand, a revelation of Mexico's historic subsoil; it is, on the other hand, an attempt to change our country into a really modern nation.... However, to transform oneself into a modern nation does not only mean the adoption of certain techniques of production, but inserting oneself in a definite universal tradition. Or to invent a new project, a new vision of man and of history.... Tamayo is neither an intellectual nor an archeologist. This modern man is also very ancient. And the force that guides his hand is not different from that which moved his Zapotec

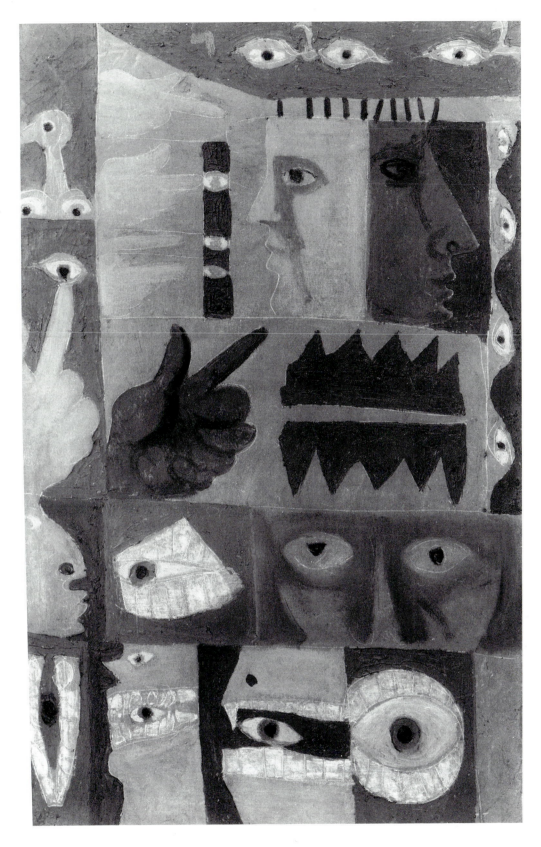

Figure 93. Adolph Gottlieb, *Pictograph #4*, 1943. $35\frac{1}{4}$ x $22\frac{7}{8}$ inches. ©
1979 Adolph and Esther Gottlieb Foundation, New York. Photo: Otto
E. Nelson.

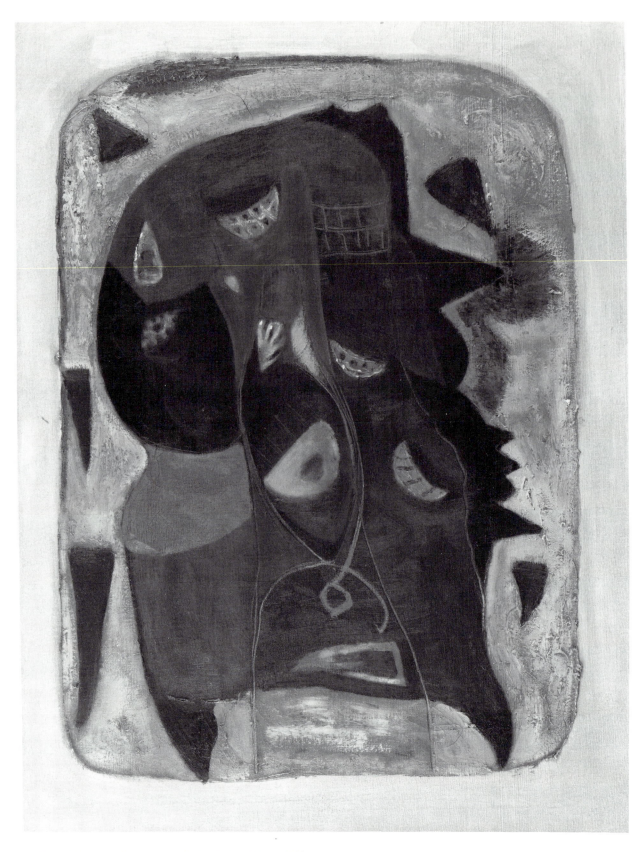

Figure 94. Adolph Gottlieb, *Persephone*, 1942. 34 x 26 inches. © 1979
Adolph and Esther Gottlieb Foundation, New York. Photo: Peter
Muscato.

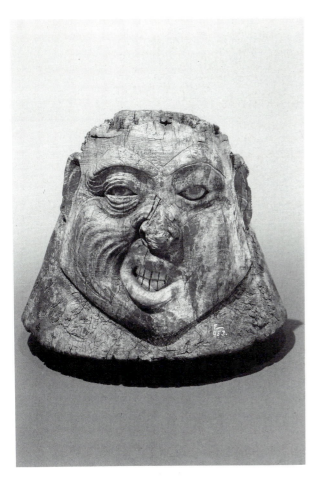

Figure 95. Tlingit war helmet. Carved wood. 12 x 13 inches diameter. The American Museum of Natural History.

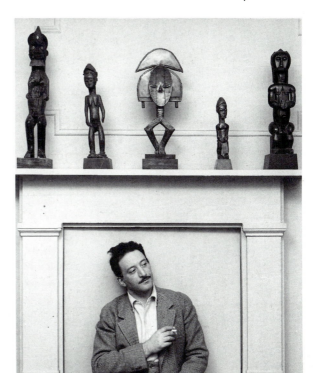

Figure 96. Aaron Siskind, Gottlieb with his collection of African carvings, 1940. © 1979 Adolph and Esther Gottlieb Foundation, New York.

ancestors. His sense of death and of life as an inseparable whole, his love for primordial elements as well as for elemental beings, reveals him as an erotic temperament, in the noblest and most ancient sense of the word.... [T]he world does not offer itself to him like an intellectual schema but as a live organism of correspondences and enmities.[24]

Like Mexican revolutionaries, Gottlieb too sees the transformation of contemporary life through the development of a modern version of ancient traditions.

SIMULTANEITY, TRANSPARENCY, AND LABYRINTH

Gottlieb's Pictographs fuse associations of human behavior in every culture, and they have "no beginning and no end."[25] They aim at creating this breadth, as Gottlieb indicated in his discussion of the predella, by simultaneity and instantaneity in image and structure. The possibility of representing simultaneity in art originated with cubism.

Simultaneity was one of the most important aspects of interwar literature and art, informing the concern with unities of space and time and the stream-of-consciousness technique. The cubist concept of simultaneity originally involved incorporating multiple views of a single object in a single image. It was quickly expanded to include the idea of collaging different images, objects, spaces, and realms of consciousness. Simultaneity or Simultanism was

an attempt to embody a *change of consciousness* in response to a feeling that sequential modes of thought and expression were inadequate to realise the fullness and complexity of life.... Instead of focusing on ... a single thread of feeling, instead of concentrating on a single clear emotion [and subject], the Simultanists tried to represent the interrelatedness of all things, mental events, and feelings which might be widely separated in time and space but which were brought together by the mind.[26]

The concept of Simultanism was influenced by Henri Bergson who also influenced the surrealists. Bergson believed that all is simultaneously present to consciousness, which is perpetually mobile, ceaselessly transforming its past into the present through memory. The present is composed of any number of interpenetrating states of being.

By Gottlieb's time, simultaneity was combined with other concepts. One was artistic continuity. According to

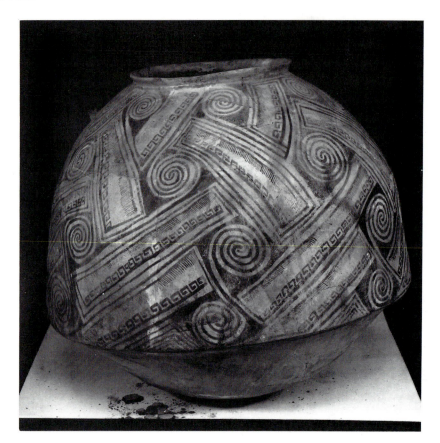

Figure 97. Sacaton red-on-buff jar from Snaketown, Arizona. 18 x 21¾ inches diameter. Arizona State Museum, University of Arizona.

Eliot, an author with a historical sense writes with the whole feeling of literary tradition in his bones so that it exists simultaneously with contemporary literature. Pavel Tchelitchew, who at this time had a strong reputation and exhibited at the Museum of Modern Art, added the concept of metamorphosis. Writing of his *Hide and Seek* of 1943, he noted that it consisted of three different subjects seen from three different vantage points: "each point of view is attached to a separate moment of time, which in the condition of metamorphosis inherent in the painting exist as one, simultaneously, indivisibly and independently."[27] In other words, simultaneity suggested constant temporal metamorphosis of the many simultaneously into the one. A third association was time and space. In a discussion of simultaneity and the presentation of several points of view, Giedeon noted:

In modern art, for the first time since the Renaissance, a new conception of space leads to a self-conscious enlargement of our ways of perceiving space. It was in cubism that this was most fully achieved. . . . It views objects relatively: that is, several points of view, no one of which has exclusive authority . . . from above and below, from inside and outside. . . . Thus, to the three dimensions of the Renaissance which have held good as constit-

uent faces throughout so many centuries, there is added a fourth—time.[28]

Giedeon continues by declaring that the relations between social development and architecture have often been too much simplified. For Giedeon, new modern spaces are complex and historical, as they have many dimensions and are many-sided, again without a single focal point or point of reference.[29] An architect can create a simultaneous representation of the varieties of world culture, consciousness, and history as a new universality.

The idea of a simultaneous past-but-present universality can be seen throughout Gottlieb's work in archetypal structures, quotations, and allusions. The concept is expressed in his Pictographs by the quotation of forms from different world cultures and times. In *Masquerade* of 1945, for example (pl. 9), Gottlieb makes good use of masks that were so common in Abstract Expressionism. He combines an Egyptian mask at the left with one derived from an Ernst image (*Woman Bird*) below it and a lion or another Egyptian god image in the center. To these are added spirals reflecting the Native American Hohokam pottery of Southern Arizona with its triangular-edged, spiral forms

(fig. 97), which Gottlieb saw in the Museum of Modern Art exhibition. Diamond forms and wedgelike copper shapes reflect other Indian art. Most images are presented in earth colors. Other works draw on other cultures: *Oracle* of 1947 contains a Greek head, while *Night Voyage* of 1946 has an Oceanic shield figure (probably drawn from the *Art of the South Seas* exhibition at the Museum of Modern Art that year). *Pictograph #4* of 1943 affiliates heads suggestive of different races or ethnic groups of humankind—white, black, and Hispanic or Pre-Columbian. Other works contain prehistoric dappling, perforations, tectiforms, and incised surfaces. Most often Gottlieb places the different references in different compartments, denying the idea of a chronological sequence of past, present, and future. Instead, the different cultures exist simultaneously. Sometimes the forms do overlap, however, as in *Recurrent Apparition* of 1946 (fig. 98) and *Night Flight* of 1951; nevertheless, significantly, the forms do not obliterate or erase one another. Intentionally, nothing is lost.

In many works, transparency is important. Transparency can be carried out in two different ways. "One is the superimposition of different configurations—bodies or lines—one over the other, without harming or obliterating any of them."[30] The second, typical of prehistoric and Indian art as we have seen before in Still and to a degree in Rothko, is making a body transparent so as to portray both its inside and outside. In Gottlieb's *Oracle*, for example, he portrays lung shapes within an arch. In other works, skeletal forms fill compartments next to fully fleshed anatomies. The eye, for Gottlieb, and others, suggests a similar pathway and simultaneity between the inner and outer worlds.[31] In still other works, such as *Recurrent Apparition*, the contrast in tones between opaqueness and transparency and closed and open outline suggests the various stages along a pathway between the two. For Gottlieb, inner and outer reality overlap.

Gottlieb further symbolized the dynamic exchange between inner man and the external world through the use of natural imagery. Like other Abstract Expressionist artists, in order to represent fragments that emerge from below and their continuity with the surface of life, Gottlieb hoped to make his paintings function as though they were

Figure 98. Adolph Gottlieb, *Recurrent Apparition*, 1946. 36 x 54 inches. Elvehjem Museum of Art, University of Wisconsin–Madison, Elvehjem Associates Fund, Friends of the Elvehjem Fund, Emily Mead Bell Fund, and Tenth Anniversary Fund Purchase. (1980.56)

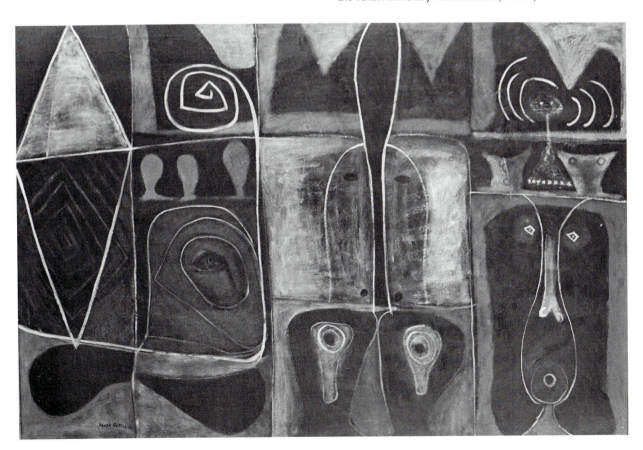

natural objects in which memories, subconscious thought, and fragments of the past parallel and interrelate with natural form. Together they constitute a continuum and synthesis of inner and outer life.

For Gottlieb what is within is nature. The advancing and retreating planes and images, their interpenetration and transparency, without any fixed barrier between memory and form, suggest the collaging of psyche, history, culture, and nature to form a new concept of the whole of history. For Gottlieb and his generation, the goal was to make their art come alive as real, as tangible, and not merely depicted, psyche and nature—hence Rothko's light dramas, Pollock's subterranean forces, Still's mesa textures, Lipton's chthonic skins, Lassaw's tendrils, De Kooning's flesh, and Newman's "dry light." It was long a goal in twentieth-century art to make a work of art an object free of the mere mimesis of nature, to make it an autonomous thing in itself, to make it pulsate and *emenate* as though the painting were a live natural creature.[32] Indeed, Gottlieb often makes his Pictographic collages of nothing more than heads, eyes, feet, wings, and so on; in other words, the work itself is a complex, layered figure.

Gottlieb sought to make his entire concept of historical experience live and breathe. He expressed the concept many times. For the artists of his era, one of the most natural subjects was the landscape of the mind:

Certain people always say we should go back to nature. I notice they never say we should go forward to nature. It seems to me they are more concerned that we should go back, than about nature. If the models we use are the apparitions seen in a dream, or the recollection of our pre-historic past, is this less part of nature or realism, than a cow in a field? I think not.[33]

The painting is alive:

If the painter's conception is realized in the form of an image, we are confronted with a new natural object which has its own life, its own beauty and its own wisdom.[34]

Like all Abstract Expressionists, Gottlieb presents human life in all its variety and multiplicity within and without as nature itself. With the contents of the Pictographs distributed equitably (prefiguring the structure and content of mature Abstract Expressionism's all-over style), he suggests the continual accretion and growth of memories and experiences, yet the elucidation of shared, germinal elements and movements of the natural world. His work is another expression of Pollock's generational statement, "I am nature."

To accent the multiplicity and interconnectedness of the images, the allusive forms, colors, and shapes interact at various levels of space across the now more loosely and flowingly constructed compartments. In *The Red Bird* of 1943 (fig. 99) the shapes and colors again suggest a forest

Figure 99. Adolph Gottlieb, *The Red Bird,* 1943. 40 x 30 inches. Solomon R. Guggenheim Museum, New York. Photo: Robert E. Mates.

scene where lurks a red bird with pegged teeth like that of the snake monster in Rothko's *Vessels of Magic.* Color accent is placed asymmetrically at the right off-center, dynamically balancing to the left a yellowish-white bone or organic form. Brighter prehistoric tectiforms at the bottom center stand out from the general earth and gray tones. White dots weave illogically between compartments and onto forms—tying them together like Oceanic art.

Gottlieb's Pictograph motifs—fragments of anatomy, birds, masks, faces, serpents, arrows, teeth—form no literal narrative. They subvert narrative:

For example, I was using these disparate images which had no rational connection and they didn't seem to make sense. If people did anything they would try to read them as a rebus, which was not my intention.[35]

Although Gottlieb drew from many cultures, he altered the imagery for artistic effect and to make the signs universal as well as local. Abstraction or semiabstraction partially frees them from their specific form and context.[36] His favorite images were those he did not understand.[37] Gottlieb developed a pictorial language which was his version of the early sign languages of Abstract Expression-

ism. It parallels the semifigurative modes of Still's life line and eye figures, Pollock's primitivistic "stenographic" notational figures, Rothko's fragments and quotations, even Lipton's calligraphic sculptural signs in *Exodus.* The Pictographs present psychic/primitive, or Primal, calligraphy of elemental signs.

Gottlieb's working method, signifiers, and results reflect the psychological nature of the Pictographs. The emphasis is on the concept of a *stream* of space and time forms as well as on the forms themselves. The Pictographs' layering and configurations, their simultaneity, fusion, and contrasts, embody the contemporary notion of a stream of consciousness, of an internal monologue and the "dream space" of the telescopic psyche—much like, and probably inspired by, Joyce's complex word combinations and puns in *Finnegan's Wake.* Surfaces and textures often overlap, as in *Recurrent Apparition* and *Totemic Figures* of 1948 and *Night Flight,* reenacting the continual interconnecting and peeling off of subterranean layers of the mind and past. Gottlieb's final surface is merely a link between the past and future.

In his early Pictographs Gottlieb seems to have clearly thought out his imagery. Later he sought a subjective free association of images and symbols and turned to the surrealist concept of automatism to initiate the stream of consciousness. His pictographic forms flow over surfaces, paralleling the active flow of thought: "They were . . . a form of picture writing or I thought of them as a kind of using an automatic process that was akin to automatic writing of the Surrealists."[38] He used automatism as a way of beginning the stream. The unknown, mysterious, and allusive forms suggest meanings emerging and receding into the mind and human consciousness.

It is instructive to compare Gottlieb's work to earlier art that breaks up the single order of Western space. In Degas's *Rue Lepic,* Cezanne's *Still Life with Plaster Cupid,* or many other late-nineteenth-century paintings, there is no single focal point. The composition is organized by the play of figural configurations and empty planes. The figures, rather than coalescing into a hierarchial whole, point in contradictory, crisscrossing directions. Gottlieb gives this spatial quality a 1940s subsconscious direction in which constellations of meanings, memories, spaces, and shapes, given equal weight, converge and then diverge within the painting's space and the psyche of the viewer. (Arrows are a frequent image.) The orderly spatial world of the Renaissance is further jumbled by Gottlieb for psychological effect, process, and experience.[39] He wrote about *Pictograph #4* in 1944:

I disinterred some relics from the secret crypt of Melpomene to unite them through the pictograph, which has its own internal logic. Like those early painters, who placed their images on the grounds of rectangular compartments, I juxtaposed my picto-

graphic images, each self-contained within the painter's rectangle, to be ultimately fused within the mind of the beholder.[40]

The pictographic space consists of the penetration and withdrawal, the repeated entrances and exits into the layers of the subconscious which the viewer must confront and complete. The title is never a fixed content but merely its point of departure. As in the works of Klee, who influenced Gottlieb, the Pictographs form a landscape through which the viewer actively journeys. Unlike Renaissance art, the viewer does not stand before a window view but is involved as an active participant psychologically and emotionally, communing with the forms and their effect through his or her mind and memories. Gottlieb overlapped shapes, as in *The Red Bird,* or buried grids, as in *Night Flight,* or allowed earlier colors to show through as pentimenti. Lines and spaces continually change, interact, and complete themselves—if ever—in the mind of the spectator. Ultimately, the works are the equivalent space to Baziotes's watery dreams and natural memories, Rothko's shadowy world, and Pollock's dense *Night Mist* or poured paintings.

Gottlieb's teeming and evocative spaces and shapes spot the uncharted and boundless depth of human experience. Totemic themes, "race memories," journeys to the "catacombs of the unconscious," or the "dim recollections of the prehistoric past" center his subjects.[41] His work charts, from the perspective of the 1930s and 1940s, a broad and comprehensive view of human experience as a labyrinthian continuum.[42]

Gottlieb's Pictographs suggest on a micro and macro scale a human journey or pathway symbolized by the teeming stream of the Pictographs. A frequent image in the Pictographs is of journey itself—the spiral, as in *Masquerade,* which suggests "site and path" motifs of Indian pottery and other art.[43] These concentric circles straighten out into a line of travel. The spiral also echoes the diagrammed passage of *The Pilgrim's Progress* (fig. 100) and similar spiritual trials. Other works such as *Birds* contain the Southwest Indian symbol for the four directions, or represent mythic quest itself, as with *Quest* of 1948. *Voyager's Return* of 1946 with its boat sail and snakelike path suggests yet another type of archetypal journey. Combining these symbols and indices of movement and direction with the several allusions of the Pictograph structure as a whole, Gottlieb defines the all-encompassing journey of humankind as a mythic, labyrinthian passage. But for his generation, the mythic labyrinth was not fiction but history.

Figure 100. Plan of the road from the City of Destruction to the Celestial City, from a nineteenth-century edition of *The Pilgrim's Progress*. Mansell Collection, London.

THE PSYCHOHISTORY OF WAR

Gottlieb's Pictographs allude to a specific journey. Like *The Pilgrim's Progress*, the Pictographs symbolically narrate travel through ominous and hostile country, through psychopathological terrain. *Pictograph—Symbol* of 1942 (pl. 10), for example, evokes a deep forest, with a dark umbrage of teeth and what appears to be a hunted fox peering out from the tall tree line and the forest of compartments. Surrounding the prey are scales, the sword of a swordfish and perhaps tusks. The wide domed head at the left draws from works in the 1941 Museum of

Modern Art exhibition, as does the very plastic, vertical profile of the mask at the upper right, characteristic of Northwest Coast masks. It suggests a malevolent beast. The painting's subtle browns, beiges, and scumbled whites—its earth tones—reinforce the sense of moving through nature and fearful, psychic life.

Probably more than any other Abstract Expressionist art, Gottlieb's art addressed contemporary history through the circuitous routes of sublimation, ritual, psyche, and myth. Gottlieb's Pictographs as well as his later work dramatize most clearly the savagery of his era as an epic journey or odyssey of the soul. They represent the

historical, emotional, and psychological experience of their time as modern allegory. Whenever World War II is discussed, it is done so in the language of high drama, barbarity, evil, and emerging cataclysm. Common in descriptions of the war are such terms as "clash of titanic power," "global war," "terror," "devastation," "demon," "heroism," "despair," "resistance," and "hope." Not only is the war the primary historical, moral, and intellectual drama of modern life, not only is it the most terrible war in history, not only were the most monstrous crimes in recorded annals committed, but for those who lived through it, it had, as Churchill often noted, the character of a biblical confrontation between the powers of light and darkness.

On several occasions, Gottlieb articulated what he saw as the relationship between his imagery and his era. In his radio address with Rothko in 1943, when asked why modern artists were using mythological characters, he stated that anyone looking at his portrait of Oedipus would see that its implications have a "direct application to life." Myth is intelligible because an artistically literate person can grasp its meanings just as he or she can grasp the global language of art or "spirit." Primitive art's "demonic and brutal images"

fascinate us today . . . not because they are exotic nor . . . nostalgic. On the contrary, it is the immediacy of their images that draws us. . . .

If we profess a kinship to the art of primitive men, it is because the feelings they expressed have a particular pertinence today. In times of violence, personal predilections for niceties of color and form seem irrelevant. All primitive expression reveals the constant awareness of powerful forces, the immediate presence of terror and fear, a recognition and acceptance of the brutality of the natural world as well the eternal insecurity of life.

Figure 101. Adolph Gottlieb, *Omen for a Hunter*, 1947. 30 x 38 inches. © 1979 Adolph and Esther Gottlieb Foundation, New York.

That these feelings are being experienced by many people throughout the world today is an unfortunate fact, and to us an art that glosses over or evades these feelings, is superficial or meaningless. That is why we insist on subject matter, a subject matter that embraces these feelings and permits them to be expressed.[44]

Myth and the contents of the psyche are, for Gottlieb, historical reality. The Pictographs and the myths of Oedipus interlace ancient and contemporary experience and critique history. Without realist illustration, they constitute a modern form of history painting that refers to international events by once-removed and condensed allusions, that is, metaphor, and psychological allegory. In his Pictographs, Gottlieb dissociates and separates his art from everything ordinary and quotidian by turning to myth.

The loss of surface reality marks the end of innocence. For many, the loss of innocence in modern warfare was abrupt. Such a loss separates the twentieth century from the nineteenth. As a veteran recalls, before the First World War:

They had been taught to believe that the whole object of life was to reach out to beauty and love, and that mankind, in its progress to perfection, had killed the beast instinct, cruelty, blood-lust, the primitive, savage law of survival by tooth and claw and club and ax. All poetry, all art, all religion had preached this gospel and this promise.[45]

The Americans did not fully lose their innocence until the Second World War. One veteran recalled his recognition of it among all-American boys:

After a while, the veneer of civilization wore pretty thin. . . . I saw this Jap machine-gunner squattin' on the ground. One of our Browning automatic riflemen had killed him. Took the top of his skull off. . . . It had rained all night and the rain had collected inside his skull. . . . I noticed this buddy of mine just flippin' chunks of coral into the skull. . . . Every time he'd get one in there, it'd splash. It reminded me of a child throwin' pebbles into a puddle. It was just so unreal. There was nothing malicious in his action. This was just a mild-mannered kid who was now a twentieth-century savage.[46]

In structure, themes, and images, Gottlieb's work presents the emotional and psychological experience of World War II. His Pictographs, for example, convey a sense of disorientation, of lost direction, of enclosure and restraint, of the confrontation with the brutal and fantastic that is the nature of war. Their labyrinthine structure, specifically defined in paintings such as *Threads of Theseus* of 1948 and the *Labyrinth* series of the 1950s, resembles that of the trenches of World Wars I and II [in, for instance, Stalingrad]: "The trenches are a labyrinth, I have already lost myself repeatedly . . . you can't get out of them and walk about the country or see anything at all but two muddy walls on each side of you."[47] The contemporary

Figure 102. André Masson, *Meurtre a l'aurore [Murder at Dawn]*, from *VVV* 2–3 (March 1943): 27.

generation felt entrenched, and in their troglodyte world of endless anxiety, fear, danger, the enemy was not only "over there" in a physical sense but before and within in an emotional one. It is perhaps not accidental that in archaic cultures the labyrinth is symbol of the passage from one world to the next or a descent to the underworld.[48]

Almost from the first, Gottlieb's Pictographs specify the war and the demonic in several images. Primitivism becomes more than just early history. Gottlieb has rendered it as barbarism and beastiality. Weapons and bloody hands appear. In *The Omen for a Hunter* of 1947 (fig. 101), hunters, weapons, and targets lurk in a maze. In *Pictograph #4* among the faces, carnivorous mouths, and a primitive bird are several hands with seemingly pointing fingers. It is an image suggestive of a drawing of the index finger as knife by Masson entitled *Meurtre a l'aurore [Murder at Dawn]* reproduced in *VVV* in 1942 (fig. 102).[49] Horned beasts are loose in the land and in the mind in two works titled *Beasts* of 1945 and 1947. In *Troubled Eyes* of 1942 (fig. 103), perhaps Oceanic jaws wrap and enclose eyes. The eyes here and in many of Gottlieb's Oedipus com-

positions draw on the Oedipus plays (cf. Rothko's *Tiresias*) for a representation of the theme of insight and new vision. Those who attain insight and truth—Oedipus and Tiresias—are physically blind. In *Troubled Eyes,* Gottlieb suggests that violence unleashes interior sight.

In *Troubled Eyes,* as in many works of the era, teeth, mouths, tusks, claws, horns, in other words, birds and animals are used to evoke prehistoric terror and savagery. *The Red Bird* of 1945 attaches the teeth to a menacing avian. This seems to have been a common idea. Herbert Read, in his essay for *Britain at War,* discussed a work by Paul Nash in these terms: "I am referring particularly to Paul Nash's pictures of aircraft. Here the machine which is most typical of the war is animated, is made into a monstrous bird threatening humanity from the skies."[50] The images of beastly, ferocious, deadly mouths and predatory, grotesque animals and birds come together in

the famous Curtiss P–40s of the China-based American planes of General Chennault, the Flying Tigers (fig. 104), as well as in other emotional, animal imagery of the war such as the submarine "Wolfpacks."[51]

Other Abstract Expressionists also used avian imagery. David Smith's *Prehistoric Bird* of 1945–46 presents a skeletal infrastructure of prehistoric birds. His *Cockfight-Variation* of 1945 presents combat. Theodore Roszak's *Spectre of Kitty Hawk* of 1946–47 (fig. 105) and Lipton's *Prehistoric Birds #1* of 1946 allude to the war, probably the new dive bombers as prehistoric birds of prey.

Other Gottlieb Pictographs suggest threats, omens and their fulfillment in evil. Gottlieb's *Evil Omen* and *Expectation of Evil* of 1945 (fig. 106) with their black and gray teeth, arrows, skeletons, and brutish heads, record this generational concern with contemporary dread, fear, and experience of evil.

Figure 103. Adolph Gottlieb, *Troubled Eyes*, 1942. $25\frac{7}{8}$ x 34 inches. © 1979 Adolph and Esther Gottlieb Foundation, New York.

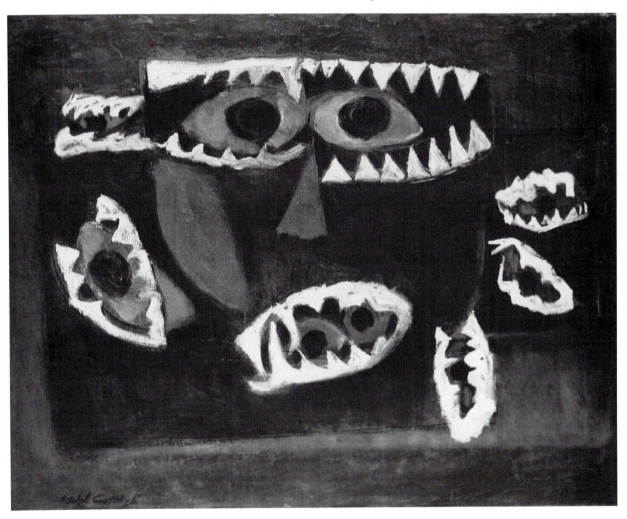

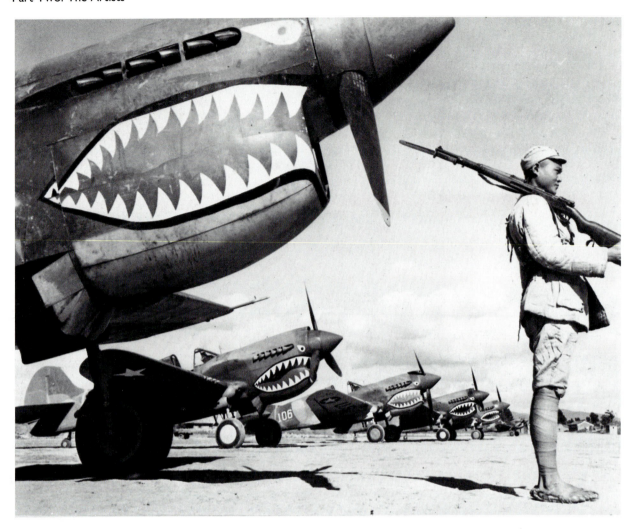

Figure 104. Curtiss P-40s of General Chennault's Flying Tigers. National Archives.

That evil was inherent and instinctual within humanity, in Martha Graham's words, as "private reality" and "public force," as "emanation" of the "individual soul," was a commonplace idea of the era.[52] Dali had made the point in his *Soft Construction with Boiled Beans: Premonition of Civil War* of 1936, in which a monstrous figure literally tears itself apart in a geological landscape. The body is both victim and aggressor, as is humanity. America, which had entered the First World War to "make the world safe for democracy," was now engaged in a war that was understood to be a product not of social or political forces alone but of the forces within mankind.[53] As Lipton said, describing his sculpture: "The drive was toward finding sculptural structures that stemmed from the deep animal makeup of man's being. . . . The ferocity in all these works relates to the biological reality of man."[54]

Gottlieb's *Prisoners* of 1947 (fig. 107) extends the use

of the Pictograph as labyrinthian maze and enclosure of the damned. Perhaps the painting was "inspired" by discovery of the concentration camps and of their inmates with stark, staring eyes, which came to light as the Allies swept across Europe in 1945. These had a separate impact coming in the last days of the war and provided new fuel for the changing concept of what humanity was capable of in the civilized world. They dealt an even deeper blow to what was left of the meliorist myth.

Like many of his colleagues, to portray the conflict further, Gottlieb drew images from the mythic and ritualistic history of humankind and from its formulations of confrontations of good and evil. He symbolized and ritualized the war as a biblical confrontation of light and darkness. Such dark elemental forces appear as beasts from the night in *Division of Darkness* (fig. 108) and *Night Forms* of 1950. In the unusual, non-Pictographic *Nocturne*

Figure 105. Theodore J. Roszak, *Spectre of Kitty Hawk*, 1946–47. Welded and hammered steel brazed with bronze and brass. 40¼ inches high, at base 18 x 15 inches. Collection, The Museum of Modern Art, New York. Purchase.

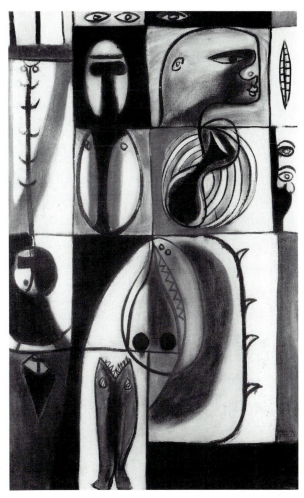

Figure 106. Adolph Gottlieb, *Expectation of Evil*, 1945. Oil, gouache, and tempera on canvas. 43⅛ x 27⅛ inches. © 1979 Adolph and Esther Gottlieb Foundation, New York. Photo: Otto E. Nelson.

(fig. 109), with its title also suggesting night and darkness, he portrays the mythic, labyrinthian contest of Theseus and the Minotaur. *Altar* of 1947 suggests primitive sacrifice and recalls Lipton's similar use of ritual: "Around 1945 I became interested in Mayan and Aztec death ritual sculptures, Molochs, and other historical deadly devouring imagery. They became important to me in terms of the hidden destructive forces below the surface in man."[55]

The Pictographs recall what Northrup Frye has called the "demonic vegetable world" of ancient fables, medieval romances, and modern literature. Sinister woods, wastelands, beasts of prey, witches, victims, instruments of death and torture, labyrinths, and mazes dot the land of Oedipus's famished kingdom, Aeneas's rivers of shades and harpies, Dante's hellish inferno, Goya's plains, and Ernst's trackless woods.[56] In another sense, the Pictographs resemble medieval depictions of the Harrowing of Hell (fig. 110) with their monsters and terrains of physical terror, torment, and mental anguish. In all of these, one has a sense of the embodiment of fears and of life poisoned at its heart.

Many of Gottlieb's Pictographs are mythic evocations, then, of the battlefront and psychic landscape of the

1940s—of its doubts, its whisperings, and its demons. He did not illustrate the war with representational art nor did he invent many of the symbols, but he revived them in new forms—in a modern realism of mind and feeling. He said shortly after the war:

Today when our aspirations have been reduced to a desperate attempt to escape from evil, and times are out of joint, our obsessive, subterranean and pictographic images are the expression of the neurosis which is our reality. To my mind certain so-called abstraction is no abstraction at all. On the contrary, it is the realism of our time.[57]

As with his creation of a natural object, Gottlieb makes concrete the history of his time, not as the external clash of armies and generals or the politics of war, but as the more real, lived fears, dreadful emotions, and psychodrama of his age.

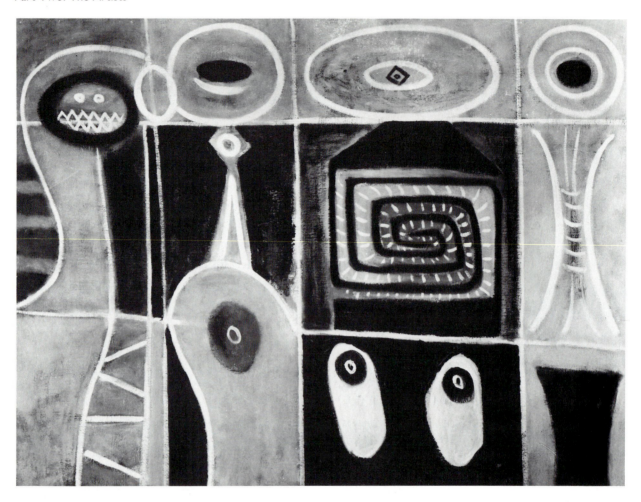

Figure 107. Adolph Gottlieb, *The Prisoners*, 1947. 36 x 48 inches. ©
1979 Adolph and Esther Gottlieb Foundation, New York. Walter
London Estate.

SPRING

During the 1940s, fear and death had been the theme of
most of Gottlieb's works, but eventually Hercules strug-
gled with Thanatos and won a springtime. As Still did in
his work, which Rothko saw as "an extension of the Greek
Persephone myth,"[58] Gottlieb used modern and ancient
myth, memory, and ritual not only to depict negation—
evil and barabarism—but also, as part of the same expe-
rience and trial, to affirm the promise of rebirth, as in
Persephone of 1942, *Ashes of Phoenix* of 1942, and
Omens of Spring of 1950 (pl. 11), the largest Pictograph
by far, with its light, emergent pink tones, budding flowers,
tendrils, and new hair.

Other works portray rebirth through an ensemble of
primitive rites and sacred ceremonies suggesting sacrifice,
prophecy, and renewal. Poignant images of the war's

"enchanted" victims and their ascending bird-spirits occur
in rare, ethereal pink and blue in *The Enchanted Ones* of
1945 (fig. 111), which also recalls depictions of the Holy
Ghost hovering above the crucified Christ in Renaissance
painting.[59] The arrow, knife, rituals, magical eyes, and
masks of *Sorceress* and *Seer* of 1947 suggest the magico-
religious sacrifice of human life to larger possibilities. In his
Altar of 1965 Lipton, like Gottlieb, refers to the practice
of sacrificing life to renew life.[60] And Martha Graham put
this cycle and experience into words when she quoted
Jung to the effect that the world originated through
sacrifice, which produced a new condition of man, an
immortal power.[61]

These allusions suggest an alliance with the dark powers
of the world that primitive religion sought to employ.
Alchemy was a favorite theme of Martha Graham, Jung,
and the surrealists, especially Kurt Seligmann, a friend of

Pollock and other Abstract Expressionists. For all of them, alchemy was a mode of transformation. For Jung the changing of lead into gold symbolized the transformation of dark unconscious forces into new life. The surrealists saw alchemy as a solvent, a means of metamorphosis into a new consciousness with new powers of fantasy. Masson was greatly interested in the sixteenth-century alchemist, theologian, and heretic Paracelsus, who is also important to Gottlieb.[62] Paracelsus sought a key to nature's secret, and through nature, to God. His alchemy was more than a search for gold; it was a search for remedies and for knowledge of the irreducible divine elements, the Prime Matter of the cosmos. All things could be dissolved into elemental units—earth, fire, air, and water. Through the powers of God the incorporeal could become corporeal and vice versa.

We see this theme in Gottlieb's *Water, Air, Fire* of 1946 and in references to alchemy in a number of other paintings, among them *Alchemist [Red Portrait]*, *Alchemist's Fluid*, and *The Alkahest of Paracelsus*, all of 1945–46 (fig. 112). Of the latter Gottlieb wrote: "*Alkahest* is a term invented by Paracelsus, 14th century [sic] physician, to designate an imaginary universal solvent, capable of dissolving all bodies."[63] Alchemy and the alkahest, like his signs and elemental shapes, symbolize Gottlieb's fundamental theme of the fluidity, mutability, and journey of all matter and life. He seeks the universal substance out of which all forms, associations, experiences, and emotions are and have been made. For him the quest for solvents is the quest for the Grail, for the key to the process of ritual transformation in the labyrinth of human life.

Figure 108. Adolph Gottlieb, *Division of Darkness*, 1947. Richard and Jane Burns.

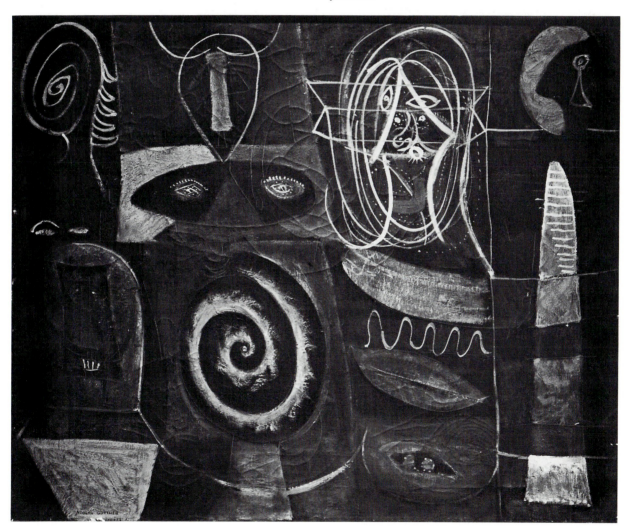

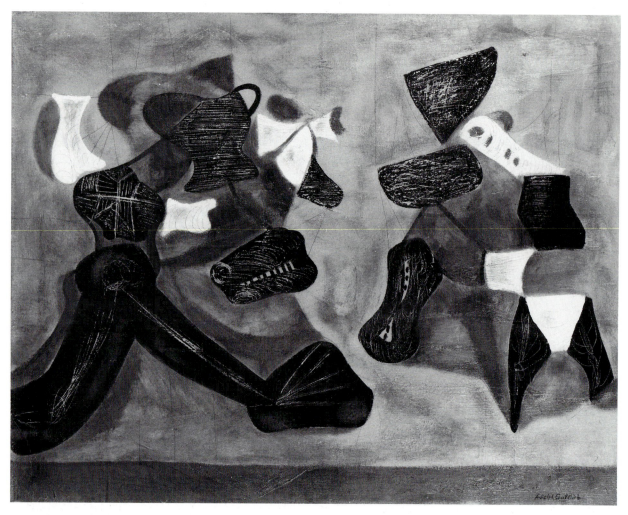

Figure 109. Adolph Gottlieb, *Nocturne*, 1945. 26 x 34 inches. © 1979
Adolph and Esther Gottlieb Foundation, New York. Photo: Allan Baillie.

CONCENTRATIONS

In the later 1940s Gottlieb gradually separated the constituents of his Pictographs, the sign forms and the labyrinth. They split into new forms—the Labyrinths, Unstill Lifes, and Imaginary Landscapes. From *Night Forms* to *Labyrinth #1, 1950* to the huge *Labyrinth #3* (fig. 113), *Trajectory*, *Interpenetration*, and the watery *Nocturnal Beams* of 1954, Gottlieb sought to make the superstructure of his Pictographs function as an expressive form and image itself. These are the most linear of his works and have the fewest interspersed images and signs. Through the dark density and graphic power of the nightmarish *Night Forms*, through the whiplash curves of the *Trajectory*, Gottlieb turned his irrational labyrinth into an autonomous image of moving power, duality (rectilinear versus curvilinear), and unity in multiplicity or mutability. In these works,

Gottlieb responded to the increased linear power and abstractness of the mature painting of his colleagues. At the same time he expanded his means of representing the concept of the continuum of history and mythic, ritualized life through imagery of the metamorphosis of dynamic forces. He adopted the idea of powerful forces—as opposed to fixed form—that is, the dominant image and richly associative metaphor of Abstract Expressionism.

The Unstill Life series consists of a single concentrated image often extended to the edge of the canvas. Within the image are Pictographic symbols, primitive heads, graphic marks, ideographs, and aspects of natural form such as tusks, horns, and barbs. In works such as *Black Silhouette* of 1949 (fig. 114), *Indian Red* of 1950, and *Castle* of 1950 (probably suggested by Kafka's *The Castle*),[64] Gottlieb rethought the motif of a single unit with parts first developed in his early tablet forms like *Persephone*. *Black*

Figure 110. Fra Angelico, *Hell* [detail of *The Last Judgement*], 1431.
Alinari/Art Resource.

175

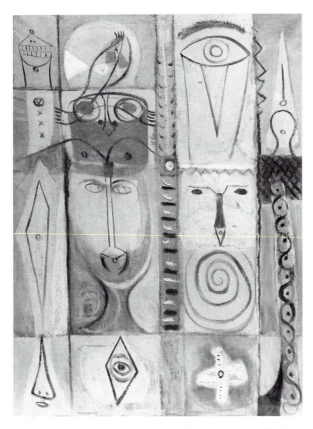

Figure 111. Adolph Gottlieb, *The Enchanted Ones,* 1945. 48 x 36 inches. © 1979 Adolph and Esther Gottlieb Foundation, New York. Photo: Robert E. Mates.

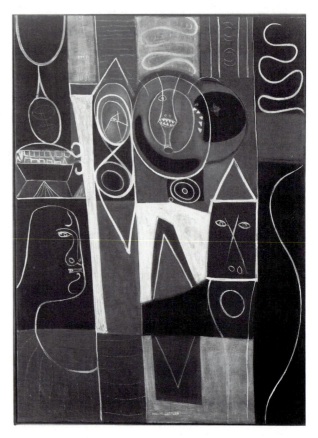

Figure 112. Adolph Gottlieb, *The Alkahest of Paracelsus,* 1945. 60 x 44 inches. Courtesy Museum of Fine Arts, Boston, The Tomkins Collection.

Silhouette consists of wedgelike limbs and edges reflective of African carvings. The silhouetted forms suggest threatening, primeval beasts hovering over a bone, echoing the carnivorous dogs of Tamayo's *Animals* of 1941 (fig. 115). Gottlieb transformed a table into a similar insect or animal in *Unstill Life* of 1952.

Gottlieb also mixed up these variants. *Blue at Noon* of 1955 (fig. 116) is the most successful hybrid, combining an activated grid or labyrinth with pictographic dot signs and "letters." The title itself is interesting and ambiguous. Does it refer to the fullness of light that noon implies, to the upturning of the day and thus, to the "up" stage of human life? Or is he being ironic, as is perhaps suggested by another work at this time entitled *Blue at Night.* Does "blue" mean melancholy? Although much of *Blue at Noon* is a bright blue, much is dark grid. Is this, then, a "darkness at noon"—a dualistic inversion of dark with light or vice versa?

With *The Frozen Sounds, Number 1* of 1951 (fig. 117), Gottlieb moved, however hesitantly, toward the resolution of his divisions. He developed a new series called Imaginary Landscapes that extended his transformation of

his labyrinths into continuous trajectories—a new type of continuum, the reduction of shapes to a few images, the denuding of the images to more expressive signs, and the concentration of the new components into shapes and then zones.

Frozen Sounds, Number 1 establishes the composition. The canvas is divided into two parts. Circles, semicircles, and lozenges lie above a brown and white scumbled zone with arrows and broad painterly trajectories or, in the terminology of the 1950s, "gestures." The composition obviously recalls a landscape division, though he did not intend merely a nature image. Gottlieb considered these paintings consistent "in a philosophic sense" with what he was doing earlier: "In other words, I've always done the same thing. That is, I'm interested in certain opposing images."[65]

The horizontal division of the canvas continues the traditional Abstract Expressionist notion of upper and lower, near and far, present, past, and future. It also recalls Gottlieb's typical play between mutable, neutral sign images and graphic flux, but in this series the canvases are separated into a flow of signs above overlapping strokes

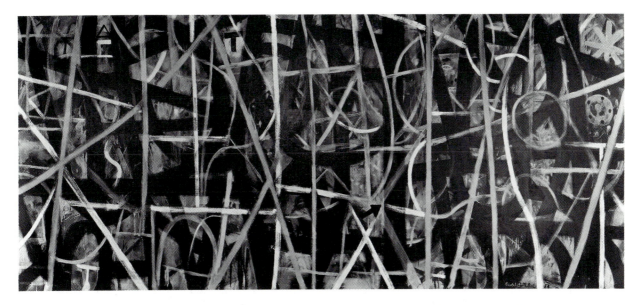

Figure 113. Adolph Gottlieb, *Labyrinth #3,* 1954. 84 x 192 inches. ©
1979 Adolph and Esther Gottlieb Foundation, New York.

that are pentimenti of the earlier signs/grids/vectors/forces.
The strokes are more prominent in *Nadir,* which recalls
in image and idea Pollock's *The Deep* of 1953, as they fill
three quarters of the painting. For the division into a few
zones, some of which are mottled or patterned, Gottlieb
may have again found inspiration in the work of Avery,
whose paintings of three or four zones with smooth or
mottled surfaces and jagged patterns he would have
known. In the 1950s Gottlieb was also friends with
Baziotes, whose evanescent, dense, iridescent surfaces
also parallel Gottlieb's new work. These Imaginary Land-
scapes may, in turn, have influenced Rothko, whose hori-
zontal works of the late 1960s have two divisions and
active brushwork.

The Imaginary Landscape series is the most original of
Gottlieb's new inventions, and it reflects his movement
into the monumentalizing of human inner life that distin-
guished Abstract Expressionism from thematically related
earlier modern art. He said of his new image that it is:

the inner world that we all have. Now in order to externalize
this you have to use visual means and so the visual means may
have some relation to the external world. However, what I was
trying to focus on was what I experienced within my mind,
within my feelings rather than on the external world which I can
see.[66]

By 1957 Gottlieb was poised on the brink of his final
accomplishment, the Burst series. In his transition period
he broke down his earlier structure and recast it in a
simpler, more dramatic, more monumental form. While
his thought and purpose remained the same, he shifted his

Figure 114. Adolph Gottlieb, *Black Silhouette,* 1949. Oil and enamel on
canvas. 31¾ x 24¾ inches. © 1979 Adolph and Esther Gottlieb Founda-
tion, New York. Photo: Otto E. Nelson.

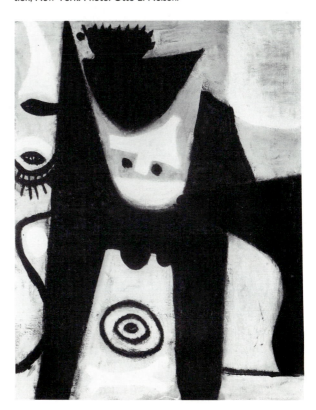

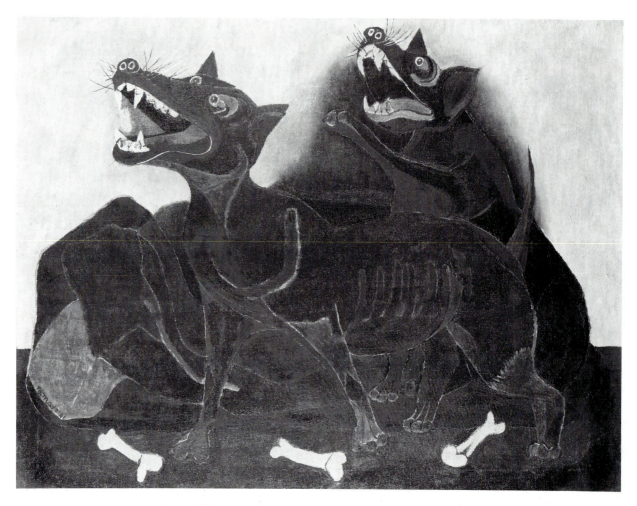

Figure 115. Rufino Tamayo, *Animals,* 1941. 30⅛ x 40 inches. Collection, The Museum of Modern Art, New York. Inter-American Fund.

emphasis back and forth from unity in simultaneous multiplicity and mutability to unity in polarity. He catapulted the dialectic into monuments of harmony and divisiveness.

THE BURSTS: CONVERGENT AND DIVERGENT ALLEGORIES

In Gottlieb's last style, themes become simple, powerful inevitabilities. The new Bursts are condensations of his Imaginary Landscapes—either into two forms or elongated, horizontal flux. These forms allow him to attain the intensity and the magnitude of the human drama he portrays. The Bursts fulfill the promise of his subjects: history as contention, as cycle, as continuum, and as ritual ensemble. Multiple episodes and symbols have been transformed into a simple stream or a dichotomy, amplified to the cosmos of the above and below. Gottlieb's mature

work signals the development of a twentieth-century allegorical painting, that, by means of abstract pictorial sign and process, acts out the drama of the age.

In works such as *Blast I* of 1957 (fig. 118) Gottlieb deduced a structure from his themes of mythic pattern. He returns to focal points as in the Pictographs, but now has only three—a sunlike disk or orb above, a more active, dynamic, or exploding form or script below, and the diffuse, atmospheric ground. These compositions emphasize duality and divergence as well as the simultaneity of the ritual cycle/form. The shapes line up in a vertical or horizontal, seemingly rational, harmony, but they also suggest a primeval intensity and drama that denies any rational, geometric order. Like the pictographic labyrinths, Gottlieb's Bursts convey an irrational rationality. A Burst like *Blast I* consists of elementary formal and imagistic contrasts: form/sign/shape versus drawing, color (red) versus noncolor (black), plane versus stroke, contained versus

active, above versus below, sun versus earth, up versus down, and coherence versus chaos. In some works, round contends with square, or the single with multiple, or even male with female.[67] In others, the circles become part of the dominating scriptive action below.

The symbols are fewer but have become more inclusive. In microscopic forms, macrocosmic meanings abound, but without specific character, event, or local context. Again the sign-shapes suggest and evoke but do not delimit themes previously rendered by symbols. At the same time, Gottlieb has dramatized his central theme of contentious counter, variance, yet unity and made of duality a process of tension, polarity, and opposition. His Bursts dramatize the "versus habit" of his generation. Like Roth-

ko's Nietzschean antithesis, they hold the tension of contrast or dissonance at maximum pitch without the consolation or optimism of nineteenth-century Hegelian or Marxian illusions of synthesis and progress.

Gottlieb's Bursts present his version of modern tragedy in which the negative—war, conflict, fear—is presented as natural, normal occurrence within the cycle of life and history. The Bursts have two forms: two percussive, opposite units, or a scriptural interaction of linear tensions below several circular units. These replace the Abstract Expressionist search for wholeness and integration (and that of the Mellons, Jungians, Martha Graham, and Mumford), seen, for example, in Pollock's *One,* with tragic, irreconcilable diversity and contention. Gottlieb joins Rothko

Figure 116. Adolph Gottlieb, *Blue at Noon,* 1955. 60 × 72 inches. Walker Art Center, Minneapolis.

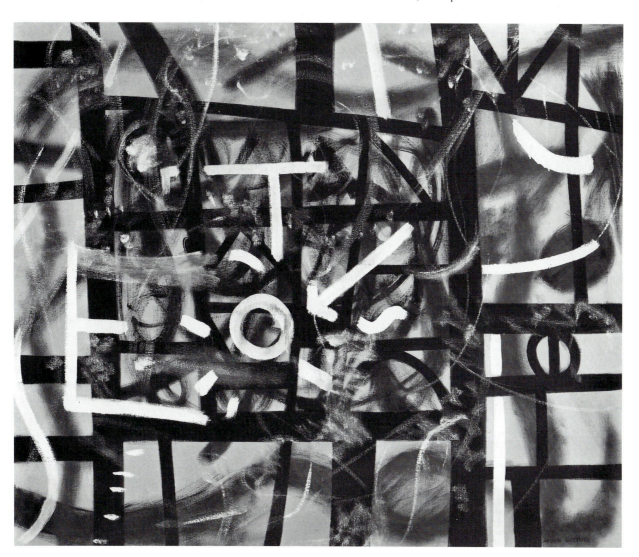

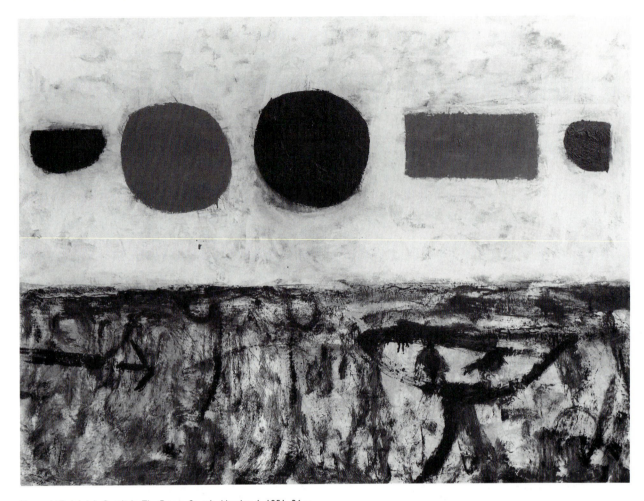

Figure 117. Adolph Gottlieb, *The Frozen Sounds, Number 1,* 1951. 36 x 48 inches. Collection of the Whitney Museum of American Art. Gift of Mr. and Mrs. Samuel M. Kootz. (57.3) Photo: Geoffrey Clements.

in originating a modern tragic art, but he differs from his friend: Rothko's work, while containing stages or periods/ shapes of tension and opposition, presents tragedy as the inevitable decline and mortality in the life cycle of all things. Gottlieb sees tragedy in abstract or pictorial reenactments of contention and strife within the psyche, human history, and in the cosmos itself. "Gross dichotomizing," according to Paul Fussell, "is a persisting imaginative habit of modern times, traceable ... to the actualities of the Great War." Fussell spells out the terms of the split:

"We" are all here on this side; "the enemy" ... is a mere collective entity.... We are normal; he is grotesque. Our appurtenances are natural; his, bizarre....[H]e threatens us and must be destroyed, or ... contained and disarmed. Or at least patronized. "He" is the Communist's "Capitalist," Hitler's Jew, Pound's Usurer ... the Capitalist's Communist. He is Yeats's "rough beast" ... Faulkner's Snopeses ... Eliot's Sweeney and young man carbuncular ... Roy Fuller's barbarian.[68]

And Fussell names the causes and their consequences: "Prolonged trench warfare, with its collective isolation, its 'defensiveness,' and its nervous obsession with what 'the other side' is up to, establishes a model of modern political, social, artistic, and psychological polarization."[69] The Second World War and the new tradition of strife put the tensions in motion, with mobile, contending forces in the "Theaters of Operations."

Gottlieb absorbed the habit. He dichotomized in simple terms in 1968, when he said the Bursts deal "primarily in polarities ... the happy and the sad, the good and evil, the sick and the well, pleasures and pain."[70] When he worked on the paintings, he "put down the discs and thought of what form would most oppose them. So [he] put in the black form." In short, as he proclaimed, "Opposites are my view of life."[71]

The Bursts recount the familiar ensemble of Abstract Expressionist themes at a more synoptic and displaced

180

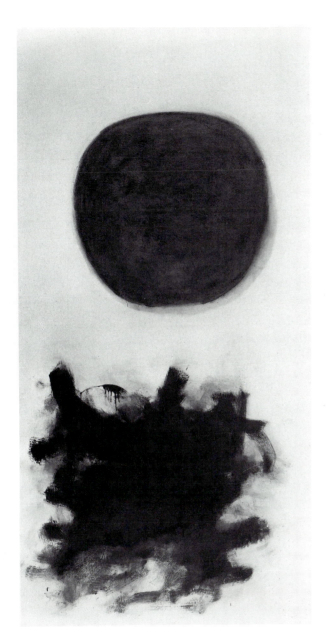

Figure 118. Adolph Gottlieb, *Blast I*, 1957. 90 x 45¼ inches. Collection, The Museum of Modern Art, New York. Philip Johnson Fund.

such as *Looming*. Others suggest complex motion, distilled flux, and its effects—for example, *Rolling,* with its cursive dramatic script; *Expanding,* with its hovering orb; *Spray* of 1959, with its vibrating orb in a halo over a stroke explosion; and *Return. Glow* of 1966 and *Smolder* of 1964 suggest light, fire, or illumination; while *Flotsam* of 1968 (fig. 120) and *Aftermath* of 1959, with its one remaining shape, suggest conclusion and debris after struggle and journey.

Some works present dualities—*Dialogue I* and *Duet* of 1962—while others make conflict explicit—*Conflict* (fig. 121) and *Jagged* of 1966. One painting, *Bullet* of 1971, specifies its title's referent source by means of its projectilelike shape. Others declare image, direction, and sign— for instance *Sign* of 1962. The end point of the cycle of history, life, nature, psyche, and self symbolically appears again in *Transfiguration* of 1957 and the Grail *Excalibur* of 1963 (pl. 12).[73]

Gottlieb's Bursts have a melodramatic immediacy typical of much mature Abstract Expressionism. His work became an art of theatrical presentations; like De Kooning's exaggerated ferocious women, Rothko's interplay of ominous light, Pollock's overwhelming forces of energies, and Still's stagy self-presentation, Gottlieb's shapes and color suggest a dramaturgy of the human "adventure."[74]

The Bursts express the themes of his earlier work in new form. The forces, cycle, process and points in the spectrum of internal and external human history are present but Gottlieb now underlines the points and fragments of the cycle through carefully chosen color, shape, placement, and paint handling. *Blast I* gives a sense of explosion in the red orb and lower black form. *Flotsam* has scumbled strokes to suggest bits and pieces of something. *Conflicts* consists of a linear distribution of discs above and an active labyrinthine script below. *Above and Below I* enacts just such a division. The shapes suggest emergence, formation, maturity, climax, flow, counterpoise, and finish—all stages of the life cycle. Fragments, splatters, drips, splashes, dots, and pentimenti record the process.

The painterliness of Gottlieb's style is itself significant. It makes the elemental forces and struggles a concrete presence and not a symbol. Painterly art is, of course, nothing new. What is new in Gottlieb's art as well as in that of other Abstract Expressionists is the transformation of painterliness itself into a direct, coarse statement of theme. The concept of inner and outer history as forcefulness, aggression, dynamism, flux, and struggle Gottlieb realized through the power of the monumental, raw, unfinished, flowing scripture of paint itself.[75]

There is a new form of temporary harmony—equilibrium: "I try to resolve these conflicts and to bring together and harmonize and find some equilibrium for these op-

level. They consist of a loose federation of interconnected, periodic happenings that add up to the theme of cyclic journey and unity. *Blast I* consists of an orb above an exploding sign. (The *Burst* series as a whole was originally entitled *Blast* but Gottlieb felt that title was misleading, suggesting something too manmade or industrial.)[72] *Argosy* with its inchoate dark ground and brushed orb suggests journey. *Above and Below I* (fig. 119) repeats this idea with more approximate signs in the lower division. Some works give a familiar sense of dread and anticipation,

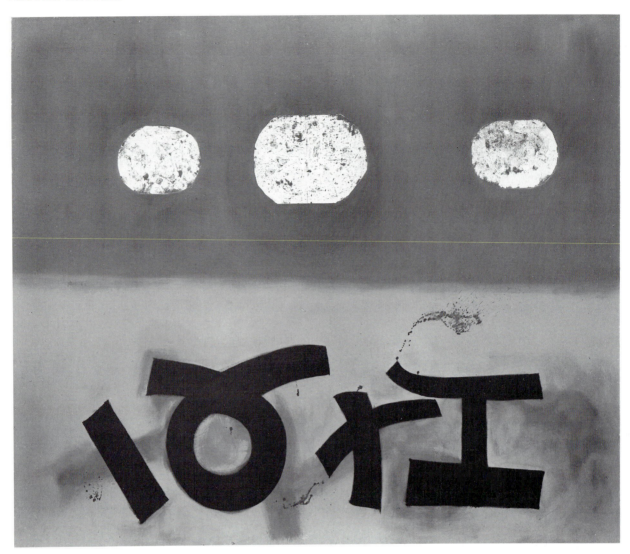

Figure 119. Adolph Gottlieb, *Above and Below I*, 1964–65. 90 x 198 inches. © 1979 Adolph and Esther Gottlieb Foundation, New York. Photo: Otto E. Nelson.

posing tendencies."[76] Unity underlies the equilibrium of opposing tendencies. The Bursts present a world of contending yet complementary forces, of unity yet polarity, of movement yet tangibility. The forms constitute different moments and shapes of the same material and force. The forms are equal in area, related if different in shape, and participate in a shared drama. They reflect one another and suggest the possibility—or impossibility—of *metamorphosis* into their opposite.

Gottlieb, with his symbolic, abstract images of living and dying cultures and civilizations, natural life, human history, and cosmic passage, evokes the underlying spiritual and ritual quality and power of Abstract Expressionism. He once said that his paintings meet people's needs for

something that transcends mere painting, something that affirms individual worth and gives the human a sense of godlike power.[77]

Seymour Lipton's description of his "formal fictions," though emphasizing his own version of Abstract Expressionist themes, illuminates Gottlieb's Bursts:

The thought of struggle and strife in the sense of opposition: Forces oppose each other in the effort for supremacy, creating tensions. The resolution of such forces results in dramatic counterplay of forms and spaces. Usually one line of force wins.

The concept of centrifugal movements, of ever-opening vistas, ever-widening experience, but always controlled through centripetal movements of containment. . . . It is an interweaving, autonomous cosmos with no beginning and no fixed end, and yet

with its own logic of determinate relationships. It is a three-dimensional plastic organism with an exterior-interior continuity—spaces and forms interlacing in continuous and discontinuous relationships.

The idea of interlocking connections, yet withal a sense of organic coherence and continuity.

The idea of the vortex, the knot, etc., as struggle, as tragedy—these are examples of the formal fiction I create.[78]

Gottlieb's fictions are modern allegories of his era, an abstract ensemble of human history, drama, action and romance in emblematic form. In other words, they stand as virtual allegories of historical and cultural cognition of his time.

Realist allegory had returned in the folk and developmental epics of the 1930s. Christian iconography, myth, and folklore were joined to present a developmental sequence that partook of a religious imagination. (In *The Magic Mountain* Thomas Mann satirized this way of thinking by comparing epics of technological development to the seven days of Creation.) Events in history were structured into an allegorical pattern and process of hu-

man hopes and strivings. In Gottlieb's work, with its representations of the complex view of the 1940s, the allegorical pattern becomes first symbolic, pictogrammatic, ritualistic, then abstract.[79] It moves from archetypal journey, path, and quest to timeless pattern and periodic process as though Gottlieb was abstracting the underlying process of the ritual ensemble of events and distilling it into a dynamic image.

Allegory as a mode draws on conventional or archetypal symbols and events that can be transitory or sequential and then fixes them in a stable and stabilizing imagery, often in an image that condenses the sequence in the "most pregnant moment," the moment that refers to what comes before and after. In other words, the moment and its image project a "structure as sequence" or a process.[80] Allegory can thus represent symbolic process—and vice versa.

Gottlieb condenses his millennial human journey of interwoven, pictographic accretions into the scriptural rituals of the Bursts. They consist of abstract analogues for ritual formulas and patterns. Use of formulas is typical of

Figure 120. Adolph Gottlieb, *Flotsam*, 1968. 48 x 72 inches. © 1979 Adolph and Esther Gottlieb Foundation, New York. Photo: Otto E. Nelson.

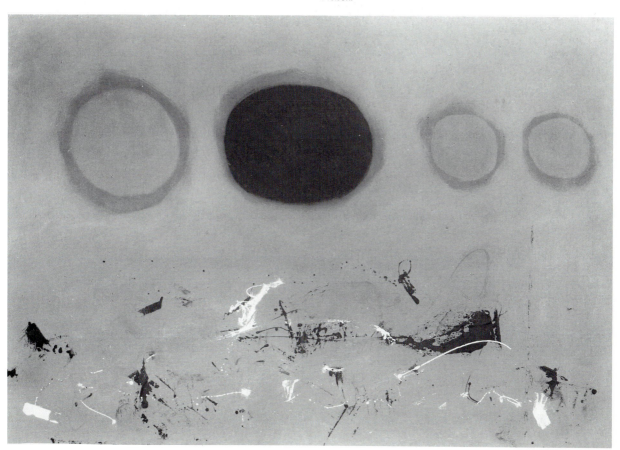

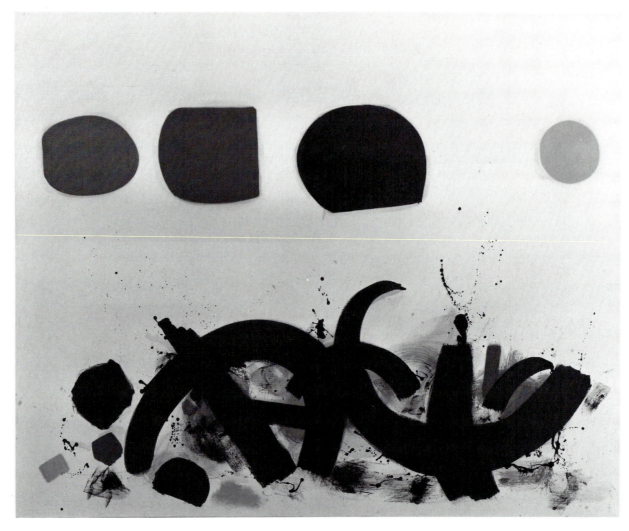

Figure 121. Adolph Gottlieb, *Conflict*, 1966. 72 x 90 inches. Flint Institute of Arts.

allegory. In Homer's use of allegory, for example, "symbolic analysis allows him to condense a protracted event the way a physicist expresses a complex interaction through a mathematical formula."[81] Space and time can be so summarized, as in the *Aeneid:* "A reference, a brief conversation between symbolic figures, can compress years and months into a few lines."[82]

In the Pictographic and abstract phases of his work, Gottlieb's paintings condense his ritualization of history and constitute equivalents to the rites of passage, trial, and mythic attainment so central to Abstract Expressionism. Like Rothko and his other colleagues, first with a variety of incidents and episodes, time and space, culture and form, folklore and ritual act, and then in dramatic, abstract movement, Gottlieb sought to find the underlying archetypal process to human life and history. The Bursts consti-

tute his most succinct statement. Their gestural microstructures suggest division into standardized, isolated, but interrelated episodes of what he considered the hidden order of the world. Gottlieb's Bursts make the symbolizing process visible. Like his earlier ensembles, Gottlieb's allegories of process are multivalent. Ritual, historic, psychic, mythic, and natural process are condensed into simple, binary, and painterly interaction and movement. The symbolic cycle and meaning of Campbell's hero illuminates and summarizes Gottlieb's last statement (Campbell may have been a direct source for his late work, as he was for other Abstract Expressionists):

Yet from the standpoint of the cosmogenic cycle, a regular alteration of fair and foul is characteristic of the spectacle of time. Just as in the history of the universe, so in that of nations: emenation leads to dissolution, youth to age, birth to death, from

creative vitality to the dead weight of inertia. Life surges, precipitating forms, and then ebbs, leaving jetsam behind. The golden age, the reign of the world emperor, alternates in the pulse of every moment of life, with the wasteland, the reign of the tyrant. The god who is the creator becomes the destroyer in the end.[83]

Like Joyce, Eliot, and others, Gottlieb developed a deathless pattern of continuity and change as his generation's deity, as a mythic mystery and pattern of tranfiguration in an allegorical epic of his time.

CHAPTER 6

BARNETT NEWMAN
New Beginnings

How often have I heard my contemporaries lament these two great accidents of their fate—"We went from the Depression right into the War"! . . . But now the War was coming to an end more speedily than we had ever imagined, and surely this must mark the beginning of a new life and a new era. . . . One could really begin again. . . . We were not in for some dull continuance of the past but a real renewal.

William Barrett, *The Truants*

It is hard to bring back from memory the real spirit of those post-war Harvard years . . . 1948—the college, I remember was so overflowing with returning veterans. . . . "*This* is the time to be alive!" I remember him [a ghostly pale veteran of the Pacific theater] saying at one point. "*This* is the start of everything!"

Michael J. Arlen, *My Harvard, My Yale*

Barnett Newman's paintings are considered by many to be the most radical of all Abstract Expressionist art. His large canvases of one or two colors with one or two narrow planes or *zips*, as he liked to call them, dispensed with form, multiple relations, and most painterly qualities. For this radical appearance, he paid the price of being the last of the original Abstract Expressionists to gain public recognition. Despite two shows at the Betty Parsons Gallery in 1950 and 1951, it was not until his exhibitions in 1958 and 1959 that his art found widespread acceptance. Yet his art's deceptive geometrical manner made him perhaps more influential in the early 1960s than any other Abstract Expressionist.

Newman's acceptance was also delayed because he was an especially articulate artist and had written a great deal in the 1940s. He wrote several catalogue introductions for individual colleagues (Gottlieb, Ferber, Stamos), and for the group as a whole (*The Ideographic Picture*), as well as for other subjects (Pre-Columbian art, Northwest Coast

Indian art). When critics and friends confronted his new paintings in 1950–51 and were baffled by their apparent utter simplicity, they reacted by declaring Newman merely an "intellectual" painter who was just "illustrating" his ideas, a stigma among artists.

Newman, however, was simply a more articulate intellectual in a literate group of artists. He was more open about his concern with ideas, and like several of his colleagues, frankly conceived of the artist as a kind of visual philosopher who brought his mind to bear on serious contemporary problems as well as on the nature and purpose of art.[1] He was not alone in this of course, but he was also willing to share with others the *de rigeur* stance of the bohemian antiintellectual if it was necessary. Witness his witty remark of 1952, "Esthetics is for artists as ornithology is for the birds."

Newman's articulateness has also led to the mistaken impression that his interests were unique, that his ideas about art and his art itself were different from those of other Abstract Expressionists. Newman himself stated that "the only common ground we all had is in the creation of a new, free, plastic language."[2] However, both his plastic language and the ideas that engendered it were shared in varying degrees by the other artists. Despite the illusionary geometry in his work, Newman sits squarely among his earlier Abstract Expressionist colleagues in theme and form. What was unique in each of the artists was the individual interpretation of common historical circumstances and a common body of cultural ideas.[3]

Newman is among the most optimistic of his colleagues in concentrating on the upturn of the cycle of the human journey. He addressed the spiritual and emotional as well as physical and cultural needs of his era and brought forth

187

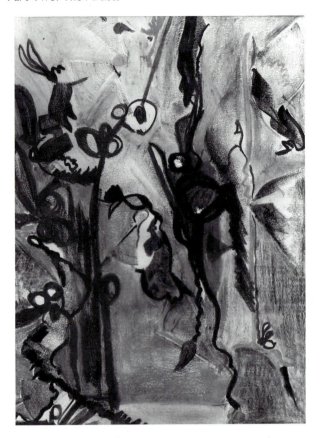

Figure 122. Barnett Newman, *The Song of Orpheus,* 1944–45. Oil, oil crayon and wax crayon. 19 x 14 inches. Reproduced courtesy of Annalee Newman insofar as her rights are concerned. Photo: Eric Pollitzer.

an image of creating anew, of starting over. The art historian Irving Lavin reminisced about these feelings during the war period: "We were convinced that after such madness men would surely create a new world, in which reason and decency would at last reign supreme."[4] For Newman, as well as for other Abstract Expressionists, however, the new beginning would take place only with a wariness that modern experience and thought had made necessary.

NATURAL AND RITUAL GENESIS

Newman was the last of the original group of Abstract Expressionists to begin painting. He was born in 1905 in New York, and as a young boy he spent several days a week examining paintings in the Metropolitan Museum. In 1919–21 he studied at the Art Students League. While continuing to study there, in 1923 he entered City College of New York where he majored in philosophy. He met Gottlieb at this time and they became close friends. When

the Museum of Modern Art opened in 1929, Newman said he was already familiar with most of its early collection of paintings.[5] In 1927 he temporarily went into the clothing business with his family so that he could save money to strike out on his own as an artist, but the crash of 1929 put an end to those plans. Instead, with Gottlieb he tried to become an art teacher, but he could not pass the art test. He ended up as a substitute teacher in the city schools. In 1933 he ran for mayor of New York on an anti-Communist program. In an interview with A. J. Liebling at the time, he revealed that he admired John Sloan, his teacher at the Art Students' League, Picasso, Kuniyoshi, Gottlieb and others.[6] No early work survives.

With the coming of war once again, Newman felt a crisis at hand—in art as well as society. In his earliest known art, in the 1940s, Newman painted generating organisms symbolizing for him the worldwide need for a new life. His first art—forty-nine drawings done between 1944 and 1946—emphasizes the process of emergence, in elemental, frequently inchoate, organic forms and structures. The drawings, for example *The Song of Orpheus* of 1944–45 (fig. 122), suggest the ancestral morphologies of humanity, including sprouting seeds, cephalopods and spermatozoids, skeletal vertebrates, and floating bird or butterfly forms. Barely differentiated from their grounds in many instances, these forms appear to sprout, germinate, and grow. Yet however reminiscent of natural history, they also symbolize, at one or two steps removed, the needs and aspirations of contemporary history.

In 1966 Newman explained his early concerns and development. He described the problem as one of subject matter and history: "the history of my generation begins with the problem of what to paint. . . . [T]he war . . . made it impossible to disregard the problem of subject matter."[7] A year later he went further:

Years ago . . . we felt the moral crisis of a world in shambles, a world devastated by a great depression and a fierce World War, and it was impossible at that time to paint the kind of painting that we were doing—flowers, reclining nudes, and people playing the cello. At the same time we could not move into the situation of a pure world of unorganized shapes and forms, or color relations, a world of sensation. And I would say that, for some of us, this was our moral crisis in relation to what to paint. So that we actually began, so to speak, from scratch, as if painting were not only dead but never existed.[8]

While the war inspired his art, like the others, Newman used no direct imagery of soldiers in battle. For him, as well as for most Abstract Expressionists, history was to be approached and resolved through intellectual and cultural analysis.

Newman's early biological and mythic pictures are nature myths symbolizing the processes of creation and

Figure 123. Barnett Newman, *Untitled,* 1944. Tempera (?), wax and oil crayon, and pastel. 17 x 15 inches. Reproduced courtesy of Annalee Newman insofar as her rights are concerned.

growth or death and rebirth. He uses an image of tangible genesis—the filling of a void by germinating forms—as a metaphor for the intangible genesis of new life, spirit, and consciousness. Perhaps the foundation of his early themes can be likened to a Zuni creation myth published in Boas's *Primitive Art* which Newman knew:

In the nethermost of the four cave-wombs of the world, the seed of man and the creatures took form and increased; even as within eggs in warm places worms speedily appear, which growing, presently burst their shells and become as may happen, birds, tadpoles, or serpents, so did men and all creatures grow manifoldly and multiply in many kinds. Thus the lowermost womb or cave-world, which was Anosin tehuli (the womb of sooty depth or of growth germination, because it was the place of first formation and dark as a chimney at night time ...) thus did it become overfilled with being.[9]

Figure 124. Wolfgang Paalen, *Somewhere in Me*, 1940. 18 x 15 inches. Whereabouts unknown.

Newman presented the theme of genesis in a variety of ways. Some compositions are vertical, some are horizontal, and in some there is no sure orientation, for example, *Untitled* of 1944 (fig. 123). In others, Newman used the aqueous qualities of watercolor to evoke the aqueous origins of life.

Rothko's early work is the most likely immediate influence on the structures of these works. Newman was close to Rothko at this time. Echoes of the aqueous Rothkos, suggestive of the primal sea, may lie behind those of Newman, while parallels to such Rothkos as *Geological Reverie* of about 1946, with its organic forms distributed over earthlike strata, can be found in Newman's early work, although Newman may orient the forms and strata more strongly vertically rather than horizontally. The verticality, however, does emphasize Newman's difference from Rothko: Newman asserts and affirms a positive

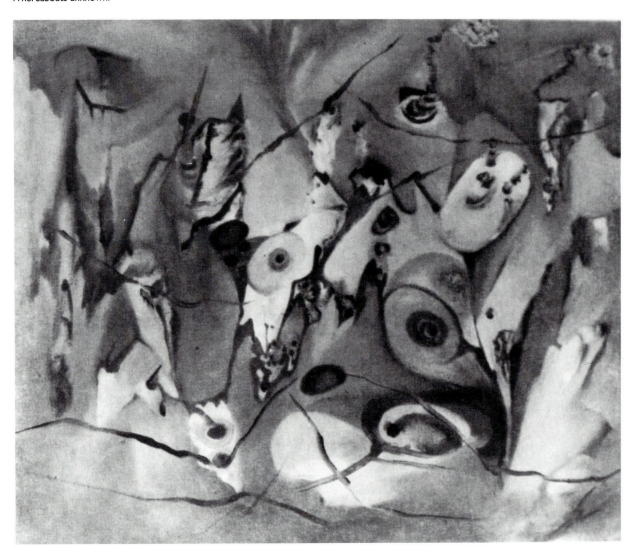

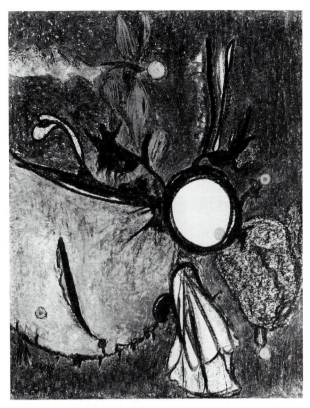

Figure 125. Barnett Newman, *Gea,* 1945. Oil and crayon on cardboard. 27¾ x 21⅞ inches. Reproduced courtesy of Annalee Newman insofar as her rights are concerned.

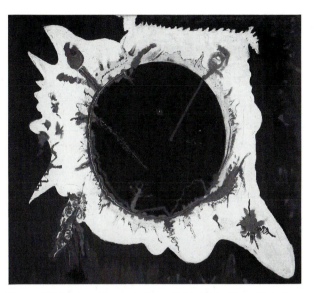

Figure 126. Barnett Newman, *Pagan Void,* 1946. 33 x 38 inches. National Gallery of Art, Washington, D.C. Gift of Annalee Newman. (1988.57.1)

gestation and growth, while Rothko suggests the layers of nature's past and entombments over space and time.

Newman's brightly colored germinating forms also resemble those of Wolfgang Paalen. For example, *The Song of Orpheus* of 1944–45, like Paalen's *Somewhere in Me* of 1940 (fig. 124), consists of free-floating linear and planar forms and shapes that appear to be eyes, in the familiar dream of spectral space of the early Abstract Expressionism of Rothko, Gottlieb, and Baziotes. What is up or down, near and remote remains undefined.

Some of Newman's work of the mid-1940s combined the biological forms of genesis with cave art, suggesting artistic and cultural origins. *Untitled,* for example, consists of looping outlines and planes evocative of the rough texture of walls. Prehistoric art was one of the great sources of interwar primitivism in the work of Miró and others. Newman may have first learned of it as a youth from one of his favorite books, Salomon Reinach's *Apollo.*[10] Reinach wrote that when the primitive artist begins to draw, he draws animals first, and then plants and men.[11] The characteristic trait of cave art is life and movement. To Reinach, these cave drawings illustrate the superimposition of the various strata of civilization. Newman's drawings of this time may thus carry an additional allusion to

the primordial past—the beginnings of art and culture as well as life.

Newman did title a few related works of this period, giving them mythic titles that tie him to many of the classical themes of Abstract Expressionism besides genesis—divinity, death and rebirth, ritual dismemberment, cyclicality, and Earth Mothers. It should be kept in mind that Newman's titles, as with other Abstract Expressionists, were applied after the work was completed in order, as he has said, to aid the viewer in understanding.[12]

Newman's *Gea* of 1945 (fig. 125) represents the myth of new life. With its butterfly forms burgeoning from an empty center, the drawing is Newman's entry into the imagery and theme of the primal Earth Mother. Gea was the Greek personification of the first being that sprang from mythic chaos. She symbolized the Earth and inexaustible powers of fecundity, giving birth to Uranus (heaven), Pontus (the Sea), and all the divine races. The subject of life emerging from mythic chaos is described in Hesiod, a pre-Socratic philosopher favored by the surrealists, especially Masson, Mumford, and by Martha Graham, among other contemporaries: "Before all things ... came Chaos."[13] Newman himself said, "I had a section of the painting as a kind of void from which and around which life emanated—as in the original Creation—for example, *Gea* done in 1945 and *Pagan Void,* 1946."[14] The myth reinforces Newman's symbolic representation of the primal force of creation and new life.

The possibly fertilized egg of the *Pagan Void* (fig. 126) represents a similar theme. It is the mythic primal egg, symbol of the unborn and unformed, out of which every-

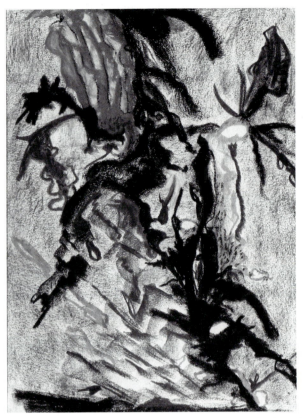

Figure 127. Barnett Newman, *The Slaying of Osiris*, 1944–45. Oil and oil crayon. 19⅞ x 14¾ inches. Reproduced courtesy of Annalee Newman insofar as her rights are concerned.

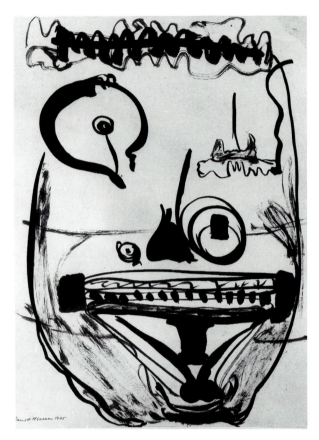

Figure 128. Barnett Newman, *Untitled*, 1945. Brush and ink. 19⅞ x 14¾ inches. Reproduced courtesy of Annalee Newman insofar as her rights are concerned.

thing grew. Jung wrote of it, "The world lies in the egg, which encompasses it at every point; it is the cosmic woman with child . . . the mother of the world is a spirit."[15] Campbell, too, wrote that the cosmic egg was known to many mythologies. Its shell is the world frame of space. The fertile seed power within it typifies the "inexhaustible life dynamism of nature."[16] Within it arises an anthropomorphic personification of the power of generation, the "Mighty Living One," as it is called in the Kabbalah. Newman has said that *Pagan Void* is also an ironic comment on Islamic abstract art, which prohibits reference such as geometric abstraction to the human figure or to "anthropomorphic shapes" as he called them.[17]

The Slaying of Osiris of 1944–45 (fig. 127) identifies more clearly the pattern of experience to which these early Newmans allude. Osiris, a king of Egypt, was murdered, cut into pieces, and scattered over the earth before his queen, Isis, united his remains and resurrected him. Frazer characterized Osiris as a vegetation god worshipped in order to renew crops. He was the personification of the yearly vicissitudes and rebirth of nature. He was also the dying and reviving god of all cultures.[18]

The Osiris theme is a synopsis of the theme of the round of life—rebirth after suffering and violent death—and was a favorite myth of intellectual life in the period. Masson, for example, engaged the Osiris myth in his work, while Pollock's scenes of ritual sacrifice and new life actually parallel it.[19] At several points, the myth intersects the Grail ritual journey. Martha Graham took notes on the Osiris myth to help her think through her 1946 dance *Dark Meadow*. The notes are from Jung:

the fate of Osiris is explained: he passes into the mother's womb, the chest, the sea, the tree, the column of Astarte; he is dismembered, re-formed, and reappears again as his son. . . . Osiris lies in the branches of the tree, surrounded by them, as in his mother's womb. The motive of embracing, and entwining is often found in the sun-myths, meaning that is the *myth of rebirth.*[20]

Jung gave the Osiris myth a psychological explanation; for him, Osiris is a theme of psychic transformation, eternal germination and rebirth.[21] Through his revival of an ancient myth and his imagery of natural, emergent life, Newman addresses historic and cultural experience in *The Slaying of Osiris.*

The Song of Orpheus asserts the role and power of art

itself to heal and bring to life again. Like much art of the interwar period, it posits an artistic role in regeneration. Orpheus's song allows him to bring the dead—his lover—back to life: "Orpheus was the mortal whose playing of the lyre approached the divine; his music was powerful enough to save the Argonauts from the Sirens, and charming enough to win his beloved Eurydice back from Hades."[22] Orpheus and Osiris dedicated themselves to disseminating culture, and both met death when they were torn or cut into pieces.

Newman's pictures of this period no doubt reflect, as Rothko's did, the influence of surrealism. Annalee Newman said Newman described some of his drawings as surrealist. In his work in the mid-1940s, he used biomorphism, metamorphosis, and automatist drawing, all of which were surrealist devices, as the basis of his generating forms. However, like his colleagues, he was turning these devices to ends specific to himself and to Abstract Expressionism. He had little interest in diaristic dream images, fantastic personages, or other surrealist themes of the elementary. He was more concerned with the rudimentary, nascent, and inchoate.

It is also interesting that Newman, who often wrote of

Native American and particularly Northwest Coast tribes, hardly draws from their art in his work. Except for the drawing of gestation entitled *The Blessing* of 1944, which may refer to the Southwest Native American ritual idea of a "gesture" from superior forces they called a blessing (as well as to the biblical idea [e.g. Ezekiel 35:25] of a covenant of peace, security, and abundance as a gift from God), and one brush-and-ink drawing of 1945 (fig. 128) which is based on Chilkat blankets (fig. 129) and suggests the fusion of the angular Chilkat image and figure and various details such as the dot teeth and eyes with gestating forms to make a face, he centered his art on world mythic and cultural traditions, much as his colleagues did. For all of his writing about the primitive, the primitive was part of a larger order that was his main concern.

Newman's art is self-consciously heroic and revitalizing. It reflects his generation's hope that the new will be not only new but better. The hope for the new is the Arcadian desire of the generation of the Second World War. It is unlike the reaction to the First World War, when a nostalgic sense of loss was expressed by English writers in comparisons of the war to the softness and beauty of Edwardian times and the Arcadian English pastoral land-

Figure 129. Chilkat blanket, Tlingit, ca. 1850. Heye Foundation, Museum of the American Indian. Photo: Carmelo Guadagno.

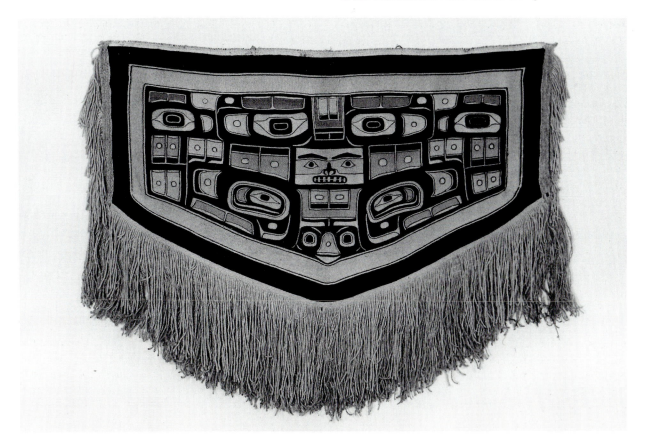

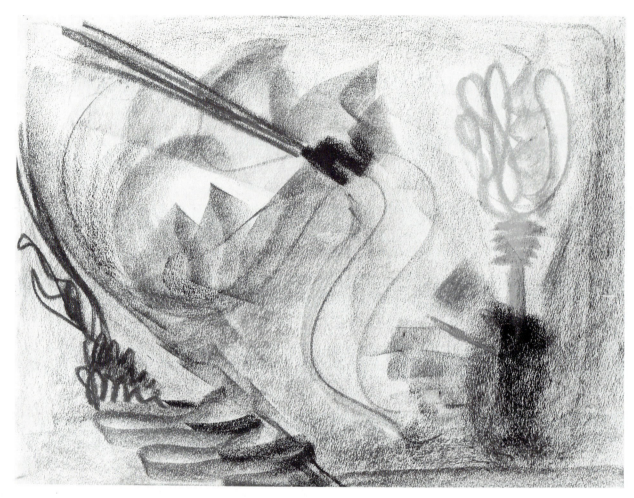

Figure 130. Barnett Newman, *Untitled*, 1944. Wax and oil crayon. 15 x 20 inches. Reproduced courtesy of Annalee Newman insofar as her rights are concerned.

scape of before the war.[23] For the generation of the First World War, the war was a shock, something different from what came before, and its members longed for a return to a more pleasant past. For the Second World War generation, catastrophe was not singular and aberrant but was accommodated as a modern tradition, so the Western past was not to be resurrected for its own sake, as escape. For this generation (in a sense as part of the cycle), there was a push to rid itself of the past:

Everything before the war had been *old* and everything after the war would be *new*. A collective act of will, or else a dream: a dream of a New Age. The prevailing metaphor was of flowers growing out of rubble. The rebuilding of Europe had begun. The terrifying A-bomb had mysteriously disappeared.[24]

The dream of the new was necessary, because, as a Japanese survivor said, "People had to believe the war was not in vain in order to live on."[25] Only in the

unprogrammed Arcadia of the new could there be relief—even if it was only temporary and limited before the past pattern and shape of human history as initiation, maturation, and decline began again.

Beginning in 1945, Newman gradually developed a new form that would mature into his final style—the ray or beam of light. A drawing of 1944 had hinted at this form. *Untitled* of 1944 (fig. 130) contained a rising or descending sprouting form that would in later works evolve into stem and bloom images of stalks and flowers and then into zips. In *Untitled* of 1945 (fig. 131) three new growth motifs appear: the zip, a vertical stripe; the falling form; and the beam, an elongated V-shape.[26] Here Newman has moved away from the biological and automatic toward the more abstract image of rising natural forms in a more landscape-like environment. He eliminates the all-over multiple forms of the earlier drawings but continues to use the entire field of the paper. These new drawings take for granted

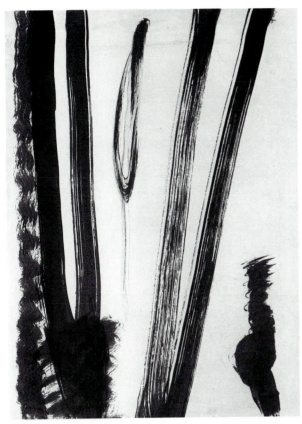

Figure 131. Barnett Newman, *Untitled*, 1945–6. Brush and ink. 23¾ x 17⅝ inches. Reproduced courtesy of Annalee Newman insofar as her rights are concerned.

the overall space or "spectral space" of before, but the shapes have been simplified and concentrated. His central idea remains the same, but is now ready to materialize or dematerialize as intangible light.

Not only his earlier motifs but also what he wrote as a catalogue introduction to Gottlieb's show at the Wakefield Gallery seem to lie behind this new image of light beams. Newman says of Gottlieb's paintings: "In these burning heads that are the soul there glows . . . inner splendor, the 'dry-light' of man's eternal quest for salvation."[27] Newman then names the source of his statement and identifies its meaning with Gottlieb. He quotes the pre-Socratic philosopher Heraclitus, popular (with the surrealists, Joyce, Eliot, and others) during the interwar period: "the perfect soul is a dry light which flies out of the body as lightning breaks from a cloud." The bursting forth of "dry light" representing "inner splendor" and the eternal human "quest for salvation" underlies the development of Newman's art and thought more than it does Gottlieb's more conflict-laden work.

By 1946 the transformation into abstraction of the metaphoric process of flowering has led to a new explo-

ration of painting. More explicit naturalistic beginnings appear in the primeval landscapes of *Genesis—The Break* of 1946 (fig. 132) and *Genetic Moment* of 1947, especially in the latter's rooting and rising forms.

Contemporary with the abstract landscape paintings are more linear ray paintings such as *The Beginning* of 1946. Distinct rays or bands of pink, white, and blue light, along with less clear bands, arise, and "fill the void."[28] One ray seems to emerge from a sprouting, semicircular ground shape at the bottom. While this motif looks back to the earlier sprouting flower and stem form, it also points to Newman's sculpture of four years later. The very verticality of the semiabstract linear bands and rays symbolizes the ascent of new life. Newman's earlier images of biological process and shapes have been condensed into an abstract shape that telescopes the process of emergence.

The creation of light is a godlike act, and in *The Command* of 1946 (fig. 133) Newman uses a ray or band to separate a light atmospheric area from a dark, earth-colored one. In this work, Newman moves to a ritual new beginning in which he modernizes primitive, magical, and Christian ceremony. Like artists of the 1930s, for example, Alexandre Hogue in his *The Crucified Land* of 1936 (fig. 134), and like his colleagues and others, he updates Christian iconography and applies it to contemporary life and history. Newman drew on this interwar tradition of ritualizing history by rendering the biblical theme of Genesis in modern and increasingly abstract form. As an artist, he identified with the Power that can create new worlds. He once said "We are in the process of making the world . . . in our image."[29] Like Still and other Abstract Expressionists, Newman sees himself as having the sacred power of a primitive seer or magician to reenact the original act of Creation.

In several ways, Newman's imagery and intent echo Jung's conception of visionary art, although Newman was never interested in psychology and the unconscious.[30] Rejecting mere forefront art of the personal psyche and everyday life, Newman attempts a visionary art that looks into the primordial chaos and evokes a superhuman world of contrasting light and darkness. Visionary art is to arise from the depths of time and will burst asunder contemporary standards of value and aesthetic form. It allows a glimpse into what has not yet become. Newman's early work is an art of visionary generation.

NEW HARMONY

Onement I of 1948 (fig. 135) is Newman's mature image. A first mark, the zip—a rough, raw, unpolished band—emerges from the ground in a pictorial recapitulation of his ideas, now rendered in a more concrete and less

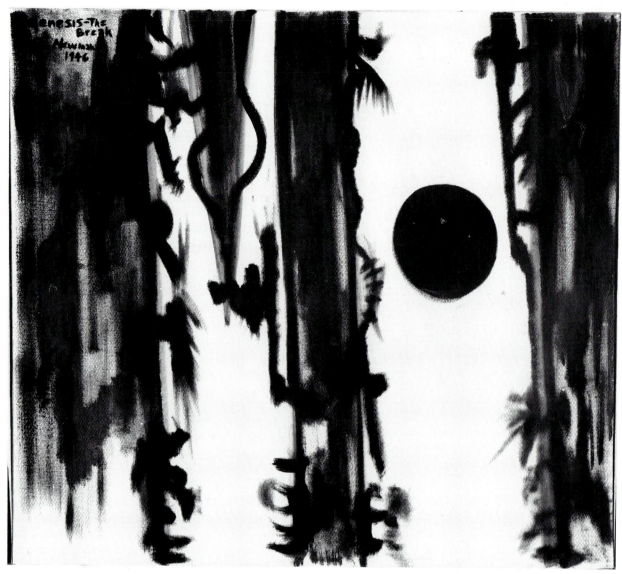

Figure 132. Barnett Newman, *Genesis—The Break,* 1946. 24 x 27 inches. Courtesy of The Menil Collection, Houston, Texas. Photo: Noel Allum.

naturally allusive way. The painting suggests a new beginning—one—the first. As with other Abstract Expressionists, in Newman's development there is a continuity of idea but a transformation of means.

Newman considered art to be first of all an expression of the mind. To bring about the new requires an original, unique creative mental act, hence "onement." He may have developed this idea partially through his interest in Spinoza, whom he studied in college, and on whom he based his first aesthetic manifesto.[31] Spinoza wrote in a seemingly rational mathematical mode of propositions and proofs. Encasing his truths in this apparent geometric simplicity (a literary style much like Newman's illusionary

geometric composition), Spinoza undertook an investigation of the different kinds of knowledge and their relationship to God.

In much philosophy before Nietzsche, epistemology was a priority. Spinoza defined God as a mental rather than physical substance whose attributes included extension, duration, and unity. To Spinoza, humanity feels divine when attaining knowledge. Intelligence is something conciliatory, just, and good—something, as Nietzsche himself wrote of Spinoza, the opposite of the instincts.[32] Adopted by Newman, this denial of the instincts differentiates him from other Abstract Expressionists. For Spinoza and Newman, the spiritual is mental—a mental "plasma" in New-

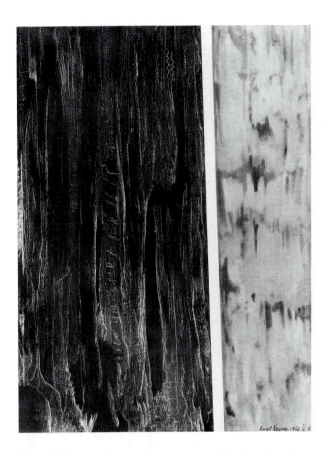

Figure 133. Barnett Newman, *The Command*, 1946. 48 × 36 inches. Oeffentiliche Kunstsammlung Basel, Kunstmuseum. Reproduced courtesy of Annalee Newman insofar as her rights are concerned.

man's own words—and new thought is new spirit.[33] To know is the principle of life, and while there were several kinds of knowledge, the highest thought is the "intellectual intuitive."[34] And an idea is an act of thought. *Onement I* may be considered an epistemological gesture. The first mark or line is the first step in gaining knowledge. Newman thus is not creating a new psyche or self but a new idea form or complex. He seeks deliverance through knowledge.

Newman also said that *Onement I* involves atonement.[35] "Atonement," coming from the Latin *adunamentum* and *adunare*, means "At-one-in-harmony," and "to unite." "Atonement" or "onement" means the action of setting at one, or being one, after discord; in short, reconciliation. It also means for Newman the condition of being at one with others, or concord, as found in the double-banded *Concord* of 1949 (pl. 13). In theology, atonement means reconciliation or restoration of friendly relations between God and sinners. *Atonement* is thus used by theologians in the sense of propitiation and expiation. It is also the meaning of Yom Kippur, the Jewish day of remembrance. As a Jew, although not a religious

one, for Newman atonement must have been particularly relevant in view of the fate of Jews during the war.[36] One sought forgiveness for allowing what happened to happen.

And *Onement* suggests another concept: America's belief in its ability to transcend the past and begin anew. America had been founded by those fleeing the disasters abroad. The American frontier's offer of the possibility of endless new beginnings was and is imbedded in the American psyche. American optimism most often consisted of a belief in America's unique divestiture of history and heritage in exchange for an eternal future. *Onement* thus implies yet again the needed and longed-for historical new beginning.

Thus, Onement after sacrifice, discord, and a reconciliation of sinners with God—these are themes of a quest for a new harmony and peace in the aftermath of World War II. There is no evidence that Newman's reconciliation is an autobiographical subject; rather, it is yet another point where the history of Newman's era breaks through, expressed in abstract form and in complex cultural argument. With his sense of salvation being represented by the new and harmonious, Newman matches Rothko's sanctification of human life.

Many of the figures who interested Newman's milieu discussed primitive propitiation and atonement. In Frazer's schemes, it is the primitive magician-artist who, as leader of his clan, creates art in ritual ceremonies to allay the wrath of the gods and to assert himself over the elements. In Jung's concept, the artist is the individual most attuned to the new healing vision from the depths of the unconscious. In Read's conception of form (from Worringer), primitive art is an act of instinctive magical propitiation which is intended to indicate an escape from the otherwise prevailing arbitrariness of existence.[37] It creates a visible expression of the absolute.[38] For Campbell, atonement, or as he spells it "at-onement," means reaching a middle point between too much morality and too much sin.[39] Harmony can be attained by giving up a sense of guilt and achieving a better balanced, more "realistic view" of the world. In addition, for Nietzsche, the Dionysian tragic art creates a harmonious oneness between man and nature and between human and human.

For Newman and these figures, the artist's concentrated, creative act redeems the discord and suffering of the world. *Onement I*, through its intuitive epistemological and metaphysical act/thought, is a declaration of a new life, a new harmony, which fills the abyss of social and historical chaos with the power of the first new color/spirit of the postwar world.

One last subject needs to be discussed in regard to *Onement I*—existentialism. By 1948 existentialism was becoming known and popular in American intellectual circles. Newman in particular must have been aware of it,

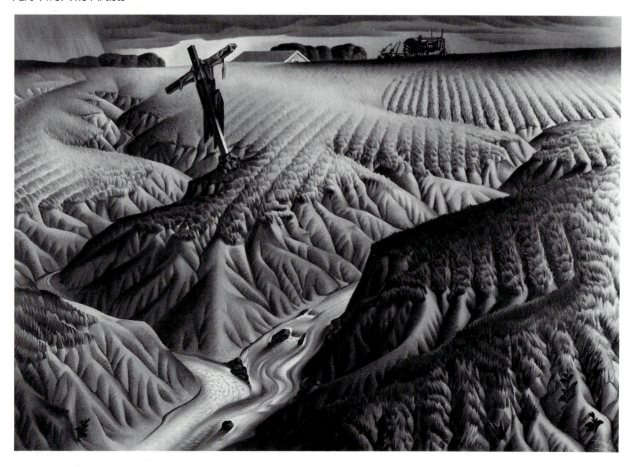

Figure 134. Alexandre Hogue, *The Crucified Land*, 1936. 42 x 60 inches. The Thomas Gilcrease Institute of American History and Art, Tulsa, Oklahoma.

since *Onement I* and several of his remarks indicate the congruence of Sartre's existentialism with the ideas Newman had developed from other sources if not its influence on them.

A key is the Alberto Giacometti show at Pierre Matisse's gallery in February 1948. Like De Kooning and many American artists, Newman admired Giacometti, and he noted that the sculptures "looked as if they were made out of spit—new things, with no form, no texture, but somehow filled. . . . I took my hat off to him."[40]

Giacometti's elongated vertical figures seemed to catch the anxious atmosphere of the postwar world. Newman apparently decided on his zip image partially as the result of the sculpture. Indeed, the catalogue to the show, with its unique presentation of the image, seems to have been an influence.[41] The front cover is a narrow, die-cut, rectilinear vertical under which appears a photo of a Giacometti scupture (fig. 136). This image apparently influenced the identification of the zip with rough-hewn and insubstantial form. In addition, Giacometti's narrowing of

the human form while asserting its linear presence in surrounding space echoes Newman's idea of the form in a void or abyss.

The Giacometti catalogue also contains an essay by Sartre, "A Quest for the Absolute," that seems to converge with and, eventually, inflect several of Newman's ideas. Sartre writes that Giacometti's art indicates a desire to begin anew:

A glance at Giacometti's antediluvian face reveals his arrogance and his desire to place himself at the beginning of time. He . . . has no faith in Progress—He considers himself no further "advanced" than his adopted contemporaries, the men of . . . Altamira. . . . The man who first had the notion of carving a man from a block of stone had to start from zero. . . . It is . . . necessary to start again from zero.[42]

There are no *a priori* aesthetic values for Sartre. For him, Giacometti had to fashion a man out of minimum precedence and substance (compare Newman's praise of Giacometti's spit-new things). Giacometti gives his human

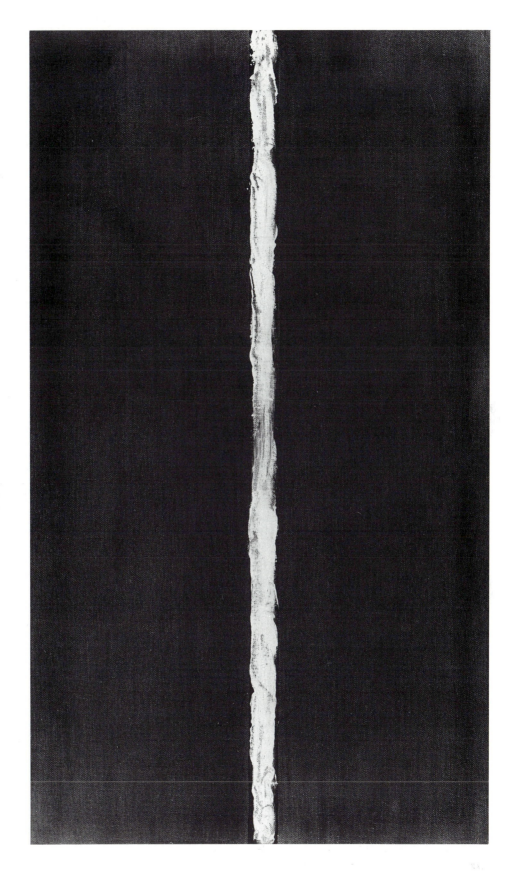

Figure 135. Barnett Newman, *Onement I,* 1948. 27 × 16 inches. Reproduced courtesy of Annalee Newman insofar as her rights are concerned.

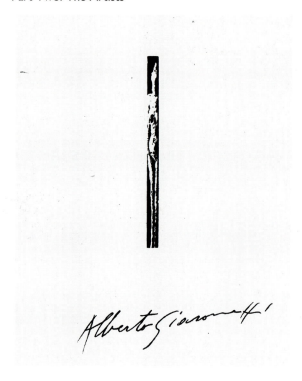

Figure 136. Alberto Giacometti catalogue cover, Pierre Matisse Gallery, 1948.

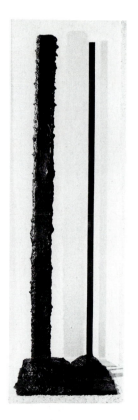

Figure 137. Barnett Newman, *Here I [to Marcia]*, 1950. [Sculpture cast 1962, base 1971.] Bronze. 107⅛ x 28¼ x 27¼ inches deep. Collection of Marcia S. Weisman, Beverly Hills, California.

form movement yet total immobility, unity in infinite multiplicity, "extensity," and the "absolute in pure relativity." He worries about the "void" but rejects objects that would fill them. He lives in a "fluctuating universe." Giacometti is forever beginning anew. His words are "wholly" and "immediately what they are." They flood Sartre's field of vision, as an idea floods his mind: "the idea has . . . immediate translucidity and is . . . wholly what it is. . . . Giacometti has found a unique solution to the problem of unity within multiplicity by simply suppressing multiplicity."[43]

For Sartre, a figure in motion has the indivisibility of a single idea or an emotion. To give perceptible expression to pure presence, to surrender the self to instantaneous emergence, Giacometti has "recourse to elongation." He has rejected—appropriately in the view of Sartre and Newman—the graceful beauty of the Greco-Roman.[44] His art is a quest for the essence that in the Sartrean formula has no previous existence.

In Sartre's philosophy, myths and legends are rejected in favor of a perpetual renewal. Newman thought that his new style freed him of these also (although he continued the associations): "We do not need the obsolete props of an outmoded and antiquated legend. . . . We are freeing ourselves of the impediment of memory, association, nostalgia, legend, myth, that have been the devices of Western European painting."[45]

This new creation takes place in the here and now. In the 1950s, Newman did sculptures influenced by Giacometti.[46] Sculptures such as *Here I, [to Marcia]* of 1950 (fig. 137) have verticals and a base comparable to the single-footed base of Giacometti's figures as well as to Newman's earlier stem and pod. Other sculptures by Newman are also titled in this fashion and connected to existentialism as well as Giacometti. *Hereness* is an existential issue discussed in the beginning of the Abstract Expressionist magazine *Possibilities* as well as in Sartre's essay on Giacometti. Hereness is a desire to make the subject concrete and contemporary, that is, "real" and "here" rather than "out there." Newman did just that—he made his zips concrete and physical. It was a long-held goal of modern art and of Abstract Expressionism (cf. Gottlieb), pre-dating Sartre's writings, to make paintings that would be symbolic and yet also have the status of real objects. In Newman's work, this goal is realized, appropriately enough, in sculpture.

"FULLNESS THEREOF"

In Newman's mature style, for example in *Cathedra* in 1951 (fig. 138), his earlier suggestions of the superimposi-

tion of several forms or of one form separating and emerging from another have been replaced by the burgeoning, extension, and duration of one element, color. Linear parts now function almost as integers, some wider, some narrower, some smooth, some rough, some light, some dark, all fused and expanded to the edges of the canvas. The compositional structure of his mature work presents a dramatic, instantly impressive (in Sartrean terms, immediate), sensuous unity, not one created by complex intricacies of form and transitions, as in much previous modern art. The incidents in his art consist of segmented bands and not multiplicities of forms and symbols. Individual paintings present a harmonious whole because different elements have been fused into a primal unity of the formerly disparate figure and ground, organism and space. In other words, Newman blended and expanded the planes and eliminated specific phenomena. The result is works that achieve the artist's goal of providing intimacy of experience: "To look at a huge painting . . . from close up is not to scrutinize the painting in its dimensions and divisions but to submit oneself to the sense of it as whole, with the zips apprehended as more or less distant echoes."[47]

The few incidents in a mature Newman painting involve the placement and alternation of narrow and expansive planes, the contrast of incorporeal and immeasurable colors, and the smoothness or roughness of the edges of his planes. The paintings are intentionally dynamic. (In planning *Vir Heroicus Sublimis* of 1950 [pl. 14], Newman originally conceived of the painting as more of a static square, then changed its proportions in order to get its

long horizontal, moving expansiveness.)[48] In the mature works, the space unfolds in an almost processional rhythm without a beginning or end. Newman's zip accents the continuum. As Clement Greenberg noted: "Surface spreads, ascends and descends, and in certain places, it pauses. The line that marks the pause does not demarcate or limit; it simply inflects the continuity."[49]

With his intuitive placements of the bands, Newman's paintings contain a series of fluid intervals, phases, and proportions across and within a color expanse that still remains whole. The paintings achieve a sense of fullness through rich color sensations modulated, phrased, accented, and given human scale by the zip. Newman said "My canvases are full not because they are full of colors but because color makes the fullness. *The fullness thereof* is what I am involved in."[50] In all of his mature work, the new spirit rendered by intangible, immaterial color is expanded to fill the canvas. With its fluid, large-scale light, Newman's style fits his emphasis on the holistic continuum of the forces, spirit, and inner life of humankind. It attempts to be the formal equivalent of the unity, commonality, and amplitude of human aspiration and effort.

In Newman's art, human passion, the intensity of feeling, has been discharged into the fluency of colored light; into the dignity, gravity, or buoyancy of hue; into immediacy, impact, and relationship. Newman seeks a high seriousness and reasoned goodness in a view of human affairs related to us by color and composition. For example, he renders the joy and sublime heroism of humanity through the rhythmically accented dazzling red of *Vir Heroicus Sub-*

Figure 138. Barnett Newman, *Cathedra*, 1950–51. Oil and magna on canvas. 96 inches x 17 feet 9 inches. Collection, Stedelijk Museum, Amsterdam.

Figure 139. Barnett Newman, *Prometheus Bound*, 1952. 11' x 50 inches. Museum Folkwang, Essen, West Germany.

limis, the exaltation of the near divineness of humanity through a powerful blue in *Cathedra*, the binding of Prometheus through the large area of black pressing down on a small band of white in *Prometheus Bound* of 1952 (fig. 139), and the drama of human fate in *The Stations of the Cross* series of 1958–66 (fig. 140) through a dramatic and stark black and white.

Human presence is also evoked through scale-producing size and bands. The small size and scale used in 1948–49 yield to larger canvases. Yet Newman always felt that the scale must be human: "I'm not interested in monuments, in overwhelming man, in creating environments [cf. Rothko]. You've got to give a person a sense of place before a painting. It must be physical and emotional."[51] Of the *Stations of the Cross* series, he said he "wanted human scale for the human cry, human size for the human scale."[52] The bigness of Newman's large paintings helps make his content sublime. What he said of Uccello's *Battle of San Romano* at the Louvre is relevant to his own work: "It is beyond the problem of size. It looks big. The content and the form are inseparable: that's scale."[53] That is also eloquence.

Human scale is also produced by means of the narrower band whose rough edges testify to their handmade character and thus to the human and organic presence. These are the actual marks of the human creator and convey directly rather than symbolically, as in earlier work, human expressive activity.

The color fields, periodically accented by zips, formulate a metaphorical situation which, when a relevant title is added, phrase and mark a particular experience in the historical and mythic life of humankind. Through configurations of sensations—of colored light, space, weight, proportion, power, and rhythm—Newman strikes a visual equivalent to a moment in the panorama of humankind's emotional experience as sought and understood in the 1940s. In the following sections, let us look at individual subjects and their visual form.

THE HEROISM OF EVERYMAN

In Newman's mature work, the all-encompassing theme is the entire human spiritual drama as he and other Abstract Expressionists defined it. Newman's points of emphasis include: the primal unity, wholeness, and harmony between humanity and nature, and among all cultures in space and time; the divineness of human creativity; the heroism and gallantry of humanity and its attempts to overcome its fate; the terror, suffering, and tragedy of human life; the fullness and greatness of the human spirit; and the expansion of consciousness through the intensification and understanding of human history. In Newman's

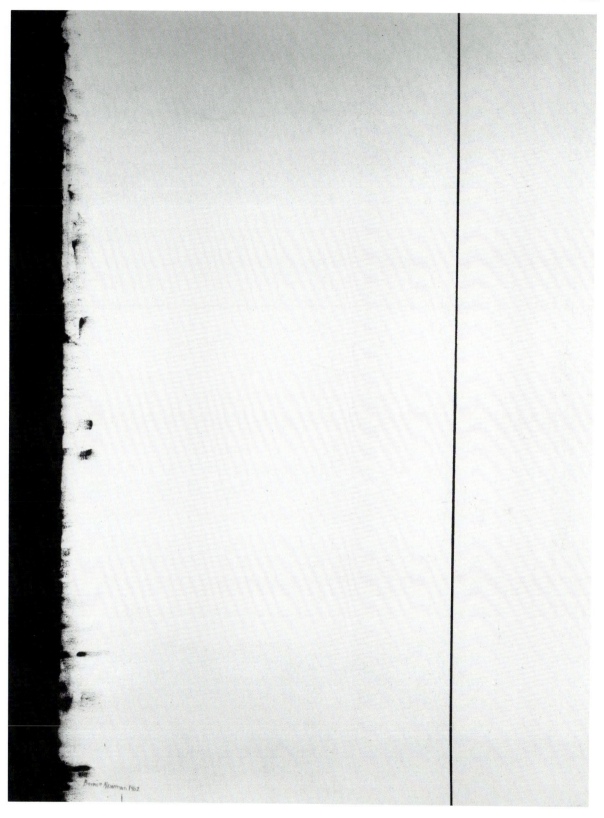

Figure 140. Barnett Newman, *Fifth Station of the Cross*, 1962. 78¼ x 60¼ inches. National Gallery of Art, Washington, D.C. Robert and Jane Meyerhoff Collection. (1986.65.5)

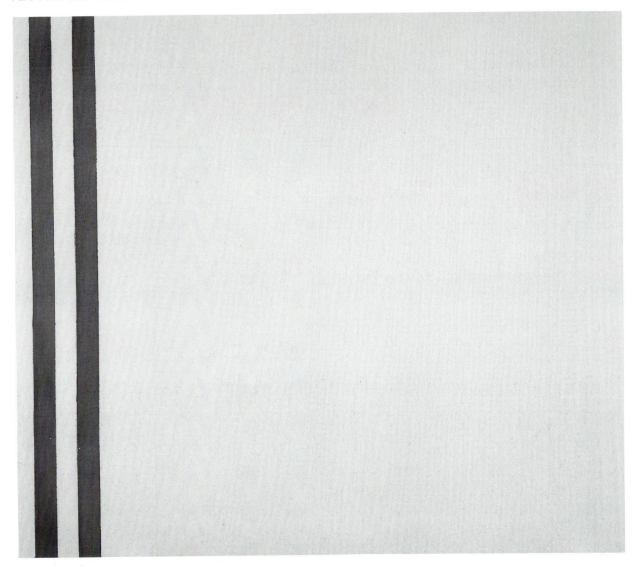

Figure 141. Barnett Newman, *Shimmer Bright,* 1968. 72 x 84 inches. Reproduced courtesy of Annalee Newman insofar as her rights are concerned. Photo: Paulus Leeser.

art, these topics are yet another replay of the experience of the crisis and the war fixed as his generation's wisdom.

Besides *Onement I,* Newman did several representations of the new and of Creation in the metaphor of color relations explained as nature. For example, the primordial new beginning appears as nature in the form of the night before the dawn in *Day Before One* of 1951, in which a deep ultramarine blue hovers over a narrow sliver of lighter blue. It appears as day, in *Day One* of 1951–52 (pl. 15), in which a full thrust of fiery red emerges from darker reds at the very edges of the canvas. These are fully abstract pictorial, allegorical paintings, the modern equivalent of Newman's symbolically naturalistic landscape/light representations of genesis. The light blue of *Primordial*

Light of 1954 repeats the theme, while the bright green of the horizontal *Dionysius* of 1949 evokes the god's natural fertility.

Light has always been a symbol of magical, mythical, and religious power in Judeo-Christian and Eastern cultures. Martha Graham cites R. S. Pandi in a way that illuminates Newman, writing: "Myths and legends are the dreams of nations. ... They are like a pane of glass thru which the past is visible . . . the eternal struggle between the powers of darkness ... Titans ... the shining ones, the gods thru various stories."[54] In notes for *The Dark Meadow of the Soul,* she added "The summoning of the condition of vision—To achieve it one enters the realm of darkness and fear, and from it is reborn into the light."[55] Light and

darkness are a frequent topic in Newman's work, from *Primordial Light* to *Shimmer Bright* of 1968 (fig. 141). They are given a more autobiographical meaning in *Shining Forth [to George]* of 1961, a tribute to his late brother, and *Anna's Light* of 1968, a tribute to his wife. Newman's color light raises the viewer from the subterranean, troglodyte world of much Abstract Expressionist art to the fullness above the horizon.

Newman's mature work, like most Abstract Expressionist art, invokes and reclothes the mythical in modern pictorial garb. Several mythical and supernatural themes persist in Newman's work. The idea of covenant, reconciliation, and accord is the subject of several paintings in which humanity is reconciled with the creative force of the godhead. In *Concord* of 1949, painted in a green reminiscent of the mythic Boscoreale frescoes *Polyphemus and Galatea* and *Andromeda and Perseus* (as *Onement*'s red-orange is of plate 6); and *Covenant* of 1949, a single maroon surface varied but not broken by lighter and darker zips, two differently lighted or edged bands run parallel to one another, establishing a concordance both pictorial and metaphoric. *The Promise* of 1949 (fig. 142) again suggests Newman's sanctification of new possibility with a rougher zip paralleling a smoother, more mature one. *The Word I* of 1946, a ray painting, and *The Word II* of 1954 suggest a sacred new beginning: "In the beginning was the Word." These paintings, together with *The Gate* of 1954, also suggest spiritual journey as found in discussion of the Promise, Word, and Gate in the Bible as well as in *The Pilgrim's Progress*.

However holistic in image and theme his work is, Newman too represents the inexorable divisions of the world. While the two zips in *Concord* and *By Two's* of 1949 suggest harmony and balance, works such as *The Third* of 1962, *The Three* of 1962, *Tertia* (fig. 143) of 1964, and *Triad* of 1965—all with a rough, incomplete

Figure 142. Barnett Newman, *The Promise*, 1949. 52 x 70 inches. Adrian and Robert Mnuchin. Photo: Malcolm Varon.

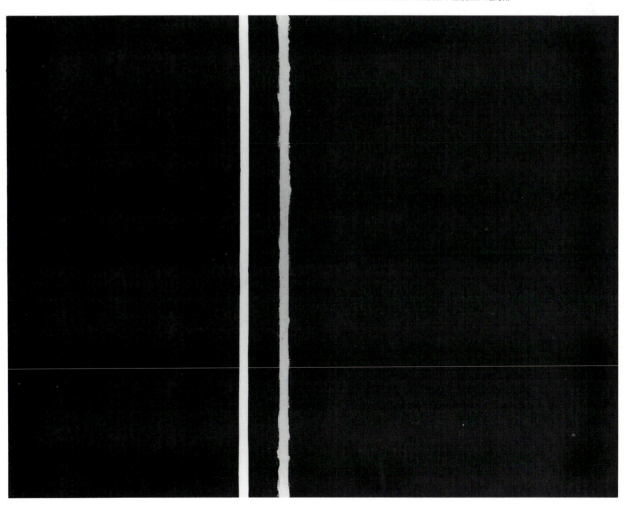

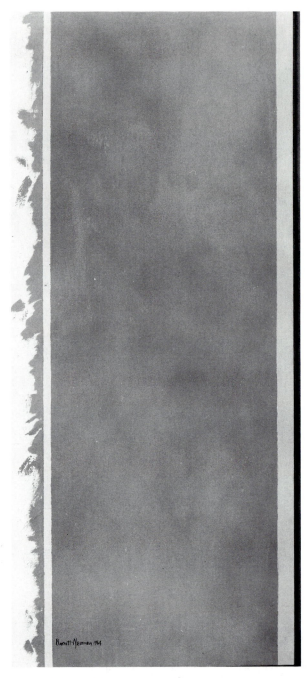

Figure 143. Barnett Newman, *Tertia*, 1964. 78 x 35 inches. Moderna Museet, Stockholm, Sweden.

edge or zip balancing a smoother one—challenge such a collective harmony. In these latter works, Newman restates the surrealist and Abstract Expressionist theme of multiple states or unity in multiplicity as irreconcilable duality, dissonance, and divergence, suggesting the inexorable fragmentation and division of the world.

Fire becomes an additional mythic symbol for this duality in Newman's art and thought. He did a series of paintings entitled *White Fire I–V* and a painting, *Black Fire I* (fig. 144), which suggest the typical symbol of divine or evil light. Fire was a common topic in Newman's cultural milieu. Nietzsche attributed the importance of the Prometheus myth to the "extravagant value which naive humanity attached to *fire* as the true palladium of every ascending culture."[56] Jung considered the libido a divine force:

The "unquenchable" fire ... is a well-known attribute of the Deity. ... Whoever is near to me, is near to the fire; whoever is far from me is far from the kingdom. Since Heraclitus, life has been figured as ... an eternally living fire. ... The fire symbolism with the meaning of "life" fits into the frame of the dream, for it emphasizes the "fulness of life" as being the only legitimate source of religion.[57]

Jung further states: "The visible father of the world is, however, the sun, the heavenly fire; therefore, Father, God, Sun, Fire, are mythologically synonymous."[58] Martha Graham noted that "the soul in its pure state consists of fire."[59] And Still compared his work to the assertiveness of the flame: "The vertical rather than the horizontal; the single projection, instead of polarities, the thrust of flame instead of the oscillation of the wave."[60]

Fire symbolism for these figures represents the internal divine. It is dualistic: while it can create, it can also destroy. According to Jung, "the sun is not only beneficial, but also destructive."[61] In Jungian theory, however, the destructiveness of the unconscious is beneficial, for it will clear the way to the new. In a similar manner, Churchill often referred to the war as a struggle to purify the world. Newman seems to have had both concepts of divine inner and human life in mind in the dualistic, elementary divisions and interrelations of *White Fire* and *Black Fire*, as did Motherwell and Gottlieb in their works both paradoxically titled *Black Sun*. (Martha Graham articulated the same theme: "aspect of white goddess white goddess of birth and growth red goddess of love and battle black goddess of death and divination.")[62]

These dualities and multiplicities reflect the concept of the life cycle. The varieties of good and evil, light and dark are further indicated in Newman's work by the idea of above and below or noon and night. Works such as *Noon Light* of 1961 (fig. 145) and *Queen of the Night II* of 1967 invoke the cycle. Martha Graham wrote similarly of the cycle: "passage of a night into dawn—a new day—another time—an incident of re-birth—Voyage ... The passage of any night is ended by an emergence into Dawn—a fresh beginning ... The rituals necessary for the re-birth of day."[63] For her and for Newman, the path of the soul goes upward and downward.[64] Newman's dualistic night and day cycles reflect the maturation in abstract form

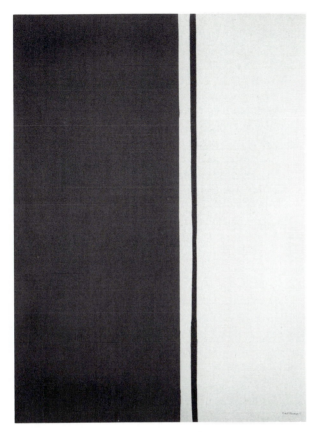

Figure 144. Barnett Newman, *Black Fire I*, 1961. 9 feet 6 inches x 84 inches. Philadelphia Museum of Art: Mr. and Mrs. Daniel W. Dietrich II.

Figure 145. Barnett Newman, *Noon Light*, 1961. Oil on raw canvas. 9 feet 6 inches x 84 inches. Reproduced courtesy of Annalee Newman insofar as her rights are concerned. Photo: Eric Pollitzer.

of the Osiris and Orpheus cycles of his earlier work.

What appears in the cycle is not just the beginning point or even the voyage or journey but the negative aspect too: the duality of human experience and its pain. This Newman addressed in works such as *The Wild* of 1950 and *Outcry* of 1958 (fig. 146), paintings in which the full symbolic potential of Newman's zip is realized as the central image and plane contrasting with the hard, clear edges of the canvas's shape. Newman replaced earlier modernist representations of tragedy or pain with a general image, more concrete but also more abstract, of flayed, lacerated, torn, vertical assertiveness—the zip—as a metaphor for the shattering of the life journey.

To affirm life, Newman more than any other Abstract Expressionist proffered a direct view of the heroism of humanity. After the Second World War, the loss of faith in human nature and its inevitable progress climaxed. This led to a belief in the need for individual responsibility and an interest in Sartrean and Kierkegaardean thought. On the negative side, it led to what Kirk Varnedoe has called "survivor humanism," the sense of wounded and victimized humanity. Newman countered such thought with the

idea of the sublime hero in works such as *Vir Heroicus Sublimis*, *Prometheus Bound*, *Uriel* (the Hebrew Prometheus) of 1954, and *Joshua* of 1950.

Newman sought to create a courageous and heroic image of humanity, as another part of the postwar healing process. He relied on concepts of sublimity that had become popular among his colleagues in his time, such as Longinus's "It is our nature to be elevated and exalted by true sublimity." Sublimity allows for human joy and pride. Sublimity resides in the artist's conception of the human effort and his or her ability to represent it. Newman admired Michelangelo for his ability "to make a cathedral out of man."[65]

Newman's concern with the hero was not an isolated instance; the hero was a common subject in his era. In the 1930s a preoccupation with heroes of the rediscovered American past was expressed in the vogue for biographies of the lives and times of heroes.[66] As part of an affirmative attitude toward the past and toward present human possibility, the Depression saw the rehabilitation of the national hero as an exemplar of what an American was and could be. Ideals were centered not just on historical

Figure 146. Barnett Newman, *Outcry*, 1958. 82 x 6 inches. Mr. and Mrs. S. I. Newhouse. Reproduced courtesy of Annalee Newman insofar as her rights are concerned. Photo: Eric Pollitzer.

events involving the hero but also on the hero's personality. The most popular hero was Lincoln, especially the Lincoln of Carl Sandburg's *The War Years,* an epic study of the lonely man presiding over America's greatest trial.

With the advent of the Second World War, the idea of heroes was given concrete form in contemporary experience. Thousands of real heroes lived and died every day in combat, and they were recognized as such, artists being called upon to record their deeds for the homefront. Indeed, the homefront itself had its heroes and heroines, the most prominent of which was Rosy the Riveter.

This need for and acknowledgment of heroism found appropriate manifestations in intellectual circles. Typically, the cultural manifestations of the hero are exemplary personages who translate human experience and the lessons of the past into a conception or paradigm in which the public can read its condition and destiny.[67] Often heroes are not so much preeminent individuals as living personifications of actual historical, cultural, and personal tendencies. They link the past and present and become guides to ideal action. In Weston's concept of the Grail quest, they provide a heritage of achievement on which a culture could draw.

Prometheus was a popular symbol of the creative hero for Newman and others. Jung wrote that Prometheus's acquiring of fire for humanity represented the attainment of a new consciousness that guides man and saves him from being at the mercy of nature.[68] For Nietzsche, Prometheus's theft of divine power led to his being bound to earth. Newman's image in *Prometheus Bound* emphasizes the cost of this heroic act. Nietzsche considered Prometheus to be a Dionysian hero and the artist to be a Promethean figure who payed dearly for his creativity:

In the *Prometheus* of Aeschylus this feeling is symbolized. In himself the Titanic artist found the defiant faith that he had the ability to create men and at least destroy Olympian gods, by means of his superior wisdom which, to be sure, he had to atone for with eternal suffering. The splendid "ability" of the great genius for which even eternal suffering is a slight price, the stern pride of the *artist*—that is the content and soul of Aeschylus's poem.[69]

In the late 1940s and 1950s there was also, of course, strong interest in Campbell's *The Hero with a Thousand Faces,* in which the mythic hero is the most successful human, the one who achieves a world historical triumph. For Campbell, the hero is the creative figure who in his efforts reflects the dying of the old and the creation of a new human spirit. The hero delineates the new human course in his or her journey. Again Martha Graham reveals the nature of the issue and the need:

they are seeking some pattern in which they can engage their destinies ... not angel in the strict Christian sense of the word,

but angel in the new sense created by the contemporary artist—a sense which is transforming the outdated hero of physical action into the new hero of spiritual action.[70]

Visual artists of the period took up the theme of the hero. Frida Kahlo's *Moses* of 1945, for example, is an epic of heroes that she says was inspired by Freud's *Moses and Monotheism.* Together with images of biological procreation and the life-death cycle, the painting portrays heroes throughout the ages, including Egyptian and Greek gods, Moses, Christ, Buddha, Alexander the Great, Caesar, Marx, Lenin, and Stalin.[71] As noted, David Smith, Seymour Lipton, and David Hare created several sculptures in the 1950s entitled *Hero* that were specifically inspired by Campbell's concept. Added to these were Newman's paintings of Prometheus, Joshua, Uriel, the Wanderer or Knight Errant (*L'Errance*), and Everyman (*Vir Heroicus Sublimis*). With their large scale, bright light, and color—"dry light of the soul"—dramatic proportions, narrative configuration, and syncopated, periodic sense of movement, they seek to create pictorial equivalents of heroic spiritual action.

Newman's heroes are taken from different cultures of the world and from the past and therefore belie his constant stress on the new and the primitive as the only palliation. The mythic and historical past provide the solid ground on which Newman's generation can stand. Like the venerable figures from the past whose wisdom Wilder quotes in *The Skin of Our Teeth,* the heroes of the past are "usable" in providing wisdom for today.

In many epochs of Western history, the hero who best illuminates the collective search and self of his time is Jesus. Jung understood the artist and Christ to be the best vehicles for representing human fate. Albert Camus understood this too. In the postwar period, he wrote that in one sense Jesus personifies the whole human drama: "He is the complete man, . . . the one who realized the most absurd condition. He is not the God-man but the man-god. And like him, each of us can be crucified and victimized—and is to a certain degree."[72]

Newman also used Christ to represent the heroism and suffering of humanity. In a series of fifteen paintings entitled *The Stations of the Cross,* Newman asks the primordial questions of his crisis-rent generation in terms of Christian ritual:

Lema Sabachthani—why? Why did you forsake me? Why forsake me? To what purpose? Why?

This is the Passion. This outcry of Jesus. Not the terrible walk up the Via Dolorosa, but the question that has no answer.

This overwhelming question that does not complain, makes today's talk of alienation, as if alienation were a modern invention, an embarrassment. This question that has no answer has been with us so long—since Jesus—since Abraham—since Adam—the original question.

Lema? To what purpose—is the unanswerable question of human suffering.

Can the Passion be expressed by a series of anecdotes, by fourteen sentimental illustrations? Do not the Stations tell of one event?

The first pilgrims walked the Via Dolorosa to identify themselves with the original moment, not to reduce it to a pious legend; nor even to worship the story of one man and his agony, but to stand witness to the story of each man's agony; the agony that is single, constant, unrelenting, willed—world without end.

> "The ones who are born are to die
> Against thy will art thou formed
> Against thy will art thou born
> Against thy will dost thou live
> Against thy will die."[73]

Newman explained the message of *The Stations:*

I was trying to call attention to that part of the Passion which I have always felt was ignored and which always affected me and that was the cry of Lema Sabachthani, which I don't think is a complaint, but which Jesus makes. And I always was struck by the paradox that he says to those who persecuted Him and crucified Him, "Forgive them for they know not what they do." But to God, and Jesus is projected as the Son of God, He says "What's the idea!"[74]

Newman altered the traditional meaning of the Stations, whose theme is the classic Western version of the death and rebirth myth. He added the last words of Christ on the Cross, "his last words as a man, to the Stations."[75] When the Son of God assumes the role of man, he assumes the fate of humanity—inevitable suffering. As Newman said: "I wanted to hold the emotion. . . . The cry, the unanswerable cry, is world without end."[76]

Newman added a fifteenth painting to the usual fourteen paintings of his stark black-and-white only dialogue of the Stations. This painting forms an emotionally existential conclusion: *Be II* of 1961–64 (pl. 16). The zip of red-orange color at the left, the only real color in the mural continuum, is Newman's answer to the "unanswered cry." Humanity and the artist must depend on themselves. In the fullness of new color and light, humanity must begin in every culture and every generation the spirit quest that defines man or woman as approaching the divine—*Cathedra.* Newman's work as a whole—the soaring, resplendent color after the trial of the war; its ensemble of themes of illness, quest, trial, and triumph is summarized and diagrammed in the *Stations.* With its fourteen stark, mortal, episodic black-and-white canvases followed by color, the surface attribute of the phenomenal world, the series condenses and dramatizes an emblematic narrative, as most Abstract Expressionist work does, a rite of passage into new life, consciousness, and being. Martha Graham put it into words for many in her generation once again.

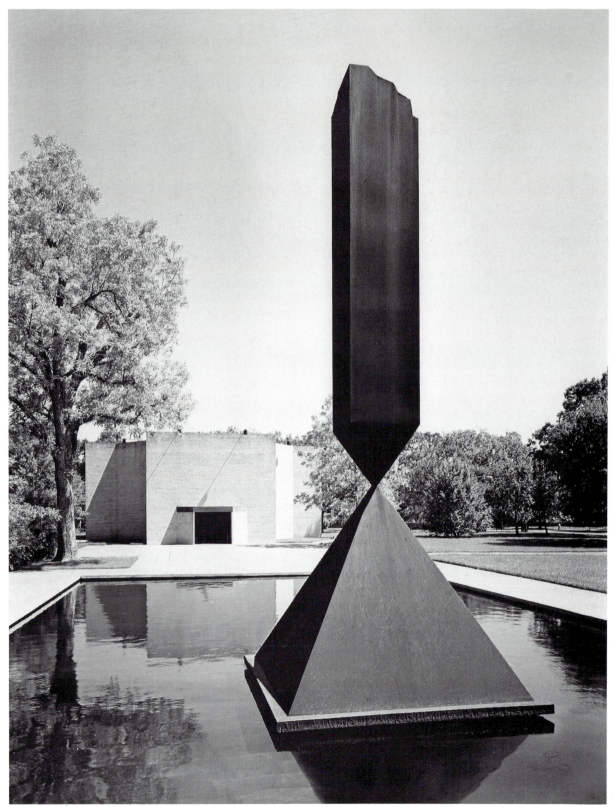

Figure 147. Barnett Newman, *Broken Obelisk,* 1963–67. Cor-ten steel.
25 feet 5 inches x 10 feet 6 inches x 10 feet 6 inches deep. Institute of
Religion and Human Development, Houston, Texas.

In a discussion of the cycles of the moon and night, she notes: "The passage of sunset into night—with its moonrise, moon high, moon set, deep dark, dawn,—as the souls' rite of passage from the death of color into birth of new color."[77]

CONCLUSION

Newman engaged and simplified the allegorical configuration of Abstract Expressionist thought and art. Two works complete this account of his thinking. The sculpture *Broken Obelisk* of 1963–67 (fig. 147) indicates his typical Abstract Expressionist engagement with issues and drama of civilization. He begins with two forms drawn from ancient Egyptian civilization, one of which was associated with death, one with light, everlasting life, fertility, and knowledge; commemorative obelisk stands atop a tomb pyramid. Newman opens up the end of the obelisk so that it seems torn and incomplete. From a self-contained shape he makes an open one; from a sign of a static, fixed civilization, he makes an incomplete and unfinished principle. He again transforms the past into his flower-and-stem motif of growth. He challenges geometrical shapes to open up and thrust upward. From the pressure downward of the obelisk and the thrust upward of the triangle, he has also created a tension of opposites and duality. In *Broken Obelisk* Newman turns icons associated with death and Western heritage into a life-affirming monument. It is most appropriate that a copy of the sculpture was placed outside Rothko's baptistry in Houston. The form of the chapel itself is based on a truncated pyramid. Newman unintentionally challenges the traditionalism and fatalism of Rothko's work with his statement of a new human thrust.

One of Newman's last paintings, *Jericho* of 1968–69 (fig. 148), carries a similar message of possibility. In the triangular *Jericho*, Newman deliberately placed his zip off center in the triangular shape of the painting to force a static, symmetrical fixed design into an active asymmetrical one. In doing this, Newman rendered his generation's deep historical and spiritual desire for a new active life through monumentality, myth, asymmetry, and movement. In *Jericho*, as in all his work, Newman created a condensed plastic symbol of a very human content—unfettered possibility. *Jericho* becomes yet another Abstract Expressionist painting of the human journey.

As did his colleagues, Newman employed religious and metaphysical symbols, myth, world traditions, ancient personages, principles of inner life, human struggle, and the rites and passage of life as his subjects. But his conclusion was dualistic and open-ended—there was no fixed conclu-

Figure 148. Barnett Newman, *Jericho*, 1968–69. Acrylic on canvas. 106 x 114 inches. Georges Pompidou National Museum of Modern Art, Paris.

sions, no right type of determinancy that would liberate the human. Like Camus, like Eliot in the line in his *Four Quartets* that the divine is the effort since the conclusion cannot be guaranteed and probably should not be trusted, Newman saw the result of thirty years of war and crisis to be simply human endeavor. For him, that was the humanly divine.

Newman's art realizes a vision of his modern experience that he developed as a new sense of metaphysical being. What he wrote of the anarchist Kropotkin is true for him also. He is a man observing his own drama, not as a narcissist looking at his self-image, but as a man engaged in the historical event. "What comes through is a heightened sense of 'Being.'"[78]

Newman's vision is existential in that he frees the self from the outworn dogmas of art and the social ideas that support them. He has painted his "New Sense of Fate," that is, the inability of humanity to control its actions and endeavors. This is Newman's contribution to Abstract Expressionist tragic art. However, his rhetorical exaltation of the human overcame the nihilism of the war generations. As the Resistance leader Camus wrote in words reflecting his own comparable feelings of human exaltation:

I exalt man before what crushes him, and my freedom, my revolt, and my passion come together then in that tension, that lucidity, and that vast repetition. ...Conquerors sometimes talk of vanquishing and overcoming. But it is always overcoming "oneself" that they mean. ...The conquerors are merely those among men who are conscious enough of their strength to be sure of living constantly on those heights and fully aware of that grandeur.[79]

WILLIAM BAZIOTES
Tremors of History

The subject matter in his [an artist's] work can be the tremors of an unstable world . . .

Baziotes, "Creative Process"

William Baziotes was among the first Abstract Expressionists to engage his era through the filter of modernist culture. His images of prehistoric aggression and natural history, his floating spectral space of near and far and remote and present time, and his figural dramas of multiple opposites all reflect the Abstract Expressionist themes of the past and its living continuity in the present. Baziotes weaves his themes through a love of symbolist aesthetics and poetry, making his forms both languid and lethal, sensual and serpentine. Like many Abstract Expressionists, Baziotes presents condensed composites of fused difference, at times in a single figural and spatial panorama of human history and fate as conceived by his generation.

The historical standing of Baziotes within Abstract Expressionism has been uneven. An original member of the loosely knit group, together with Matta and Motherwell, he was among the first to absorb surrealism and its devices such as automatism and biomorphism in the beginnings of the 1940s. In 1947 his *Cyclops* (fig. 149), won first prize at the Chicago Art Institute, among the first instances of official recognition of work by an Abstract Expressionist in the 1940s. By the 1950s, however, this recognition had waned. As Abstract Expressionism became identified, or rather, misidentified as Action, gesture, and color-field painting, Baziotes's delicate, controlled spectral forms were misunderstood as representing only the preliminary surrealist years of Abstract Expressionism and not its new, full, abstract force. This assessment was based on the now-repudiated idea of thematic difference between the semifigurative and abstract work of the artists. Baziotes's themes, despite his career-long use of semifigurative imagery, are fully those of early and mature Abstract Expressionism. For us, the imagery illuminates even more clearly themes other Abstract Expressionists transmuted into a more abstract form and pattern.

Baziotes was born in 1912 in Pittsburgh to a family of Greek origin. (Like Gorky, his heritage was important to him.) The next year his family moved to Reading, Pennsylvania, where his father operated a restaurant. Baziotes was suspended from high school in 1928 and went to work at the Case Glass company making "antique" glass. He attended a drawing class in the evening and met the poet Byron Vazakas, who introduced him to Symbolist poetry, a lifelong interest.

For an American artist, Baziotes showed an unusual openness to modern art in the 1930s. In 1931 he went to see a Matisse exhibition at the Museum of Modern Art and in 1933 wrote a review of the German and Viennese expressionists Kokoschka, Hofer, and Barlach. That summer he moved to New York and enrolled in the National Academy of Design, where he studied with Gifford Beal, Charles Curran, and Ivan Olinsky. In 1936 he exhibited unknown works at the Municipal Art Gallery and joined the WPA as an art teacher and easel painter, remaining until December 7, 1941. Throughout the 1930s, he read widely, especially in the works of the Symbolist poets, Verlaine, and Thomas Mann.

From the very first, like many Abstract Expressionists, Baziotes saw his work as developing out of the past and the traditions of art. As a young man, he had attended Greek schools and studied his ancestors' language, history,

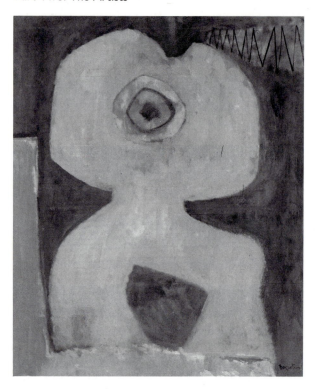

Figure 149. William Baziotes, *Cyclops,* 1947. 48 x 40 inches. Walter M. Campana Memorial Collection (1947.468). © 1989 Art Institute of Chicago. All rights reserved.

mythology, art, and dance.[1] Appropriately, at the Academy of Design he studied the traditional history of art from Greece onward. As it did Abstract Expressionism as a whole, this love of tradition would inform his contemporary explorations. For example, in some self-portraits of 1939–40 (pl. 17), he presents himself as a clown. These portraits reflect the combined influences of the modern and the Old Masters—Picasso's blue period, Rouault, and Watteau's *Giles.*[2] At the same time, Baziotes studied Maillol and Picasso's neoclassic figures of the early 1920s.

For Baziotes, too, contemporary history imposed itself. As the war broke out, his work of 1938–39 records an early interest in allusions to violent struggle, deformity, aggression, and self-mutilation. In *Untitled,* a watercolor of 1939 (fig. 150), a figure seems literally split in two by a central, gaping mouth. The feet are clawlike and the eyes seem to reside on different sides of the mouth. Picasso and Miró (in the *Tableaux Sauvages*) are the apparent sources behind this work. Baziotes had seen Miró in 1937 and felt his work indicated a way beyond non-objective, that is, geometric, abstraction.

The Picasso exhibition at the Museum of Modern Art only three months after the beginning of World War II seemed to point a way for Baziotes, as it did for many of

his colleagues. Picasso's aggressive imagery, especially the internal/external body exchange in *Girl Before a Mirror* and the dismembered bodies and rent forms of *Guernica,* provided the inspiration for modern painting that alluded to history as aggression. So did Picasso's Minotaur series, which Baziotes admired for its ability to depict bestiality in humanity. Yet Baziotes's work has perhaps a greater violence than Picasso's. Like much surrealist art, the violence takes place *internally:* Mayhem is instinctual and less political than in Picasso.

Other works suggest the mechanical quality of the violence and its strange remoteness. *Untitled* of about 1939 (fig. 151) multiplies the aggressive mouths but combines them with membranelike lines suggesting interiority and with a turnkey that makes the violent figure seem a mock, toy form. (The key is a surrealist and Jungian symbol suggesting the unlocking of hidden mysteries. While it may be too early for Baziotes to know surrealism well, making it an unlikely source here, such a symbolic key appears in Pollock's work *The Key* of 1946 which he probably did know.) Baziotes's early work thus presents the aggression, sadism, physical hurt, and fear that subtly lurks behind much Abstract Expressionist art in forms that hint at the more complex modern forms and thought of his later work.[3]

Baziotes was the first Abstract Expressionist to associate with the surrealists, meeting Kurt Seligmann in 1939 and Gordon Onslow-Ford and Matta in 1940. He exhibited with them at the New School for Social Research in 1941 in conjunction with Onslow-Ford's lectures, and in the *First Papers of Surrealism* exhibit with Hare and Jimmy Ernst. He met Motherwell that year and in 1942 joined him, Pollock, Peter Busa, and Gerome Kamrowski at Matta's apartment to experiment with automatism. (In 1940–41 he, Pollock, and Kamrowski by themselves had experimented with automatism.)[4] In 1943, he exhibited with Pollock, Motherwell, and others in the collage show at The Art of This Century gallery and in 1944 had his first one-person show there. From 1946 to the late 1950s, he showed almost every year at the Kootz Gallery.

Through this association with the surrealists, Baziotes moved toward his mature form. He was deeply attracted to their approach, which allowed for an imaginative semi-abstraction. For this, the concept of automatism was significant. Typically, his use of automatism was as a means of beginning without planning. After the first markings on the canvas, Baziotes's interests would take over and he would form his themes. As he said in 1950, "The artist feels like a gambler. He does something on the canvas and takes a chance in the hope that something important will be revealed."[5] Later he wrote that when he returned to his canvas, he began the Abstract Expressionist journey through memory: "It is there, when a few brush strokes

214

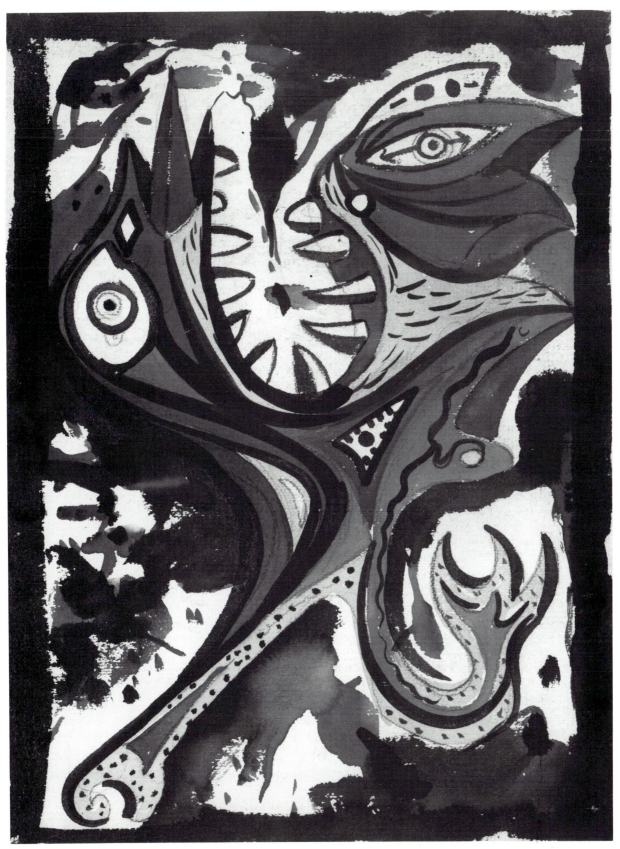

Figure 150. William Baziotes, *Untitled*, ca. 1939. Watercolor and graphite on paper. 12 x 9 inches. Estate of William Baziotes. Photo: Earl Ripling for BlumHelman Gallery, New York.

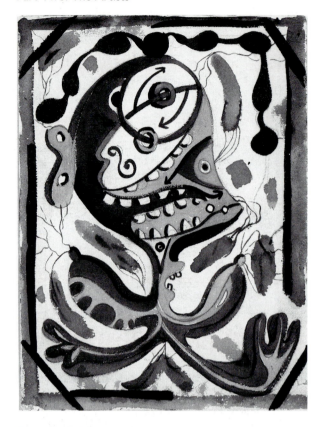

Figure 151. William Baziotes, *Untitled*, ca. 1939. Watercolor. 12 x 9 inches. Estate of William Baziotes. Photo: Jerry L. Thompson for BlumHelman Gallery, New York.

start me off on a labyrinthian journey, that I am led on to the more real reality."[6]

The Butterflies of Leonardo da Vinci of 1942 (pl. 18) exemplifies Baziotes use of automatism in which it is fused with the larger concepts of metamorphosis, Matta's interlocking internal and external space, and maybe Masson's labyrinthine revelations. In surrealist theory, Leonardo Da Vinci was important for his statement that the cracks on a wall can suggest innumerable forms. Here Baziotes's automatism is almost a physical meandering, suggesting the expansion of the spreading, spiraling lines of the organic membranes. Automatism thus becomes associated with the idea of growth and passage. As Matta defined his morphological science of growth: "That is to follow a form through to a certain evolution. For instance, from a seed to a tree, the form is constantly changing under certain pressures, until it arrives at the final form, and then disintegrates."[7] Evolution is the principle and subject of Baziotes's work.[8]

In *Accordion of Flesh* (fig. 152) Baziotes expanded his early themes. The painting consists of compartments of

geologic forms, human anatomies, amoebic shapes, and stained, "antique" glass or crystalline webs and forms. Baziotes also develops his variant on the sources and nature of interiority. Cellular structure, fleshlike forms, geological fissure, and fluids and vessels make the painting evocative of a natural organism divided into its internal and external parts. In the 1930s, he had read medical texts, he said, in order to learn what is beneath his skin so as to express human form on canvas.[9] While the study of anatomy is, of course, not new among artists, Baziotes used it to record the Abstract Expressionist idea of the painting as an organism itself. Here he combines the microscopic and macroscopic in his jeweled, viscous imagery of an internal world.

Baziotes turned to a popular surrealist and symbolist image, the mirror, to render further internal life. In *The Mirror at Midnight I* of 1942 (fig. 153), he suggests the overlapping, compartmental world of stones and jewels, of cellular beginnings in a gothic, dark, ambiguous space. In an essay of 1949, "The Artist and His Mirror," Baziotes wrote "To me a mirror is something mysterious, it is evocative of strangeness and other worldliness."[10] The mirror facilitated an examination of fundamental internal forces of the whole universe, becoming a tool to embrace all beings and natures.[11] He also said that *Mirror at Midnight I* embodied the spirit of a favorite Charles Baudelaire poem, "Favors of the Moon." Baudelaire is often identified with the mirror and Baziotes frequently quoted from his *Intimate Papers:* "The dandy ought to aspire uninterruptedly to be sublime. He should live and sleep before a mirror."[12] The crepuscular and incandescent color of these early works and their overrichness are also Baudelairean.

Baziotes absorbed Baudelaire's themes, particularly the primeval perversity of man. In images of silent night, water and the sea, of vapors and phosphorescent colors in works such as *The Balcony* of 1944 (fig. 154), he fused Baudelaire with his generation's themes, many of which had originated, interestingly, in Baudelaire and symbolist poetry. For many besides Baziotes, including Motherwell, Breton, Hare, and Pollock in the early 1940s, Baudelaire was at the root of modern imagery.[13] In 1935 Baziotes wrote that his goal was to translate the Symbolist poets' soul states into art, and in 1947 he declared in Baudelairian terms:

> To be inspired that is the thing
> to be possessed; to be bewitched:
> to be obsessed; that is the thing.
> to be inspired.[14]

In 1944, Baziotes broke with Matta and briefly moved toward a more rigid structure, as though he needed to step in that direction before he could paint a more fully

open composition. *The Parachutists* of 1944 (fig. 155) suggests his absorption of Synthetic Cubism in its rectilinear compartments, which he uses—in his thematic and expressive way—as a dangerous labyrinth. The parachutists referred to are most likely those that jumped behind enemy lines before D-Day.[15] Baziotes presents them as chutes floating downward into an interlocking web.

Baziotes was "fascinated with webs and labyrinths."[16] In *The Web* of 1946 (fig. 156), perhaps inspired by Mallarme's references to spider webs, for instance in *Frisson d'hiver,* he corners a biomorphic form in a web of lines that seem to capture the way an animal is roped. From the left side, another much larger biomorph, visible only as a dark tone in reproduction, is superimposed on the first form, suggesting a different kind of web, that of family or kind. The smaller biomorph is thus entangled by both kinds of web. *The Web* is perhaps the best single example but Baziotes's

work is full of webs and animals as linear spiderlike filaments. In *The Parachutists,* then, with its interlocking web, he floats soldiers into a possibly lethal enclosure, at once cubist, natural, historical, and metaphoric.

Night Mirror of 1947 (fig. 157) bonds the idea of closure and connectedness with the internal and external states of being to produce the familiar concept of the life cycle. The painting consists of three forms. At the left is a seemingly wrapped, mummified woman, perhaps reflecting Egyptian funerary practices. A wrapped embryonic or fetal form, which should be smaller in size but here is roughly equal, lies at the right. The internal forms at the right and all the wrapped figures seem drawn from primitive art—from Australian bark paintings exhibited at the Museum of Modern Art in 1941.[17] At the center is an angular but undulating biomorphic form within which are, once again, cellular forms reminscent of Ernst's *Sea Shells.*

Figure 152. William Baziotes, *Accordion of Flesh,* 1942. 20 x 26 inches. Estate of William Baziotes. Photo: Courtesy BlumHelman Gallery, New York.

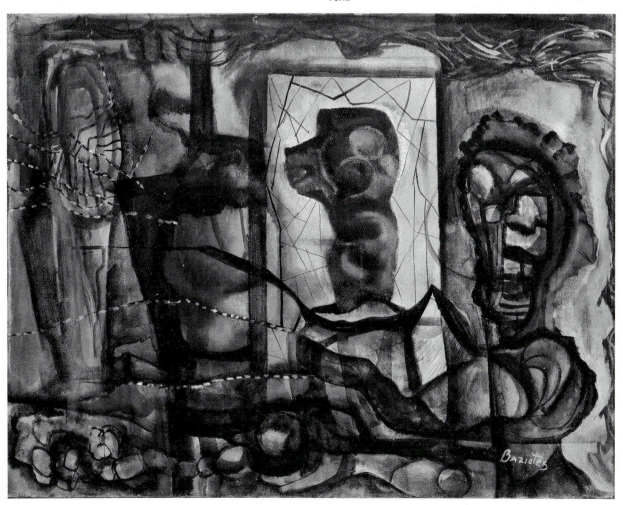

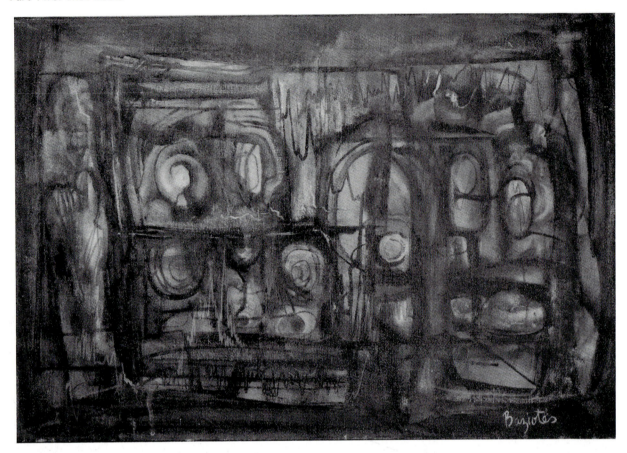

Figure 153. William Baziotes, *The Mirror at Midnight I*, 1942. 16 x 12 inches. Private collection.

All three forms are connected as though intravenously or umbilically, which, with the stages of life represented and with the slight female shaping, suggests the cycle from birth to maturation and also from elemental to full form.

A REDEFINITION OF HUMAN NATURE

By 1947 Baziotes's work gradually simplified and, like David Smith, Roszak, Lipton, Ferber and others, he became increasingly concerned with using natural history and not just nature to evoke his themes. Working parallel to the Abstract Expressionist search for the cultural past, he roots the human in its physical heritage. His award-winning *Cyclops* of 1947 fits this type of combination. *Cyclops* consists of another biomorphic form that appears at first to be simply a cute teddy bear or childlike figure with a short, stumpy form and a large eye in the center, bathed in an amorphous fluid. To its right a wrapped, knifelike form enters and points to the figure. The painting suggests a mythic duality of physical and cultural heritage, innocence

and threat. Baziotes explained his thinking for the painting by referring to a personal contemporary experience as a confrontation with a form of the living primeval:

one afternoon, a nice day, my wife and I went to the Bronx zoo. I went to see my favorite animal—the Rhinoceros. I heard unearthly cries, the elephants were being fed. I had some peanuts, and as I gave them to the rhino, he sucked in my hand and held it. My wife got scared but I was terribly interested. He was playful and cute and toylike, but at the same time, he chilled me. He seemed prehistoric and his eyes were cold and deadly.[18]

In *Cyclops* Baziotes defines the physical memories of humanity that, like the psychological, lurk below the surface.[19] While Lewis Mumford and Jung put forth the idea, it is perhaps their source, Nietzsche, who summarized it best: "That which his ancestors most liked to do and most constantly did cannot be erased from a man's soul. . . . It is quite impossible that a man should *not* have in his body the qualities and preferences of his parents and forefathers: whatever appearances may say to the contrary."[20]

Dwarf of 1947 (pl. 19) further elaborates these themes of the heritage of the innocent and lethal together. It

consists of a single figure painted in a loose, soft manner, with a truncated hand held up, a stepped head, a toothy mouth and eye form, and a circular head and mouth form below as its genitals. *Dwarf* combines the eye of a lizard, suggesting the inhuman and unknown, with grotesqueness. And as an image of roughly human shape, it is the physical equivalent of Gottlieb's and Dali's distorting psychic mutation—neurosis—of the 1940s, a synthesis that mocks utopian notions of a new, better resolution to humanity's problems. In a letter to Alfred Barr on April 26, 1949 explaining the work, Baziotes said, "I think these forms are inspired from having looked at the lizards and prehistoric animals."[21] The mouth and eye he tied to the grin of a

crocodile, with its dualities of horror and human. To the animal, Baziotes joined the human—the broad flowing form refers to the sagging flesh and muscles of a mature woman while the lower oval form is a feminine sex symbol. It is also a mouth and thus the equivalent of the *vagina dentata* image of the surrealists. *Dwarf* also recalls pre-Columbian Dwarf and Jaguar Babies works, with their notched head form,[22] and, additionally, a Roman statue of a prince (fig. 158) that was a favorite of his at the Metropolitan.[23] The *Prince* has one good hand and, most significantly, one with the fingers broken off.

With its mutilated limbs, *The Dwarf* is rooted in history. Just as social realist painting had caricatured human form

Figure 154. William Baziotes, *The Balcony*, 1944. 36 x 41 inches. Private collection, Santa Barbara, Calif. Photo: Courtesy of the Santa Barbara Museum of Art.

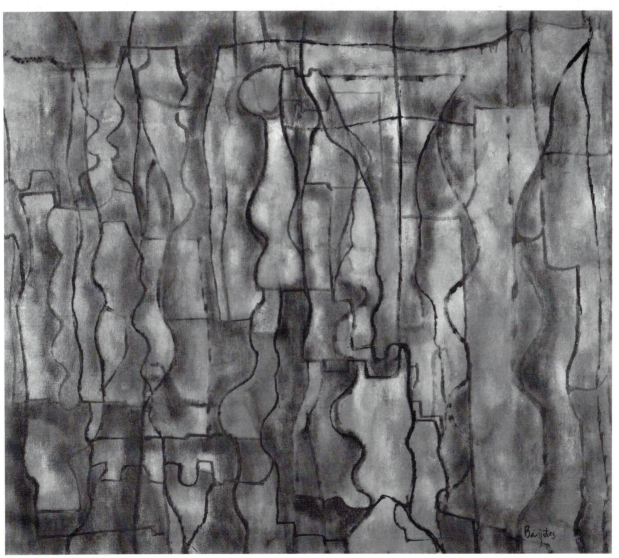

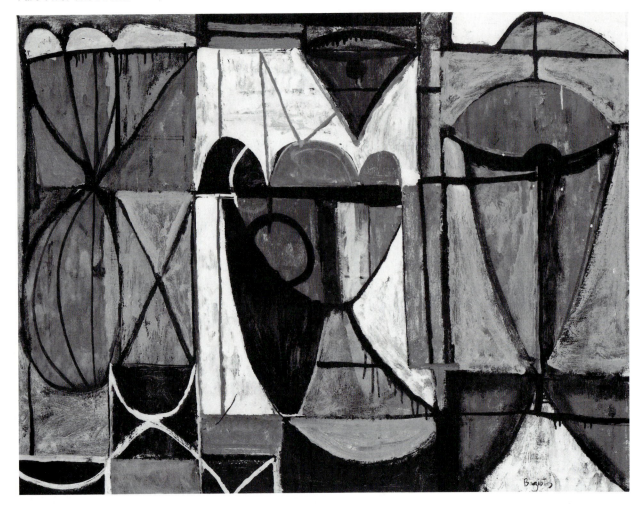

Figure 155. William Baziotes, *The Parachutists*, 1944. Duco enamel on canvas. 30 x 40 inches. Estate of William Baziotes. Photo: Courtesy BlumHelman Gallery, New York.

to indicate the warping effects of poverty and economic class in the 1930s, Baziotes alters anatomy to propose the causes and effects of humanity in the 1940s. He indicated that the figure also refers to photographs of mutilated soldiers of World War I (fig. 159). Thus for Baziotes, the images of the first war and its effects are a touchstone. Artists of the preceding generation also referred to the mutilated men of that war: especially interesting are Masson's pomegranate symbols of exploding skulls and seed forms (a dualistic life and death symbol), and Ernst Kirchner's imagery of mutilation in *Self-portrait as a Soldier* of about 1915 (fig. 160), which manifested a fear so deep that it eventually led to his nervous breakdown. The cruel, grotesque forms of the mutilated could be shocking at first, but after repeated exposure, like so many Abstract Expressionist war themes, the grotesque becomes natural and universal:

One of the most amazing things about this war is the way the bizarre and unnatural become the normal after a short time. Take this hospital and its atmosphere: after a long talk with him, an eighteen-year-old without legs seems like the *normal* eighteen-year old. You might even be surprised if a boy of the same age should walk in on both his legs. He would seem the freak and the object of pity. It is easy to imagine, after seeing some of these men, that *all* young men are arriving on this planet with stumps instead of limbs.[24]

Throughout Baziotes's work, as in *Dwarf* and *Cyclops,* innocence is combined with terror. It was a common pairing in the first war, especially the contrast of iron and flesh or pastoral image and military steel prevalent in literature. The contrast was understood in the Second World War too. In the caption to a photo (fig. 161) in the exhibition catalogue *Britain at War,* the point is reaffirmed: "TANKS ON A COUNTRY ROAD. Once more, the contrast

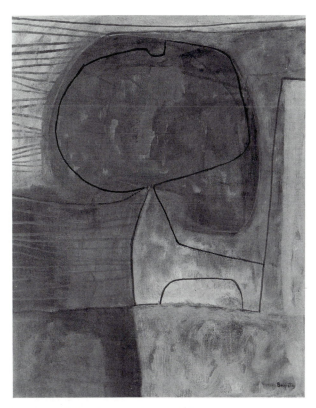

Figure 156. William Baziotes, *The Web*, 1946. 30 x 24 inches. Herbert F. Johnson Museum of Art, Cornell University: Membership Purchase Fund and David M. Solinger Fund, 77.44. Photo: Jon Reis.

of tragic mechanism and the famous old-fashioned loveliness of Britain."[25] A woman recalls the imposition of deadly fear and war on innocent, pastoral sentiment: "When the war broke out, I was dancing at a seaside resort. . . . I remember gazing out over the English Channel: how could people go to war on such a lovely day and kill each other? It was so unreal. . . . I never thought I could sit and read to children, say, about Cinderella, while you could hear the German planes coming."[26] Baziotes often alluded to this combination of external harmlessness and lurking inward danger in referring to the "sharks underneath" human action.[27]

In the forms of his painting, dualities such as innocence and savagery and beauty and terror meet, their roots in historical and emotional experience transformed and naturalized as primary human traits, as figural characteristics such as toylike form, delicate color, cute proportions, and reptilian teeth and eyes. Through his imagery, Baziotes has transmuted the tremor of history and intersected history, personal experience, and cultural theme.

There is a sense of unreality in *The Cyclops, The Dwarf,* or *The Somnambulist* of 1951 (fig. 162) as if they are glimpsed through a fog or a dream. Space, placement,

scale and time are often difficult to define and quantify. This part real, part dream quality is characteristic of Baziotes's work throughout. On the one hand, it reflects symbolist aesthetics: the emphasis on the mirror, the dream, the hidden, the trance, the apparition. On the other, it reflects the psychic shock of historical events, as though what has happened has not been fully digested. This feeling is typical in wartime, as frequently noted by soldiers: "The same holds true with life at the front. The same horrible unrealness that is so hard to describe."[28]

The unreal as feeling detached and looking at oneself from outside is a common wartime emotion. One thinks of the vocabulary of detached action in the theaters of operation in the war. Both Rothko and Baziotes verbalized this theme, likening the figures and shapes in their work to drama. Baziotes himself declared his spaces to be a "stage for certain characters that are playing certain parts."[29] In this they were adapting a popular concept of the 1940s, in Mumford's words, that history "is the dynamic working out of the drama of a culture . . . against which men act their parts."[30] War creates such a feeling of detachment as a kind of theater and drama, a sense of being on set, of seeing oneself play a role.[31] In the First War, theater was the favorite form of entertainment for soldiers on leave; in the Second, it was the movies. Fussell notes:

If killing and avoiding being killed are the ultimate melodramatic actions, then military training is very largely training in melodrama.

"Our own death is indeed, unimaginable," Freud said in 1915, "and whenever we make the attempt to imagine it we can perceive that we really survive as spectators." It is thus the very hazard of military situations that turns them theatrical. And it is their utter unthinkableness: it is impossible for a participant to believe that he is taking part in such murderous proceedings in his own character. The whole thing is too grossly farcical, perverse, cruel, and absurd to be credited as a form of "real life." Seeing warfare as theater provides a psychic escape for the participant: with a sufficient sense of theater, he can perform his duties without implicating his "real" self and without impairing his innermost conviction that the world is still a rational place. Just before the attack on Loos, Major Pilditch testifies to "a queer new feeling these few days, intensified last night. A sort of feeling of unreality, as if I were acting on stage . . ."

Carrington testifies to the division of the psyche into something like actor, on the one hand, and spectator, on the other.[32]

And World War II continues the immensity of the feeling:

For me it's B.W. and A.W.—before . . . and after the war. . . . I get this strange feeling of living through a world drama . . . you look forward to the glamor and have no idea of the horror. . . . You're finally down to one squad, out ahead of the whole thing. You're the point man. What am I doing here—in this world-cataclysmic drama—out in front of the whole thing?

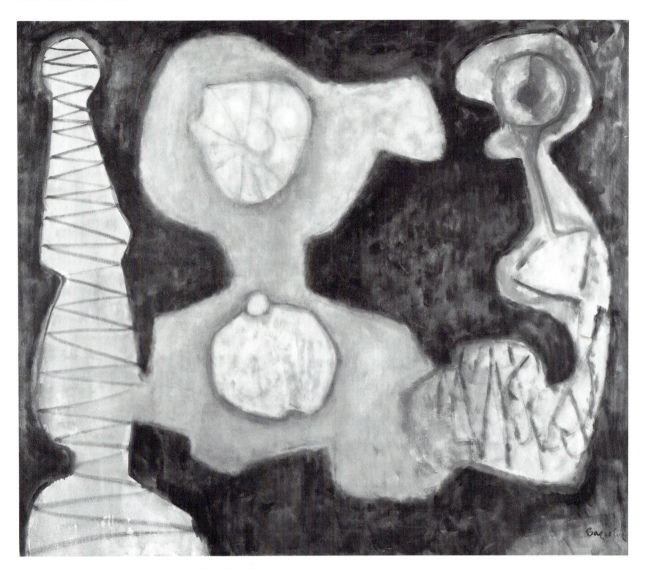

Figure 157. William Baziotes, *Night Mirror*, 1947. 50 x 60 inches. Vassar College Art Gallery, Poughkeepsie, New York. (55.6.3) Gift of Mrs. John D. Rockefeller III.

(Laughs) You saw those things in the movies, you saw the newsreels . . . It seemed unreal. All of a sudden, there you were. . . . I was acutely aware, being a rifleman, the odds were high that I would be killed. At one level, animal fear . . . On the other hand, I had this great sense of adventure . . . seeing the armies. . . . I was schizophrenic all through this period. . . . But I was acutely aware of how really theatrical and surreal it was.[33]

The innocent, the unreal, the perverse, the cruel, and the theatrical—multiple symbolist aesthetics chosen by Baziotes as his personal expression of his view of humanity in the 1940s—are extensions and developments of war-time life. Baziotes is a master dramatist of the historical surreal. Though different from the public anthropological ritual dramas of Still and Pollock, Baziotes's work represents the impact of his public history through concentrated shorthand, figural attribute and ghostly, grotesque shape. Varieties of human behavior suggested by elliptical edge, teeth, color, and spectral veil signify what had been fully represented in illusionistic art as murder, bestiality, and danger (see chapter one). For Baziotes, as for Gottlieb and others, his mature art is a condensed complex of polyvalent humanity and its historical life process. The multiple elements of his figures allow him to move from one disparate human characteristic and experience to another. Unexpected juxtapositions in form incorporate an epic range to human life as physical potentials.

Figure 158. Roman, *Prince*, first century A.D. Bronze. The Metropolitan Museum of Art, Rogers Fund, 1924.

Figure 159. William Baziotes, *Dwarf*, drawing after photographs of mutilated soldiers of World War I. From Letter to Alfred Barr, 1949, Collection of the Museum of Modern Art, New York.

Figure 160. Ernst Kirchner, *Self-Portrait as a Soldier*, 1915. 27¼ x 24 inches. Allen Memorial Art Museum, Oberlin College. Charles F. Olnay Fund, 1950.

Baziotes's figurative paintings constitute yet another form of Abstract Expressionist epic allegory. For him, anatomy is truly destiny. Baziotes defined the range he incorporated:

What impressions, events, moods, set off a painting? Man—the tragic-comic in man. Man, the ape and evolution. The fear in man. Man's duality. Pierrot. . . . The feelings of life in spring. The night. The moon. And animals—the rhinoceros, a dangerous clown. . . . The age of the dinosaurs and great bird-lizards flying overhead.[34]

Baziotes's *The Dwarf* and *Cyclops* are key images of the 1940s. They record for posterity the redefinition of human nature through the alteration of personality under the impact of the war that is taking place, a change quite different from Still's and even Pollock's recasting of personality and psyche. War changes both single and group

Figure 161. "TANKS ON A COUNTRY ROAD. Once more, the contrast of tragic mechanism and the famous old-fashioned loveliness of Britain," Army photograph, from *Britain at War* (New York: The Museum of Modern Art, 1941), p. 43.

personality. As one veteran noted as he moved up the line in the First World War, "What effect this experience would have on our lives we could not imagine, but at least it was unlikely that we should survive without some inner change. Towards this transmutation of our personalities we now marched."[35] And as another noted after the second when the veterans came home to their families, "War ... is a notable breeder of personality and physical changes and many of those engaged couples who had been compatible before the war were so changed physically and psychologically, that there was no longer any compatibility."[36]

Through its absorption of the tremors and cataclysms of the time, Baziotes's work internalizes the experience of human behavior and rearranges the cultural combination

known as human nature at a particular time. With his presentation of human beings as part prehistorical, part natural history, part charming cuddly toy, part dangerous beast, part real, and part unreal, he indicates his understanding of the new fundamental characteristics of human beings in the war and postwar worlds.

Dwarf and *Cyclops* condense the dramas of the conflictive traits of human beings and human nature. They embody the multiple, varied, but holistic personages of the panorama of human roots and archetypal possibilities of Baziotes's era's concept of human fate. As *American Gothic* did for an earlier generation, Baziotes's figures encompass historiocultural behavioral complexes extending far into the reaches of time. Like figures in the 1930s, his figures are living things, sums of behaviors of a living

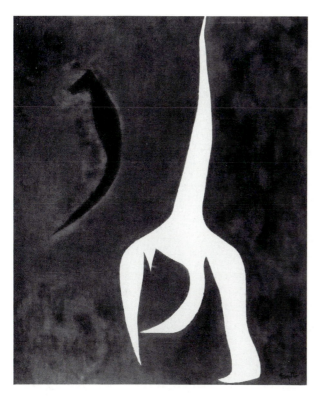

Figure 162. William Baziotes, *The Somnambulist*, 1951. 48 x 40 inches. Estate of William Baziotes. Photo: Courtesy BlumHelman Gallery, New York.

society, civilization, history, in Benton's words, a thought and behavior complex, and a forties ancestral portrait.

His imagery also embodies the tragic transformation wrought by revelations of abhorrent human behavior in his time and how they were absorbed. As the nuclear physicist Philip Morrison, who helped build the A-bomb, relates,

This is the legacy of World War Two, a direct legacy of Hitler. When we beat the Nazis, we emulated them. I include myself. I became callous to death. ... We fought the war to stop fascism. But it transformed the societies that opposed fascism. They took on some of its attributes.[37]

Baziotes reconstructed the human figure to make it consist of the newly "human" characteristics and found the paradigmatic human personality for his time: "The things in my paintings are intended to strike something that is an emotional involvement—that has to do with the human personality and all the mysteries of life, not simply colors or abstract balances."[38]

LIVING MEMORY

In the 1950s, Baziotes's interest in biological roots led to an increasingly aggressive and at times more prehistoric

form. For example, he found Herman Melville's classic novel of great interest and painted *Moby Dick* of 1955 (fig. 163). After almost a century of indifference, Melville's novel emerged in this period as a novel of great interest and the subject of several studies. Jung considered it, in his classic *Modern Man in Search of a Soul*, the "greatest American novel," and it was a constant reference point in the Abstract Expressionist and New York School circle. Besides Baziotes, Lipton, Roszak, Jenkins, Francis, and Stamos knew and alluded to it.[39] Pollock, who named one of his dogs Ahab, originally entitled his painting *Pasiphaë, Moby Dick*. Critics Greenberg, Ashton, O'Doherty, and Rosenberg, in "Action Painting," discuss Abstract Expressionism with analogies to the story of the white whale. Different figures found the novel appealing in different ways.[40] Baziotes was fond of quoting its first sentence: "It is a damp, drizzly November in my soul," thereby equating characteristics of nature to human beings again.

In words and in his three-piece series of monstrous heads from *Molochs* to *Moby Dick* (fig. 164), Lipton presented perhaps the most complete statement of Moby Dick's significance, which helps illuminate its meaning for Baziotes. To Lipton, Melville's novel encompasses the human race and its problems.[41] The disturbed captain searches for the monstrous white whale to eliminate darkness and chaos but discovers the confusion is not external but internal. Lipton's sculptures deal, he says, with the dark tragic areas of life and the attempts to circumvent them. Ahab and Moby Dick are hunter and the hunted; they make up the forms of the sculptures, the whale on the inside, Ahab on the outside trying to "encompass evil and dissonance" within. To Lipton the sculptures with their "gaping jaws" and violent dismemberment combine opposing forces and symbolize darkness becoming light. *Moby Dick,* he declares, is an allegory for World War II: "Moby Dick consumed my interest at the time, but only because it rang bells deep in my being. It was the symbol of destruction and the anti-Platonist conception that evil is at the center of the universe."[42]

While Baziotes's *Moby Dick* is a less lethal image than Lipton's, consisting of a large, distant form moving through the watery veil of crepuscular light, at once amniotic, melancholic, and mineral,[43] these ideas lie behind his work as well as Lipton's. Baziotes's painting suggests a scenic space where the heroic myth of the hunt could take place. Such a voyage suggests once again a voyage into the wilderness of self and into a world of wild, natural, unknown forces to search for and kill the beast, a virtual nautical Grail quest.

Aggressive nature can be found in the prehistoric *The Flesh Eaters* of 1952 (fig. 165) in which Baziotes combines once again the small, amoebic fetal form with a larger, lethal image. The fetal form, with its seemingly generating,

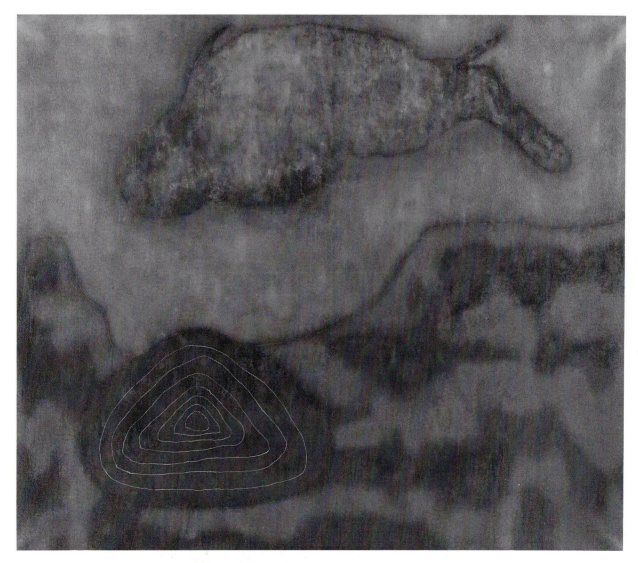

Figure 163. William Baziotes, *Moby Dick*, 1955. 60 x 72 inches. Estate of William Baziotes. Photo: David Allison for BlumHelman Gallery, New York.

expanding weblike shape lies on a vertical ground that suggests closeness to the picture plane as it rises top to bottom. To its right a zigzag line resembles the scarlike smile of the rhino once again. At the top right is a biomorphic bird form similar to the writhing forms of De Kooning's *Labyrinth* and Baziotes's *Moby Dick* as well as the bull horns Baziotes kept on the wall of his home. Beneath it lies a humanoid form with a scaly "head" and shoulders. While this form resembles Masson's biomorphic sculpture *Metamorphosis* of 1927, it most likely was intended to suggest dinosaur forms. Baziotes once said he had a nostalgia to be a dinosaur, and he considered animals to be part human and vice versa—"Brother-Animal."[44] He once sent a paleontological diagram of the

Triassic, Jurassic, and Cretaceous periods to Herbert Ferber,[45] whom he said resembled a mammal from the Cretaceous period, and he spent many years reading about prehistoric life and studying fossils, shells, and minerals in the Museum of Natural History. Flora and fauna thus form his idea of memories and survivals and the roots of humankind.

Other works in the 1950s consist of repeated fusions of the near and far, of time and space, and of the prehistoric and contemporary. *Dusk* of 1958 (fig. 166) suggests, in planar and linear form, a pterodactyl, a snake, and a brontosaurus on delicate, phosphorescent but sea-cool, mother-of-pearl colors. The painting ground is delicate, soft, and sensuous yet ghostly or spectral, somewhat

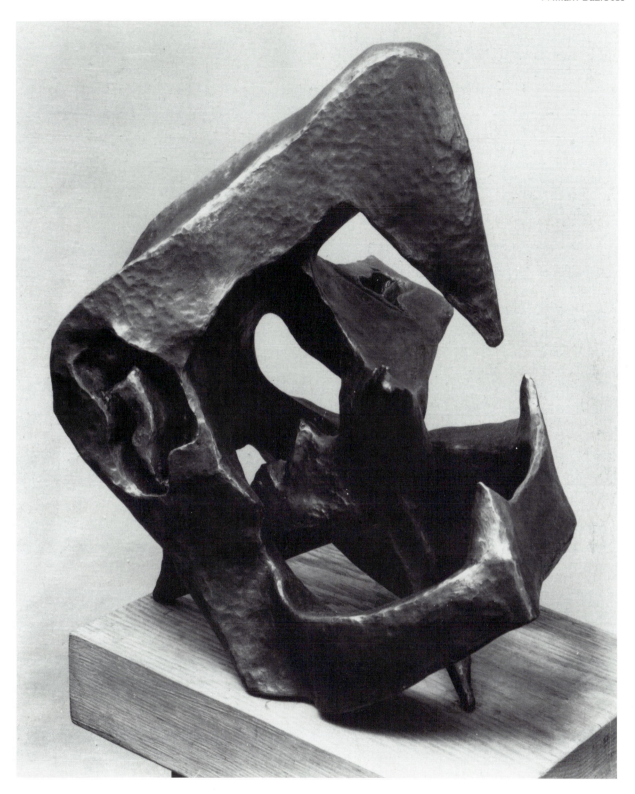

Figure 164. Seymour Lipton, *Moby Dick #1*, 1946. Lead. Height 16 inches. Courtesy Michael Lipton.

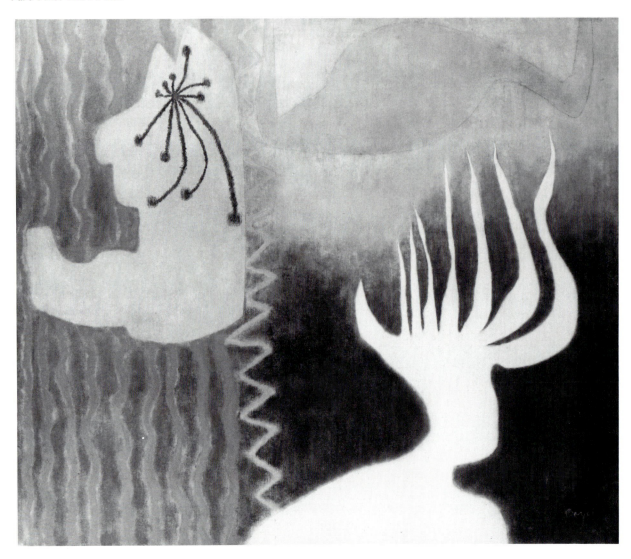

Figure 165. William Baziotes, *The Flesh Eaters,* 1952. 60 x 72 inches. Estate of William Baziotes. Photo: Otto E. Nelson for BlumHelman Gallery, New York.

like Rothko's early dream forms from space and time. *Aerial* of 1957 takes the same themes and characteristics skyward.

Finally, Baziotes grounds his themes in an integrated world culture and its living presence in a variety of works, from *Egyptian* and *Pompeii* of 1955 (fig. 167) to the medievalizing *Scepter* of 1960–61 (fig. 168). Pompeii was a favorite image of disaster in the interwar period (see, for example, the poetry of Hilda Doolittle). To Soby's Daliesque Inquisition, Rothko's Trojan war, and Gottlieb's killing fields, Baziotes added another analogy of historical cataclysm. In viscous but delicate forms, organic shapes, and a sun-darkening ash cloud, Baziotes created another

emblem of his time. He described the gray, spiky form rising from the bottom of the picture as "the symbol of death and ruin."[46]

This "history" painting is made, in the Abstract Expressionist manner, ancient and geological. He noted that he had studied the Boscoreal frescoes and admired the way the Romans used geology—the sense of clay, rock marble, and stone—in their art. "The entire background and upper part of the picture symbolized all this to me." Like Rothko, he admired ancient Roman wall painting with its effects of age and time: "In the last year or two I found myself drawn to the Roman civilization. This civilization, with its decadence, satiety, subtlety and languor interested me and

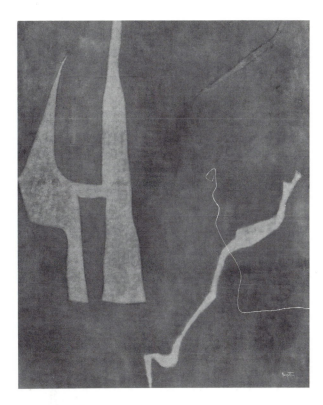

Figure 166. William Baziotes, *Dusk,* 1958. 60⅜ x 48¼ inches. Collection, The Solomon R. Guggenheim Museum, New York. Photo: Robert E. Mates.

I kept returning to their wall painting with their veiled melancholy and elegant plasticity."[47]

Baziotes combines the ancient root cultures, geology, and natural history to suggest the continued presence of the ancient in modern life. And like many of his colleagues, he sees himself and his art as well as his experience as part of the living continuity with the past: "If I love the classic so much, then, I want to be classic. . . . I love the old masters and grow closer to them every day. They are my conscience, and certain of them are my brothers."[48] Baziotes emphasized his living heritage as a Greek-American and would often tell favorite stories of "My uncle Odysseus, in Allegheny."[49] Like Joyce's Ulysses in Dublin, or De Kooning's "Greece on Tenth Avenue," the past lives on.

Baziotes would journey into his own past recreating connections. He spent his summers in his hometown where he would walk up and down Main Street, all the time remembering: "The whole past becomes a picture to me. It may look like I'm having fun, but I'm refilling myself."[50] Later he wrote "I feel fortunate in that 'I can go home again,' for the town is very inspiring for my painting and each day brings in some connection between the past

and present that is fascinating."[51] One thing he absorbed was the rhythm of Greek folk dancing:

I think, beside the natural influence of this country, the fact that my parents were Greek and lived in a neighborhood that was made up of Greeks from the Near East may have had some effect on my work. This influence, I believe, was mostly watching and feeling the attitude these Easterners had towards life and their music and dancing. I would sometimes go to a wedding that lasted two or three days. In their music that had no beginning or end the slow indolent rhythms of the dance and the cat-like singing would leave me in a pleasant state; this was a feeling of everything dropping away, of leaving you in a dream state; of being half-hypnotized, of time standing still, of life becoming magical.[52]

Many paintings draw on the idea of magical journey itself. *Scepter* suggests the combination of a medieval sword, meandering languid biomorph, and human form, a multiple image of life and death, swimming in a dense space. Here with its sense of adventure, Baziotes parallels the medieval Romance quest. The meandering linear form journeys through a delicate but opulent, languid, spectral, or sea space in which the above and below are again made deliberately impossible to decipher. Is this sea or sky, mind or imagination, perceived or conceived? (Water moving is also a familiar metaphor of time passing.) Is it a natural form or yet another oblique reference to danger, this time to the serpentine, jeweled daggers Baziotes loved at the Metropolitan Museum of Art?[53] Into a similar image of the journey through memory, *Serpentine* of 1961, almost imprinted in the space as in a Rothko work, Baziotes has projected a family grouping. The two linear forms, one wide, one narrow, may suggest different stages of growth—youth and maturity—within Baziotes's habitual opposites and familiar periodicity. Similarly, while the forms appear to be natural, they carry Baziotes's other associations. The slow, nuanced rhythm, for example, reflects the curves of a Greek sculpture at the Metropolitan Museum and, again, languid Greek dancing.[54]

The rhythms of Baziotes's art thus take on implications of culture as well as of movement through time and space. His image then relates to Rothko's temporal patterns of endless historical transitions and stages, Gottlieb's ritual process, and Pollock's endless continuum. It represents the past but also the future. It is history being made or recreated. As his colleague Noguchi said at the opening of his own museum, which exhibits his past: "You can only learn by looking at the past. . . . What is tomorrow? Is it the past or a continuity with the flow of time? For the first time here in the museum I've been able to see my work in an historical sense."[55] Like Noguchi, Baziotes considered himself to be living in the three times simultaneously, forming a "time spectrum."[56] He was not interested in

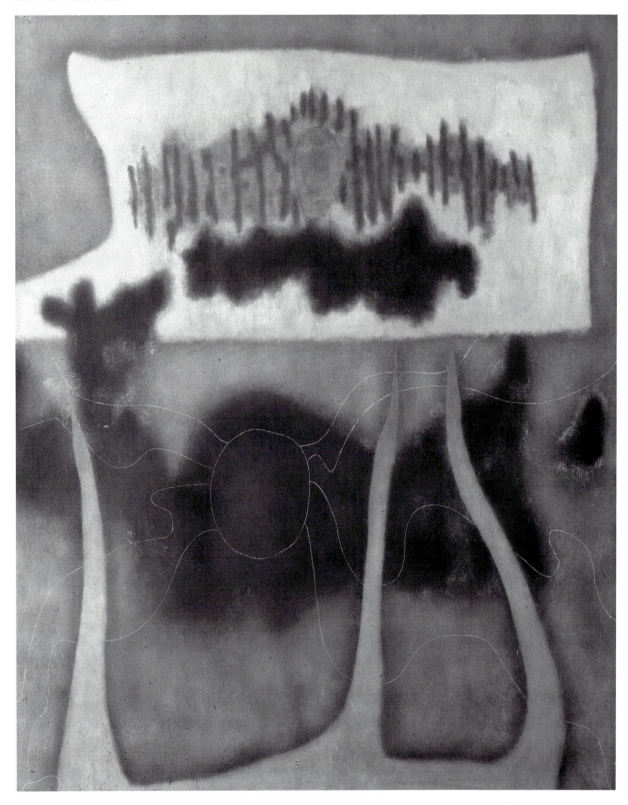

Figure 167. William Baziotes, *Pompeii,* 1955. 60 x 48 inches. Collection,
The Museum of Modern Art, New York. Mrs. Bertram Smith Fund.

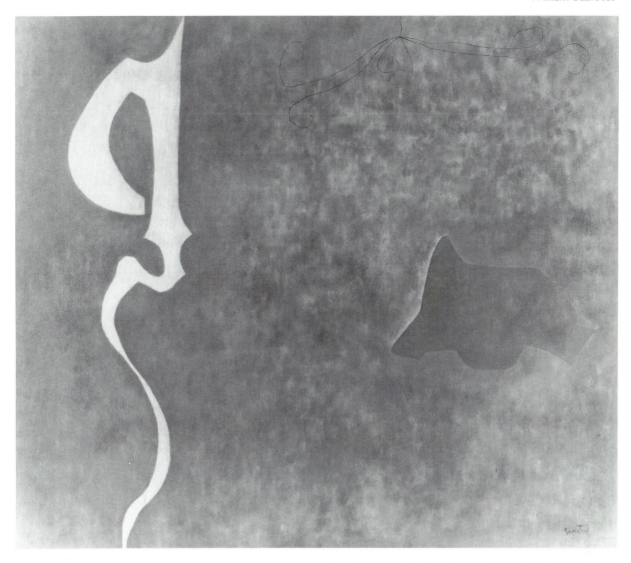

Figure 168. William Baziotes, *Scepter*, 1960–61. 66 x 78⅛ inches. National Museum of American Art, Smithsonian Institution, Gift of S. C. Johnson and Son, Inc. (1968.52.15)

being only modern. He recognized that "all motion is in circles," as Mann's Hans Castorp said, "[in] space and time, as we learn from the law of periodicity."[57]

Through *image* and not through abstract mythic pattern, then, Baziotes realizes the themes of his historiocultural mix. In Baziotes's work, natural and expressive allusion forms a plasmic organism in which the actual flora and fauna are merely concentrated manifestations of principles and forces. As in the figurative range of his Abstract Expressionist colleagues (and even of artists such as Arp and Benton), the forms constitute a concrete nexus of the manifest energies and "causes" of the world. Baziotes produces a haunting and mysterious art that in its style as

well as form evokes the life force over space and time. It self-consciously sets a mood.

Baziotes knew that after each war a decivilizing or "de-poeticization" sets in and that in the twentieth century there had been tremendous losses.[58] Thus, for his generation, along with the aridity of modernity and modernism, the emptiness of American bourgeois business culture, and the illusions of the possibilities of science, modern history also had brutalized the human. As his equivalent to Klee's wonder, the Surrealists' marvelous, Still's force, Rothko's *sacra*, Gottlieb's tension, De Kooning's coarseness, Pollock's ancient energies, the primitive's *wakonda*, Bergson's vitalism, Freud and Jung's libido, Campbell's

mythic fluidity, religion's God, or science's energies, Baziotes sought to restore bejeweled vital mystery as a life force. He contracts and then lets life breathe slowly outward.

Rothko, Gottlieb, Newman, and Baziotes fused the major themes of Abstract Expressionism in subtle emblems of the period's voyage and search. The next two, Pollock, and De Kooning, are less history-minded. They combine Abstract Expressionist concepts with a greater variety of personal elements, from Pollock's quest for psychic regeneration to De Kooning's savage satires on the here and now. They thus diffuse and open the concepts up for others. Differences between these artists and the others are not hard and fast, however, and I make no claim of absolutes.

JACKSON POLLOCK
Ancient Energies

When the world becomes monstrous, and commits crimes I cannot prevent, I always react with the assertion that there is a world outside and beyond this one, other worlds, human, creative, to pit against the inhuman and destructive forces.

Anaïs Nin, 1938

Ah, ah . . . this is new. Vitality, energy—new!

Giorgio Morandi, 1950

Jackson Pollock helped to establish American painting, Abstract Expressionism, and his own art as the vanguard of postwar modern painting. His abstract art—"gesture" painting constructed by extended lines, spots, and swaths of paint—visually contrasted with the "color-field" painting of Rothko, Still, and Newman. Joined with De Kooning's art, Pollock's led many observers to differentiate thematically as well as stylistically between the two branches of Abstract Expressionism. Such a difference cannot be sustained.

Neither can the style and meanings of Pollock's work be separated. Pollock intuited his subjects and their stylistic expression from the commonplaces of the period. Pollock's art is both a formal breakthrough and an individual statement of historical themes pervasive in his milieu. His genius is that he created a powerful visual form to embody the needed reconstructive energies. His approach is to represent them through transforming ritual, depth psychology, and anthropology.

THE 1930S: POLLOCK AND BENTON

Jackson Pollock was born in Cody, Wyoming, in 1912 but his family left within the year. After living briefly in Arizona,

where Pollock explored Indian ruins in 1923, the family settled in California. He attended his second high school, Manual Arts High School, in Los Angeles. During a bumpy academic life—he was temporarily expelled in 1929—he began taking classes in clay modeling and life drawing. On January 31, 1930, he wrote his brother Charles indicating his future direction as an artist of rhythmic drawing:

school is still boresome . . . this term i am going to go but one half day the rest i will spend reading and working at home . . . in school i will take life drawing and clay modeling. i have started doing some thing with clay and have found a bit of encouragement from my teacher, my drawing i will tell you frankly is rotten it seems to lack freedom and rhythem [sic] it is cold and lifeless.[1]

Later in 1930 he went to New York, where he entered Thomas Hart Benton's class on life drawing, painting, and composition at the Art Students League because his brother was enrolled. It was a fortunate choice.

Pollock absorbed Benton, studying with him until 1932. He posed for his murals at the New School for Social Research and took classes in mural painting under his direction. Benton became Pollock's mentor, encouraging him to continue to work. Pollock summered with Benton on Martha's Vineyard until 1937 and kept in contact with him throughout his career by telephone. Benton even visited his studio in the early 1940s, though Pollock had changed direction around 1938–39 and embraced the modernism that Benton partially repudiated. In 1944 Pollock himself declared that he had reacted against Benton's art.[2] Nevertheless, a strong structural relationship between Benton's and his own work persisted throughout his career.[3]

Pollock's mature work reflects Benton's rhythmic and

energetic compositions. Benton himself recognized that some of Pollock's rhythmic patterns, "even to the end of his productive life," corresponded to patterns he himself had used. He said:

Jack did not have a logical mind. But he did catch on to the contrapuntal logic of occidental form construction quite quickly. In his analytic work he got things out of proportion but found the essential rhythms. . . . Jack did finally reject my ideas about the social function of art. . . . He followed a Benton *example* but this was in matters of form rather than content.[4]

As we noted, Benton's art and thought add up to a form of conceptual allegorical realism consisting of a synthesis of original ideas and modern and traditional elements. His influence is evident in Pollock's early work, when he follows Benton in subject as well as style. A painting such as *Going West* of 1934–38 (fig. 169) is a typical example. Pollock's subject derives from the 1930s and Benton's work. It reflects the fundamental concept of transition

through imagery and forms of transit, which were represented in Benton's work by his rhythmic compositions, elongated shapes, and historical flow. In the 1930s, imagery of transit in the form of wagons, trains, planes, and other images indicated the profound hope in movement itself as a redeeming force.[5] Pollock supports the theme with Benton's rhythmic structuring. An all-over curve unites the foreground of rocks and earth with the background of the clouds over the mountains. The straight lines of the wagons both counter and reinforce the ground curve from right to left, while the bumpy mountains and straight edges of the house provide a counterpoint to the single curve of the clouds. Light and dark areas flicker across the surface. While there is a firm three-dimensional spatial construction, as with Benton, the all-over design is also as evident in two dimensions as in three. In addition to Benton, the influence of the American symbolist Albert Pinkham Ryder, the only American master Pollock said ever interested him,[6] is present in the intense darkness,

Figure 169. Jackson Pollock, *Going West,* 1934–38. Oil on gesso on composition board. 15⅛ x 20⅞ inches. National Museum of American Art. Gift of Thomas Hart Benton.

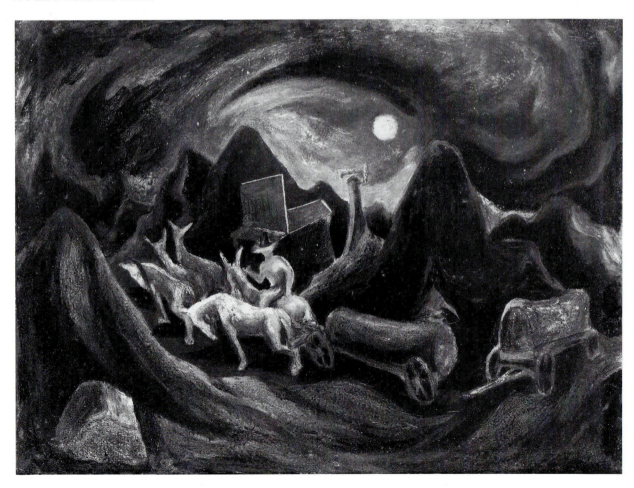

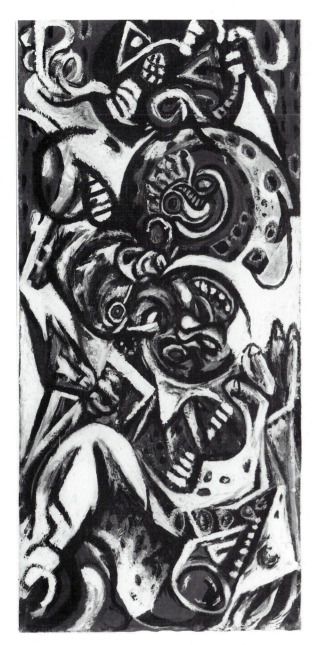

Figure 170. Jackson Pollock, *Birth*, ca. 1938–41. Oil on canvas mounted on plywood. 46 x 21¾ inches. Private collection on loan to the Tate Gallery, London.

the thick painterly treatment, the rugged simple shapes, and the piercing moon and dramatic sky.

Clearly Pollock's work of the 1930s follows Benton's stylistic principles, though Pollock's individuality is evident in the more painterly flatness and more introspective mood. When in 1938–39 he rejected Benton's obvious subject matter and his traditional formal elements, his work may at first appear to be free of Benton's influence. However, rhythmic counterpoint remains characteristic of

his work. Moreover, specific Bentonian design ideas reappear throughout Pollock's oeuvre. The arrangement of curving and straight shapes and forms around an imaginary pole, a standard Bentonian design concept, can be still seen in *Birth* of about 1938–41 (fig. 170), despite Pollock's decisive new involvement with Native American art and Picasso. And *Flame* of about 1934–38 (fig. 171) combines Benton's swirling rhythms with a dramatic, almost abstract all-over image of conflagration. All of these sources, however, are now used to develop his new and now lifelong topic, the forces of transformation.

RITUAL

The difficulties that would plague Pollock and the original art that would sustain him manifested themselves in 1938. That year he was hospitalized in the Westchester division of New York Hospital for alcoholism, which had already troubled him for several years and would continue on and off for the rest of his life. To occupy himself, he hammered out a copper plaque with figures (fig. 172). The doctor to whom he presented the plaque has remembered how Pollock described its circular swirl of figures: "When Mr. Pollock presented the plaque he spoke of it as the cycle of man. Moving away from infancy and parents, mating, the chaos of life and death at top, man helping another to the left and death at the base. I can hear him talking now as he pondered this out."[7] Among the first recorded comments by Pollock, it is Pollock's version of a life struggle and it clearly states many Abstract Expressionist themes: archetypal primaries and dualities of life, growth, struggle, union, cyclicality, and temporal longitude. Pollock never disengaged from these interests.

Like his colleagues, Pollock turned to rituals to represent the life cycle and its generating forces and powers. Although he worked with Alfaro Siqueiros for two months in 1936 and experimented with new techniques, his work in the years 1938–40 was more influenced by the Mexican painter José Clemente Orozco, who repeatedly visited and worked in the United States in the 1920s and 1930s. Besides his murals in California, New York, and New Hampshire, Orozco exhibited in the Weyhe Gallery in New York and was the subject of magazine articles and publications throughout this time. Orozco's dramatic presentations of violent conflicts and his compelling baroque compositions attracted Pollock and aided his turn toward the increasingly introspective. His work presented a direction that Pollock understood as a personal as well as historiocultural expression. Pollock's search for an art of "cosmic mystery, life and death"[8] was rendered in Orozcoan forms transformed into ritual.

Pollocks' [*Bald Woman with Skeleton*] of 1938–41 (pl.

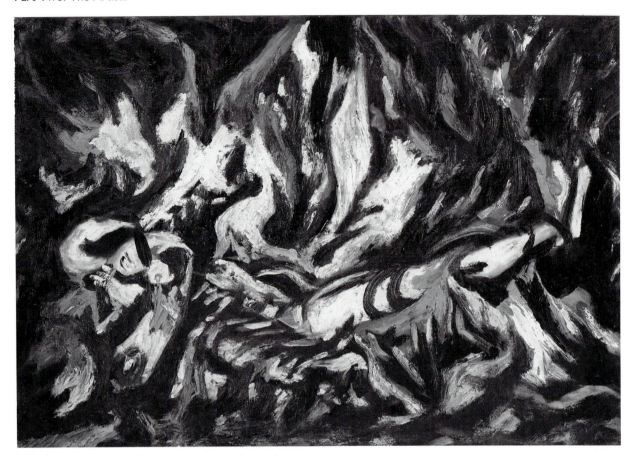

Figure 171. Jackson Pollock, *Flame*, ca. 1934–38. Oil on canvas mounted on composition board, 20½ x 30 inches. Collection, The Museum of Modern Art, New York. Enid A. Haupt Fund.

20)[9] consists of a scene of a ritual sacrifice in which a fully fleshed woman lies over a skeleton whose head consists of an animal skull but whose body resembles the horizontal skeleton figure in the *Modern Education* panel of Orozco's Dartmouth mural series *An Epic of American Civilization*. These forms are surrounded by many figures, creating a composition of an individual protagonist and the masses typical of Orozco. Lying below the main figures is a snake (barely visible in reproduction) derived from the last panel at Dartmouth (fig. 173). For both Orozco and Pollock, the snake generally symbolizes a primitive deity. In its contrast of fleshy and skeletal figures combined in a public ceremony, *[Bald Woman with Skeleton]* suggests primitive revitalization through ritual sacrifice, death, and rebirth.

[Composition with Ritual Scene] of 1938–41, with its earth colors, dense crowds, skeletal forms on altars, and animal skulls, also evokes ritual sacrifice. Here Pollock combines Orozco's mass scenes with Benton's design principles. But perhaps the most violent expression of

transformative ceremony and violence takes place in *[Naked Man with a Knife]* of 1938–41 (fig. 174). Pollock drew the composition from Orozco's work in general, in which the thrusting of a knife through a figure in violent struggle is typical, but here one of Orozco's ink illustrations for Mariano Azuela's novel of the revolution, *Under Dogs*, which was in the collection of the Delphic Studio in New York and reproduced in their publication of Orozco's work in 1932 (fig. 175), may have been the direct source. Orozco's work is more socially specific than Pollock's: he drew a soldier attacking a peasant with a knife amidst a general battle scene. Pollock turned his composition, in which a naked figure sacrifices another, into a series of closely focused, very muscular forms, multiple biomorphic crisscrossing, and extended body parts (perhaps from El Greco) and rhythms. The Pollock is more traditional in its emphasis on nudity but no less powerful or violent than the Orozco, yet it is also more ambiguous and more mythic. Pollock expands the human figure and spreads it out across the ritual bier and canvas, thus distilling the

Figure 172. Jackson Pollock, plaque with figures, 1938. Oxidized copper. Diameter 18 inches. Private collection.

general abstract principle from the more concrete Orozcoan situation and transforming its sociopolitical meaning.

INHERITED RESOURCES

In 1939 Pollock began four years of psychotherapy that would aid him in an identification with the growing interest in the themes of Jungian thought. In this year too he turned toward mythic and American Indian subject matter, which would be important to his art for the rest of his life. And around 1939, he also turned toward modernism and Picasso. All these changes would, just eight years later, vault him into his position as a leading postwar artist.

In 1938–41, as we have seen with his ritualistic pictures, Pollock turned to primal subjects. Pollock had spent some time in the Southwest as a boy but his developing interest in the primitive seems to have been a product of the 1930s. His teacher Benton frequently discussed African sculpture in his classes, but Pollock's orientation was to his own allegedly "indigenous" culture—Native American art and thought. In the early 1930s he and his brother Charles bought a collection of books on Native Americans, the publications of the American Bureau of Ethnology.

These extremely important books reflected the growing fund of knowledge about Native American art, culture, and mythology.[10] They formed the most comprehensive view of Native American art and thought in the late nineteenth and early twentieth centuries. Totemism, equivalents of Levy-Bruhl's participation mystique, the divinity of nature and its elements, the symbolic quality of Indian thinking, the sacredness of the world, rites and rituals, and ritual symbols of the nature such as lighting, arrows, and snakes are among the many topics presented. Similarly, the publications are among the first broad records of Native American art from Eskimo carvings to Zuni pottery. With these books, Pollock attained, at minimum, a basic understanding of their culture and art. The same publications were collected by the surrealists in Paris and are responsible for their first exposure to and absorption of Native American art in their work.[11] And they were a profound stimulus for a young eleven-year-old boy named Joseph Campbell, who read them all. After that, Campbell set off in a direction that made him, in many ways, heir to Frazer and Jung as the foremost mythologist of the mid-century. Pollock would own Campbell's and Henry Robinson's *Skeleton Key to Finnegan Wake* of 1944 and later *The Hero with a Thousand Faces.*

Pollock also owned Frazer and Benedict's *Patterns of Culture*, among other anthropological studies. He saw the exhibitions and catalogues of Native American and prehistoric art at the Museum of Modern Art, clipping out reproductions of masks from the former from *The New*

Figure 173. José Clemente Orozco, *Snake*, panel 2 in *The Epic of American Civilization*, 1932–4. Fresco. Courtesy of the Trustees of Dartmouth College, Hanover, New Hampshire.

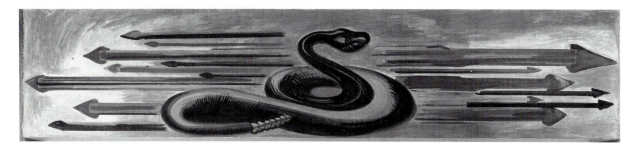

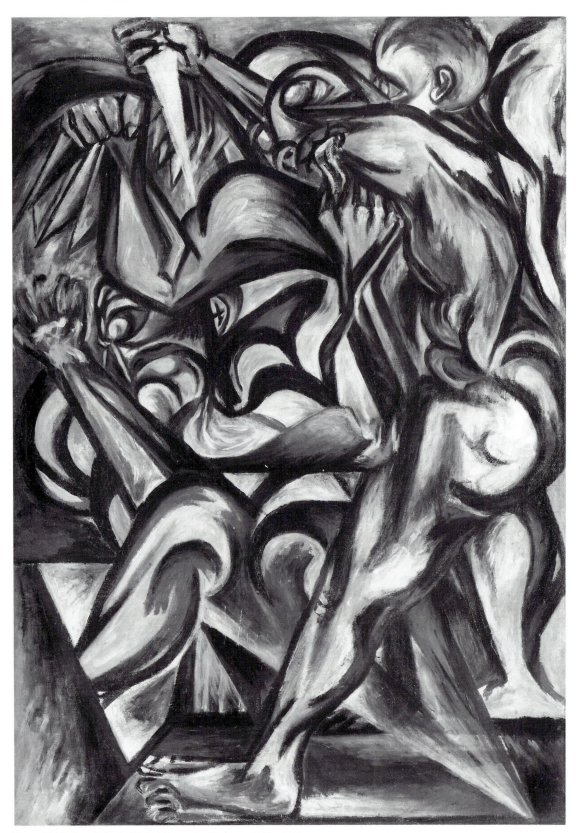

Figure 174. Jackson Pollock, *[Naked Man with a Knife]*, ca. 1938–41. 50 x 36 inches. The Tate Gallery, London.

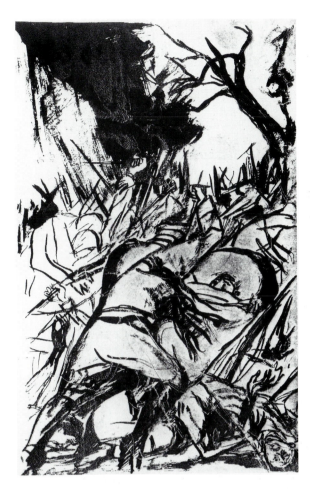

Figure 175. José Clemente Orozco, drawing for illustration to Mariano Azuela, *Under Dogs*, 1929.

than an archaicizing Abstract Expressionist like Rothko and Gottlieb. Nevertheless, given the contemporary understanding of Jungian psychology as crosscultural memories and the widespread concept of fusing the past with the present in a living continuum, Pollock's primitivism must be seen, like Still's, as his personal version of the past. Indeed, the catalogue to the Native American exhibition in the Museum of Modern Art refers to the art as representing "Living Traditions" for modern life. By means of an intimate relationship with his art, as Eleanor Roosevelt wrote, the American Indian preserved and renewed his heritage. Pollock found this living tradition or heritage within the realm of the unconscious, its respository. For him, Native American art and cultural traditions formed a particular corpus of inherited experience and values which contributed a "usable past," in Van Wyck Brooks' words, that would, almost in his symbolism, "fertilize the present."

In 1944 Pollock answered a question about how being a westerner affected his work in the following words:

I have always been very impressed with the plastic qualities of American Indian art. The Indians have the true painter's approach in their capacity to get hold of appropriate images, and in their understanding of what constitutes painterly subject-matter. Their color is essentially Western, their vision has the basic universality of all real art.[14]

His art from around 1938 onward employs numerous Native American forms and subjects, as he translates his quest for the life cycle into an analogy of the Indian quest for supernatural power. The subjects and forms of totemism—totem poles, serpents, masked gods—and of fertility, procreation, ritual initiation, and journeys to the spirit world, abound in his work.

The question arises whether Pollock's introspection, his turn to the primal and mythic, is a strictly autobiographical concern with his own personal problems, for which he seeks new life and a personal rebirth, or is historical, reflecting the needs of his period. It is both. In psychological parlance, he has transferred his personal needs to the world at large. As Anaïs Nin said similarly of a friend at this very time, "At last the world and he are synchronized, his personal agonies are matched by the universal one."[15] Pollock's search was that of his generation, as Eleanor Roosevelt's words once again remind us. According to his brother Charles, Pollock was well aware of the issues of his artistic culture.[16] By adopting the contemporary ensemble of need and response, he became a participant in as well as witness of his world. He became its subject as well as its creator. As with Still, psychocultural regeneration and ritual is both personal and public. In a time of needed renewal, both personal and historical, Pollock created such an art in his own terms.

A strong early example of Pollock's emerging primal art

York Times, and he also discussed Navaho sand painting presented at the Native American show in 1941 with his analyst.[12] Like many of his colleagues, Pollock visited the Franz Boas collection of Northwest Coast art at the Museum of Natural History as well as the Museum of the American Indian. His brother Jay collected many Native American, especially Navaho, blankets in 1924–25, which Jackson "knew well."[13] And both the surrealists, his primary modernist influence except for Picasso, and Jung, who can be characterized as a psychologist of the primal, shared many of the same ideas and sources, that is, the primitive mentality in their understanding of the primitive.

By 1941 Pollock thus had a great deal of exposure to primitive and especially Native American art. At first he seems to limit references to the primal as the past—the most obvious example is the biomorphic painting entitled *Something of the Past* of 1946—and thus his fundamentalism seems to be more a combination of mostly the primitive and psychological or what I call the primal. He appears more as a typical primitivist artist like Still rather

is [Circle] of about 1938–41 (fig. 176). The painting reflects the transition from Orozco to Native American form and subject. It consists of snake and marine forms (eels and shellfish) in a continuous dynamic swirl. Snakes and water life are Indian symbols of fertility frequently found in sand paintings as well as in Southwest art in general. And the sea is a symbol (see Tanguy, Rothko, Baziotes, Gottlieb, Jung) of the unconscious and of the landscape of the mind. The circular shape itself is typical of many sand paintings; it represents the circle of the earth. [Circle] also contains many abstract markings that are pictographic signs, derived from Native American clothing and facial decoration, of the cosmos, of the suns, stars, and sea and their powers. Pollock presents his basic fusion of Native American and psychic symbols of the past and future in dynamic symbolic and expressive form partially derived, as they will be repeatedly, from sand painting.

This is Pollock's subject matter for the rest of his life. [Circle] symbolizes, along with ritual, what Pollock will later represent with his pourings: the archaic, psychic and natural energies of fertility and creation—the invisible, transhuman powers. As Lee Krasner said: "For me, all of Jackson's work grows from this period; I see no sharp breaks but rather a continuing development of the same themes and obsessions."[17]

With Birth Pollock designates the next step in the life cycle in Native American form. The composition reflects Northwest Coast Indian totem poles in its verticality, its top head with angularized eye sockets or ovoids, its stacked arrangement of other animal heads, and its spread leg and claw foot. Its central composition of swirling animal heads further reflects typical Northwest Coast design. What animals these are it is too difficult to ascertain with any assurance. They may be birds, perhaps eagles, or swirling plumed serpents. The curving upside-down mask in the center resembles Eskimo masks in the collection of the American Museum of Natural History.[18] The triangular heads in the lower half suggest Picasso, whose absorption into Native American topics indicates the uses Pollock makes of him. The heavily outlined forms reflect, besides Bentonian rhythm, the emphasis on curvilinear lines or formlines of Northwest Coast art. The lines interconnect the varied symbolic species on Pollock's poles as on Native American ones, creating a sense of continuity and analogy, unity and division of shape and form, line and field. Pollock's lines do not swell and diminish as do Northwest Coast formlines, and his forms also overlap more than in Northwest Coast art, where forms are flat. Still, this Pollock is flatter than his earlier work and the forms are more adjusted or compressed to the field with very little negative space, again in a way typical of Northwest Coast Indian art. Birth evokes the two-dimensional, nonconcen-

tric rhythmic system of Northwest Coast Indian art, where there is a constant flow of movement, broken at rhythmic intervals by sudden changes of motion and direction.[19]

Native American totem poles are heraldic statements, relating in graphic form violent and expressionist myths of the origins of families. They are, in the words of the surrealist Wolfgang Paalen, "true vertebral columns of the myths and landmarks of social life" and "bear the seal of the same severe and powerful rhythm that ordered the existence of these peoples."[20] They thus represent the gateway to the world of the spirits, like Still's life line and Rothko's portals. With its swirling totemic forms, Pollock's Birth evokes the ancestral identities, histories, and spiritual order. Here Pollock engages his period's biomorphism as totemic, mythic animal life, in other words, Native American deities.

Masked spirits are an important part of Native American art and thought. The wearing of masks creates another gateway to the underworld, to the spirits, to another identity, to one's totem animal, and to the supernatural power of the animal the masks symbolize. In the catalogue for the Museum of Modern Art show, Douglas and D'Harnoncourt write that the term kachina used by the Pueblo Indians refers to supernatural beings such as the spirits of the dead, and clouds and rain. Masked Indian dancers representing kachinas are turned into supernatural beings by wearing masks.[21] "This faith in the power of masks is common among many native races throughout the world."[22] Elsewhere they write that masks are used in myths, rituals, and ceremonies to prepare for a successful hunt, to drive away evil spirits, and to heal the sick by evocating the masked spirit.[23] Furthermore, some masks of the Northwest Coast were carved in the likenesses of spirits or mythical beings who were believed to be ancestors of families. The masks have features that exaggerate human features in a grotesque manner. Wearing and owning the power, a masked figure can then affect nature and make the earth fertile, for example, make it rain. By donning masks in ritual, an individual can alter his being and identity, transform himself, and travel to the spirit world:

Masks are metaphors of altered self ... objects of immense power.... To the Kwakiutl masks are living beings whose powers are literally those of life and death, for masks take people from one world and move them to another and, in so doing, bring about death and rebirth. ... [T]he human dons the mask of a spirit because he wants to seek the powers of eternal life the spirits possess.[24]

The most famous mask of the Northwest Coast is the transformer mask which consists of an animal mask over a human one. By wearing the mask, a person attains the transformer's power. Masks are the primitive's tool of

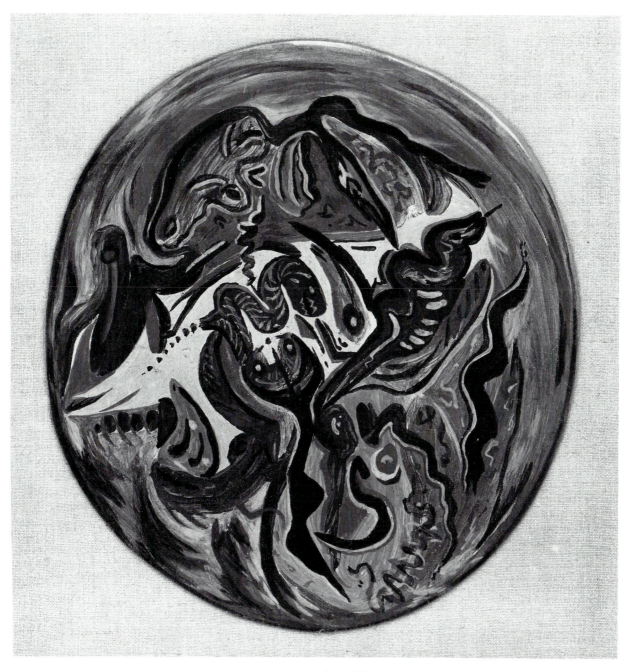

Figure 176. Jackson Pollock, *[Circle]*, ca. 1938–41. Oil on composition board, 11¾ x 11 inches diameter. Collection, The Museum of Modern Art, New York. Gift of Lee Krasner in memory of Jackson Pollock.

transformation into an animal spirit and supernatural being of greater power.

Masked figures, as well as others in Pollock's early work, are thus not simply, if at all, surrealist hybrids from the personal unconscious as they have traditionally been described in the literature, but specific beings—nature deities. They are figural representations of the archaic, magi-

cal, natural forces of the world. *Masqued Image* of 1938–41, for example, employs Picasso-like face masks in its rectilinear field of swirling, overlapping forms, while *[Composition with Masked Forms]* of 1941 (fig. 177) distributes Indian masks along a horizontal axis. While the painting is rather Orozcoan in its composition of forms dispersed in a heavily painted field, the head at the upper left of the

241

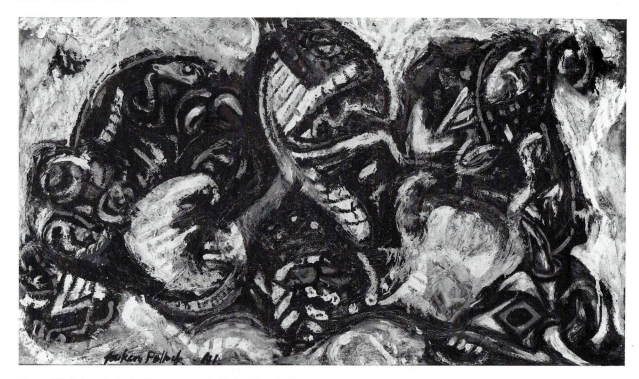

Figure 177. Jackson Pollock, [Composition with Masked Forms], 1941. 27¾ x 50 inches. Private collection. Photo: Eeva-Inkeri.

painting resembles a Northwest Coast mask. A bull-like head is at the lower right. Both forms as well as the fish (?) head in the center are outlined and angularized in mouth and lips, resembling the socket forms of Native American art of the Northwest Coast.

Pollock's paintings are not simply representations of even merely formal evocations of Native American masks, but in their action, movements, and intense frenzy, they express the powers of the sacred, natural world of the masked animal spirits. His masks, through their illusionary power, convey the sacred spirit and power of the primal human being and his totemic animal spirit. And with these Native American cultural images, Pollock seeks to alter his and his culture's identity.

THE EARLY FORTIES

Pollock was the only Abstract Expressionist to undergo Jungian psychotherapy. Yet however direct his experience, Pollock's interest in Jungian thought, or rather in the cultural amplification of it, is more a reflection of the emergence of Jungianism in American cultural life than it is of only personal concerns. Pollock's early interest in Jungian therapy had many sources, not the least of which was the influence of his friend John Graham. Pollock met

Graham in the late 1930s after Graham had published a significant and unusual article for that time in an American art magazine in 1937; the article was called "Primitive Art and Picasso."[25] Graham also published System and Dialectics of Art that year through the Delphic Studio, which had put on exhibitions of Orozco's work. (It is also significant that Robert Goldwater published his classic Primitivism in Modern Art in 1938. Graham's and Goldwater's writings, which along with Pollock's and Still's turn in the late 1930s to Native American art, may have been the earliest signals of a developing interest in primitivism in America, which climaxed with the Bollingen Foundation and its multilevel crosscultural primalism.) Graham's influence was widespread in the American avant-garde. Undoubtedly he had an effect on Pollock, becoming perhaps Pollock's first personal source of direct contact with European modernism. In response to the article, Pollock wrote Graham a letter and visited him in his studio,[26] and Graham, in turn, was so impressed with Pollock's work that he intended to add Pollock's name to the list of prominent young American artists he was preparing for the second edition of his book.

Sophisticated and extremely knowledgeable about recent modern art, Graham advanced ideas about subject matter that were more in line with the central thrust of mainstream Abstract Expressionism than with Benton and

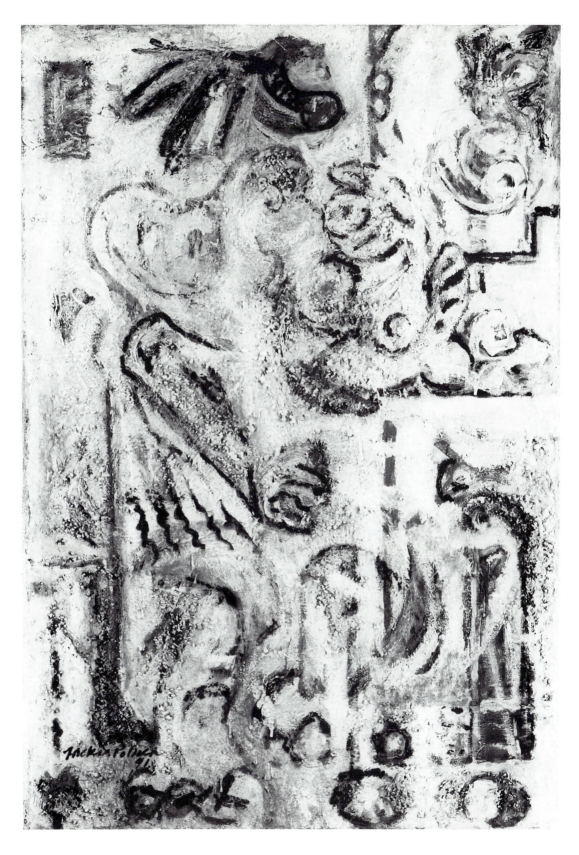

Figure 178. Jackson Pollock, *The Magic Mirror*, 1941. Oil and granular filler on canvas. 46 x 32 inches. Courtesy of The Menil Collection, Houston, Texas. Photo: Hickey and Robertson, Houston.

Orozco. Graham was interested in the unconscious and the primitive, that is, in the connectedness of what we have called the primal. In his article Graham declares, "The unconscious mind is the creative factor and the source and the storehouse of power and knowledge, past and future. The conscious mind is but a critical factor and clearing house."[27] Further, in accord with basic recapitulation theory, Graham remarks that so-called primitive people, children, and geniuses have greater access to the unconscious than others. For Graham, primitive art brings forth the individual and collective wisdom of past generations. A modern, evocative, and intuitional art also allows one to get in touch with the primordial past and "collective wisdom" stored in the unconscious as memories of the immemorial past and allows for a more spontaneous exercise of design and composition and more elemental components of form. Primitive art expands the unconscious mind and reveals a source of unlimited procreative power.[28] For Graham, Picasso had this greater access to the unconscious, so much so that he believed Picasso had evoked primordial, primitive artistic forms in his art. Ultimately it was from the primordial past in the unconscious that form and the pure power of art arose.

It is probably at least in part through Graham that Pollock became interested in Jung, Picasso, and the value and relationship of the primitive and the unconscious. (Graham went with Pollock to his Jungian analyst's office in 1941.)[29] But even without Graham, Pollock, in his turn to modernism at that moment, would have absorbed these topics elsewhere, as his colleagues did. Graham is simply a more identifiable entry point to a network of concepts that made up a strain of the intellectual and cultural history of his era. And Pollock probably read Jung. Not only did he define himself as a Jungian, but a list of writings on Jung is to be found in his archives now on deposit at the Archives of American Art in Washington, D.C. He would have been aware of the widespread interest in Jung in New York and the establishment of the Bollingen Foundation and the Psychology Club about the same time his psychotherapy began. There is no doubt some level of Jungian influence in Pollock's work, especially in its themes of initiation rites, mythic and primitive thinking, and sacred nature symbolism. The very idea of Jungian depth psychology rationalized for Pollock his use of Native American inherited traditions as representative of the psychic heritage and living tradition of humankind.

At the end of 1939 and at the beginning of the war, Pollock was drawn to modern art, especially Picasso's work such as *Guernica* and drawings for it shown at the *Picasso: Forty Years of His Art* exhibition at the Museum of Modern Art in 1939. In the early 1940s Pollock expressed his admiration for Picasso, feeling, as De Kooning did, that Picasso was the best, and to be the best, he

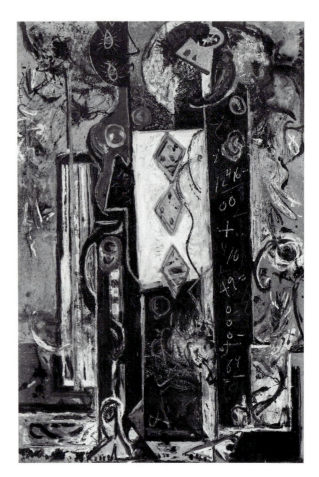

Figure 179. Jackson Pollock, *Male and Female*, ca. 1942. 73 x 49 inches. Philadelphia Museum of Art: Gift of Mr. and Mrs. H. Gates Lloyd.

would have to outdo him. Pollock's notebooks in the late 1930s, some of which were done while he was under Jungian therapy and are known as the "psychoanalytic" drawings [sic], contain innumerable sketches of torn and rent horses, bulls, and warriors. These drawings, many of which appear to be doodlings rather than full drawings, reflect his emerging approach to Picasso and modern art—he will select and use those elements that ratify and expand his emerging themes and their formal expressions. Hence Pollock draws from Picasso's art figures ripped by the overpowering forces of the world.

The Magic Mirror of 1941 (fig. 178) reflects Pollock's turn to subjects of psychological and inner life. The mirror as a symbol of looking within is standard, from Old Master *vanitas* paintings—which this picture roughly resembles with its biomorphic creature sitting down looking to the right—to Picasso's *Girl Before a Mirror*. In her dance *Herodiade* of 1944, originally called *Mirror Before Me*, Martha Graham also used mirrors for the look within, for self-knowledge and the revelation of inner life, as did

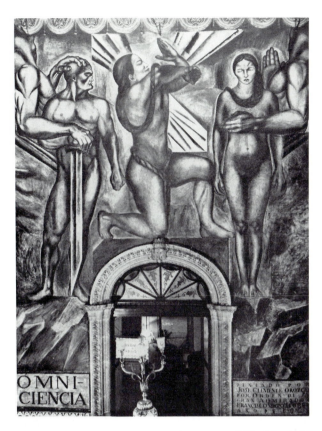

Figure 180. José Clemente Orozco, *Omniscience*, 1925. Casa de los Azulejos, Mexico City.

Pollock's friend Baziotes in such works as the Baudelaire-like *Mirror at Midnight I* of 1942.

The Magic Mirror both announces Pollock's concern with this interiority and connects it to Native American thought. He has rendered the image in hard-to-decipher fragments that evoke Native American signs. The wiggly lines in the center of the figure suggest lightning snakes typical of Southwest Indian art and sand painting. The yellow form above suggests some kind of feathered headdress. And the entire surface of sand, while perhaps an allusion to Native American sand and rock painting, deliberately evokes the buried strata we have seen, for example, in Rothko and Gottlieb. Within the psyche lies the buried past.

Male and Female of 1942 (fig. 179) presents a common subject of mythology, Jungian psychology, surrealism, and the art of the era—the union and balancing of opposite tendencies. Ernst's *Of This Men Shall Know Nothing* of 1923, for example, consists of a crescent symbol of a female penetrated with male symbols. Masson fused male and female forms in his themes of the metamorphoses of opposites.[30] Jung elaborated a theory of male and female parts of the unconscious which should be fused to bring

about a greater psychological harmony. And Martha Graham described a Jungian concept of male and female that may be particularly relevant to Pollock: "Each man takes with him into the far country of his experience an image of Woman. . . . She is the feminine aspect of himself from which he can never escape—Each man is a clown saint devil poet prophet hunter warrior lover Priest One who kills One who makes whole."[31] In his painting Pollock seeks the union of these two opposites and thus balance, harmony, and wholeness.

Orozco employed the union of the male and female principles as an allegory of creation and transfiguration, which he represented by rays of cosmic sun in his *Omniscience* of 1925 (fig. 180). Pollock seems to follow this idea of transfiguration in *Male and Female*. The composition is also partially based on Picasso's *The Studio* owned by Peggy Guggenheim (fig. 181) as well as earlier drawings of his own. The two figures, whose sex is unclear and much debated, dominate the composition. In the Picasso, a sculpture of a male head is on the left and a painting of a full female is on the right. In the Pollock, the figure on the right has a different Picassoid head—a black, flat, rectilinear plane—numbers, and perhaps a Picassoilike head/foot. Its profile is a curvaceous breast and has a triangular sex much like Miró's triangular genitalia, an image which Pollock will continually use. On its left is another curvaceous figure with sparkling eyes, a blue erect (?) penis pointing toward the other figure's genitalia, and a Northwest Coast head-as-joint foot. The figures are held together by diamonds, like the backdrop planes in Picasso still-life paintings of the 1920s, and by scumbled and linear bursts, which also surround both figures and echo the sparks of the eyes. These bursts, like Orozco's rays, suggest the powerful moment and bursting forth of union. They are also among Pollock's first attempts to use automatic writing in his work. It was at this time that, after a meeting with Motherwell, he was asked to show in a major exhibition emphasizing psychic automatism. He refused, but did say that he was already convinced of the "role of the unconscious in art."[32]

The number symbolism in the painting points to the divination aspects of numerology. Masson used number symbolism in the drawings that were published a year later in America (*Anatomy of My Universe*). In Native American art, the number four is a standard reference to the four directions or corners of the earth; and the numbers four and twelve are important in Joyce's *Finnegan's Wake* which Pollock greatly admired, where they represent, among other things, the four weeks in the lunar month, the four elements, the four points of the compass, and the four stages of the cycle of history. Finally, number symbolism was discussed by Kurt Seligmann as a way of symbolizing alchemical, Jungian, and cosmic forces, in *View*

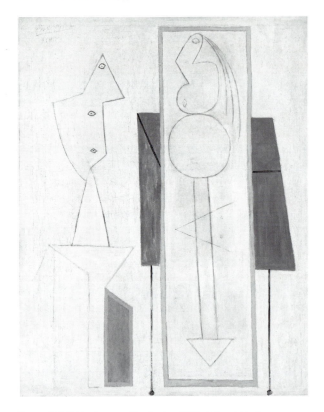

Figure 181. Pablo Picasso, *The Studio*, 1928. Oil and black crayon on canvas. 63⅝ x 51⅛ inches. Peggy Guggenheim Collection, Venice (The Solomon R. Guggenheim Foundation). Photo: David Heald.

Figure 182. Jackson Pollock, *Mural*, 1943. 7 feet 11¾ inches x 19 feet 9½ inches. Collection, The University of Iowa Museum of Art, Iowa City. Gift of Peggy Guggenheim.

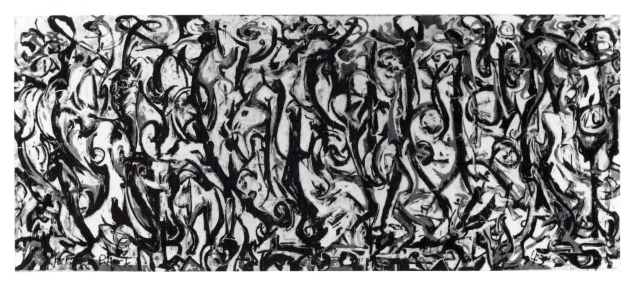

in 1942.[33] What the numbers in Pollock's painting mean is not clear but they seem to suggest some mythological way of divining the future from hidden knowledge.

The year 1943 was a turning point in Pollock's young career. Support from the WPA came to an end but Pollock attracted the patronage of Peggy Guggenheim when he exhibited a collage and painting at her gallery, and with the advice of Piet Mondrian she decided to give him his first one-person show. She also commissioned his largest painting, *Mural* (fig. 182).

The controversial *Moon Woman Cuts the Circle* of 1943 (fig. 183) presents another symbolic image of Native American mythic and psychological, that is, sacred/unconscious, questing. The composition consists of an Indian with headdress at the right and a countercurve terminating in a bird-crescent shape holding a knife at the left. Much debate about whether this painting is Native American or Jungian in inspiration and what each shape and symbol specifies misses the point.[34] This is a distinction without significant difference. Both Native American myth and Jungian subject reflect the symbolic, cyclic passage of spirit life in the cosmic, supernatural, seasonal, and inner worlds. The psychological and the primitive intertwine and are not opposite as debaters contend. Indeed, Jung's discussion of a moon woman, which is argued to be the source of Pollock's theme, is based on *Hiawatha,* that is, Longfellow's version of a Native American myth. The forms themselves, while reflecting Bentonian rhythms, also reflect Native American sand painting in that the swelling bird form echoes similar animal deities whose heads terminate the elongated bodies in Navaho sand painting (fig. 184). Frequently at the foot of such open curves lie hermaphroditic figures. In Pollock's painting, the Indian has swell-

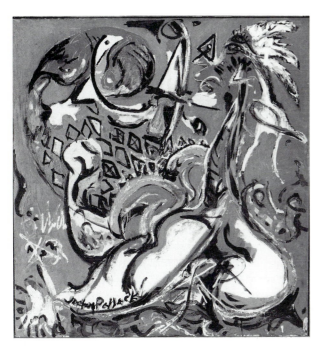

Figure 183. Jackson Pollock, *Moon Woman Cuts the Circle*, ca. 1943. 42 x 40 inches. Centre Georges Pompidou National Museum of Modern Art, Paris.

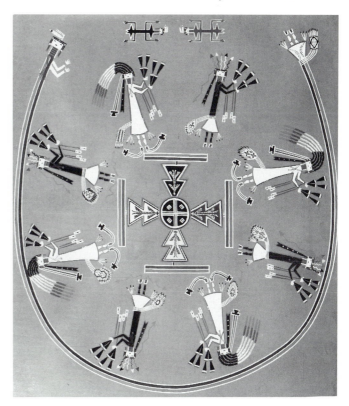

Figure 184. Water People, sand painting, 1937 (?). Singer: Black Son's Son. Collected by Franc J. (Mrs. Arthur) Newcomb at Tsebitoh, Arizona or by Bitah-hochee near Winslow, Arizona. Wheelwright Museum of the American Indian. Photo: Rod Hook.

ing breasts but wears a male headdress and thus may be such a hermaphroditic form. The knife suggests the Jungian version of ritual cutting in the title but as we have seen, violent ritual is nothing new to Pollock. On the whole the painting, like most of Pollock's work at this time, reflects a primal fusion of Native American mythology and subconscious symbolizations. *Moon Woman Cuts the Circle* represents Pollock's search for the generative forces and symbols of life. Martha Graham can elucidate the general meaning of the moon imagery for us: "The ritual of the Goddess of Renewal—the crescent Moon—implicit with promise of fulfillment."[35]

What is formally new in this work is most significant. While Pollock has increasingly used his desire for rhythmic compositions as an expression of the power of the inner events taking place, here more than in his previous paintings he allows the figure to merge or melt into the surrounding ground (which is deep blue, perhaps signifying the sky location of the event). Welding figure and ground, Pollock imbues the ground with the figure so that the ground takes on significance as a dynamic force. As in *The Magic Mirror,* and all his colleagues' early work, the engendering fields and environment, the very subsoil from which all life and especially spirit life emerges, or in which it lies hidden, is a live symbol. The ground is not a neutral background but a participating force. *Moon Woman Cuts the Circle* is a figure composition anticipating his later all-over painting, but it is also the fusion of a figure with the

all-enveloping primal inner and outer, above and below, powers of the world. Symbolic figure is joined with symbolically expressive formal structure.

Pollock searched for expressive means to represent the generative forces. In 1942–43 he achieved his first breakthrough with the expressive and symbolic automatist bursts and writings. It is around this time that he also experimented with automatism and pouring paint, the latter seemingly for the first time since his technical investigations with Siqueiros.[36] In [*Composition with Pouring II*] of 1943 (fig. 185), the automatic splashes in *Male and Female* reach their first stage of maturity. Many splatters and pourings fill up a field. A figure is suggested by a bottom arm and claw, the location of which indicates that the painting may have been worked on originally from several angles. We see the growth of several Pollock characteristics: the inscribing of line as biological form as well as expressive mark, an all-over field of power and activity, an equal interchange between negative and positive shapes (that is, what is over or under, or up and down, is not clear), and a field of swirling, biomorphic, thinning and thickening shapes, lines, and energy. The painting consists of echoing and more integrated curvilin-

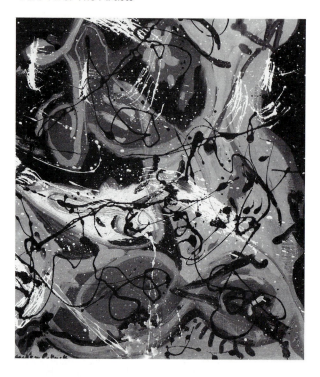

Figure 185. Jackson Pollock, *[Composition with Pouring II]*, 1943. Oil and enamel on canvas. 25⅛ x 22⅛ inches. Hirshhorn Museum and Sculpture Garden, Smithsonian Institution, Gift of Joseph H. Hirshhorn, 1966. (66.4082)

ear spots, splatters, planes, shapes, and lines. Pollock is moving toward a greater homogeneity of elements, which will find their ultimate conclusions in the poured paintings of 1947–50.

Pollock's automatist scumbling and area filling appears in *The She-Wolf* of 1943 (fig. 186). Close examination reveals that the entire surface was once covered with the marks that now constitute the wolf and that Pollock painted over the marks with the grey Native American diamond forms below the torso of the animal and the rounder areas above. Ridges of the previous paint marks are still visible in these areas. Pollock has outlined a figure and ground onto his field of automatist scumbling.

She-Wolf refers to the myth of the nursing animal who suckled the human children Romulus and Remus, who then founded Rome. The figure has triangular teats, and there is a pictographic fetal form below the head at the left. (Pollock represents nature's nurturing qualities through myth much the same way Rothko did in the large-breasted figures of *The Omen of the Eagle* and *Entombment,* and Still in his vernacular *Pietà*.) The animals' head looks as if it has been subjected to an x-ray, that is, it has something of a skeletonal infrastructure. Across the center of the animal, Pollock has drawn an arrow taken from Zuni Pueblo pottery designs (fig. 187). With this arrow, Pollock suggests

a symbolic revelation of the interior of the animal. As Douglas relates in the catalogue of the Indian show of 1941 (there are many examples in volume one of the Bureau Publications too), the triangle and line represent heart and windpipe, that is, the animal's internal organs, much like Still's x-ray ribs, Gottlieb's organic forms, and surrealist skeletons. In Zuni art, the arrow passes through the mouth, that is, from the outside to the inside; it is a symbol of life and of the gateway to the inner spirit of the animal. Pollock's inner arrow is yet another symbol of interiority.

Although Pollock's painting is entitled *She-Wolf,* the animal seems to have been begun as a bull (left) and as a deer (right) with its swirling line resembling the antlers of Zuni deer. Pollock's she-wolf is a composite animal to which he gave a more generous association than Martha Graham, who saw wolves as predatory creatures of ancestral memory.[37] *She-Wolf* consists of dark, turbulent, automatist marks as forces that found and ground the very image itself, forces and marks, however, that extend beyond the confines of the single figure. Thus it is a pictorial and imagistic realization of the dark but generous ancestral/totemic/subconscious forces of nature within and without.

Pollock's last painting of 1943, *Mural* was painted in one night for Peggy Guggenheim. Even without the burden of a descriptive or associational title, Pollock ratifies his direction. With the use of Bentonian design poles for the contours of biomorphic forms extended along a horizontal axis, with independent extensions of Northwest Coast formlines, he filled this long canvas with swirling, teeming, biomorphic deities with heads and eyes and perhaps even vertebrae.[38] Again it is the netherworld of primal forces that he has dispersed in his elongated rhythms. Contour and form are both ground and figure. Pollock has painted a stream of unconscious beings/forces/forms in an almost ritual procession across the canvas. This is his most integrated work to date, with the organic rhythms swirling into one another like Analytic Cubism passage. Here dense, expressionist, ritualistic, rhythms of organic and spirit forces and compositional power fuse and foretell his abstract works. As in his two earlier precocious abstractions, Pollock temporarily achieved a new level from which he stepped back before leaping forward to a higher plane.

After this plateau of linear and expressive integration, in 1944 Pollock wavered among a number of stylistic idioms, sometimes employing small forms as organisms he associated with night, sometimes using broader planes. All subjects and images present metaphors for the archaic unconscious, and for the light and dark forces of human behavior against the background of the war.

Night is the end of the day-to-night cycle of light and existence, and a standard metaphor in the mid-1940s. It

appears frequently in the art of the period (e.g. Rothko's *Noctural Drama,* Gottlieb's *Sounds at Night*) and in its intellectual culture. In *The Tiger's Eye* of October 1949 a special section discussed night as a symbol of darkness of nature and the mind. Martha Graham writes of a woman whose power is broken submitting herself to the healing of the night, which is a time of rebirth. Night brings about metamorphosis, and it reflects the passage into the emerging dawn, the time of a fresh beginning.[39] In Campbell and Jung, one journeys into the night or night-sea of the psyche.[40] For Baziotes and Motherwell, too, one voyaged into the night, into the unknown on an unknown vessel.[41]

Pollock worked along similar lines in *Night Ceremony* of about 1944 (fig. 188) in which the space teems with overlapping, rather triangular, incised, linear, organic beings. The large and small forms are grounded in dark black: here animated, ritual, organic potencies lurk in the night. *Night Ceremony* consists of Native American ceremonial figures constituted by charged Indian zigzag lightning forms pierced by arrows. These figures closely resemble the decorated figures in the rain ceremonial of the Sia tribe of

the Southwest.[42] Like Pollock's snakes, the arrows and lightning figures personify the fertile and darker forces of Native American ceremony as well as the unconscious.

Pollock did few works that directly allude to the war. He exhibited the early *Flame* in the Metropolitan Museum of Art's *Artists for Victory* exhibition in 1942. This painting and exhibition seemed to inspire the one painting that relates to the contemporary carnage, *Burning Landscape* of 1943 (fig. 189), in which forms spatter and spread in bright reds and yellows. *Burning Landscape* seems an attempt to capture the explosive power of the war within Pollock's automatist experiments. After the end of the war in 1947, like his colleagues and others, he made another reference in the drawing *War* (fig. 190), which is inspired by Orozco's work. It consists of stacks of heads and bodies similar to those Orozco often represented, a crescent moon, a woman, a cow/bull(?), and a levitated and vertical, perhaps crucified, figure. *War* suggests death and rebirth. Thus, despite the absence of any direct representation of catastrophe, Pollock met the war as well as the crisis in the West and perhaps in his own life on his

Figure 186. Jackson Pollock, *The She-Wolf,* 1943. Oil, gouache, plaster on canvas, 41⅞ x 67 inches. Collection, The Museum of Modern Art, New York. Purchase.

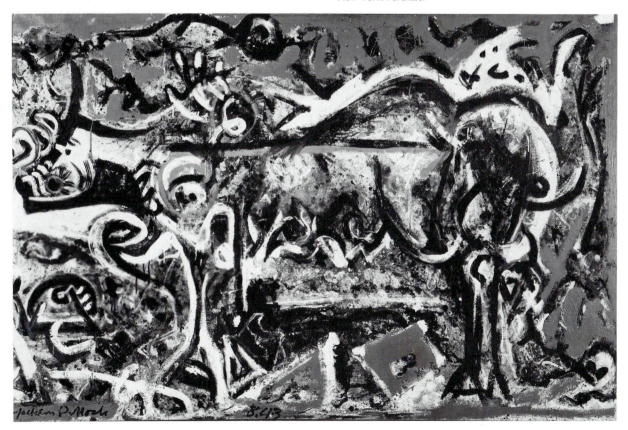

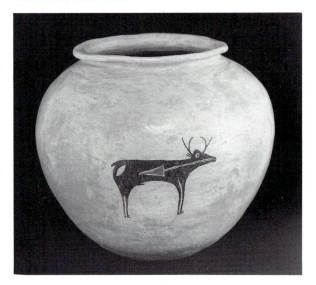

Figure 187. Pottery drum jar, Zuni Pueblo. The Taylor Museum of the Colorado Springs Fine Arts Center. Originally reproduced in Rene D'Harancourt and Frederich Douglas, *Indian Art of the United States* (New York: The Museum of Modern Art, 1941), p. 107.

own terms, and except for the stack of bodies, in his own symbols. His images and style represent his response as mythic, ritual, and psychic regeneration.

TRANS-HUMAN FORCES: THE POURED PAINTINGS

In 1945, after the years in New York City, Pollock moved to Springs, Long Island. In Springs, near the ocean, Pollock seemed to turn even more to nature imagery. He had a creek, Accobonac, on his property and paintings in 1946 were divided up into two series, *Sounds in the Grass* and *Accabonac Creek*. From the former come two paintings that are key transitional works to his mature style, *Eyes in the Heat* and *Shimmering Substance*.

Eyes in the Heat (fig. 191) is a great step. Pollock has drawn, if not dug or excavated, short curvilinear rhythms in a thick, turgid, impastoed surface in which contrasting flat, thinly painted eyes lurk. *Eyes in the Heat* reveals what has happened—the ground, with all the associations that Pollock has developed for it, has swallowed up his figures; that is, nature, force, power, deity, subconscious have surged forward and been made manifest as a swirling intense force. After many hesitations, Pollock uncovered what he had been painting since the 1930s—the driving forces and trans-human spiritual powers which underlie the world and which, if manifested anew, lead to its transformation.

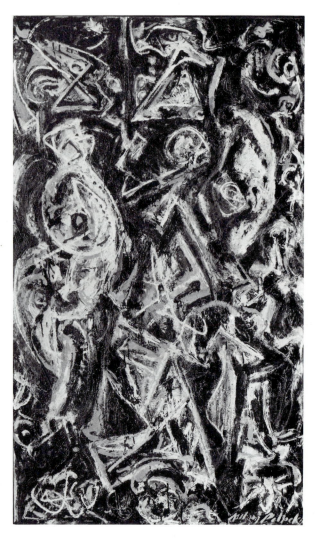

Figure 188. Jackson Pollock, *Night Ceremony*, ca. 1944. Oil and enamel on canvas. 72 x 43⅛ inches. Private Collection.

The subject indicated in the title and image confirm the continuity with earlier themes. In surrealist theory, as we have noted, eyes represent the passageway between the inner and outer worlds, and they are thus another form of the idea to which Pollock had referred with his masks, totem poles, and lifeline arrow.[43] Heat is another symbol for the power within, the unconscious, which was understood in the 1940s as the vehicle for creative transformation of the world at large, as Edward Renouf wrote in the American Surrealist magazine *Dyn:*

I hardly dare to predict that modern art—perhaps in conjunction with psychoanalysis—may someday offer us the clues to the constructive and total synthesis we so desperately need. ... For great syntheses are sudden insights, bursts of intuition that come to investigators and philosophers not in answer to calculations but in moments that are poetic in their mystery and intensity.

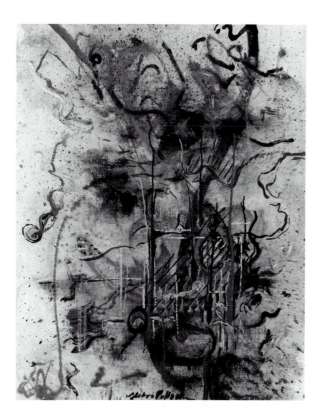

Figure 189. Jackson Pollock, *Burning Landscape*, 1943. 36 x 28$\frac{7}{16}$ inches. Yale University Art Gallery. Gift of Peggy Guggenheim.

Such intuitions are fusions of unconscious associations, like all art. And like art they need heat: fertile, brooding, animal heat, the heat of primordial passion that most scientists have banished into the unconscious and isolated there. . . . [I]s it not conveivable [sic] that the modern artist's release and revindication of the unconscious, and of its creative heat and all-embracing fusions and mysterious, symbolic insights, and his deliberate integration of unconscious into conscious activity will someday give us the clues to methods and intuitions that will achieve the new synthesis?[44]

For Renouf, Pollock and many of his generation the release of the creative unconscious and its contents, and not politics, constituted the act of the sociohistorical reform and regeneration of the world. The surrealists Breton, Ernst, and the American David Hare also indicated such a public and not merely private use of the unconscious when, in the editorial statement at the front of every issue of their magazine *VVV* in the early 1940s, they indicated that the Vs stood for victory over the forces of "regression and death" (the Axis) through the "liberation of man" with the forces from the "depths of the unconscious." With Abstract Expressionists such as Pollock and Still, altering conscious life meant tapping the creative past within, and that constitutes a mode of historical and cultural action. Through the reconstitution of psychic life, the call for social

and historical change of the 1930s and 1940s interfaces with and transforms modern art and modern life.

In *Shimmering Substance* (fig. 192) Pollock eliminated the eyes, the last specific trace of figuration. *Shimmering Substance* consists of swirling, commalike impasto strokes, less thick than in *Eyes in the Heat*, combined with thinner, flat, yellow and red circles. The circles have, most significantly, been deliberately placed within the field and are echoes of the eyes of the previous painting. Pollock's painting has swallowed figuration in a crisscrossing of lines and a few circular planes. Form has been dissolved into its constituents, matter and energy. Pollock's theme has been more clearly realized than ever before in his now abstract image. Although it has been said that a conflict between figurative and nonfigurative art troubled him throughout his life, Pollock's real struggle was to find original form for the underlying and generative forces and struggles of primal spirit, nature, and psyche, and thus of human nature. With *Shimmering Substance* Pollock arrives at the brink of an intense, expressive form that will reveal in a more concrete fashion than his totemic personifications the operations and transformative energies of life that an individual if not a culture can conjure.

Around late 1946 and early 1947, Pollock's technique of pouring and dripping paint matured. He used it until 1950, and it is considered his classic style. While some of the early poured paintings such as *Watery Path* and *The Nest* seem almost abstract narratives of their titles—even though the titles were added later—most are almost totally abstract with very little narrative quality. The early paintings of 1947 have very thick and dense overlays; but by the end of 1947 with *One* [*Number 31, 1950*] (pl. 21), they are more airy, as Pollock extends his linear traceries and opens up his paint fabric to allow bare canvas to show through.

In mature paintings such as *One*, there are no traditionally closed and contoured shapes; form has been dissolved into an all-over surface of rhythmic and energetic lines, spots, and spatters. Pollock developed an original technique of pouring and dropping fluid enamel paint from sticks, trowels, syringes, cans, and brushes from all four sides of the canvas as it lay on the floor. The web of lines and spots creates a space in which figure and ground distinctions are eliminated. These linear webs also end the distinction between deep and shallow space, as two and three dimensions now seem to be one and the same thing. Pollock also dissolves the distinction between drawing and painting. Pollock's lines are not the traditional first step in the rendering of a figurative shape but independent entities, much like Naum Gabo's constructivist linear planes of force or Gottlieb's scriptural cycles. The result is a holistic image of line and spots, drawing and painting, color and space.

251

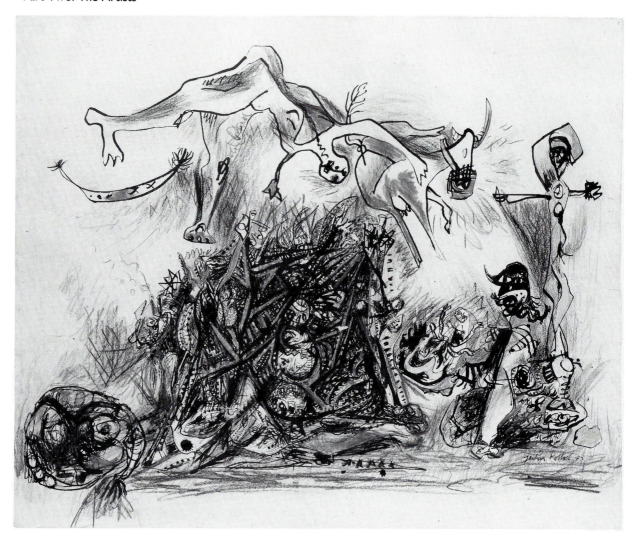

Figure 190. Jackson Pollock, *War*, 1947. Brush, pen and black ink, and colored pencils on paper. 20¾ x 26 inches. The Metropolitan Museum of Art. Gift of Lee Krasner Pollock, in memory of Jackson Pollock, 1982. (82.147.25)

Pollock's poured paintings are characterized by an almost baroque contrapuntal logic, a rich system in which lines and spatters are countered by others, with every gesture countered by the superimposition of other gestures, an endless web of swelling, inverting, compressing, accelerating, syncopating and expanding linear forces. Pollock has detached line from conventional notions of the figure and employed it to render rhythm and flux independently. The surface consists of an all-over equal density of lines and spots. The rhythms characteristic of his work from the 1930s have swallowed shape and transformed it into myriad, small sensations of crisscrossing lines and colors, into pictorial and painterly energy.

In this release of organic rhythms, Pollock manifests his underlying debt to Benton. In these abstract works, Pollock's ideas of automatist spontaneity, independent expressive linearity, and holistic design are combined with the principles of Benton's rhythmic structuring. *One* consists of an all-over rhythm of Benton's innumerable curves, straight lines, and counter curves in a kind of frozen dynamic equilibrium. Pollock has eliminated shape altogether, and lines—of different color, size, direction, and position—are now free to echo, parallel, and counter one another ceaselessly. *One* seems to be nothing but endless rhythm and energy. It thus reflects Benton's conception of rhythm as the endless repetition and variation of similar elements. Further, pictorial balance is achieved with respect to the whole and the frame of the canvas. Space is

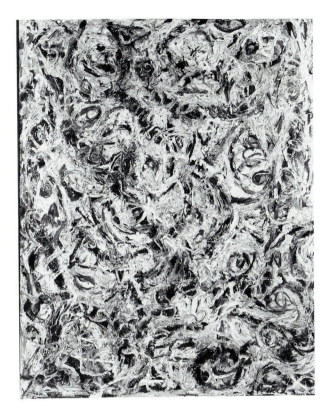

Figure 191. Jackson Pollock, *Eyes in the Heat,* 1946. 54 x 43 inches. Peggy Guggenheim Collection, Venice © The Solomon R. Guggenheim Foundation.

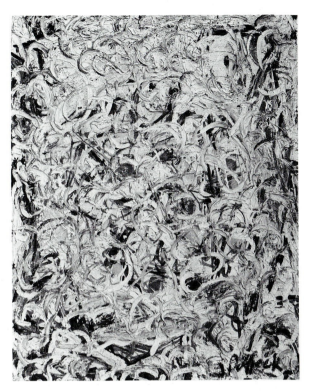

Figure 192. Jackson Pollock, *Shimmering Substance,* 1946. From the Sounds in the Grass Series. 30⅛ x 24¼ inches. Collection, The Museum of Modern Art, New York. Mr. and Mrs. Albert Lewin and Mrs. Sam A. Lewisohn Funds.

continuous if not deep, as lines and colors advance then quickly recede under others in undulating, serpentine rhythms. Space is thus created by the layering of line upon line, which is analogous to Benton's conception of space as the superimposition of form upon form.

Pollock's famous technique of pouring paint and using the entire arm, not just the wrists in the creation of a rhythmic composition probably also reflects an original Benton suggestion of the paralleling of physiological movement in plastic structure.[45] The flux and flow of energy in Pollock's painting also indicates his understanding of the organic consciousness that Benton noted we feel in our bodies and in the world around us. Benton wrote:

Forms in plastic construction are never strictly created. They are taken from common experience, re-combined and re-oriented. This re-orientation follows lines of preference also having definite biological origin. Stability, equilibrium, connection, sequence movement, rhythm symbolizing the flux and flow of energy are main factors in these lines. In the "feel" of our own bodies, in the sight of the bodies of others, in the bodies of animals, in the shapes of growing and moving things, in the forces of nature and in the engines of man the rhythmic principle of movement and counter-movement is made manifest. But in our own bodies it can be isolated, felt and understood. This mechanical principle

which we share with all life can be abstracted and used in constructing and analyzing things which also in their way have life and reality.[46]

For both Pollock and Benton, these principles that inform all life and reality are manifested in art.

Pollock further makes the spatters and lines work together as an equilibrium of matter, power, force, and effect. The striking energy of these works makes clear that this move to abstraction was not simply formal in intent. Pollock had long tried to express the underlying forces and processes of his totemic deities as well as symbolize them through their primal structure. His breakthrough occurred when he realized the limits of originally expressive but still semifigurative images. He had tried in his earlier work to combine figuration with mythological expressive activity and activation of surfaces. The result was turgid, dense pictures too full of marks, lines, and figurative elements, such as, for example, *Night Ceremony.* By the mid-forties he had gradually subsumed the forms, and by 1947–50, he had eliminated them but still conveyed meanings through the combination of an actual act of exterior physical energy (the movement of the arm in the pouring technique) and inward energy and force

(abstract automatism). Natural, psychic, and mythic activity became one and the same, both metaphorically and actually in the process of pouring and dripping. Traditional organic forms and shapes disappeared in these more concentrated, rhythmic, and unified pictures. What Pollock wrote as a description of his work has thus been realized: "states of order—organic intensity—energy and motion made visible—memories arrested in space, human needs and motives—acceptance."[47]

Like his Abstract Expressionist colleagues, Pollock developed an abstract art that is a continuation selection, and heightening of earlier works. Like their work, it is, on one level, a form of organic abstraction pitched to a new height of force. Like them, he has changed a symbolic figurative to an abstract pictorial mode in which he will realize his themes through the form, structure, and rhythmical functionings of the pictorial elements. And like them, Pollock uses conceptual allusions and abstract vestiges of organic life to reveal and expand understanding of the roots of the earth's organisms. Pollock's poured paintings are, like his early works with their primal "painterly subject matter," and like Abstract Expressionism in general, abstract, painterly, modernist metaphors and ideographs of the eternal life cycle and its forces.

Pollock's paintings are also extended developments of several central surrealist ideas, including metamorphosis, biomorphism, automatism, and the generative subconscious. In their way, Pollock's extended curvilinear fields are surrealist metamorphosis multiplied a thousandfold to an epic scale.

Most of the paintings from 1947 have nature-related titles as well as images. Although many of the titles were given by friends at a naming session after the paintings were done, according to Lee Krasner, Pollock never accepted a suggestion unless it fit his own ideas.[48] The titles and their meanings evoke the potency of natural metamorphosis of organism as well as landscape and the cosmos. An examination of them will situate Pollock's abstract work further. Those of 1947 are of particular importance because the style of his paintings at this period remained the same whether the paintings bore verbal or simple numerical titles. The pictures do not illustrate the titles in a literal way, except in a very few works, so we are free to examine the concerns suggested by Pollock's titles.

Full Fathom Five of 1947 represents Pollock's concept of nature. The title is taken from a passage in Shakespeare's *The Tempest* that was quoted in "The Sea," a special section in the December 1947 issue of *The Tiger's Eye.*

Full Fathom five thy father lies; Of his bones are coral made; Those are pearls that were his eyes; Nothing of him that doth fade But doth suffer a sea-change Into something rich and strange (I.ii.379–402)

With this work Pollock confirms his turn to nature as a symbol of change. Indeed another painting of this year, *Sea Change,* takes its title from the same quote. Pollock alludes to the greatest agent of natural metamorphosis, the sea; in fact, the very words sea change have become an English-language idiom denoting metamorphosis and transformation.

The sea's capacities were referred to by other figures in Pollock's milieu. Eliot and Joyce both employed the same "full fathom five" passage in their writings. Martha Graham wrote of the lost continents beneath the surface of a personal "inland sea,"[49] and of the ocean, sky, clouds, and fog as disguises of the principle of "maternity." Jung wrote that from wind and water man shall be "born anew."[50] And Campbell gave the sea's metamorphic capacities mythic dimension:

As the consciousness of the individual rests on a sea of night into which it descends in slumber and out of which it mysteriously wakes, so, in the imagery of myth, the universe is precipitated out of, and reposes upon, a timelessness back into which it again dissolves. And as the mental and physical health of the individual depends on an orderly flow of vital forces into the field of waking day from the unconscious dark, so again in myth, the continuance of the cosmic order is assured only by a controlled flow of power from the source.[51]

Pollock's linear continuums and his occasional verbal associations for his paintings, the titles, evoke themes of eternal change, eternal metamorphosis, and eternal life.

The titles of several abstract paintings further convey a sense of the natural world as mythic and primal, for example, those drawing on the primitive's ritual cycle of the seasons, which is so important to the lives of those dependent on them. *Summertime: Number 9A, 1948* (pl. 22) with its bright yellows and whirling skeins vaguely evocative of the insect and plant life of Masson and Gorky is one example. Another is *Autumn Rhythm* of 1950 (fig. 193) with its tan tones and mostly linear skeins. These are counterpart seasonal paintings to one done in 1946 that is not poured, *Banners of Spring.* These seasonal paintings suggest an identification with this basic life cycle of nature and its symbolism, such as rites of passage, of stages or periods of human life. These references reflect a seeking of the essential rhythms of the world, a ritual unfolding of nature.

It was natural for Pollock to associate his understanding of these themes with the cosmos as many other artists had done. In works such as *Comet,* with a white diagonal cutting through the surface; *Vortex,* with its circular swirlings; *Shooting Star,* with its racing white lines; and *Reflection of the Big Dipper* (fig. 194), all of 1947, Pollock suggests that the nature of the universe above is the same as the sea and world below. The parabolas and dots of

interstellar shapes are signs of a cosmic unfolding. Like artists from Masson to Miró to Lipton, Pollock's dynamism is the manifestation of the interior-exterior organism and of the continuity and connection of which everything, large and small, is a part.

Pollock associated the exterior universe with his own mental universe—in both senses of the term. He attributed to nature and the cosmos what he understood nature to be according to his era's view. Pollock naturalized the cosmos. Through his biomorphic metamorphoses, extrapolated to the world above and below, Pollock made of the universe a vast organism. By this time, Pollock considered biomorphic form to consist of underlying energies and forces and not entities. He discussed nature in such terms in the 1950s: "My concern is with the rhythms of nature . . . the way the ocean moves. . . . [T]he ocean's what the expanse of the West was for me. . . . I work from the inside out, like nature."[52]

In a radio interview with William Wright, Pollock said his interest was in expressing inner forces, not merely natural objects:

[Wright:] Mr. Pollock, the classical artists had a world to express and they did so by representing the objects in that world. Why doesn't the modern artist do the same thing?
[Pollock:] . . . The modern artist is living in a mechanical age and we have a mechanical means of representing objects in nature such as the camera and photograph. The modern artist . . . is working and expressing an inner world—in other words—expressing the energy, the motion, and other inner forces.

Pollock's manifold biomorphic metamorphoses and manifestations of organic dynamism, which he terms "inner forces," place him squarely within the governing aesthetic for many artists of the period—vitalism. Pollock's art reflects this philosophical alternative to cubism, its subjects and its structures. Pollock's art symbolizes and acts out the principle of the eternal and internal dynamism of life that predominated in the art of Moore, Arp, Hepworth, Benton, Read, and surrealism in the interwar period. Pollock alone almost completely freed vitalism from entities of form. In his abstract paintings, interior forces and energy course without final form. As a means of signifying biomorphic process, they are a more dynamic and more abstract version of the surrealist/Abstract Expressionist concept of metamorphic transformation. Being antirational, his painting implies and conveys a dynamic power of unspecific spirituality and suggests a physically based but transformed consciousness in all matter.

Pollock's statement that he painted visible energy and motion, organic intensity, memories arrested in space, and human needs and motives is a near-manifesto of Bergsonian vitalism. For Henri Bergson, life is striving, a need for invention, a creative evolution. Through the human body,

Figure 193. Jackson Pollock, *Autumn Rhythm*, 1950. 8 feet 10½ inches x 17 feet 8 inches. The Metropolitan Museum of Art, George A. Hearn Fund, 1957.

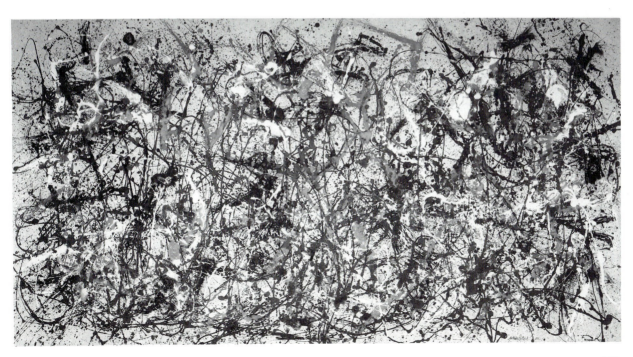

vital movement courses and pursues moral life. Bergsonian philosophy describes an organic consciousness in harmony with Pollock's (and Benton's) implicit understanding of natural action. For Bergson, life is imbued with organic consciousness, a sense of spirituality beyond mere biological or physical determinacy. Organic consciousness is seen in continuous movement: "Consciousness is co-extensive with life. . . . Matter is inertia. . . . But with life there appears free . . . movement."[53]

Vitalist effort unites space and time. In the Wright interview, Pollock described himself as working with "space and time." For Bergson, time plays a leading part in the creative evolution of human life and consciousness. Time means mobility, a state of flow, a sense of inner indivisible continuity (duration). He wrote that the essense of duration is flow, not simple snapshots or single changes that are real, but flux, continuity of transition and creation. It is changeability itself that is real and substantial. Memory is part of that organic flow, as Pollock and Bergson state. For Bergson, all consciousness is memory, conservation and accumulation of the past in the present, and anticipation of the future. "To retain what no longer is, to anticipate what as yet is not—these are primary functions of consciousness."[54] Consciousness represents a simultaneity of the past and future in the present, manifested not in succession but as a single perception somewhat like cubist and Abstract Expressionist simultaneity. The content of evolution and its duration are one and the same thing.

There is no finality in Bergsonian vitalist consciousness, no predetermined form, no separate single units, no single direction—only endless energetic movement and its interconnectedness in time and space of the past and future, of the organic and spiritual. Bergson summed up:

On the one hand, there is matter, subject to necessity, devoid of memory, . . . which adds nothing to what the world already contains. On the other hand, there is consciousness, memory with freedom, continuity of creation in a duration in which there is real growth;—a duration which is drawn out, wherein the past is preserved indivisible; a duration which grows like a plant. . . . We may surmise that these two realities, matter and consciousness, are derived from a common source. . . . [M]atter is the inverse of consciousness, if consciousness is action unceasingly creating and enriching itself. . . . I see in the whole evolution of life on our planet a crossing of matter by a creative consciousness, an effort to set free, by force of ingenuity and invention, something which in the animal still remains imprisoned and is only finally released when we reach man.[55]

Bergson's spiritual energy or vitalism reflects the basic procreative urge of the universe and has deep affinities with and reinforces other concepts of eternal creation found in figures from Heraclitus to Nietzsche, Bergson, Read, and Jung. For all of these thinkers, the triumph of life is ceaseless creativity, the perpetual creation of the possibility, which, through the work of a particular artist, becomes objectified in image and form. Creating primal vitality, as in his Native American ritual, mythic, and psychological subjects, Pollock has combined all as single conceptual form and expression: the underlying transhuman and generative powers of the world. Previously his work had symbolized and personified mythic powers and forces in his totemic nature deities; now it manifested them directly. As Douglas McAgy said of Rothko's mythic works, "They call to mind the myths where gods are interchangeable with the forces of nature."[56] Typically for the Abstract Expressionists, Pollock has replaced expressive cultural symbol with pictorial metaphor, has made abstract mythic and spiritual force manifest and concrete.

In his abstract vitalist painting, Pollock employed the surrealist technique of linear automatism on a larger scale than had ever been done before. As noted, automatism is a method intended to record the spontaneous impulses, the unforeseen and antirational vitality of the subconscious, in lines and marks from which the artist picks up cues to make a painting or drawing. Pollock had experimented with automatism in his earlier work when he combined automatist procedures and energetic markings with totemic figuration and symbolization. In his abstract work, he threw out the second stage of the process, the making of a figurative form, and concentrated on the first stage, expanding it to an epic scale, a world unto itself. Pollock expanded the concept of subconscious vitality to a procedure and a content intended to fulfill his lifelong search for the generative forces and cycle of human existence. No longer would a symbolic figure or mythic god represent the potency and fertility and transformative power of the world. Abstract form, relationship, and functioning themselves would. Pollock represented the subconscious and its powers once again but through pictorial means alone. Ritual transit and ceremonial change (which replaced thirties symbolic concepts of historical movement, such as that illustrated in *Going West*) would be rendered by pictorial transit. Sacred vitalism or Native American mythic netherworld powers and cosmic fecundity would be rendered free of earlier symbols and deities such as snakes and masked spirit powers (although in 1947 he compared his painting on the floor from all four sides to ritual sand painting).[57] Pollock's abstract art exemplified American concepts of automatism or the continuity of the past and present and in Renouf's words cited earlier, automatism's creative "boundless reaches of presentiment and memory of man and the physical universe" which "summed-up and reintegrated the personal and cultural past" with new life.

For Pollock, for Mary Mellon, and for many others of their era, the attempt to expand or redefine a human soul or consciousness by many means and in other cultures was an effort to indicate that the human was not circum-

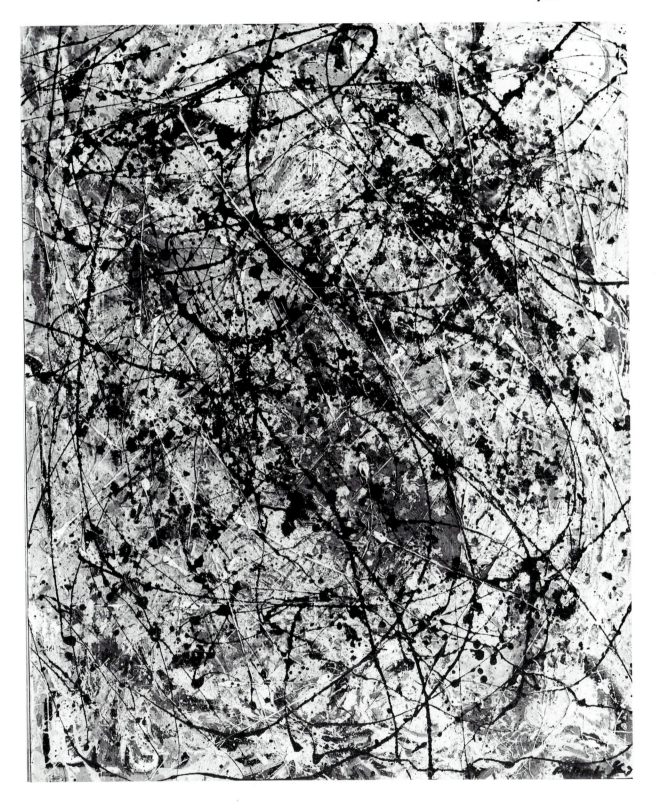

Figure 194. Jackson Pollock, *Reflection of the Big Dipper*, 1947. $43\frac{3}{4}$ × $36\frac{3}{16}$ inches. Collection, Stedelijk Museum, Amsterdam.

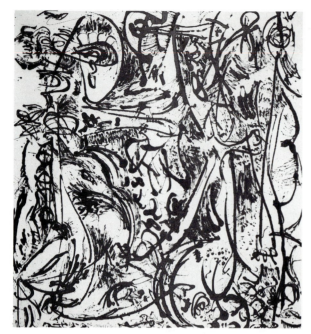

Figure 195. Jackson Pollock, *Echo (Number 25, 1951)*. Enamel paint on canvas. 7 feet 7⅞ inches x 7 feet 2 inches. Collection, The Museum of Modern Art, New York. Acquired through the Lillie P. Bliss Bequest and the Mr. and Mrs. David Rockefeller Fund.

one represented or symbolized. Proceeding through association and evocation rather than cubist description and analysis, Pollock has interwoven in his work the sea, cosmos, psyche, myth, and human spirit as analogous and overlapping activities. Through concrete realization of primal human potency in action, Pollock has literally bodied forth the hope of amelioration through continual creativity itself. But it is not so much just optimism that he reaches for, as an equivalent to the surrealist "marvelous," a revelation of that which comes from within with such power and force that it transforms and expands. Pollock fulfilled his youthful goal of expanding consciousness. He was not an intellect, however, but an artist who, through the force of his own personality, emotional groping and formal imagination, was more capable than most of realizing the hope of physical and spiritual transition which dominated his era and its forms—a hope shown in the words of a survivor of Regensburg:

Three men had come into my office in Regensberg in the winter of '46. One of them was Nathan Silberberg. Before the war, he'd been editor of the *Moment*, the largest Yiddish paper in Poland. He said, "You're getting us food, clothing, and shelter. Now we need something for the *Geist*, the spirit."[59]

scribed or single but manifold, complex, and varied. Throughout his career, Pollock searched for some sort of occult, natural, sacred, vitalistic, psychic, cosmic harmony and wholeness. With his abstract form in all its creativity, its endless eternal flux, its duration, its ceaseless beginnings and ends, its interlacings of space and time, its infinite renewals pictorially and thematically, Pollock sought the infinite expansiveness of creative consciousness. He sought to disinter and demonstrate as the necessary root of his era and his own being a natural new energy lying within the individual.

Organic, spiritual, vitalist energy, the thirties concept of transformative movement, the primitive's ceremonies of growth, increase, and spirit power, the surrealists' automatist generative subconscious impulse, Freud's and Jung's psychic vitalism, nature's cycle of the season, mythic nurture and ritual questing, the physical movements of the human body in its operations and procedures—all of these Pollock condensed into an allegorical statement about endless human potential and transformation. Pollock's poured paintings evoke the life-giving energies of the life process at a time in the history of the West when such a symbol was perceived to be deeply needed, when there was an "overwhelming sense of release from the war and of energy waiting to find its own creative channels."[58]

For Pollock and all the Abstract Expressionists, and for modernism in general, the goal was to be formally what

RECAPITULATION

In 1951 Pollock returned to previous modes, that is, imagery resurfaced in his paintings, which again specifically spoke of his lifelong themes. Most of the paintings are in black. As an artist who was primarily a draftsman, Pollock had become even more dependent on line in his poured paintings. It was perhaps inevitable that when he returned to figuration, he would focus on line. And to do line, color was not necessary. Pollock's poured paintings had used a great deal of black, but it was usually layered with other colors. In the 1950s he chose to work with black alone which, when combined with white, was an issue in Abstract Expressionist and New York School painting around this time. Lee Krasner said of an exhibition of Pollock's black paintings, "The 1951 show seemed like monumental drawing, or maybe painting with the immediacy of drawing—some new category."[60] In his black paintings, Pollock pioneered a new monumental paper/easel/mural mode of drawing, and while less original and more old-fashioned even within his own oeuvre, the paintings nonetheless extend the painting-as-drawing mode in modern art. Pollock is thus completely consistent with the Abstract Expressionist emphasis on direct, immediate, and intimate recordings of the self as something larger than the self. He elevated the graphic sketch to a new level and thus opened up further possibilities that would be developed in the 1960s by very different artists.[61]

Pollock's achievement is evident in works such as *Echo: Number 25, 1951* (fig. 195), which contains at least one figure. Here he outlined the forms with a long, rather even line that functions as contour edge to the plane, which is not painted but the beige cloth of the canvas. Between the vertical figure and the elongated forms are a profusion of marks. Pollock returned to drawing as outline but sought a way to render the interstitial plane as the fruition of the skeins from his poured paintings. The paint is stained into the canvas, giving a somewhat even surface, but there is still a difference between the gloss of the paint and the texture of the cotton duck canvas. (His staining of the black paint into the unprimed canvas led to the color staining of second-generation color-field painters like Helen Frankenthaler, Morris Louis, and Kenneth Noland, although James Brook may have first used the technique.)

The work combines in new ways Pollock's classic linear and marking mode with more traditional drawing as contour. But the figure itself is open and incomplete in its contours and this, combined with the uniform color and

Figure 196. *Echo* mask, Kwakiutl. $11\frac{1}{2}$ x $12\frac{3}{8}$ inches wide and 6 inches. Collection of the Michael R. Johnson Gallery, Seattle.

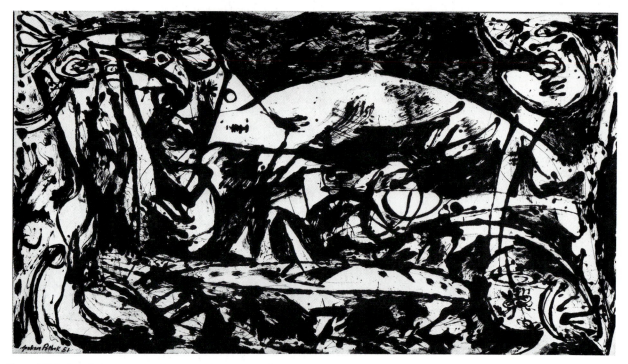

Figure 197. Jackson Pollock, *Number 14, 1951*. Oil on canvas. 57⅝ x 106 inches. The Tate Gallery, London.

the linearity and strength of the ground, reflects the Abstract Expressionist mode of enmeshing and integrating the figure within the ground.

Echo probably alludes to Pollock's earlier use of sound as a pathway to the underworld and subconscious deep, as in the *Sounds in the Grass* series. The figure's head seems to be all ear and mouth. Similarly, Northwest Coast Indians had a type of mask called the Echo mask, which when worn provided a pathway to the sounds of the animal spirit world (fig. 196). Pollock's head reflects the rectilinear mouth and forehead fins of the mask. These masks were reproduced in the Bureau publications and displayed at the American Museum of Natural History; *Echo* thus reasserts in form, subject, and theme the continuity of Pollock's sources and interests.

Other variants of the negative/positive using line and mark are *Number 11* and *Number 14, 1951* (fig. 197). Here Pollock evokes his earlier compositions of anatomies buffeted by rhythmic grounds and forces. The figure planes (in sepia in *Number 11*) consist of empty spaces shaped by linear contours and dense conglomerates of marks that are virtually complete planes. While there are some details inscribed, and planes formed by marks, these two paintings have moved away from *Echo's* compromise of line and spot toward the positive and negative, outside and inside figure planes and fields.

Perhaps the climax of both the style and meaning of

these black paintings is the half black, half color *Portrait and a Dream* of 1953 (fig. 198), which Pollock did after he had abandoned his exclusively black pourings. To the right is a double head considered a Pollock self-portrait. Pollock outlined the planes and filled them heavily with dense paint. To the head's right is an equally active but much more open figure created by exclusively black outlining and skein planes as well as a few puddles. The head and figure, mind and body are both open and closed, veiled and excavated, free and locked in their respective ways.

It is interesting to compare this work to Still's color self-portrait *1950–B*. Both painters invest their portraits with matter and force. Still more clearly evokes landscape and sky in his cosmic, planar self-portrait. Pollock's portrait is more clearly linear, and he has combined it with a body portrait enmeshed in struggle with its interior and exterior environment. Both artists project images of themselves as the forces they seek to unlock.

In 1952–53 Pollock returned to color painting in such recapitulations of his pouring technique as *Blue Poles*, with its reprise of Benton's imaginary poles. From this time until his death, Pollock seemed to flounder. His black pourings apparently led to a dead end, and he lurched from painting to painting and style to style. There is very little consistency in his last two years of work.

The Deep of 1953 (fig. 199), for example, presents a

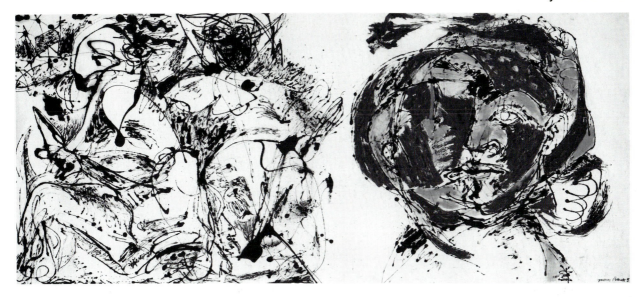

Figure 198. Jackson Pollock, *Portrait and a Dream,* 1953. 4 feet 10⅛ inches x 11 feet 2½ inches. Dallas Museum of Art. Gift of Mr. and Mrs. Alger H. Meadows and the Meadow Foundation, Inc.

Figure 199. Jackson Pollock, *The Deep,* 1953. Oil and enamel on canvas, 86¾ x 59⅛ inches. George S. Pompidou National Museum of Modern Art, Paris.

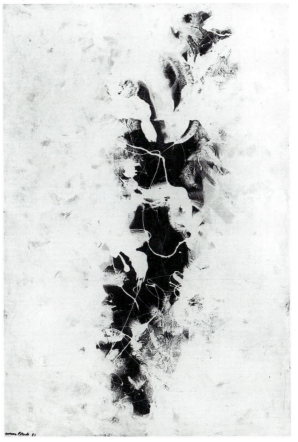

clear example of Pollock's profound sense of looking below as looking within. It is a brushy, simple, and too descriptive example of a figure/ground, above/below relationship. *The Deep* is a literal example of the tradition of the depths of being that extends from De Chirico: "The truly profound work will be drawn by the artist from the innermost depths of his being,"[62] to Jung: "presentiment . . . suddenly allows us to look down once more into the dismal dark depths, out of which for a moment the terrible animal nature of the . . . god of light emerges. . . . There, where the deep sources of the ocean are, the leviathan lives; from there the all-destroying flood ascends, the all-engulfing food of animal passion,"[63] to Campbell's concept of the deep as the place of tritons and herald of the psyche.

Easter and the Totem of 1953 (fig. 200) reflects a new influence in Pollock's work, Matisse, which probably came not from a personal interest in Matisse, who is out of keeping with Pollock's entire oeuvre, but from his wife Lee Krasner, who was seeking to combine Matisse's color with her own dynamism. Pollock's pleasantly colored painting is much more planar than most of his work and is not much related to his pouring technique. The totemic figure at the left and anatomical fragments at the right reflect his association of totemism with spiritual rebirth and its Christian symbol, the resurrection of Christ. Other paintings such as *Ocean Greyness, Greyed Rainbow, Moon Vibrations, Ritual, Four Opposites,* and *Scent* recapitulate his previous conceptual and pictorial thought, but less and less consistently and successfully.

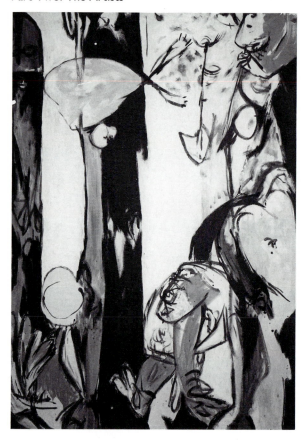

Figure 200. Jackson Pollock, *Easter and the Totem*, 1953. 6 feet 2¼ inches x 58 inches. Collection, The Museum of Modern Art, New York. Gift of Lee Krasner in memory of Jackson Pollock.

By 1956 Pollock had stopped painting altogether. The confusion in his painting echoed that in his personal life and the ever-wretched bouts of drinking. It was like 1938 all over again, but he did not get another chance to recover. Driving on a country road in eastern Long Island, Pollock played games with the speed of his car and the fears of his guests. He lost as he flipped off a curve, killing himself and one terrified young girl for which, if he had lived, he could have been convicted of manslaughter.

CONCLUSION

Pollock's art is an optimistic art. His classic paintings re-create primal vitality as the wellspring of human life. In seeking to redo the present by recovering the past, he, in Martha Graham's words about Jung and Klee, "simply avails himself of the lost energies in the creation of his world."[64] He manifests his understanding, whether he was fully cognizant or not, of the secularly divine powers and the need for creativity at the center of his epoch. Primal, perpetual fecundity and fluidity is the marvel and the final state he seeks. In the vitalist, idealistic beliefs of many of the period:

In man alone, . . . vital movement pursues . . . through that work of art, the human body, which it has created on its way, the creative current of the moral life. Man, called on at every moment to lean on the totality of his past in order to bring his weight to bear more effectively on the future, is the great success of life. But it is the moral man who is a creator in the highest degree,—the man whose action, itself intense, is also capable of intensifying the action of other men, and, itself generous, can kindle fires on the hearths of generosity. . . . Although they are the culminating point of evolution, yet they are nearest the source and they enable us to perceive the impulsion which comes from the deep.[65]

WILLEM DE KOONING

A Fever of Matter

The type of woman who approaches you in the street in Italy and says "Please give me a cigarette" isn't looking for a smoke.

GI Handbook, 1943

Willem de Kooning presents a paradox. In many quarters, he is considered the quintessential Abstract Expressionist. His *Attic* of 1949 (fig. 201), *Excavation* of 1950, and *Woman I* of 1950–52 (fig. 202), with their dense, compressed forms and bravura brushwork immediately caught the imagination of the American public in the early 1950s. Together with Harold Rosenberg's popular characterization of his work as "Action Painting," De Kooning helped to establish Abstract Expressionism as an original modern American style.

Yet in many ways De Kooning is less representative of the main threads of Abstract Expressionism than many of the others. He is the most conservative of the artists. He is much more attached to the Old Master tradition than any of them, drawing constantly on the legacy of Western figure painting. When he has drawn on modern sources, he has chosen the early figure painters such as Matisse and Picasso, and not Ernst or Miró. At times, De Kooning has even criticized the idea of modern movements and ideologies as such. In general, his art bridges the gap between the grand tradition of figure painting and modern dislocations and reinventions. Pollock's designation of De Kooning as a "French" painter was accurate in this sense.[1]

Further, De Kooning is a realist in the sense of painting everyday figures, scenes, and locales. Again this is unusual. Except for some works by Gorky, Baziotes, and Motherwill, De Kooning is alone in being inspired by visual perceptions and themes from the everyday world, including interior spaces, the city, and the actual landscape of Long Island. The central thrust of Abstract Expressionism did not share an absorption in the visually anecdotal that paintings with titles such as *Town Square* or *Woman on a Sign II* indicate.

These two elements, tradition and realism, help explain why De Kooning was so popular and influential in the 1950s. His art was more familiar and hence more accessible than Still's totemic fields, Pollock's pourings, or Newman's austere color compositions. It could be more easily understood and absorbed. Combined with his powerful use of painterliness for his figures, his work proved irresistible to many.

Nevertheless, De Kooning is, of course, an Abstract Expressionist. He was able to turn his conservativeness to his advantage. He infused Old Master and School of Paris traditions, as well as his realism, with the vein of ancient, primitivist, and vitalist content that defines Abstract Expressionism. He gave mainstream Abstract Expressionism a more grand, traditional, and at the same time more prosaic resonance than any of the other artists. De Kooning responded to the themes of the continuum of life, the forces of nature, the duality of human nature, and the ceaseless creativity and fertility of human experience within his grand and vulgar manifestations of everyday life. Further, unlike the others, he was able to turn these and other Abstract Expressionist themes into farcical theater. De Kooning is the satirist of the group, caricaturing and ridiculing human beings with a flamboyant, mocking anthropology, transforming the psychological and emotional metaphors of the crisis, war, and postwar world and culture into fictional hilarity. With endless energy and invention, De Kooning succeeds in imposing patterns of

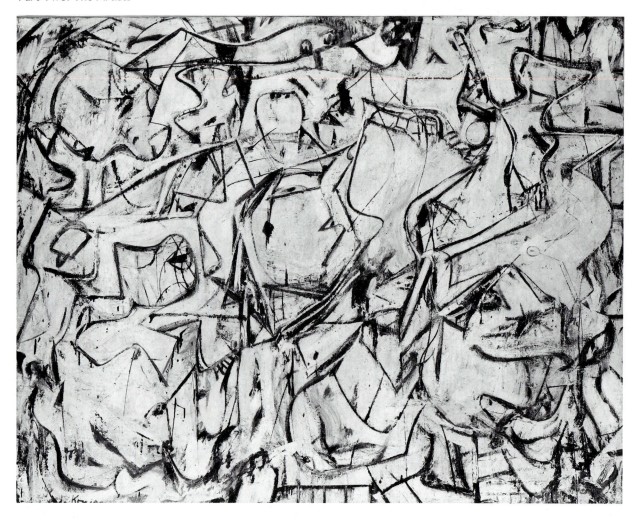

Figure 201. Willem de Kooning, *Attic*, 1949. Oil, enamel, and newspaper transfer on canvas. 61⅛ x 81 inches. Jointly owned by the Metropolitan Museum of Art, New York, and Muriel Kallis Newman, in honor of her son Glen David Steinberg, The Muriel Kallis Steinberg Newman Collection, 1982. (82.16.3)

comedy and theater upon the experience and cultural explications of his time.

THE EARLY ABSTRACTIONS

Willem de Kooning was born in 1904 in Rotterdam, Holland. His father was a liquor distributor and his mother owned and ran a bar for sailors. In 1909 his parents divorced, but in an unusual decision, he was given into his father's custody. His mother appealed and took rights to him. In 1916 he apprenticed to a commercial art firm for four years. At the same time, he enrolled in the night school of the Rotterdam Academy of Fine Arts and Techniques. There he learned basic traditional techniques

of drawing and painting. In 1926 he emigrated to America, landing in Hoboken, New Jersey. Until 1935 De Kooning painted on weekends while, like the Pop artists he later influenced, he earned his living designing window displays for department stores and painting signs and commercial murals.

Gradually he became involved in what was then the underground world of modern American painting. In 1929 he met John Graham, in 1930 David Smith, and in 1931 Arshile Gorky. Later he became friendly with Stuart Davis. Along with a year on the WPA in 1935, these friends convinced him to reverse his priorities. Before he had worked, and painted on the side; now he would paint, and work on the side.

De Kooning's very early work is the most sophisticated

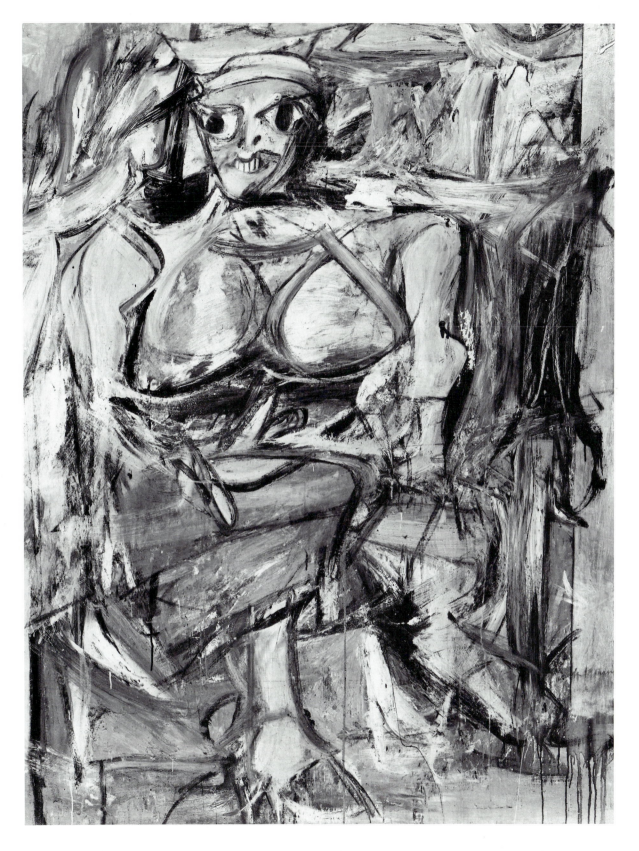

Figure 202. Willem de Kooning, *Woman I*, 1950–52. 6 feet 3⅞ inches x 58 inches. Collection, The Museum of Modern Art, New York. Purchase.

modernist painting of all the early work of the Abstract Expressionists. Paintings such as *Untitled* of around 1931 (fig. 203) are excellent abstract works, if limited in expression.[2] *Untitled* suggests a shallow space, recession into depth, and adherence to the picture plane as well as an enigmatic contrast between oval and straight edge. While the work is a typical thirties geometrical abstraction, the effect is more uncertain and dislocating than is usual with such a style.

Other abstract works in the 1930s reflect the profound influence of his friend Gorky, from whom he later said he "took the hint" regarding modernism.[3] Gorky's interest in the work of Leger, Picasso, and Miró can be seen in De Kooning's works of the same period. *Pink Landscape* of 1938 and *Elegy* of around 1939, for examples, evoke the flat, biomorphic shapes of Miró and Gorky, particularly the general rounded rectangular shapes of the latter's *Self-Portrait* of 1937. De Kooning's paintings are simpler and more colorful than Gorky's work, however—perhaps

reflecting the Pompeian frescoes that he, like his colleagues, admired. They are also more blocky, showing his familiarity with Mondrian and the Abstract Creation group, and perhaps Jean Helion, whose *Composition* of about 1934 (fig. 204) used quite similar flat and round rectilinear shapes. Helion was one of the most influential European geometrical abstractionists in New York in the late 1930s; he was its enthusiastic spokesperson while a principal advisor to Albert Gallatin's Gallery of Living Art, then housed at New York University. De Kooning knew Helion's work.[4]

The forms of all De Kooning's early abstractions, whether suggesting still life, figure, or landscape as original source, lie at the edge between representation and pure abstraction. *Pink Landscape,* for example, seems to be both a landscape with sailboats underneath a moon[5] and an almost undecipherable abstract composition with Helion-like abstract shapes. This shifting was also true in a larger sense. At this time De Kooning was also doing figure

Figure 203. Willem de Kooning, *Untitled,* ca. 1931. 23⅞ x 33 inches. Collection of the artist.

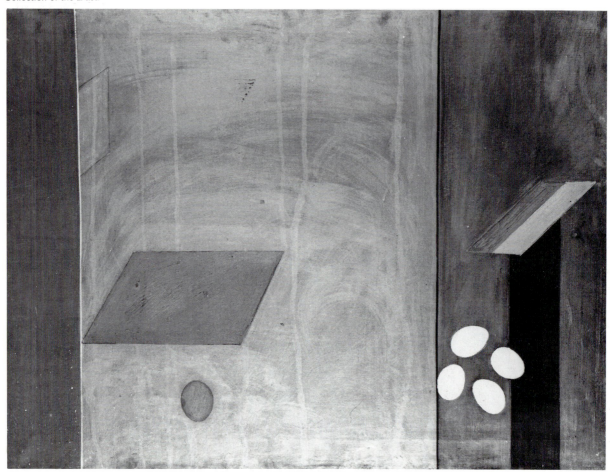

studies, and he increasingly moved toward greater representation, thereby beginning an oscillation between abstraction and representation that would characterize his entire career.

THE MEN AND WOMEN: THE FIGURE AS CULTURAL COMPOSITE

De Kooning's abstractions indicate a knowing, sophisticated modernist who, in the 1930s, was ahead of his fellow Abstract Expressionists. His awareness of Miró, Mondrian, Helion, and others is a sign of an artist who was ready in the 1940s to blossom with a midcentury modernist style. But he did not. Instead, he turned *against* modernism to figure painting, in particular to a conservative, that is, realist mode of figure painting, in his series of paintings of men in the late 1930s and early 1940s. Ironically, just when the regionalist impulse was losing its power and the

Spanish Civil War was moving his colleagues to a different, more modernist point of view, De Kooning went in the opposite direction. This turn makes clear his fundamental conservatism. He is the figure painter of Abstract Expressionism, just as Renoir was the traditional figure painter of impressionism. It is significant that De Kooning, Gorky, and Graham, all immigrants to America as young adults, were more advanced in the 1930s than their American counterparts. Yet in the 1940s, they were more conservative. All remained figure painters and serious draftsmen at bottom, even Gorky with his painterly anatomical tableaux. The other Abstract Expressionists, less knowledgeable and seemingly more restricted by American provincialism in the 1930s, became more radical in the 1940s. None of them was an Old Master influenced figure painter in the end. Lacking the burden of the European and modernist tradition, the Americans could be more venturesome. The general American subject of the thirties, the epic allegorical struggle for secure life, aided the dissolution of traditional

Figure 204. Jean Helion, *Composition*, ca. 1934. 56⅞ x 78¾ inches. The Solomon R. Guggenheim Museum, New York. Photo: Robert E. Mates.

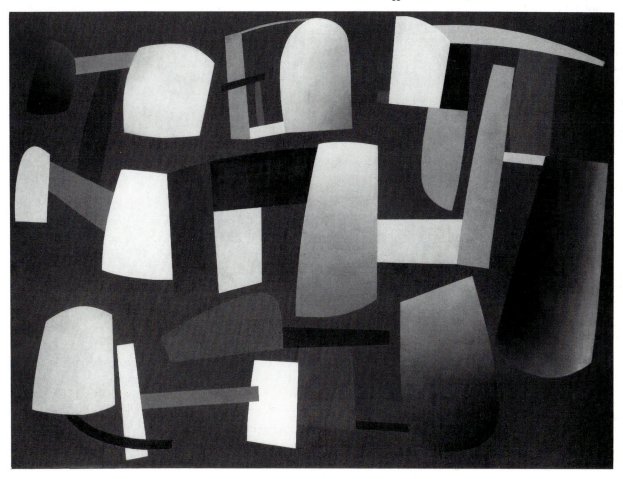

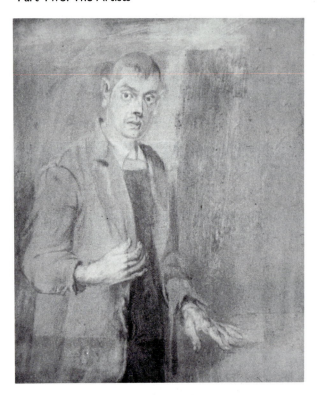

Figure 205. Willem de Kooning, *Man*, ca. 1939. Oil on paper mounted on composition board. 11¼ x 9¾ inches. Private collection, New Orleans.

Figure 206. Willem de Kooning, *Self-Portrait with Imaginary Brother*, ca. 1938. Pencil. 13⅛ x 10¼ inches. Private collection. Photo: Rudolph Burckhardt.

subject matter such as figure painting that Gorky, De Kooning, and Graham generally continued. "Provincial" American art, together with surrealism, helped clear the decks for other topics in the 1940s.

However belatedly and incompletely in his *Men* series, De Kooning responded to the effects and mood of the Depression, although he was indifferent to the era's Communism.[6] *Man* of ca. 1939 (fig. 205), a painting he was to show in 1942, typifies the series' somber, introspective, and elusive men in plain interiors. Some of the figures, like this one, are self-portraits from photographs or mirrors. Others resemble his friends Rudolph Burchardt and the dance critic Edwin Denby, though none is very specific in detail or visage.

For many of his *Men* series, De Kooning used a mannequin he constructed himself:

What I did was, I made a dummy to work from. I took a pair of my work pants, and I put them in liquid glue with a little plaster in it and then I put them on and bent a couple of times, so the pleats were natural, then I sat near the radiator and let it dry, then I took it off, and it stood by itself. Then I swiped some of those metal things they use for traffic signs, and I kind of made a figure with those pants hanging from it, and a jacket.[7]

De Kooning said he saw himself standing there and was very moved. The mannequin made him feel sorry for himself. At this time, De Kooning was creating window displays of mannequins with painted features and clothing.[8]

With the advent of his use of a mannequin and his interest in portraiture, De Kooning restricted his more purely modernist tendencies. He became inspired by elements of the real world as well as art and combined the real with the conservative, the modern with the Old Master tradition.

Self-Portrait with Imaginary Brother of around 1938 (fig. 206) exemplifies the combination. The painting's concept reflects Gorky's Picassoid and Corot-like *Portrait of Myself and My Imaginary Wife* of the same period. At the same time that the figures are inspired by the real world and by modernist Gorky, they are also inspired by drawings of the Le Nain brothers and Millet, whom Gorky also drew upon in this period. Both artists use the Le Nains' draper folds and soft gray lines. De Kooning further combines the folds with his mannequin shapes.

Manikins of around 1939–42 (fig. 207) also reflects De Kooning's combination of art and life. This example consists of two dressed mannequins in a store window.[9] The head of another mannequin lies below, and a man looks through a window on the left of the display. The pencil

drawing is of something seen or remembered from the real world. It captures the longing and want of the Depression, and it reflects De Kooning's new modern source, Picasso. The eyes and flared nostrils of the visages resemble works from the *Picasso: Forty Years of His Art* exhibition in 1939, particularly *Guernica* and *Negro Sculpture before a Window*.

Within one work, from drawing to drawing, and from drawings to paintings, De Kooning alternated highly finished and roughly finished passages. On the whole, his drawings are not elaborate presentation drawings, but De Kooning did use the medium often throughout his career to record, think, and plan.[10]

Fusions of different stylistic elements also form the basis of his paintings at this time. *The Glazier* of about 1940 (fig. 208) consists of a man seated before a wall and next to a table. The color tones echo the yellow ocher and terra cotta of the Pompeian works in the Metropolitan Museum. The ever-present mannequin folds are here, as are the pleating and folding of Gorky's figures. The figure's shoulders are lightly drawn into a sharply contrasting triangular form. The figure itself seems androgynous, reflecting the

Figure 207. Willem de Kooning, *Manikins*, ca. 1939–42. Graphite on paper. 13½ x 16¼ inches. Collection of the Whitney Museum of American Art. Purchase, with funds from the Grace Belt Endowed Purchase Fund, the Burroughs Wellcome Purchase Fund, the H. van Ameringen Foundation, the Norman and Rosita Winston Foundation, Inc., and the Drawing Committee. (84.5) Photo: Geoffrey Clements.

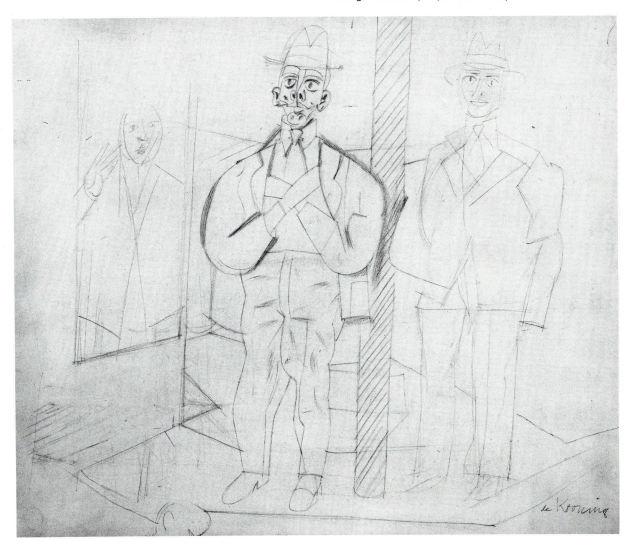

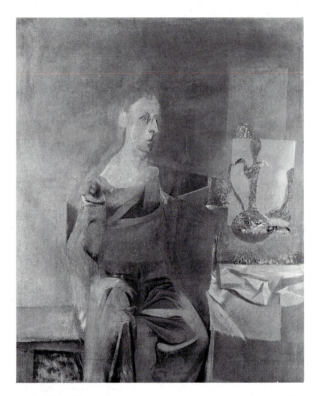

Figure 208. Willem de Kooning, *Glazier*, ca. 1940. 54 x 44 inches. The Metropolitan Museum of Art. From the Collection of Thomas B. Hess, jointly owned by the Metropolitan Museum of Art and the heirs of Thomas B. Hess, 1984. (84.613.1)

shoulder, scoop neckline, and bodice in the Metropolitan's portrait of *Mademoiselle Françoise Le Blanc* by Ingres.[11]

This disjunction of sexual identity is part of a larger disjunction that characterizes De Kooning's work throughout his career. Figural continuity and wholeness, and anatomical consistency and integrity, are subject to a process of dislocation, dismemberment, and reintegration on a new level. The figures and composition form spatial and anatomical, animate and inanimate, and temporal collages or fusions. De Kooning combines multiple references and quotations from art history, modernism, tradition, and life. As in Rothko's *The Omen of the Eagle,* the fusion of disparate elements reflects an attempt to combine a variety of associations within the single figure, within a new dynamic, continually shifting wholeness.

Seated Figure (Classic Male) of about 1940 (fig. 209) is another example of De Kooning's fragmentation and recombination to achieve a synthetic style and concept through the single figure. Simultaneously, the figure brings together allusions to a simple male nude, classical musculature—perhaps from a Boscoreale panel at the Metropolitan (fig. 210), a Michelangelesque "power of nature" (De Kooning's description of Michelangelo),[12] a series of abstract shapes, and a series of disjointed body parts—

some round, some flat, some organic, some inanimate. De Kooning assembled and disassembled these artistic signifiers, contexts, realities, and significations as he rearranged and ruptured the anatomy of the figure's whole chest, neck, and head. (There are similar anatomical emphases and detachments in Gorky's drawings of classical subjects, for example, the Parthenon Horses of 1939.) In the De Kooning, the figure's body itself is extended and elaborated by ghosts or "willful pentimenti," in Sally Yard's apt description of a previous outline of a head and shoulder.[13] At his groin lies a red phallus. For the first time, De Kooning substitutes a leg for a shoulder. All of this takes place in a room with a window square at the right.

De Kooning's *Men* solidifies and heralds his entire oeuvre. The paintings are fusions of tradition and modernism, past and present, art and life, art and the everyday, all within the single-figure mode of traditional painting. The men form painted collages of different modes of expression. The pictures strive toward an open, fragmented envelope of influence, source, context, period, time, association, and reality. The commingling of the aggregate figures suggests a rifeness and a profusion within the continuum of a single form that lies at the heart of De Kooning's art.

As De Kooning brought his series of men to a close in the early 1940s, he turned to the subject of an earlier drawing, *Reclining Nude (Juliet Browner),* of about 1938 (fig. 211). The nude, drawn in his conservative style except for the odd foot and the abstract Helion-like shapes in the background of the room, is a traditional rendering of abundance. She practically fills the space. She is all luxuriousness of flesh, swelling and ripeness, all smoothness and sensuality, a nude as a landscape reminiscent of the breadth of Henry Moore's reclining figures of swelling nature, although there is no question of direct influence here. The figure also recalls Ingres' nudes, especially the grisaille *Odalisque* acquired by the Metropolitan Museum in 1938.[14] Her elongated elegance foreshadows another type of ripeness and abundance with which De Kooning's aggregate figure and environment will be integrated in the 1950s.

While continuing traditionalist drawings in 1940–41, especially in portraits of his future wife, Elaine Fried, De Kooning painted *Seated Woman* of 1940 (fig. 212), which gives evidence of a new approach. Here De Kooning paints the seated female figure, a basic subject of Western painting and full of art-historical associations. He was undoubtedly influenced by Ingres. An Ingres revival in the 1930s, when the Metropolitan Museum acquired several paintings, led De Kooning, Gorky, and Graham to adopt Ingres's linearity and two-dimensionality, as well as such features as sweeping shoulders and bodiced breasts. De Kooning even sandpapered several early paintings of women to approximate Ingres' polished surfaces.[15]

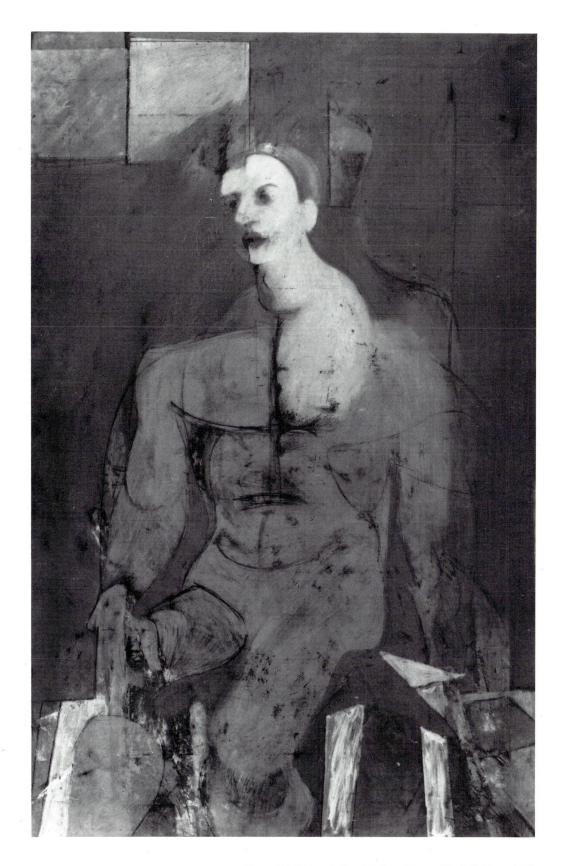

Figure 209. Willem de Kooning, *Seated Figure (Classic Male)*, ca. 1940. Oil and charcoal on plywood. 54⅜ x 36 inches. Galerie Beyeler, Basel.

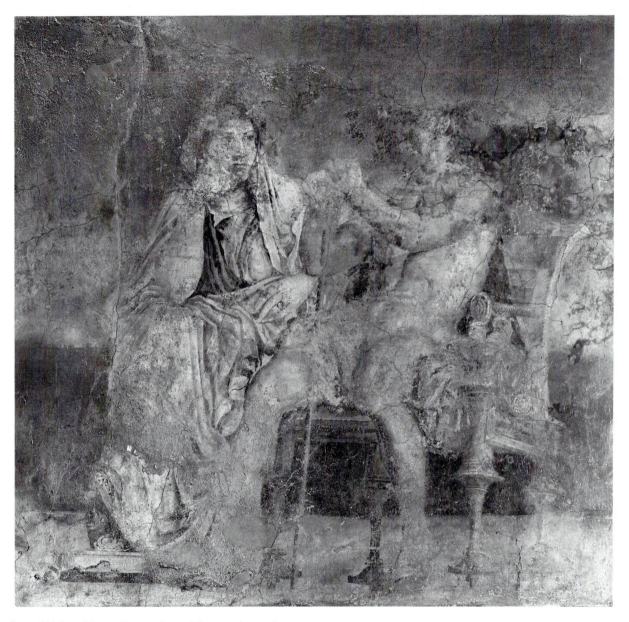

Figure 210. *Seated Figures,* Boscoreale panel, first century A.D. Fresco. 59 inches x 6 feet 4 inches. Metropolitan Museum of Art, Rogers Fund, 1903. (03.14.6)

Seated Woman reflects the increasing modernist disjunction in De Kooning's work, as the right shoulder and arm do not quite fit the upper torso. The other arm is a swift, curving biomorphic summary in a flesh tone. Both of these elements reflect Picasso's disjunctive bone drawings, while De Kooning's arm resembles the arm of a seated woman next to the classical male in the Boscoreale panel at the Metropolitan Museum. Picasso's own *Seated Woman,* a work that influenced Motherwell's *Emperor of China* of the same period, may lie behind the flat and

curving hairdo. Graham's Ingresque *Lucifera* may have been the intermediary between the Picasso and the De Kooning.

A similar unity of the traditional and modern figure, of abstraction and realism, of modernism and art history can be found in *Woman* of 1942. It also reflects the influence of Ingres, while at the same time it synthesizes the early work of Picasso and Matisse. Picasso's influence appears in the Synthetic Cubist repetitions or "willful pentimenti" and extensions of the head, shoulders and arms, as well as in

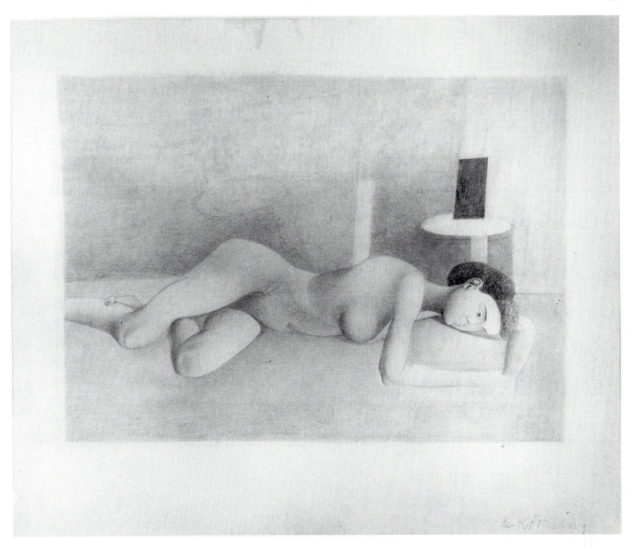

Figure 211. Willem de Kooning, *Reclining Nude (Juliet Browner)*, ca. 1938. Graphite on paper, 10½ x 13 inches. Mr. and Mrs. Steven J. Ross.

the double profile face and rectilinearity of anatomical parts. Similarly, Matisse may lie behind the combination of drawn lines and large, flat, bright planes of color, the paralleling of the arm of the armchair, and the flattening of the figure so that foreshortened forms are eliminated. The woman both expands beyond and contracts to flatness, except for her breasts which suggest heavy roundness.

De Kooning decisively turns toward Picassoid dislocation in *Pink Lady* of about 1944 (fig. 213). The composition is more disjointed, more extended, more exfoliated, and more violently rhymed than any earlier De Kooning work. In the painting, a seated woman with echoes of previous forms and influences rests her head on her arm. She has three heads, one in profile, and several necks and shoul-

ders. The figure has become more savage—it has a toothy grin, aggressively foreshortened and swinging breasts, and rather garish color. De Kooning spreads the figural anatomies in a Matissean background once again, but this time joins them with a quotation from the Boscoreale wall frescoes.

The figure now seems joined or disjointed by forces beyond her simple action or inaction of resting. One might suspect automatist influence, but while De Kooning's figures have a linear and spontaneous look, this quality did not arise from automatism. Many paintings, especially at this period, were based on drawings and were worked out in advance and simply adjusted anew on the canvas.[16]

Pink Angels of about 1945 (pl. 23) is a key transitional work. It is a single-figure composition that heralds his

273

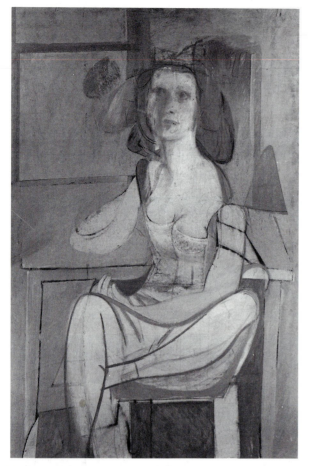

Figure 212. Willem de Kooning, *Seated Woman*, 1940. Oil and charcoal on composition board. 54¼ x 36 inches. Philadelphia Museum of Art: The Albert M. and Elizabeth M. Greenfield Collection. (74.178.23)

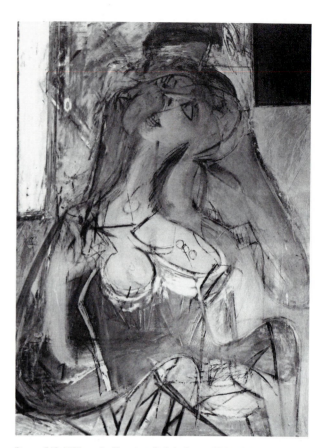

Figure 213. Willem de Kooning, *Pink Lady*, ca. 1944. Oil and charcoal on canvas. 52 x 40 inches. Private collection.

famous *Woman* of 1950–52. *Pink Angels* resembles Old Master compositions of nudes at their toilettes with their backs toward the viewer, which De Kooning, with his strong knowledge of art history, probably knew. While based in tradition, the painting is the first statement of the all-over, high-pitched, stridently dynamic environmental anatomical fields of the late 1940s. And while the picture again reflects the elongated, flat, pink limbs of Picasso's seated figures, there is also a new source behind it— Picasso's most famous picture of excess and extreme dismemberments, *Guernica*. De Kooning found the Picasso retrospective of 1939–40 at the Museum of Modern Art "staggering," and he drew on *Guernica* and its drawings for a number of years. To De Kooning, like Pollock, Picasso was the man to beat.[17]

In *Pink Angels* anatomy swings and sweeps, arches, narrows, and tenses. Heads and eyes tear across the picture space. Forms derived from Picasso and Matisse curve just enough to indicate volume while they reject any

traditional modeling that would add to their fullness. The central form and its disparate members cohere, organize, and break apart. Forms open up and fragment across the space. *Pink Angels* was De Kooning's most violent picture to date. It is a painting of surging energies and forces that rend the human body, much like Orozco's series *Los Teules* of 1947, paintings of violent dismemberments, the early drawings for which had influenced Pollock. Could this violent art in its oblique way be a subtle response to the carnage and frenzy of the climax of everyone's reality in 1945, the war, as *Guernica* was Picasso's response to his homeland's warfare? Much art from Mexico to England seems particularly violent in the mid and late 1940s.

THE CONTINUUM OF ART HISTORY

Up to this point De Kooning exhibited an indecisive attitude toward modernism. From a youthful commitment to it, he moved away and then back again as long as he could relate it to the single-figure grand tradition of Western painting which he sincerely respected.

In his essays "Renaissance and Order" and "What Abstract Art Means to Me" of 1950 and 1951 respectively, he criticized modernist notions of an absoluteness and purity in art, the critical posturing and theorizing that went with such absolutes, and the pressures of "movements,"[18] saying that "it is talking that has put 'Art' into painting."[19] He rejected the absoluteness of art, the illusion of pure form, indeed, any idea of purity itself. (On this point, he criticized Kierkegaard for his comment "To be purified is to will one thing," which De Kooning said made him sick.) Similarly, he abstained from the belief prevalent among Abstract Expressionists like Still and Newman that one could create art anew. He satirically described this as painting out of "John Brown's body." He felt that as an artist, he could not realistically go back to scratch, but merely to academy representationalism, which is in fact where he started.[20] No one could really go back to the beginning. For De Kooning, in art one idea is as good as another and "style" is a fraud: "I'm not so crazy about my style. . . . I'd just as soon paint some other way."[21] He said of cubism: "It didn't want to get rid of what went before. Instead it added something to it."[22]

De Kooning viewed himself as an eclectic painter who could be influenced by any past art, although he would never paint completely in its style. In a key statement he said that there is a train track in the history of art that goes all the way back to Mesopotamia, but it skipped non-Western traditions such as the Orient, the Mayas, and the American Indians.[23] His wife Elaine recently described the feeling in the 1940s as a "continuum" in which all past art was equally present. She noted that in New York in the 1940s there was the idea that avant-garde Paris no longer existed and that, uniquely in New York, all periods and kinds of art were equally available, perhaps for the first time in history. To her the feeling in the early 1940s anticipated André Malraux's concept of "museums without walls."[24]

De Kooning and his early supporters Thomas Hess and

Figure 214. Willem de Kooning, *Labyrinth*, 1946. Calcimine and charcoal on canvas. 16 feet 10 inches x 17 feet. Allan Stone.

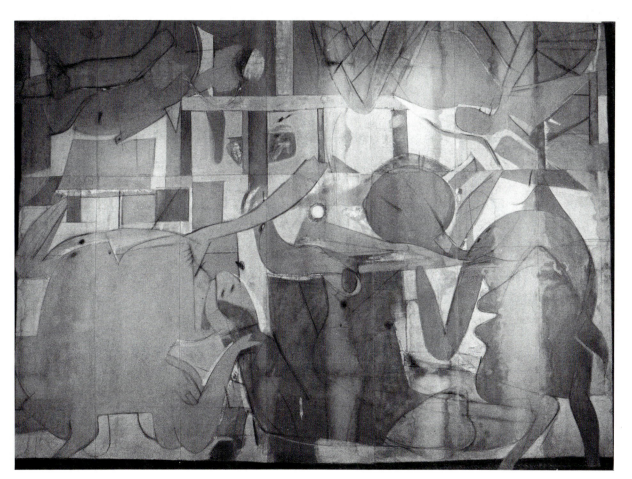

Harold Rosenberg termed his style a "no-style," but it is really all styles. It lacks modernist purity, but its multivalence and aggregate associations parallel the artistic and literary styles of his period. De Kooning quoted from the past of art history the way Rothko quoted from Greek art, or the way Eliot, Pound, and Joyce would join language, characters, and mythic figures of previous literature to contemporary literature. Art history and the grand manner of figure painting provided De Kooning with the means to make an all-inclusive statement. Synthesizing tradition, the real, and the modern, his men and women form art-historical collages. Fragments of different styles join in a composite of associations past and present, real and artistic. De Kooning himself said he found it very satisfying to do something that has been done for thirty thousand years.

De Kooning partially fused the human record with art that he associated with the contemporary. Like Eliot, Joyce, and most Abstract Expressionists, De Kooning conceived of his art as a part of the living whole of all the art that has ever been done. But the tradition is not so powerful that the modern artist cannot modify and enlarge it, in Eliot's words, "by the introduction of the new." De Kooning expressed this idea when he said artists of today "keep influencing the old masters. Maybe some of the young painters take things from Monet. But it was someone like Clyfford Still who probably never looked at Monet, who got them to see it."[25]

Figure 215. Willem de Kooning, *Judgment Day*, formerly *Study for Labyrinth*, 1946. Oil and charcoal on paper. 22⅛ x 28½ inches. The Metropolitan Museum of Art. From the Collection of Thomas B. Hess, jointly owned by the Metropolitan Museum of Art and the heirs of Thomas B. Hess, 1984. (84.613.4)

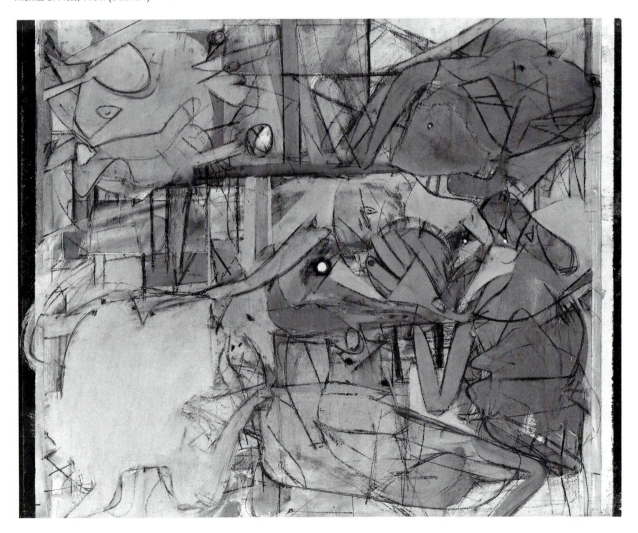

276

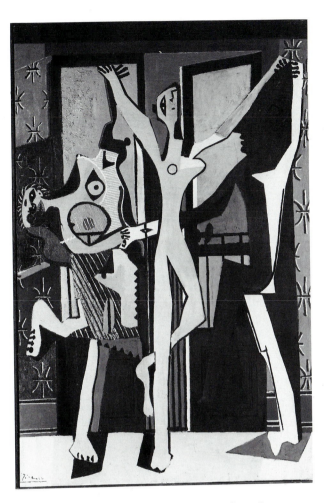

Figure 216. Pablo Picasso, *Three Dancers*, 1925. 84⅝ x 55⅞ inches. The Tate Gallery, London.

PORTMANTEAU PAINTINGS

In the lower righthand corner of *Pink Angels* lies an abstract curvilinear form with sharp edges and several appendages. This odd biomorphic shape is a forerunner of De Kooning's next phase, the animate and inanimate fields of the late 1940s, which he began with his large scenery backdrop, *Labyrinth* of 1946 (fig. 214). De Kooning painted the backdrop for a dance recital given by Marie Marchowsky, a former Graham dancer, in 1946. An earlier painting (fig. 215) has been traditionally called a preliminary study for *Labyrinth,* but according to De Kooning's secretary, Edward Lieber, it was originally a separate work, entitled *Judgment Day.*[26] The subject is the great Greek, Martha Graham, Gottlieb and surrealist myth of the Minotaur. While De Kooning, like Newman and Still, showed no noticeable interest in the theme of the unconscious or in surrealism proper, he nevertheless incorporated aspects of them from his artistic milieu.

The background may contain four figures based on the Boscoreale frescoes in the Metropolitan Museum,[27] but they have been transformed by two profound influences. One is Picasso. The flat, sharply edged forms of *Guernica* are reflected in both the study and in the finished work. The composition of jagged and curvilinear forms distributed across a rectilinear and compressed space also follows the general arrangement of Picasso's work. Some of De Kooning's specific shapes relate to those of *Guernica,* such as the triangular head of the figure rushing in with the light, an echo of which can be found in yellow in the upper right of both *Labyrinth* works. In both a diagonal axis flows from that form to the lower left. In the finished backdrop, the eyes of the form at the upper left reflect those of the slain figure at the lower left of *Guernica*. De Kooning may have also turned to another Picasso, appropriately *Three Dancers* of 1925 (fig. 216). This work, consisting of stretching, elongated, twisting figures in a rectilinear space, may have provided his general composition.

Another major source is his perennial one, Gorky, who by now had well developed his mature anatomical tableaux. Drawings by Gorky such as *Untitled* of 1943 (fig. 217) are likely influences on De Kooning's work. This Gorky drawing contains rounded biomorphic shapes, some of which also have elongated appendages. The vertical figure to the right of *Judgment Day [Labyrinth]* reflects a similar form in the Gorky. In both works the space is indeterminate and, as is true for both artists throughout their careers, it is not clear whether the scene is located indoors or outdoors. In the Gorky drawing and the De Kooning study, the compositions are split in half at the left by some kind of horizontal wall line.

In the translation from *Judgment Day [Labyrinth]* to the finished backdrop, De Kooning adopted another Gorky device of selectively painting out forms, in other words, camouflage. Forms have obviously been painted out and are just visible underneath the paint, creating a variety of ghostly shapes or pentimenti once again. In the finished work as opposed to the study, the figure at the right has been shortened and parts of it have been painted out: the breast and head now appear as independent shapes. This is typical Gorky camouflaging. De Kooning's statement in a letter in 1949 declaring that it was impossible to get away from Gorky's influence was both a true and honest statement.[28]

Against a plane of rectilinear forms, De Kooning created a style compressing and fusing the twisting forms of dancers; allusions to ancient, surrealist, and Abstract Expressionist myth and structure; Gorkyesque form and composition; and Picassoid flattening and truncating. The result is a formal language of odd jumps, of compressed and contorted forms. The figures gain in power and seem

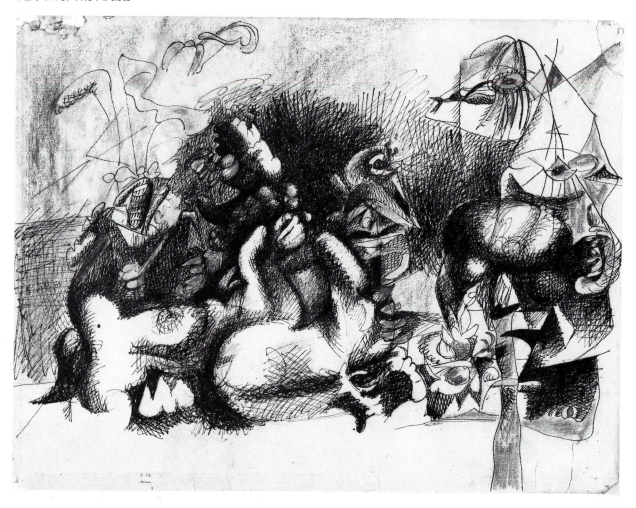

Figure 217. Arshile Gorky, *Untitled,* 1943. Pen and ink and pastel on ivory paper, 17¼ x 23 inches. Collection of Mrs. Edwin A. Bergman, Chicago.

dramatically, frenetically active. Significantly, directly in the center of the painting is a blank circle like an eye, suggesting that the painting space itself is perhaps organically alive.

In the development of his work from 1947 to 1950, the black and white abstractions, De Kooning continually drew on the amalgam of Gorky and Picasso. The black *Painting* of 1948 (fig. 218), for example, relates to such Gorky works as the pencil drawing *Sochi* of 1943 and *One Year the Milkweed* in its biomorphic shapes, painterliness, cascading rhythms, and outlined forms. (In 1944 De Kooning had shown Gorky how to use a sign brush that allowed Gorky to paint with fine, precise lines, which De Kooning echoed here.) The white abstraction *Mailbox* of 1948 (fig. 219) consists of mostly Gorky-derived, malleable, two- and three-dimensional biomorphic blots fluently outlined, or rather their contours are arbitrarily formed by black contours on white. The shapes nevertheless

remind one of *Guernica* with its upward-facing shapes. While De Kooning said that lack of money was the reason he did mostly black or white paintings at this time, the influence of the only black, white, and gray *Guernica* seems also to have been important.

Most significant for these works is De Kooning's interest, almost unique among the Abstract Expressionists, in the real visual world, in everyday scenes and objects, in the banal. Inordinately sensitive to his visual environment, De Kooning would search out shapes and forms in it. As his friend Edwin Denby pointed out in a poem subtitled "The designs on the sidewalk Bill pointed out": "The sidewalk cracks, gumspots, the water, the bits of refuse,/They reach out and bloom under arclight, neonlight."[29] This search may ultimately be rooted in the surrealist espousal of Leonardo Da Vinci's principle of closely examining objects such as walls for forms, but a more likely source for the

idea may be Gorky's interest in camouflage. Gorky was known to study and stare at the earth in order to gather information for his work. In the study of animal camouflage from which camouflage doctrine is derived, it is necessary to look hard at surfaces. Time and concentration are necessary to recognize the hidden insects and animals merging with the environment. De Kooning paintings such as *Black Friday* (fig. 220) and *Dark Pond* of 1948 and *Town Square* of 1949 (fig. 221) consist of indecipherable, seemingly animate and inanimate shapes whose identities and inspiration are unknown. *Black Friday,* for example, contains curvilinear, spiderlike biomorphic forms resembling those in *Labyrinth* but even more indeterminate. At the left is a tall house with three roof pentimenti, which suggests that the biomorphic shapes are outside, but that too is uncertain. *Town Square* similarly consists of ex-

tended curvilinear shapes that resemble nothing in particular in a town square. Instead, the painting recalls *Guernica* with its jumbled white rectilinearity and curvilinearity, and its configurations such as the extended arms and the neck with head of the soldier at the left which appear in both works.

The titles themselves suggest a dialogue with the real world. In the paintings exhibited in De Kooning's first one-man show in 1948, titles include *Light in August* from Faulkner's novel (whose cover in the New Directions edition of 1946 De Kooning's black painting resembles);[30] *Orestes,* which was given its title by the editor John Stephens of *The Tiger's Eye; Asheville,* the name of the North Carolina city near Black Mountain College where De Kooning briefly taught at this time; and *Mailbox,* which was chosen for no particular reason.[31] As De Kooning said

Figure 218. Willem de Kooning, *Painting,* 1948. Enamel and oil on canvas, $42\frac{5}{8}$ x $56\frac{1}{8}$ inches. Collection, The Museum of Modern Art, New York. Purchase.

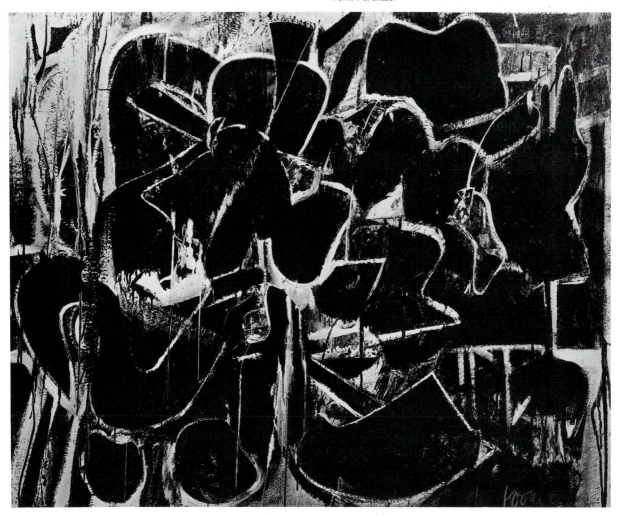

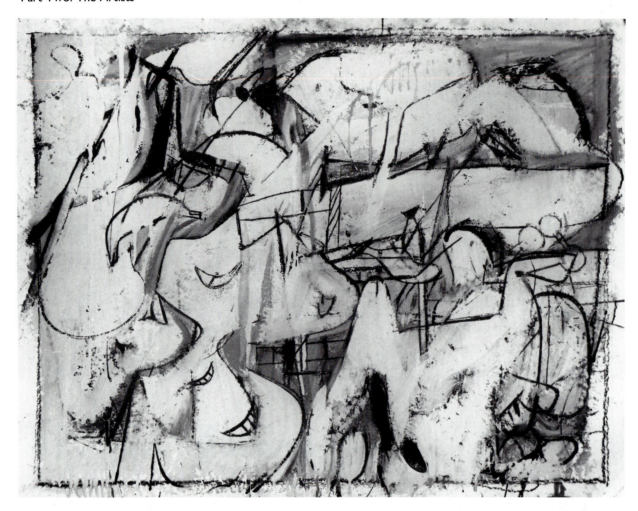

Figure 219. Willem de Kooning, *Mailbox*, 1948. Oil, enamel, and charcoal on paper, mounted on cardboard. 23¼ x 30 inches. Edmund P. Pillsbury Family Collection.

in 1951, "If an artist can always title his pictures, that means he is not always very clear."[32] The anchoring of his pictures with titles was quite free, yet unlike most other Abstract Expressionists, De Kooning gave titles that, like his imagery, include references to commonplace things and specific places. Nevertheless specific identities, spaces, and shapes of the forms remain indeterminable. The black and white paintings form what has become known as a "no-environment," in which allusions to reality and the quotidian are telescoped into unknown shapes.

De Kooning's black and white pictures consist of a range of imprecise shapes suggesting a continuity of things both organic and inorganic in a space both indoors and outdoors. There is an overall unity of figuration without complex figures, an infrastructure of continual combinations and compounds. Forms are heterogeneous, malleable, and continuous. They crisscross, interchange, and

merge with one another. Developed out of visual perceptions, they are objective descriptions charged with elemental significance, sensation, and expression. In these works, as well as in *Attic* and *Excavation*, De Kooning's forms oscillate between abstract pictorial form and "real object" and between object and anatomy. There is a homogeneity of heterogeneous shapes and oblique associations, of fragments, juxtapositions, penetrations, and overlappings, both art historical and everyday.

Much was made in the 1950s by Hess and Rosenberg of De Kooning's "ambiguity," which was given an existential cast, but for all their leaps and jumps De Kooning's forms are all quite similar. De Kooning simply reduces all forms—whether Picassoid, Gorkyesque, or "real"—to fragments of an everyday yet art-historical flux. Figure and object, figure and ground, what is actual and what is derived from earlier art participate in a continual metamorphosis, a

280

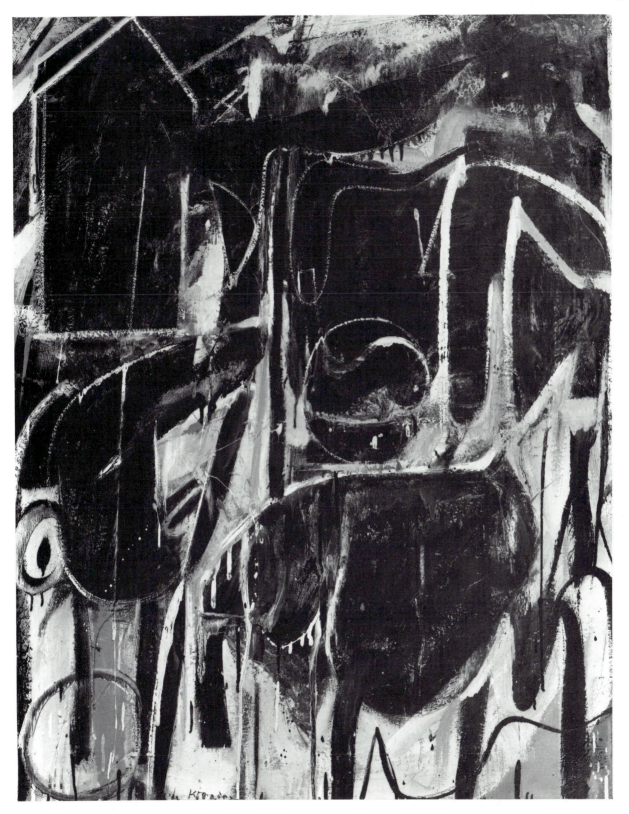

Figure 220. Willem de Kooning, *Black Friday*, 1948. Oil and enamel on composition board. 48 x 38 inches. The Art Museum, Princeton University, partial gift of Mr. and Mrs. Gates Lloyd.

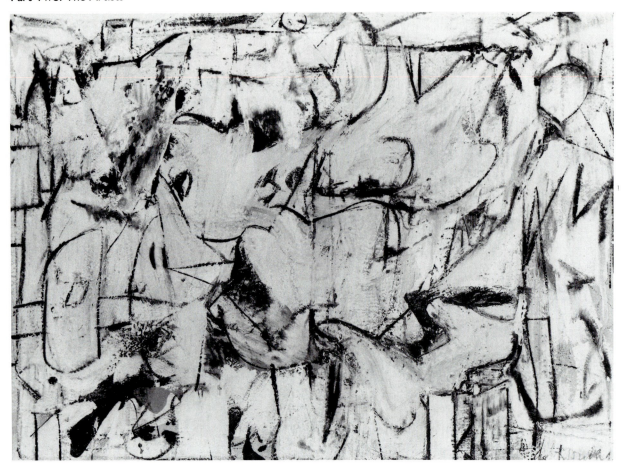

Figure 221. Willem de Kooning, *Town Square,* 1949. Oil and enamel on paper mounted on composition board. 17¾ x 23¾ inches. Collection, Richard E. Lang and Jane M. Davis, Medina, Washington. Photo: Paul Cacapia, Seattle.

unique continuum of vitality, a painterly opportunism of multiple and simultaneous flow. De Kooning achieved the Abstract Expressionist continuum on his own terms. His black and white paintings give a feeling, in his words, of "one wind blowing throughout the whole picture."[33]

De Kooning's is a portmanteau continuum, consisting of run-on forms, paralleling Joyce's invention of synthesized words such as "wielderfight" and "penisolate," Faulkner's "littleused," "inyawning," and "maneyes," and Gertrude Stein's stream of words without punctuation.[34] In several works, like his colleagues, De Kooning uses letters as parts and "triggers" of his continuum.[35] In the early 1940s, he fused the past and present of art history and time and space in his simple figures, and in the fifties fused object and figure, near and far, outdoors and indoors, figure and ground in a run-on compound without beginning or end. De Kooning replaced his single-figure continuums of mo-

dernity and tradition with an intricate matrix of the real and the artistic, the object, form, and space.

Gorky's and Picasso's anatomical fields were undoubtedly models for De Kooning, but his matrix continuums stand between their still recognizable anatomies and the distilled, purer, diagrammatic continuums of Pollock's linear webs and Newman's fields of color. De Kooning's post-1945 fields are intricate, stuffed, and additive. They are realist—of the visual world—yet they reflect an unseen power that envelops and dominates them.

The climax of this mode comes in the great paintings *Attic* and *Excavation,* which consist of sharp-edged, truncated forms in an all-over field of continuous fragmentation. Shapes have both linear and curvilinear edges, suggesting the conjoining of manmade and organic forms. Forms overlap, interpenetrate, and multiply. The nature and source of certain shapes can be identified. For ex-

ample, heads from *Guernica* appear at the upper left of *Attic*.[36] Additional shapes from that source are the hand at the left, which is attached to a rectilinear curving shape that resembles a typical hollow head under a raised arm, a traditional pose found in many cubist works, such as Archipenko's *Woman Combing Her Hair*. Both De Kooning paintings reflect *Guernica*; *Excavation* also echoes the triangular wedge-shaped figures of *The Demoiselles d'Avignon*.

These paintings reflect cubist influence. The continuous spreading of flat, angular fragments, the equalization of figure and ground, the emptying of anatomical volumes, and the *passage* of one shape into another are all cubist. Here De Kooning has replaced his earlier use of pentimenti with the fuller repetition of distinct planes. But De Kooning uses cubist syntax not to analyze single forms but to structure the stream, variety, and interconnectedness of planes. *Attic* and *Excavation*, with their flat biomorphism, fuse Analytic Cubism's multiple planes with the savage rending and tearing more typical of *Guernica*.

Cubist fragmentation perhaps reaches its apotheosis with these two De Koonings. At the same time, their distinctive quality derives from De Kooning's joining of cubist fragmentation with Abstract Expressionist vitalism, resulting in the frenzied portmanteau continuum. Near and far, organic and inorganic (*Excavation* has a door image in the center), body part and environment, the real and the abstract, stream. De Kooning portrays an ongoingness, or interconnected world which lies at the root of and absorbs everything. Such an interrelatedness constitutes one of the central themes of interwar and Abstract Expressionist art. Lee Krasner expressed it best when she said her work represents "the need to merge against the need to separate."[37] De Kooning's continuum consists of the *struggle* to unify, to arrive at a wholeness among the ruptures artistic—and otherwise.

The titles *Attic* and *Excavation* suggest a continuous if mundane world above and below, as did the subterranean, cosmic, and landscape topics of Pollock's *The Deep* and Rothko's *Geological Reverie*. Indeed, in their discussions of *Excavation*, several critics have suggested an analogy to geological fissures and accretions.[38] Excavation also lies at the root of the dream of Joyce's *Finnegans Wake*, where layers of superimposed time necessitate "excavations" of language and literature. One critic described De Kooning's works as the continual accretion of experience:

A section of the surface may open out, revealing great depths, then instantly close. . . . As the eye roams, a part of the image will emerge from indistinctiveness into identity, a fragmentary find . . . may suggest a whole, which in turn is swallowed up in a still larger whole that no eye can comprehend . . . a phenomenon

that parallels . . . dreamlike associations . . . an indeterminate field of memories, stretching into the future . . . memories that follow one another. . . . Memory and projections . . . growth and decay, nature, history, and their sublimations in myth are all present, synthesized in a single image which is many images in one; a neverending narrative of abstract formal developments . . . just as life continually adds to and superimposes new experiences on our memories of the past.[39]

De Kooning's *Attic* and *Excavation* represent his absorption of the Abstract Expressionist theme of simultaneity, variety, and continuity as projections and retentions in the instant moment of the *now*.

In his works of 1946 to 1950, De Kooning continually adjusted forms. His working method underlines the image of a heterogeneous, intricate continuum. De Kooning started these pictures in different ways. Sometimes he began by drawing letters. He often relied on drawings which he cut out and superimposed on one another, sometimes tracing some forms and then removing the drawings. He continually added and subtracted new forms, so that the final pictures are accretions taken out of context but carrying signs of their sources. *Attic* and *Excavation* seem to consist of scissor-edged forms, cut and reassembled. They are ever new combinations of like and unlike forms and of ritual dismemberment and reconstruction (cf. Newman's *The Slaying of Osiris*). These pictures and those of subsequent years, such as the studies for *Woman I*, with their free-flowing assembly of related and ever varied cut parts also recall Matisse's cutouts, which were then rather well publicized contemporary creations.

In the works, there is no preconceived final form. De Kooning's method has been understood as a "slipping glimpse"; he himself said "While I'm working, I get the idea. . . . [Y]ou have it and then you lose it again and then get it again."[40] De Kooning's famous inability to finish makes up part of the image. The pictures reflect his sense of creative journey, passage, additions, and subtractions. Again then in Abstract Expressionism, artistic process is one with the final image, artistic creation is one with artistic temperament, artistic process is one with visual process. The final image is a direct record of its making. There is no finished painting as there is no finished process in De Kooning's image of fragmented continuity. Although De Kooning later solved his need to adjust and revise continually by just stopping and not "finishing," it is evident that his method is part of his message—a continual beginning, a continual wiping out and redoing, a continual recommencing of the same or like elements. His pictures are cross-sections or frozen instants of a continuum of activity. The cut and sliced body parts and objects of the environment reflect a splintered sense of temporality, an underlying rupture and unity to the diversity of space, object, and

time. What has come before will come after only in a different form. De Kooning's works of the late 1940s give a sense of retention and anticipation.

"HELLO YANK": SEXUAL BULLETS

At the end of the 1940s, De Kooning's work stands halfway in the developing tradition of Abstract Expressionism. In the early forties, he engaged the grand manner but with the Abstract Expressionist notion of an imagery of the past and present together. Similarly, in the late forties, he put forth images from the real world while at the same time fusing them with Abstract Expressionist vitalism. In so doing, he established the major thrust of fifties painting in America, known as Action Painting, an urbanized, quotidian vitalism. De Kooning's half-and-half approach dominates the remainder of his career.

De Kooning painted *Woman I* (fig. 202) from 1950 to 1952. The figure is more painterly than his previous women. Anatomical parts seem less sharp edged, and the figure as a whole is more a product of the continuous environment, or "no-environment," of ceaseless brushwork, than are his women and other subjects of the 1940s. The picture-making process especially indicates the sense of continuity that De Kooning is after. The "finished picture" records only the final pause in a two-year process of painting and repainting. Rudolph Burchardt's famous photographs of six stages of work record just six versions among many. Creative process and theme, creativity and idea, join once again as the blotches of paint/stroke/shape thrust into, through, and out of the figure into the surrounding space. The figure, as has often been noted, is generally cubist in form as she emerges from the overlapping of angular and round shapes. But in contrast to Analytic Cubist work, the figure embedded in the field of shifting space and light is not static but composed of an aggressive, savage nature.

In *Woman I* figure and ground merge, united by shared vitalist brushstrokes, color, and touch. Stroke and shape define the picture space as well as the object. The figure has strong outlines and interchanged body parts—a leg as the left shoulder—as it continually shifts, disassembles, reassembles, and disappears in a field of strokes. De Kooning keeps his pentimenti of shoulders and legs, his classical seated pose, while at the same time he breaks the figures into a frenzied assemblage of parts. As in his portmanteau paintings, the subject is a continuum as much as anything else. The body and its environment are cues and clues, capable of only temporary cessation, that is, only temporary concretion in womanly form. The figure is interchangeable with the unfinished interminable field of

strokes and forces that constitute it. A later painting of 1955 in this mode is in fact named *Interchange*.

With *Woman I*, the fragmentation and admixture of figure and ground are complete. The female figure is a collage/montage interfusion of moving abundance, densely packed and interlaced with space, and an abstraction of elements in a classical/Picassoid/Matissean pose. As in the black and whites, De Kooning's figures become more painterly as he relies on formal analogies, continuities, and rhyming though the fluidity, velocity, and shaping of painterly brushwork.

With *Woman I* De Kooning found an image that concentrated all of his themes and opened up new ones. *Woman I* and the five subsequent paintings in the series, *Woman II–VI* as well as pictures like *Woman and Bicycle* of 1952–53 represent another art-historical continuum—a conjoining of an everyday contemporary figure, primordial earth goddess, and life principle. Of the Abstract Expressionists, only De Kooning would develop a traditional figurative image that stated his and their principles. The weighty mass and form manifest the weight of meaning his figures hold in the larger order of things. *Woman I* is producer and product of the formative forces for this generation—amoral vitalist instinct, with its equal capacity for good and evil, in disregard for what humankind ought to be.[41] It presents an organism let loose in the world, a culture of limbs and labyrinths, and a figural embodiment of the culture, principles, and experiences of the 1940s.

The painting is a festival of symbolic discourses, ritual performances, and imagery. Through the signifier of figure alone, De Kooning creates a world system of body language that interprets human life and tracks meanings of culturally encoded experience. De Kooning describes his motives in excerpts from an interview entitled "Content is a Glimpse . . ." of 1963:

The Women had to do with the female painted through all the ages, all those idols. . . . It did one thing for me: it eliminated composition, arrangement, relationships, light—all this silly talk about line, color and form—because that was the thing I wanted to get hold of. I put it in the center of the canvas . . . So I thought I might as well stick to the idea that it's got two eyes, a nose and mouth and neck . . .

Painting the *Women* is a thing in art that has been done over and over—the idol, Venus, the nude. . . . Today artists . . . want to get a hold of things. . . . Forms ought to have the emotion of a concrete experience. For instance, I am very happy to see that grass is green. At one time, it was very daring to make a figure red or blue—I think now it is just as daring to make it flesh-colored.

Content is a glimpse of something, an encounter like a flash. It's very tiny . . . content. When I was painting those figures, I was thinking about Gertrude Stein—as if one of them would say, "How do you like me?" . . .

I wasn't concerned to get a particular kind of feeling. I look at

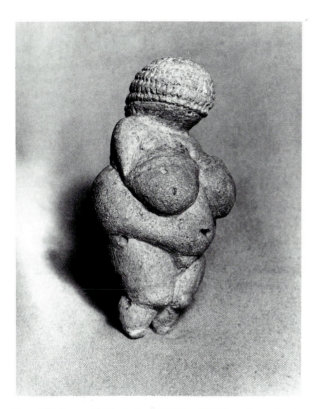

Figure 222. *Venus of Willendorf,* ca. 25,000 to 20,000 B.C. Stone. Height 4⅜ inches. Natural History Museum, Vienna.

them now and they seem vociferous and ferocious. I think it had to do with the idea of the idol, the oracle, and above all the hilariousness of it. . . .

I cut out a lot of mouths. First of all, I thought everything ought to have a mouth. Maybe it was like a pun. Maybe it's sexual. But whatever it is, I used to cut out a lot of mouths. . . . It always turned out to be very beautiful and it helped me immensely to have this real thing. . . . Maybe the grin, it's rather like the Mesopotamian idols, they always stand up straight, looking to the sky with this smile, like they were just astonished about the forces of nature you feel.[42]

In this extended statement, De Kooning ties together realism, the primordial, the fertility goddess, the art-historical continuum of images, and the forces of nature. Like *Woman I,* these words, in a virtual free association, represent most completely his fundamental themes. *Woman I* is a ferocious, real, and banal image, at once primordial and contemporary. She is *Greece on Eighth Avenue* (in the title of a later work)—De Kooning's version of Joyce's mythic figures in Dublin, a contemporary commonplace variant of the mythic figure Gae, a Molly Bloom and Anna Livia Plurabelle.

Seemingly for the first time since his Boscoreale figures of the early 1940s, De Kooning roots his image in the

primordial past. In 1949 De Kooning attended a meeting at The Club where Joseph Campbell spoke, and was impressed with what he said. A short time later, he met Campbell and his wife, the former Graham dancer and choreographer, Jean Erdman, at Bard College and inquired half jokingly what he should do next.[43] What he did was turn toward mythic figures; he has indicated that the Venus of Willendorf (fig. 222), the fertility idol of thousands of years ago, gave him the idea for *Woman I.*[44] In studies for the painting, he toyed with references to Picasso's *Three Dancers* in the eye/breasts configuration and to Cycladic idols in her pelvis.[45] De Kooning related the figure's smile to that of Mesopotamian idols, many of which were on display at the Metropolitan Museum, such as the standing figures from Tell Asmar of 2600 B.C. In *The Hero with a Thousand Faces,* Campbell connected fertility figures, mothers of life and death, to Sumero-Babylonian astral mythology and to Mesopotamia.[46]

At the same time, the primordial idol behind *Woman I* can be found in all cultures throughout time. The final image evokes, among others, Rubens, Goya, Rouault, and Hals. De Kooning himself has spoken of the figure, as an image of Gertrude Stein, both of the women she wrote about and, I suspect, of Picasso's 1906 portrait of her as a large woman, seated at the same angle, with equally large and almond shaped eyes (fig. 223). Elaine De Kooning also relates that he frequently suggested her mother reminded him of Stein. She wore lots of makeup and jewels and was very "tyrannical."[47] Further references possibly include Chaim Soutine whose exhibition at the Museum of Modern Art in 1950–51 De Kooning was known to admire. Soutine's art, in which it is difficult to distinguish between the paint and flesh or earth, may partially lie behind the increased painterliness of *Woman I.* (De Kooning once said he would like to paint like Ingres and Soutine at the same time). And De Kooning's *Woman I* connects with the Northern Romantic tradition represented by Munch's *Madonnas* of 1895–1900. Munch's nude posits a saintly, religious, and sexually fatal character; sperm stream around the border of the lithograph and a seemingly frightened, perhaps dead, fetus.

De Kooning described the figure in *Woman I* as a conduit for the "forces of nature," thus connecting his art with a fundamental theme of surrealism and Abstract Expressionism. But De Kooning is unique among the Americans (except for the fertility and moon images of Pollock) in presenting the determining and generating forces through the image of a woman. *Woman I* may be inspired by many visual and art historical cues but it represents no particular individual; the figure is part of and vehicle for the impersonal order of nature. *Woman I* pictures not just an icon but a totem. The figure represents the ancestral forces still alive today on Eighth Avenue. De

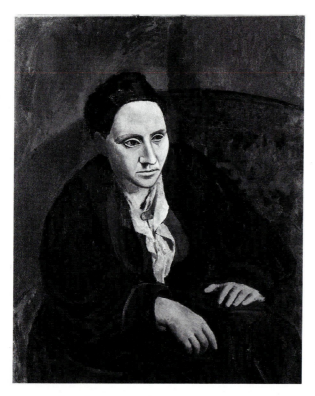

Figure 223. Pablo Picasso, *Gertrude Stein*, 1906. 39¼ x 32 inches. The Metropolitan Museum of Art. Bequest of Getrude Stein, 1946. (47.106)

Kooning's *Women* paintings are images of pagan forces, of creatures of instinct who represent the female principle.

The woman is an Earth Mother image, and like the Venus of Willendorf, is all sexuality with exaggeratedly large breasts and thighs, all procreativity and female abundance, all animation, a sexual idol and icon. In his use of such an idol De Kooning joins other twentieth-century masters, such as Picasso, who sculpted the *Venus of Lapigue,* and Masson, who drew the Paleolithic *Venus of Grimaldi* and wrote in a sketchbook in the mid-1920s "Woman-fecundity/fertility."[48] *Woman I* is also heir to Masson's fertility figures, which lie behind the forms in his *Anatomy of My Universe* of 1943. The mythic figures Semiramis, Ishtar, Earth Mother, Mantis, and the Minotaur represent, in Masson's words, pre-natal life, murder, death.[49] They are seductive and fatal force, fecundity and aggression, indifference and amorality. De Kooning presents Woman as the talisman and symbol of reproductive or Human Life energies and of vitality typical of the Grail quest and its female symbols and ancient rites.

Woman I is thus a variant on the interwar and war tradition. Her interchangeable body parts remind one of similar surrealist interchanges such as the *vagina dentata* images of Miró and Masson. The figure's carnal body, leering grin, and rapacious, overbearing appearance sug-

gest a person who devours. In one way, she seems a unique extension of the surrealist theme of the praying mantis, the primordial insect who kills after the sexual act. Miró described the sexual themes to which De Kooning ultimately is heir: "When I make a large female sex image, it is for me a goddess, as the birth of humanity ... a fecundity figure, but all the same it is menacing. ... You understand well that this is humanity, it is always menacing on the right and on the left, above and below, we are menaced."[50] De Kooning sexualized the Abstract Expressionist themes of fertility and vitalism and drew on modern and traditional images to do it. Lionel Trilling's description of the modern in modern literature sums up De Kooning's and the mostly interwar theme found in *Woman I:* "Nothing is more characteristic of modern literature than its discovery and canonization of the primal, non-ethical energies."[51]

While primordial and traditional, the figure of *Woman I* is concrete, everyday, and banal. De Kooning felt that forms "ought to have the emotion of a concrete experience," and so his women seem equally drawn from everyday American life. De Kooning has indicated several contemporary sources for the image. She is sister to the giant figures with broad "American smiles" seen on mail trucks and billboards,[52] and she reflects what De Kooning saw as the comic aspect of grimacing and predatory women shopping around Union Square in New York.[53] She may be a response to beautiful women De Kooning knew whom he said "irritate" him sometimes.[54]

For some of the studies for the painting, De Kooning cut smiles from women in magazine advertisements, such as one for Camel cigarettes, and pasted them on his preliminary figures (fig. 224). The smiles come from the section of the Camel advertisement that represented the "T-zone" or "taste zone." The copy read "Be kind to your T-zone."[55]

Taste is certainly an issue in *Woman I.* The woman smiles luridly and vulgarly and makes a tawdry impression that De Kooning himself regarded as "hilarious." Rather than attempt any peaceful or "pure" abstraction, De Kooning considered his art to always be wrapped up in a "melodrama of vulgarity."[56] To make his version of the primordial women even more contemporary, he painted popular sex symbols Marilyn Monroe in 1952 and Mae West in 1964.

Underlying De Kooning's immediate, personal, and cultural sources was the changing attitude toward women in the1940s resulting from the war. De Kooning's representation of Woman as a creature of the art-historical tradition and the modern banal is not new. For example, Reginald Marsh had used such a combination of Michelangelesque breadth and vitality in his working women at play in the 1930s (fig. 225). Something intervened to change

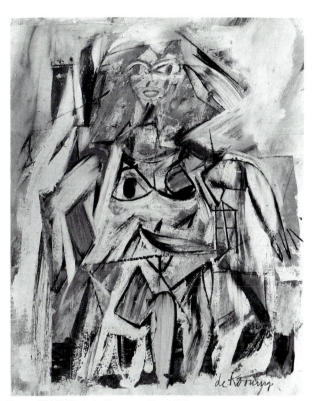

Figure 224. Willem de Kooning, "Study" for *Woman I*, ca. 1950. Oil and enamel on paper, with pasted color photoengraving. 14⅝ x 11⅝ inches. The Metropolitan Museum of Art. From the Collection of Thomas B. Hess, jointly owned by the Metropolitan Museum of Art and the heirs of Thomas B. Hess, 1984.

that 1930s icon into *Woman I* and psychologically to validate De Kooning's image as emotionally permissible. That was the war, the socially revolutionary experience that also profoundly altered relations between the sexes. Simply put, the war was an assault on prewar morality. The brutality of the war altered men and women's feelings about themselves, sex, and love. *Woman I* is not just an icon of desire but of human folly, not just an ancient art-historical talisman, but an involuntary response to the recent experience of women as talismans, the wartime and GI obsession, Women and sex.

War and sexuality have often been linked:

After considering the matter for centuries, the ancients concluded that one of the lovers of Venus is Mars. And Eros, some held, is their offspring. Since antiquity everyone who has experienced both war and loss has known that there is a curious intercourse between them. The language of military attack—*assault, impact, thrust, penetration*—has always overlapped with that of sexual importunity.[57]

The war brought a massive sexual revolution among American women and men. Citizen armies engaged in

total warfare produced profound changes in what were formerly small town American mores. Warfare and the conditioning of army life transformed soldiers into impersonal autonomous aggressors:

The psychological effect of lessons in hand-to-hand killing proved brutalizing. Lack of feminine companionship encouraged vulgarity, almost stilled courtesy. The individual civilians poured into the crucible of hate, brutality and organized murder undergo a subtle change. ... No matter how forceful or unusual the personality, eventually it succumbs to habit, discipline, propaganda and mass psychosis. He becomes a soldier with salient characteristics and reactions. He embodies myriad vices, virtues and traits including profanity, vulgarity, chronic complaining, skepticism, irritability, brutality, respect for rights of colleagues, disrespect and envy of civilians, loneliness ... a type of fatalism, despair, animalism.[58]

It was a time of quick, intense, impersonal, and anxious sexual license and the development of mass vulgarity and obscenity. Wartime romance filled the imagination of both sexes leading to "furlough fashions," hasty marriages, anxious separations, and short passionate affairs born out of loneliness, isolation, and fear. Sexual slang was the argot of the day.

Hard drinking and the denial of privacy were common features of military life. So was self-assertion in a virtually exclusively male society for months, and in the Pacific, years on end. Coarse language was often used with sexual explicitives to discuss contemptuously "Women, Women, Women." Irwin Shaw explains:

Occasionally a soldier will deviate a little and his control will leave him, like a pitcher tiring in the late innings, and he will talk about frivolous things like what he thinks ought to be done with Germany after the war. But very soon he will catch himself and start talking about the blonde girl he knew back at Purdue who measured thirty seven and three quarter inches around the chest, so help him God.[59]

James Jones speculated on the reason for such conversation: "When the presence of death or extinction are always just around the corner or next cloud, the comfort of women takes on a great importance."[60]

Pinups were used to alleviate and to focus fears and obsessions. Betty Grable and others were most popular, but Jane Russell's full figure resting in a pile of hay was the most erotic and made her famous before her movie, *The Outlaw*, was ever released (fig. 226). It was advertised with slogans suggesting that there were two big reasons to see the movie. Such an image made clear that the experience and mind-set of male barrack life had penetrated civilian life to such an extent that it was being commercialized. Domestic culture was being transformed by the culture of military experience and life. Pinups, a famous British cartoon heroine Jane, and the pictures in *Stars and Stripes* were often patted or touched before

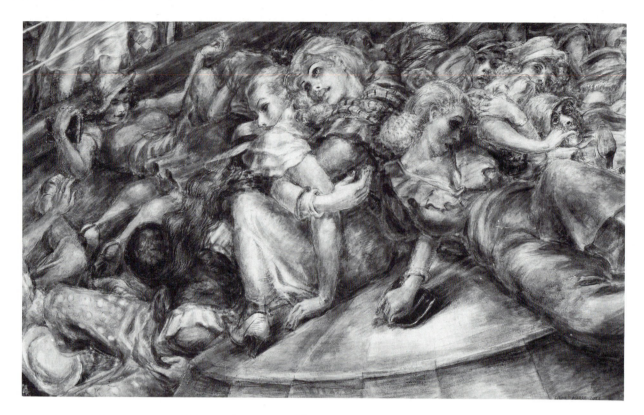

Figure 225. Reginald Marsh, *The Bowl*, 1933. Tempera on masonite. 35⅞ x 59¹⁵⁄₁₆ inches. Courtesy of The Brooklyn Museum. Gift of William T. Evans.

and after combat and thereby became the literal talismans of the Second World War. And the common habit of giving one's war machine, whether ship or plane, a female name or decorating it with a female icon revealed a great deal about the relation of the psychology of war, sex, and comfort.

Both individual soldiers and collective government freed themselves from civilian society with wartime obsessions and promiscuity. Wartime broadcasts to sow dissent included information about the sexual lives of German general staff and Nazi party bosses. Wartime entertainment, especially the USO shows, emphasized the sexual, causing uproars back home. The frenzied search for instant pleasure overcame both men and women, for they knew that the soldier might not be there or alive tomorrow. Newspaper descriptions of jitterbug marathons and swing dancing reveal the deep psychological fears: "this noisy exhibition of abandoned convulsions was all in keeping with a mad world in which madmen are conflicting to dominate the continent."[61]

Behind all this bravado was fear and anxiety. Nell Kimball, a famous New Orleans madame, described the feeling that gripped the male population in time of war.

"I've noticed it before, the way the idea of war and dying makes a man raunchy, and wanting to have it as much as he could. It wasn't really pleasure at times, but a kind of nervous breakdown that could be treated with a girl and a set to."[62]

The "comfort of women" was often found in the dislocated, lonely, and frequently desperate Allied and Axis female population. At home, soldiers waiting for postings overseas had nothing to do on weekend passes in small towns except seek out female companionship. The romance of the uniform was powerful for most women at the time.[63] For other soldiers, companionship was soon provided by entrepreneurs. There was an explosion of brothels, including the notorious "brothels on wheels," and it was big business: one house in Hawaii made ten million dollars a year during the war. Venereal disease was rampant, and there was constant worry in the Allied High Command about the health of soldiers and the possible loss of troop strength. The United States forces began providing prophylactics for its troops. In Europe where victorious armies were greeted warmly by both professionals and the unprofessional, promiscuity became rife (fig. 227). In England:

288

Figure 226. Jane Russell in *Outlaw*, 1943. Courtesy The Museum of Modern Art Film Archives.

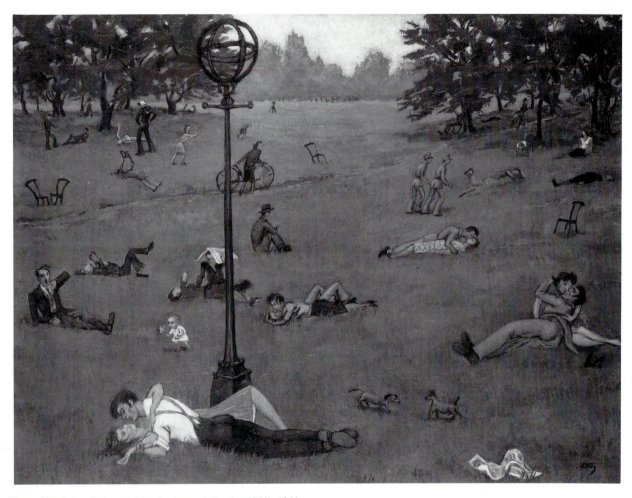

Figure 227. Emlen Etting, *Holiday Battleground (London 1944)*, 1944. Courtesy Midtown Gallery.

The girls were there—everywhere. . . . At the Lyons Corner House on Coventry Street they came up to soldiers waiting in doorways and whispered the age-old questions. At the underground entrance they were thickest, and as the evening grew dark, they shone torches on their ankles as they walked and bumped into the soldiers murmuring "Hello, Yank," "Hello, soldier," "Hello, dearie!"[64]

In wartorn Naples virtually a third of the female population engaged in some kind of prostitution. In Germany the defeated population had to survive somehow and the GI with his paycheck and PX privileges and loneliness solved that. Although officially discouraged, fraternization with German women was common.

Military victory had been won by millions of young men wrenched from local towns and villages and thrust out into a dangerous and lethal world. Basic patterns of life had been disrupted for so long that mass wartime psychology could not be easily turned off nor soldiers and civilians reconditioned overnight, if ever. In the postwar world the prevalence of wartime psychology could be seen in immensely popular war novels such as Norman Mailer's *The Naked and the Dead*, James Jones's *From Here to Eternity*, and Irwin Shaw's *The Young Lions*, which portrayed the relations between violence, sex, and the role of the individual in a mechanistic war.

Combat was presented . . . as either sublimation of sexual energy or as direct sexual release. The characters battled their way . . . in search of an emotional catharsis on the field of battle, making their choices between heroism, wanton butchery, or cowardice. . . . In [an] . . . echo of their military conditioning, male potency was usually equated with an individual's prowess as a warrior—and comparisons were frequently drawn between a soldier's ungovernable sexual impulse and the war itself. . . . Not only did these books play an important part in preparing the public for a more open and explicit discussion, [much as the publication of the Kinsey report did in 1948] but one of the main themes—the

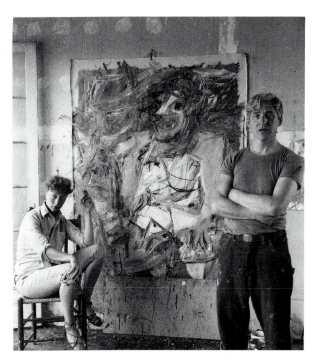

Figure 228. Willem and Elaine de Kooning, 1953. Photo: Hans Namuth.

confrontation between the final human citadel of sexuality and man's technological capacity for self-destruction—was to become the focus of much contemporary literature.[65]

De Kooning's *Woman I* and his subsequent Women paintings—indeed, his increasingly aggressive images throughout the 1940s and 1950s—are rooted in the social, sexual, and imaginative effects of the coarsening and promiscuity of the war. *Woman I* turns the cubist language of penetration and the Abstract Expressionist theme of vitalism into a theatrical set-to of implicit sexual thrust and counterthrust, aggression and barely contained forces.[66] The lewd form of *Woman I,* with the newly popular Jane Russell-type, large-breasted figure, strikes the familiar image of the predatory "Hello, dearie" and unites Woman with the fundamental themes of postwar cultures—sex and violence. Is it accidental that the most popular male image to emerge in the postwar years—Marlon Brando playing the crude, violent, but highly muscular and sexy Stanley Kowalski in *A Streetcar Named Desire*—wore and popularized the T-shirt that had been strictly GI underwear until that time? And that De Kooning himself (fig. 228) struck a pose in this domesticated wartime artifact?

In the figure's exaggerated form, De Kooning's belief that it is "hilarious" is realized. *Woman I* presents a melodramatic theater of the body and of the menacing forces of flesh, a farcical dramaturgy to contrast with the

solemn stages and actors of Rothko's and Baziotes's figures. With deceptive comic smile, ludicrous, fantastic anatomy, and frenzied flesh, the figure not only records the end of American sexual innocence, and the prewar (if not nineteenth-century), genteel, subtle Claudette Colbert–type figure and concepts of personal relationships, but makes a travesty of boy-girl relations. For De Kooning, what has come out of the war is absurdity and folly. Satire and comedy are the appropriate modes for his history as fiction, for what comes after the prewar code of subtle human warmth and intimacy between the sexes is its antithesis—forthright aggression and carnality. The absurdity of desire and hope abridged resides in this figure. As Fussell notes, "Every war is ironic because every war is worse than expected. Every war constitutes an irony of situation because its means are so melodramatically dispropriate to its presumed ends."[67] The figure of *Woman I* is rent by a rhetoric of anatomy melodramatically disappropriate for prewar but not postwar experience.

De Kooning alone made women the central focus and representative image of the modern experience and consciousness. *Woman I* is an appropriate image for the duality of Eros and Thanatos, woman and nature, a ruthless, amoral primordial/present, victim/assailant. While he paints a single figure, she is more than that—she is a single example of something larger than herself, another variant of the Abstract Expressionist totemic forces. She represents the "genrification" of the Abstract Expressionist totemic emblem and the renewal of the archaic as the loss of civilization.

CITY VITALISM

From 1951 to 1955, De Kooning worked with his woman image in both drawings and paintings. Anatomy, his emblematic figurative force born of stroke, became paint and then abstract evocation of place. Painterly flux dispersed into environmental activity. What was inside became outside too. The figural continuum was transformed into a spatial one again, like his portmanteau abstractions. The shaping of active fragments, of glimpses and impressions became his "no-environment."[68] This time the shapes and fragments are evocative of the mood and feeling of a place, glimpsed through a popular philosophy, New York existential thought.

Paintings such as *Police Gazette* of 1954–55 and *Gotham News* of 1955–56 (fig. 229) refer in title to the pulse of New York City. Elaine de Kooning said the titles reflect sex-and-violence tabloids found at newsstands.[69] The paintings themselves conjure up the hectic, bustling squalor and activity of the city. De Kooning ascribed to the city an image of rectilinear forms in instability and constant change.

Shapes overlap, speed, flow, crash within an envelope of vignettes. Forms are less identifiable, if they can be identified at all, than in paintings of the late 1940s. To retard drying in *Gotham News,* De Kooning temporarily affixed newspapers, which when removed left ghostly imprints. These function as suggestive fragments of contemporary news and city life, comparable in a way to the ghostly allusions of anterior form and life of Rothko, Baziotes, Tomlin, Pousette-Dart, and Martha Graham. Unlike them, however, De Kooning's subsurface ghosts allude to the vulgar present.

Garish reds and sooty yellows and blacks suggesting dirty walls and graffiti as well as city streets evoke the dense squalor of the city. Shapes have absorbed energy; they expand and travel, and there is no clear beginning or end to either the image or the picture. With the abstract massing and packing, De Kooning once again rested his image on activity, stream, continuity, force, and vitality.

De Kooning citified or urbanized Abstract Expressionist vitalism, that is, he temporarily rid their concept of continuous force of its organic basis and reattributed it to the energy, the movement, the flow of traffic—in short, to the experience of the city. This urban vitalism would have enormous consequences for American painting of the 1950s. De Kooning, along with another urban vitalist, Franz Kline, simultaneously led and reflected this development. The change is instrumental in the definition of fifties art and the New York School, which made the city a subject. Indeed, De Kooning's influence, directly and through Kline, undoubtedly lies behind the style of the New York School. His theme of the active city is fully consistent with many of his earlier interests. Additionally, the change from a single figure to the city environment and its mood may have been the direct or indirect result of the impact of Rosenberg's Action Painting idea, which gained immediate popular acceptance in 1952–53. It should be remembered that Rosenberg had De Kooning in mind when he wrote the article on Action Painting. Hess added further to the notion of a De Kooning existential Action Painting process when he wrote about and illustrated the continual process of adjustment and alteration in De Kooning's creative method.[70]

This notion of Action Painting dominated interpretation of the artist for years.[71] According to Action Painting, artists are not interested in making a painting but in engaging and freeing themselves from the past in the act of painting. Meaning and intentions are defined by and limited to the act of painting. Form and image are of secondary importance in an ultimate process of searching for self. Painting involves keeping oneself open to all possibilities and contradictions, to resisting all systems and "isms." De Kooning's method, his open form, his engagement with the realist everyday world, and with the city,

his concept of the stream, and the lack of finish in his final image were dressed up in existential cliché.

De Kooning's art needs no existential purpose ascribed to it. His continuously open figures, his realism, and his method of continuous adjustment were already in evidence, long before the advent of existentialism in New York. And much of what was described as Action Painting or existential in the fifties was simply a realistic/urbanized version of forties ideas.[72]

There is, however, some evidence of existential influence and parallels to existential thought in De Kooning's work. De Kooning himself said, "We weren't influenced directly by Existentialism, but it was in the air, and we felt it without knowing about it. We were in touch with the mood."[73] At some point De Kooning read Kierkegaard, whom Hess described as one of De Kooning's favorite philosophers. De Kooning also titled a reclining nude he showed at Allan Stone's gallery in 1964 *No fear but a lot of trembling* after Kierkegaard's *Fear and Trembling.*

In a way, though, De Kooning is something of a natural existentialist, if existentialism is defined as having one's idea in a state of constant flux, as never achieving a fixity to them or to one's artistic self-image, and as seeing the creating of a painting as contingent on immediate experiences, whatever they may be.

De Kooning's openness and technique may truly reflect not mere philosophy but a postward trend. Newspaper travel reports in Germany, for example, intersperse accounts of sights and stimuli on the road with philosophic and historical reflections presented in a loose, anecdotal style. They reflect the antisystem, anti-ideology, and anti-order mood that dominated Europe after the cataclysm of the war. These accounts relate a series of adventures punctuated by contingent and unexpected fragmentary experiences. In postwar German journalism, life was seen as an open situation, and not a hierarchy of old or new, contemporary or past. In these writings there is a testing of impulses, ideas, readings, and events as though the authors were tentatively dipping into a totally new knowledge and experience in the wake of the destruction of all they had intellectually claimed or known.[74] There was of course no direct contact between De Kooning and German journalism, but its improvisatory style seems parallel to De Kooning's approach and mood; however it is only a mood. In the 1950s the Joycean, Eliotian, Giedionesque, Abstract Expressionist stream lost its complex, historical underpinnings and became understood as individual, free action.

PARKWAY PASTORALES

Without a figure and with an attention to environment and to the contingent, De Kooning engaged the landscape

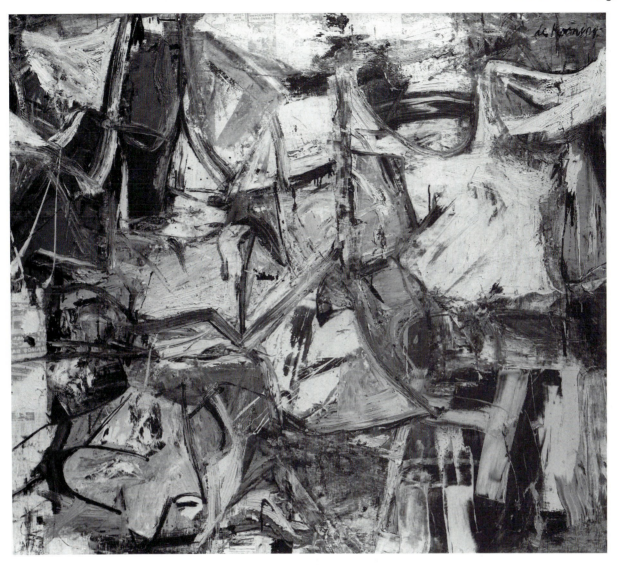

Figure 229. Willem de Kooning, *Gotham News*, 1955. Oil on canvas. 69 x 79 inches. Albright-Knox Art Gallery, Buffalo, New York. Gift of Seymour H. Knox, 1955.

in the late 1950s. On his journeys to Long Island at this time, De Kooning was increasingly taken with the landscape by the road and its horizons and "in-betweenness," that is, its position halfway between city and country. This landscape and the sense of movement through it, yet another face of the Abstract Expressionist theme of transit, were his next subject, lasting until he moved to Springs, Long Island, in 1963 after having a studio built.

Paintings such as *Parc Rosenberg* of 1957, *Pastoral*, and *Rosy-Figured Dawn at Louse Point* (pl. 24), both of 1963, reflect this turn. Natural colors predominate: earth browns, sky or deep blues, yellow lights, and an occasional reminiscence of his pink landscapes of the late 1930s. The pictures convey a sense of earth, air, sky, and even temperature and humidity. De Kooning has reduced, simplified, and enlarged his vitalist stroke forms and arranged them around the horizontal/vertical axes that also predominate in the urban landscapes. The mostly rectilinear strokes suggest concentrated and fluid blocks and planes of natural space. Yet the paintings still evoke De Kooning's earlier work in their sense of underlying cubist grid, torsion of form, forceful all-over spread, and even impact of splattered paint. In its title, *Rosy Fingered Dawn at Louse Point* also combines the ancient—"rosy figured dawn" from Homer—with the contemporary, dialectically opposite banal and vulgar sounding "louse point."

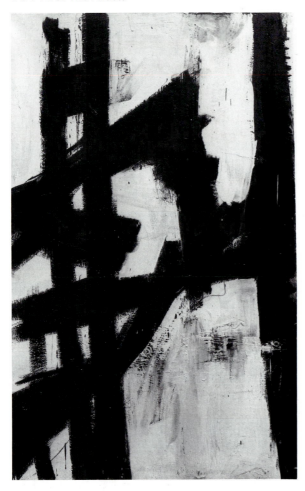

Figure 230. Franz Kline, *New York, New York*, 1953. 79 x 51 inches. Albright-Knox Art Gallery, Buffalo, New York. Gift of Seymour H. Knox, 1956.

No doubt De Kooning's close friend and fellow gesture artist Franz Kline partially lies behind this condensation, as De Kooning himself has admitted. The two artists reciprocate influence throughout the 1950s. Kline's black and white abstractions of the 1950s, such as *New York, New York* (fig. 230) and *Chief* were indebted to De Kooning's own early black and white work. Now De Kooning was influenced by Kline's own development. Kline's work is, on the whole, always simpler and starker than De Kooning's, which usually involves more variety of space and suggestions of form and object. De Kooning's parkway paintings allude to visual experience and recently identifiable objects, Kline less so.[75] De Kooning's Parkway Pastorales in turn then influenced Kline's last series of color paintings, such as *Provincetown II* of 1959,[76] although Kline's color paintings seem to be arranged configurations rather than the even flowing fields of his colleague.

De Kooning's urban parkways are wonderful developments of many of his interests. Their subject suggest the "result of associations . . . a highway and the metamorphosis of passing things."[77] Real things become cues for abstract forms, as De Kooning blurs the identity of something seen. Similarly, he was inspired by the idea of form in motion, of the flow, change, and metamorphosis of his environment.

Additionally, the very openness and contingency of reacting to what one encounters on the open road has an existential ring to it. The late fifties marks the time of the Beat generation and Jack Kerouac's *On the Road*. The road experience is a popular American iconic experience. A later version of this theme became a popular film of the 1960s, *Easy Rider*.

De Kooning's parkways suggest a stable, monumental, yet fluid, powerful, compressed but open experience that matches the visual and conceptual world they picture. Here form and idea are one. But for all their continuity with De Kooning's earlier approach, they suggest the emergence in explicit form of his late direction and theme: landscape as well as woman as nature.

LIPSTICK LANDSCAPES

De Kooning said *Woman I* reminded him of a watery feeling he associated with the country: "the landscape is in the Woman, and there is Woman in the landscape."[78] In 1955, he painted *Woman as Landscape* in his early 1950s style, but the unity or oneness of woman, water, and nature come to full fruition in his late work, begun in 1963 on Long Island. This new unity adds a smoldering, baroque richness to his work.

De Kooning's move to Springs inspired a new synthesis of many of his conceptual and stylistic themes, such as the fusion of tradition and modernity, past and present, the matrix continuum, woman as nature, environmental generation, the gentrification of elemental principles, the sexualization of the creative principle, and the prosaic popularization of Abstract Expressionism as a whole. These were reinvigorated by his move to the wonderful light, color, and air of the rural landscape of eastern Long Island. De Kooning told Rosenberg why the effect on his art of the move was so strong: "I wanted to get in touch with nature, not painting scenes from nature, but to get the feeling of that light was very appealing to me. . . . I was always very much interested in water."[79]

Among the first of his new syntheses of woman and nature is *Woman, Sag Harbor* of 1964 (fig. 231), painted on a wooden door. (De Kooning considered creating a triptych of wooden doors.) Inspired by a woman he saw on the streets of Sag Harbor,[80] the painting turns away

from the stable, monumental, even restful landscapes of even a year earlier and looks back to the sexual, erotic, voluptuous figures of the early 1950s. But unlike those, the figure in *Sag Harbor* is all of a piece; that is, De Kooning in this and many other figure paintings in the 1960s seems to begin with a more or less complete figure. In some ways, they are closer to his *Labyrinth* shape and appendage form than to his subsequent anatomical montages.

Woman, Sag Harbor and other figure paintings also display an increased amount of pink and red flesh. They deliberately recall the Renaissance tradition as De Kooning defined one of its origins: flesh is the "stuff people were made of" and the reason oil painting was invented.[81] These late figures writhe and shimmer in their very fleshiness. They scatter and spread, not so much in *Woman, Sag Harbor* and *Clam Diggers* of 1964 (fig. 232), as in others such as *Two Women* of 1964 and *Woman on a Sign II.* They remind one of De Kooning's admiring remark about Soutine, that he built a surface of flesh as substance and material.[82] And they recall Mann's exposition of the interior organic continuum:

What then was life? It was warmth, the warmth generated by a form-preserving instability, a fever of matter, which accompanied the process of ceaseless decay and repair of albumen molecules that were too impossibly complicated, too impossibly ingenious in structure. ... It was not matter and it was not spirit, but something between the two. ... Yet why not material—it was sentient to the point of desire and disgust, the shamelessness of matter become sensible of itself, the incontinent form of being. It was a secret and ardent stirring in the frozen chastity of the universal; it was a stolen and voluptuous impurity of sucking and secreting. ... It was a pullulation, an unfolding, a form-building (made possible by the overbalancing of its instability, yet controlled by the laws of growth inherent within in it), of something brewed out of water, albumen, salt and fats, which was called flesh, and which became form, beauty, a lofty image, and yet all the time the essence of sensuality and desire. For this form and beauty were not spirit borne. ... Rather it was conveyed and shaped by the somehow awakened voluptuousness of matter, of the organic, dying-living substance itself, the reeking flesh.[83]

De Kooning thus reintroduced the single figure in his late paintings. While their locations are not often clear—they are in a new version of De Kooning's ambiguous space—most of them are glimpsed in the countryside. This setting informs his color and his compositional and textural choices. Like the urban parkway series, the pictures seem full of land, water, and sky. It is largely impossible to distinguish end from means. De Kooning said:

When I came here I made the color sand—a big pot of paint that was the color of sand. As if I picked up sand and mixed it. And the grey-green grass, the beach grass, and the ocean was all

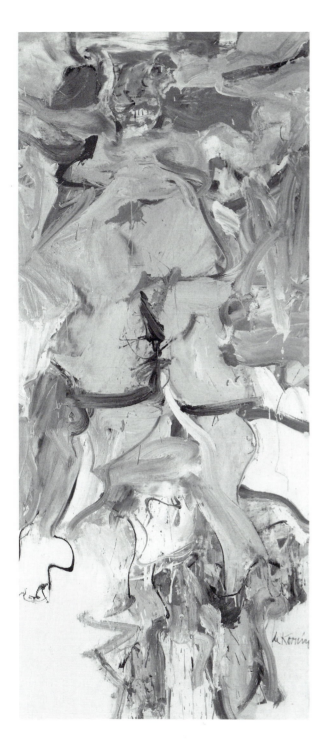

Figure 231. Willem de Kooning, *Woman, Sag Harbor*, 1964. Oil on wood (door). 80 x 36 inches. Hirshhorn Museum and Sculpture Garden, Smithsonian Institution. Gift of Joseph H. Hirshhorn, 1966.

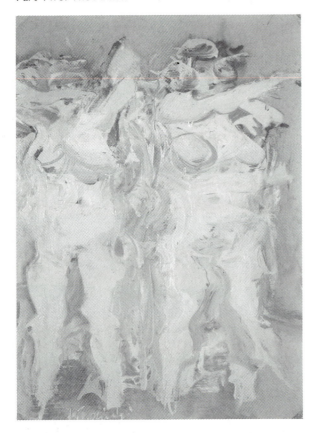

Figure 232. Willem de Kooning, *Clam Diggers*, 1964. Oil on paper mounted on composition board. 20¼ x 14½ inches. Collection Mrs. Tyler Gregory.

kinds of steely grey most of the time. When the light hits the ocean there is a kind of grey light on the water. . . . Indescribable tones, almost. I started working with them and insisted that they give me the kind of light I wanted.[84]

Woman in Landscape III of 1968 and *Woman in the Water* of 1972 (pl. 25), among many others, reflect this notion of paint as evocative of figures and nature. Pinks, blues, grays, yellows, and reds—along with the elimination of distinct figure contour and rhyming of stroke—merge the figure with the earth and water, the very color and substance of nature. Other paintings of the 1970s, such as *North Atlantic Light,* formerly *Untitled XVIII* of 1977 (pl. 26), evoke land and nature by themselves without reference to figural substance.

Most late paintings suggest combinations of figure and nature either through fragmented masses of strokes or deliberate signs of figures without full form. Few De Koonings of this time are without the color sign of flesh, pink. While he had used pink since *Pink Landscape* of 1938, the association of pink with flesh and therefore human form in his landscape is inescapable. It is flesh

without figuration. With the interpenetrating brushstrokes the flesh tones suggest the unity not just of figure with the ground but of figure with nature. In certain pictures, De Kooning distributes signs of anatomical parts to underlie this unity. In the top center of *Montauk I* of 1969 (fig. 233) and *Untitled XIV* of 1977, partial faces lurk and peer out from a frenzy of strokes. Along with the color and interchangeability of his shape-strokes, these anatomical fragments, as in the earlier *Attic* and *Excavation,* suggest the absorption of the human within the environment. This time the environment is nature. As some titles indicate—*Screams of Children Come from Seagulls* and . . . *Whose Name Was Writ in Water* of 1975—nature and man are the same thing.

De Kooning had long been attracted to the idea of extending the female form through her reflection in water. Such an image could be found in still photographs from the late-forties film *Bitter Rice* (fig. 234), in which the voluptuous Silvana Magnani and friends were immersed in the wet earth they worked as peasants. De Kooning associated his *Woman I* with such a memory of women by canals in his native Holland. And about figures in eastern Long Island, he said, "I'm working on a water series. The figures are floating, like reflections in the water. The color is influenced by the natural light. That's what is so good here."[85]

In his works of this period, figures are not just *in* the landscape but they *are* landscape itself. The fluidity, movement, light, twisting, and shimmering of similar forms, colors, and forces suggest and indeed represent their conceptual and pictorial intertwining. De Kooning said "I look for the part of picture . . . that is part of nature." For him, and for many of the interwar generation, humanity is nature in the sense of the life force. In De Kooning's words, "Its nice to hang around the whole day, sometimes, in the grey, then go home with the feeling that you're part of the world, with this greyness. The colors are better muted and the wind blowing everywhere is breathing life." De Kooning put it as clearly as Pollock, "Because I am nature, too."[86]

Coming from nature, the artist must also be nature itself. Like his colleagues, De Kooning wanted art to be a natural thing in and of itself. For all of his craft, De Kooning sought to make his paints crystallizations of nature: "I want a picture to seem as if it had grown naturally, like a flower. I hate the look of intervention of the painter always butting in."[87] Earlier he had said that "The attitude that nature is chaotic and that the artist puts order into it is a very absurd point of view."[88] Like Pollock's work and Abstract Expressionism in general, a painting has a life of its own: "I didn't plan it. It's just the way it came out."[89]

De Kooning's late abstract landscapes also contain archaic and primordial references. The trees outside his

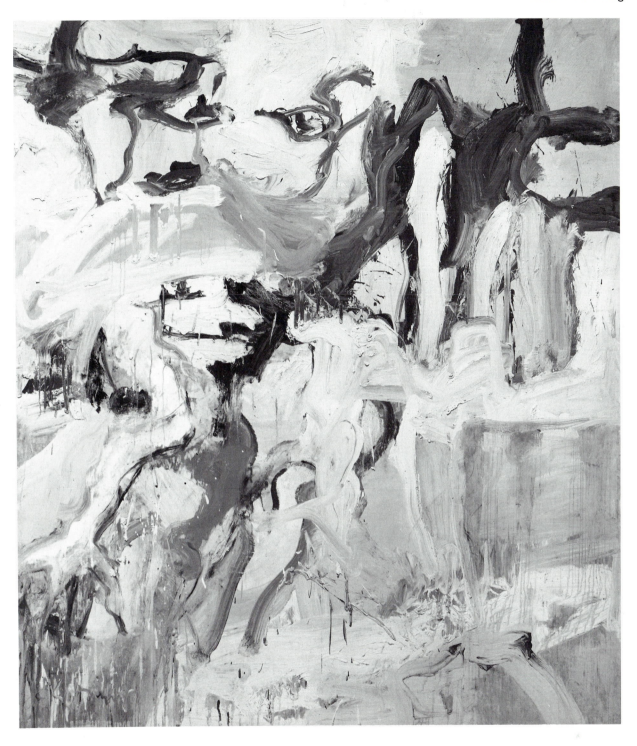

Figure 233. Willem de Kooning, *Montauk I*, 1969. 88 x 77 inches. Wadsworth Atheneum, Hartford. The Ella Gallup Sumner and Mary Catlin Sumner Collection. Photo: E. Irving Blomstrann.

Figure 234. Silvana Magnani in *Bitter Rice*, 1948. Courtesy The Museum of Modern Art Film Archives.

studio, he said, must have looked the way they did centuries before when the Indians were there. For De Kooning, that is "timelessness." He was also fascinated by the underbrush around him, "the entanglement of it. Kind of biblical."[90] Nevertheless, despite all the constant talk of timelessness, he typically felt "it is really commonplace."[91]

When asked in 1950 why he was working in only black and white, the artist replied that among other reasons, color is "a great seducer."[92] With the reemergence of color in these later works, De Kooning re-explores sexuality. In some of these later works, it is signified by allusions to erotic women, some with legs open as in *Woman in the Water* and *Woman on a Sign II*. While such poses are to be seen many times at the beach—the figure in the former picture seems to be seated in a beach chair—and are thus typically banal, they also reflect the pose of a Pre-Columbian sculpture De Kooning owned. Other pictures with figures in related positions are even

more explicit: the woman in *Woman on a Sign II* with red for her genitals almost anticipating magazines like *Hustler;* and in a rare *Man* of the same year, the erect earth-colored phallus of a man who may also be sitting in water. Other works convey a sense of fertility not through human image, although that is always implicit in a De Kooning, but through the very sensuality and richness—the voluptuousness—of the paint. The swelling, lush, writhing biomorphic strokes suggest an abstract Rubensian fertility. The watery, fluid, bright, and even garish paint made of pigment and safflower oil has such a looseness to it that it could be considered sleazy, like an overly made-up woman with bright lipstick.

In many ways, these last abstract landscapes are comparable to other Abstract Expressionist artists' work. While De Kooning accepts and is flattered by comparisons to Matisse, these works once again echo Gorky, especially such painterly works as *Flower of the Watery Mill.* They

evoke Pollocks such as *Eyes in the Heat*, with the swirling strokes of paint dotted with eyes. The figures enmeshed in landscapes also resemble later Pollocks such as *Echo* and *Number Five, 1952*. And they epitomize themes of interwar/war periods as found in Masson's *The Earth* of 1939 (fig. 235) and Henry Moore's reclining figures. Moore's sculptures are similar to De Kooning's work in their complex associations. They too tie together references to the primordial of Pre-Columbian sculpture, the classical of the grand tradition, contemporary everyday figures, and landscape material and shape. Moore also recalls the human as nature, embedded in the earth and in the artistic imagery of human history. Both artists present the world to be experienced through the human body. De Kooning's view of that world, reflecting his Dutch background and the experience of World War II, however, is much harsher.

Irony abounds again. Allusions to the pastoral were common in English literature, especially the writing of Edmund Blunden. In the First World War nature was represented as something innocent, comforting, restorative, and hence antithetical to the landscape being experienced on the Western front.[93] For De Kooning and the surrealist/Abstract Expressionist generation, nature was dualistic and hence ironic: the more it forms a symbol of an oasis, the more it undercuts this idea with its underlying reality as the source of aggressive instinct. Their nature is a modern version, as so much Abstract Expressionism is, of the old myth *Et in Arcadia ego*, of death in Arcadia. Again nature is a symbol of the duality of human nature and the struggle within and without. De Kooning's modern pastorales are redemptive but perilous ironies.

Figure 235. André Masson, *The Earth*, 1939. Sand and oil on wood. 17 x 20⅞ inches. Georges Pompidou National Museum of Modern Art, Paris.

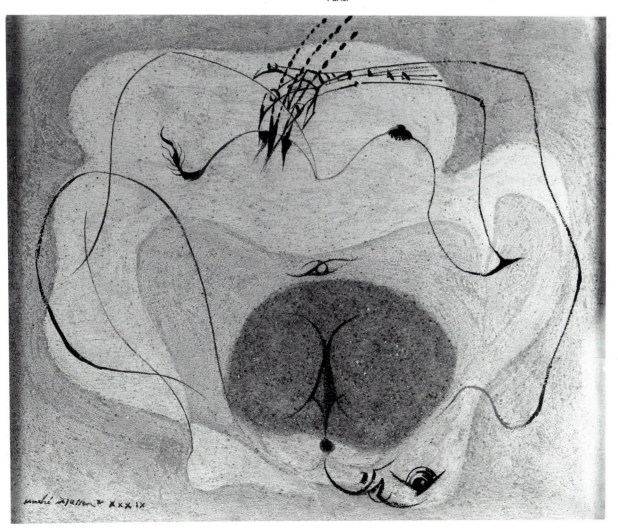

299

CONCLUSION

De Kooning's late work presents a painterly biomorphism and vitalism, a sense of the human, implicitly or explicitly present, spreading out before us and engulfing us. Even the new works of the early 1980s, while De Kooning seems to be once again moving into a simplifying phase, evoke the figure/nature image. For an Abstract Expressionist, the world is an organism and human life is to be expressed by the life of nature. As De Kooning said in 1950, "There is a time when you just take a walk: and you just walk in your own landscape."[94]

Robert Motherwell engages Abstract Expressionist history and culture in a unique manner. He stands astride three generations of art—the School of Paris, Abstract Expressionism, and the New York School—as he attempts to make his art the heir to European modernism.

ROBERT MOTHERWELL

The School of Paris Meets New York

Among the Abstract Expressionists, Robert Motherwell is the heir to the grand modern tradition. No other member of the Abstract Expressionist group has been so devoted to extending it and associating his art with it. In fact, first as a contributor to the Abstract Expressionist magazines and co-editor of one, *Possibilities,* then as an editor of *The Documents of Modern Art* series, he became the spokesperson in America for both modern art in general—as all Abstract Expressionists often had to be in the 1940s—and for Abstract Expressionism in universities and in liberal opinion. His numerous statements, his longevity, and his work have thus tended to orient popular notions of Abstract Expressionism toward his conception of it as the subjective expression of a private statement and as the pictorial realization of personal emotion. Motherwell also aligns Abstract Expressionism strongly with ideas of the universal as the extension of the personal and with the simple symbolist "correspondences" between feeling, idea, and form. His work blurs the differences between Abstract Expressionism and the New York School which, in perfect symmetry with the "grandfather" model of history, was in tune with a more personal and mundane world of earlier School of Paris modernism. Motherwell's art and thought parallels, blends into, but also stands apart from mainstream Abstract Expressionism. Like many artists discussed in the next chapter, he adapts the themes and topics of Abstract Expressionism to his broader and looser conception of modern art.

Like Degas among the Impressionists or Prendergast among The Eight, Motherwell exhibited with the Abstract Expressionists but ultimately must be considered as a separate and distinct artist. Despite his self-appointment as spokesperson and catalyst for Abstract Expressionism,

only parts of his work can be considered as representative of central Abstract Expressionist tenets, among them, vitalism, duality, drama, tragedy, monumentality, and the range of human possibility. Motherwell's repeated emphasis on personal feeling, spontaneity for its own sake, autobiographical event, gesture, and mutability of form between the actual visual world and pictorial abstraction is a very personal variation on the School of Paris, Abstract Expressionism, and the New York School welded together. The locus of his art and thought is not in Abstract Expressionist discourse about an ancient and historical collective but in a world of artistic form and everyday experience raised to the level of universal experience, a more French mode of modernism. Motherwell has the Romantic capacity to turn the mundane personal incident into destiny.

Chronology helps explain his position. Motherwell, born in 1915, was among the youngest and least artistically experienced of the Abstract Expressionist group. Motherwell and Newman are the only Abstract Expressionists for whom there is no artistic record for the 1930s. In other words, in contrast to most of the others, Motherwell did not start painting until 1940–41, after Meyer Schapiro advised him to paint (advice Schapiro has given to many, including this author, through the years). In the 1930s, when most of his future colleagues were on the WPA, Motherwell was a student at Stanford and then at Harvard and Columbia, where he studied philosophy. He missed the powerful and formative artistic experience of that decade—ten years of crisis and search for the redefinition of art. Instead Motherwell arrived in New York in the early forties, picking up on the movement to modernism but without his colleagues' sense of urgency and despera-

tion or the thematic undercurrents of the 1930s which continued to reside in their work.

Motherwell's turn to modern art was partially intellectual, for his years in school had acquainted him with elements of the modern intellectual tradition. He had traveled to Europe to work on a paper on Delacroix and romanticism and to study French culture. As he described his differences from the others at the beginning of the war:

One of the things that struck me then was how little general interest there was in Paris per se. When I first began to love Parisian painting, as an adolescent, it occurred to me that this painting was that of a cultural milieu, not that there happened to be a lot of gifted men in one place. And I set out teaching myself modern French culture as I could. I also spent a year, 1938–39, in Paris, before New York.[1]

He knew of Freud,[2] Joyce, and the symbolist poetry tradition independently of painting. Motherwell may have been more friendly with European artists than Americans at this time. In 1941 he went to Mexico with Matta who, with Wolfgang Paalen, introduced him to surrealism.[3] He was a foreigner to the New York scene because he had never been forced to endure what his colleagues had.

In a way Motherwell is the first artist of the post–Abstract Expressionist generation concerned with a lyricism, hedonism, and subjectivity that are more typical of the 1950s. At the same time, he admired both the School of Paris and such figures as Matisse, Brancusi, and Moore. Thus, while the other Abstract Expressionists were seeking sources in ancestral archetypal behaviors, world culture, ritual and totemism, and Greco-Roman tragedy, Motherwell was also interested in the pleasures of life, the search for self-authenticity, and other fifties themes. Only Lee Krasner, briefly, and Hans Hofmann combined a similar School of Paris interest with Abstract Expressionism and the New York School.

Motherwell constantly emphasized feeling for its own sake. As early as his discussion of Mondrian in 1942, he defined modern art as rejecting the external world because of a necessity to come to terms with the "felt quality of reality."[4] From the beginning he saw the art of his time as seeking to objectify emotion. He also saw feeling in Romantic terms of bridging the gulf between one's lonely self and the world. "The need is for felt experience—intense, immediate, direct, subtle, unified, warm, vivid, rhythmic. Everything that might dilute the experience is stripped away. ... Abstract art is an effort to close the void that modern men feel."[5] He described an *Auto-Portrait* as not abstract because it is an imaginative representation of himself. "It's feeling-content happens to be just how I feel myself (hence its name, 'Auto-portrait'), expressed as directly and clearly and as relevantly as I can

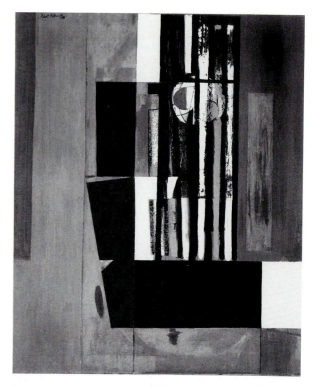

Figure 236. Robert Motherwell, *Spanish Prison Window*, 1943–44. 52¼ x 42¼ inches. Courtesy Philadelphia Museum of Art: Private Collection.

communicate the concrete pattern of my senses."[6] And he rejected merely formal art. Art is also an expression of an artist's identity: "An artist's mind is finally ... relevant to all, whether they see it or not, for it is only a medium as subtle and exact in feeling as art that can express the felt truth, which after all, is one's identity of being."[7] Thus while his colleagues were writing and painting "ancient truths" of space and time, Motherwell was searching for himself through feeling and form, a very European and New York School but not very Abstract Expressionist mode. His colleagues' idea of originality was to submit themselves to the ancient or collective imagination and extend and add something to it; his was to represent personal emotion in a new, inventive way.

Motherwell is thus neither a complete first- nor second-generation figure, as an examination of important parts of his work makes clear. His early work is typified by *The Little Spanish Prison* of 1941, *Spanish Prison Window* of 1943–44 (fig. 236), and *Pancho Villa, Dead and Alive* of 1943 (fig. 237). The first two may have been suggested by Henry Moore's print *Spanish Prison* of about 1939 (fig. 238) which was circulated in America to raise money for soldiers of the Spanish Civil War.[8] They use semi-abstract form and composition—linear shapes and windows, one with a figure behind bars—to present a pictorial equivalent

to the idea and feeling of a Spanish prison. *Pancho Villa, Dead and Alive* consists of two semifigurative shapes— from Picassos such as *The Studio* of 1927–28 in the Museum of Modern Art, and from Mondrian and Matisse—disposed between rectilinear shapes, thus forming an ensemble of the organic and the architectonic. Though seeming like a Rothko in this, Motherwell's painting is very different. Rather than presenting a complex of signs of the past, Motherwell chose a remote twentieth-century event that he took from a book. *Pancho Villa, Dead and Alive* was partially inspired by photos of the Mexican revolution and especially of Pancho Villa's bullet-riddled body.[9]

The subject is topical, but its associations with immediate events of contemporary history or the Second World War are negligible. (He did do a painting called *La Resis-*

tance in 1945.) In 1951 Motherwell made a revelatory statement that shows his awareness of what was current while at the same time rejecting it. In a talk on "The Rise and Continuity of Abstract Art" he said, "The recovery of the past through the present needs teaches us what is relevant. That is, the immediate demands of one's subject matter determine what is living in past cultures. But the subject matter of modern art is another topic."[10] But is it? Not for other Abstract Expressionists, for whom the past lives today as it will live tomorrow. For Motherwell, modern art is partially the product of exclusively contemporary feelings of modernity. For the others, most often the contemporary is a single, uniquely formed instance of the traditional round of human affairs.

The evocation of Spanish and Mexican, that is, the

Figure 237. Robert Motherwell, *Pancho Villa, Dead and Alive,* 1943. Gouache and oil with collage on cardboard. 28 x 35⅞ inches. Collection The Museum of Modern Art, New York. Purchase.

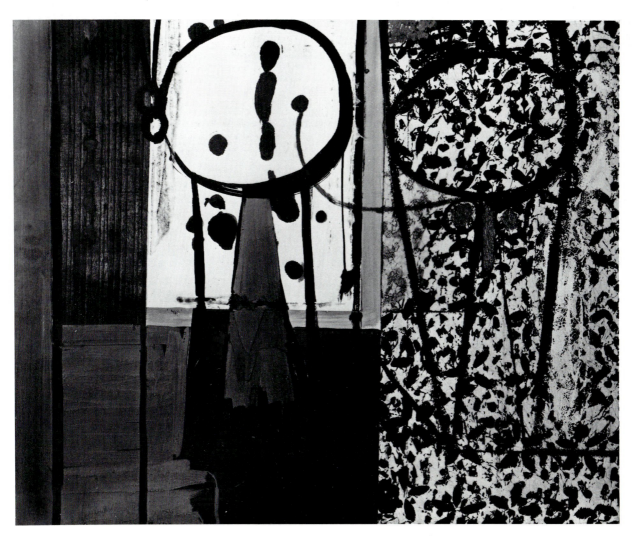

Figure 238. Henry Moore, *Spanish Prisoner*, ca. 1939. Lithograph. 14⅜ x 12 inches. Art Gallery of Ontario, Toronto. Gift of Henry Moore, 1976.

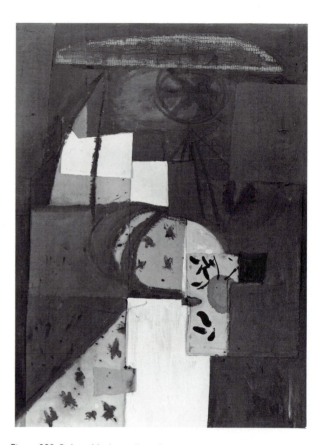

Figure 239. Robert Motherwell, *In Grey with Parasol*, 1947. Collage and oil on canvas. 47⅜ x 35½ inches. Art Gallery of Ontario, Toronto. Gift from the Women's Committee Fund, 1962.

ethnic and foreign, was part of Motherwell's cultivation of foreign countries. The lure of the foreign and the exotic is both Romantic and very American—the sense that High Culture is somewhere else, usually in Europe. When he painted *Little Spanish Prison*, Motherwell had just returned from Mexico, where he saw Mediterranean culture and folk art for the first time. Beginning with *Spanish Prison Window*, Motherwell frequently associated color with a culture or a particular modern artist. For example, red and ochre can signify Mexico; blue—sea and sky—Matisse and Picasso.[11] He uses Mexican folk colors as well as the sharp differentiation between color in a similar associative way. Other associations are with feelings—white for éclat, yellow for freedom, orange for happiness; a flutter for the intimate, large and architectural forms for the monumental and austere.[12]

His evocation of a place, its experience, and its culture, while superficially similar to the Abstract Expressionists' use of Egyptian or Greek or Native American association is ultimately different. While the other Abstract Expressionists construct a human pattern across layers of time and space, Motherwell uses the country to signify some general principle or event: the Spanish Elegies represent contemporary political tragedy, as does the green *Irish Elegy* of 1965.

Motherwell's use of Mediterranean color or shape to evoke a country is closer to the early tendency in twentieth-century art to use a national tradition to evoke a heritage and its significance. For example, Maillol's *La Mediterranée* with its pneumatic forms signifies the classic past of France as stable structure, and Nolde and the German Expressionists used the gothic and the woodcut to evoke Germanic anxiety and pathos. Motherwell is heir to this type of natural or ethnic evocation rather than to the construction of a tradition of the psychic life and heritage of the world. Interestingly, Mann in *The Magic Mountain* stands between these uses of other cultures. In his novel, he uses the Slavs to symbolize passivity, mysticism, and tyranny; the Italians for Renaissance rational humanism, belief in progress, and republican governance; and the Germans to mediate and balance the two modes of culture, government, life, and psyche.

What seems lacking in Motherwell from the start are the fundamental subjects of the Abstract Expressionists—

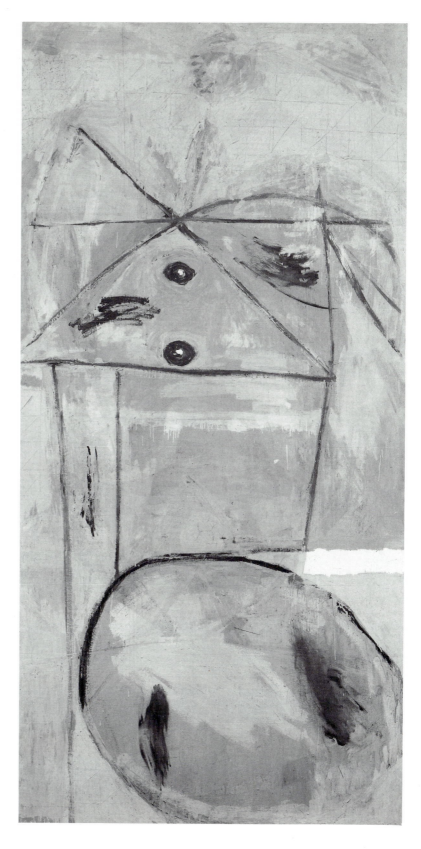

Figure 240. Robert Motherwell, *The Homely Protestant*, 1948. Oil on composition board. 96 x 48¼ inches. The Metropolitan Museum of Art, New York. Gift of the artist, 1987. (87.60)

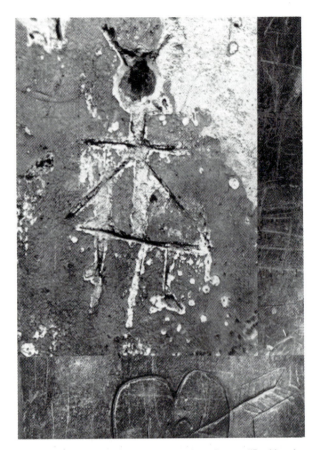

Figure 241. Brassai, Parisian walls, detail, from Brassai, "Du Mur des Cavernes au Mur d'Usine," *Minotaure* 3–4 (New York: Arno reprint, 1968), p. 7.

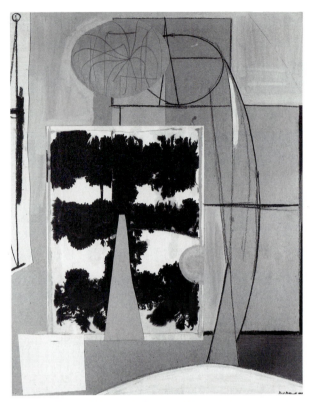

Figure 242. Robert Motherwell, *Figure with Blots,* 1943. Oil and collage on paper. 45½ x 38 inches. Courtesy David Mirvish.

nature, with all its implications of the connectedness of the internal and external world; primal psyche, with its survivals, struggles, prototypes, and inheritances; and the past and primitive, with their rituals, totems, memories, ancestral sources, and traditions. Instead he generalizes from the subjective, the personal, the eventful, and the quotidian. Jung's division of the artist into the psychological and the visionary is most appropriate and revealing for much of Motherwell's art and its relationship to the Abstract Expressionists. Motherwell's interest in inner life, like that of the Schools of Paris and New York, relates to Jung's concept of the psychological and not to the primal visionary and the space/time continuum. The central stream of Abstract Expressionist art invokes the primordial, the demonic, the cosmic, the fecund, and the abyss while Motherwell most often invokes passion, love, joy and sorrow—the foreground of life. Few maturing Abstract Expressionists would have done subjects such as *In Grey with Parasol* in 1947 (fig. 239), a painting that evokes simple pleasure, the forms perhaps inspired by figurative Picasso and a charming but mundane figure in Seurat's *A*

Sunday Afternoon on the Island of the Grand Jatte;[13] or *The Homely Protestant* of 1948 (fig. 240), with its simple, thinly drawn stick figure derived from Picasso, perhaps Brancusi (*The Little French Girl* and *Newborn*), and Brassai (graffiti on Parisian walls [fig. 241]). In the last, the rough surface of the wall and the shapes are quite similar to the Motherwell.

Motherwell's use of automatism suggests a further difference. While he earlier popularized the view that surrealist automatism was to be used only in a plastic way— that is, as a means to suggest forms that evoke personal feeling, as in *Figure with Blots* of 1943 (fig. 242)—his view is personal. He understood the surrealists' use of automatism as a mode for beginning to assemble a dream world of semireal yet fantastic forms. The Abstract Expressionists used automatism as a starting point for the descent into the buried past of our unconscious and the Joycean stream of our ancient being. As Gottlieb noted in a discussion of totemic themes and memories, "If it was right for Delacroix and Matisse to travel to far and strange places like Tunis and Tahiti for subjects, what is wrong with travelling to the catacombs of the unconscious, or the dim recollections of a prehistoric past?"[14] For both the Surrealists and the Abstract Expressionists, automatism

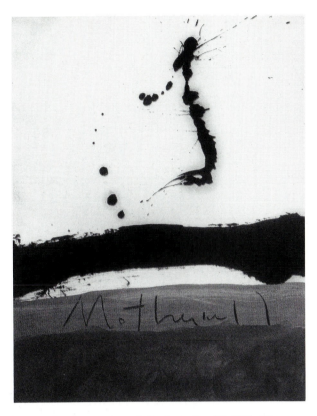

Figure 243. Robert Motherwell, *Beside the Sea #2,* 1962. Oil on rag paper. 29 x 23 inches. Courtesy Knoedler Gallery.

was a rationalization for beginning a painting without a visual subject. Motherwell, however, uses it more formally, as a creative principle, to construct paintings and subjects that would end, although they did not begin, in an evocation of elements of the visual world such as walls, rooms, semi-abstract figures, and other forms associated with the foreground understanding of political events, life, and culture. Motherwell uses automatism as a technique, without the underlying combination of surrealism and Joyce that propels his Abstract Expressionist colleagues.

Motherwell did link automatism and psychology when writing of the *Spanish Prison*, which he said consists of "a dialectic between the conscious (straight line, designed shapes, weighed color, abstract language) and the unconscious (soft lines, obscured shapes, *automatism*) resolved into a synthesis which differs as a whole from either."[15] He added, "The hidden Spanish prisoner must represent the anxieties of modern life, the intense Spanish-Indian color, the splendor of any life."[16] While the comment about the synthesis is a standard Abstract Expressionist concern, the painting itself supports the second sentence: it foregrounds modern anxieties and their association to topical political events as well as evocations of culture

through color, rather than tapping the past and fusing it with the present.

Other automatist works throughout Motherwell's career, such as the *Iberias, Spanish Painting with the Face of a Dog,* both of 1958 and the *Beside the Sea* series of 1962 (fig. 243), were made by a creative principle of doodling, of drawing without preconception, then recognizing something emotional or visually subjective, and then completing the form. Though he continually attributed the beginning of Abstract Expressionism automatism to his influence, Motherwell's concept is an original contribution: he made it into a way of directly translating impulse and feeling onto canvas.

The fusion of feeling and form, the simple automatist spontaneity, and the structural are present throughout Motherwell's work. They are clearly evident for example in the very un-Abstract Expressionist series of the fifties, the *Je t'aime* paintings. *Je t'aime, #2* of 1955 (fig. 244) consists of the words "Je t'aime," which seem to be written on a wall, and some organic shapes. These works underscore Motherwell's use of a canvas as wall surface. While Rothko, of course, employed architectural forms and allusions to evoke the past and the environment, Motherwell uses them only as surfaces. Further, the wall is a frequent subject of the New York School from Oldenburg's street collages to Rauschenberg's "combines" as well as the new French influence, Dubuffet. Motherwell's use of it reflects an adaptation to the new American and French art of the 1950s.

Unique to him also is the French "I love you" which is personal and autobiographic, reflecting his need to be loved after the breakup of his marriage.[17] That he renders the words in French reflects again his attempt to elevate and associate himself with a grand foreign tradition, even though American art, it was becoming increasingly clear, was at this time more accomplished than contemporary European art.

The fifties in America were the last period of the declining, naive idealization and emulation of European life and taste that has dominated American culture periodically. In the late 1940s, young artists and critics like Kenneth Noland and Sam Hunter still went to Europe. The trip to Europe was still something special and use of the G.I. Bill reinforced prewar notions of art as being European and not American. It took a number of years, until just about the mid-fifties, for both America and younger artists to realize fully that more important art was being done in New York for the first time in American history.

The words "Je t'aime" also declare Motherwell's interest in calligraphy, which had surfaced in *Viva* of 1946 in which the title is spelled out in the canvas (perhaps a reference to the public "resurrection" of the immediate postwar years). He seems ready for the Action Painting gesture,

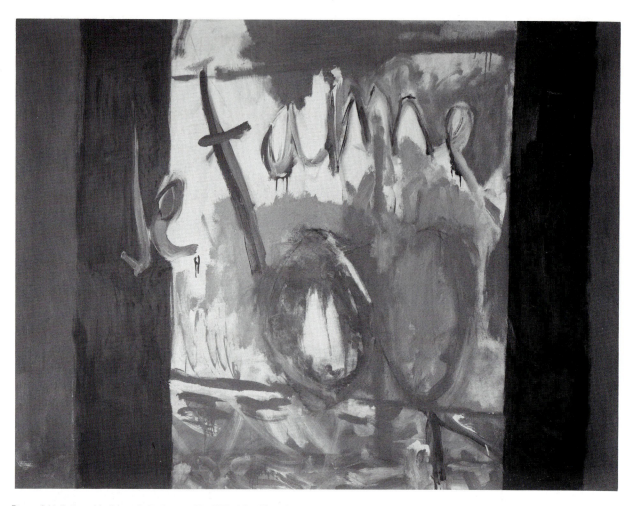

Figure 244. Robert Motherwell, *Je t'aime, #2*, 1955. 54 x 72 inches. Courtesy Robert Motherwell. Private collection, New York.

the physical act that cannot be detached from the meaning of the work,[18] as he seeks fresh life experiences and varies his forms to present them. While some gestural paintings evoke art history or European modern tradition, such as *Spanish Painting with the Face of a Dog*, which recalls Goya's later Black paintings, most represent a vitalist gesturalism of the everyday. For example, the *Summertime in Italy* series of 1960 (fig. 245) consists of automatist calligraphy, structural gesture, and summer color as well as cultural allusions, evocations of landscape, place, and experience and perhaps allusions to art history (Moore's *Reclining Figures?*) all within the context of summer trip, a mundane event, in the Mediterranean. It also harks back to his *The Homely Protestant* in its enlarged drawing. The *Beside the Sea* series suggests a further allusion to the look and vitality of nature—the spray of the ocean against a sea wall near his summer home.[19]

Black and White of 1961 (fig. 246) dramatically realizes

the fifties concept of vitalist movement—gesturalism, divorced, of allusion to nature. In this record of vitality, the symbolism of the dynamic as an image of the life force reaches a climax. Painterly motion has been enlarged yet condensed, made into a single yet far-reaching sign of the life flux and force. Motherwell's gesturalism has its roots in fifties Action Painting and existential concepts of the effort and flux of being and identity. And while his gesturalism has parallels to many New York School artists, it typically also parallels contemporary Europeans such as Mathieu (fig. 247). Motherwell's gestural works also evoke Picassos such as *Swimming Woman* of 1929, one of several similar works in the great Picasso show in 1939. At the same time this expressive gesturalism and splattering can be found in the *Lyric Suite* of the 1960s and collages such as *Metaphor and Movement* and *Unglueckliche Liebe* of 1974 and *The Irish Troubles* and *Dance* of 1981. In a recent work, *Wall Fragment* of 1982, the

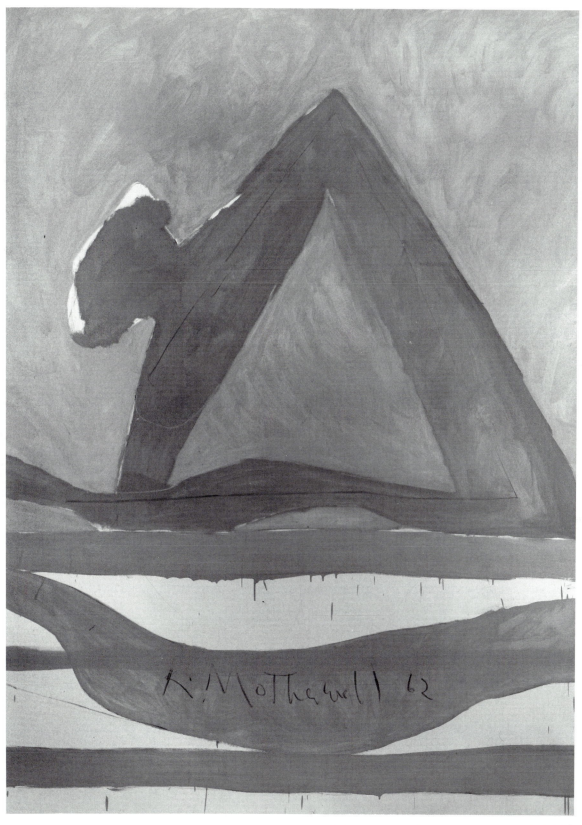

Figure 245. Robert Motherwell, *Summertime in Italy #28*, 1962. 96½ x 72½ inches. Courtesy Knoedler Gallery.

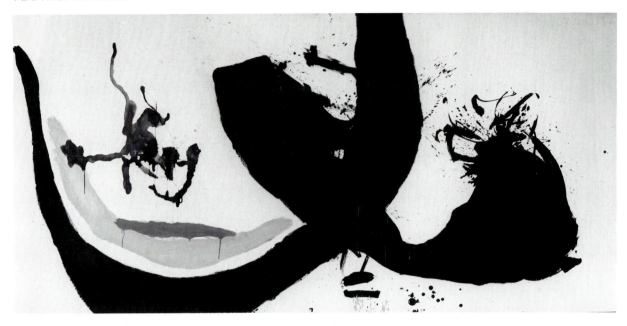

Figure 246. Robert Motherwell, *Black on White,* 1961. 78 x 163$\frac{3}{16}$
inches. The Museum of Fine Arts, Houston. Purchase.

Figure 247. George Mathieu, *Homage to Charlemagne,* 1956. Krannert
Art Museum, University of Illinois at Urbana-Champaign. Gift of Mr.
Peter Rubel, 1958.

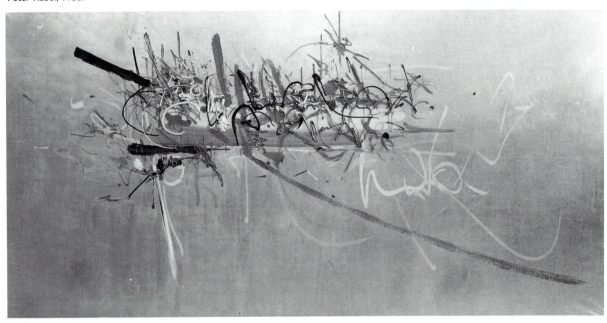

Figure 248. Robert Motherwell, *Collage [In Yellow and White with Torn Elements]*, 1949. Collage of casein and papers. 47¾ x 35½ inches. Courtesy Robert Motherwell.

Figure 249. Robert Motherwell, *The French Line*, 1960. Oil and collage on laminated rag paper. 30 x 23 inches. Mr. and Mrs. Bagley Wright, Seattle. Courtesy Robert Motherwell. Photo: Peter A. Juley and Son.

gesture verges on unconscious quotation from a late Gottlieb. These works suggest gesture as life exuberance for its own sake, as well as authenticity of impulse realized and objectified in feeling projected by shape. The short emblematic spatter or stroke evokes fifties existential authenticity in action.

Motherwell's greatest formal accomplishment, his expansion of the collage into a freely expressive medium, underlines his uniqueness and separateness. Collage is central to his work, and he considered collage the modern substitute for still lifes.[20] Collage answered his notion of painting as an "ensemble of painting and architecture and sculpture," which are the terms in which he discussed Mondrian in the early 1940s. Motherwell gradually extended and enlarged the medium and its possibilities throughout the 1940s, but especially after the impact of Schwitters's more expressive work and Matisse's cut-outs, shown in New York in the late 1940s, which is evident in *Collage (In Yellow and White with Torn Elements)* of 1949 (fig. 248).

Motherwell's collages for the most part reflect a range of experience absent in his colleagues' work, an autobio-

graphical, hedonistic, topical, and quintessentially mundane world. While his collages of the 1940s are representational and figurative as traditional collage is, the later ones are more varied. *Historie d'un Peintre* of 1956 is autobiographical. In *The French Line* of 1960 (fig. 249) Motherwell combines a work of lyric waves and strong color allusions to French culture with foreign travel (a symbolist voyage?) and a time of personal joy. In other collages, he uses pieces of sheet music, labels, wrapping paper, and other flotsam and signs of the voyage of his life. His contrast of the smooth, geometric, and torn edges, of painterly and finished surfaces, and of the controlled and the animated is typical. In the 1970s his collages become even more architectonic, wall-like, and classical, elevating the personal touch and feeling to the monumental and grand. Motherwell's collages indicate the centrality of the personal in his work—the opposite of the search for the impersonal round of life of most Abstract Expressionists.

Yet his Abstract Expressionist and symbolist sense of passage is evoked in *The Voyage Ten Years After* of 1961 (fig. 250). This work reveals the continuity and transformation of the earlier Baudelaire-, cubist-, and Matisse-influenced *The Voyage* of 1949 (fig. 251), with its inter-

Figure 250. Robert Motherwell, *The Voyage Ten Years After*, 1961. 69 x 210¼ inches. Courtesy Robert Motherwell.

locking units suggesting the sun of romantic North Africa. The spreading blots of *The Voyage Ten Years After* are partially inspired by the stained work of Helen Frankenthaler, his wife of the time. Both *Voyages* allude to Baudelaire's dictum of modern art as voyage toward the new. In the earlier *Voyage,* movement is horizontal and simply suggests a trip in scale, elevation, and loftiness; the later Motherwell seeks to represent, as he later said, the bright color of "human aspiration"[21] and "one's fate and character."[22] But again, most significantly, there is no movement into depths of time. In other words, the journey occurs in the frontal, lateral foreground and involves single aspects of life, as opposed to his colleagues' most significant layering of figures, spaces, and consciousness. Motherwell's epic voyaging is not into the depths of many lives and cultures but into the immediate enlarged into the universal.

Figure 251. Robert Motherwell, *The Voyage,* 1949. Oil and tempera on paper mounted on composition board, 48 inches x 7 feet 10 inches. Collection, The Museum of Modern Art, New York. Gift of Mrs. John D. Rockefeller III.

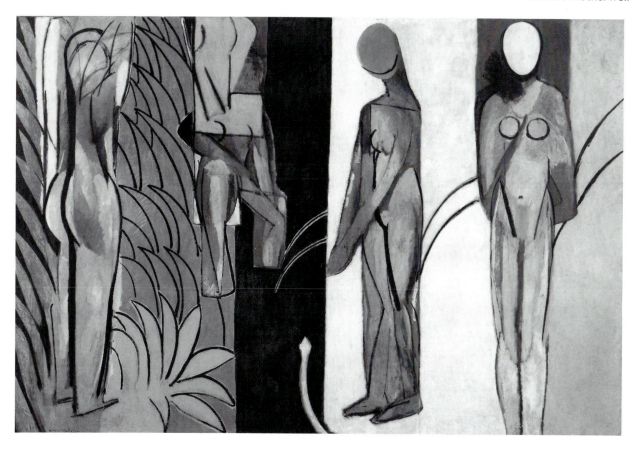

Figure 252. Henri Matisse, *Bathers by a River*, 1916–17. 8 feet 7 inches x 12 feet 10 inches. Charles H. and Mary F. S. Worcester Collection. (1953.158) © 1989 Art Institute of Chicago. All Rights Reserved.

THE ELEGIES

With the Elegies to the Spanish Republic series, Motherwell contributes to the Abstract Expressionist stylistic idiom of painting as powerful and savage theater. The Elegies firmly established Motherwell as a member of the Abstract Expressionist group. These friezes of black rectilinear and biomorphic shapes welded together in a white ground created a cadenced, immediate, and monumental tension that attains the drama of the power of the best Abstract Expressionist work. In their large scale, flat impervious surfaces of darkness, and dichotomy of opposites locked together forever in conflictive and convulsive rhythms of contraction and expansion, flux and stasis, unity and disparity, Motherwell provided one of the significant images of his generation. The genesis, motives, and expression of the Elegies reveal Motherwell's complex combination of Abstract Expressionism's universal themes and the very personal and subjective.

The Elegy shapes evolve from his earlier ensembles of

figures and architecture. These black and white dramas reflect Matisse's influence, in the form of his *Bathers by a River* (fig. 252), and his decoupages and ink drawings exhibited at Pierre Matisse Gallery and reproduced in art magazines in the late 1940s. In the Elegies Motherwell enlarged and arranged his shapes for the first time along a horizontal axis, which allows a rhythmic flow that activates the shapes. Though not rendered in the interlocking, dense, transitory metamorphoses of his colleagues, Motherwell's dualities monumentalize and dramatize the "versus habit" as inchoate and unresolvable process.

The Elegies did not begin as tributes to the Spanish Republic. Motherwell's first elegy was a small automatist sketch he did in 1948 to illustrate Harold Rosenberg's poem about suffering and sadism, "A Bird for Every Bird," which was to be included in the never published second issue of *Possibilities* they were editing.[23] The sketch contains the basic black and white shapes and composition and would have been easy to enlarge in reproduction.[24] Motherwell placed the sketch in a drawer and forgot

313

about it until a year later, when, again to illustrate a poem, he found and enlarged it. This second sketch in casein was entitled *At Five in the Afternoon* (fig. 253), from a refrain in a poem "Lament for Ignacio Sanchez Mejias" by Garcia Lorca about the death of a matador, for which it was to be used. These first two sketches were not illustrations of any specific events in the poems but captured their general feeling of anxiety, suffering, and death.

That the first drawing was found and expanded upon and made into the first Elegy painting, entitled *Granada* in 1949 is significant. The composition was examined within a very changed context in 1949. By that time mature Abstract Expressionism was well underway, and the visual impact of increasingly large and dramatic work, for example, De Kooning's black paintings, must have had an impact on Motherwell. In other words, Motherwell's Ele-

gies as they developed in the late forties were partially a product of maturing Abstract Expressionism, then roughly two years old and established. Motherwell's monumental concept started with this picture.[25]

In a number of paintings in 1950 Motherwell moved to associate the structure with cities in Spain such as Malaga, Madrid, and Seville in imitation of André Malraux speaking about Spanish towns in the Civil War. In 1954 after several false starts, with *Elegy to the Spanish Republic #34*, Motherwell found his tribute, dirge, or lament to the broken Spanish Republic of fifteen years earlier.[26] To Motherwell the crushing of the Spanish Republic was his coming of age into the twentieth century's Thirty Years War. As Orwell noted about the intelligentsia, he went to war psychically over the Spanish Civil War. In several statements Motherwell noted how important it was to

Figure 253. Robert Motherwell, *At Five in the Afternoon*, 1949. Casein on composition board. 15 x 20 inches. Collection Helen Frankenthaler. Photo: Peter A. Juley and Son.

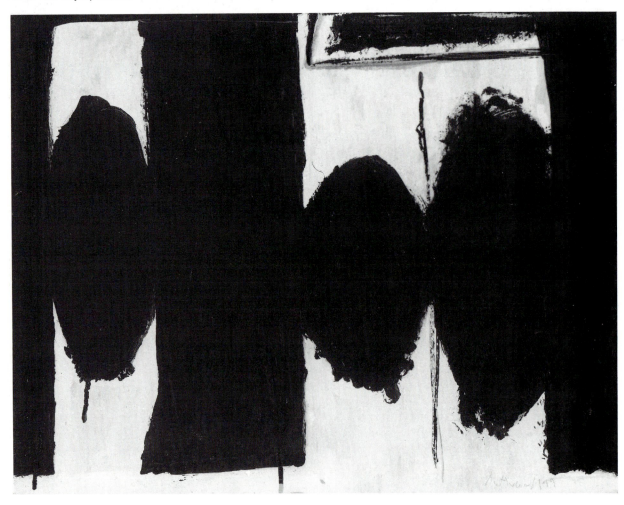

him (while at the same time revealing he had a bizarre assessment of World War II). While he felt that the Spanish Civil War was precious in both meanings of the word, he could not relate to and understand the struggle of the Second World War. He said:

It was the last time it was possible for one to feel total involvement. We all despised Hitler, of course, but World War II was more like a sequence in the continuing European drama of forming empires. Where in Spain, the Civil War represented the question of if Spain would enter the twentieth century. In that sense, it was unique because Liberal intellectuals felt about it as one man, throughout the world.[27]

Motherwell has identified the Elegies as funereal paintings, as Rothko identified his. Later he stated that they are not political but his private insistence that a terrible death

happened that should not be forgotten.[28] He also noted that they are about the contrast and interaction between life and death.

Motherwell came to the format of the Elegies through other, nontragic art—Matisse and modernist poetry—and not through the step by step evolution of his idea in a series of works throughout the forties. Indeed he continued to associate the form with poetry and specifically with Lorca, entitling a work in 1951 *Spanish Elegy: Garcia Lorca Series* before deciding on the Spanish Republic association.[29]

This indicates that he saw his era in terms of a single personal coming-of-age and tragedy that only cultivated poetry could treat. Motherwell's refinement seems to single out and elevate one tragedy into a universal. This is again different from most of the others who retreated

Figure 254. Robert Motherwell, *Elegy to the Spanish Republic No. 34*, 1953–54. 80 x 100 inches. Albright-Knox Art Gallery, Buffalo, New York. Gift of Seymour H. Knox, 1957.

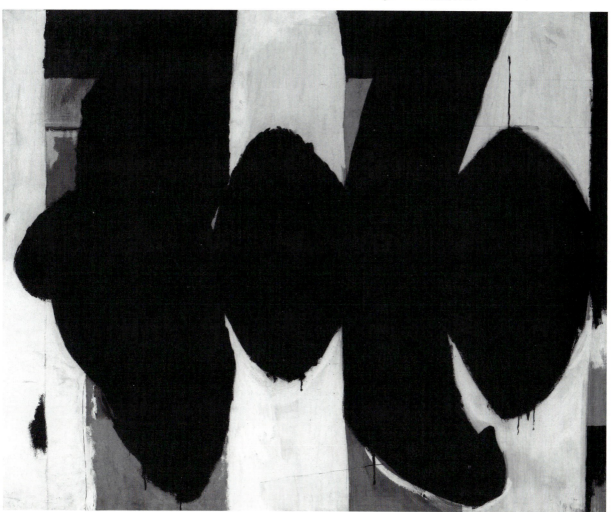

into the collective past to come to terms with their sense of communal tragedy. The tradition of tragedy and its root causes are what they are after, not a single terrible event that should not be forgotten. And as is often the case with Motherwell, there was an autobiographical component which also affected the work: Motherwell's first wife had left and he succumbed to feelings of rejection, abandonment, and loss.[30]

In the elegies Motherwell again uses color to represent a culture. The black and contrasting white function as signs of light and dark—although the white in most of his elegies is really background and not an equal participant like the white in Kline's work. "They are essentially the Spanish black of death contrasted with the dazzle of a Matisse-like sunlight."[31] Black symbolizes the black of Latin civilization, black funeral carriages, women in black, and sharply de-

fined shadows.[32] Through personal experience, public event, and literary evocation, Motherwell's Elegies reflect a general sense of life and tragedy brought forth as a Spanish sense of death, which he says he got from Lorca, his Mexican work, bullfights, travel in and photos of Mexico and its revolution, Goya, and dark Spanish interiors.[33] Motherwell's sense here is very Romantic, very much like Delacroix in *Massacre at Chios,* where a single event becomes a political tragedy. For the first time Motherwell also captured a sense of the elemental, primal, and inchoate in the Elegies.

With *Elegy to the Spanish Republic #34* of 1952–53 (fig. 254), Motherwell set the subject as well as the composition of the series. While the Elegies are varied—some like *#100* are more architectonic, others like *#34* are more organic and metamorphosing—they all have the

Figure 255. Robert Motherwell, *The Figure 4 on an Elegy,* 1960. Oil on paper. 22⅞ x 28¾ inches. Estate of H. H. Arnason. Courtesy Robert Motherwell. Photo: Steven Sloman.

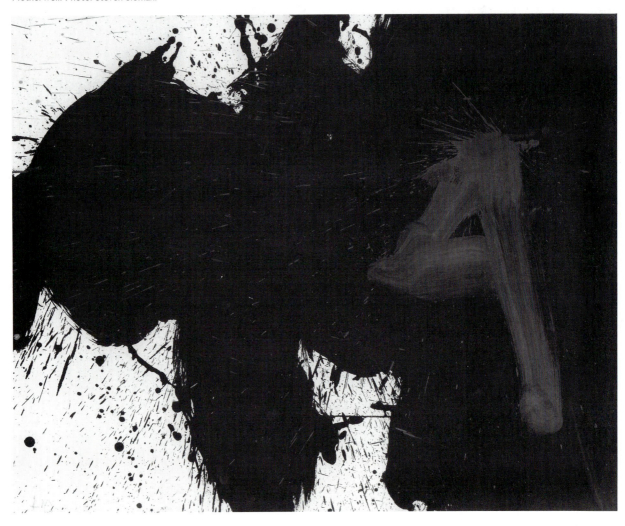

tense push-pull of the geometrical versus the more un-formed, the architectural versus organic, the moving and changing versus the static and tethered, and seemingly, his own interest in the rational and conscious versus the more automatist and subconscious. Motherwell said he sought to make his panel and oval layout "more moving."[34] This tense drama of moving, incomplete, and divergent forms constitutes one of the central dramas of the age. At this point Motherwell moved away from his earlier Picassoid and Mondrian structures toward the surrealist/Abstract Expressionist drama of threatening forces. He vivified his work in the Elegies. Rothko's Nietzschean dichotomies, as Rothko described them, are related dramas of the static and the transient. So are Gottlieb's Bursts. And *#34* is built on contrasting shapes and the interplay of positive and negative space, much as *The Voyage* was. Mother-

well's response to Matisse's cutouts lies behind this first mature Elegy. The sense of horizontal journey has been restrained, and Motherwell has upscaled and dramatized the forms and made the bars part organic, even phallic, along with the ovals. The background of everyday colors of red, blue, and green overlayed with the emblematic drama reflects almost a rude intrusion into quieter experience. In the painting contrast and willful insertion, a cerebral two worlds, dominate. What was formerly figure and architecture has been enlarged, transformed, and emblematized in almost a ritual cadence of contrast and opposition.

More explosive is *The Figure 4 on an Elegy* of 1960 (fig. 255). Here the bars and ovals have been integrated into a drama of convulsive, exploding, and splattering black on white. The unresolved contrasts and tensions usually held

Figure 256. Robert Motherwell, *Elegy to the Spanish Republic #128,* 1974. Acrylic on canvas. 96 x 120 inches. Courtesy Knoedler Gallery.

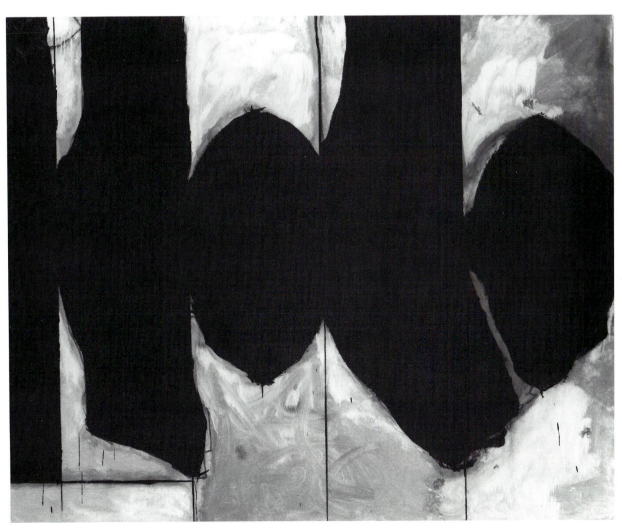

in check are here literally torn apart and extended to the edge and beyond. New York School gesture and splatter are here, as well as an anticipation of Motherwell's later *Lyric Suite,* but how different this work is from them. This is *depicted* drama as well as symbolic breakup. And it must stand as one of the great images of a war-inured generation. The forms are evocative of the detonating and spattering of the earth by shellfire, although Motherwell had no such idea in mind. But the shattering quality may well reflect an imagination that had experienced real images of war, which lingered in the unconscious. Here the modern sense of endless war—the modern Thirties Year War—and its transformation of the Western imagination as evidenced by its transformation into Motherwell's concept of Spanish death stands naked. *The Figure 4 on an Elegy* unintentionally evokes the experiences of detonation of the shattering psychic ordnance remaining in the mind of man from twentieth-century wars. Besides Jung, Fussell and others have noted the lingering effects years after the actual wars. As a veteran and writer recalls: "I was deep in my (archeological) work again, and had, as I thought, put the war into the category of forgotten things. . . . [But] the war's baneful influence controlled still all our thoughts and acts, directly or indirectly."[35] The dark and titanic explosiveness in *Elegy with Figure 4* is the product of the seared psyche that still shapes the range of the modern imagination.

Another type of work in which nature appears as merely dramatic Romantic turbulence and atmosphere is *Elegy to the Spanish Republic #128* of 1974 (fig. 256). This flow of organic, rectilinear, and oval bars and spaces locked lightly into black by thin lines against a turbulent sky evokes the romantic nature of novels of the nineteenth century.

With the *Reconciliation Elegy* of 1978 (fig. 257) Motherwell attempts to remark on the rebirth of democracy in Spain. Designed for The National Gallery in Washington, this large elegy combines a sense of horizontal interlocking journey, a sense of the wall through allusions to his earlier Spanish prison paintings, and a sense of release and separate parts joining together through the spacing. The oval/bar at the left seems almost literally to reach out toward the shapes at the right. The shapes seem more fluid and changeable than usual because Motherwell used particularly liquid paint. Here Motherwell carries the implicit rhythm of the Elegies into a large work that echoes the sense of purposeful movement underlying Abstract Expressionist art. Martha Graham's dances of expansion and contraction, Rothko's continuums, Gottlieb's tense ritual polarities, Pollock's endless expansion, termination, and recommencing are variants of this emblematic life process so fundamental to vitalist Abstract Expressionism. As do other Abstract Expressionists, Motherwell seeks a sense of total immediacy and directness. The whites are stronger and more equal in this Elegy than in others. Motherwell has said about the *Reconciliation Elegy:*

White has always conveyed to me the radiance of life. . . . In a curious way in the *Reconciliation Elegy* my black forms, the life-death forms, are becoming personages, instead of black stones . . . the black and white are beginning to merge. . . . In 1974, I had five major surgical operations during three weeks, and "died" twice on the operating table. As a youth, I had asthma, as badly as Proust, and often was literally choking to death. . . . Death has been a continual living presence to me, so to speak. I perhaps generalized, as artists do, into something less personal, through various . . . forms, certain plastic weights, through events whose death I deeply cared about, that of the Spanish Republic, that of my friend David Smith the sculptor, and so on. . . .

Figure 257. Robert Motherwell, *Reconciliation Elegy*, 1978. Acrylic on canvas. 120 x 364 inches. National Gallery of Art, Washington, D.C. Gift of the Collectors Committee.

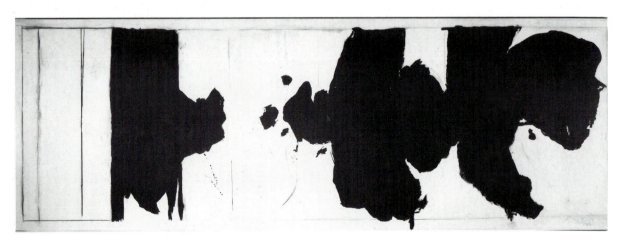

Thus *Reconciliation* has multiple meanings ... *Reconciliation* (hopefully) of the Spanish peoples, reconciliation with Death and Life. ... Against the background of possible nuclear holocaust, we must even reconcile ourselves to the fact that western man, in choosing centuries ago to exploit nature rather than marry her, has doomed himself ... with an industrial technology for which there is neither the wisdom nor the political mechanism to control. ... The *Reconciliation Elegy* is not less for Spain, but is also for all mankind. ... Meanwhile, each individual seeks his own private ecstasy.[36]

The *Reconciliation Elegy*, then, as Motherwell writes, summarizes his approach: a combination and extension of the personal, the liberal political, and European modernism. Paintings of death relate to earlier and contemporary events in a continuum of human possibility. It is not just

with this work but with the Elegies in general that Motherwell joins what I have called a more Jungian sense of creativity—the visionary—with his more usual opposite psychological concerns. Here the elemental and dramatic dominate. He comes to believe, as other Abstract Expressionists did earlier, that life and death are intertwined and part of the same process. He has expanded his tradition of modernism to include not just Picasso and Mondrian but Goya. His permanently unresolved, conflictive, and unreconcilable Elegy emblems bring forth the Abstract Expressionist antagonisms. Motherwell contributed black and white "protagonists in the struggle between life and death"[37] to his period's psychologized imagination. Before the war, the pattern of struggle was between individuals, as in Benton, or between man and exterior nature as in

Figure 258. Robert Motherwell, *Open #97 [The Spanish House]*, 1969. Acrylic and charcoal on canvas. 92½ x 114½ inches. Collection of the artist. Courtesy Robert Motherwell.

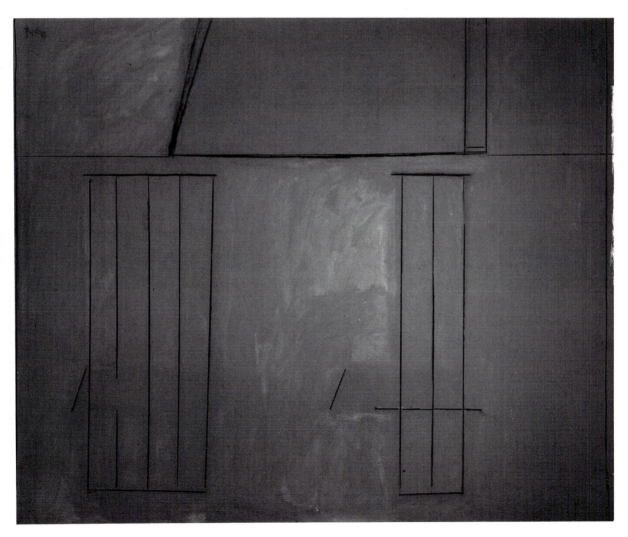

Curry, or between class in Social Realist work, or between ignorance and new technology in WPA murals. With Motherwell the struggle is internal, framed in terms of life principles that he found in his view of Spain, elevated, and cultivated for himself as for others through the modern tradition.

THE OPENS

Motherwell's art has always been concerned with the open and closed, the free and controlled, the limited and the open-edged, and the positive and negative. With the advent of the Open series in the late 1960s, he found a way to realize these issues. The Opens consist most often of a large field of a single color in which a rectangular shape has been drawn in the upper half. In some works, such as *Summer Open with Mediterranean Blue* of 1974 (pl. 27), the rectangle is closed and even on all sides. In others the rectangle is incomplete—open at the top and higher at the left than right side—so that the inside is outside and vice versa.

The Open form was discovered by accident when Motherwell one day placed a small painting (*Summertime in Italy*) on an unfinished one. The resulting shape suggested the form of the Opens when he outlined the smaller canvas in charcoal. While catalyzed by this accident, the creation of the Opens was simply a new outcropping of a direction already in motion. Calligraphic drawing was a major Motherwell mode from the 1940s onward, as was the architectonic imagery of the central rectangle, which originated in his Picassoid and Mondrian interests and forms of that time. At the same time the Opens take into account the flat color-field painting of the 1960s, the large paintings of Newman, the closer calibration of internal design and format of the shaped canvas of the 1960s, and simpler, more geometric modes. Yet they are fully Motherwell in their accent on scale, sensuality and

Figure 259. Robert Motherwell, *In Plato's Cave #1*, 1973. Acrylic on canvas. 72 x 96 inches. Courtesy Knoedler Gallery.

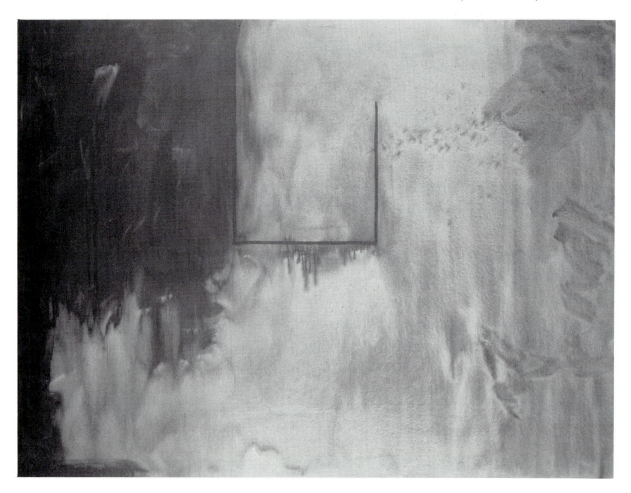

association of color, and the cerebral blend of seemingly opposite elements.

Motherwell has fused these personal and contemporary elements into an image that both extends and layers his basic Abstract Expressionist and personal themes. The rectangle evokes a host of associations such as wall, window, banner, that are once again quotidian. He has characterized the Opens as partially a response to planar white-washed adobe facades with "beautifully proportioned" doors and windows cut into them.[38] They also allude to art-historical memories of Matisse's and Picasso's windows and the balance of the indoors and outdoors. In *Open #97* [*The Spanish House*] of 1969 (fig. 258), for example, rectangles on an orange field suggest the window bars on a hot sunstruck house that he had seen in a photograph.[39] Motherwell's method of working is more like Ellsworth Kelly's than that of the Abstract Expressionists; that is, he works from memories or impressions of the visual world rather than from "memories" of a prehistoric or ancient past. Unlike Kelly, however, he rarely worked from a motif toward form. He usually worked in the opposite direction, discovering the motif and associations as he worked. In *Open #97* Motherwell evokes his typical associations through form and color. The orange is mottled and varied, lighter and darker, glowing and receding, suggesting not just wall but atmospheric light and the sun-drenched hedonism of the ethnic, nationalist, cultural, European experience. It is like Matisse in a New York School style, with elements of heat, folk color, and the generative forces of the sun.

Motherwell thus turns his Opens, as he did his Elegies, to his foreground interests. *The Garden Window* of 1969 (pl. 28), one of the first Opens, suggests just that—a Matisse and Bonnard view through a window into a garden. *Summer Open with Mediterranean Blue* evokes the Mediterranean basin and sea with its stark contrasts of shape and light. Compare this to Newman's *Cathedra:*

one painting seems early modern European in content while the other seems mythic and heroic. Motherwell has said of California and its color that it is on the same meridian as Barcelona and northern Greece. In this meridian there are arid blue skies, green or blue oceans, black sharply-edged shadows, and bright sunlight.[40]

Other works cross over into some Abstract Expressionist themes, although Motherwell's approach is very much like nineteenth-century literary allusion. The *In Plato's Cave* series of the 1970s evokes the mysterious world of the known and unknown in terms of shadowy grays in a dark interior. Plato's famous story of art as the shadow of reality, which Motherwell absorbed from a poem by Delmore Schwartz, is an apt source for the paintings. *In Plato's Cave #1* of 1973 (fig. 259) he suggests a dark light around a window or house. It can be compared to Rothko's portal murals where the idea of passage, threshold, doorway, and opening is similar. Unlike Rothko, however, Motherwell's painting emphasizes the physical and emotional approach to the passage, while Rothko immediately absorbs the viewer into it.

CONCLUSION

Motherwell's Opens reflect his dilemma. They are epic paeans to the pleasures of the everyday forefront of life, yet they can quickly turn toward more standard Abstract Expressionist doubt and tension. They are sober yet hedonistic, quiescent as a summer's day yet turbulent and threatening like his Elegies. He defines them in terms of feelings: "What freedom there is in being allowed to open in every dimension, to feel complete empathy."[41] For him the Opens, as all his work, realize the sensuality of the concrete yet expressive everyday world elevated beyond itself.

CHAPTER II

THE EXPANSIVENESS OF ABSTRACT EXPRESSIONISM

Defenceless under the night
Our world in stupor lies . . .
May I, composed . . .
Of Eros and of dust,
Beleaguered by the same
Negation and despair,
Show an affirming flame
 W.H. Auden, *September 1939*

In the 1940s the themes of Abstract Expressionism and its original culture were pervasive. The Abstract Expressionist combination of ritual, psychology, world traditions, and nature dramas proved to be fertile material for many artists of various ages and stylistic tendencies. We may now look at the central threads of Abstract Expressionism in the work of widely different artists from Richard Pousette-Dart to Hans Hofmann and Ad Reinhardt. While they are mainly American modern and postwar artists, their relationship to Abstract Expressionism is determined less by their personal inclusion at different moments in the group than by their commitment to its historiocultural admixture. Remembering losses and ritualizing history, for example, transformed two older artists who were not originally Abstract Expressionists into major contributors to the group. The work of Bradley Walker Tomlin and Hans Hofmann highlights the power of the new historical aesthetic to recast the School of Paris and early modern art.

BRADLEY WALKER TOMLIN

Bradley Walker Tomlin adds a commemorative, lyric note to Abstract Expressionism. While he was considered a member of the group, however, it held his lyricism against him in the 1950s when the image of the tortured artist held sway. In that era, inarticulate or existential despair was considered the most popular and intellectually acceptable artistic stance. Pollock's drunkenness and the violent bar scene of The Club set the standard for the heroes of tortured macho. Motherwell was a purveyor of this image, and in memorial comments upon Tomlin's death in 1953, characterized him as never understanding despair the way he, Pollock, and Philip Guston did. To Motherwell, Tomlin lacked the *de rigeur* self-torment and anxiety. He was merely a dilettante, "whether he succeeded or not" in overcoming himself.[1] In spite of this Motherwell "tribute," Tomlin participated in the experiences of the 1940s, aligned himself with the artistic climate that it produced, and created significant Abstract Expressionist art.

Tomlin was among the oldest Abstract Expressionists and it was only in the first half of the 1940s under the impact of the growing Abstract Expressionist historical and cultural mix that he began to do truly innovative modern work. The war was the subject and catalyst as he turned toward the communal inner life of his time. Next to Rothko's, his work best memorializes his generation. In works such as *Defeat* of about 1940, with its tribute to France;[2] *Burial* of about 1943, with its smoke, mausoleum, and Greek head crowned with intensely green laurel leaves; and *To the Sea* of 1943 (fig. 260), Tomlin responded to the physical and emotional facts of the war in wistful sadness and sense of loss.

To the Sea refers to the sailors who died in the attacks on Allied shipping that were nearly fatal to the Allied cause in 1943. As Tomlin noted:

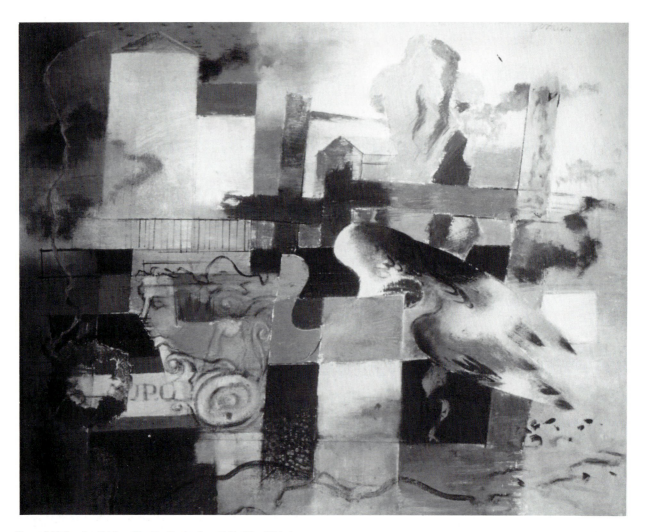

Figure 260. Bradley Walker Tomlin, *To the Sea*, 1942. 30 x 37 inches. Courtesy of Mrs. Louise Benton Wagner.

This painting, *To the Sea*, was painted during the period throughout which the toll of sinkings of Atlantic shipping had been particularly heavy, and I have endeavored to put down on canvas some of the thoughts which I had at that time.[3]

To the Sea is truly elegiac in tone and substance. In a cubist grid structure, Tomlin presents several symbols of war, makes the contemporary dead continuous with those of the ages, and suggests a journey from buildings and pier on shore at the top of the painting to death in the eternal sea below. He balances a seagull or "graveyard angel" at the right with a wreath, paralleling the levitation of the spirit symbol in Gottlieb's *The Enchanted Ones*. Tomlin also suggests a "conversation with time immemorial"[4] by his suggestion of continuity with the dead sailors of the past (of which T.S. Eliot, whom he greatly esteemed, wrote in *Britain at War*). *To the Sea* contains a truncated

(and mutilated?) classical torso seen from behind and a figurehead, which would adorn the front of older ships rather than modern ones. Tomlin later revealed his sense of time as a continuum when he called his friend Frank London's work an "evocation of reality in which time moves fluid as a river, where past and present are fused in a dream."[5] (He also characterized the continuum of art the same way: "We know that the stream of art is constantly renewed and that it flows with the inevitability of a great river.")[6] To underline the sense of endless time in this painting, wavy lines terminate the bottom of *To the Sea*. The painting is done in cool gray and white tones, adding an appropriate note of contemplation and remembered feeling.

By the later 1940s and, more importantly, after the end of the war, Tomlin's work became more aggressive. Like many of his compatriots, Tomlin displayed more passion

and let go more anger and fury at the end of the war than he expressed during it. And as with them, he continued to paint the war long after it ended in August 1945. Indeed, with the return of the veterans, the new information about the war's conduct and effects and the incomprehensible concentration camps, and the first publications of memoirs and stories, the war almost dominated the latter part of the forties as it had the first part. No longer was one overwhelmed with the daily events, however; now more thoughtful analysis than ever before was possible.

Tomlin's paintings of this time indicate the war's continuing effects. They are suffused with lurking bestial imagery, with swirling, animated figural form-as-forces interlocked with labyrinthine mazes.[7] Beginning with *Autocrats* (a later

version of the *Aspirant to Power* of about 1942), *Death Cry, Battle Anthem, Maneuver for Position* and *Number 3* (fig. 261), Tomlin employed automatist practice and the idea of linear rhythm as image, stream of time, and aggressive force to work through and come to terms with the experience of the war. Gottlieb's late Pictographs such as *Sounds in the Night,* Krasner's *Little Painting* series, and Miró and perhaps Gorky lie behind these works, as Tomlin gradually became friendly with many Abstract Expressionists at this time.[8]

However, central to Tomlin's work throughout his career is Picasso's *Three Musicians,* which he had copied in 1937. Its vertical, interlocking figural and spatial structure underlie many of Tomlin's compositions. It is evident, for example, in one of his best and most characteristic works

Figure 261. Bradley Walker Tomlin, *Number 3,* 1948. 40 x 50⅛ inches. Collection, The Museum of Modern Art, New York. Gift of John E. Hutchins in memory of Frances E. Marder Hutchins.

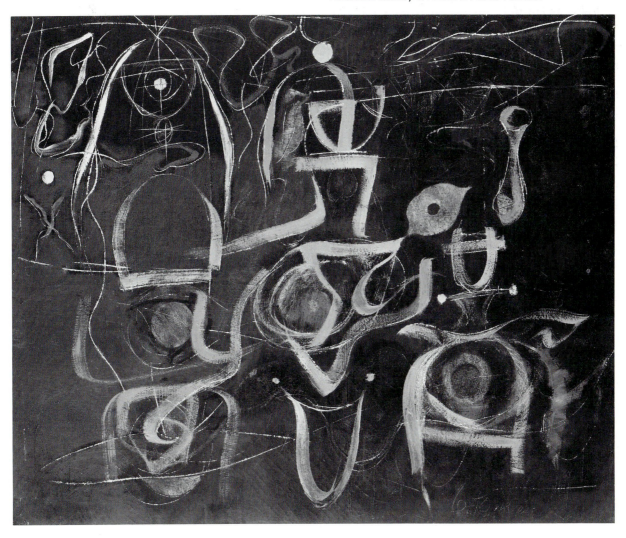

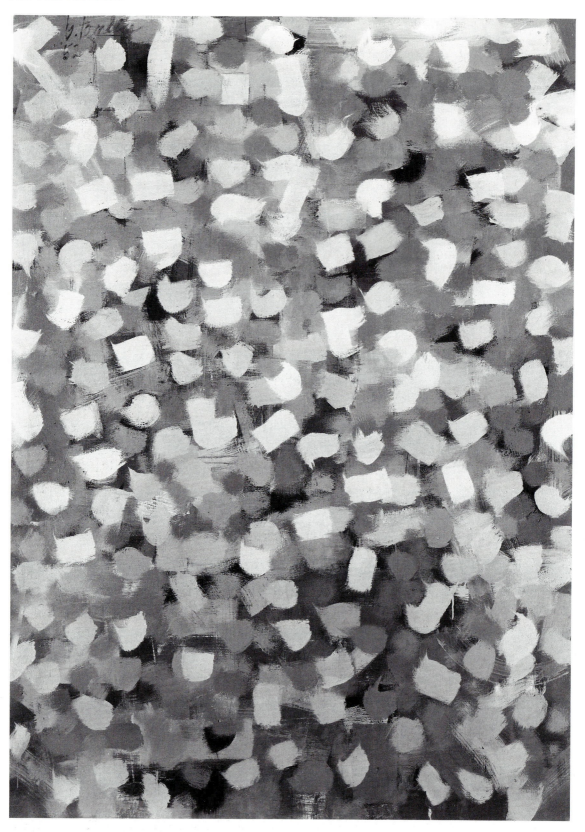

Figure 262. Bradley Walker Tomlin, *Number 8 (Blossoms)*, 1952. 66 x 48 inches. The Phillips Collection, Washington, D.C.

of the late 1940s, *All Souls' Night* of 1947 (pl. 29). As in the lost *The Offering* of 1946, *Tension by Moonlight* of 1948, and *Small Wind Disturbing a Bonfire* of 1949, Tomlin uses ritual, most probably drawn from *The Golden Bough*, to comment on contemporary life and needs. The festival of All Souls, Frazer notes, is one of those cross-cultural rites that fuse Christianity with pagan ceremony. The festival is "a continuation of an old heathen feast of the dead" celebrating death and resurrection.[9] With its white ribbon figures—one with a cross as part of its form, another with the horns of a devil—over a ghostly white and dark ground, and in its pictographic drawing and Picassoid alignment and figural disposition, *All Souls' Night* presents not only a haunting allusion to the cycle, but also the idea that the dead did not die in vain but as part of

the beginning of a new stage.[10] *Small Wind Disturbing a Bonfire* is more linear and more abstract. Bonfires, according to Frazer, are ceremonies staged to ward off misfortune.

At the end of the 1940s Tomlin seemed to arrive at a comfortable position with botanic imagery, as did Lipton in the 1950s. After the 1950 Monet exhibition, which included Monet's more abstract *Water Lilies* series, several American artists fused an impressionist view of nature with the style of Abstract Expressionism. Tomlin's petal series, for example, *Number 8* (*Blossoms*) of 1952 (fig. 262), is more delicate in color and less aggressive in imagery than before. The petal paintings also hark back to Tomlin's wistful early works. Nevertheless, like Lipton's works, they reflect a new view of Abstract Expression-

Figure 263. Hans Hofmann, *Spring*, 1944–45. Oil on wood panel. 11¼ x 14⅛ inches. Collection, The Museum of Modern Art, New York. Gift of Mr. and Mrs. Peter A. Rubel.

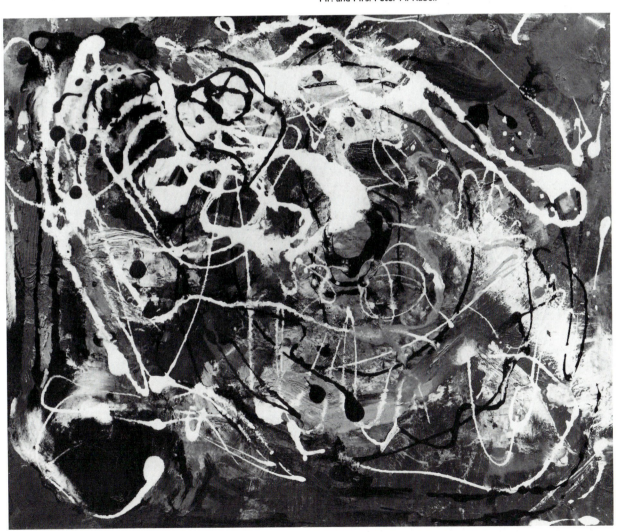

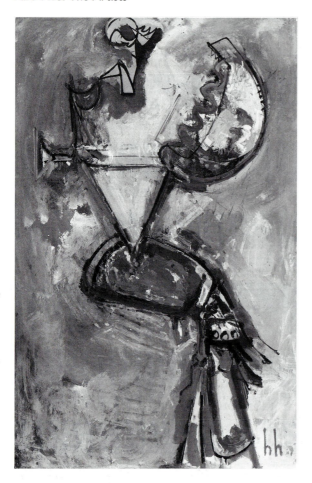

Figure 264. Hans Hofmann, *Idolatress I*, 1944. Oil and aqueous media on composition board. 60⅛ x 40⅛ inches. University Art Museum, University of California at Berkeley. Gift of the artist.

ism's themes. They consist of a vitalism of layered spots in a continual flicker and flux. The spots themselves are single brushstrokes condensing into their shape the right angle and curvilinear planes and imagery of his early work and of cubist design as a whole. An implicit grid structure underlies the works (and is visible in *Number 2*). Thus Tomlin's last works, before his premature death in 1953, present a unique vitalist continuum of renewing, *flowering*, energetic force—quintessential Abstract Expressionist thought and response to history realized in a haunting elegiac pastoral.

HANS HOFMANN

Another older artist exemplifies the passage of early modernism into the mid-twentieth century largely through the originality and strength of the Abstract Expressionist cultural complex. Hans Hofmann's mature art synthesized early modern cubist structure and Fauvist vitalism with Abstract Expressionist themes, channeling his exuberance and painting culture through the Abstract Expressionist cycle of ritual resurrection. As opposed to Tomlin and others, however, Hofmann's new Abstract Expressionist work is aggressive if not strident.

Throughout the 1930s, Hofmann's style was a mixture of cubist architectonic structuring and Fauvist color interaction. Works with such titles as *Little Blue Interior* and *Provincetown Harbor* indicate his commitment to early modernism done in vital color contrasts and cubist order. He was never interested in surrealism, however, and was thus actually quite conservative as an artist at this time.

Hofmann began his turnabout in the 1940s with works like *Spring* (fig. 263), a dripped work of overlapping spots, splatters, and lines. While the work as a whole resembles an automatist Kandinsky, its free vitality and Persephone theme indicate a new direction for Hofmann. Along with School of Paris work, Hofmann hit stride with *Idolatress I* (fig. 264), *Aggressive,* and *Apparition* of the mid-1940s, in which he adopted the Abstract Expressionist theme of ritualizing historical aggression. The form of *Idolatress I* is forceful, incoherent, and possibly archaic. Hofmann employs the biomorph or anthropomorphic shape, open at the top like a gaping jaw. After virtually a half-century of lively pictorial constructions of nature and still lifes, Hofmann's instinct for drama has taken a turn toward elemental brutality, and his time working through the human soul (and civilization) in a rite of passage.

Cataclysm [*Homage to Howard Putzel*] of 1945 (fig. 265) suggests an ectoplasmic explosion (which makes an informative dialectic contrast to Newman's ectoplasmic, mythic egg of new life, *Pagan Void* of 1946). Fragments of forms and pieces spew outward from a swirling center. The explosive force of *Cataclysm,* painted in what may be the most cataclysmic year in modern Western history, foretells the similar explosiveness of Motherwell's *Elegy with Figure 4* and other works, and the spatters of Gottlieb's abstracts labyrinths. *Cataclysm* makes clear the emotional, psychological, and historical experiences that prepared their abstract art, as well as the forces to which they gave rise and which they articulated.[11]

Following the upheaval of *Cataclysm,* Hofmann painted a work with upward spiraling and vigorously splashing anthropomorphic forms. *Resurrection* of 1948 (fig. 266) advances the human journey of the 1940s to the next stage of the cycle of war and rebirth. Hofmann uses his Fauvist and expressionist vigor and brushwork in combination with Abstract Expressionist "natural" figurative form to allude to the end of the war and the hope of rebirth. Trial, death, and resurrection—the classical themes of anthropological ritual—are rendered, once again, in modern abstract form.

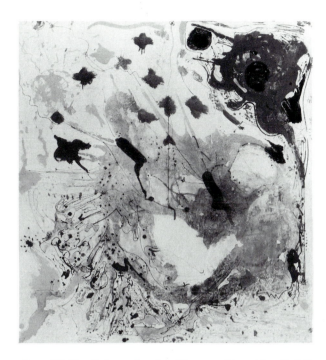

Figure 265. Hans Hofmann, *Cataclysm [Homage to Howard Putzel]*, 1945. Watercolor on gesso, cardboard panel. 51¾ x 48 inches. Courtesy of Andre Emmerich Gallery, New York. Photo: Kevin Ryan.

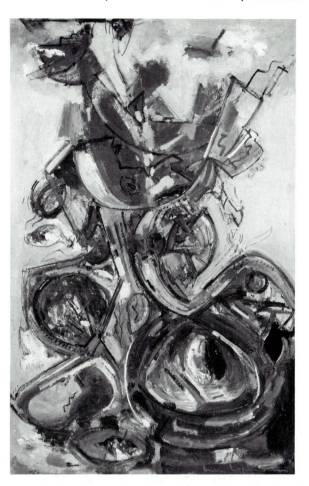

Figure 266. Hans Hofmann, *Resurrection*, 1948. Oil on board. 72 x 48 inches. Courtesy of Andre Emmerich Gallery, New York. Photo: Kevin Ryan.

And to climax the end, a ritual celebration of life. Besides representing the up side of the cycle, *Bacchanale* of 1946 and *Ecstasy*—in their swirling, pulsating, anthropomorphic forms rendered with symbolically vigorous brushwork—suggest the festival at the end of the funeral ceremony in many cultures. They parallel the ancient rites of anthropomophic deities and their representation of the vegetation spirits that are recounted in *The Golden Bough*.

In the following years Hofmann's art flourished, especially when he stopped teaching in 1958. He extended his Abstract Expressionist style to encompass and restate his longstanding Fauvist everyday vitality in more abstract, dynamic terms. Works such as *Fantasia in Blue* of 1954 or *Orchestral Dominance in Green* of 1954 are abstract versions of School of Paris liveliness and hedonism; they reflect Hofmann's interest in spatial tensions and the push-pull dynamics of abstract planes and forces combined with the painterly vitalism characteristic of much of the New York School style of the 1950s. Works such as *Elegy* of 1950, the splatter-filled *The Prey* of 1956, and four works from 1960—the irregular *Black Goddess,* the cubist, rectilinear *The Gate* (fig. 267), *Pre-Dawn,* and *Cathedral*—all continue to repeat the central core of Abstract Expressionism in new terms.

Hofmann thus joins Motherwell, Reinhardt, and others in synthesizing European modes with the original American contribution of the 1940s. It may be through Hof-

mann's mix that many of the New York School got their start. Artists such as Marisol, Milton Resnick, Larry Rivers, and Richard Stankiewitz studied with Hofmann and came to their youthful styles through his expansive composite of earlier modernism and Abstract Expressionism. In a way, Hofmann is responsible for the compound of Abstract Expressionism with other elements that led to the abstract realism of the later New York School.

THEODORE STAMOS

While Tomlin and Hofmann had been painting for many years and only matured in the 1940s, younger artists such as Theodore Stamos and Les Krasner almost immediately began with Abstract Expressionist principles.

More than any other Abstract Expressionist except perhaps Baziotes, Stamos rendered immediate experience as nature. His first one-person exhibition in 1943 at Betty

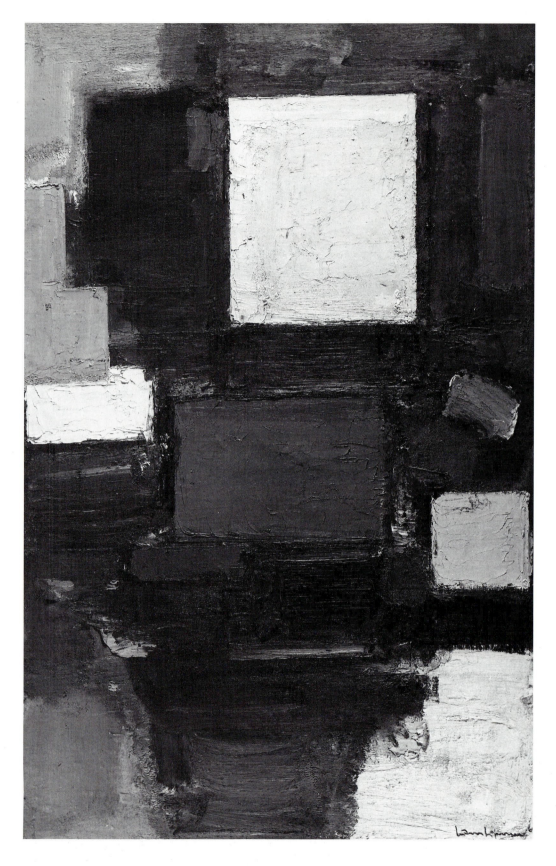

Figure 267. Hans Hofmann, *The Gate,* 1960. 74⅝ x 48¼ inches. The
Solomon R. Guggenheim Museum, New York. Photo: Robert E. Mates.

Parsons consisted of several works of sea forms, rocks, and anemones. Nature was for him the central life force and emblem in which the paradigm of human possibility was to be found. When he was a child his father had taken him to the Long Island shore to collect flowers and seasonal plants.[12] Like several of his colleagues, he visited the American Museum of Natural History to study its minerals and gems. He also read about evolution and botany.[13] As Newman wrote in the introduction to Stamos's show at Betty Parsons in 1947, however, his is more than a bland naturalism. It is a totemic affinity and participation with nature in its ritual dramas:

Communion with nature, so strongly advocated by the theorists as the touchstone of art, the primal aesthetic root, has almost always been confused with a love of nature. ... That is why the historic attitude of the artist toward nature has been, in non-primitive peoples, one of sensibility. The concept of communion became a *reaction to* rather than a *participation with,* so that a concern with nature, instead of doing what it was supposed to do—give man some insight into himself as an object in nature—accomplished the opposite and excluded man: setting him apart to make nature the object of romantic completion.

The work of Theodoros Stamos, subtle and sensuous as it is,

reveals an attitude toward nature that is closer to true communion. His ideographs capture the moment of totemic affinity with the rock and the mushroom, the crayfish and the seaweed. He re-defines the pastoral experience as one of participation with the inner life of the natural phenomenon. One might say that instead of going to the rock, he comes out of it. In this Stamos is on the same fundamental ground as the primitive artist who never portrayed the phenomenon as an object of romance and sentiment, but always as an expression of the original noumenistic mystery in which rock and man are equal.

Stamos is able, therefore, to catch not only the glow of an object in all its splendor but its inner life with all its dramatic implications of terror and mystery.[14]

Stamos's totemic identification with the primitive's participation mystique can be seen in paintings such as *Ancestral Flow* of 1945 (fig. 268) and *Sounds in the Rock* of 1946 (fig. 269). In the former, Stamos's gentle vitalism suggests sprouting biomorphic or ectoplasmic forms rhythmically rolling and branching above and below ground, while in the latter linked rock and masked mushroom forms grow.

Once again, however, these themes are not strictly about natural life but also about human life. Stamos fused nature with the world rituals of Frazer's *The Golden*

Figure 268. Theodore Stamos, *Ancestral Flow,* 1945. 14 x 22 inches. National Pinakothek and Alexander Soutzos Museum.

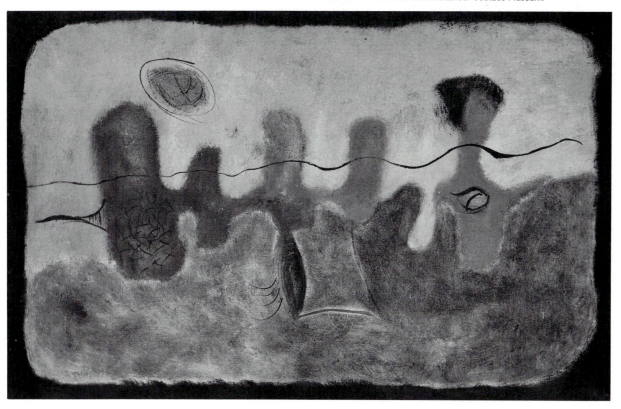

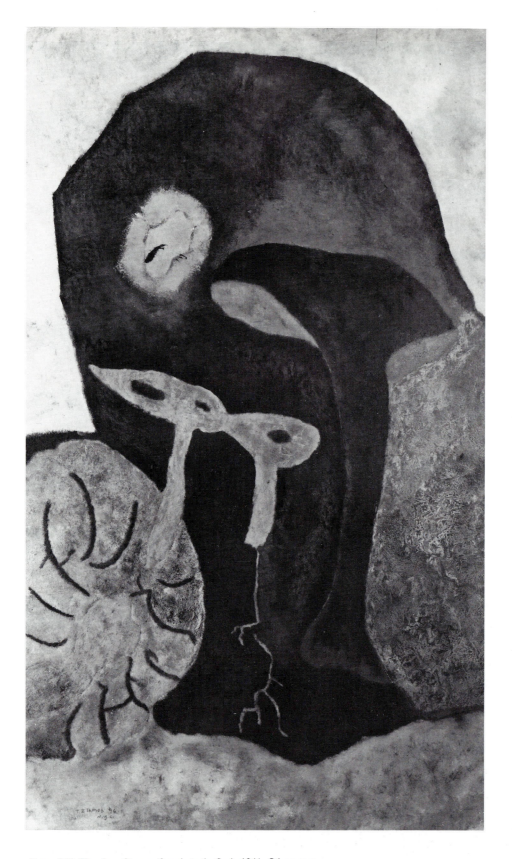

Figure 269. Theodore Stamos, *Sounds in the Rock,* 1946. Oil on com-
position board, 48⅛ x 28⅝ inches. Collection, The Museum of Modern
Art, New York. Gift of Edward W. Root.

Bough to heal the land of the 1940s. These figures are thus more than natural forms; they are vegetation deities, animal and vegetable anthropomorphic spirits of death and resurrection, of the harmony and health of the land. Like Frazer's innumerable spirits or even the Grail nature drama deities, Stamos's forms are expressions for the dormant powers of the world. They are so old as to be natural in themselves; in other words, they form a natural human ancestry to which Stamos noted he journeyed through "shells and webbed entanglements. The end of such a journey is the impulse of rememberance and the picture created is the embodiment of the ancestral world" existing once again in the mind.[15]

In works such as *Omen* and *Shofar in the Stone* of 1946 (pl. 30), Stamos employs a natural imagery of a claw arm, leaf spines, a rock monolith, and a flower to suggest a nature cult of ritual sacrifice for renewal of vegetation and life. *The Altar #1* of 1948 (fig. 270) also embodies the historical custom of sacrifice. It is part gestating form

with roots descending into the soil (cf. Rothko), part stone bier, and part megalith. *The Altar #1* combines ancient nature cult with vitalist life force. Of the related *Archaic Release* of 1947 Stamos noted that his work is the result of the study of humanity and its relationship to natural phenomena. "Today I am trying to project my ties with the archaic past and have bowed downed [sic] to the praying mantis and its use and symbolic meanings to the ancients."[16] *Cosmological Battle* of 1945 extends this earthly drama to the heavens.

Stamos moved toward abstract embodiments off these themes. In the 1950s, his work took on a more specific Greek quality (e.g. *Delphi* of 1959) as he explored his roots through visits to Greece. He also fused his pantheism with explorations of Eastern philosophies and art. The culture of the 1940s was diffused in work about more general nature, the sun, and ancient life. The initial cultural complex of the 1940s was thus broadened, but through-

Figure 270. Theodore Stamos, *The Altar #1*, 1948. Oil on masonite. 36 x 48 inches. Collection Savas Family.

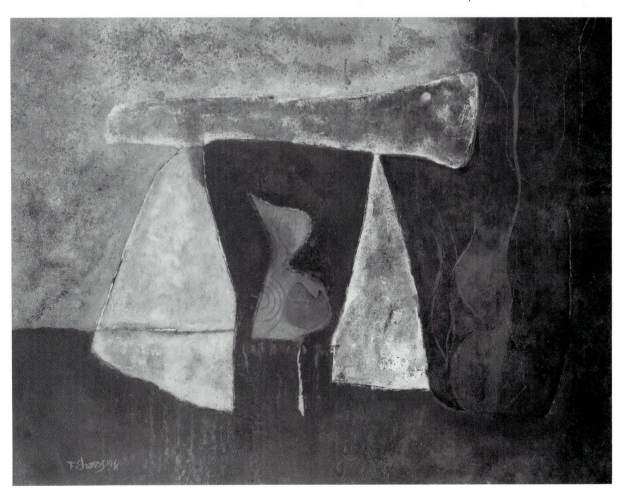

out his career he kept to his initial search for a distilled divine principle and for continuity and renewal.

LEE KRASNER

Like Stamos, Lee Krasner became an Abstract Expressionist early in her career, but, unlike him, she was first committed to the School of Paris which studied at Hans Hofmann's school in New York. To this she added Pollock's influence and that of the developing Abstract Expressionism when she met and married him in the early 1940s. From this rich painting culture, Krasner's art extended the boundaries of Abstract Expressionist art to articulate more fully than the others the search for the primal units of communication as well as of myth and experience.

In her first distinctive work, the late series of the 1940s entitled *Little Image,* of which *Continuum* is an example, she added a refined version of Pollock's all-over style. *Continuum* exhibits a delicate continuous web of lines and dots that reveals Krasner's grasp of the fundamental theme behind all-over painting—continuity, unity, and vitality. In this work, the webs are lighter in line, denser, more even, and more fully continuous than in Pollock's painting. For *Continuum,* she seems to have drawn on the admired figure of Mark Tobey and his method of white writing. Although Tobey's influence is unacknowledged, Pollock—and thus probably Krasner—knew his work in the 1940s.[17]

The original contribution of Krasner's *Little Image* series, however, and of her work throughout is her development of metalanguage painting, that is, the concern with an elemental, archetypal, archaic visual *and* verbal image. This concept was fundamental to interwar and Abstract Expressionist art. Surrealism had sought to combine the visual and verbal, as in Miró's archaic cave painting and sign and word canvases. Pollock's and Gottlieb's pictographs—especially the former's *Stenographic Figure* of 1942 and the latter's *Letter to a Friend* of 1948—De Kooning's *Zurich* of 1947, Tomlin's *Number 9 (In Praise of Gertrude Stein)* of 1950, Stamos's *World Tablet* and *Saga of Ancient Alphabets* of 1948, perhaps Ad Reinhardt's *Abstract Painting* of 1948, and David Smith's *Letter* of 1950 are attempts to fuse elemental and often archaic pictorial marks with graphic script. This tradition could also be found in Stein, Pound's Chinese ideograms, and Joyce's Indo-European puns and words. For these figures, the goal generally was to find the beginnings of human communication and communion and to make archaic and modern consciousness simultaneous through common graphic denominators. As Kunitz noted, "When you touch language, you touch the evolution of consciousness and the history of the tribe. You reach for ... a common tool, and find to your

surprise that it has a cuneiform inscription on the handle."[18]

Krasner's hieroglyphics, like *Untitled (Little Image)* of 1949 (fig. 271), reflect her similar combinations of Hebrew writing and fairy tales with the archaic unconscious. Krasner's father often told her Russian fairy tales and stories, and she studied Hebrew manuscript illuminations and calligraphy. Such references to ancient writing run throughout her art. Later she said of the *Little Images:* "I think it does suggest hieroglyphics of some sort. It is a preoccupation of mine from way back and every once in a while it comes into my work again. For instance, in my 1968 show at the Marlborough I have a painting called *Kufic,* an ancient form of Arabic writing."[19] These forms well up from her unconscious memory. In this regard, Krasner may have felt at home with the idea of the artist as vessel, an idea that Pollock, Jung, and others shared.

Krasner lost her way in the early 1950s, changing her direction several times. Her work consisted of rethinkings of Mondrian's verticals, Matisse color architecture, and Pollock's figural imagery. Like Motherwell, she did city themes, such as *City Vertical* of 1953, and everyday topics in paintings such as *Porcelain* of around 1954. She also made collages of torn painted paper, such as *Bird Talk* of 1955. These last works reflect her interest in mosaic construction. Other works exhibit a too-generic version of the swirling dynamic forms and paint known as gesture and Action Painting.

Only in the late 1950s and 1960s, in works such as *Three in Two* of 1956, *Fecundity* and *Cornucopia* of 1958, and *Combat* and *Gaea* (fig. 272) of the mid-1960s does she recapture the Abstract Expressionist themes and urgency. These works are still strongly Pollockian, reflecting his mid-forties and early fifties swirling, vertical biomorphs. Nevertheless, they restate the fundamental federation of the Abstract Expressionist cycle of mythic birth and death in dynamic, fecund imagery. Some of the works have been described as monstrous, which she accepts in an Abstract Expressionist way: "I wouldn't call it monstrous or underworld. You use the word *monstrous* as though it were relegated to a realm other than man. I would call it basic, insofar as I am drawing from sources that are basic."[20] They also reflect the personal turbulence of her life after Pollock's death, but they hint as well at the Matissean cutout decorativeness and color that flowers in her work in the 1970s.

Major works such as *Majuscule* of 1971 (fig. 273) brilliantly combine Hofmann's and Pollock's vitalist rhythm, Matisse's flat, floral color and Orientalist pattern, 1960s hard-edge color-field painting, Joyce-like scriptive elementaries, and her own subliminal glyphic writing, perhaps from memories of the Celtic manuscripts she loves.[21] *Majuscule* and works such as *Palingenesis* of 1971 and

Figure 271. Lee Krasner, *Untitled*, 1949. Oil on composition board, 48 x 37 inches. Collection, The Museum of Modern Art, New York. Gift of Alfonso A. Ossorio.

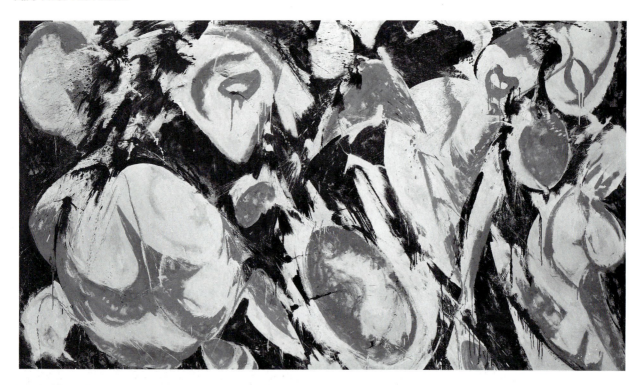

Figure 272. Lee Krasner, *Gaea,* 1966. 69 inches x 10 feet 5½ inches. Collection, The Museum of Modern Art, New York. Kay Sage Tanguy Fund.

Mysteries and *Rising Green,* both of 1972, are among the finest American painting in recent years. They attain a newly found serenity integrated with the complex themes of Abstract Expressionist generative dynamics.

In the late 1970s Krasner added a double meaning to the Abstract Expressionist idea of incorporating the past in the present and future cycle. In works such as *Imperfect Indicative* (fig. 274) and *Imperative* of 1976, she fused her own past—her youthful, charcoal figure drawings and their ghostly rubbings on other pieces of paper—into a new style of collages. She has said that this synthesis of her past in the present was done in order to make a personal, stylistic continuum or "oneness" of memories of the past.[22] These works seem to evoke architecture and the figure rather than the natural world and are, in one sense, more cubist than Abstract Expressionist. With their flashing angular shapes, indeed, they evoke the gothic while referring by title to the tenses of language—and humanlife. Krasner characterized her own long development in terms of the constant changes of the continuum:

My own image of my work is that I no sooner settle into something than a break occurs ... but despite them I see that there's a consistency that holds out, but is hard to define. All my work keeps going like a pendulum: it seems to swing back to something I was involved with earlier. ... For me, I suppose that change is the only constant.[23]

Despite her hesitancies, Krasner has been committed to the central core of Abstract Expressionism. She has extended it to represent a rhythmic, gestating fullness of the modern and archaic, scriptive, dynamic space-and-time continuum of the human journey that is both harsh and vibrant. She has made Abstract Expressionist art that, in it best moments, ranks with the best.

RICHARD POUSETTE-DART

Pousette-Dart's paintings reveal the utter secular religiosity at the heart of much Abstract Expressionism. Whether the sacred is routed into ritual, vitalist dynamism, or illumination, the cultivation of the ineradicable, intangible, all-powerful life force beyond human power is its greatest statement. Pousette-Dart once wrote in his notebooks that each painting is a *"creative* prayer"

the greater the art the more religious
—by religious I mean the most creative
—by most creative I mean the most penetrating
bursting somehow
through the particular to the universal[24]

In his work, Pousette-Dart develops his own variant of the Abstract Expressionist theme of regenerative move-

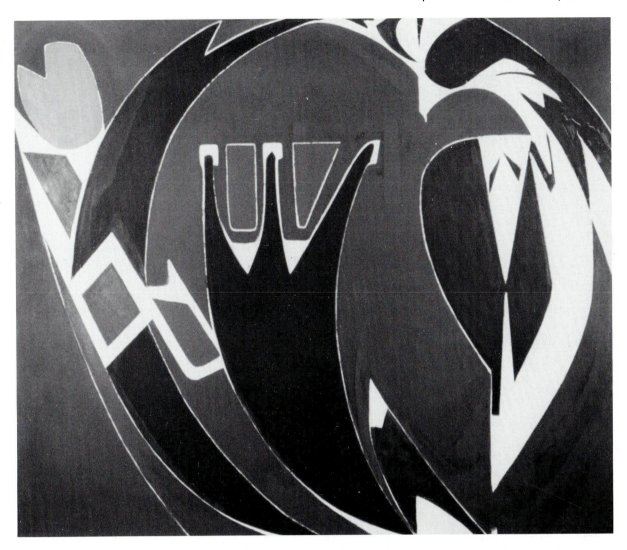

Figure 273. Lee Krasner, *Majuscule*, 1971. 69 x 82 inches. Collection FMC Corporation, Chicago.

ment and force as a cosmic radiance. His early work, for example, *Symphony Number I, The Transcendental* of 1942 (fig. 275) (along with Rothko's *Slow Swirl by the Edge of the Sea*, the first big Abstract Expressionist painting) anticipates Abstract Expressionist scale and all-over epic composition and fusions. Pousette-Dart's painting consists of ideographic forms in continual overlapping and generation from within and between one another—a nose comes out of an eye, the eye is part of a larger eye, skulls, mouths, arms, and snakes multiply. A stream of creative impulse is thus traced with Abstract Expressionist themes of interconnectedness, simultaneity, vitalist dynamism, multiplicity, and holism.

In *Comprehension of the Atom, Crucifixion* of about

1944 (fig. 276), Pousette-Dart unites the concept of Christian rebirth with the dangers of science, suggesting the polarities of choices. Placing a cross in the center, he laces and layers the curvilinear contours of an undefined totemic figure, a fish symbol, and other pictographic forms. The painting also combines a black and yellow contrast with a dark to light, ghostly white structure. The ghostliness suggests the formed and unformed, present and absent, conscious and unconscious, known and unknown, figure and ground. In other words, it is a transitional symbol that conveys different stages and states of being from above and below in a literal and figurative sense. The emphasis on transit is here combined with a powerful expressive explosiveness that indicates the transforma-

337

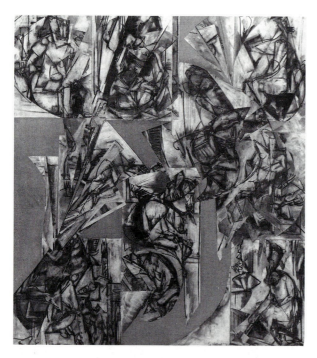

Figure 274. Lee Krasner, *Imperfect Indicative*, 1976. Collage of charcoal and paper on linen. 78 x 72 inches. Courtesy Robert Miller Gallery.

tions are not necessarily peaceful. This aggressiveness, however, is rare in Pousette-Dart. (He was a pacifist during the war.)

Comprehension of the Atom, Crucifixion also asserts the basic dream-layer space of Pousette-Dart's work and Abstract Expressionism. Although much was made in the 1960s of the flatness of Abstract Expressionist works, they were never flat. Rather, they took off from Synthetic Cubist overlapping to create a simultaneity, transparency, intricacy, and interconnectedness of imaginary form and space. "Layering," Pousette-Dart noted, "is an analogy to life itself."[25] Pousette-Dart's space is comparable to Rothko's fragment compounds and ebbs and flows, Baziotes's membrane fluid, Gottlieb's pictographic complexes, and Pollock's dense underworld. As he moved toward greater abstraction, for instance, in *Path of the White Bird* and *Golden Dawn* of 1952, the labyrinthine quality of his work equaled that of his colleagues.

In *Blood Wedding* (pl. 31) and *Illumination Gothic* of 1958, Pousette-Dart's pictographic, subterranean world is joined with plumes of dazzling color and mosaic sparkle. Besides the sense of movement, bejeweled color itself (especially in the latter's allusion to illuminated manuscripts) assumes the role of the life force. (As a young man,

Figure 275. Richard Pousette-Dart, *Symphony Number 1, The Transcendental*, 1942. Oil on linen. 90 x 120 inches. Collection of the artist.

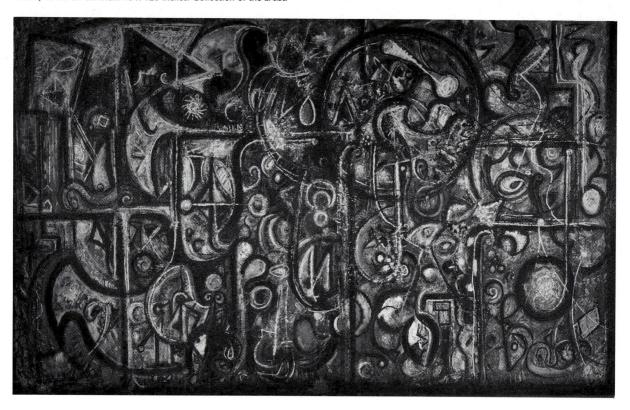

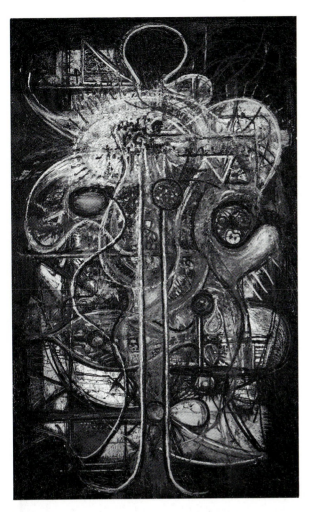

Figure 276. Richard Pousette-Dart, *Comprehension of the Atom, Crucifixion*, ca. 1944. Oil on linen. 77½ x 49 inches. Collection of the artist.

moons and suns (as in Van Gogh's *Starry Night*) through the religious structure of the triptych. Biomorphic vitalism becomes radiant, molecular, microscopic and macroscopic vitalism, an abstract, atomized gothic light, a sacred cosmogony, and a secular Creation. Space is time, and time space as in *Time is the Mind of Space, Space is the Body of Time, Numbers 1–3* of 1982.

Color dots and spiraling shapes form and unform and dematerialize. (Spirals are the symbols of growth and evolution.)[28] As in Rothko's work and Pollock's *Unformed Figure* of 1953, material and immaterial formation itself is a major theme. The building up and breaking down of form and of real physical surface—from impasto concentrations to thinner passages—reenacts Pousette-Dart's version of the theme of transition and transformation, formation and dissolution, expansion and contraction, the multiple stream and continuum with and of the world above and below. His painting is another Abstract Expressionist symbol of epochal, epic passage, in other words, transience and eternity.

Pousette-Dart's work thus reinvigorates the sacred as defined by Mircea Eliade, "Since every creation is a divine work and hence an irruption of the sacred, it at the same time represents an irruption of creative energy into the world."[29] Sacred cosmogony is the supreme divine manifestation. It is preeminently real and the source of all life and fecundity.[30] Pousette-Dart wrote

I strive to express the spiritual nature of the universe. Painting for me is a dynamic balance and wholeness of life; it is mysterious and transcending, yet solid and real.[31]

Like most Abstract Expressionism, Pousette-Dart's work attempts to reenact the mythic act of creation, the work of the gods.

Pousette-Dart studied the history of art, especially the Old Masters, medieval Florentine and Siennese art, Byzantine mosaics, stained glass, and moderns like Ryder and Van Gogh who emphasized the power of light and color.)[26] As in Rothko's divine radiance, Pollock's *White Light* and *Phosphorescence*, Newman's *Command* and *Day One*, and Baziotes's *Dusk*, radiating and trembling light becomes immaterial vitalism honoring and evoking spiritual force. Pousette-Dart has noted:

I am concerned with what burns its way through into its own reality. It is the quality of penetration and intensity which is religious in an art sense and which is art in a religious sense.[27]

In the 1960s and 1970s, Pousette-Dart further developed his own form of intangible transition by making circular forms in space divisible into atomic dots reminiscent of pointillism. In his triptych *Radiance* of 1973–74 (pl. 32), he journeys to the edge of the earth and to cosmic

AD REINHARDT

Ad Reinhardt lies on the margins of Abstract Expressionism. Uninterested in natural history and psychic life, he appears to be more of a geometrical painter than the others. Indeed, he is often claimed as the inspiration for much 1960s art from minimalism to conceptual art. Nevertheless, his work and thought partially draw on the Abstract Expressionist subjects of world culture and its reincarnation in modern guise. They also employ the cyclic stream in an original way, as he draws on the Eliotian thesis of much Abstract Expressionism: "the end is in the beginning."[32]

Reinhardt often wrote of and defined a cyclic continuum in the history of art. He noted in "Cycles through the Chinese Landscapes" that "It seems to be true that in that 'cycle' for all times and places, there is much to say . . . on

early, primitive and archaic 'attempts,' and ... late realist and expressionist 'developments.' "[33] Like his colleagues, he felt there was not linear progression but endless continuity and re-creation of the same types of things. For them, these things were behaviors, forces, personages, and archetypes; for him, they were just forms. For Reinhardt, art history is the recurrence of similar styles, types of painters, and stylistic characteristics such as brushwork in different cultures, although because of their different circumstances ultimately these things will appear different. He felt there were no fundamentally new forms in the world. In his review of George Kubler's *The Shape of Time,* he praised its conception influenced by Henri Focillon's *The Life of Forms,* that: "Perhaps all the fundamental technical, formal and expressive combinations have already been worked out at one time or another," and rejected the idea of complete originality and "the tradition of the new." For him there was a finite set of images, formats, conceptions, and expressions in which the new is only a contemporary selection of tradition.

We have seen that the concept of a modern artist's continuity with tradition is a standard tenet of Abstract Expressionism and its milieu. The idea of the fundamental or archetypal can be found in Rothko's statement that despite all changes in appearances and cultures, fundamental mythic and psychological ideas persist. It is, among others, a Jungian and Campbellian idea: the mythic and the past experience or archetype must be expressed in modern guise to conform with experiences of the new era. It is related to the concept of cultural and behaviorist ritual archetypes of the 1930s and 1940s. It has affinities to a Joycean idea from *Ulysses*—"metempsychosis," which his character Bloom explains: "It's Greek: from the Greek. That means the transmigration of souls. ... Some people believe that we go on living in another body after death, that we lived before. They call it reincarnation. That we all lived before on the earth thousands of years ago or on some other planet. They say we have forgotten it. Some say they remember their past lives." Bloom goes on to explain the intermittent continuity and recurrence of different souls, nations, civilizations, and characteristics. With *Finnegans Wake,* Joyce takes the idea further, using Vico's concept of the recurrent cycle of construction and destruction. And all of these concepts are, of course, related

Figure 277. Ad Reinhardt, *Number 18, 1948–49.* 40 x 60 inches. Collection of Whitney Museum of American Art. Purchase. (53.13)

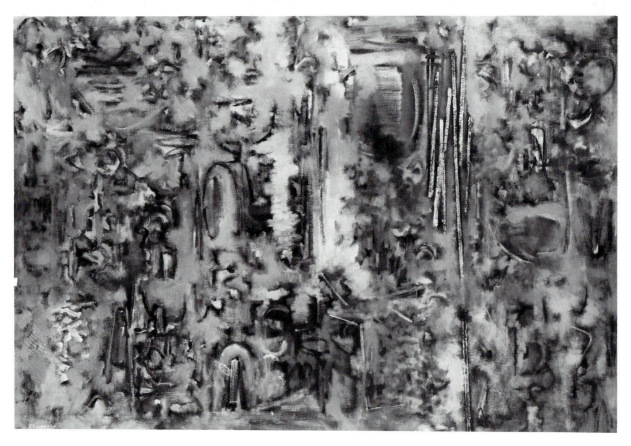

340

to Nietzsche's eternal recurrence, Heraclitus, Still's recapitulation, and Krasner's *Palingenesis*.[34] It is but a short step to the idea of national psyches and cultural personalities that can and should recur, such as ancestral personages and ritual Earth Mother goddesses in modern guise. The past retraces and renews itself in the waxing and waning of civilizations, figures, types, experiences, and needs. In a way, this thinking suggests there is virtually a single world consciousness and personality, infinitely varied, but linked in "oneness."

Reinhardt's *Number 18, 1948–49* (fig. 277) focuses on the signifying structure of this history-induced search for connectedness—the continuum of flux, formation, and dissolution. With the seemingly painterly, automatist dynamism or action of this painting, activity itself seems more important than any form. Reinhardt, however, apparently abandoned painterly art for more geometrical work, as in *Abstract Painting—Grey* of 1950 (fig. 278) and the brighter

hard-edged red and blue paintings of the early 1950s, and around 1956 he arrived at his distinctive black paintings such as *Abstract Painting* of 1963 (fig. 279).

In the black paintings, which he continued to paint for the rest of his life, he eliminated color interaction, visible motion of brushwork, innumerable variations, in favor of an image of virtually a single color, quiescence, contemplation, and microscopic variation. On the surface, the paintings seem to reject his early cyclic continuum as well as most themes of Abstract Expressionism. Yet the themes do continue to inform and structure the work subtly.

Reinhardt's mature continuum consists of a new form of the end as the beginning and the holistic oneness of all. The single tones in the black paintings provide seemingly unitary color, but on close examination the wholeness separates into several closely-tuned but different square and rectangular forms and into colors such as blue-black and brown-black. In other words, the unity of the

Figure 278. Ad Reinhardt, *Abstract Painting—Grey*, 1950. 30 x 40 inches. The Metropolitan Museum of Art. Gift of Henry Geldzahler, 1976.

Figure 279. Ad Reinhardt, *Abstract Painting*, 1963. 60 x 60 inches. Collection, The Museum of Modern Art, New York. Gift of Mrs. Morton J. Hornick.

black paintings is made up of barely perceptible ever-shifting variety. The concept of transit also remains, though not through typical Abstract Expressionist busy brushwork, but through multiple variations from overall black unity to the other tones and back to the single all-over color again. The end of one color form and the beginning of another, as well as its relationship to the all-over form and color, are difficult to determine. As in mature Rothko dynamism, differentiation of individual shapes and simultaneous unity with the ground are subtly established so emergence and dissolution are ever so slightly suggested.

In "Cycles through the Chinese Landscape" Reinhardt had explained such variations in terms of Abstract Expressionist dualism, although uniquely he gives it a Chinese cast: "The old yin-yang dualism includes the existent and non-existent, the seen and the unseen."[35] Like the Chinese landscapes he discussed, his black paintings "can look organized and organic, atmospheric and airless, immanent and transcendent, ideal, unreal and most real."

Reinhardt's quest for infinitude, immeasurability, and openness is similar to the central threads of Abstract Expressionist thought and practice. In "Cycles through the Chinese Landscape" he says "The Eastern perspective begins with an awareness of the 'immeasurable vastness' and 'endlessness of things' out there, and as things get smaller as they get closer, the viewer ends up by losing (finding?) himself in his own mind."[36] With Reinhardt's *Abstract Painting,* as in all his black paintings and in Ab-

stract Expressionism in general, the work absorbs the viewer. Closeness as well as distance is required to grasp its workings fully.

Additionally, Reinhardt turned toward the fusion of East and West as his variant of the unity and wholeness of world culture. He defined himself that way as a virtual Chinese "sage-scholar-hermit-gentleman," and his thought and way of speaking and writing, for example, in essays such as "Twelve Rules for a New Academy"[37] consist of a plethora of quotations usually from the ancient Chinese or other Far Eastern sages. Much like Wilder, Eliot, Joyce, and his colleagues, for Reinhardt wisdom and knowledge are to be gained by, if not the ascendancy of non-Western, nonmodern, or antirational and conscious thought and culture, at least the combination of them with Western thought.

During his travels to the Orient and elsewhere Reinhardt took slides of architecture, painting, sculpture, and other arts. When he lectured, he organized these slides by motifs, patterns, and forms such as doorways, buttocks, windows, and faces, forming an encyclopedic world unity of archetypal expressive forms.[38] However, Reinhardt preferred the East to the West, and his lectures and imaginary art history consisted of comparisons to the detriment of the West. For Reinhardt, the ideal form is most often Oriental.[39] His favorite forms included the mandala, the circled square, the squared circle, the map of heaven and earth, and the chart of spiritual energy and transformation as cross and interlace. He combined Abstract Expressionist themes of unity and variety, continuum, cosmic painting, and abstract diagram of the life force with Eastern shape, thus fusing West and East in an all-over design. *Abstract Painting* with its vertical cross forms constitutes an ideograph that diagrams and expresses the perpetual world order.

To be sure, Reinhardt rejects central aspects of Abstract Expressionism, or rather critical misunderstandings of the work as emotional frenzy, self-expression, and painterly action for its own sake, and his dedication to such a repudiation virtually squeezes the life out of his work and nearly fulfills his idea of art-as-art without cultural and emotional expression and reference or usefulness. His colorless icons of exclusive, negative, absolute, and timeless form may be his personal attempt to transcend the claims of his colleagues or, more likely, of their supporters. Nevertheless, his statement in "Twelve Rules for a New Academy" that the art tradition stands as the "antique-present" model of what has been achieved and need not be achieved again is an original variation of the space-time continuum, and reaffirms that the Abstract Expressionist "timelessness" is not ahistorical but reflects the modern traditionalism central to Abstract Expressionism.

NEO-ROMANTICISM

Abstract Expressionism is an American style developing in the American milieu of 1940s. Its culture had great breadth and it proved capable of attracting the experienced and the novice, the nondoctrinal religious and the critical, the uncertain and the overconfident. However, it also shared central tenets with other cultural complexes. One is well-known, surrealism. Others are not—the American 1930s and 1940s, for example, which have been a major focus of this book. But another, mostly unknown in America, that should be mentioned for future research is the British wartime culture known as Neo-Romanticism.

Like the early years of Abstract Expressionism, Neo-Romanticism of the late 1930s to 1950s was largely forgotten until most recently. It has been rediscovered in the collapse of Greenbergian and Modernist paradigms of the rigid development of modern art. In exhibitions such as "A Paradise Lost: The Neo-Romantic Imagination in Britain 1935–55" at the Barbican Art Gallery in 1987[40] and others, it is evident that the English-speaking peoples on both sides of the Atlantic responded to war in several similar ways, ways that were not beholden only to French surrealism. Although surrealism influenced both Abstract Expressionism and neo-Romanticism, the Anglo-American arts fused it with, if not subordinated it to, other major concerns.

Among these concerns are the major themes that they shared. One was the Quest. Neo-Romantic art often portrayed voyage and *The Quest* (fig. 280). Artists Cecil Collins and John Piper, for example, represented a search for a new Eden or Arcadia in the maws of the war. Such a theme led to the sacrilization of nature and landscape that was a standard feature of Abstract Expressionism. Neo-Romantic cycled nature, as in Ceri Richards's *Cycle of Nature* of 1944, or brutalized it by analogizing it to human predatoriness, as in Eric Hosking's *Heraldic Attitude Adapted by Barn Owl* of 1944–47. Another shared

Figure 280. Cecil Collins, *The Quest*, 1938. 109.2 x 144.8 cm. Private collection.

Figure 281. David Jones, *Aphrodite in Aulis*, 1941. Pencil, ink and water-color on paper. 62.9 x 49.8 cm. The Tate Gallery.

Figure 282. Graham Sutherland, *Thorn Tree*, ca. 1945. 127 x 101.5 cm. The British Council. © ARS, New York/Cosmospress, 1989.

concept was the assertion of Life against Death. If breasts nurture or if nature is defined as ineradicable life dynamism in Abstract Expressionist work, in John Minton's *Recollection of Wales* of 1944 Welsh life and land swell forward in a flow of leaves and organic forces, indicating the British too understood nature's capacities as a symbol of ineffable vitality and power.

A third joint conception is the interweaving of periods of time. T. S. Eliot's (but strangely not Joyce's) mix of the past and present of his mythic method and his archetypes of fertility and quest were major influences in both groups.[41] Much like Abstract Expressionists, David Jones, for example, superimposed Arthurian legend, Catholic iconography, and classical mythology on war imagery in his work as he too made a "laminated, transparent montage of periods and signs from mythic time, the Middle Ages, and the Western Front" (fig. 281).[42] As with the Abstract Expressionists, for the British an alternative history of art and humankind linked together primeval (Celtic), ancient, gothic, and modern periods, thereby creating a primal continuum or genealogy that circumvented the High Renaissance and Baroque.

And like Abstract Expressionism, a harsh realism and sense of hurt, injury, and vulnerability especially in the postwar years was primary in Neo-Romanticism. Graham Sutherland works such as *Thorn Tree* of about 1945 (fig. 282), for example, represented the torn world and history itself with Christian and natural symbolism of thorns.

To be sure, the visual style of neo-Romanticism is substantially different from Abstract Expressionism. It combined its references to surrealism and especially the horrific Masson with Blake, Palmer, gothic spaces, and precious and precise drawing. Neo-Romanticism remained a figurative art unlike Abstract Expressionism. It also lacked the developmentalism of the American 1930s, its archetypal patterning of history and experience, and the combination of Jungian psychology, anthropologism, and ritual of the 1940s. Nevertheless, significant continuities suggest that Abstract Expressionism arises not simply from the unique genius of the artists, nor from their singular culture and historical complex alone but from common responses in the Anglo-American West to a shared history. By the end of the 1940s, however, another historical and cultural matrix began to form and displace both.

PART 3

TRANSFORMATIONS

VERNACULAR ABSTRACTION
The Domestication of Abstract Expressionism

As a twelve-year-old girl I discovered that the world was not a sheltering place. . . . The scars are inside. There isn't any bottom any more. There isn't any foundation any more.

Nora Watson, a mountain woman

Hell is the denial of the ordinary.

John Ciardi, *The Gift*

In the late 1940s, Abstract Expressionism became more than an expression of the interwar and war generations. It and its successors offered an entirely new mode and language for many artists with new and even contradictory interests. Abstract Expressionism became a language of painterly dynamism, abstract force and vitality, and unitary design. As such it was open to a new, mostly younger generation who lacked the experience and the motives of the first generation. One of the younger artists, Grace Hartigan, said frankly, "I began to get guilty for walking in and freely taking their [Pollock's and De Kooning's] form . . . [without] having gone through their struggle for content, or having any context except an understanding of formal qualities. . . . I decided I had no right to the form—I hadn't found it myself."[1]

These artists expanded Abstract Expressionism to what is called the New York School, a semiabstract and abstract art of urban vitality, everyday emotions, quotidian concerns, visual perception, and a psychology of personal, autobiographical, subjective feelings. With the New York School, the dynamic, painterly surface of much Abstract Expressionism became a melodramatic expression of the disorderliness of life and a test of one's character and integrity. The artists and critics of the New York School domesticated and transformed Abstract Expressionism

into an art that was, in most ways, the opposite of that of the first generation. We have already seen some examples of this transformation and effect in the work of De Kooning and Motherwell in the 1950s. Let us now look at the chief mechanism for its domestication and absorption by the American public, existentialism, and the conditions that led to its prominence in American culture.

THE NEW HERITAGE

What happened after the war? What happened to the men and women who had fought and endured and were now returning to a transformed world at home? What was waiting for the returning veterans? Hollywood symbolized the popular hopes and the more telling results in several movies, and thus two movies indicate the course of events. In a film financed by the government to allay veterans' fears, *The Enchanted Cottage* of 1945, a soldier who was about to leave on his honeymoon when he was called up at the beginning of the war returns disfigured.[2] His wife abandons him, but he falls in love with a "plain" maid. They honeymoon in a New England cottage which had been used by other newlyweds. The place is magical, full of life and love, with flowers blooming. The two take on a new physical and emotional beauty and are transformed. In this Hollywood romance (actually quite accurate in its reporting of servicemen's fears of losing their families after years away), the effects of the war are removed and a better life begins anew. *The Enchanted Cottage* thus presents in appropriate postwar and domestic terms the hope for renewal of the cycle of life inherent in Abstract Expressionism, which will continue after the

war (cf. Pollock's *The Enchanted Forest* of 1947, a poured painting of a thematically parallel magical, ritual transformation, and Gottlieb's *The Enchanted Ones* of 1945, a painting that may be about a grimmer type of enchantment).

One of the finest movies to come out of the war and another illustration of the problems of returning soldiers is *The Best Years of Our Lives* of 1946.[3] The epic-length film depicts the struggle to adjust to a world that is neither prewar domestic nor wartime military. *The Best Years of Our Lives* begins with a scene of three veterans of three different ages and classes—a seaman significantly named Homer who has lost his arms, an army sergeant, and an airman, returning to "Boone City" (a name symbolic of the American frontier) in the front gun turret of a bomber as it flies low over the American countryside. The image is that of a menacing bomber full of warriors who, like the bomber itself without its guns and bombs, are now de-fanged in the postwar period, surveying the home landscape. The warriors, now different in experience, skills, personality, and their very physical being from before, must shift themselves into a new, less lethal, and seemingly more domestic, ordinary, social reality.

Their previous world has undergone physical and other changes. In many ways, the world has passed them by, they no longer fit the everyday world. The problems of adjustment to civilian life ensue—infidelity and collapse of a war-induced marriage, alienation from family and friends, and cultural estrangement. The army sergeant's children do not relate to his wartime experiences but are interested in new problems such as the bomb and radioactivity of which he knows little. The veterans are alienated. Despite their personal achievements, the war did not provide them new employment skills. Ironic connections between wartime and postwar experiences follow: the army sergeant, previously encouraged to fight, is now encouraged to make money. The change from the communal character of national self-sacrifice to self-centered, amoral business ethics shocks him. The veterans' war world has thus undergone an emotional and psychological change and the men must readjust their war-developed personalities and values to domestic life and experience. Nevertheless, the film ends on a hard but optimistic note. The initially unsuccessful veteran airman finds work helping to convert the now scrap-heap warplanes into homes for other returning veterans. Instruments of destruction have been transformed into instruments of construction. In other words, the former soldier and his war weapons became domesticated, transformed, and reborn while never quite leaving their war experience and altered selves behind. The transformation of war planes into homes and fighting men into civilians modernizes biblical and pagan myths of swords being turned into plowshares

and the phoenix being reborn. *The Best Years of Our Lives* documents the beginning of the end of the Abstract Expressionist culture and history and the birth of the postwar world and the ultimate sources of the new art.

Once the war ended, many assumed that "normalcy" could be achieved and the war left behind, but the tremendous psychological, emotional, and social effects of the war could not be just turned off. The war became a powerful imaginative continuity that survived into postwar life. Detaching itself from normal location in chronology and from its accepted historical causes and effects, the war became a world experience in another sense—"all-encompassing, all-pervading, both internal and external at once, the essential condition of consciousness in the twentieth century."[4] Alfred Kazin noted that it was not long after the end of the Second World War that even the most liberal of intellectuals abandoned the idea that the war had ended anything. There were:

so many uncovered horrors, so many new wars on the horizon, such a continued general ominousness, that "*the* war" (that is, the Second) soon became War anywhere, anytime—War that has never ended, War as the continued experience of twentieth-century man.[5]

The mentality of the Abstract Expressionist historiocultural complex became largely a permanent, homeless world view (endlessly trumpeted in art criticism as the "timeless," quoting a letter to *The New York Times* in 1943). For many participants in the Second World War, "battle" was understood as a condition of the human heart, "warfare" a continuation of everyday psychological dynamics by other means.[6] Abstract Expressionism presents the surreal, the deadly, and the cruel as the natural throughout space and time. The war continued on in a new understanding and set of expectations, a twentieth-century "universal" pattern of human experience and habit. In a sense Nazism partially won the war because what was commonly accepted after the war as human nature and the possible order of things includes the images and changes Abstract Expressionism documented.

Nevertheless, changes did occur in the postwar period. In the immediate euphoria about a possible new age, profound adjustments to the historical situation, needs, and dynamics of Western culture took place, much like those at the beginning of the war. To investigate these changes, let us step back into Abstract Expressionism before examining the new paradigm.

THE UNIVERSAL AND THE SELF

The crisis in the West and the war were tremendous communal experiences in which the group or collective

public needs dominated. The demands of total war for self-sacrifice were particularly intense. In the wake of World War I, demands were made for an end to human inefficiency and waste through the elimination of human variety. Ideologies dedicated to expressing communal needs and interests, from the search for heritage to Marxism and Fascism, evolved. In the art and thought of the 1920s to 1940s, in many ways the individual was of secondary importance. From the De Stijl dismissal of the traces of human weakness to the machine aesthetic of the 1930s, utopian strivings subordinated individual rights and expression to other concerns. Impersonal order and collective goals reigned. The historian William McNeil recalls of the 1930s and 1940s:

In my youth I had strong affinity for the notion of a closed universe, whose future was foreordained by its past. I felt an elevation of spirit in thinking of myself and all around me as part of a hurtling process that far transcended human will and consciousness; a process that submerged humanity, earth, solar system and galaxy; and the universe itself in cosmic change whose lines may well have fixed from the moment of the Big Bang and whose future, however, unclear to us, was as certain as the past.[7]

World War II was a climax of interwar ideologies of the dominance of group need over individual rights, not only in its total involvement, but also because the enemy itself was indifferent to human rights. As Hitler said, when informed of the loss of Stalingrad, "What is the life of the individual. Nothing. The individual must die. It is the nation that matters."[8] The Second World War was just that, a world war of the masses of civilians. Few individuals mattered within its suffocating experience.

Abstract Expressionism, with its conceptions of the fundamental forces, was one artistic realization of the era's collective, suprapersonal powers. While it is certainly true that Abstract Expressionist art is the product of unique personalities and subjective combinations of interests, a majority of the artists aimed at and insisted on the eternal, the collective, and the timeless. They saw the individual as an example of the particularized universal and not as something private and personal. Rothko, for example, declared "Painting ... is not a form of self-expression. Painting ... is a language by which you communicate something about the world."[9] He felt no artist can or should strip himself of the bonds of will, intelligence, and civilization. Newman also noted that as an artist he was not merely concerned with personal feeling and the subjective mystery of his own personality.[10] Lipton recalled that Benedict had taught him that the private and social are not different but the same.[11] And as a young student in a psychology course entitled "Personality in Art," Pousette-Dart wrote, "The greater a work of art, the

more abstract and impersonal it is, the more it embodies universal experience, and the fewer specific personality traits it reveals."[12]

The Abstract Expressionists reflected their era's belief that individual identity was to be found as part of a larger organism, whether economic, cultural, natural, or mythic. For Americans of the thirties, Wood's *American Gothic* indicated the individual was a historical, cultural, and economic product. Wilder considered the theater the vehicle of general experience: "It is through the theatre's power to raise the exhibited individual action into the realm of idea and type and universal that it is able to evoke our belief."[13] For Eliot, poetry is not the expression of emotion or personality, but an escape from them. For Nietzsche, the individual was less important than a hierarchy of ranked individuals. His higher type need not be unique or individual but only superior. Campbell argued that the goal of myth is to reconcile social type with the collective organism, individual consciousness with the universal will: "Rites of initiation and installation, ... teach the lesson of the essential oneness of the individual and group; seasonal festivals open a larger horizon. As the individual is an organ of society, so is the tribe or city—so is humanity entire—only a phase of the mighty organism of the cosmos."[14] Perhaps Martha Graham best summed up the question of the individual, the subjective, the collective, and the artistic for Abstract Expressionist culture when she described it as nonpersonal and suprahuman. For *Dark Meadow of the Soul* of 1946, she wrote that the artist creates for the community but is still independent:

Art without belief—that is, community belief, is not easy to create. Problem of producing significant art in an individualistic and skeptical age ... To believe that your impressions hold good for others is to be released from the cramp or confinement of personality.[15]

In her terms, the artist creates for all, and the individual, when enlarged and changed through the life process, grows, as one critic notes.

It is through [her theme of the cultivation of being] that the legends of the soul's journey are retold with all their gaiety and their tragedy and the bitterness and sweetness of living. It is at this point that the sweep of life catches up the mere personality of the performer and while the individual ... becomes greater, the personal becomes less personal.[16]

Abstract Expressionism does not represent the triumph of the individual but the drama of the individual seeking community—historical, psychic, natural, social, temporal, and cosmic. It is a search for his or her place in the holistic pattern and old and new tradition. It is an art of personal views of the impersonal powers of the world, including heroic destiny, and the sweep of canonical histories. One recalls Pollock's phrasing of the powers: "The painting,"

Pollock once said, "has a life of its own. I try to let it come through."[17]

THE DESTRUCTION OF THE COLLECTIVE WILL

While collectivity could explain, it could also excuse. Robert Graves, author and veteran of the First World War, notes:

In the Punch-and-Judy show of our century ... there are no more guilty and also, no responsible men. It is always, "We couldn't help it" and "We didn't want that to happen." And indeed, things happen without any one in particular being responsible for them. Everything is dragged along and everyone gets caught somewhere in the sweep of event. We are all collectively guilty, collectively bogged down in the sins of our fathers and in our forefathers.[18]

The collective could prove to be more terrible than just a danger in the wrong hands. Coming face to face with the bones and ashes of the Nazi system assured the collapse of the belief in the perfectibility of humankind after centuries of utopian strivings. What Auschwitz, Buchenwald, Dachau, Bergen-Belsen revealed—crematoria, masses graves, cordwood stacks of human beings, skeletal survivors—transformed the definition of evil in Western history and the modern world. The systematic, industrial sadism, the brutality, the moral, physical, and spiritual denigration of individual human beings transformed the imaginative and cultural landscape of the West and helped put an end to the utopianism of group consciousness. With the further discovery of a parallel systematic violation of human rights in the prewar illusionary utopia, the Marxist Soviet Union, the concept of totalitarianism as the greatest danger to human rights took hold among Western intellectuals. As discussed in Hannah Arendt's widely influential *The Origins of Totalitarianism,* authoritarianism came to be seen as the modern experience in mass society. The effects of Western history and the World Wars thus ended up residing in a resistance to a new negative force, collectivism and totalitarianism.

These years of forced collective self-sacrifice brought about a reaction. Political statements that the war itself had been fought for individual rights were commonplace in the West. Many of those in the "intellectual Resistance" in Europe were severe critics of humanism in the 1920s and 1930s but found themselves in the 1940s and 1950s awakening to a new respect for its values. The coming of Fascism and Nazi Socialism had led most to reaffirm their commitment to the role of independent moral judge and public conscience and to rescuing both liberalism and socialism from the onslaught. Like virtually everyone in the prewar period, including the Fascists, the intellectuals of the Resistance thought they were saving Western civilization. Like their opponents, they affirmed a belief in courage, enthusiasm, and the necessity to endure sacrifice for an idea; they also expressed faith in a spiritual revolution that would restore vitality and purpose to an aging continent. As one scholar of the intellectual Resistance notes:

What distinguished the intellectual Resistance from its foe was not a more dispassionate outlook, but an ardent defense of the individual. It opposed Fascism in the name of traditions, whose commitment to reason and measure it respected and revived.

The creativity of the Resistance intellectuals was largely confined to attempts at synthesis between these traditions—juxtaposing ideals such as humanism and individualism, freedom and justice. They were preservers rather than innovators; they restated beliefs and testified to their efficacy as guides to conduct. If the "generation of 1914" emerged from World War I in a state of profound disillusionment, the reverse can be said of the Resistance generation, whose values survived and were strengthened by the war.[19]

During the war, intertwined with the resistance to collective evil, the need to cultivate and to reconstruct life, and the desire for individual dignity and freedom from political tyranny, there grew the seeds for the next epoch in Western cultural, intellectual, political, and spiritual history—the reassertion of the worth and rights of the individual. The shift can be seen in two comments, both of which begin with statements on the war and its effects and end with what will be existential and individual "action" for personal freedom and liberation from both the collective and utopian, and from political tyranny. The first is by a Holocaust survivor, discussing the forty years since his liberation from a camp. He divides the two eras of pre- and postwar by a mere comma:

I believe we represent ... the determination to overcome despair and to defy death by recreating life. We have been able to remember the pain of the past and to transmit it so as to warn others of what can happen. We showed that it was possible to fight for life in a world of death, for freedom in a world marred by tyranny.[20]

The second is a poem, *The Gift,* by the veteran and poet John Ciardi:

In 1945, when the keepers cried *kaput,*
Joseph Stein, poet, came out of Dachau
like half a resurrection, his other
eighty pounds still in their invisible grave

Slowly then the mouth opened and first
a broth, and then a medication, and then
a diet, and all in time and the knitting mercies,
the showing bones were buried back in flesh,

and the miracle was finished, Joseph Stein,
man and poet, rose, walked, and could even
beget, and did, and died late of other causes
only partly traceable to his first death...
He noted—with some surprise at first—
that strangers could not tell he had died once...

In the spent of one night he wrote three propositions:
That Hell is the denial of the ordinary. That nothing lasts.
That clean white paper waiting under a pen

is the gift beyond history and hurt and heaven.[21]

Here Abstract Expressionist and war themes of death and resurrection, "refleshing" of bones, healing, generation, and the miraculous power of life yield to the reassertion of ordinary life over the epic, the recognition of the transitory and contingent nature of life, the need for a *tabula rasa*, and the rejection of history and utopias. Ciardi captures the mood of the late 1940s, that it is necessary to lower one's sights, eliminate the world-historical yearnings of the prewar and war periods and begin again with just a blank piece of paper. The latter forms the basis of much existential thought and Action Painting and the ideology of the New York School of the 1950s in which there are no absolutes in value or morality, just a blank slate. Man is free of historical and social limitations and faces an open choice in which previous guidelines have collapsed.

Some of this existential ideology was implicit in Abstract Expressionist culture from the start. In *Dyn* of 1942, for example, Edward Renouf stated the goal using the unconscious as the spontaneous cultivation of human possibility and potential:

The modern artist does not seek his salvation in the hope for or belief in any perdurable utopian finality, but in the dynamism itself of progressive trial, search, discovery, construction, action. The value of his art, like the value of life itself, does not lie in any hypothetical perfection—the glamorous figment that in fact represents sterility and death—but in the very process and fullness of ever-changing effort, adaptation and evolution. ... Modern painting, by reason of its spontaneity, its shattering of the conscious image ... [affirms] the creative ... unconscious. ... [M]odern artists [are] acutely responsive to the social and moral realities of the day. ... Modern art is revolutionary. ... [I]nstitutions [should] be kept flexible to allow ... as great a degree as possible of spontaneous unfolding and evolving of human personality and its quintessential instrument and expression: creation. ... Thus the nuclear problem of modern painting is the problem of transfiguring life into plastic statement—and of course not merely the life of which we are already aware, but above all the boundless oceans of protean and ever-evolving and changing potentialities and realizations of which we have as yet not become aware. Thus the painting is a metaphor that expresses the life of the painter. It is implicitly a biography that as metaphor comes closer to the vitality of life and its protean awareness than

could any ... theoretical or factual statement. It fuses fact with its ambient world ... via subtle ellipses ... allusions, fusions of unconscious and conscious, of realizations and insights with mysterious presentiments. And of course the biography of the artist is not merely his biography ... [but] also a chapter out of the biography of his time and culture.[22]

Renouf's statement links many Abstract Expressionism themes to the idea of creative, open-ended revolution and thus to action and spontaneous creation, ideas central to the culture evolving in the late 1940s and first half of the 1950s.

In general, the rejection of the virtually impersonal interchangeability of human beings and the revival of individualism and emphasis on universal individual rights in the postwar period began bearing immediate fruit in major adjustments in American life.

Despite its collective pressures, "the pattern of ... war is shaped in the individual mind by small individual experiences."[23] A greater individualism and self-confidence develops in battle because the soldier feels he is the only one out there. Heroes in postwar fiction such as Norman Mailer's *The Naked and the Dead,* or Irwin Shaw's *The Young Lions* were alone in battle. They went into combat or "engaged in action" on the battlefield and made *choices* between heroism and safety with no one to help. As one veteran put it: "you couldn't convince a GI anybody was out there fightin' the fuckin' war but him."[24] In *The Best Years of Our Lives,* the sergeant-become-banker emphasizes the new knowledge gained by the war when he decides to give a loan to a veteran who has no collateral. He declares that he has seen soldiers stripped of everything but themselves. He could tell whether they would make it in combat or not. What counts, he noted, was individual character—"what was inside."

On the homefront too there was a sense of self-reliance. At first reliance was collective. One worker for General Motors, Don Johnson, noted, "We were in a survival mode. People knew that, and they worked together to get the job done. We had a common purpose. We worked as a team. We had the skills. We had the machinery. We had the know-how. We achieved. ... A rule was established that said, 'You can do it if you put forth effort.'" Then, Johnson continues, that reliance carried on into peacetime life: "Many of those people still carry those skills, those drives, with them."[25] Blacks and women too developed more of a belief in themselves (fig. 283), although they were put on hold after the war: "You don't have to be just a homemaker. You can be anything you want to be."[26] The war years offered new possibilities.[27] For even the Japanese Americans, stripped of their rights and sent to camps, it could be said that the evacuation "strengthened you."[28]

353

Warfare, however, can often be the most existential of situations. And not just in battle itself; with the tremendous disruptions of normal life in time of total war, life can only be lived in an improvisational, open way. Jung described life even in neutral Switzerland: "It is the most hellish suspense one can image. Everything is provisional, and life moves from day to day."[29]

The lonely figure engaged in battle and the citizen in suspense formed a new psychological landscape for the postwar period:

Which is to say that anxiety without end, without purpose, without reward, and without meaning is woven into the fabric of contemporary life. Where we find a "parapet" we find an occasion for anxiety, self-testing, doubts about one's identity and value, and a fascinating love-loathing of the threatening, alien terrain on the other side.[30]

Such anxiety became permanent in the postwar world and it was kept alive by the power and permanence of the war effort in Western society. Militarism—the sense of being permanently at war and the resulting need for a standing army and a huge military establishment—became ingrained. Before the war, the military "just wasn't part of a normal person's experience."[31] After the war an adversarial condition—the Cold War—fit into the psychic slot of the enemy, a legacy that made competition, rivalry, and fear permanent features of the world. Evil, aggression, and hostility became the new, ironic, natural experience and tradition. A fascination with horror and the grotesque made them seem inexhaustible. As one survivor noted, "There is something curious about the fascination with horror that isn't exhausted. It takes the bottom out of the world, especially in combination with the bomb. . . . I had the impression of no . . . base to the world. The unpredictability. The no-bottom world is unmanageable."[32] Gottlieb's wartime declaration of "eternal insecurity" reveals the new vulnerability. There was loss of faith in human beings because of the weakness and conformity: "There's something in some men that will seek power and the rest of us will follow. There are few dissenters, too few."[33]

The psychic disorder of constant tension became the postwar order: "Today, the development has been headlong. Our military and political leaders seem to be in a trance."[34] The human nature of the new Everyman was described by a French Catholic priest responding when asked if bestial militarism and the murder of whole populations were uniquely German: "This is human. It happened before. The Spanish, in the Inquisition under God, destroyed an entire population. . . . It can happen again."[35]

It was through the development of the interest in individual rights and self-reliance, and the resulting, creative struggle of the human being in lonely isolation, that exis-

tential concepts helped transform the understanding of Abstract Expressionism into its 1950s paradigm of the melodramatic struggle and existential predicament of the individual personality and artist in an anxious world. As Abstract Expressionism had absorbed and adapted surrealism and the culture of its milieu for its own ends, American artists of the 1950s absorbed and adapted Abstract Expressionism for theirs.

EXISTENTIALISM: MAN MAKES HIMSELF

Popularized existentialism suggests that each person exists as a kind of monad, tied to his subjectivity, confronted with reality or "facticity" of an oppressive objective world and its institutions. He or she exists as a human being only by recognizing the situation, acknowledging radical freedom and responsibility, and charting an individual course without any illusions of utopia. In this scenario, one recognizes the situation, effects, and anxieties of the war.

Soon after the war, the Abstract Expressionists became familiar with the writings of a war veteran, Jean-Paul Sartre, a Resistance figure, Albert Camus, and Soren Kierkegaard. Sartrean existentialism arrived in America after it became the postwar attitude of many French intellectuals. Rothko indicated its growing power in 1948 in his discussion of artistic forms as being in a "unique situation" in the essay "The Romantics Were Prompted," published in the Abstract Expressionist magazine *Possibilities,* edited by Rosenberg and Motherwell. In the essay, Rothko also discussed the important existential questions of identity and solitude. The journal's original name was *Transformation.* Motherwell, in a letter, simply crossed out the word and changed it to *Possibilities,* indicating the abrupt and partially willful transition from previous interests to existentialism.[36] An editorial in *Possibilities* discussed the sublime and its relation to the "here and now," the latter being, again, Sartrean issues and, indeed, Sartrean terminology. Sartre himself came to America in the 1940s and Newman heard him speak. Indeed, Sartre's essays on European art, as noted, were influential. The Abstract Expressionist sculptor David Hare, with whom Sartre stayed while in New York, was the subject of an essay by Sartre.

Camus's writings became popular in the 1950s and reinforced many attitudes and beliefs of New York School artists, with its emphasis on the irrationally absurd. In 1946, an issue of the *Partisan Review* consisted of fiction by Sartre, and Genet, and the opening chapter of Camus's *The Plague.* De Kooning has said existentialism was in the air in the late 1940s. According to Tom Hess, as noted above, De Kooning's favorite philosopher was Kierkegaard

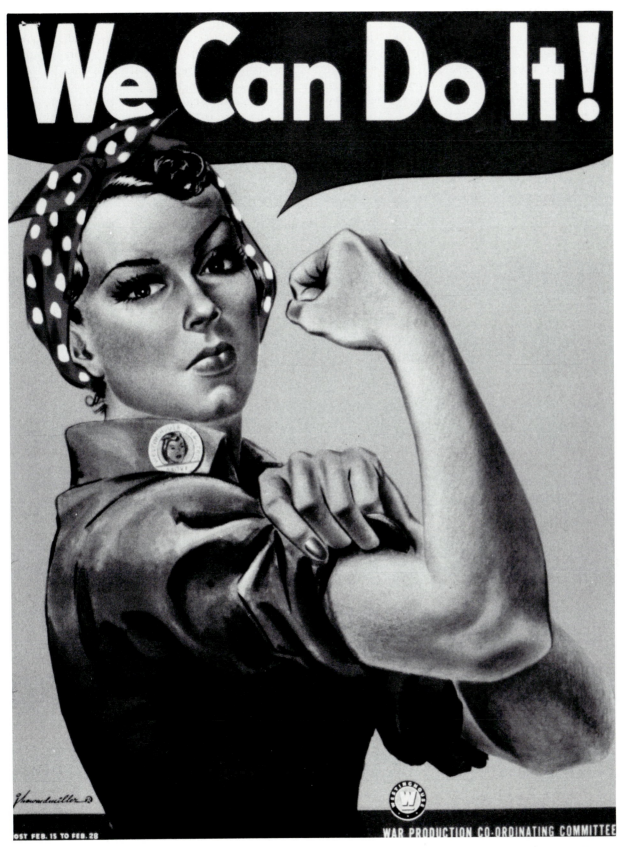

Figure 283. Edward Miller, *We Can Do It!*, ca. 1943. Poster, National Archives.

and his favorite book *Fear and Trembling.* It was a favorite of many other Abstract Expressionists, including Rothko, who praised it in a lecture of the late 1950s.

Despite this surge of interest in existentialism in the late 1940s and early 1950s, however, it should be kept in mind that there is no evidence that most Abstract Expressionists were anything more than superficially interested in it; rather they were responding to the epoch-making change taking place. There is no evidence, for example, that Pollock or Still were interested. Gottlieb later said "I don't know much about existentialism."[37] And they continued to respond strongly to their fundamental interests as evidenced in their reaction to Campbell upon his appearance at The Club and to the publication of his *The Hero with a Thousand Faces.* The mature form of Abstract Expressionism developed without much help from existentialism. The artists' interest in it was an effort to keep up with the new intellectual fashions.

Nevertheless, the existential concept of Sartre, in particular, is illuminating and relevant in different ways to Abstract Expressionism and its successor, the New York School of the 1950s. Let us briefly examine what the artists may have gained (besides what has been indicated in the separate chapters on the artists) as well as what paved the way for the different art and thought of the New York School of the 1950s. Existentialism both repudiates and extends the art and thought of Abstract Expressionism.

Jean-Paul Sartre's writings, together with his leading role in France during the Occupation, conferred upon him great prestige. Although his main existential work, *Being and Nothingness,* was not translated into English until 1956, his plays and other writings were well known. Beginning with *The Flies* of 1943, Sartrean thought flowed into America. In addition, *Nausea* of 1938 and his lectures on existentialism were among the best-known works in the English-speaking world.

While undoubtedly a major philosophical contribution to Western culture, Sartrean existentialism was influential partially because of its debt to the effects of the Nazi occupation of France—the Resistance situation in Western Europe that affected the thought of the West.[38] Such a situation gave rise to the idea of individual responsibility for one's actions, the fundamental concept of Sartrean existentialism. In the limited situation of the war and Occupation, French citizens had to test their own loyalties and choose their own path in the face of fear and stress. In a moral sense, someone was only as good as his or her acts. In the choices made in resisting an occupying army, a person was defined, committed, and revealed. Sartre applied this sense of lucid commitment to daily life after the war, considering choice and decision to determine one's fate as free of social or other limitations. Sartrean

existentialism demanded a maximum freedom and responsibility of the person. For Sartre, in direct opposition to the interwar period, terror was other people.

Drawing on the lessons and legacy of the Resistance's call for freedom and responsibility, humanism and choice, Sartre argued that people define themselves through action. They are nothing other than what they make of themselves. For Sartre, human reality and worth is not predetermined. Rather, it depends on a person's conduct and behavior in an uncertain, contingent, and open world. Relying on an introspective mode of self-analysis, the French and the Cartesian tradition, he maintained that what we can best know and affect is our own inner self. Our moods, anxieties, and decisions in the particular situation in which we find ourselves are the means with which we come to understand and make ourselves. Consciousness, however clouded, is a key. Consciousness is the understanding of the situation in which the individual finds himself. The concept of *pour-soi* (for oneself) or self-awareness, is the goal in contrast to *en-soi* (in oneself) beings who are not aware. Sartre, in the famous story *Nausea* described the worst behavior of the waiter who is self-deceptive, who plays at being a waiter, but refuses to acknowledge that he is one. (This parable parallels the Resistance situation of deciding honestly whether one accepts the Occupation situation by ignoring it or resists.) For Sartre, consciousness is autonomous, and freedom is a mental attitude that all are capable of attaining, no matter what. Freedom and human nature are contingent, unique, and ephemeral, obeying no inner logic and reflecting no grand design. One forms oneself in improvisatory action, through individual creativity and choice, in whatever everyday situations one finds oneself. One became engaged, that is, committed consciously and clearly to something.

Without a fixed definition of the human, one is free and obligated to invent individual being at every moment and thus deny that one's condition is natural and inevitable, like an object's. To make oneself free of *a priori* values, Sartre conceived of organizing one's life as a project, as a series of actions and commitments freely, independently chosen. It is through projects that one creates oneself and for oneself. For Sartre, self-transformation is the human enterprise. Life is endless, open possibilities. It is through possibilities that there can be a transformation of the actual. Values are to be found in the course of action and not before. To live is to live without deceiving oneself. Life is, however, not an adventure, but merely a series of events, and every event in the world can be revealed only as an opportunity or chance. We make ourselves in our day-to-day situation as, for example, Antoine, the central character of *Nausea,* gradually realizes.

As in Mailer's and Shaw's writing and in Fredric March's words in *The Best Years of Our Lives,* Sartre's arguments

reflected the tendency in and after the war and in the Resistance to reduce political, historical, and cultural questions to the level of *personal conduct* and *character*. They reflect the individual's confrontation with himself or herself and the need to destroy one's comfortable alibis. In its time, of course, Marxists and others criticized Sartrean existentialism for ignoring the historical and social limits to possibilities for self-creation. Sartre himself always insisted that he had no political program and that the liberation and fulfillment of the individual were still possible in any culture. For Sartre, it was simply the individual's responsibility. (There were postwar attempts to liberate Marxism from mechanical socialism and its illusions of historical inevitability in view of the need to reassert the priority of human rights. During Mussolini's reign, the Italian Carlo Rosselli, for example, wrote in his *Liberal Socialism* that socialism, understood in its broadest meaning and judged by its results, is liberalism in action. The responsibility for making freedom a concrete reality rests with the individual: "Without free men … a free state is impossible.")[39] Nevertheless, Sartre and the popularity of existentialism caught the postwar ethos. As the President of the German Federal Republic, Richard von Weizsacker, said at the Harvard commencement of 1987, "What we [Germany] wanted most [in the immediate postwar world] were fundamental ethics."[40]

In Sartrean existentialism, then, possibility, choice, and decision define and make the individual. "Existence precedes essence," he said. There is no determining essence to human nature and life. There is no ordering purpose, no teleology, no psyche, no *Weltanschauung* that defines one. Sartre rejects the ready-made identity resulting from the underlying collective forces of history, community, class, and state.

It should be clear that Sartrean existentialism in its central meanings contradicts most Abstract Expressionist themes, subjects, and attitudes. By arguing that consciousness is free of determination, Sartre rejects the concepts of the eternally human, ancient, and timeless laws, the natural being, and the psychological determinancy of the human being and life. Sartre repudiates the notion of the preconceived essence which the individual or society as a whole simply realizes.

For Sartre, nothing predetermines. There are no *a priori* values or beliefs or symbols or universal myths that shape one. There are no universals, and no preconditions for change, for self-realization, or self-transformation. The universe does not operate on past values. Temporal continuity is lost, as past and present are separable. The past does not matter. There are no eternal values by which one can or should conduct oneself. Tradition cannot judge us. Anatomy is not destiny. No noumena directs us. No gods, no legacy, no environment, no ancient self, no

human solidarity define our nature and our choices. We cannot transcend our daily life and being. Salvation is not formed in the history of man's psyche or in his evolutionary growth.

For Sartre, we make and choose our own content. Life is a ceaseless attempt to remake oneself. The cost of maintaining one's freedom is never to settle on one's identity. We must escape being and constantly reconstitute ourselves. Decision and action in the here and now are the profoundly human mode of transformation. There is no development process to the human, just endless contingent choice. Individual independent action, not general or universal meanings nor holistic histories of humankind over space and time count. The self is created through everyday experience, not by recapitulating the past.

One can see that Sartre's thought reflects an individual's and a soldier's pent-up desire to attack entrenched authority and its forces. One can also see why the Bollingen Foundation declined to publish Sartre's *Being and Nothingness*. For all other influences on Abstract Expressionism, some kind of essence, whether psychic, natural, or anthropological, precedes and determines existence and humankind. Sartre ultimately rejected the traditional prerequisites for a human nature, for man is nothing but what he makes of himself. Man's destiny lies within himself, and does not come from others.

Despite the central differences between Abstract Expressionism and Sartre's thought, Sartrean existentialism was partially adopted, at least verbally and in art criticism, from the late 1940s onward, and Rothko's complete statement, "The Romantics Were Prompted," indicates how. Around this time, like Newman, he repudiated history and ghosts, both formative concepts. In *Possibilities,* his words about situations, silence, and identity are combined with statements about hybrid gods and organisms. Rothko describes his shapes as organisms in a situation. Existential thought has thus been *grafted* onto and inconclusively mixed with previous Abstract Expressionist themes. Discussion of both together is bizarre, but it indicates how Rothko sought to synthesize existentialism, arbitrarily, with previous conceptions.

Nevertheless, there are some legitimate areas of confluences between Sartrean existentialism and with Abstract Expressionist thought. Both insisted on the relevance of ideas to life. For Sartre, becoming was the central principle and purpose. Man was a being who was not made, but was always in the making. This ongoing process of making reinforced Abstract Expressionist concepts of process, including cyclicality and vitalism. Even if Sartre de-deified the process, withdrew it from history, and reinserted becoming in the everyday, realist quotidian world, process and change—action—were central to him and had been to Abstract Expressionism and its culture throughout. The

Part Three: Transformations

Abstract Expressionist conception of perpetual metamorphosis and the continuous motion of the stream conjoined with Sartre's engaged action.[41] Eliot, for example, wrote in *Four Quartets* of movement as the pattern: "At the still point of the turning world. Neither flesh nor fleshness; Neither from nor towards; at the still point, there the dance is. But neither arrest nor movement . . . The detail of the pattern is movement." Ferber's sculpture *The Action is the Pattern* of 1949 (fig. 284) with its prehistoric beasts among swirling lines bridges the gap between Abstract Expressionist pattern and the new emphasis on abstract action for its own sake.

Creation for Sartre is immediate, contingent, spontaneous. His conceptions and, indeed, political beliefs, reflecting the make-up of Resistance units, emphasize the small, flexible, decentralized, self-questioning, continually open and fluid group of self-conscious individuals. The informal and spontaneous was a political and existential principle, and for the Abstract Expressionists, an artistic and cultural one. For both, *transition* is the key. As Roquentin, a character in *Nausea* says, "A series of little changes occurs in me without my being aware of it, and then one fine day, a veritable revolution takes place." Sartrean existential and Abstract Expressionist evolutionary processes are related and not totally opposed in this way.

Sartrean existentialism thus flows into and reinforces earlier ideas as they were expressed pictorially. In its way, it forms a new phase separate from but joined to Abstract Expressionism by a "comma," as in the citation above. If there is a basic change in Abstract Expressionism from its formative years before 1947, when the work is semifigurative and symbolic, it is that it becomes more direct, immediate, and active representation, fulfilling the long-

Figure 284. Herbert Ferber, *The Action is the Pattern,* 1949. Lead with brass rods. Height 18 inches. Collection of Kate and Christopher Rothko. Photo Courtesy of Herbert Ferber.

sought goal of making the actual work a direct experience of the ideas and feeling. Direct pictorial means largely replace symbolic representations of their idea.

Existentialism was thus part of the postwar shift of emphasis from the collective to the individual as the vehicle and agent for creativity and change. Perhaps its influence on some Abstract Expressionists may be compared to the final portal of a Gothic cathedral done in a style different from its earlier one. Just as earlier Abstract Expressionism created images partially drawn from a Surrealist, Freudian biological language, and infused them with those of his rival, Jung, mature Abstract Expressionism infused this mixture with existentialist directness, perpetual metamorphosis, and sense of struggle.

For the first generation of Abstract Expressionism, then, existentialism is, at the most, a late and incomplete influence at best. It is only with the New York School, many of whom were very young in the late 1940s and early 1950s, that existentialism became a primary cultural influence.

THE 1950s

All of these historical, intellectual, cultural, and experiential events of the war and its aftermath effected a great change in American art and culture. A new interpretive paradigm of Abstract Expressionism took hold, one that emphasized the personal and improvisatory. In the 1950s the Abstract Expressionism image of motion which represented a ritual, cyclic course of civilization was newly cast or miscast as an image of personal crisis and the making of oneself. The mythic hero became the existential hero. The collective self became the individual self. The escape from personality became the trumpeting of personality. The metamorphosis of nature, self, culture, and history became the making of a personal identity. The continuum became open and unfinished process. The physical stream of time and space became concrete action, spontaneity, and physical gesture. The concept of the "automatic" was changed to the "improvisatory."[42] Collective and public psyche and memory became personal, psychic subjectivity. The historical became the everyday and quotidian, in other words, a realist setting of normal, Western bourgeois social life, the here and now rather than the space and time of world cultures. Struggle and conflict became the battle of life and personal conduct in an amoral world. One-on-one melodramatic combat became the tense struggle for one's integrity in the oppression of social conformity. The theaters and operations of war became those of the self. The seeking of essences beyond exteriors became the cultivation of the contingent and accidental. The collective spiri-

tual reconstruction and transformation of Western civilization became the concrete emotional gesture testifying to one's authenticity in the void. Critical understanding of first-generation Abstract Expressionism, which had barely begun, was transformed in the 1950s by new theories and set along a different track. When postwar American art critics and historians were becoming established, they absorbed Abstract Expressionism through the lenses of postwar paradigms.

One popular critical view was Harold Rosenberg's "Action Painting" essay, where the emphasis was put on the concrete effort and action of painterly gesture and not on what was symbolized.[43] For Rosenberg, the canvas was "an arena in which to act," where what was analyzed and expressed was not an object but an event. Painting was an autobiographical act of self-creation, of the expression of the artist's creative personality. The artist is an actor playing a role, recording his "psychic state, concentration, relaxation of the will, passivity, and alert waiting." His gesture on the canvas is a gesture of liberation in the "Open Road" from political, esthetic, and moral value. The American artist is antiphilosophical, lacks "verbal flexibility" and creates only private myths.

Rosenberg's Action Painting conception transformed Abstract Expressionism and its themes into existential theater. The concept of Action Painting transformed wartime dramaturgy into postwar melodramatic personal encounter with the self and everyday society. Abstract Expressionist ritual and mythic process of "beginning, maturation, and decline" was watered down and generalized, according to the new art criticism, as a spontaneous, dynamic process of the creative making of the self through, in Rosenberg's words, "inception," "duration," and "relaxation." Action Painting emphasized the personal psychology of the artists in a turbulent search for a true, "authentic" identity in the world, the struggle for which was equated with the dynamic movement of brushwork. Painterly impulse became revelatory of internal motivation.[44] Literate artists became inarticulate and anti-intellectual, in the American tradition of Walt Whitman. Rosenberg's criticism and this first interpretation of Abstract Expressionism transformed the public art of the 1940s into the individualistic art of self-discovery and lonely integrity of the New York School.

Another critical interpretation was in terms of the American tradition. This thesis reflected the continuing search for America's own artistic identity. Best expressed by John McCoubrey in his *American Tradition in Painting*,[45] this popular understanding argued that Abstract Expressionism reflected traditional American concerns with emotional honesty; rough, unrefined if not violent surfaces and forms; and naive feelings. McCoubrey combined this idea of the American as noble savage in some existential

angst prompted by society's phoniness. This interpretation is even more creative than Rosenberg's. However, the stereotype of aggressive but sincere naive feeling significantly bridged the gap between modern, American, abstract art and the public. Previously, only figurative art such as that of the Ash Can group or Thomas Hart Benton, among twentieth-century artists, could represent such democratic American feelings. The conception of American art as rough but honest was a tradition in America as indicated in the writing of Thomas Wolfe and Thomas Craven in the 1930s.[46] Now the conception could be democratic, American, *and* abstract. The concept of the American tradition as the root of Abstract Expressionism and the New York School made the acceptance of abstract art possible in America.

These conceptions became rationalizations for coopting Abstract Expressionism to the New York School of the 1950s. Abstract Expressionism became associated with new artists who emphasized the American Scene in abstract terms, the urbanization of vitalism, and personal authenticity, freedom, and anxiety expressed as messy painterliness. The Club, the Abstract Expressionist meeting place in 1950, became the setting by the mid-1950s for the New York School and its different interests.

Franz Kline, for example, became perhaps the most important artist of the 1950s after De Kooning. Before 1950 he was an American scene painter of trains, local landscapes, and portraits. He had no interest in or experience with any of the Abstract Expressionist core themes and subjects. After developing a new interest in cubism in 1946, under the influence of the black portmanteau De Koonings of the late 1940s, he changed to his famous black-and-white gestural style—witness *New York, New York*. These works adapt the mode of continual dynamism to abstract evocations of urban life. On both a visual and metaphysical plane, the forms resemble the city, its girders

Figure 285. Grace Hartigan, *Grand Street Brides*, 1954. 72 x 102½ inches. Collection of the Whitney Museum of American Art. Gift of an anonymous donor. (55.27) Photo: Geoffrey Clements.

and its energies which the egotism of New Yorkers loves to stress. Other works such as *Caboose* allude to his love of trains.

In stark, melodramatic, thrusting black and white planes, Kline converted the dynamism, scale, and impact of Abstract Expressionism and its ethos of transformation into a *style* open to all in the 1950s. Many of these artists became known as Tenth Street artists, after the place where they exhibited and lived. For them the city and other subjects were key. But no first-generation Abstract Expressionist had been interested in the city except for De Kooning, briefly, Krasner, and, as a tribute to Mondrian, Gottlieb (e.g. *New York City* of 1947, and *Man Looking at Woman II* of 1949). Pollock, for example, ridiculed the idea.[47]

Other artists fused Abstract Expressionist vitalism and imagery of movement not only with the city's energy and structure but also with subjective city experiences. In the store windows of Grace Hartigan's *Grand Street Brides* of 1954 (fig. 285), painterly brushwork is the quintessential vehicle for indicating process and the subjective feeling invoked by the *visual* exterior scene. Here feeling is personal and the psychology is of romance and not space and time.

City vitalism and painterly gesture were made more concrete in sculpture and the Happenings and Environments at the end of the decade. Sculptors such as John Chamberlain created works (e.g. fig. 286) that combine the dynamism of De Kooning with the violence of car crashes, a type of violence worlds apart from the 1940s. In Happenings, living sculptures and paintings, or Painter's Theater, the poverty, richness, anxiety, and refuse of the

Figure 286. John Chamberlain, *Essex*, 1960. Automobile body parts and other metal, relief. 9 feet x 6 feet 8 inches x 43 inches deep. Collection, The Museum of Modern Art, New York. Gift of Mr. and Mrs. Robert C. Scull and Purchase.

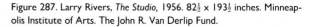

Figure 287. Larry Rivers, *The Studio*, 1956. 82½ x 193½ inches. Minneapolis Institute of Arts. The John R. Van Derlip Fund.

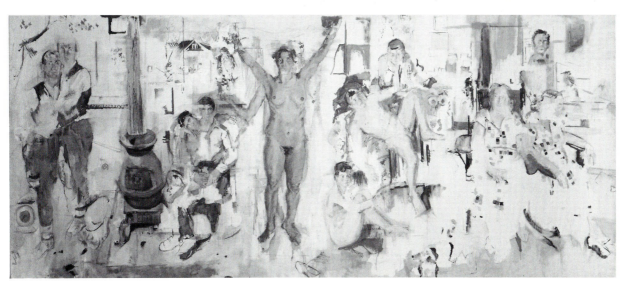

city were rendered through urban junk and scraps, disorderly thrown paint, and continuous interaction among the artists, the environment, and the audience. These were environmental collages of everyday life, experience, and feeling. While one of the chief Happening artists, Allan Kaprow, based his idea on the photographs of Pollock working, unlike Pollock's art, Kaprow's emphasized existential randomness, contingency, discontinuity, improvisation, and accident and chance for their own sakes. The momentary of Fourteenth Street in New York was more important to him than the eternal and archetypal of Abstract Expressionism.

Larry Rivers's work, such as *The Studio* of 1956 (fig. 287), intersperses sharply focused details with looser sketchy areas. He combines "real" vignettes in a loose, painterly, now mundanely episodic, continuum. That he adapted the Abstract Expressionist idea of continuity and change for his work can be seen in his statement that his subject is "life":

Life ... [is] everything but everything as it moves through the individual depositing mountainous amounts of materials, adding and destroying and organizing on new bases as it passes through, creating associations, memory and passion.[48]

Rivers reveals how the continuum of memory and transit has become a subjective train of associations from *everyday life* and not memories of the ages, thereby stating the idea of the unconscious for many in the 1950s. Perhaps the climax of this more quotidian stream of consciousness is Robert Rauschenberg's Combines—urban walls of discontinuous layers of painterly gesture, feeling, action, images, objects, and graffiti.

And lastly, nature was transformed in the 1950s, becoming a place of visual memory and personal experience. Helen Frankenthaler's *Mountains and Sea* of 1952 (fig. 288), for example, while drawn from Gorky, Marin, and Pollock in style and technique, presents as nature her own memories of summer vacations in Nova Scotia, a far cry

Figure 288. Helen Frankenthaler, *Mountains and Sea,* 1952. 86¾ x 117¼ inches. Collection of the artist, on extended loan to the National Gallery of Art, Washington, D.C.

from Abstract Expressionism nature. The 1950s, then, changed Abstract Expressionism principles to an abstract, subjectivist version, original in its own way, of the American everyday realist and Ash Can tradition.

By the early 1960s another transformation had taken place as a reaction to the melodrama, the subjectivity, the theatricality, the anxiety, and the formlessness of the New York School. In the art of Minimal sculpture, second-generation color-field painting, and Pop art, the tenets of Abstract Expressionism virtually disappear in objective (and noncollective) impersonality, color and design for their own sake, media imagery, and commercial technique. Roy Lichtenstein takes up the idea of the hero again but only as a subject of farce and satire (fig. 289). The war heroes he presents are, in his words, "fascists" and there is no felt reality or identification with their role. The hero has become the antihero. Perhaps the wittiest and most mocking image is that of the brushstroke (see fig. 290) which ridicules the image and rhetoric of transit and change for its overselling in the 1950s as self-projection and spontaneous honesty.

In the criticism of the late 1950s and early 1960s, Clement Greenberg's long ridicule of and indifference to Abstract Expressionist ideology and his concentration on a very personal and ultimately untenable view of its formal achievements as a search for greater flatness and purity of the medium became, for the first time, the dominant view. Greenberg had recognized and dismissed the artists' ideology as early as 1947:

Gottlieb is perhaps the leading exponent of a new indigenous school of symbolism which includes among others Mark Rothko, Clyfford Still, and Barnett Newman. The "symbols" Gottlieb puts into his canvases have no explicit meaning but derive, supposedly, from the artist's unconscious and speak to the same faculty in the spectator, calling up, presumably, racial memories, archetypes, archaic but constant responses. Hence the archeological flavor, which in Gottlieb's painting seems to come from North American Indian art and affects design and color as much as content. I myself would question the importance this school attributes to the symbolical or "metaphysical" content of its art; there is something half-baked and revivalist, in a familiar American way, about it. But as long as the symbolism serves to stimulate ambitious and serious painting, differences of "ideology" may be left aside for the time being. The test is for art, not in the program.[49]

Through the formalist criticism of Greenberg and his supporters, Abstract Expressionism took on an impersonal cast as a search for stylistic innovation for its own sake. Formalist studies place the art within selected sources, virtually all from the approved modern tradition including Picasso, surrealism, and Miró. In this type of criticism, topics such as nature and automatism were rediscovered by critics but transformed. Abstract Expressionism archetypal nature was seen as the creation of merely visual parallels to nature's appearance and surface, virtually an abstract impressionism. Action painting was translated back into automatism but only of a personal subjective variety; that is, criticism of the 1960s acknowledged sur-

Figure 289. Roy Lichtenstein, *Whaam!* 1963. Magna on canvas. 2 panels, entire work 5 feet 8 inches x 13 feet 4 inches. The Tate Gallery, London.

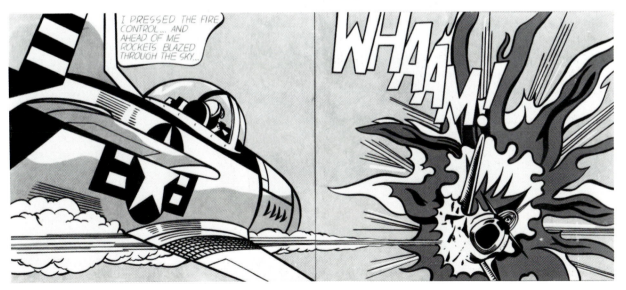

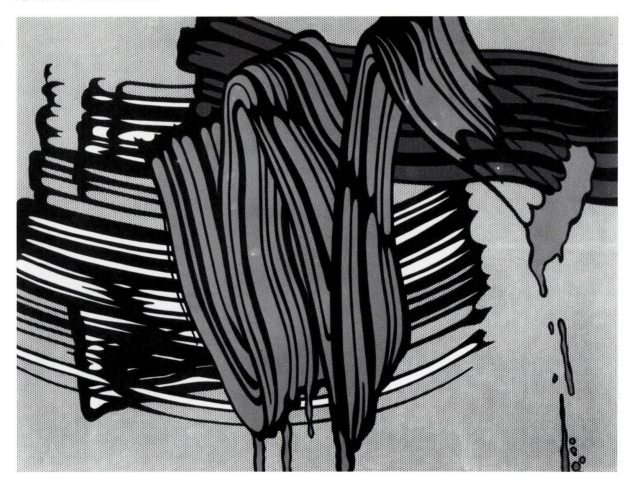

Figure 290. Roy Lichtenstein, *Big Painting VI*, 1965. Oil and magna on canvas. 7 feet 8½ inches x 10 feet 9 inches. Kunstsammlung Nordrhein-Westfalen, Dusseldorf. © Roy Lichtenstein/VAGA New York 1989.

realist but not Joycean and Jungian sources so that the evocation of unconscious life was the spontaneous evocation of personal, subjective memory and light, foreground psychology again. The 1960s version of the unconscious partially remained that of the 1950s—everyday feelings and quotidian memory. The angst was reduced or eliminated entirely. Thematic wholeness and the connectedness of space and time was understood and appreciated only in terms of an original, all-over style. The organic, live object became the impersonal, literal object. Sixties criticism thus continued to assert the 1950s concepts of nature, the local and topical, subjectivity and self-expression as the subjects of Abstract Expressionism within its own attempts to examine its modern stylistic sources. In this criticism as in literature after existentialism in Europe:

Increasingly, writers were drawn toward a private, formalistic literature freed from utilitarian constraints, epitomized by the French *nouveau roman*. What Sartre characterized as a new "anti-novel" abandoned the conventions of engaged literature altogether in favor of a self-conscious hermeticism that necessarily restricted its appeal to a small circle of initiates. . . . Art was its own justification, an ideal transcending place and time. It had ceased to be a weapon, a lesson, or a cry of protest.[50]

After more than forty years of protest art, in which American art of the interwar to postwar period rose to preeminence in the Western world, in the 1960s art for art's sake, that demon of American art and Abstract Expressionism, reappeared as a value and as a starting point for that decade's discussions. (It is only with the writing of other critics such as Irving Sandler and Dore Ashton at the end of the 1960s that style art criticism has begun to be laid to rest.)[51] Yet despite its tenseness, peace in the 1950s and 1960s meant that it was again possible to wake up in the morning and not worry about the fate of

the world before breakfast. For many in the west, healing was to be ordinary, for art and society. As Orozco said after Mexico's twentieth-century revolution and civil war, "we have had enough of revolution. ... We want time now to work and to rest."[52] Despite the new, smaller wars and the tension of the Cold War—which were only the latest examples in the new twentieth-century recall of war as the normal condition of humankind—art began to relax and did not seek to reform the world, for the moment. The exterior world situation did not press as before and reconstruction was no longer the agenda.

EPILOGUE

In the greatest history painting of modern times, *Guernica,* recalling the carnage that began a relentess decade, Picasso placed a small flower next to the hand of the dismembered soldier. In this tiny image of symbolic rebirth in nature, he defined the extremities and longings of his time.

More than anything else the core themes of Abstract Expressionism bear witness to this collective or human drama of its time. They forged linkages to past disasters, to epic ordeals, and to new life, as they sought to meet their historical charge—understanding the root causes of contemporary experience and overcoming the experience through a spiritual as well as physical resurrection. Abstract Expressionism directed redemption through modern form and thought.

Abstract Expressionist art is among the most powerful icons of these extreme feelings and human needs. In dramatizing the inner life and history of their era, Abstract Expressionists can be said to have built painterly monuments to common experiences and made symbols for its ideals.

To be sure, in one sense, an approach with references to Aeschylus and Christ romanticizes and makes grandiose the crude, brutal, and useless waste of human life. By suggesting that the crisis in the West and the war were just new versions in the history of human disaster and suffering, Abstract Expressionist art can seem to trivialize. It runs the risk of merely aesthetically redeeming, in Nietzsche's words, and thus normalizing the terrible and unspeakable. But realism, the literal rendering of the mundane is inadequate for presenting images of the world conflict and the camps. Only a dark language of grotesque allusions, metaphors, metonymies, of great historical events detached from specific locations, and of mythic and psychic

representations, only an art of cosmic struggle can begin to express its dark time in convincing fashion. Newspapers, newsreels, and military art, not to mention direct participation in the homefront or abroad, had already provided the facts of the experience; representative art had provided the propaganda. It was the task of Abstract Expressionism to provide the interpretation.

In their style of rhetorically high, pictorial diction in the Grand Manner—indicated by their heroic conception and scale, their grammar of power and force, and their concentration on engagement with historical and cultural event—the Abstract Expressionists expressed faith in an ability to address permanent human needs through ideas in paint, as Joyce, Mann, Wilder, and Eliot among others did through words. Their belief in the possible impact of moral systems and a moral order remains a fundamental ideal. In this, they were like other intellectuals in the period such as members of the Resistance in Europe—Sartre, Mounier, Camus, and others—who posed basic questions about human nature and the foundations of a moral order. While the Abstract Expressionists did not completely share their confidence in the power of human reason or the perfectibility of humanity, like their predecessors and colleagues, they reserved the right to consider the fate of their civilization and to search for ways to bring about its regenesis.

In such an art, there is a belief in universal standards of conduct, of educability, and the power of moral suasion. The Abstract Expressionists presented contemporary experience not only as shattering revelation but also as an initiation into a stronger state of consciousness. To the artists, in many instances, altering society through awareness of a socio-historical psychic life was necessary for

367

regenerating the world. Many felt the antidote to the West's collapse lay within; it is in the unconscious, in humanity's inner life, that one "must change the Furies into beneficent powers."[1] Abstract Expressionism went beyond mere interpretation of the roots of crisis and war to aim at the reffirmation and at moments even transfiguration of the humanity that created the cataclysms.

Abstract Expressionism is thus a synthesis of older values and ideas. The artists indirectly restated first principles and traditional beliefs—human courage, common human worth, the hope of human endeavor, the possibility of change, respect for human feeling and dignity, but dressed them in more modern terms, in a new if ancient pattern and artistic idiom. They were preservers and protectors as well as critics, indeed more so because these principles were under murderous assault in their time. They provided the healing of eternity as a ground to stand on before beginning again.

Their works thus correct the impression that modernism in the first half of the twentieth century is marked exclusively by themes of despair, skepticism, or alienation. The sense of decline is only part of a complex response to the crisis of the West. Abstract Expressionism transcends the injuries of modern experience by acknowledging the degradations and then offering its own form of resistance. From Still's and Pollock's archaism through Gottlieb's and Motherwell's contending forces to De Kooning's amoral fertility idols to Newman's sublime new starts and regenerations, Abstract Expressionism is about the human spirit—defiant, resistant, and affirmative in the face of all.

Like the seers they emulated, the Abstract Expressionists sought to tutor humanity: "Beginning to think is beginning to be undermined."[2] With its themes of the expansion of the mind to include both the unconscious, the past, the primitive mentality, the occult, and the world, Abstract Expressionism climaxes the interwar quest to redefine the human. With its revolutionizing, cognitive suggestions, it sought to expand the normative, to change the conceptual map of the individual suffering from too much modernity. Their radicalism is simple: think and relate along different lines and you will act along different lines. Reform is reassessment, new analysis is new thinking. By interpreting culture, their art modifies it: "Modern art, like modern science, recognizes the fact that observation and what is observed form one complex situation—to observe something is to act upon and alter it."[3]

Although they began and largely remained as part of a generation that taught human history as merely resignation before the elemental forces beyond human control, several ended up—whatever the exact impact of existential resistance—believing in a possible amelioration, in a spiritual rebirth, even for just a moment. For historians, Marx-

ists, liberals, and even the right, the rebirth of the West required a change in the way history was perceived so that antecedents and signs of a new catastrophe could be understood in the future. They thus had a historical end in painting: the trial of humanity and its possible passage to a higher spiritual life. Whatever human limitations, many still held out hope for higher potential, promise, and spiritual evolution.

Abstract Expressionism creates a narrative like *The Pilgrim's Progress* of the journey of mankind and the powers that determine its experience. In so doing, it attempts a secular spiritualism that could be valid in the twentieth century. For the Abstract Expressionist, there is a divineness in a mysterious or mystic life force of the unconscious, in occult biology and natural science, and in ritual history. As Baziotes wrote:

It is the greatness of spirit in a painting that compels us to return to it, time after time. We go back ... not for new discoveries but for the renewal of a great *experience*. ... Some mysterious force, some strange energy occurs as soon as brush touches canvas. ... Therefore, when I look at contemporary painting, I must judge it by the one criteria I have. It is a level of painting where the interest is not only in the physical aspect of paint, but also in the drama and poetry of the soul of man."[4]

Abstract Expressionist artists present a modern, literate definition of the human soul as experienced in the crisis and war years, a view of mankind, for better or worse, that was intended to have the force of universal spiritual truth. It seems to have succeeded to some extent as evidenced by its lasting power in the popular imagination, even in the 1950s, as representative of the new human condition.

Abstract Expressionism thus constitutes a sacred and profane allegorical epic, a biblical and ritual drama and romance for the modern age. It interlocks with, on the one hand, human history, its restrictions, its brutality, and its losses. On the other hand, it constitutes a virtual primer of sacred life with its gods, pagan and Christian rites, fecundity symbols, myths, reenactments of Creation, cosmic durations, and images of fire and light. The artists divorced the spiritual from religious dogmas and creeds, despite the use of Christian and pagan imagery, and concentrated it in a vision of the sacred that would be made palatable to modern, agnostic, and intellectual audiences through concepts of the psyche, nature, the cosmos, the primitive, and personal development. Abstract Expressionism testifies to the ineradicable need for a form of spiritual life and, indeed, to its essential rebirth in times of trial, whatever its disguised form in a secular age. Its themes of torment and sacrifice, affirmation and redemption, as in the writing of Eliot, Joyce, or Jung, affirm a twentieth-century secularized Christianity or evangelicalism and a psychic, primitivist

and traditionalist variant of the Northern Romantic theme of genesis.

In a statement in preparation for her great psycho-mythic dance of 1946, *Dark Meadow of the Soul,* Martha Graham summarized the redemptive thrust of Abstract Expressionism. While taking notes from *From Ritual to Romance* and from Joyce, she considered making a dance of fertility rites and ritual and cyclic rebirth that would sum up the intersection of Abstract Expressionism, its culture, and history and commemorate the Abstract Expressionist transfiguration of history into a secular, spiritual cosmogony for its age. With these words and dance, as with the mysterious power of Abstract Expressionism, we feel ourselves in the presence of some of the deepest experiences of modern art.

Perhaps a kind of invoking from within oneself the Powers of the
Spirit to bring about a better condition—a health of the land, the World . . .
Perhaps a kind of "Fertility Ritual."
 not for rain but for growth on a Waste Land.
 —after a War . . .
Could I make a drama of resurrection.[5]

NOTES

INTRODUCTION

1. William De Kooning quoted in the film *De Kooning on De Kooning*, Whitney Sales Ross producer, New York, Cort Productions, 1982.

2. Adolph Gottlieb, quoted in David Sylvester, "Adolph Gottlieb: An Interview with David Sylvester," *The Living Arts* 1 (June 1964): 3.

CHAPTER 1. THE PSYCHOLOGY OF CRISIS

1. André Malraux, "D'une jeunesse européenne," in Andre Chamson et al., *Ecrits* (Paris: Bernard Grasset,1927), 148, cited in James Wilkinson *The Intellectual Resistance in Europe* (Cambridge: Harvard University Press, 1981), 2. I am indebted to Wilkinson's study throughout this study.

2. For the American artists' familiarity with the book, see Dore Ashton, *The New York School: A Cultural Reckoning* (New York: The Viking Press, 1973), 17; for Richard Pousette-Dart, see Judith Higgins, "To the Point of Vision: A Profile of Richard Pousette Dart," in *Transcending Abstraction: Richard Pousette-Dart, Paintings 1939–1985*, ed. Sam Hunter (Fort Lauderdale, Florida: Museum of Art, 1986), 15.

3. See Warren Sussman, "The Thirties," in *The Development of an American Culture*, ed. Stanley Cohen and Lorman Ratner (New York: Prentice-Hall, 1970), 179–218, reprinted as "The Culture of the Thirties," in Warren Sussman, *Culture as History* (New York: Pantheon, 1984), 150–83.

4. Sir Edward Tylor, *Primitive Culture* (London, 1871); reprinted in two volumes, *The Origins of Culture* and *Religion in Primitive Culture* (New York: Harper Torchbooks, 1958): 1:1.

5. Margaret Mead, *Coming of Age in Samoa*, foreword by Franz Boas (New York: American Museum of Natural History, 1928), x.

6. John J. Honigmann, *The Development of Anthropological Ideas* (Homewood, Illinois: Dorsey Press, 1976), 192–231.

7. Ruth Benedict, *Patterns of Culture* (New York: New American Library Mentor, 1934), 42, 16.

8. Honigmann, *The Development of Anthropological Ideas*, 192.

9. Benedict, *Patterns of Culture*, 52–119, 160–205.

10. Ibid., 1.

11. Ibid., 2.

12. Marlene Park and Gerald E. Markowitz, *New Deal for Art* (New York: Gallery Association of New York State, 1977), 25.

13. Holger Cahill, "American Resources in the Arts," in *Art for the Millions*, ed. Francis O'Connor (Boston: New York Graphic Society, 1973), 33–40.

14. Ibid., 37.

15. This phrase of the 1920s and 1930s was originated by Van Wyck Brooks in "On Creating a Usable Past," *The Dial* 64 (April 11, 1918): 337–41, and then popularized in the 1930s for different ends. For a discussion of the "usable past" in the 1930s, see Alfred H. Jones, "The Search for a Usable American Past in the New Deal Era," *American Quarterly* 23 (December 1971): 710–24.

16. Mitchell Siporin, "Mural Art and the Midwestern Myth," in O'Connor, *Art for the Millions*, 64.

17. Siporin, cited by Cahill, "American Resources in the Arts," 42.

18. Cahill, "American Resources in the Arts," 44.

19. James M. Newell, "The Evolution of Western Civilization," in O'Connor, *Art for the Millions*, 61.

20. For a discussion of some of the differences between upstate New York murals and New York City murals, see Park and Markowitz, *New Deal for Art*, 1–63, and Marlene Park, "City and Country in the 1930s: A Study of New Deal Murals in New York," *Art Journal* 39 (Fall 1979): 37–47.

21. I am grateful to Professor Greta Berman for this information.

22. Sheldon Cheney, *Expressionism in Art* (New York: Liveright, 1934), 5–6.

23. For a study of the Curry Topeka murals, see M. Sue Kendall, *Rethinking Regionalism: John Steuart Curry and the Kansas Mural Controversy* (Washington: Smithsonian Institution Press, 1986), for an examination of the psychological and mythic pattern in many American murals, see Karen Ann Marling, "A Note on New Deal Iconography: Futurology and the Historical Myth," in *Prospects* 4 (1979): 420–40; see also Karal Ann Marling, *Wall-to-Wall America: A Cultural History of Post-Office Murals in the Great Depression* (Minneapolis: University of Minnesota Press, 1982).

24. Thomas Hart Benton, *An American in Art* (Lawrence: Kansas University Press, 1969), 148.

25. Lyman Field, "Thomas Hart Benton's History Painting" (paper delivered at the symposium, The Restoration of Thomas Hart Benton's Murals: The America Today Murals, Williams College, April 13, 1985).

26. See this and other important essays in R.A. Billington, ed., *Frontier and Section: Selected Essays of Frederick Jackson Turner* (New Jersey: Prentice-Hall), 1961.

27. Benton, *An American in Art*, 150.

28. Frederick Jackson Turner, "The Significance of the Frontier," in Billington, *Frontier and Section,* 37. The following statements are from this essay, pages 38, 62, 37, and 61.

29. Benton, *An American in Art,* 25. Interestingly, Benton's interest in Taine was not unique. The surrealizing artist Louise Bourgeois discussed Taine at the Abstract Expressionist meeting place, The Club, in 1950. See Robert Goodnough, ed., "Artists' Sessions at Studio 35 (1950)," in Robert Motherwell and Ad Reinhardt, *Modern Artists in America* (New York: Wittenborn Schultz, 1951), 11.

30. Hippolyte Taine, *Lectures of Art,* trans. John Durand (New York: Henry Holt, 1875), 13. The following citations are from this book.

31. Although he approached such a psychological model, there is no evidence that Benton was influenced by behavioral theorists who were becoming prominent in the period. For a discussion of the use of behavioral psychology in advertising at this time, see Donald Bush, *The Streamlined Decade* (New York: George Braziller, 1975), 22–33.

32. Thomas Hart Benton, "Art and Nationalism," in *The Modern Monthly* 8 (May 1934): 232–36, reprinted in Matthew Baigell, *A Thomas Hart Benton Miscellany* (Lawrence: Kansas University Pres, 1971), 51.

33. Benton, *An American in Art,* 155–56. For Benton, ibid., 56–57, subject matter itself would *generate* new artistic forms:

I had come to believe that meanings had a generative function. I concluded that the forms of a Giotto, for instance, resulted quite as much from the meanings that inspired him as from his technical discoveries or his observations of nature. As I now saw it, his religious stories had a constructive as well as a communicative place in his art. Form was, therefore, to a much greater degree than our modern artists realized, a "function" of the subject.

34. Ibid., 66.

35. Benton, "Art and Nationalism," 55; Benton, *An Artist in America,* 3d ed., rev. (Columbia: University of Missouri Press, 1968), 201.

36. Benton, interview in *Demcourier* 8 (February 1943): 3–5, 20–24; reprinted in Baigell, *A Thomas Hart Benton Miscellany,* 101.

37. Ibid.

38. Benton, interview in *Art Front* 1 (April 1935), 2, reprinted in *A Thomas Hart Benton Miscellany,* 59.

39. Benton, *An Artist in America,* 328; interview *New York Sun,* April 12, 1935, reprinted in Baigell, *A Thomas Hart Benton Miscellany,* 78; "Painting and Propaganda Don't Mix," *The Saturday Review* 43 (December 24, 1960): 16–17, reprinted in *A Thomas Hart Benton Miscellany,* 114.

40. For a discussion of El Greco's influences on Benton's work, see Marilyn Stokstad, "El Greco in the Ozarks," in *Benton's Bentons* (Lawrence: Kansas University Press, 1980), 32–48.

41. The use of nature as a mirror of cultural pattern was a frequent metaphor in the 1930s. In keeping with his complex pattern of struggle and triumph, Curry portrayed natural forces as threatening and ruinous, as in *The Mississippi* of 1935, or rich and full, as in *Wisconsin Landscape* of 1938–39. Wood's landscapes or "culturescapes" also reveal development, but in contrast to Curry, his *Stone City* of 1930, *Fall Plowing* of 1931, or *Haying* of 1939 reflect no dramatic struggle for existence, no Rubensian drama and pathos. They present an image of stylized, concentrated, mythic abundance—nature as utopia. They are comparable to Curry's *Wisconsin Landscape.* In Wood's work, rolling, swelling, fertile hills flow through space, through seasons, through time ever rich and untroubled, covered with rows of corn or wheat. In their stylized fullness, in their smooth and rounded forms and flowing lines, they reflect the decorative style of "moderne" streamlining that was turning planes, trains, and other machines into naturalized shapes and force, symbolizing for those caught in the throes of the Depression the idea of progress and America "moving again." Though his landscapes reflect the traits and efforts of the machine, and Wood, as a supporter of southern agrarianism, had an ambiguous attitude toward the machine, he has managed to turn nature into a machinelike surface and order. Simple, precise, and efficient, nature continually produces and never needs oil or a spare part. Wood's idea of a pattern of American life reflected the thirties ideas of streamlined efficient American nature, streamlined abundance. As with Streamline Modern style, he identified technological progressive utopianism with natural rhythm. For a discussion of nature as means and symbol of technological progress, see Bush, *The Streamlined Decade.*

42. As Benton defined his style beginning with the *American Historical Epic.* See Thomas Hart Benton, "My American Epic in Paint," *Creative Arts* 3 (December 1928): xxxi–xxxvi, reprinted in Baigell, *A Thomas Hart Benton Miscellany,* 19.

43. For a discussion of Benton's stylistic sources and development, see Matthew Baigell, *Thomas Hart Benton* (New York: Abrams, 1973).

44. Benton, *An American in Art,* 75.

45. Benton, "The Arts of Life in America," 1932, reprinted in Baigell, *A Thomas Hart Benton Miscellany,* 28.

46. Stuart Davis, "Abstract Painting Today," in O'Connor, *Art for the Millions,* 126.

47. John Lane, *Stuart Davis: Art and Art Theory* (Brooklyn: Brooklyn Museum, 1978), 12.

48. Davis, "Analogical Emblems," 1933, Halpert Papers, cited in ibid.

49. Lane, *Stuart Davis: Art and Art Theory*, 28.

50. Margaret Mead, *Sex and Temperament, in Three Primitive Societies* (New York: William Morrow and Co., 1935), xiv.

51. Benton, *An American in Art*, 51.

52. Benton, *An Artist in America*, 297.

53. Orwell cited in Paul Fussell, *The Great War and Modern Memory* (London: Oxford, 1975), 109. Fussell's acclaimed study (to which I am indebted throughout this study) reveals how the First World War shaped modern literacy thought and imagination in ways very similar to the influence of the "collapse of the West" and the Second World War on Abstract Expressionist work.

54. Anaïs Nin, *The Diary of Anaïs Nin* (New York: Harcourt Brace Jovanovich, 1967), 2:293, 309.

55. Barbara Norek, in Mark Jonathan Harris, Franklin Mitchell, and Steven Schechter, *The Homefront: America During World War II* (New York: G. P. Putnam's Sons, 1984), 25.

56. Edward Osberg, in ibid., 23.

57. Quoted in Studs Terkel, *The Good War* (New York: Ballantine, 1984), 460.

58. Robert Rasmus, a businessman, in ibid., 46.

59. Fussell, *The Great War and Modern Memory*, 317–18.

60. See Wilkinson, *The Intellectual Resistance in Europe*.

61. Maxine Andrews in Terkel, *"The Good War,"* 291.

62. James Covert in Harris, Mitchell, and Schechter, *The Homefront*, 74.

63. Sheril Jankovsky Cunning, in ibid., 72.

64. Ibid., 70.

65. Seymour Lipton, personal communication, December 7, 1983.

66. Francis Merrill, *Social Problems on the Home Front* (New York: Harper Bros., 1947), 2, cited in John Costello, *Virtue under Fire* (Boston: Little, Brown and Co., 1985), 204–5.

67. Sybil Lewis, in Harris, Mitchell, and Schechter, *The Homefront*, 38.

68. Dellie Hane, in ibid., 181.

69. Forbes Watson, "What Can I Do?" *Magazine of Art* 35 (January 1942): 3, reprinted in Ellen Landau, "'A Certain Rightness': Artists for Victory's 'America in the War' Exhibition of 1943," *Arts Magazine*, 60 (February 1986): 43.

70. Landau, "'A Certain Rightness,'" 43–44.

71. I am grateful to Sanford Hirsch, director of the Adolph and Esther Gottlieb Foundation, for this information.

72. Alfred Frankfurter, "The Editor's Review," *Art News* 39 (October 12, 1940): 7.

73. Manny Farber, "Artists for Victory: Metropolitan Museum of Art Opens Great Exhibition," *Magazine of Art* 35 (December 1942): 278, cited in Landau, "'A Certain Rightness,'" 47.

74. Lillian Hellman, *An Unfinished Woman* (New York: 1969), 130, cited in Fussell, *The Great War and Modern Memory*, 311.

75. Robert Kee, "Mercury on a Fork," *Listener* (February 18, 1971): 208, cited in ibid.

76. Monroe Wheeler, "The Artist and National Defense," in *Britain at War* (New York: The Museum of Modern Art, 1941), 9. Quotations from Eliot, Read, and Carter are on pages 8, 12, and 74.

77. In foreword to James Thrall Soby, *Salvador Dali* (New York: The Museum of Modern Art, 1941), 7.

78. See Landau, "'A Certain Rightness,'" 46–52. It replaced the 1930s emulation of Honoré Daumier and other social protest artists.

79. James Johnson Sweeney, *Joan Miró* (New York: The Museum of Modern Art, 1941), 78.

80. Don McFadden, a deputy sheriff, in Terkel, *"The Good War,"* 145.

81. Herbert Read, *The Politics of the Unpolitical* (London: Routledge, 1946), 149.

82. See Fussell, *The Great War and Modern Memory*, 121.

83. Peggy Terry, a mountain woman, in Terkel, *"The Good War,"* 108.

84. Adolph Gottlieb and Mark Rothko, "The Portrait and the Modern Artist," transcript of a broadcast on "Art in New York," Radio WNYC, October 13, 1943, in Adolph and Esther Gottlieb Foundation Archives, New York.

85. Theodore Roszak, statement in *Fourteen Americans*, Dorothy Miller, ed. (New York: The Museum of Modern Art, 1946), 59.

86. Erika Doss, "Thomas Hart Benton and Surrealism," paper delivered at College Art Association, February 18, 1983.

87. Cited in Sydney Simon, "Concerning the Beginnings of the New York School, 1939–43: An Interview with Peter Busa and Matta," *Art International* 11 (Summer 1967): 17.

88. Ernst, 1934, quoted in Uwe M. Schneede, *Max Ernst*, trans. R. W. Last (New York: Praeger, 1972), 148; Breton, *The Second Surrealist Manifesto*, 1929, cited in Lucy Lippard, ed., *Surrealists on Art* (Englewood, New Jersey: Prentice-Hall Spectrum, 1970), 28.

89. Breton, "The Manifesto of Surrealism," 1924, cited in Marcel Jean, ed., *The Autobiography of Surrealism*, Documents of 20th-Century Art series, ed. Robert Motherwell (New York: Viking, 1980), 123.

90. Recent research has lessened the role of automatism, which was once thought to be paramount for all Abstract Expressionists. Now it is seen as less important in the work of Gorky, Rothko, De Kooning, and Still among others. See, for example, Dore Ashton, *About Rothko* (New York: Oxford, 1983); Harry Rand, *Arshile Gorky: The Implications of Symbols* (Montclair, New Jersey: Allenheld and Schram, 1980); and Sally Yard, "Willem De Kooning's Women," *Arts Magazine* 53 (November 1978): 96–101.

91. Brauner, cited in J. H. Matthews, *The Imagery of Surrealism* (Syracuse: Syracuse University Press, 1977), 145.

92. Motherwell, "The Significance of Miró," *Art News* 58 (May 1959): 66.

93. Edward Renouf, "On Certain Functions of Modern Painting," *Dyn* 2 (July/August 1942): 22.

94. Ibid.

95. Schneede, *Max Ernst*, 168.

96. Breton, "Surrealism and Painting," 1928, cited in André Breton, *Surrealism and Painting*, trans. Simon Watson Taylor (New York: Harper and Row Icon, 1965), 29.

97. Cited in Carola Giedion-Welcker, *Jean Arp*, trans. Norbert Guterman (New York: Abrams, 1957), xiv.

98. Carolyn Lanchner, "André Masson: Origins and Develop-

ment," in Lanchner and William Rubin, *André Masson* (New York: The Museum of Modern Art, 1976), 85–86.

99. See Lawrence Alloway, "The Biomorphic '40s," *Artforum* 4 (September 1965): 18–22.

100. Quoted in Giedion-Welcker, *Jean Arp*, xxvii.

101. Lanchner, "Andre Masson: Origins and Development," 110.

102. Breton, "Artistic Genesis and Perspective of Surrealism," 1941, reprinted in *Surrealism and Painting*, 51–52.

103. Arp quoted in Giedion-Weckler, *Jean Arp*, xxvii.

104. For a discussion of Levy-Bruhl's influence on Surrealism and Miró, see Sidra Stich, *Joan Miró: The Development of a Sign Language* (St. Louis: Washington University, 1980), and Evan Maurer, "Dada and Surrealism," in *"Primitivism" in 20th Century Art* (New York: The Museum of Modern Art, 1984), 2: 542–43.

105. Wheeler, in Soby, *Salvador Dali*, 7.

106. Robert Motherwell, in Sidney Simon, "Concerning the Beginnings of the New York School, 1939–43: An Interview with Robert Motherwell," *Art International* 11 (Summer 1967): 23.

107. In "Surrealist Painting," *The Nation* 159 (August 1, 1944): 193.

108. Newman, "Las Formas Plasticas del Pacifico," *Ambos Mundos* 1 (June 1946), reprinted as "Art of the South Seas," *Studio International* 179 (February 1970): 71.

109. Annalee Newman, personal communication, April 4, 1978.

110. Quoted in "Jackson Pollock: An Artists' Symposium, Part I," *Art News* 66 (April 1967): 29.

111. Ibid., 29–30.

112. In Maz Kozloff, "An Interview with Matta," *Artforum* 4 (September 1965), 25.

113. Robert Goldwater, *Space and Dream* (New York: Walker and Co., 1967), 8.

114. Fussell, *The Great War and Modern Memory*, 139.

CHAPTER 2. PROPAEDEUTICS

1. Still, statement in *Clyfford Still*, foreword by Katherine Kuh (Buffalo: Albright-Knox Art Gallery, 1966), 16. The following statements about the Abstract Expressionists and politics come from these sources: Rothko, in John Fischer, "The Easy Chair / Mark Rothko: Portrait of the Artist as an Angry Man," *Harper's Magazine* 241 (July 1970): 17; Baziotes, letter to Byron Vazakas, cited in Mona Hadler, "The Art of William Baziotes," Ph.D. diss., Columbia University, 1977, 15; Baziotes, in *Right Angle* 3 (June 1949): 4; Newman, quoted in A. J. Liebling, "Two Aesthetes Offer Selves As Candidates To Provide Own Ticket for Intellectuals," *New York World*, November 4, 1933; Newman, cited in Thomas Hess, *Barnett Newman* (New York: The Museum of Modern Art, 1971), 24–25; Newman, cited in Dorothy Seckler, "The Frontiers of Space," *Art in America* 50 (Summer 1962): 87; Newman, in introduction to Peter Kropotkin's *Memoirs of a Revolutionist* (New York: Horizon Press, 1968); Orozco, cited in David Elliot, "A Beginning," in *Orozco 1883–1949* (Oxford: Museum of Art, 1980), 16; Gottlieb, in Jeanne Siegel, "Adolph Gottlieb at Seventy: I Would Like to Get Rid of the Idea that Art

is for Everybody," *Art News* 72 (December 1973): 57; Gottlieb, in an interview with Andrew Hudson, May, 1977, typescript on file at the Adolph and Esther Gottlieb Foundation in New York; and Motherwell, in Max Kozloff, "An Interview with Robert Motherwell," *Artforum* 4 (September 1965): 33–37.

Francis O'Connor, a leading art historian of the 1930s, summed it up this way (*WPA: Art for the Millions* [Boston: New York Graphic Society, 1973], 27):

That the Artists Union had a Communist Party "fraction" is certain. Such influence was natural since the Party was the only disciplined body capable of galvanizing the disorganized and panic-stricken artists into effective groups. The artists accepted this leadership not because they were willing to accept the at times obtuse Party line and strict Party discipline, but because they saw no contradiction between the Party's aims and their economic needs. It was a purely pragmatic and essentially an apolitical relationship.

Nevertheless, recent writing by several critics have led to an attempted political recontextualization of Abstract Expressionism. Beginning with Max Kozloff's "Abstract Expressionism During the Cold War," *Artforum* 9 (May 1973): 43–54, there has been an attempt by the political left to associate the Abstract Expressionists with "American Imperialism and the Cold War" and thereby to discredit it among the intelligentsia.

A French-Canadian Marxist, Serge Guilbaut, in an article "The New Adventures of the Avant-Garde in America," *October* 15 (Winter 1980): 61–78, and in his book *How New York Stole Modern Art* (Chicago: University of Chicago Press), 1983, along with the British critic Francis Frascina in *Pollock and After* (New York: Harper and Row, 1985)—which also contains essays by Kozloff, Guilbaut, T. J. Clark, and David and Cecile Schapiro, among others—recently made the largest statement of the position that the Abstract Expressionists essentially collaborated in American capitalist designs for domination of Western Europe. Guilbaut asserts that the American artists "stole" what he characterizes as "French" painting by opportunistic complicity with the "ideology" of postwar American efforts to capitalize on European prostration following the war by enlarging American markets there. The artists were allegedly co-opted in the Cold War during the late 1940s, taking up American ideological positions of "freedom" and "individualism" (Kozloff demurs from such deliberateness) in the struggle with the Eastern bloc and becoming formalists under the direction of Clement Greenberg's ideas, best expressed in "Avant-Garde and Kitsch" and "Towards a Newer Laocoon." The outcome was their immediate artistic dominance of the world and their economic success by about 1950.

None of this has convinced informed observers. Indeed, the tendentious argument is faulty on so many levels—from the artists' political convictions, to the continued use of Greenberg and Rosenberg as the artists' spokespersons, to the claims of immediate financial success by the early 1950s—that it would take an article itself to separate fact from fiction. It is best to say that, in short, this vein of Late Marxist writing depends on faulty premises; specious associations; perpetuations of original critical misunderstandings; simplistic political recontextualizations and entrapments; quotations out of context; factual errors; dismissal

of personal, cultural, and intellectual concerns; sweeping abstractions and generalizations; pernicious political distortions; and willful ignorance of the intentions, subjects, forms, and imagery of the artists.

2. Martha Graham, *The Notebooks of Martha Graham* (New York: Harcourt Brace Jovanovich, 1973), 185. Unless otherwise indicated, all Graham citations are from this source.

3. Pollock, quoted in "Unframed Space," *The New Yorker* 26 (August 5, 1950): 16.

4. Interview with Martin Friedman, August, 1962, 2B, 13, typescript on file at the Adolph and Esther Gottlieb Foundation, New York.

5. Graham, *The Notebooks of Martha Graham*, 305.

6. Quoted in a discussion of the dance *Mary Queen of Scots*, in *The Notebooks of Martha Graham*, 311–12.

7. Joseph Campbell, *The Hero with a Thousand Faces*, A Bollingen Foundation publication (London: Sphere—Abacus Books, 1975), 284.

8. Ibid., 35.

9. Graham, *The Notebooks of Martha Graham*, 302.

10. Sigfried Giedion, *Space, Time, and Architecture: The Growth of a New Tradition* (Cambridge: Harvard University Press, 1941), 7.

11. In "The Editor's Review," *Art News* 39 (November 23, 1940): 16.

12. William Barrett, *The Truants* (New York: Doubleday Anchor, 1983), 9.

13. Dore Ashton, *About Rothko* (New York: Oxford University Press, 1983), 25.

14. Robert Motherwell, "Notes on the Artist," in John H. Baur, *Bradley Walker Tomlin* (New York: Whitney Museum of American Art, 1957), 11.

15. T. S. Eliot, "Tradition and the Individual Talent" (1921) reprinted in James Scully, ed., *Modern Poets on Modern Poetry* (London: Collins Fontana, 1966), 61.

16. Giedion, *Space, Time, Architecture*, vi.

17. Ibid., 8.

18. Ibid., 7.

19. Ibid., 5.

20. Ibid., xxxiii.

21. In Robert Goodnough, ed., "Artists' Sessions at Studio 35 (1950)," in Robert Motherwell and Ad Reinhardt, *Modern Artists in America* (New York: Wittenborn, Schulz, 1951), 11–12.

22. For a discussion of Joyce's influence, see Evan Firestone, "James Joyce and the First Generation New York School," *Arts Magazine* 56 (June 1982): 116–21.

23. Brooks and Lassaw in Christopher R. Crosman and Nancy E. Miller, "Speaking of Tomlin," *Art Journal* (Winter 1979): 114.

24. Smith, quoted in Robert Motherwell, "David Smith: A Major American Sculptor: A Personal Appreciation," *Vogue* 145 (February 1965): 135, reprinted in *Studio International* 172 (August 1966): 65. In this regard, it should be noted that automatism was frequently conceived by the Abstract Expressionists as a means of initiating the stream and not only as random invention as was more often the case among the surrealists.

25. Quoted in Joe D. Bellamy, ed., *American Poetry Observed:*

Poets on Their Work (Urbana: University of Illinois Press, 1984), 146.

26. Seymour Lipton, cited in Albert Elsen, *Seymour Lipton* (New York: Abrams, 1974), 58.

27. Annalee Newman, personal communication, April 4, 1978.

28. Peter Busa, personal communication, February 1, 1978.

29. Stanley Kunitz, personal communication, March 21, 1978.

30. Herbert Ferber, personal communication, April 13, 1978.

31. Roberta Tarbell, "Seymour Lipton's Sculptures of the 1940s: Intellectual Sources and Thematic Concerns," lecture given at the College Art Association, New York, February 13, 1986.

32. Eleanor Roosevelt, introduction, in Frederic Douglas and Rene D'Harnoncourt, *Indian Art of the United States* (New York: The Museum of Modern Art, 1941; reprint in 1969), 8.

33. Robert Motherwell, in conversation with R.C. Hobbs, cited in Barbara Cavaliere and R.C. Hobbs, "Against a Newer Laocoön," *Arts Magazine* 51 (April 1977), 111; Betty Parsons, personal communication, November 7, 1978.

34. Clay Spohn, personal communication, May 9, 1977.

35. See Fischer, "The Easy Chair," 16.

36. See the records of Pollock's library in Francis V. O'Connor and Eugene V. Thaw, eds., *Jackson Pollock: Catalogue Raisonné of Paintings, Drawings, and Other Works* (New Haven: Yale University Press, 1978), 4: 195.

37. Stamos, in conversation with Barbara Cavaliere, in Barbara Cavaliere, "Theodore Stamos in Perspective," *Arts Magazine* 52 (December 1977): 115 n. 18.

38. Peter Busa, personal communication about Gorky, February 1, 1978; Hare acknowledged having read *The Golden Bough* to the scholar Mona Hadler (personal communication, May, 1988).

39. Frazer's evolutionism was rooted in the Enlightment belief in progress. Human society gradually improves through the process of individual reasoning. In other words, society is improved through individual mental processes. Progress takes place when ignorance is replaced by knowledge. To Frazer, culture thus functions as science does. Culture evolved in a unilateral direction toward its peak, Western culture, which emphasizes the scientific. Frazer's schema has since been repudiated, but in its day it was considered radical, for it proposed the unity of man's mind, that is, that people of the non-Western world were not "inferior." Frazer's further thought, that non-Westerners were simply "ignorant," although they could be educated to the level of the Western white, seems patronizing and even racist today, but it is important to realize that in its time Frazer's fundamental view of the universality of the mind was a radical step forward.

In their emulation of the primitive modern art, Abstract Expressionism contributed in some measure to the end of nineteenth-century ethnocentrism and racism. The artists' interests implied a repudiation of the idea of a permanent, fixed hierarchy of the races with the white eternally on top. The artists put forth an equality of mental capacity, mind, and culture which, together with a beginning recognition of Native American and other non-Western heritages and with similar developments in other fields, led to greater acceptance and integration of primitive societies as part of human history as a whole by 1940. For a discussion of the variety of responses to Native American art

and culture, see Aldona Jonaitis, "Creations of Mystics and Philosophers: The White Man's Perceptions of Northwest Coast Indian Art from the 1930s to the Present," *American Indian Culture and Research Journal* 5 (1981): 1–48. Abstract Expressionists also contributed to the development of a pan- or multicultural approach by combining their appreciation of primitive art with its ritual uses. In other words, they did not extract the art for only formal use but sought to emulate its ritual, magical purposes.

40. Wolfgang Paalen, "Totem Art," *Dyn* 4–5 (December 1943), cited in *The Notebooks of Martha Graham,* 205.

41. Stanley Walens, *Feasting with Cannibals: An Essay on Kwakiutl Cosmology* (Princeton: Princeton University Press, 1981), 24.

42. Busa, personal communication, February 1,1978; Ferber, personal communication, April 13, 1978; and Kunitz, personal communication, March 21, 1978.

43. See Sidra Stich, *Joan Miró: The Development of a Sign Language* (St. Louis: Washington University Gallery of Art,1980), 9–10, and Evan Maurer, "Dada and Surrealism," in William Rubin and Kirk Varnedoe, eds., *"Primitivism" in Twentieth Century Art* (New York: The Museum of Modern Art, 1983), 2:542.

44. Lucien Levy-Bruhl, *How Natives Think,* trans. L. A. Clare (New York: Alfred Knopf, 1926), 60. Levy-Bruhl's thesis of a primitive mentality was strongly criticized in his time by many anthropologists such as Paul Radin, Robert Lowie and Bronislaw Malinowski, who felt it smacked of ethnocentrism. They argued that the primitive could think objectively or scientifically. For example, he could grow crops. Moreover, they criticized his use of old-fashioned methods such as Frazer's comparative anthropology of examples from around the world rather than from one culture alone. He also did no field work. However, Levy-Bruhl's language more than his thesis seems to have been the cause of much of the opposition to his argument because ultimately, most anthropologists agreed that the primitive's thinking was, at least in part, mystic—seeing supernatural forces in objective things and experience.

At the same time, Levy-Bruhl's work is increasingly being recognized today as prefiguring cognitive relativity, the recognition of the *differences* in ways of thinking and viewing the world that is prevalent in anthropology today. Such a view rejects the one mind and psychic unity approach of Levy-Bruhl's earlier critics as well as Frazer. By means of Levy-Bruhl and others, the Abstract Expressionists anticipated today's concepts of psychic alternatives to Western ways of thinking and acting. For a discussion of Levy-Bruhl's forethought, see C. Scott Littleton, introduction to Lucien Levy-Bruhl *How Natives Think* (Princeton: Princeton University Press, 1985).

45. E. D. Hirsch, *Validity in Interpretation* (New Haven: Yale University Press, 1967), 105, cited in Paul Fussell, *The Great War and Modern Memory* (London: Oxford University Press, 1975), 139.

46. See Lucy Lippard, *Ad Reinhardt* (New York: Abrams, 1981).

47. See Fussell, *The Great War and Modern Memory*, 137–44. James Brooks recently referred to the reception of Abstract Expressionism in the 1960s as not part of a down cycle or "slough of despond," thereby indicating his familiarity with *The*

Pilgrim's Progress: see Brooks and Lassa in Crosman and Miller, "Speaking of Tom," 114.

48. In Housman, ed., *War Letters of Fallen Englishmen,* 69, cited in Fussell, *The Great War and Modern Memory,* 139–40.

49. The significance of Weston's study and of *The Golden Bough* undoubtedly grew because they were singled out for praise by Eliot in his notes to *The Waste Land.* In William Troy's essay, "Prelude: Myth, Method, and the Future," in the Spring 1946 issue of the American little magazine *Chimera,* to which Campbell and the surrealist critic Nicolas Calas also contributed essays and which Gottlieb owned, Troy noted that "everyone" had read Weston's book and accepted her thesis of the survival of a "pre-Christian initiation pattern."

50. Francis Ford Coppola's *Apocalypse Now* of 1979 extended the analogy of the mythic journey and romance to the Vietnam war. In the film, *The Golden Bough* and *From Ritual to Romance* are seen in Marlon Brando's primitive camp in Cambodia far up river from "civilization." Coppola has described the work as a philosophic inquiry into the mythology of war and the human condition and declared that its structure is also partially based on Joseph Conrad's novel, *Heart of Darkness.* Brando plays a renegade American officer named Kurtz who has regressed to a primordial way of life and battle and who thus threatens the established order. He frequently quotes Eliot's poem "The Hollow Men." Kurtz is eventually killed by the principal character, an American soldier, who has journeyed through many trials to reach the deep interior of the war, his civilization, and himself.

51. Jessie L. Weston, *From Ritual to Romance* (Cambridge: Cambridge University Press, 1920; reprint, New York: Doubleday/Anchor, 1957), 203–4.

52. Reproduction in *The Tiger's Eye* 6 (December 1948): 58; Still, letter to *The Tiger's Eye* 7 (March 1949): 60.

53. *The Notebooks of Martha Graham,* 191.

54. Barnett Newman, *Adolph Gottlieb,* Wakefield Gallery, 1944, Adolph and Esther Gottlieb Foundation Archives, New York.

55. Lipton quoted in Roberta Tarbell's "Intellectual Sources for and Thematic Concerns of Seymour Lipton's Sculptures of the 1940s," lecture given at the College Art Association, February 13, 1986.

56. Quoted in Seldom Rodman, *Conversations with Artists* (New York: Capricorn, 1961), 82.

57. Barbara Reise, interview April 1964, quoted in Reise, "Primitivism in the Writings of Barnett Newman," Master's thesis, Columbia University, 1965, 2.

58. John Graham's article "Primitive Art and Picasso," *Magazine of Art* 30 (April 1937): 236–39, 260, reflects his awareness of Jungian thought. Annalee Newman in a personal communication, April 4, 1978, noted that Newman read Jung but was not "interested" in Jung's concept of the archetype. Ernst Briggs, artist and student of Still and Rothko at the California School of Fine Arts in the late 1940s, in a personal communication, March 22, 1978, stated that Still mentioned Jung's *Modern Man in Search of a Soul* to him. The book was passed around the school at that time. See Mary F. McChesney, *A Period of Exploration: San Francisco 1945–1950* (Oakland: Museum of Art, 1973), 21. Betty Parsons, personal communication, November 7, 1978; Krasner

in "Lee Krasner," in Cindy Nemser, *Conversations with 12 Women Artists* (New York: Charles Scribner's Sons, 1975), 96, says she read Jung. Martha Graham began therapy with a Jungian, Frances Wickes, in 1946; she cites Jung repeatedly in her *Notebooks*.

59. Carl G. Jung, *Modern Man in Search of a Soul*, trans. W. S. Dell and C. F. Baynes (New York: Harcourt Brace and World Harvest, 1933), 145.

60. Carl J. Jung, *Psychology and Religion* (New Haven: Yale University Press, 1938), 58–59. Jung was influenced in the historical and mythic aspect of his thought by Johann Jacob Bachofen, Nietzsche, and Jack Burkhardt.

61. Compare to the discussion of personality and culture in Mead and Benedict, chapter one.

62. Like the Abstract Expressionists, Jung considered the overemphasis on science as one of the central cultural problems of the modern era. And in his thought science was a product of consciousness. The unconscious mind created mythology. See Carl G. Jung, *Psychology of the Unconscious* (New York: Dodd, Mead and Co., 1916), 22–24.

63. Jung, *Psychology with Religion,* 6–7.

64. Ibid., 4.

65. For Jung's discussion of art, see *Modern Man in Search of a Soul,* 155–63.

66. Ibid., 169.

67. Ibid., 172.

68. Gide, quoted in Wilkinson, *The Intellectual Resistance in Europe* (Cambridge: Harvard University Press, 1981). For discussions of the psyche as the arena of the West's cultural problems and their resolution, see, among other works, Jung's *Modern Man in Search of a Soul* and Freud's *Civilization and Its Discontents* and *Moses and Monotheism.*

69. Carl G. Jung, *Memories, Dreams, Reflections,* ed. Aniela Jaffe, trans. Richard and Clara Winston (New York, 1963), 203, cited in Fussell, *The Great War and Modern Memory,* 112–13.

70. See William McGuire, *Bollingen: An Adventure in Collecting the Past* (Princeton: Princeton University Press, 1982).

71. Quoted in Ibid., 49.

72. Ibid., 68–69.

73. Ibid., 36.

74. The change in American culture from the thirties to the fifties is perhaps exemplified by Sigfried Giedion and Thornton Wilder. Giedeon's *Space, Time and Architecture* of 1941 summarized the thrust of much of American art and thought at the eve of America's entry into the war. It reflects the response of America in the 1930s to the pressure of contemporary history in the form of a utopian hope for a new modern architectural tradition. By the late 1950s Giedeon had transformed that search into a Bollingen-like search for a mythic, primordial tradition. In his A. W. Mellon Lectures in the Fine Arts of 1957, published as the two-volume *The Eternal Present* by the Bollingen Foundation in 1962, he fuses Frazer's, Levy-Bruhl's and others' ideas as well as mythic, primitive, and world traditions in an effort to define the primaries of experience from which modern humankind can learn and from which an even deeper new tradition can be fashioned. Wilder's writing follows the same pattern, moving from *Our Town* of 1938 to *The Skin of Our Teeth* of 1942 to

the archaic and mythic in *The Ides of March* and *Alcestiad* of the late 1940s.

75. McGuire, *Bollingen,* 69–70.

76. Olga Froebe in ibid., 143.

77. McGuire, *Bollingen,* xix.

78. Thomas Bender, "With Love and Money," *The New York Times Book Review,* October 7, 1983, 3.

79. McGuire, *Bollingen,* 138. One of the ironies of the reception of Abstract Expressionism is that criticism of Abstract Expressionism, especially in the 1960s, relied on comparison and linkages to the School of Paris which had very little interest in Jung.

The French still are still not interested in Jung. In a recent essay by Maurice Pleynet, "For an Approach to Abstract Expressionism," in Michael Auping, ed., *Abstract Expressionism: The Critical Developments* (Buffalo: Albright-Knox Art Gallery, 1987), 41–42, the author criticizes Jung's concepts as "puerilities," preferring those of Freud.

80. Quoted in McGuire, *Bollingen,* 291.

81. William Troy, "Postlude: Myth, Method, and the Future," *Chimera* 4 (Spring 1946): 81.

82. For De Kooning and Graham, Jean Erdman, personal communication, June 5, 1983. The following references in this section are from Campbell, *The Hero with a Thousand Faces.* Page references are given in the text.

83. "The Portrait and the Modern Artist," transcript of a broadcast on art in New York, Radio WNYC, October 13, 1945, in the Adolph and Esther Gottlieb Foundation Archives, New York.

84. Karl Leabo, *Martha Graham* (New York: Theatre Art Books, 1961), unpaged.

85. "Sweeney, 1937," in *Martha Graham: The Early Years,* Merle Armitage, ed. (New York: Da Capo, 1978), 69.

86. "Graham, 1937," in ibid., 84–85.

87. Martha Graham, *The Notebooks of Martha Graham,* intro. by Nancy Wilson Ross (New York: Harcourt Brace Jovanovich, 1937), 205.

88. Elsen, *Seymour Lipton,* 29.

89. Ibid., 37.

90. Jack Burnham, *Beyond Modern Sculpture* (New York: George Braziller, 1968), 94. The following remarks in this section are from this source.

91. Ibid., 100.

92. Hepworth, quoted in J. L. Martin, Ben Nicholson, Naum Gabo, eds., *Circle: International Survey of Constructive Art* (London: Faber & Faber, 1937), 113, cited in Burnham, *Beyond Modern Sculpture,* 93–94.

93. Auguste Rodin and Paul Gsell, *Art* (Boston: Maynard and Co., 1912), 166, cited in Burnham, *Beyond Modern Sculpture,* 55.

94. Moore in *Unit I* (1934), quoted in Burnham, *Beyond Modern Sculpture,* 95.

95. In William Wright, "An Interview with Jackson Pollock," 1950, published in Francis V. O'Connor, *Jackson Pollock* (New York: The Museum of Modern Art, 1967), 80.

96. Leabo, *Martha Graham,* 170

97. Maurer, "Dada and Surrealism," 544.

98. Jung, *Modern Man in Search of a Soul,* 186–87.

99. Ibid., 66.

100. Lewis Mumford, *The Condition of Man* (New York: Harcourt Brace Jovanovich Harvest, 1944), 14–15. Many Abstract Expressionist themes can be found in Mumford's writings, which were well known in their period.

101. Quoted in Sidney Janis, *Abstract and Surrealist Art in America* (New York: Reynal and Hitchcock, 1944), 65.

102. Seymour Lipton, statement temporarily loaned to author, Dec. 7, 1983.

103. Graham, *The Notebooks of Martha Graham,* 33.

104. Ibid., 103.

105. Campbell, *The Hero with a Thousand Faces,* 295–6.

106. Quoted in Elsen, *Seymour Lipton,* 37.

107. Larry Lutchmansingh, "Sir Herbert Read's Philosophy of Modern Art," Ph.D. diss., Cornell University, 1974, 29.

108. Rothko, cited in Peter Selz, *Rothko* (New York: The Museum of Modern Art, 1961), 14.

109. See letter to Patricia [Still], June 1954, in *Clyfford Still* (San Francisco: San Francisco Museum of Modern Art, 1976), 122.

110. Spohn, personal communication, September 28, 1977; Briggs, personal communication, March 22, 1978.

111. Annalee Newman, personal communication, April 4, 1978.

112. Herbert Ferber, personal communication, April 13, 1978.

113. Dore Ashton, *The New York School* (New York: Viking, 1973), 17, 86, 129.

114. See *The Tiger's Eye* I (March 1948).

115. Friederich Nietzsche, *Homer's Contest,* in *The Portable Nietzsche,* Walter Kaufmann, ed. and trans. (New York: Viking Penguin, 1976), 32.

116. Friederich Nietzsche, *The Gay Science,* trans. Walter Kaufmann (New York: Random Vintage, 1974), 168–69.

117. Ibid., 292.

118. Friederich Nietzsche, *The Will to Power,* trans. Walter Kaufmann and R. J. Hollingdale (New York: Random Vintage, 1968), 427.

119. For an example of the responses to a recent disaster, see the coverage of the explosion of the Challenger shuttle and President Ronald Reagan's statement (written by Peggy Noonan) in *The New York Times,* Wednesday, January 29, 1986, 1–10. The modern pattern of coping with and transcending disaster is evident: an analysis of causes; a comparison to past disasters; the requisite discussion by experts; and a description of the "President as Healer." Reagan's speech concentrates and exemplifies the mode. It names and identifies the grief of loss; posits a long perspective of human effort; makes analogies with previous experiences and explorers such as Sir Francis Drake; recognizes the need for heroes, memory and memorialization; valorizes human effort as religious questing with a quote from a World War II airman—the astronauts "slipped the surly bonds of earth to touch the face of God"; and characterizes the expansion of the human horizon as an eternal quest of the human spirit.

120. Winston Churchill, *The Second World War: Closing the Ring* (Boston: Houghton Mifflin, 1951), 6.

121. Paul Ricoeur, *Freud and Philosophy* (New Haven: Yale University Press, 1970), 54.

122. Lipton, quoted in Elsen, *Seymour Lipton,* 20.

123. Thorton Wilder, *The Skin of Our Teeth,* 1942, republished in Henry Hewes, *Famous American Plays of the 1940s* (New York: Dell, 1960), 109.

CHAPTER 3. CLYFFORD STILL

1. In Sam Hunter, *Masters of the Fifties* (New York: Marisa del Re Gallery, 1985), unpaged.

2. It should be noted that we have an incomplete record of Still's work. The only works generally available are those Still has given to museums to indicate his view of his stylistic and chronological development.

3. Letter from Still, Pullman, Washington, to Mrs. Elizabeth Ames, former Executive Director of Yaddo, in the Yaddo Archives, Saratoga Springs, New York.

4. Still, cited in *Clyfford Still* (San Francisco: San Francisco Museum of Modern Art, 1976), 108.

5. In these early works, Still drew on the culture of the Native Americans of the Columbian Plateau in eastern Washington. The Plateau Native Americans were mostly hunters and gatherers who had a strong commitment to the spirit quest. Washington State College in Pullman, where Still taught art from 1933 to 1941, is located near the reservations of such tribes as the Nespelenis, Chelos, and Colades. Still taught summer school, probably on the Nespelenis reservation, in 1937 and 1939. The brochure for the summer program (on file at the Washington State University library) advertised the area as one in which the Indian tradition and "native material" survived in their original setting. Students would study "native types" and view native festivals, it said, since Indian art embodied the ideas of the modern school. More than any other Abstract Expressionist, Still experiences directly a primitive culture.

6. Clyfford Still, "Cezanne: a Study in Evaluation," Master of Fine Arts Thesis, Washington State College, 1935, 22.

7. Still, in *Clyfford Still,* foreword by Katherine Kuh (Buffalo: Albright-Knox Art Gallery, 1966), 16–17.

8. For an excellent discussion of this theory, see Stephen Jay Gould, *Ontogeny and Philogeny* (Cambridge: Harvard University Press, 1977).

9. Clay Spohn, epigraph, *Clyfford Still* (Buffalo, 1966); Spohn, personal communication, June 27, 1977.

10. Daniel Brinton, *The Myths of the New World: A Treatise on the Symbolism and Mythology of the Red Race of America* 3d ed. (Philadelphia: David McKay, 1905), 309.

11. Ruth Underhill, *Red Man's Religion* (Chicago: The University of Chicago Press, 1965), 92. "Earth Shaking" has another meaning, especially in the Pacific Northwest. As Underhill notes in *Red Man's America* (Chicago: University of Chicago Press, 1953), 314, a modern Indian religion was called the Shaker Church. To join, Native Americans were told to give up wickedness and become Christians. Ceremonies involved shaking or dancing by those overcome with holy power. Trance and ceremony were thus combined with Christianity. Given his hostility to Christianity, Still probably took his idea from the old culture.

12. Mircea Eliade, *Shamanism,* Bollingen Series 76 (Princeton: Princeton University Press, 1964), 8.

13. Ruth Benedict, *Patterns of Culture* (New York: New American Library, 1934), 177.

14. Sir James Frazer, *The Golden Bough* (New York: Macmillan, 1922), 70.

15. Herbert Read, *Art Now* (New York: Harcourt, Brace and Co., 1934), 46.

16. For Ernst's interest in shamanism, especially Native American shamanism, see Evan Mauner, "Dada and Surrealism," in William Rubin and Kirk Varnedoe, *"Primitivism" in Twentieth-Century Art* (New York: The Museum of Modern Art, 1984), 566–74.

17. Brinton, *The Myths of the New World*, 301.

18. Seymour Lipton, in *Magazine of Art*, 1947, cited in Albert Elsen, *Seymour Lipton* (New York: Harry Abrams, 1974), 22.

19. Martha Graham, *The Notebooks of Martha Graham* (New York: Harcourt Brace Jovanovich, 1973), 149.

20. Edward M. Weyer, Jr., *The Eskimos: Their Environment and Folkways* (New Haven: Yale University Press, 1932), 401, cited in Underhill, *Red Man's Religion*, 89.

21. Underhill, *Red Man's America*, 64. For a discussion of the symbolism of the shamanic drum, see Eliade, *Shamanism*, 168–73.

22. Still's titles are problematic. He has denied that titles on works exhibited at the Art of This Century gallery and Betty Parson's were his own. They were put on, he maintains, for the amusement of the gallery staff. Yet he has admitted exhibiting titled works. For example, Mrs. Clyfford Still, letter to Joshua Taylor, July 11, 1975, published in *Clyfford Still*, 1976, 106, admits that *1938–N–1* (PH–206) was originally entitled *Totemic Fantasy*. When he had a one-person show in 1943 at the San Francisco Museum of Art, his work also had titles which must have been his because he did not object. They were minimally descriptive, however, and not interpretive. The titled works for this exhibition, as listed in the museum's accession files, are:

 The Green Wing
722. *Figures in Black and White*
723. *Two Heads*
724. *Premonition*
725. *Forms in Blue*
726. *Green Wheat*
727. *Figure on Blue Denim*
728. *Yellow Pelvis*
729. *Forms with Yellow Line*
730. *Form with Green Head*
731. *Figure in Line*
732. *Man with Sheaf*
733. *Figures in Red and Black*
734. *The Yellow Plow*
735. *The White Place*
736. *The White Hand*
737. *Figures in Red and Black*
739. *Night*
740. *Forms*
741. *Man with Orange Lily*
742. *Form in White*
743. *The Yellow Elevator*
744. *Prairie Winter*
745. *Freight Leaving Town*
746. *The Snow Plow*
747. *Mrs. Earle Bleu*
748. *Mr. Hargroves*
749. *Miss Carske*
750. *The Sculptor, Mr. Pritchard*
751. *Wife of the Artist*
752. *Self-Portrait*

Titles of Still's works in the Art of This Century Gallery, February 12 to March 2, 1946, include:

1. *The Comedy of Tragic Deformation*
2. *Buried Sun*
3. *Siamese Cat and Daughters*
4. *Quicksilver*
5. *Jamais*
6. *The Grass Widow*
7. *The Apostate*
8. *Self-Portrait*
9. *Theopathic Entities*
10. *Nemesis of Esther III*
11. *Biomorphic Mechanism*
12. *Elegy*
13. *Premonition*
14. *The Spectre and the Perroquet*

Installation photos of the 1943 exhibition show several recognizable works, including *Untitled* (PH–298), which was painted on blue denim during the war. Still lists it (*Clyfford Still*, 1976, plate 7) as being exhibited in the 1943 exhibition but only gives it a numerical title. *PH–223*, a gift from Peggy Guggenheim to the San Francisco Museum of Art, originally bore the title *Self-Portrait*. This painting was exhibited in the Art of the This Century show and can be seen on the wall behind Guggenheim in an installation photograph Still published in *Clyfford Still*, 1976, 132. Peggy Guggenheim asserts that this was Still's own title. Still nevertheless denies that such titles as *The Grail* and *Self-Portrait* are his own; however, the titles of those works in the Peggy Guggenheim Museum are in his own handwriting. (See Angelica Rudenstine, *Peggy Guggenheim Collection, Venice* [New York: Harry Abrams and The Solomon R. Guggenheim Foundation, 1985] 708–9.) It is unlikely that titled works shown in exhibition such as *The IntraSubjectives* of 1948 arranged by his close friend at the time Barnett Newman would have been so displayed without at least tacit approval from Still. Still simply seems to have been ambivalent about titling his work until the late 1940s when, as part of his increasingly aggressive philosophic position, he repudiated any verbal descriptions.

23. Frazer, *The Golden Bough*, 819–22.

24. Carl G. Jung, *Psychology of the Unconscious*, trans. with an introduction by Beatrice Hinkle (New York: Dodd, Mead and Co., 1916), 149.

25. Ibid., 132.

26. Joseph Campbell, *The Hero with a Thousand Faces* (London: Abacus, 1975), 271.

27. Jung, *Psychology of the Unconscious*, 55.

28. Ibid., 49–86.

29. Ibid., 206–7. An emphasis on the hand is also to be found in the *Chronus* series of paintings by the Abstract Expressionist sculptor David Hare. See Mona Hadler, "David Hare's Cronus Series," *Arts Magazine* 53 (April 1979): 142.

30. Frazer, *The Golden Bough,* 743–44.

31. In B. J. Townsend, "An Interview with Clyfford Still," *Gallery Notes* (Buffalo: Albright-Knox Gallery of Art) 24 (Summer 1961): 9.

32. For an additional discussion of Levy-Bruhl's influence in the period, for example on Jung, Read, Cassirer, and others, see Stephen Polcari, "Intellectual Roots of Abstract Expressionism: Clyfford Still," *Art International* 25 (May/June 1982): 22.

33. Lucien Levy-Bruhl, *How Natives Think,* trans. Lilian A. Clare (New York: Alfred Knopf, 1926), 98–99.

34. *Art News* 46 (May 1947): 50.

35. Quoted in Ti-Grace Sharpless, *Clyfford Still* (Philadelphia: Institute of Contemporary Art, University of Pennsylvania, 1963), unpaged.

36. Quoted in foreword by Kuhn, *Clyfford Still,* 1966, 10.

37. Ibid., 11.

38. Eliade, *Shamanism,* 19.

39. Campbell, *The Hero with a Thousand Faces,* 271.

40. Ernest Briggs, personal communication, May 18, 1977.

41. Ibid.

42. See Eliade, *Shamanism,* 58–59, and 159–60.

43. Clay Spohn, personal communication, September 28, 1977.

44. Still, in Katherine Kuhn, "Clyfford Still, the Enigma," *Vogue* 155 (February 1970): 218.

45. Still, "Cezanne: A Study in Evaluation," 28.

46. Jung, *Modern Man in Search of a Soul,* 240–41.

47. Ibid., 156–57.

48. Still, quoted by E. A. Carmean, Jr., in the introduction to *American Art at MidCentury: The Subjects of the Artist* (Washington, D.C.: National Gallery of Art, 1978), 41, n. 56.

49. Jung, *Modern Man in Search of a Soul,* 172.

50. Ibid.

51. Ibid., 211.

52. Still, quoted in Dorothy Seiberling, "Abstract Expressionists, Part II: The Varied Art of Four Pioneers," *Life* 47 (November 16, 1959): 94–95.

53. Lewis Mumford, *The Condition of Man* (New York: Harcourt Brace Jovanovich, 1944; reprint, 1972), 13.

54. Still adopted and fused Nietzsche's visual similes and metaphors with his Native American images. For Nietzsche in *Beyond Good and Evil: Prelude to a Philosophy of The Future,* trans. with an introduction by R. J. Hollingdale (Middlesex, England: Penguin Books, 1973), 123, the artist and the higher type or Superman reached for the future with a "creative hand" which made a new path to one's "enlargement." In *The Gay Science,* trans. Walter Kaufmann (New York: Random House, 1974), 332, Nietzsche writes that the higher type looked down from a height and rank above the herd: "Like trees we grow ... not in one place only ... but equally upward and outward and inward and downward.... This is our fate ... we grow in *height.*"

"Ruling" from above, the higher type may have many eyes, since he, like the shaman, has many "perspectives" and is beholden to no one. Ultimately for Nietzsche, *The Twilight of the Idols* and *The Anti-Christ,* trans. R. J. Hollingdale (Middlesex, England: Penguin, 1968), 85, as for Still, "Every individual may be regarded as representing the ascending or descending line of life."

55. Friedrich Nietzsche, *The Will to Power,* trans. Walter Kaufmann and R. J. Hollingdale (New York: Random House, 1968), 3.

56. In *Clyfford Still,* 1966, 17.

57. Nietzsche, *The Gay Science,* 83.

58. Ibid., 84; see also *Beyond Good and Evil,* 184.

59. Richard Schacht, *Hegel and After* (Pittsburgh: University of Pittsburgh Press, 1975), 195.

60. Nietzsche, *The Will to Power,* 356.

61. Nietzsche, *The Twilight of the Gods,* 73.

62. Ibid., 72.

63. Nietzsche, *Beyond Good and Evil,* 173–78.

64. Nietzsche, *The Twilight of the Idols,* 102–3.

65. Jan Schueler, in Mary McChesney, *A Period of Exploration: San Francisco 1945–1950* (Oakland: The Oakland Museum, 1973), 47.

66. Graham, *The Notebooks of Martha Graham,* 45.

67. Nietzsche, *Beyond Good and Evil,* 125.

68. Holger Cahill, *Looking South to The Polar Star* (New York: Harcourt Brace, 1947), 219.

69. Still, in *Clyfford Still,* 1966, 18.

70. In letter to Mary Rothko, May 1951, published in *Clyfford Still,* 1976, 119.

71. In letter to Gordon Smith, January 1, 1959, published in *Paintings by Clyfford Still* (Buffalo: Albright Gallery of Art and The Buffalo Fine Arts Academy, 1959), unpaged.

72. Still, quoted in Sharpless, *Clyfford Still,* unpaged.

73. Still, in *Clyfford Still,* 1966, 16.

74. Still, quoted in Sharpless, *Clyfford Still,* unpaged.

75. Letter to Smith, in *Paintings by Clyfford Still,* unpaged.

76. Still, quoted in Sharpless, *Clyfford Still,* unpaged.

77. Ibid., and Ernest Briggs, personal communication, May 18, 1977. Pollock shared this dislike of the International Style of architecture. He said, "I was in a house designed by Mies once; I felt so taut I couldn't say anything" (Selden Rodman, *Conversations with Artists* [New York: Capricon, 1961], 84).

78. Still, in *Clyfford Still,* 1966, 17

79. In letter to Smith, in *Paintings by Clyfford Still,* unpaged.

80. Ibid. It is noteworthy that the Indians of the Northwest Coast see themselves as similarly involved in a life-and-death struggle. Stanley Walens, *Feasting with Cannibals: An Essay on Kwakiutl Cosmology* (Princeton: Princeton University Press, 1981), 99–100, writes: "It is impossible to understand Kwakiutl life and myth ... without seeing how the Kwakiutl themselves envision the animal world, which—in terms of the constant struggle for food, for death and life ... —is not so much around them as part of them."

81. In letter to Smith, in *Paintings by Clyfford Still,* unpaged.

82. Friederich Nietzsche, *On Truth and Lie in an Extra-Moral Sense,* 371, cited in Richard Schacht, *Nietzsche* (London: Routledge and Kegan Paul, 1983), 72.

83. Nietzsche, *Beyond Good and Evil,* 49.

84. Still, letter to Patricia [Still], in *Clyfford Still,* 1976, 122. For a discussion of Abstract Expressionism and Language, see Ann Gibson, "Abstract Expressionism's Evasion of Language," *Art Journal* 47 (Fall 1988): 208–14.

CHAPTER 4. MARK ROTHKO

1. Mark Rothko and Clay Spohn, "Questions to Mary Rothko," 1947, California School of Fine Arts (now The San Francisco Art Institute), copy on deposit at The National Gallery of Art Library, Washington, D.C. This and the subsequent statements in this paragraph are excerpted from the same questionnaire.

2. Sheldon Cheney, *Expressionism in Art* (New York: Liveright, 1934), 17.

3. James Johnson Sweeney, *Plastic Redirections in 20th Century Painting* (Chicago: The University of Chicago Press, 1934), 3.

4. Mark Rothko and Adolph Gottlieb, "The Portrait and the Modern Artist," mimeographed script of broadcast, WNYC, October 13, 1943, The Adolph and Esther Gottlieb Foundation Archive, New York.

5. Mark Rothko, letter in the collection of the George C. Carson family, copy on deposit at The Archives of American Art, Washington, D.C., cited in Bonnie Clearwater, *Mark Rothko: Works on Paper* (New York: American Federation of the Arts, 1984), 26.

6. Despite his statement about the importance of Negro sculpture, for Rothko, the West's root cultures were more ancient than primitive. Rothko in fact criticized primitive art as "brutal" to a friend, Stanley Kunitz (personal communication, March 21, 1978) although he could not completely escape the general Abstract Expressionist approval of it, especially that of Gottlieb and Newman, to whom he was close in the early 1940s.

7. Dore Ashton, *About Rothko* (New York: Oxford University Press, 1983), 59. Ashton has also noted that Rothko was interested in ancient art.

8. Joseph Solman, interview, March 3, 1978, cited in Diane Waldman, *Mark Rothko: A Retrospective* (New York: Harry Abrams and The Solomon R. Guggenheim Museum, 1978), 40.

9. Bonnie Clearwater, "Tragedy, Ecstasy, Doom: Clarifying Rothko's Theory on Art," paper delivered at the College Art Association, New York, February 13, 1986, and published as "Selected Statements by Mark Rothko" in Alan Bowness, ed., *Mark Rothko 1903–1970* (London: Tate Gallery, 1987), 66–75.

10. It is interesting to note that the use of fragments of the past is a common artistic theme across cultures in the interwar period, from Kurt Schwitters's *merz* collages of nostalgic letters, tickets, and so on, and T. S. Eliot's quotation in *The Waste Land* from Ezra Pound, "These fragments I have shored against my ruins," to Lewis Mumford's idea of creating a new contemporary "whole" human being by reuniting "specialized fragments"; see Lewis Mumford, *The Condition of Man* (New York: Harcourt, Brace Jovanovich Harvest, 1944; reprint 1972), 8.

11. Greek culture had long been identified with rationalism but by the 1940s with Rothko and others, its irrationalism was trumpeted. As E. R. Dodds, *The Greeks and the Irrational* (Berkeley: University of California Press, 1951) points out in a study in which he cites Tylor, Frazer, and Levy-Bruhl, the Greeks were not immune to the irrational mental world found in primitive societies and the modern West.

12. It is unusual that in the 1945 catalog to Still's exhibition, Rothko capitalized "Myth-Maker." Nietzsche did not but Ernst Cassirer did in his *Essay on Man* (New Haven: Yale University Press), 1944. It is not known whether Rothko knew Cassirer's work, but Stanley Kunitz in a personal communication of March 21, 1978, said that unspecified poets did.

13. Andre Breton, "Situation du Surrealism entre les Deux Guerres," *VVV* 2/3 (March 1943): 44.

14. Mark Rothko, statement in Sidney Janis, *Abstract and Surrealist Art in America* (New York: Reynal and Hitchcock, 1944), 118.

15. Dore Ashton, *The New York School: A Cultural Reckoning* (New York: Viking Compass, 1972), 137.

16. Joseph Campbell, *The Hero with a Thousand Faces* (London: Abacus-Sphere, 1975), 129.

17. Douglas MacAgy, "Mark Rothko," *Magazine of Art* 42 (January 1949): 20–21.

18. Leon Kochnitsky, "A Magic Portico," *View* 6 (May 1946): 19.

19. Mumford, *The Condition of Man*, 9.

20. Ashton, *About Rothko*, 63.

21. Ibid., 68.

22. Graham, *The Notebooks of Martha Graham*, 235.

23. Anonymous, "Indefinite Idea," review in an unspecified newspaper on file, Betty Parsons Papers, #493, Archives of American Art, New York.

24. For additional discussion of the theory of evolution and Rothko, see Stephen Polcari, "The Intellectual Roots of Abstract Expressionism: Mark Rothko," *Arts Magazine* 54 (September 1979): 125. See also Robert Rosenblum, *Notes on Rothko's Surrealist Years* (New York: Pace Gallery, 1981); and Kirk Varnedoe, "Abstract Expressionism," in *"Primitivism" in Twentieth Century Art*, ed. William Rubin and Kirk Varnedoe (New York: The Museum of Modern Art, 1984), 2:595–659.

25. Mark Rothko, letter to *The New York Times*, July 8, 1945, Section 2: 2x.

26. Mark Rothko, statement in David Porter, "A Painting Prophecy—1950" (Washington: David Porter Gallery, 1945), unpaged.

27. Wolfgang Paalen, "Totem Art," *Dyn* 4/5 (December 1943): 18.

28. Graham, *The Notebooks of Martha Graham*, 175.

29. Jung, *Psychology of the Unconscious*, 5.

30. Ibid., 30–31.

31. David Hare, exhibition catalogue, Alessandra Gallery, 1976.

32. Harold Rosenberg, "Rothko," *The New Yorker* 46 (March 28, 1970): 92.

33. Victor and Edith Turner, "Religious Celebrations," in *Celebration Studies in Festivity and Ritual*, Victor Turner, ed. (Washington: Smithsonian Institution Press, 1982), 201.

34. Solon Kimball, introduction to Arnold Van Gennep, *The Rites of Passage* (Chicago: The University of Chicago Press, 1960), ix. Van Gennep's book, originally published in 1909, is the pioneering study of rites of passage.

35. Campbell, *The Hero with a Thousand Faces*, 18.

36. Carl G. Jung, *Four Archetypes*, trans. R. C. Hull Bollingen Series 20 (Princeton: Princeton University Press, 1975), 51.

37. Campbell, *The Hero with a Thousand Faces*, 216.

38. Graham, *The Notebooks of Martha Graham*, 287.

39. Anna Chave, "Mark Rothko's Subject Matter" (Ph.D. diss., Yale University, 1982), 138–60.

40. John Farrow, director, *Wake Island*, 1942, with William Bendix, Robert Preston, and Brian Donlevy. Unlike such films, however, and more like wartime photography, Rothko's figures are anonymous. As Paul Fussell writes in *The Boy Scout Handbook and Other Observations* (New York: Oxford, 1982), 231, "For the myth-making memory, the principle of anonymity is one way of sanctifying the war. ... Because the war was a common cause, no ordinary person in it has a right to appear as anything but anonymous."

41. For American biography, see Edgar Johnson, "American Biography and the Modern World," *North American Review* 245 (Summer 1938), 379, cited in Alfred Jones, "The Search for a Usable American Past in the New Deal Era," *American Quarterly* 23 (December 1971): 721; for the war, see *The World at War*, narrated by Laurence Olivier, Thames Production, 1979, episode three.

42. Quoted in Dore Ashton, "Letter from New York," *Cimaise*, 6 (December 1958): 38–39.

43. Ernest Briggs, personal communication, May 18, 1977, said Rothko told him in the late 1940s that Still had influenced his turn toward abstraction. For additional discussion of Still's influence on Rothko, see Polcari, "The Intellectual Roots of Abstract Expressionism: Mark Rothko," 129–30. See also, Waldman, *Mark Rothko*, 51–52.

44. Rothko, quoted in Katherine Kuh, "Mark Rothko—Recent Paintings," *The Chicago Art Institute QUARTERLY*, 48 (February 1–March 31, 1954): 68.

45. Ashton, *About Rothko*, 112–13.

46. Rothko, "The Romantics Were Prompted," *Possibilities* 1 (Winter 1947–48): 84. The following remarks are from this source.

47. Mark Rothko, unpublished notebook on children's art in the collection of the George C. Carson family.

48. Martha Graham, cited in Merle Armitage, *Martha Graham: The Early Years* (New York: Da Capo, 1978), 134; originally published in 1937.

49. Mark Rothko, interview with William Seitz, 1952, cited in Clearwater, "Selected Statements by Mark Rothko," in Bowness, *Mark Rothko*, 73.

50. Vincent Bruno, "Mark Rothko and the Second Style," lecture, College Art Association, February 1984, Toronto.

51. Mark Rothko, quoted in Ashton, "Letter from New York," 38.

52. Ashton, *About Rothko*, 115.

53. For a discussion of Rothko's abstract entombments, see Chave, "Mark Rothko's Subject Matter," 148–60, and Anna Chave, *Mark Rothko: Subjects in Abstraction* (New Haven: Yale University Press, 1989).

54. In the 1950s Rothko often spoke of his work as "oval," as did Eliot. See Ashton, *About Rothko*, 159.

55. Dore Ashton, "The Rothko Chapel in Houston," *Studio International* 181 (June 1971): 274.

56. Cited in William Seitz, *Abstract Expressionist Painting in America* (Cambridge: Harvard University Press, 1983), 102.

57. Quoted in Werner Haftmann, *Mark Rothko* (New York: Marlborough Gallery, 1972), ix.

58. Leroy Leatherman, photographs by Martha Swope, *Martha Graham: Portrait of the Lady as an Artist* (New York: Alfred Knopf, 1966), 79.

59. In this, Rothko's work is like that of many of this era, including Giedeon, whose ideal type of modern architecture is organic (see Sigfried Giedion, *Space, Time and Architecture* [Cambridge: Harvard University Press, 1941], 872); Joyce who uses a symbolic human organ for every chapter in *Ulysses*, to mark the unfolding tale of modern and ancient time; and Rivera in his Detroit murals where he compares the factory process of producing a car to the fruition of an embryo within the human body.

60. Mark Rothko in Porter, *A Painting Prophecy—1950*, unpaged.

61. Rothko, quoted in Ashton, "Letter from New York," 40.

62. Rothko, "Statement on His Attitude in Painting," *The Tiger's Eye*, 9 (October 1949): 114.

63. Mark Rothko, quoted in "A Symposium on How to Combine Architecture, Painting, and Sculpture," *Interiors* 110 (May 1951): 104.

64. Mark Rothko, quoted in Selden Rodman, *Conversations with Artists* (New York: Capricorn 1961), 93–94. Rothko's objectification and serialization of emotion is matched by others. For example, Martha Graham, *The Notebooks of Martha Graham*, 431, in her notes for the dance of Mary, Queen of Scots, *In the End Is My Beginning*, described the emotions Elizabeth was to represent: "fear, anguish, hate, compassion." Baziotes, too, in a letter to the poet Byron Vayzakas, April 2, 1934, excerpted in Mona Hadler, "The Art of William Baziotes" (Ph.D. diss. Columbia University, 1977), 141, compared Bonnard and Verlaine in a related objective, multiple and cyclic manner: "Bonnard picks color in paint, as Verlaine in words ... a little sadness, a little gaiety, and a little naughtiness. All under it, he is serious."

65. Rothko, quoted in "A Symposium on How to Combine Architecture, Painting, and Sculpture," 104.

66. Rothko, statement in *The Tiger's Eye* 9 (October 1949): 114.

67. Robert Hobbs, personal communications with Motherwell and Ferber, cited in "Mark Rothko," Robert Hobbs and Gail Levin, *Abstract Expressionism: The Formative Years* (New York: The Whitney Museum, 1978), 120.

68. Mark Rothko, quoted in Brian O'Doherty, *American Masters: The Voice and the Myth* (New York: Random House, 1973), 153.

69. Nietzsche, *The Birth of Tragedy*, 102.

70. Ibid., 101.

71. For additional discussion of the use of musical notations, see Ashton, *About Rothko*, 86.

72. See Phyllis Rosenzweig, *The Fifties* (Washington: The Hirshhorn Museum), 1980.

73. Clearwater, "Tragedy, Ecstasy, Doom," notes that Rothko approved of David Sylvester's review of his retrospective at the Whitechapel Art Gallery in 1961, describing it as a "masterly penetration into the subject and meaning of my work." In the review, Sylvester compared Rothko's light to that of Chartres.

74. Peter H. von Blanckenhagen and Christine Alexander, *The Paintings from Boscotrecase* (Heidelberg: F. H. Kerle Verlag,

1962), 58. The following observations are drawn from this source, pages 58–61.

75. Novalis, cited in Will Grohmann, *Paul Klee* (New York: Harry Abrams, 1955), 286.

76. Harvard's paintings have since scandously gone to ruin.

77. Mircea Eliade, *The Sacred and The Profane: The Nature of Religion* (New York: Harcourt Brace Jovanovich, 1957), 26.

78. Still's shamanistic climbing of a notched ladder and celestial journeys to the sky similarly would have begun through a sacred gateway to the sky, the aperture at the top of a tent.

79. Rothko, cited in Lee Seldes, *Legacy of Mark Rothko* (New York: Holt, Rinehart, and Winston, 1978), 51.

80. Ibid., 44.

81. Brian O' Doherty, "The Rothko Chapel," *Art in America* 61 (January/February 1973), 18.

82. In the art world of the 1930s and 1940s it was recognized that the ancient and primitive worlds represented the forces of destiny as "the gods" and there was a consequent attempt to symbolize the transformation of such forces in modern history. They would be represented by imagery of the new powers. Rivera, for example, deliberately founded a machine image in his Detroit frescoes of the automobile industry on the forceful shape of a pre-Columbian god, and Orozco interspersed modern historical figures and instruments such as weaponry with his pre-Columbian and Christian gods in his symbolizing in the Dartmouth murals of the odyssey of the historical forces of the Americas.

CHAPTER 5. ADOLPH GOTTLIEB

1. Mary Davis McNaughton and Lawrence Alloway, *Adolph Gottlieb: A Retrospective* (New York: The Arts Publisher, 1981), 11.

2. Interview with Dorothy Seckler, October 25, 1967, Archives of American Art, 9–10, cited in ibid. Seckler's interview is one of several with Gottlieb also on file at the Adolph and Esther Gottlieb Foundation in New York:

Martin Friedman, August, 1962
Gladys Kashdin, April 28, 1965
John Jones, November 3, 1965
Dorothy Seckler, October 25, 1967
Stewart Kranz, ca. February/March 1968
Andrew Hudson, May, 1968

Unless otherwise indicated, interview citations are from these sources.

3. Jeanne Sigel, "Adolph Gottlieb at Seventy: I Would Like to Get Rid of the Idea that Art is for Everybody," *Art News* 72 (December 1973): 58.

4. Interview with Jones, 5. Others Gottlieb read at this time were Joyce, Pound, Proust, nineteenth-century writers and the Russians (interview with Seckler, 13). He also exhibited what must be another Eliot-inspired work, *Sweeney*, at the Dudensing show.

5. Interview with Friedman, 1B, 8.

6. Mona Hadler, "The Art of William Baziotes" (Ph.D. diss., Columbia University, 1977), 131.

7. Gottlieb described the making of the box works in an interview with Jeanne Siegel, WBAI, May 1967, published in Jeanne Siegel, "Adolph Gottlieb: Two Views," *Arts Magazine* 42 (February 1968): 30. He said:

I started painting these objects in boxlike arrangements. They were fragmented pieces of things that had been worn and weathered, and they had no connection with each other. So therefore I divided them, and I made boxes—I painted boxes which had compartments, and each one of these things was isolated, so that you saw it by itself. But then there was a total—a sort of a total combination.

8. Adolph Gottlieb and Mark Rothko with Barnett Newman, letter to Edward Alden Jewell, *The New York Times*, June 7, 1943, on file at the Adolph and Esther Gottlieb Foundation Archive.

9. Quoted in "Adolph Gottlieb: An Interview with David Sylvester," *The Living Arts* 1 (June 1963): 4.

10. Interview with Seckler, 17.

11. Interview with Friedman, 1A, 20.

12. Jung, *Psychology of the Unconscious*, cited in MacNaughton, *Adolph Gottlieb*, 36.

13. MacNaughton, *Adolph Gottlieb*, 51, n. 39, notes that dates in Gottlieb's work are uncertain. Those works completed before 1941 were actually given their dates later and therefore the years are approximate. Those paintings given dates after 1941 are more reliable, since Gottlieb and his wife have kept records.

14. Quoted in Stephen Polcari, "Gottlieb on Gottlieb," *New York NightSounds* 1 (March 1969): 11.

15. Interview with Friedman, 1A, 3.

16. Interview with Seckler, 4. Gottlieb owned several books, including at least one in German, on African and other non-Western art.

17. MacNaughton, *Adolph Gottlieb*, 27, n. 43, notes that by 1942 Graham intended to add Gottlieb to his list of outstanding American painters, a list that included Pollock, De Kooning, and others.

18. Gottlieb, letter to Paul Bodin, March 3, 1937, The Adolph and Esther Gottlieb Foundation Archives.

19. Interview with Seckler, 17.

20. Gottlieb, along with Rothko and the central stream of Abstract Expressionism, has more of an affinity with contemporary post-modernist art and thought such as that of the architect Michael Graves than with the modernist purity of the new for its own sake.

21. Interview with Friedman, 2B, 15.

22. When I, as a young graduate student, interviewed him in 1968, Gottlieb told me that he thought modern artists were no different from artists at any time, being as much a part of tradition as any Old Master.

23. Interestingly, Gottlieb's friend in the early 1940s, Barnett Newman, attempted to define the "tradition" of both Gottlieb and Tamayo as American. In an essay entitled "La Pintura de Tamayo y Gottlieb," *La Revista Belga* 2 (April 1945): 16–25, he declared that both sought an art that was a mixture of native sources and modern elements. Both Tamayo and Gottlieb, according to Newman, wanted to establish an American tradition on terms different from the American art of the previous

decade. Newman's essay is a misstatement of Gottlieb's interest in a world tradition and consciousness as a search for a modern American primitive tradition.

24. Octavio Paz, *Tamayo En La Pintura Mexicana*, trans. Sita Garst (Mexico: Universidad Nacional Autonoma de Mexico, 1959), 23–30.

25. Gottlieb, quoted in John Gruen, *The Party's Over* (New York: The Viking Press, 1967), 257.

26. Virginia Spate, *Orphism* (New York: Oxford University Press, 1979), 20–21. For the possible parallel influence of Ezra Pound's Imagist poetry and concept of collaging fragments from the past on Gottlieb, see April Kingsley, *Adolph Gottlieb: Works on Paper* (New York: Art Museum of America and the Adolph and Esther Gottlieb Foundation, 1985).

27. James T. Soby, *Tchelitchew* (New York: The Museum of Modern Art, 1942), 34.

28. Sigfried Giedeon, *Space, Time, and Architecture* (Cambridge: Harvard University Press, 1941), 436.

29. Ibid., 875.

30. See Sigfried Giedeon, *The Eternal Present: The Beginnings of Art,* The A. W. Mellon Lectures in the Fine Arts, 1957, Bollingen Series 35 (New York: Pantheon Books, 1962), 50.

31. In surrealist theory, a seer could be represented by an eye. See, for example, such an eye on the cover of the American Surrealist magazine *View* 3 (December 1943). John Graham also noted that the eye was the pathway between the internal and external. See Marcia Epstein Allentuck, introduction to John Graham's *Systems and Dialetics of Art* (Baltimore: The John Hopkins Press, 1971), 6, n. 9.

32. In the 1960s, the idea of art as object was developed along industrial lines. To minimalist sculptors and painters, the art object became a nonsymbolic design and thing in itself.

33. Gottlieb, "The Ides of Art," *The Tiger's Eye* 1 (December 1947): 43.

34. Gottlieb, letter to *The New York Times*, July 22, 1945.

35. Interview with Jones, 2. These irrational connections are somewhat like those of surrealist poetry, which used prepositions 'de' and 'a' to draw words into unforeseen combinations and constructions outside rational jurisdictions. See J. H. Matthews, *The Imagery of Surrealism* (Syracuse: Syracuse University Press, 1977), 69–71.

36. Interview with Seckler, 17.

37. Siegel, "Adolph Gottlieb: Two Views," 30.

38. Interview with Jones, 1.

39. Interview with Friedman 1A, 22.

40. Statement in Sidney Janis, *Abstract and Surrealist Art in America* (New York: Reynal and Hitchcock, 1944), 119.

41. Gottlieb, "Unintelligibility," unpublished typescript for the symposium *The Artist Speaks,* The Museum of Modern Art, May 5, 1948, 3, on file at the Adolph and Esther Gottlieb Foundation Archives.

42. The labyrinth was also a favorite theme of the surrealists, and especially Masson.

43. W. Jackson Rushing, "Ritual and Myth: Native American Culture and Abstract Expressionism," in Maurice Tuchman, ed., *The Spiritual in Art: Abstract Painting 1890–1985* (Los Angeles and New York: Los Angeles County Museum of Art and Abbeville Press, 1986), 279.

44. Rothko and Gottlieb, "The Portrait and the Modern Artist."

45. Philip Gibbs, *Now It Can Be Told*, 1920, 131, cited in Paul Fussell, *The Great War and Modern Memory* (London: Oxford University Press, 1975), 8.

46. E. B. C. (Sledgehammer) Sledge, professor of biology and ornithology, in Studs Terkel, *"The Good War"* (New York: Ballantine, 1984), 59–60.

47. Major Frank Isherwood, letter, 1914, published in Christopher Isherwood, *Kathleen and Frank,* 1971, 426, cited in Fussell, *The Great War and Modern Memory,* 51.

48. Mircea Eliade, *Shamanism*, Bollingen Series 76 (Princeton: Princeton University Press, 1964), 51.

49. *VVV* 2/3 (March 1943): 27. I am indebted to Carmen Stonge, in a report in my seminar, "Primivitism and Modern Art," State University of New York at Stony Brook, Fall 1984, for this information.

50. Herbert Read, "The War as Seen by British Artists," in *Britain at War* (New York: The Museum of Modern Art, 1941), 12. See also Carl Sandburg, and Lt. Commander Edward Steichen, "A Procession of Photographs of the Nation at War," *The Museum of Modern Art Bulletin* 9 (June 1942): 14, "Smooth and terrible birds of death—smooth they fly, terrible their spit of flame, their hammering cry, 'Here's lead in your guts.'" During the 1930s the thesis of Giulo Douhet (*The Commander of the Air,* 1921) that aerial bombing would quickly destroy enemy cities and populations dominated popular and military discussion. Aerial bombardment so terrified popular imagination that with war seemingly imminent in the Munich crisis a significant portion of London's population fled in fear and anticipation.

51. In one of the ironies of modern culture and history, such a use of bird and animal imagery transforms this symbol of the *streamlined moderne* of America of the 1930s into its opposite. The bird's head DC–3, symbol of the unity of machine with natural form and thus of vitality and progress, for example, became the principal means of transportation in the war.

52. Graham, *The Notebooks of Martha Graham*, 47.

53. As the narrator notes in the film *The Mortal Storm,* directed by Frank Borzage, Metro-Goldwyn-Mayer, 1940.

54. Lipton, cited in Albert Elsen, *Seymour Lipton* (New York: Abrams, 1974), 29.

55. Ibid., 27.

56. Fussell, *The Great War and Modern Memory*, 312–13.

57. Gottlieb, "The Ides of Art," 43.

58. Rothko in *Clyfford Still*, Art of This Century Gallery, February 12–March 7, 1946, Archives of American Art, unpaged.

59. Sanford Hirsch, director of the Gottlieb Foundation, personal communication, November 8, 1985, brought this painting to my attention. He believes Gottlieb may have intended the figures to represent those of the camps.

60. Elsen, *Seymour Lipton*, 55.

61. Graham, *The Notebooks of Martha Graham*, 184.

62. Carolyn Lanchner, "André Masson: Origins and Development," in William Rubin and Carolyn Lanchner, eds., *André Masson* (New York: The Museum of Modern Art, 1976), 151.

63. Gottlieb, "New York Exhibitions," *Limited Edition* 5 (December 1945), 6.

64. Miriam Roberts, *Adolph Gottlieb Paintings 1921–1956* (Omaha: Joslyn Art Museum, 1980), 57.

65. Interview with Seckler, 20.

66. Ibid., 21.

67. Gottlieb, in a discussion of *Counterpoise* with Adlai Stevenson, quoted in Gay Talese, "Stevenson Studying Abstract Art," *The New York Times,* December 23, 1959, 17.

68. Fussell, *The Great War and Modern Memory,* 75–76.

69. Ibid., 76.

70. Quoted in Charlotte Willard, "In the Art Galleries," *The New York Post,* January 10, 1965, 20.

71. Quoted in Polcari, "Gottlieb on Gottlieb," 11.

72. Harry Rand, "Adolph Gottlieb in Context," *Arts Magazine* 51 (February 1977): 129.

73. In this cycle or periodicity of emotion, Gottlieb echoes Rothko's "tragedy, ecstasy, doom" grouping as well as that of Martha Graham, *The Notebooks of Martha Graham,* 103. In *I Salute My Love,* Graham proposes a typical *ensemble* of thematic emotions parallel to Gottlieb's: "Love/Battle/Death/divination Life/ birth-growth."

74. Quoted in Polcari, "Gottlieb on Gottlieb," 11.

75. As with his early work, Gottlieb describes the multiple sides of the life/human, natural, cultural/cosmic voyage. In this regard, it was not just Rothko who referred to his own works as presenting "civilizations." In 1964, Gottlieb sent postcards of different cultural idols, from Greek civilizations to Whistler, with orb shapes drawn over them, thereby wittily absorbing their associations into his dramaturgy of the historical life cycle. See Adolph Gottlieb, "Postcards from Adolph Gottlieb," *Location* 1 (Summer 1964): 19–34.

76. Interview with Friedman, 2A, 8.

77. Gottlieb, in an interview with Anthony Janson, Whitney Museum of American Art Archives, February 15, 1968. Like other Abstract Expressionists, Gottlieb made art for houses of religious worship, including the Steinway House in New York City. These works consist of Pictographic symbols for religious worship—symbols of light rays, beams, and stars.

78. Quoted in Elsen, *Seymour Lipton,* 33.

79. See Craig Owens, "The Allegorical Impulse: Toward a Theory of Postmodernism," *October* 12 (Spring 1980): 67–86.

80. Ibid., 72.

81. Michael Murrin, *The Allegorical Epic* (Chicago: The University of Chicago Press, 1980), 7.

82. Ibid. Allegory has affinities to Giedeon's definition of history in *Space, Time, Architecture,* vi, *"History is not a compilation of facts, but an insight into a moving process of life . . . such insight is obtained not by the exclusive use of panoramic survey, the bird's-eye view, but by isolating and examining certain specific events intensively, penetrating and exploring them in the manner of the close-up."*

83. Campbell, *The Hero with a Thousand Faces,* 295–6.

CHAPTER 6. BARNETT NEWMAN

1. Thomas B. Hess, *Barnett Newman* (New York: The Museum of Modern Art, 1971), 15.

2. Newman, quoted in Neil A. Levine, "The New York School Question," *Art News* 64 (September 1965): 40.

3. In this regard, a few words must be said about the thesis proposed by Thomas Hess in *Barnett Newman,* which has been accepted by a number of critics and historians. Hess argues that Newman's painting and ideas reflect the influence of the Jewish mystical sect, the Kabbalah. His evidence is that books on the Kabbalah, especially those by Gershom Scholem, were in Newman's library, that Newman made two statements to Hess which indicated his awareness of Kabbalah, and that explanations of his titles can be found in these Kabbalah texts. Newman probably had read these books in his library, but there were many others there too—on anthropology, philosophy, psychology, and natural science—that had nothing to do with the Kabbalah and that are more typical of the reading of the Abstract Expressionists. Parallels to Newman's titles and statements can be found in these books as well.

Newman's ideas are part of the Abstract Expressionist matrix. What the Kabbalah seems to be is a related conception to ideas also found in other writers more familiar to the period. Its similarity is indicated by the fact that Scholem's *On the Kabbalah and Its Symbolism* is on the specialized booklists of the Jungian Foundation. Scholem himself had lectured to the Jungian Foundation in Eranos, Switzerland. He was personally close to the Jungian group there, yet he said "Even though I should have had strong affinity to Jung's concepts, which were close to religious concepts, I refrained from using them" (Scholem, quoted in William McGuire, *Bollingen: An Adventure in Collecting the Past* [Princeton: Princeton University Press, 1982], 153). Newman does not draw on the Kabbalah but on the ideas that have their origin in the more usual period sources.

4. Irving Lavin, November 14, 1982 memorial service for H. W. Janson, in "Words in Memory of H. W. Janson," *CAA Newsletter* 7 (Winter 1982): 3.

5. Newman, quoted in Pierre Schneider, *Louvre Dialogues* (New York: Atheneum, 1971), 211.

6. A. J. Liebling, "Two Aesthetes Offer Selves as Candidates to Provide Own Ticket for Intellectuals," *New York World-Telegram,* November 4, 1933, cited in Hess, *Barnett Newman,* 24–25.

7. Newman, in conversation with Thomas B. Hess in a public program at the Solomon R. Guggenheim Museum, New York, May 1, 1966, cited in Brenda Richardson, *The Complete Drawings, 1944–1969* (Baltimore: The Baltimore Museum of Art, 1979), 15, n. 8.

8. Newman, 1967, cited in Harold Rosenberg, *Barnett Newman* (New York: Harry Abrams, 1977), 27–28.

9. Frank H. Cushing, "Zuni Creation Myths," 13th Annual Report, Bureau of American Ethnology, 381, reprinted in Franz Boas, *Primitive Art* (New York: Dover, 1955), 308.

10. Newman in Schneider, *Louvre Dialogues,* 210.

11. Salomon Reinach, *Apollo* (New York: Charles Scribner's Sons, 1924), 2–4; originally published in 1904.

12. Hess, *Barnett Newman,* 80. See also Lawrence Alloway, "The Stations of the Cross and the Subjects of the Artist," *Barnett Newman: The Stations of the Cross/Lema Sabachthani* (New York: The Solomon R. Guggenheim Museum, 1966), 12; and Robert Goodenough, "Artists' Sessions at Studio 35 (1950)," in *Modern Artists in America,* ed. Robert Motherwell and Ad Reinhardt (New York: Wittenborn Schultz, 1951), 15.

13. As cited in Richardson, *The Complete Drawings*, 58.

14. Dorothy Seckler, "Frontiers of Space," *Art in America* 50 (Summer 1962): 86, cited in ibid.

15. Carl G. Jung, *Psychology of the Unconscious*, trans. with an introduction by Beatrice Hinkle (New York: Dodd, Mead and Co., 1916), 388.

16. Joseph Campbell, *The Hero with a Thousand Faces* (London: Abacus, 1975), 237.

17. Newman, "The Plasmic Image," unpublished essay, 1945, excerpted in Hess, *Barnett Newman*, 38.

18. Sir James Frazer, *The Golden Bough* (New York: Macmillan, 1922), 402–62.

19. For Masson, see Carolyn Lanchner, "André Masson: Origins and Development," in William Rubin and Carolyn Lanchner, eds., *André Masson* (New York: The Museum of Modern Art, 1976), 143.

20. Martha Graham, *The Notebooks of Martha Graham* (New York: Harcourt Brace Jovanovich, 1973), 192.

21. Jung, *Psychology of the Unconscious*, 436.

22. Richardson, *The Complete Drawings*, 55.

23. For a discussion of the English pastoral and the First World War, see Paul Fussell, *The Great War and Modern Memory* (New York: Oxford University Press, 1975), 231–69.

24. Michael Arlen, "Time Warp," in Diana DuBois, ed., *My Harvard, My Yale* (New York: Random House, 1982), 75.

25. Akira Miura, in Studs Terkel, *"The Good War"* (New York: Ballantine Books, 1984), 202.

26. Richardson, *The Complete Drawings*, 90.

27. Barnett Newman, catalogue foreword to *Adolph Gottlieb*, Wakefield Gallery, February 7–19, 1944, catalogue foreword, Adolph and Esther Gottlieb Foundation, New York.

28. Newman, personal communication, October 1969.

29. Newman, quoted in Goodenough, "Artists' Sessions at Studio 35 (1950)," 31.

30. Newman's concepts and entire frame of reference parallel Jung's mythic psychology. He shares with Jung symbols such as fire, divine light, natural imagery, the primal egg, and rebirth myths. Yet Newman denied that he was interested in the most fundamental Jungian concept, the archetype, and in psychological processes in general (Annalee Newman, personal communication, April 4, 1978). He said ("The Plasmic Image," in Hess, *Barnett Newman*, 38): "No matter what the psychologists say these forms [images] arise from, that they are the inevitable expression of the unconscious, the present painter is not concerned with the process. Herein lies the difference between them [the forms] and the Surrealists."

Newman never wrote about the unconscious. Nevertheless, most of his subjects and ideas, although he may have considered them to be from the arena of metaphysics rather than psychology, parallel and arise from the intellectual milieu of his time. Newman is thus like Still, Reinhardt, De Kooning, and others, all of whom had little interest in the unconscious but developed themes related to those who did. Newman summarized his attitude in a way that illuminates Jung's relationship to him and to other Abstract Expressionists: "If some one were a Jungian, he'd understand me and I'd understand him; but we'd disagree on terminology" (Quoted in Barbara Reise, "Primitivism in the Writings of Barnett B. Newman: A Study in the Ideological Background of Abstract Expressionism" [Master's thesis, Columbia University, 1965], 42.

31. Hess, *Barnett Newman*, 17.

32. Friederich Nietzsche, *The Gay Science*, trans. Walter Kaufmann (New York: Random Vintage, 1974), 261.

33. See Newman, "The Plasmic Image," in Hess, *Barnett Newman*, 37–39.

34. Annalee Newman, personal communication, April 4, 1978.

35. Quoted in Hess, *Barnett Newman*, 53.

36. It is noteworthy that, the citation of the Nobel Prize in 1986 to Elie Wiesel, one of the great historians of the Holocaust and the man who defined it as such, praised Wiesel for seeking "atonement" in his writings.

37. According to Annalee Newman, personal communication, April 4, 1978, Newman only read Worringer late in his life after Clement Greenberg mentioned a possible relationship between the two.

38. Herbert Read, *The Meaning of Art* (London, Farber and Farber, 1931), 41.

39. Campbell, *The Hero with a Thousand Faces*, 113.

40. Quoted in Hess, *Barnett Newman*, 57.

41. See Ann Gibson, "Barnett Newman and Alberto Giacometti," *Issue* 3 (Spring/Summer 1985): 2–10.

42. Jean Paul Sartre, "The Quest for the Absolute," reprinted in Jean Paul Sartre, *Essays in Existentialism*, Wade Baskin, ed. (Secaucus, New Jersey: Citadel Press, 1979), 388–90.

43. Ibid., 397. "Unity in multiplicity" was a common issue in the period. The problem, as indicated by Mary Mellon, Jung, and Lewis Mumford, was to find a new wholeness that allowed for, yet reconciled, division and difference. The surrealist Yves Tanguy suggested the surrealist solution. For example, in *Infinite Multiplicity* of 1942, he initiated a stream-of-continuous creation and division in space and time through imagery of endless primordial/biomorphic/geological/human metamorphoses.

44. Newman criticized the Greco-Roman artistic, but not literary, tradition. See Barnett Newman, "The Object and the Image," *The Tiger's Eye* 1 (March 1948): 111.

45. Barnett Newman, "The Sublime is Now," *The Tiger's Eye* 1 (December 1948): 51–53.

46. See Gibson, "Barnett Newman and Alberto Giacometti," 6–8.

47. Rosenberg, *Barnett Newman*, 61.

48. Annalee Newman, personal communication, April 4, 1978.

49. Clement Greenberg, *Barnett Newman* (Vermont: Bennington, 1958), unpaged.

50. Quoted in Seckler, "Frontiers of Space," 86.

51. Quoted in Stephen Polcari, "Newman: Quality in Art," *New York NightSounds* 1 (October 1969): 11.

52. Barnett Newman, "The 14 Stations of the Cross, 1958–1966," *Art News* 65 (May 1966): 57.

53. Quoted in Schneider, *Louvre Dialogues*, 212.

54. Graham, *The Notebooks of Martha Graham*, 212.

55. Ibid., 181.

56. Nietzsche, *The Birth of Tragedy*, 71.

57. Carl G. Jung, *Psychology and Religion* (New Haven: Yale University Press, 1938), 43.

58. Jung, *Psychology of the Unconscious*, 99.

59. Graham, *The Notebooks of Martha Graham*, 176.

60. Still, letter to Ed Cahill and Dorothy Miller, June 1954, published in Clyfford Still, *Clyfford Still* (San Francisco: San Francisco Museum of Modern Art, 1976), 122.

61. Jung, *Psychology of the Unconscious*, 128.

62. Graham, *The Notebooks of Martha Graham*, 235.

63. Ibid., 128.

64. Ibid., 176.

65. Hess, *Barnett Newman*, 17, n. 1.

66. Alfred Haworth Jones, "The Search for a Usable American Past in the New York Era," *American Quarterly* 23 (December 1971): 719–24.

67. Paul Ricoeur, *Freud and Philosophy* (New Haven: Yale University Press, 1970), 38–39. According to Ricoeur, Prometheus and Anthropos (cf. Wilder's Mr. Anthrobus) are such mythic heroes.

68. Carl G. Jung, *Modern Man in Search of a Soul* (New York: Harcourt, Brace and World, 1933), 96.

69. Nietzsche, *The Birth of Tragedy*, 70–71.

70. Graham, *The Notebooks of Martha Graham*, 294.

71. Hayden Herrera, *Frida: A Biography of Frida Kahlo* (New York: Harper and Row, 1983), 326.

72. Albert Camus, *The Myth of Sisyphus*, trans. Justin O'Brien (New York: Vintage, 1960), 79.

73. Newman statement in *Barnett Newman: The Stations of the Cross*, 9.

74. Newman, "Conversation," May 1, 1966, The Solomon R. Guggenheim Museum, quoted in Hess, *Barnett Newman*, 99.

75. Alloway, "The Stations of the Cross and the Subjects of the Artist," 14.

76. Newman, "The 14 Stations of the Cross," *Art News* (65 (May 1966): 57

77. Graham, *The Notebooks of Martha Graham*, 133.

78. Barnett Newman, foreword to Peter Kropotkin, *Memoirs of a Revolutionist* (New York: Horizon Press, 1968), xv.

79. Camus, *The Myth of Sisyphus*, 65.

CHAPTER 7. WILLIAM BAZIOTES

1. Mona Hadler, "The Art of William Baziotes" (Ph.D. diss., Columbia University, 1977), 4–7.

2. Ibid., 29–33.

3. As another literate Abstract Expressionist, Baziotes continued to learn about the war in his later years. He read the work of William Shirer and Hugh Trevor-Roper. Ethel Baziotes, personal communication, June 6, 1986.

4. Marticia Sawin, "'The Third Man,' or Automatism American Style," *College Art Journal* 47 (Fall 1988): 181. For the experiments of Baziotes, Motherwell, Matta, Pollock, and Kamrowski, see Jeffery Wechsler, *Surrealism and American Art, 1931–1947* (Rutgers: Rutgers University Art Gallery, 1977), 68.

5. Quoted in Robert Goodnough, ed., "Artists' Sessions at Studio 35 (1950)," Robert Motherwell and Ad Reinhardt, *Modern Artists in America* (New York: Wittenborn Schultz, 1951), 15.

6. Quoted in John Baur, *The New Decade: Thirty-Five American Painters and Sculptors* (New York: The Whitney Museum of Art, 1955), 10.

7. In Max Kozloff, "Interview with Matta," *Artforum* 4 (September 1965): 24; cited in Hadler, "The Art of William Baziotes," 87.

8. Ethel Baziotes, personal communication, June 6,1986 noted the importance of evolution to him. She also said that he studied Darwin and the Galapagos Islands.

9. Ibid.

10. Baziotes, "The Artist and His Mirror," *Right Angle* 3 (June 1949): 3–4.

11. See Hadler, "The Art of William Baziotes," 194–96.

12. *Baudelaire, His Prose and Poetry*, T. R. Smith, ed. (New York: Random, The Modern Library, 1919), 226, cited in Hadler, "The Art of William Baziotes," 193. See also Mona Hadler, "William Baziotes, A Contemporary Poet-Painter," *Arts Magazine* 51 (June 1977): 102–10; and Melinda Lorenz, "William Baziotes (1912–1963): The Formation of a Subjectively Based Imagery" (Master's thesis, University of Maryland, 1972), 59.

13. Hare stated in Hadler, "The Art of William Baziotes," 151, that "Baudelaire was a hero in the early forties. Baudelaire, Rimbaud and Kafka were pillars of the Surrealist movement." See also Hadler, "William Baziotes: A Contemporary Poet-Painter."

14. Baziotes, "Statement," *The Tiger's Eye* 1 (October 1948): 55.

15. Ethel Baziotes concurs, personal communication, June 6, 1986.

16. Ibid. He read a study of spiders, J. Henri Farber's *The Life of the Spider* (New York: Hodder and Stoughton, 1912).

17. Mona Hadler, "William Baziotes: Four Sources of Inspiration," in Michael Prebble, introd., *William Baziotes: A Retrospective Exhibition* (California: Newport Harbor Art Museum, 1978), 90.

18. Quoted in Donald Paneth, "William Baziotes, A Literary Portrait," 6, Baziotes File, Archives of American Art, New York.

19. As Baudelaire noted, "This primitive irresistible force is man's natural perversity, which makes him forever and at once both homicidal, murderer, and hangman." See Charles Baudelaire, "Edgar Allan Poe: His Life and Works," in *The Painter of Modern Life*, ed. J. Mayne (New York: Phaidon, 1965), 96.

20. Friederich Nietzsche, *Beyond Good and Evil*, trans. with an introduction by R. J. Hollingdale (Harmondsworth, England: Penguin 1973), 184. Carl Jung conceived man as retaining traits from physical and psychic evolution. In *Modern Man in Search of a Soul*, trans. W. S. Dell and Cary F. Baynes (New York: Harcourt Brace and World, 1933), 126, he wrote: "Just as the human body connects us with the mammals and displays numerous relics of earlier evolutionary stages going back even to the reptilian age, so the human psyche is likewise a product of evolution which, when followed up to its origins, shows countless archaic traits." Lewis Mumford, *The Condition of Man* (New York: Harcourt Brace Jovanovich Harvest, 1944), 4, cites Darwin as also indicating the shaping of human behavior by the biological past: "we understand that man's nature is continuous with that of animal creation: the biological past of many organisms has shaped the organs of his own body: their needs, their impulses, their urges have laid channels for his own conduct."

21. The eye may also connote the deadly or evil. For a discussion of the evil eye in Surrealist literature, see Hadler, "William Baziotes: Four Sources of Inspiration," 88.

22. Ibid., 89.

23. Ethel Baziotes, personal communication, June 6, 1986.

24. Paul Fussell, "My War," in *The Boy Scout Handbook* (London: Oxford, 1982), 267.

25. *Britain at War* (New York: The Museum of Modern Art, 1941), 43.

26. Jean Wood, a dancer, in Studs Terkel, *"The Good War"* (New York: Ballantine, 1984), 213.

27. Ethel Baziotes, personal communication, June 6, 1986.

28. Fussell, "My War," 267.

29. For Baziotes, see Paula Franks and Marion White, eds., "An Interview with William Baziotes," *Perspective* 2 (1956–57): 30; for Rothko, see his "The Romantics were Prompted," *Possibilities* 1 (Winter 1947–48): 84.

30. Mumford, *The Condition of Man*, 13.

31. See Paul Fussell, *The Great War and Modern Memory* (London: Oxford, 1975), 191–230.

32. Ibid., 191–92.

33. Robert Rasmus, businessman, in Terkel, *"The Good War,"* 36–39.

34. In "Symposium: Creative Process," *Art Digest* 28 (January 15, 1954): 16.

35. Ernest Parker, *Into Battle, 1914–1918*, 1964, cited in Fussell, *The Great War and Modern Memory*, 114.

36. Willard Waller, *The Veteran Comes Back*, cited in John Costello, *Virtue Under Fire* (Boston: Little, Brown, and Co., 1985), 193.

37. Philip Morrison, a physicist, in Terkel, *"The Good War,"* 516.

38. Franks and White, "An Interview with William Baziotes," 30.

39. See Evan Firestone, "Herman Melville's *Moby Dick* and the Abstract Expressionists," *Arts Magazine* 54 (March 1980): 120–24.

40. Rosenberg, for example, described American action painters as taking to the canvas as Ishmael took to the sea. Motherwell appreciated the novel for its discussion of white, a color he used to symbolize human emotion. De Kooning said that, like Ishmael, he turned to the sea for inspiration. Most saw the novel as a struggle between man and nature, and between man and his inner being.

41. The following remarks are from interviews with Lipton presented by Roberta Tarbell, "Seymour Lipton's Sculptures of the 1940s: Intellectual and Thematic Concerns," paper delivered at the College Art Association meeting, New York, February 13, 1986.

42. Lipton, 1960, quoted in Albert Elsen, *Seymour Lipton* (New York: Abrams, 1974), 28.

43. Lawrence Alloway, *William Baziotes: A Memorial Exhibition* (New York: Solomon R. Guggenheim Museum, 1965), 12.

44. Ethel Baziotes, letter to Mona Hadler, June 12, 1975, published in "Four Sources of Inspiration," 100, n. 74.

45. Hadler, "The Art of William Baziotes," 230.

46. William Baziotes, statement for the Museum of Modern Art, 1955, on file at the Archives of American Art, New York.

47. Ibid.

48. William Baziotes, "Notes on Painting," *It Is* 4 (Autumn 1959): 11.

49. Thomas Hess, "William Baziotes, 1912–63," *Location* 1 (Summer 1964): 88.

50. Baziotes, in Paneth, "William Baziotes, A Literary Portrait," 13.

51. William Baziotes, letter to Dorothy Miller, August 9, 1957, the Museum of Modern Art Library, New York.

52. In the Museum of Modern Art Questionnaire, 1951, Archives of American Art, New York.

53. Ethel Baziotes, personal communication, June 6, 1986.

54. Barbara Cavaliere, "An Introduction to the Method of William Baziotes," *Arts Magazine* 51 (April 1977): 130.

55. Isamu Noguchi, in *Newsday*, May 10, 1985, Sec. 3, p. 17.

56. Ethel Baziotes, personal communication, June 6, 1986.

57. Thomas Mann, *The Magic Mountain*, trans. H. T. Lowe-Porter (Great Britain: Nationwide Books, 1980), 382.

58. Ethel Baziotes, personal communication, June 6, 1986.

CHAPTER 8. JACKSON POLLOCK

1. Quoted in Francis V. O'Connor and Eugene V. Thaw, eds., *Jackson Pollock: A Catalogue Raisonné of Paintings, Drawings, and Other Works* (New Haven: Yale University Press, 1978), 4: 209, section D7.

2. Jackson Pollock, answers to a questionnaire in *Arts and Architecture* 61 (February 1944): 14.

3. For additional discussion of Pollock's relationship to Benton, see Stephen Polcari, "Jackson Pollock and Thomas Hart Benton," *Arts Magazine* 53 (March 1979): 120–24; and Francis O'Connor, "The Genesis of Jackson Pollock: 1912–1943" (Ph.D. diss., Johns Hopkins University, 1965), 114–25. For Benton's design principles, see Thomas Hart Benton, "The Mechanics of Form Organization," *The Arts* 1 (November 1926): 285–89; 2 (December 1926): 340–42; 3 (January 1927): 43–44; 4 (February 1927): 95–96; 5 (March 1927): 145–48.

4. Thomas Hart Benton, letter to O'Connor, cited in Francis V. O'Connor, "The Genesis of Jackson Pollock: 1912 to 1943," *Artforum* 5 (May 1967): 17. "Occidental" was erroneously spelled "accidental" in the original text. See letter by Francis O'Connor, *Artforum* 5 (Summer 1967): 5.

5. See Karal Ann Marling, *Wall-to-Wall America* (Minneapolis: University of Minnesota Press, 1982), 136–39.

6. Pollock, answers to a questionnaire, 14.

7. Dr. James H. Wall, letter to Francis O'Connor, March 28, 1974, published in O'Connor and Thaw, *Jackson Pollock*, 4: 124; for a preliminary drawing, see 3: 445r.

8. Seymour Lipton used these words to describe Orozco's influence on his own work. Quoted in Albert Elsen, *Seymour Lipton* (New York: Harry Abrams, 1974), 16.

9. For Pollock's titles I am following the procedures laid down by O'Connor and Thaw in *Jackson Pollock: A Catalogue Raisonné*. For example, those titles that are documented to be Pollock's appear without brackets. Bracketed titles have not been given to the works by Pollock but by O'Connor and Thaw in their *Catalogue Raisonné*. Works with titles enclosed in parentheses are also not Pollock's but have become standard in usage.

10. W. Jackson Rushing independently came to the same conclusion. See his "Jackson Pollock and Native American Art," paper delivered February 13, 1986, College Art Association, New York, published as part of "Ritual and Myth: Native American Culture and Abstract Expressionism" in Maurice Tuchman, ed., *The Spiritual in Art: Abstract Painting 1890–1985* (Los Angeles: Los Angeles County Museum of Art; New York: Abbeville, 1986), 281–82.

11. Elizabeth Cowling, "The Eskimos, the American Indians, and the Surrealists," *Art History* 1 (December 1978): 484–550.

12. Donald E. Gordon, "Pollock's *Bird*, or 'How Jung Did not Offer Much Help in Myth-Making,'" *Art in America* 68 (October 1980): 53, n. 50.

13. Charles Pollock, letter to author, January 19, 1983.

14. Pollock, in answers to a questionnaire, 14.

15. Anaïs Nin, *The Diary of Anaïs Nin*, ed. Gunther Stuhlmann (New York: Harvest Harcourt Brace Jovanovich, 1967), 306.

16. In letter to author, January 19, 1983.

17. In an interview with B. H. Friedman, *Jackson Pollock: Black and White* (New York: Marlborough-Gerson Gallery, 1969), 6.

18. Irving Sandler suggests a likeness to a mask reproduced in John Graham's "Primitive Art and Picasso," *Magazine of Art* 30 (April 1937): 236. See discussion of Graham's possible influence in Irving Sandler, "John D. Graham: The Painter as Esthetician and Connoisseur," *Artforum* 7 (October 1968): 50–53, cited in Kirk Varnedoe, "Abstract Expressionism," in William Rubin and Kirk Varnedoe, *"Primitivism" in 20th Century Art* (New York: The Museum of Modern Art, 1984), 2:616–17.

19. Bill Holm, *Northwest Coast Indian Art* (Seattle: University of Washington Press, 1965), 92–93.

20. Wolfgang Paalen, "Totem Art," *Dyn* 4/5 (1944): 12–13. See Martha Graham, *The Notebooks of Martha Graham* (New York: Harcourt Brace Jovanovich, 1973), 205.

21. Frederich Douglas and Rene D'Harnoncourt, *Indian Art of the United States* (New York: The Museum of Modern Art, 1941), 111.

22. Ibid.

23. Ibid., 172–73.

24. Stanley Walens, *Feasting with Cannibals: An Essay on Kwakiutl Cosmology* (Princeton: Princeton University Press, 1981), 59.

25. Graham, "Primitive Art and Picasso," 236–39, 260.

26. Nicholas Carone in Jeffrey Potter, *To a Violent Grave: An Oral Biography of Jackson Pollock* (New York: G. P. Putnam's Sons, 1985), 56.

27. Graham, "Primitive Art and Picasso," 237.

28. Ibid. See also *John Graham's System & Dialectics of Art*, ed. with an introduction by Marcia Allentuck (Baltimore: Johns Hopkins Press, 1971), 47.

29. Gordon, "Pollock's *Bird*, or 'How Jung Did not Offer Much Help in Myth-Making,'" 51, n. 14.

30. William Rubin, "André Masson and Twentieth Century Painting," in William Rubin and Carolyn Lanchner, *André Masson* (New York: The Museum of Modern Art, 1976), 49.

31. Graham, *The Notebooks of Martha Graham*, 137.

32. Francis V. O'Connor, *Jackson Pollock* (New York: The Museum of Modern Art, 1967), 26. See also Francis O'Connor, "The Genesis of Jackson Pollock: 1912–1943," 209–11, and Andre Fermigier, "Paris/New York/1940–45," *Art de France* (Paris: n.p., 1964), 220–23.

33. See Kurt Seligmann, "Magic Circles," *View* 1 (February/March, 1942): 3.

34. See Elizabeth Langhorne, "Jackson Pollock's 'The Moon Woman Cuts the Circle,'" *Arts Magazine* 53 (March 1979): 128–37, and William Rubin, "Pollock as Jungian Illustrator: The Limits of Psychological Criticism, Part I," *Art in America* 67 (November 1967): 104–23.

35. Graham, *The Notebooks of Martha Graham*, 130.

36. In fact, in 1941 Pollock discussed and experimented with automatism with Baziotes and Gerome Kamrowski. See Jeffery Wechsler, *Surrealism and American Painting, 1931–1947* (New Brunswick: Rutgers University Art Gallery, 1977), 55.

37. Graham, *The Notebooks of Martha Graham*, 224–25.

38. Rushing, "Ritual and Myth: Native American Culture and Abstract Expressionism," 285, sees *Mural* as reflecting Kokopelli and Pueblo mythic figures found on Hohokam pottery.

39. Graham, *The Notebooks of Martha Graham*, 128–78.

40. Joseph Campbell, *The Hero with a Thousand Faces* (London: Sphere-Abacus, 1975), 273; Jung cited in Graham, *The Notebooks of Martha Graham,* 192.

41. Robert Motherwell, quoted in Ad Reinhardt, *Pax*, 1960, cited in Lucy Lippard, *Ad Reinhardt* (New York: Harry Abrams, 1981), 51, n. 78.

42. See Matilda Coxe Stevenson, "The Sia," *Bureau of Ethnology Report* 11 1889–1890 (Washington: Smithsonian Institution, 1894), 88.

43. Perhaps he knew that Jung wrote of eyes and heat as symbols of the unconscious on back to back pages. See Carl Jung, *Psychology of the Unconscious* (New York: Dodd, Mead and Co., 1952), 128–29. See also Elizabeth Langhorne, "A Jungian Interpretation of Jackson Pollock's Art Through 1946" (Ph.D. diss., University of Pennsylvania, 1977), 335.

44. Edward Renouf, "On Certain Functions of Modern Painting," *Dyn* 2 (July/August, 1942): 21.

45. Benton, "The Mechanics of Form Organization," 4: 95–96.

46. Ibid., 96.

47. Cited in O'Connor and Thaw, *Jackson Pollock: A Catalogue Raisonné*, 4:253.

48. Lee Krasner, personal communication, June 25, 1977.

49. Graham, *The Notebooks of Martha Graham*, 228.

50. Jung, *Psychology of the Unconscious*, 351.

50a. Quoted in O'Connor and Thaw, *Jackson Pollock: A Catalogue Raisonné*, 4:250.

51. Campbell, *The Hero with a Thousand Faces*, 225.

52. Quoted in B. H. Friedman, *Energy Made Visible* (New York: McGraw-Hill, 1972), 228.

53. Henri Bergson, *L'Energie Spirituelle* [Mind energy], trans. H. Wildon Carr (New York: Henry Holt and Co., 1920), 11–17.

54. Ibid., 8.

55. Ibid., 22–23.

56. Douglas McAgy, "Mark Rothko," *Magazine of Art* 42 (January 1949), 21.

57. Jackson Pollock, "My Painting," *Possibilities* 1 (Winter 1947): 79.

58. William Barrett, *The Truants* (New York: Doubleday Anchor, 1983), 31.

59. Joseph Levine, a social worker who went to Germany to work with the death-camp survivors, in Studs Terkel, *"The Good War"* (New York: Ballantine, 1984), 440.

60. Quoted in Friedman, *Jackson Pollock: Black and White*, 7.

61. For discussions of the black pourings and their sources, see Lawrence Alloway, "Jackson Pollock's Black Paintings," *Arts Magazine* 43 (May 1969): 40–43; and Francis V. O'Connor, *The Black Pourings 1951–1953* (Boston: Institute of Contemporary Art), 1980.

62. Cited in André Breton, *Surrealism and Painting*, 1928, reprinted in André Breton, *Surrealism and Painting* (New York: Harper and Row Icon, 1972), 18.

63. Jung, *Psychology of the Unconscious*, 124–25.

64. Graham, *The Notebooks of Martha Graham*, 178.

65. Bergson, *Mind Energy*, 32.

CHAPTER 9. WILLEM DE KOONING

1. Pollock, quoted in Selden Rodman, *Conversations with Artists* (New York: Capricorn, 1957), 85.

2. It should be noted that, once again with the early work of an Abstract Expressionist, the dates are only approximate.

3. De Kooning briefly lived with Gorky around 1934, rather than sharing a studio as it sometimes has been alleged.

4. De Kooning discusses Helion in Emile de Antonio and Mitch Tuchman, *Painters Painting* (New York: Abbeville Press, 1984), 40.

5. Jörn Merkert, "Stylessness as Principle: The Painting of Willem De Kooning," in Jörn Merkert, Paul Cummings, and Claire Stoullig, *Willem De Kooning* (New York: Whitney Museum of American Art, 1983), 120.

6. Thomas Hess, *William De Kooning* (New York: George Braziller, 1959), 12.

7. Amei Wallach, "At 79, De Kooning Seeks Simplicity," *Newsday* (December 4, 1983), part 2, 22.

8. Elaine de Kooning, interview, December 2, 1982, cited in Harry F. Gaugh, *De Kooning* (New York: Abbeville Press, 1983), 7.

9. Sally Yard, "Willem De Kooning's Men," *Arts Magazine* 56 (December 1981), 134.

10. Paul Cummings, "The Drawings of Willem De Kooning," in Merkert, Cummings, and Stoullig, *Willem de Kooning*, 11–23.

11. Yard, "Willem de Kooning's Men," 139.

12. Cited in Gaugh, *De Kooning*, 8.

13. Yard, "De Kooning's Men," 138.

14. For a discussion of Ingres and De Kooning, see Melvin Lader, "Graham, Gorky, De Kooning, and the 'Ingres Revival' in America," *Arts Magazine* 52 (March 1978): 94–99.

15. Rudi Blesh and Harriet Janis, *De Kooning* (New York: Grove Press, 1960), 14.

16. Sally Yard, "Willem de Kooning's Women," *Arts Magazine* 53 (November 1978), 87. De Kooning was not interested in the theory or practice of automatism (Elaine De Kooning, personal communication, April 27, 1987).

17. Quoted in the film, *De Kooning on De Kooning*, Courtney Sales Ross producer, New York, Cort Productions, 1982.

18. Willem de Kooning, "The Renaissance and Order," *Trans/formation* 1 (1951), reprinted in Thomas Hess, *Willem de Kooning* (New York: The Museum of Modern Art, 1968), 141–43; and "What Abstract Art Means to Me," lecture at The Museum of Modern Art symposium, February 5, 1951, in *The Museum of Modern Art Bulletin* 18 (Spring 1951), reprinted in Hess, *Willem de Kooning* (1968), 143–46.

19. "What Abstract Art Means to Me," 143.

20. De Kooning, quoted in Rodman, *Conversations with Artists*, 103.

21. Quoted in Edwin Denby, "My Friend De Kooning," *Art News Annual* 29 (1964): 84, 156.

22. De Kooning, "What Abstract Art Means to Me," 146.

23. De Kooning, "The Renaissance and Order," in Hess, *Willem de Kooning* (1968), 142.

24. For the "continuum," see Sales Ross, *De Kooning on De Kooning*. Other remarks by Elaine de Kooning, personal communication, April 27, 1987.

25. Quoted in "Is Today's Artist With or Against the Past," *Art News* 57 (Summer 1958), 27.

26. Edvard Lieber, personal communication, June 16, 1989.

27. Cummings, "The Drawings of Willem De Kooning," 16.

28. Willem de Kooning, Letter in *Art News* 47 (January 1949), 6.

29. Quoted in Hess, *Willem de Kooning*, 1959, 25.

30. Charles Stuckey, "Bill De Kooning and Joe Christmas," *Art in America* 68 (March 1980): 70–71.

31. Ibid.

32. Quoted in Robert Goodnough, ed., "Artists' Sessions at Studio 35 (1950)," in Robert Motherwell and Ad Reinhardt, eds., *Modern Artists in America* (New York: Wittenborn Schultz, 1951), 14.

33. As told to Rudolph Burckhardt, and recounted, November 30, 1977, to Yard, "Willem de Kooning's Women," 99.

34. Faulkner was a favorite author of De Kooning. Gaugh, *De Kooning*, 14, n. 26, relates from an interview with Edwin Denby, November 24, 1982 that Denby would read Stein while posing for De Kooning in the 1940s.

35. Elaine De Kooning, personal communication, April 27, 1987.

36. Gaugh, *De Kooning*, 36.

37. Lee Krasner, quoted in Cindy Nemser, "Lee Krasner," in *Conversations with Twelve Women Artists* (New York: Charles Scribner's Sons, 1975), 90.

38. See Leo Steinberg, "Month in Review" [De Kooning], *Arts Magazine* 30 (November 1955): 46, and Andrew Forge, "De Kooning's Women," *Studio International* 176 (December 1968): 248.

39. Merkert, "Stylessness as Principle," 124.

40. Quoted in Judy Wolfe, *Willem de Kooning, Works from 1951–1981* (New York: Guild Hall, 1981), 7.

41. It is not insignificant that the powers of the primitive world, *mana*, were also neither inherently good nor evil but worked for benefit or misfortune, according to how they were used. See Ruth Underhill, *Red Man's Religion* (Chicago: University of Chicago Press, 1965), 28. And this concept of amoral powers accorded with Jung's definition of God and of forces of the unconscious.

42. Willem de Kooning, "Content Is a Glimpse . . . ," excerpts from an interview with David Sylvester, BBC; published in *Location* I (Spring 1963); reprinted in Hess, *Willem de Kooning*, 1968, 148–49.

43. Jean Erdman, personal communication, June 5, 1984.

44. In Sales Ross, *De Kooning on De Kooning*.

45. Yard, "De Kooning's Women," 101.

46. Joseph Campbell, *The Hero with a Thousand Faces* (London: Sphere Abacus, 1975), 259.

47. Elaine de Kooning, in Sales Ross, *De Kooning on De Kooning*.

48. Cited in Carolyn Lanchner, "André Masson: Origins and Development," in William Rubin and Carolyn Lanchner, eds., *André Masson* (New York: The Museum of Modern Art, 1976), 145–48.

49. Ibid., 148. Guy Davenport, in *The Geography of the Imagination* (San Francisco: North Point Press, 1981), 26, notes the pervasiveness in twentieth-century literature as well as art of such Persephone- or Eurydice-like symbolic figures.

50. Quoted in George Raillard, *Miró: Ceci est la couleur de mes rêves* (Paris, 1977), 186, cited in Sidra Stich, *Joan Miró: The Development of a Sign Language* (St. Louis: Washington University, 1980), 38.

51. Cited in William Barrett, *The Truants* (New York: Anchor Doubleday, 1983), 181.

52. De Kooning in Hess, *Willem de Kooning*, 1959, 21.

53. Meyer Schapiro, lecture, Columbia University, December 12, 1968.

54. De Kooning in Rodman, *Conversations with Artists,* 102.

55. See Hess, *Willem de Kooning*, 1968, 77.

56. "What Abstract Art Means to Me," 145.

57. Paul Fussell, *The Great War and Modern Memory* (London: Oxford, 1975), 270.

58. John Costello, *Virtue Under Fire* (Boston: Little, Brown and Company, 1985), 74–75. The following remarks are from this source.

59. Ibid., 78.

60. Ibid., 79.

61. Ibid., 124.

62. Ibid., 211.

63. Virginia Rasmussen quoted in Mark Jonathan Harris, Franklin Mitchell, and Steven Schechter, *The Homefront America During World War II* (New York: G. P. Putnam's Sons, 1984), 174.

64. Costello, *Virtue Under Fire,* 233.

65. Ibid., 261.

66. David Smith illustrated the idea of a connection between sex and wartime violence in his sculpture *Rape* of 1945 in which a woman is assaulted by a phallic cannon, and Noguchi ritualized the connection in his set for Martha Graham's biblical *Judith.* He designed a tent support for the warrior Holofernes consisting of crossed spears suggesting thighs penetrated by a bestial demon resting on a large phallic form.

67. Fussell, *The Great War and Modern Memory,* 7.

68. Harold Rosenberg, "De Kooning 2. On the Borders of the Act," in *The Anxious Object* (New York: Horizon, 1964), 126.

69. Elaine de Kooning, in Sales Ross, *De Kooning on De Kooning.*

70. See Thomas Hess, "De Kooning Paints a Picture: Woman," *Art News* 52 (March 1953): 30–33, 64–67.

71. See Lawrence Alloway, "De Kooning: Criticism and Art History," *Artforum* 13 (January 1975): 46–50.

72. For example, De Kooning's inability to finish is described as his existential dilemma. However, by definition, the continuum is never finished. Even the Surrealists indicated the lack of finish in their Heraclitian definition of life, as in Masson's *There is No Finished World* of 1943.

73. De Kooning, interview, June 16, 1959, cited in Irving Sandler, *The Triumph of American Painting* (New York: Harper and Row Icon, 1976), 98.

74. James D. Wilkinson, *The Intellectual Resistance in Europe* (Cambridge: Harvard University Press, 1981), 144–45.

75. Harry Gaugh argues, in *The Vital Gesture—Franz Kline* (Cincinnati Art Museum and New York: Abbeville Press, 1985), 107–23, that a number of Kline abstractions are based on figures.

76. Gaugh, *De Kooning,* 66–68.

77. De Kooning, in Harold Rosenberg, "An Interview with De Kooning," *Art News* 71 (September 1972): 55.

78. Quoted in Thomas Hess, "De Kooning Paints a Picture," *Art News* 52 (March 1953): 64.

79. Quoted in Rosenberg, "An Interview with De Kooning," 58.

80. Gaugh, *De Kooning,* 77.

81. De Kooning, "Renaissance and Order," 142.

82. Quoted in Margaret Statts and Lucas Matthiesen, "The Genetics of Art," *Quest '77* I (March/April 1977): 70–71.

83. Thomas Mann, *The Magic Mountain* (Great Britain: Nationwide Book, 1980), 275–76.

84. Quoted in Rosenberg, "An Interview with De Kooning," 59.

85. Quoted in Charlotte Willard, "In the Art Galleries," *The New York Post,* August 23, 1964, 44.

86. In C. B. Pepper, "The Indomitable De Kooning," *The New York Times Magazine,* November 20, 1983, 91.

87. Ibid.

88. De Kooning, "The Renaissance and Order," 143.

89. Quoted in Wolfe, *Willem de Kooning,* 15.

90. Quoted in Rosenberg, "An Interview with De Kooning," 58.

91. Quoted in Thomas Hess, "De Kooning's New Women," *Art News* 64 (March 1965): 75.

92. Quoted in Louis Finkelstein, "The Light of De Kooning," *Art News* 66 (November 1967): 29.

93. See Fussell, *The Great War and Modern Memory,* 238–69.

94. In "Sketchbook I: Three Americans," film script, Time Inc., New York, excerpts in Maurice Tuchman, *The New York School: The First Generation* (Greenwich, Connecticut: The New York Graphic Society, 1977), 51.

CHAPTER 10. ROBERT MOTHERWELL

1. Quoted in Max Kozloff, "An Interview with Robert Motherwell," *Artforum* 4 (September 1965): 35.

2. Dore Ashton, *The New York School* (New York: Viking, 1973), 122.

3. Sidney Simon, "Concerning the Beginnings of the New York School: 1939–1943: An Interview with Robert Motherwell," *Art International* 11 (Summer 1967): 21.

4. Robert Motherwell, "Notes on Mondrian and Chirico," *VVV* 1 (June 1942): 59–60.

5. Robert Motherwell, "What Abstract Art Means to Me," *Museum of Modern Art Bulletin* 18 (Spring 1951): 6.

6. Robert Motherwell, "A Prophecy—1950," David Porter Gallery, Washington, 1945, unpaged, Archives of American Art, New York.

7. Quoted in John Gruen, *The Party's Over* (New York: Viking, 1972), 196.

8. Motherwell wrote an evaluation of Moore's work in *New Republic* 113 (October 22, 1945): 538.

9. H. H. Arnason, *Robert Motherwell*, 2nd ed. (New York: Abrams, 1982), 20. The book was Anita Brenner's *The Wind Swept Over Mexico*.

10. Robert Motherwell, "The Rise and Continuity of Abstract Art," lecture, Fogg Museum of Art, Harvard University, published in *Arts and Architecture* 68 (September 1951): 41.

11. Dore Ashton, "On Motherwell," in Robert Buck and Jack Flam, eds., *Robert Motherwell* (New York: Albright-Knox Art Gallery and Abbeville, 1983), 35–36.

12. Robert Motherwell, cited in Natalie Edgar, "The Satisfaction of Robert Motherwell," *Art News* 64 (October 1965): 40.

13. E. A. Carmean, "Robert Motherwell and Collage," paper delivered at the Solomon R. Guggenheim Museum, January 8, 1985.

14. Adolph Gottlieb, "Unintelligibility," typescript of lecture at The Artist Speaks symposium, The Museum of Modern Art, May 5, 1948, on file at the Adolph and Esther Gottlieb Foundation, New York.

15. Motherwell in Sidney Janis, *Abstract and Surrealist Art in America* (New York: Reynal and Hitchcock, 1944), 65.

16. Ibid.

17. Jonathan Fineberg, "Death and Maternal Love: Psychological Speculations on Robert Motherwell's Art," *Artforum* 17 (September 1978): 55.

18. Jack Flam, "With Robert Motherwell," in Flam and Buck, *Robert Motherwell*, 12.

19. Motherwell, in Arnason, *Robert Motherwell*, 147.

20. Dore Ashton, "Robert Motherwell: The Painter and His Poets," in Arnason, *Robert Motherwell*, 10.

21. Robert Motherwell in E. A. Carmean, *Reconciliation Elegy* (New York: Skira Rizzoli, 1980), 74–77.

22. Robert Motherwell, "A Tour of the Sublime," in "The Ides of Art: Six Opinions on What is the Sublime in Art," *The Tiger's Eye* 1 (December 15, 1948): 46–48.

23. The process of sketching, from doodling to finished form, is illustrated in E. A. Carmean, "Robert Motherwell's Spanish Elegies," *Arts Magazine* 50 (June 1976): 94.

24. Arnason, *Robert Motherwell*, 26.

25. Robert Motherwell, personal communication, August 17, 1977 cited in E. A. Carmean, "Elegies to the Spanish Republic," in E. A. Carmean and Eliza Rathbone, *American Art at Mid-Century: The Subjects of the Artist* (Washington: The National Gallery of Art, 1978), 100.

26. Ibid.

27. Motherwell, conversation with Carmean, October 28, 1977, in ibid., 101, n. 39.

28. Robert Motherwell, quoted in Margaret Paul, *An Exhibition of the Work of Robert Motherwell* (Northampton, Massachusetts: Smith College, 1963), 99.

29. Robert Hobbs, "Motherwell's Concern with Death" (Ph.D. Diss., University of North Carolina, 1975), 217, cited in Carmean, "Elegies," 102.

30. Fineberg, "Death and Maternal Love," 55.

31. Motherwell, personal communication, August 17, 1977, cited in Carmean, "Elegies," 102.

32. Motherwell, in Grace Glueck, "The Mastery of Robert Motherwell," *The New York Times Magazine* (December 2, 1984), sec. 6, 78.

33. Motherwell, personal communication, August 17, 1977, in Carmean, "Elegies," 102–3.

34. Ibid.

35. Stanley Casson, *Steady Drummer*, 1920, 269–70, cited in Paul Fussell, *The Great War and Modern Memory* (London: Oxford, 1975), 325.

36. Quoted in Carmean, *Reconciliation Elegy*, 74–76.

37. Motherwell, in Glueck, "The Mastery of Robert Motherwell," 82.

38. Ibid., 80.

39. Arnason, *Robert Motherwell*, 168.

40. Motherwell, in Glueck, "The Mastery of Robert Motherwell," 82.

41. Motherwell, in Gruen, *The Party's Over*, 195.

CHAPTER 11. THE EXPANSIVENESS OF ABSTRACT EXPRESSIONISM

1. Robert Motherwell, "Notes" in John Baur, *Bradley Walker Tomlin* (New York: Whitney Museum of American Art, 1957), 11–12.

2. This painting was exhibited along with works by Gottlieb, Rothko, Graham and others at the First Annual Exhibition of the Federation of Modern Painters and Sculptors at the Riverside Museum in 1941.

3. Tomlin, cited in Grace Pagano, "Six Painters," *American Artist* (April 1945), in Jeanne Chenault, *Bradley Walker Tomlin* (Buffalo: The Buffalo Fine Arts Academy, 1975), 17.

4. John Ashberry, "Tomlin: The Pleasures of Color," *Art News* 56 (October 1957): 29, cited in Chenault, *Bradley Walker Tomlin*, 17.

5. Tomlin, foreword to catalogue of London retrospective held in Woodstock in 1948, cited in Chenault, *Bradley Walker Tomlin*, 17.

6. In "The Schism Between Art and the Public," lecture transcript, The Federation of Modern Painters and Sculptors, March 1949, published in Chenault, *Bradley Walker Tomlin*, 162.

7. According to the collectors Lucille and Walter Fillin, "A Collector's Notes on Bradley Walker Tomlin," in Chenault, *Bradley Walker Tomlin*, 163, after the war Freud and Existentialism made an impression on Tomlin.

8. Several Abstract Expressionists claim to be the primary source behind Tomlin's forms. Gottlieb's influence is certain. Tomlin expressed his admiration for Gottlieb's work and was particularly friendly with him at this time. According to Lee Krasner in Cindy Nemser, "Lee Krasner," *Conversations with 12 Artists* (New York: Charles Scribner's Sons, 1975), 90, Tomlin saw her *Little Image* painting series at this time, too.

9. Sir James Frazer, *The Golden Bough* (New York: Macmillan, 1922), 417–18.

10. This idea was popularly expressed in the 1944 film *White Cliffs of Dover*, when the principal character, played by Irene Dunne, an American who has given both her husband and son in the two world wars, says we must not break faith with the dead; that is, we must find something positive in the costs and sacrifices of the wars.

11. Hofmann also subtitled the work as an homage to Howard Putzell who unexpectedly died in 1945. Putzell had worked for Peggy Guggenheim's Art of This Century Gallery and then opened his own gallery, the 67 Gallery, in 1945. He included Hofmann in an exhibition entitled "Challenge to the Critics."

12. Barbara Cavaliere, "Theodoros Stamos in Perspective," *Arts Magazine* 52 (December 1977): 104–5.

13. Ibid., 106. Cavaliere cites Darwin's *Power of Movement in Plants*, which is the title of a 1945 painting, *Gray's Botanical Textbook*, William Buckland's *Geology and Minerology, Considered with References to Natural Theology*, Douglas Campbell's *The Structural Development of Mosses and Ferns*, Elizabeth and Alexander Agassiz's *Seasides Studies in Natural History*, and J. Henri Fabre's *The Life of the Spider* which, as noted, Baziote also owned.

14. Cited in Ralph Pomeroy, *Stamos* (New York: Harry N. Abrams, 1977), 19.

15. In "The Ides of Art," *The Tiger's Eye* 1 (December 1947): 43.

16. Stamos, unpublished statement for Betty Parsons gallery, 1947, in Cavaliere, "Theodoros Stamos in Perspective," 107.

17. See P. J. Karlstrom, "Jackson Pollock and Louis Bunce," *The Archives of American Art Journal* 24 (1984): 22–27.

18. In *American Poetry Observed: Poets on Their Work*, ed. Joe Bellamy (Urbana: University of Illinois, 1984), 146.

19. Quoted in Nemser, "Lee Krasner," 90. Lucy Lippard compared Reinhard's *Abstract Painting* of 1948 to Kufic script also. See Lucy Lippard, *Ad Reinhardt* (New York: Abrams, 1981), 58.

20. Ibid., 98.

21. Marcia Tucker, *Lee Krasner: Large Paintings* (New York: Whitney Museum of American Art, 1973), 16.

22. Krasner in Nemser, "Lee Krasner," 95. Krasner has gone on to say, "I am never free of the past. I have made it crystal clear that I believe the past is part of the present, which becomes part of the future. I believe in continuity" (Quoted in Ellen Landau, "Lee Krasner's Early Career, Part Two: The 1940s," *Arts Magazine* 56 [November 1981], 87).

23. In Tucker, *Lee Krasner: Large Paintings*, 8.

24. Quoted in Judith Higgins, "To the Point of Vision: A Profile of Richard Pousette-Dart," in Sam Hunter, ed., *Transcending Abstraction: Richard Pousette-Dart, Paintings* (Fort Lauderdale: Museum of Art, 1986), 14.

25. Ibid., 18

26. Lawrence Campbell, "Pousette-Dart: Circles and Cycles," *Art News* 62 (May 1963): 56. See also Higgins, "To the Point of Vision," 16.

27. Quoted in John Gordon, *Richard Pousette-Dart* (New York: Whitney Museum of American Art, 1963), 7.

28. Higgins, "To the Point of Vision," 21.

29. Mircea Eliade, *The Sacred and the Profane* (New York: Harcourt Brace Jovanovich Harvest, 1957), 97.

30. Ibid., 28–81.

31. Pousette-Dart in Hunter, *Transcending Abstraction*, 9, cited from Carter Ratcliffe, "Concerning the Spiritual in Pousette-Dart" *Art in America* 62 (November/December 1974): 90.

32. Lippard, *Ad Reinhardt*, 63.

33. Ad Reinhardt, "Cycles through the Chinese Landscape," *Art News*, Dec. 1989. Reprinted in *Art as Art: The Selected Writings of Ad Reinhardt*, Barbara Rose, ed. (New York: Viking, 1975), 213.

34. "Palingenesis" is another concept of recapitulation. Stephen Jay Gould summarizes it in *Ontogeny and Philogeny* (Cambridge: Harvard Belknap, 1977), 484: "1. For Bonnet, the ontogenic unfolding of the individuals already preformed in the egg—referring especially to the 'end' stage of 'ontogeny,' the resurrection of each body at the end of time from a 'germ of restitution' preformed in the original homunculus within the egg. 2. For Haeckel [a key late nineteenth-century advocate of recapitulation], the true repetition of past phylogenetic stages in ontogenetic stages of descendants." Krasner's *Palingenesis* evokes the idea of continuity with a single, slightly tilted, centralized, swirling continuum of both green seed and leaflike forms that seem to break forth or unfurl. An organic, apparently dinosaurlike form in raspberry emerges at the top right of center of the painting. The central rhythm turns back into itself before continuing.

35. Reinhardt, "Cycles through the Chinese Landscape," 214.

36. Ibid.

37. Ad Reinhardt, "Twelve Rules for a New Academy," *Art News* 56 (May 1957): 37–38, 56, reprinted in *Ad Reinhardt: Twenty-five Years of Abstract Painting* (New York: Betty Parsons Gallery, 1960), unpaged.

38. Dale McConathy, *A Selection From 1937 to 1952* (New York: Marlborough Gallery, March 1974), unpaged.

39. Ibid.

40. See David Mellor, ed., *A Paradise Lost: The Neo-Romantic Imagination in Britain 1935–55* (London: Barbican Art Gallery & Lund Humphries, 1987).

41. Ibid., 46.

42. Ibid.

CHAPTER 12. VERNACULAR ABSTRACTION

1. Quoted in Irving Sandler, *The New York School: The Painters and Sculptors of the Fifties* (New York: Harper and Row Icon, 1978), 113.

2. John Cromwell, director, *The Enchanted Cottage*, starring Robert Young, Hillary Brooke, Dorothy McGuire, 1945. *The*

Enchanted Cottage was a government financed remake of a 1924 movie, with a screenplay by Arthur W. Pinero.

3. William Wyler, director, *The Best Years of Our Lives,* screenplay by Robert Sherwood, based on a novel by MacKinlay Kantor, with Fredric March, Dana Andrews, Harold Russell, and Myrna Loy, 1946.

4. Paul Fussell, *The Great War and Modern Memory* (London: Oxford, 1975), 321.

5. Alfred Kazin, *Bright Book of Life* (Boston, 1973), 81, cited in ibid., 74.

6. Ibid., 217.

7. William McNeil, "Encounters with Toynbee," *The New York Times Magazine,* December 29,1985, 24.

8. Quoted in *The World at War,* episode 20, narrated by Laurence Olivier, Thames television.

9. Rothko, October 27, 1958, partially transcribed by Dore Ashton, in *The New York Times,* October 31, 1958, reprinted in Dore Ashton, *About Rothko* (New York: Oxford University Press, 1983), 144.

10. Newman, "Plasmic Image," in Thomas Hess, *Barnett Newman* (New York: The Museum of Modern Art, 1971), 38.

11. Lipton, personal communication, December 7, 1983.

12. Quoted in Gail Levin, "Richard Pousette-Dart's Emergence as an Abstract Expressionist," *Arts Magazine* 54 (March 1980): 125.

13. Thornton Wilder, *Three Plays* (New York: Harper and Row, 1962), x.

14. Joseph Campbell, *The Hero with a Thousand Faces* (London: Sphere Abacus, 1975), 324–25.

15. Martha Graham, *The Notebooks of Martha Graham* (New York: Harcourt Brace Jovanovich, 1973), 170.

16. Karl Leabo, *Martha Graham* (New York: Theatre Arts, 1961), 1954, unpaged.

17. Jackson Pollock, *Possibilities* 1 (Winter 1947), 79.

18. Robert Graves, in *Problems of the Theater,* trans. Gerhard Nellhaus (New York, 1964), 31, cited in Fussell, *The Great War and Modern Memory,* 204.

19. James Wilkinson, *The Intellectual Resistance in Europe* (Cambridge: Harvard University Press, 1981), 277. I have been indebted to Wilkinson's study throughout this book.

20. Benjamin Meed, "For Holocaust Survivors, 40 Years of New Life," *The New York Times,* May 31, 1986, 27.

21. John Ciardi, *Selected Poems* (Fayetteville: The University of Arkansas Press, 1984), 115–16.

22. Edward Renouf, "On Certain Functions of Modern Painting," *Dyn* 2 (July/August 1942): 19–21.

23. Sir Geoffrey Keyes (John Maynard's brother), "A Doctor's War," in George Panichas, ed., *Promise of Greatness* (1968), 193–94, cited in Fussell, *The Great War and Modern Memory,* 31.

24. Ray Wax, stockbroker, in Studs Terkel, *"The Good War,"* (New York: Ballantine, 1984), 302

25. Quoted in Mark Jonathan Harris, Franklin D. Mitchell, and Steven J. Schechter, *The Homefront* (New York: G. P. Putnam's Sons, 1984), 157–58.

26. Frankie Cooper, in ibid., 132.

27. Sybil Lewis, in ibid., 121.

28. Margaret Takahashi, in ibid., 109

29. Jung, quoted in William McGuire, *Bollingen: An Adventure in Collecting the Past* (Princeton: Princeton University Press, 1982), 4.

30. Fussell, *The Great War and Modern Memory,* 320.

31. Telford Taylor, in Terkel, *"The Good War,"* 460.

32. Nora Watson, in ibid., 576–77.

33. Elliot Johnson in ibid., 261.

34. John Grave, in ibid., 525.

35. Jacques Raboud, in ibid., 422.

36. Motherwell, letter to David Smith, May 21, 1947, exhibited in "David Smith: The Hirshhorn Museum and Sculpture Garden Collection," Washington, D.C., 1979.

37. In Gladys Kashdan, interview, April 28, 1965, transcript on file at the Esther and Adolph Gottlieb Foundation, New York, 17–18.

38. See Wilkinson, *The Intellectual Resistance in Europe,* 80–88.

39. Quoted in ibid., 225.

40. Quoted in Anthony Lewis, "When We Could Believe," *The New York Times,* June 12, 1987.

41. For a discussion of the linkage of metamorphosis and existential action in postwar art, see Mona Hadler, "David Hare's Cronus Series," *Arts Magazine* 53 (April 1979): 143–44.

42. Tomlin noted this change in Robert Goodnough, ed., "Artists' Sessions at Studio 35 (1950)," in Robert Motherwell and Ad Reinhardt, *Modern Artists in America* (New York: Wittenborn Schultz, 1951), 19.

43. Harold Rosenberg, "The American Action Painters," *Art News* 51 (Sept. 1952): 22–23, 48–50.

44. For an analysis of Martha Graham's that similarly recasts it as psychological improvisation and subjectivity, in other words, as a form of Action Painting in dance, see Susan Leigh Foster, *Reading Dancing* (Berkeley: University of California Press, 1986).

45. John W. McCoubrey, *American Tradition in Painting* (New York: George Braziller, 1963).

46. See Bret Waller, "Curry and the Critics," in *John Steuart Curry: A Retrospective Exhibition* (Lawrence: University of Kansas Museum of Art, 1970), 43, for a discussion of cultural identity in the writings of Thomas Wolfe and Thomas Craven. Waller notes that in *Look Homeward Angel* Wolfe "depicted himself (in the person of Eugene Gant) as brilliant, crude, naive, blunt, and honest—all characteristics of an authentic American talent. Thomas Craven put it this way: if the nations of Europe are united on anything, it is that America is a pretty distinct place—a country of rude and unseeming practices which by no standard of comparison can be termed European. It is reasonable to suppose that some of these characteristics must appear in any genuinely American art". Waller also notes that these ideas appear in John Baur's interpretation of John Steuart Curry. Such interpretations posit a virtual American stereotype as America's culture identity.

Significantly, many European critics have seldom gotten beyond this initial response to Abstract Expressionism. As William Rubin noted in 1967 in "Jackson Pollock and the Modern Tradition, Part I," *Artforum* 5 (February 1967): 14–22, many Europeans and especially the French see Abstract Expressionism and particularly Pollock's abstractions as the chaotic outpourings of "existential cowboys." The most recent notable manifestations of the confusion of painterly dynamism with emotional turbulence

and nationalist image has been the Beaubourg catalogue of the Jackson Pollock retrospective in 1982 where Pollock is interpreted by French writers in "action" poems, and the writing of the French-Canadian Serge Guilbaut. Even in 1985 the American critic and painter Stephen Ellis, "The Bronze Age, the Iron Age, the Age of Gold," *Issue* 3 (Spring/Summer, 1985): 18, noted that many European painters seem to have little more than superficial understanding of Abstract Expressionism; "they confuse it with Tenth Street or Cobra painting, confusing manner with substance." European critics seem to have repeated the situation in American art in the first decades of the twentieth century when the cubist manner was absorbed but the founding principles little understood.

47. In Selden Rodman, *Conversations with Artists* (New York: Capricorn, 1961), 84.

48. Quoted in "A Discussion of the Work of Larry Rivers," *Art News* 60 (March 1961), 45, cited in Sandler, *The New York School*, 110.

49. Clement Greenberg, in a review of Gottlieb's work in *The Nation* December 6, 1947, reprinted in *Clement Greenberg: The Collected Essays and Criticism*, ed. John O'Brian (Chicago: University of Chicago Press, 1986), 2: 187. The artists recognized Greenberg's indifference to their ideology. Still and Newman particularly criticized his approach. And, despite the record of Greenberg's support for his work, when Nicholas Carone asked Pollock who understood the content as opposed to the style of his work, Pollock said, "There's only one man who really knows what it's about, John Graham." See Jeffrey Potter, *To a Violent Grave: An Oral Biography of Jackson Pollock* (New York: G. P. Putnam's Sons, 1985), 183. For a detailed discussion of Greenberg's dismissal of Abstract Expressionist ideology, see Barbara Cavaliere and Robert C. Hobbs, "Against a Newer Laocoon," *Arts Magazine* 51 (April 1977): 110–17.

50. Wilkinson, *The Intellectual Resistance in Europe*, 262.

51. See Irving Sandler, *The Triumph of American Painting* (New York: Harper and Row, 1970) and Dore Ashton, *The New York School* (New York: Viking Compass, 1973).

52. Quoted in Alma Reed, *Orozco* (New York: Oxford University Press, 1956), 184.

EPILOGUE

1. Martha Graham, *The Notebooks of Martha Graham* (New York: Harcourt Brace Jovanovich, 1973), 258.

2. Albert Camus, *The Myth of Sisyphus and Other Essays* (New York: Vintage, 1960), 4.

3. Sigfried Giedeon, *Space, Time and Architecture* (Cambridge: Harvard University Press, 1941), 6.

4. Baziotes, 1963, statement originally published in Barbara Cavaliere, "An Introduction to the Method of William Baziotes," *Arts Magazine* 51 (April 1977): 131, reprinted in Michael Preble, *William Baziotes: A Retrospective Exhibition*, with essays by Mona Hadler and Barbara Cavaliere (Newport Beach, California: Newport Harbor Art Museum, 1978), 26.

5. Graham, *The Notebooks of Martha Graham*, 191.

SELECTED BIBLIOGRAPHY

Concentration is on more recent material on Abstract Expressionism as well as on basic texts.

GENERAL BOOKS, ARTICLES, AND CATALOGUES

Alloway, Lawrence. "The Biomorphic Forties." *Artforum* 4, no. 4 (September 1965): 118–22.

———. "Melpomene and Graffiti." *Art International* 12 (April 1968): 21–22.

———. "Residual Sign Systems in Abstract Expressionism." *Artforum* 12 (November 1973): 36–42.

———. *Topics in American Art Since 1945*. New York: Norton & Co., 1975.

Ashton, Dore. *The New York School: A Cultural Reckoning*. New York: Viking Press, 1972.

Auping, Michael, ed. *Abstract Expressionism: The Critical Developments*. New York: Harry N. Abrams, Inc. in association with Albright-Knox Art Gallery, 1987.

Carmean, E. A., Jr., Eliza Rathbone, and Thomas B. Hess. *American Art at Mid-century: The Subjects of the Artist*. Washington, D.C.: National Gallery of Art, 1978.

Champa, Kermit S. *Flying Tigers: Painting and Sculpture in New York 1939–46*. Providence, Rhode Island, and Worcester, Massachusetts: Bell Gallery, Brown University, and College of the Holy Cross, 1985.

Firestone, Evan R. "Herman Melville's Moby Dick and the Abstract Expressionists." *Arts Magazine* 54 (March 1980): 120–24.

———. "James Joyce and the First Generation New York School." *Arts Magazine* 56 (June 1982): 116–21.

Geldzahler, Henry. *New York Painting and Sculpture 1940–70*. New York: E. P. Dutton, 1969.

Gibson, Ann. *Issues in Abstract Expressionism: The Artist-Run Periodicals*. Ann Arbor, Michigan: UMI Research Press, 1990.

Goldwater, Robert. "Reflections on the New York School." *Quadrum* 7/8 (1960): 17–36.

Goossen, Eugene C. "The Big Canvas." *Art International* 2 (1958): 45–7.

Grabenhorst-Randall, Teree. *Jung and Abstract Expressionism: The Collective Image Among Individual Voices*. Hempstead, New York: Emily Lowe Gallery, Hofstra, 1986.

Graham, John. "Primitive Art and Picasso." *Magazine of Art* (April 1937): 236–39, 260.

———. *Systems and Dialectics of Art*. Ed. Marcia Epstein Allentuck. Baltimore: The Johns Hopkins Press, 1971.

Greenberg, Clement. *Art and Culture: Critical Essays*. Boston: Beacon Press, 1961.

Hobbs, Robert C., and Barbara Cavaliere. "Against a Newer Laocoon." *Arts Magazine* 51 (April 1977): 110–17.

Hobbs, Robert C., and Gail Levin. *Abstract Expressionism: The Formative Years*. Ithaca and New York: Cornell University and The Whitney Museum of American Art, 1978.

Hunter, Sam. *Modern American Painting and Sculpture*. New York: Dell, Laurel edition, 1959.

Janis, Sidney. *Abstract and Surrealist Art in America*. New York: Reynal and Hitchcock, 1944.

Kokkenen, Eila. "John Graham During the 1940's." *Arts Magazine* 51 (November 1976): 99–103.

Lader, Melvin. "Graham, Gorky, de Kooning and the Ingres Revival in America." *Arts Magazine* 52 (March 1978): 94–99.

Lader, Melvin, and Fred Licht. *Peggy Guggenheim's Other Legacy*. New York: The Solomon R. Guggenheim Museum, 1987.

Motherwell, Robert, and Ad Reinhardt. *Modern Artists in America*. New York: Wittenborn Shulz, 1951.

O'Brian, John, ed. *Clement Greenberg: The Collected Essays and Criticism*. Vols. 1–2. Chicago: University of Chicago Press, 1986.

Selected Bibliography

Polcari, Stephen. "The Intellectual Roots of Abstract Expression-
ism." Ph.D. diss., University of California at Santa Barbara,
1980.

Polcari, Stephen, and Ann Gibson. "New Myths for Old: Redefin-
ing Abstract Expressionism." Special Issue *Art Journal* 47 (Fall
1988).

Robson, Deidre. "The Avant-Garde and the On-Guard—Some
Influences on the Potential Market for the First Generation
Abstract Expressionists in the Nineteen Forties and Early
Nineteen Fifties." *Art Journal* 47 (Fall 1988): 215–21.

———. "The Market for Abstract Expressionism: The Time Lag
Between Critical and Commercial Acceptance." *The Archives
of American Art Journal* 25 (1985): 19–23.

Rodman, Selden. *Conversations with Artists.* New York: Capri-
corn, 1961.

Rose, Barbara. *American Art Since 1900.* New York: Praeger,
1967.

Rosenberg, Harold. *The Tradition of the New.* New York:
Horizon Press, 1959.

Rubin, William. "The New York School—Then and Now." Parts
1 and 2. *Art International* 2, nos. 2/3, 4/5 (March/April, May/
June 1958): 23–26; 19–22.

Sandler, Irving, introduction, *Defining Modern Art: Selected
Writings of Alfred Barr, Jr.* Ed. Sandler and Amy Newman
(New York: Abrams), 1986.

———. *The Triumph of American Painting: A History of Ab-
stract Expressionism.* New York: Harper and Row, 1970.

Schimmel, Paul, et al. *The Interpretative Link: Abstract Surrealism
into Abstract Expressionism: Works on Paper 1938–48.* New-
port Beach, California: Newport Harbor Art Museum, 1986.

Seitz, William C. *Abstract Expressionist Painting in America.*
Cambridge: Harvard University Press, 1983.

Sivard, Susan. "The State Department 'Advancing American Art'
Exhibition of 1946 and the Advance of American Art." *Arts
Magazine* 58 (April 1984): 92–99.

Tuchman, Maurice. *New York School: The First Generation.*
New York, 1967.

Wechsler, Jeffrey. *Surrealism and American Art 1931–47.* New
Brunswick: Rutgers University Art Gallery, 1977.

WILLIAM BAZIOTES

Alloway, Lawrence. *William Baziotes: A Memorial Exhibition.*
New York: Solomon R. Guggenheim Museum, 1965.

Cavaliere, Barbara. "An Introduction to the Method of William
Baziotes." *Arts Magazine* 51 (April 1977): 124–31.

Hadler, Mona. "The Art of William Baziotes." Ph.D. diss., Colum-
bia University, 1977.

———. "William Baziotes, a Contemporary Poet-Painter." *Arts
Magazine* 51 (June 1977): 102–10.

Hare, David. "William Baziotes, 1912–63." *Location* 1 (Summer
1964): 85–86.

Lorenz, Melinda. "William Baziotes, 1912–63: The Formation of
a Subjectively Based Imagery." M.A. thesis, University of Mary-
land, 1972.

Preble, Michael, Mona Hadler, and Barbara Cavaliere. *William*

Baziotes: A Retrospective Exhibition. Newport: Newport
Harbor Art Museum, 1978.

Preble, Michael, and Ethel Baziotes. *William Baziotes: Paintings
and Works on Paper: 1952–61.* New York: Blue Helman,
1984 (1988).

Sandler, Irving. "Baziotes, Modern Mythologist." *Art News* 53
(February 1965): 28–30, 65–66.

Still, Clyfford. *William Baziotes: Late Work 1946–1962.* New
York: Marlborough, 1971.

WILLEM DE KOONING

Alloway, Lawrence. "De Kooning: Criticism and Art History."
Artforum 13 (January 1975): 46–50.

Cummings, Paul, Jörn Merkert, and Claire Stoullig. *Willem de
Kooning.* New York and Munich: Whitney Museum of Amer-
ican Art, W. W. Norton and Co., and Prestel-Verlag, 1983.

Hess, Thomas B. "Pinup and Icon." *Art News Annual* 38 (1972):
223–37.

———. *Willem de Kooning.* New York: George Braziller, 1959.

———. *Willem de Kooning.* New York: Museum of Modern
Art, 1968.

Rosenberg, Harold. *Willem de Kooning.* New York: Harry N.
Abrams, 1974.

Stuckey, Charles F. "Bill de Kooning and Joe Christmas." *Art in
America* 68 (March 1980): 66–79.

Waldman, Diane. *Willem de Kooning.* New York: Abrams, 1987.

———. *Willem de Kooning in East Hampton.* New York: The
Solomon R. Guggenheim Museum, 1978.

Wolfe, Judith. *Willem de Kooning: Works from 1951–1981.* East
Hampton, New York: Guild Hall, 1981.

Yard, Sally E. "Willem de Kooning: The First Twenty-Six Years in
New York." Ph.D. diss., Princeton University, 1980.

———. "Willem de Kooning's Men." *Arts Magazine* 56 (Decem-
ber 1981): 134–43.

———. "Willem de Kooning's Women." *Arts Magazine* 53
(November 1978): 96–101.

ADOLPH GOTTLIEB

Davis, Mary R. "The Pictographs of Adolph Gottlieb: A Synthesis
of the Subjective and the Rational." *Arts Magazine* 52 (Novem-
ber 1977): 141–47.

Doty, Robert, and Diana Waldman. *Adolph Gottlieb.* New York:
Whitney Museum of Art, 1968.

Gottlieb, Adolph. Papers. The Adolph and Esther Gottlieb Foun-
dation, New York.

Hirsch, Sandford. *Adolph Gottlieb.* New York: Knoedler Gallery,
1985.

Kingsley, April. *Adolph Gottlieb Works on Paper.* San Francisco:
The Art Museum Association of America, 1985.

McNaughton, Mary Davis. *Adolph Gottlieb Pictographs 1941–
53.* New York: Andre Emmerich Gallery, 1979.

McNaughton, Mary Davis, and Alloway, Lawrence. *Adolph Got-
tlieb: A Retrospective.* New York: The Arts Publisher, Inc.,
1981.

Polcari, Stephen. "Adolph Gottlieb's Allegorical Epic of World War II." *Art Journal* 47 (Fall 1988): 202–7.

———. "Gottlieb on Gottlieb." *New York Nightsounds* 1 (March 1969): 11.

Rand, Harry. "Adolph Gottlieb in Context." *Arts Magazine* 51 (February 1977): 112–13

Roberts, Miriam. *Adolph Gottlieb, Paintings 1921–56.* Omaha, Nebraska: Joslyn Art Gallery, 1979.

Sandler, Irving. *Adolph Gottlieb: Paintings 1945–1974.* New York: Andre Emmerich Gallery, 1977.

Wilkin, Karen. "Adolph Gottlieb: The Pictographs." *Art International* 21 (December 1977): 27–33.

———. *Adolph Gottlieb: Pictographs.* Alberta: The Edmonton Art Gallery, 1977.

HANS HOFMANN

Bannard, Walter Darby. *Hans Hofmann.* Houston: Museum of Fine Arts, 1975.

Goodman, Cynthia. *Hans Hofmann.* New York: Abbeville, 1986.

———. *Hans Hofmann as Teacher.* Provincetown: Provincetown Art Association, 1980.

———. "The Hans Hofmann School and Hofmann's Transmission of European Modernist Aesthetics to America." Ph.D. diss., University of Pennsylvania, 1982.

LEE KRASNER

Cavaliere, Barbara. "An Interview with Lee Krasner." *Flash Art* 94/95 (January/February 1980): 14–16.

Landau, Ellen G. *Lee Krasner: A Study of Her Early Career.* Ph.D. diss., University of Delaware, 1981.

———. "Lee Krasner's Early Career, Part One: 'Pushing in Different Directions.'" *Arts Magazine* 56 (October 1981): 110–22.

———. "Lee Krasner's Early Career, Part Two: The 1940's." *Arts Magazine* 56 (November 1981): 80–89.

Nemser, Cindy. "The Indomitable Lee Krasner." *The Feminist Journal* (Spring 1975): 4–9.

Polcari, Stephen. *Lee Krasner and Abstract Expressionism.* Stony Brook, New York: State University of New York at Stony Brook Gallery, 1988.

Rose, Barbara. *Lee Krasner: A Retrospective.* Houston and New York: The Museum of Fine Arts and The Museum of Modern Art, 1983.

Tucker, Marcia. *Lee Krasner: Large Paintings.* New York: Whitney Museum of American Art, 1973.

ROBERT MOTHERWELL

Arnason, H. H. *Robert Motherwell.* 2nd ed., revised. New York: Abrams, 1982.

———. "Robert Motherwell and His Early Work." *Art International* 10 (January 1966): 17–35.

Carmean, E. A. *The Collages of Robert Motherwell: A Retrospective Exhibition.* Houston: Museum of Fine Arts, 1972.

———, ed. *Robert Motherwell: The Reconciliation Elegy.* Geneva and New York: Skira/ Rizzoli, 1980.

———. "Robert Motherwell's Spanish Elegies." *Arts Magazine* 50 (June 1976): 94–97.

Fineberg, Jonathan. "Death and Maternal Love: Psychological Speculations on Robert Motherwell's Art." *Artforum* 17 (September 1978): 52–57.

Hobbs, Robert C. "Motherwell's Concern with Death in Painting: An Investigation of His Elegies to the Spanish Republic Including an Examination of His Philosophical and Methodological Considerations." Ph.D. diss. University of North Carolina, 1975.

———. "Robert Motherwell's Elegies to the Spanish Republic." In *Robert Motherwell.* Dusseldorf: Stadtische Kunsthalle, 1976.

Mattison, Robert S. "The Emperor of China." *Art International* (*Lugano*) 25 (November/December, 1982): 8–14.

———. *Robert Motherwell: The Formative Years.* Ann Arbor, Michigan: UMI Research Press, 1987.

Van Hook, L. Bailey. "Robert Motherwell's *Mallarme's Swan.*" *Arts Magazine* 57 (January 1983): 102–6.

BARNETT NEWMAN

Alloway, Lawrence. *Barnett Newman: The Stations of the Cross.* New York: The Solomon R. Guggenheim Museum, 1966.

Canaday, John. "Art with Pretty Thorough Execution—Newman and Alloway Provide the Rope." *The New York Times,* April 23, 1966.

Cavaliere, Barbara. "Barnett Newman's 'Vir Heroicus Sublimis': Building the 'Idea Complex.'" *Arts Magazine* 55 (January 1981): 144–52.

Gibson, Ann. "Barnett Newman and Alberto Giacometti." *Issue* 3 (Spring/Summer 1985): 2–10.

Goossen, E. C. "The Philosophic Line of Barnett Newman." *Art News* 57 (Summer 1958): 30–31.

Hess, Thomas B. *Barnett Newman.* New York: Walker and Company, 1969.

———. *Barnett Newman.* New York: The Museum of Modern Art, 1971.

Polcari, Stephen. "Newman: Quality in Art." *New York Nightsounds* 1 (October 1969): 8.

Reise, Barbara. "Primitivism in the Writings of Barnett B. Newman." Master's thesis, Columbia University, 1965.

———. "The Stance of Barnett Newman." *Studio International* 179 (February 1970): 49–64.

Richardson, Brenda. *Barnett Newman: The Complete Drawings, 1944–1969.* Baltimore: The Baltimore Museum of Art, 1979.

Rosenberg, Harold. *Barnett Newman.* New York: Abrams, 1978.

JACKSON POLLOCK

Arts Magazine 53 (March 1979). Special issue devoted to Jackson Pollock.

Bozo, Dominique, et al. *Jackson Pollock.* Paris: Centre Georges Pompidou, 1982.

Selected Bibliography

Frank, Elizabeth. *Jackson Pollock.* New York: Abbeville Press, 1983.

Freke, David. "Jackson Pollock: A Symbolic Self-Portrait." *Studio International* 184 (December 1972): 217–21.

Friedman, B. H. *Jackson Pollock: Energy Made Visible.* New York: McGraw-Hill Book Company, 1972.

Johnson, Ellen H. "Jackson Pollock and Nature." *Studio International* 185 (June 1973): 257–62.

Kagan, Andrew. "Improvisations: Notes on Jackson Pollock and the Black Contribution to American High Culture." *Arts Magazine* 53 (March 1979): 96–99.

Krauss, Rosalind. "Jackson Pollock's Drawings." *Artforum* (January 1971): 58–61.

Landau, Ellen. *Jackson Pollock.* New York: Abrams, 1989.

Langhorne, Elizabeth L. "Jackson Pollock's *Moon Woman Cuts the Circle.*" *Arts Magazine* 53 (March 1979): 128–37.

———. "A Jungian Interpretation of Jackson Pollock's Work Through 1946." Ph.D. diss., University of Pennsylvania, 1977.

Levine, Edward. "Mythical Overtones in the Work of Jackson Pollock." *Art Journal* 26 (Summer 1967): 366–68, 374.

Lieberman, William. *Jackson Pollock: The Early Years.* Santa Fe: The Gerald Peters Gallery, 1988.

———. *Jackson Pollock: The Last Sketchbook.* New York: Johnson Reprint and Harcourt, Brace, Jovanovich, 1982.

O'Connor, Francis V. *The Genesis of Jackson Pollock: 1912–1943.* Ph.D. diss. Baltimore: Johns Hopkins University, 1965.

———. "The Genesis of Jackson Pollock: 1912–1943." *Artforum* 5 (May 1967): 16–23.

———. *Jackson Pollock.* New York: Museum of Modern Art, 1967.

———. *Jackson Pollock: The Black Pourings, 1951–53.* Boston: Institute for Contemporary Art, 1980.

O'Connor, Francis V., and Eugene V. Thaw, eds. *Jackson Pollock: A Catalogue Raisonné of Paintings, Drawings, and Other Works.* New Haven: Yale University Press, 1978.

O'Connor, Francis V., and Eugene V. Thaw, eds. *Jackson Pollock: New Found Works.* New Haven: Yale University Art Gallery, 1978.

O'Hara, Frank. *Jackson Pollock.* New York: George Braziller, 1959.

Polcari, Stephen. "Jackson Pollock and Thomas Hart Benton." *Arts Magazine* 53 (March 1979): 120–24.

———. "José Clemente Orozco and Jackson Pollock: Epic Transformations." Forthcoming.

Potter, Jeffrey. *To a Violent Grave: An Oral Biography of Jackson Pollock.* New York: G. P. Putnam's Sons, 1985.

Robertson, Bryan. *Jackson Pollock.* New York: Abrams, 1960.

Rohn, Matthew L. *Visual Dynamics in Jackson Pollock's Abstractions.* Ann Arbor, Michigan: UMI Research Press, 1987.

Rose, Barbara. *Pollock Painting.* Photographs by Hans Namuth. New York: Agrinde Publications, 1980.

Rose, Bernice. *Drawing Into Painting.* New York: Museum of Modern Art, 1980.

———. *Jackson Pollock: Works on Paper.* New York: Museum of Modern Art and the Drawing Society, 1969.

Rosenblum, Robert. *Images Coming Through.* New York: Jason McCoy, Inc., 1988.

Rubin, David. "A Case for Content: Jackson Pollock's Subject Was the Automatic Gesture." *Arts Magazine* 53 (March 1979): 103–9.

Rubin, William. "Jackson Pollock and the Modern Tradition." Parts 1–4, *Artforum* 5 (February, March, April, May 1967): 14–22; 28–37; 18–31; 28–33.

———. "Notes on Masson and Pollock." *Arts* 34 (November 1959): 36–43. Correction in December issue, p. 9.

———. "Pollock as Jungian Illustrator: The Limits of Psychological Criticism." Parts 1 and 2. *Art in America* 67 (November, December, 1979): 104–23; 72–91. Discussion: William Rubin et al., *Art in America* 68 (October 1980): 57–67.

Stuckey, Charles F. "Another Side of Jackson Pollock." *Art in America* 65 (November 1977): 80–91.

Welch, Jonathan. "Jackson Pollock's 'The White Angel' and The Origins of Alchemy." *Arts Magazine* 53 (March 1979): 138–41.

Wolfe, Judith. "Jungian Aspects of Jackson Pollock's Imagery." *Artforum* 11 (November 1972): 65–73.

Wysuph, C. L. *Jackson Pollock: Psychoanalytic Drawings.* New York: Horizon Press, 1970.

RICHARD POUSETTE-DART

Hunter, Sam, et al. *Transcending Abstraction: Richard Pousette-Dart, Paintings 1939–1985.* Fort Lauderdale, Florida: Museum of Art, 1986.

Kuspit, D. B. "Pousette-Dart in Black and White." *Art in America* 70 (February 1982): 126–28.

Levin, Gail. "Richard Pousette-Dart's Emergence as an Abstract Expressionist." *Arts Magazine* 54 (March 1980): 124–29.

Richard Pousette-Dart. New York: Andrew Crispo Gallery, 1976.

Richard Pousette-Dart Drawings. New York: Andrew Crispo Gallery, 1978.

AD REINHARDT

Lippard, Lucy. *Ad Reinhardt.* New York: Abrams, 1981.

Masheck, Joseph. "Five Unpublished Letters from Ad Reinhardt to Thomas Merton and Two in Return." *Artforum* 17 (December 1978): 23–27.

Rose, Barbara, ed. *Art-as-Art, The Selected Writings of Ad Reinhardt.* New York: Viking Press, 1975.

Rowell, Margit. *Ad Reinhardt and Color.* New York: Solomon R. Guggenheim Museum, 1980.

MARK ROTHKO

Anderson, Max. "Pompeian Frescoes in The Metropolitan Museum of Art." *The Metropolitan Museum of Art Bulletin* 49 (Winter 1987/88).

Ashton, Dore. *About Rothko.* New York: Oxford University Press, 1983.

———. "The Rothko Chapel in Houston." *Studio International* 181 (June 1971): 27.

Bowness, Alan. *Mark Rothko 1903–1970* London: The Tate Gallery, 1987.

Breslin, James E. B. "The Trials of Mark Rothko." *Representations* 16 (Fall 1986): 1–41.

Chave, Anna C. *Mark Rothko: Subjects in Abstraction.* New Haven: Yale University Press, 1989.

Clearwater, Bonnie. *Mark Rothko: Works on Paper.* Introduction by Dore Ashton. New York: Hudson Hill Press, 1984.

———. "Shared Myths: Reconsideration of Rothko's and Gottlieb's Letter to *The New York Times*." *Archives of American Art Journal* 24 (1984): 23–25.

De Menil, Dominique. *The Rothko Chapel.* Houston, 1979.

Haftman, Werner. *Mark Rothko.* Marlborough-Zurich (March 21–May 9 1971).

Liss, Joseph. "Willem de Kooning Remembers Mark Rothko: 'His House Had Many Mansions.'" *Art News* 78 (January 1979): 41–44.

O'Doherty, Brian. *Rothko: The Dark Paintings 1969–70.* New York: Pace Gallery, 1985.

Polcari, Stephen. "Intellectual Roots of Abstract Expressionism: Mark Rothko." *Arts Magazine* 54 (September 1979): 124–34.

———. "Mark Rothko: Heritage, Environment, and Tradition." *Smithsonian Studies in American Art* 2 (Spring 1988): 33–63.

Rathbone, Eliza. "Mark Rothko." In *American Art at Mid-century: The Subjects of the Artist,* by E. A. Carmean, Jr., Eliza Rathbone, and Thomas B. Hess. Washington, D.C.: National Gallery of Art, 1978.

Rosenblum, Robert. *Modern Painting and the Northern Romantic Tradition: Friedrich to Rothko.* New York: Harper and Row, 1975.

———. *Notes on Rothko's Surrealist Years.* New York: Pace Gallery, 1981.

Sandler, Irving. *Mark Rothko Paintings.* New York: Pace Gallery, 1983.

Selz, Peter. *Mark Rothko.* New York: Museum of Modern Art, 1961.

Tsujimoto, Karen. *Mark Rothko 1949: A Year in Transition.* San Francisco: San Francisco Museum of Modern Art, 1984.

Waldman, Diane. *Mark Rothko, 1903–1970: A Retrospective.* New York: The Solomon R. Guggenheim Museum, 1978.

THEODOROS STAMOS

Cavaliere, Barbara. "Theodoros Stamos in Perspective." *Arts Magazine* 52 (December 1977): 104–15.

Pomeroy, Ralph. *Theodore Stamos.* New York: Harry N. Abrams, 1974.

CLYFFORD STILL

Clyfford Still: Thirty-Three Paintings in the Albright-Knox Art Gallery. Buffalo: The Buffalo Fine Arts Academy, 1966.

Clyfford Still. Marlborough-Gerson Gallery (October–November 1969).

Clyfford Still. San Francisco, San Francisco Museum of Modern Art, 1976.

Gibson, Ann. "Regression and Color in Abstract Expressionism." *Arts Magazine* 55 (March 1981): 144–53.

Goossen, E. C. "Painting as Confrontation: Clyfford Still." *Art International* 4 (Summer 1960): 39–43.

Kuspit, Donald B. "Clyfford Still: The Ethics of Art." *Artforum* 15 (May 1977): 32–40.

———. "Symbolic Pregnance in Mark Rothko and Clyfford Still." *Arts Magazine* 52 (March 1978): 120–25.

O'Neill, John P., ed. *Clyfford Still.* New York: The Metropolitan Museum of Art, 1979.

Paintings by Clyfford Still. Buffalo: Buffalo Fine Arts Academy and Albright Art Gallery, 1959.

Polcari, Stephen. "The Intellectual Roots of Abstract Expressionism: Clyfford Still." *Art International* 25 (May/June 1982): 18–35.

Sharpless, Ti-Grace. *Clyfford Still.* Philadelphia: Institute of Contemporary Art of the University of Pennsylvania, 1963.

Sims, Lowery S. "Clyfford Still." *Flash Art* 94/95 (January/February 1980): 4–7.

BRADLEY WALKER TOMLIN

Baur, John I. M. *Bradley Walker Tomlin.* New York: Whitney Museum of American Art, 1957.

Chenault, Jeanne. *Bradley Walker Tomlin: A Retrospective View* (Hempstead: Emily Lowe Gallery, Hofstra University, 1975).

———. "Early Paintings by Bradley Walker Tomlin." *Arts Magazine* (December 1983): 88–89.

Crosman, Christopher B., and Nancy Miller. "Speaking of Tomlin." *Art Journal* 80 (Winter 1979): 107–16.

INDEX

Works of art are to be found in the list of illustrations.

Index

Index

Index